FEMINISM
AND ART HISTORY

Questioning the Litany

Edited by
Norma Broude and Mary D. Garrard

ICON EDITIONS

1817

HARPER & ROW, PUBLISHERS, New York

Cambridge, Philadelphia, San Francisco
London, Mexico City, São Paulo, Sydney

Book designed by C. Linda Dingler

Page layout by Abigail Sturges

Library of Congress Cataloging in Publication Data

Main entry under title:
Feminism and art history.
 (Icon editions)
 Includes index.
 1. Feminism and art—Addresses, essays, lectures.
2. Feminism in art—Addresses, essays, lectures.
I. Broude, Norma. II. Garrard, Mary D.
N72.F45F44 1982 701′.03 81–48062
 AACR2
ISBN 0-06-430525-2
 83 84 85 86 10 9 8 7 6 5 4 3 2
ISBN 0-06-430117-6 (pbk.)
 92 10

Contents

Preface and Acknowledgments

Just over ten years ago the first feminist challenge was levied at the history of art with the publication in 1971 of Linda Nochlin's essay "Why Have There Been No Great Women Artists?", a consideration of the social and sexual prerequisites for the emergence of artistic genius. That was closely followed by the College Art Association (C.A.A.) session chaired by Nochlin in 1972 entitled "Eroticism and the Image of Woman in Nineteenth-Century Art," in which raw sexism in the creation and use of female imagery was so memorably exposed.[1] Over the past decade, stimulated in part by Nochlin's example, but also by the rapidly changing perception of women made possible by a changing social order, a number of papers, articles, and essays have appeared that both sustained the momentum and broadened the base of those earliest feminist questionings of our discipline's deeply held, but completely unexamined, sexual preconceptions.[2]

In response to these efforts, a session entitled "Questioning the Litany: Feminist Views of Art History" was held at the annual College Art Association Meeting in New York in 1978, under the sponsorship of the Women's Caucus for Art. Co-chaired by H. Diane Russell and Mary D. Garrard, the session's purpose was to gather papers whose subjects were, in one way or another, reconsiderations from a feminist perspective of some of the standing assumptions of the discipline of art history—papers that held out, collectively, the possibility of the *alteration* of art history itself, its methodology and its theory, an aim to be distinguished from the *additions* to art history that were being provided in the same period by the rediscovery of numbers of forgotten women artists. In the following year, 1979, at the C.A.A. meeting in Washington, D.C., the Women's Caucus for Art sponsored a second "Questioning the Litany" session, chaired by Christine Mitchell Havelock, in which the approach taken in the first session was continued and extended.

It was early in 1979 that the two of us decided to create and co-edit this book. The initial stimulus for this collection of essays was provided by the "Questioning the Litany" sessions themselves, the interest they generated, and the exhilarating sense of possibility

the papers contributed to them had suggest-ed. That stimulus is reflected in the book's subtitle, and in the fact that four of the essays included here—those by Luomala, Alpers, Sherman, and one by Broude—were first de-livered at a "Questioning the Litany" session.

In projecting the book, however, we decid-ed to go beyond recording the particular pro-grams of 1978 and 1979, and to collect papers and articles written over the past decade—and even earlier—that would best represent the full scope of the challenge that feminism has placed before art history. Thus, two of the seventeen essays included were first pub-lished in the pioneering *Feminist Art Journal,* the one by Mainardi on quilts in 1973, and the one by Hofrichter on Judith Leyster in 1975. Another four of the essays were origi-nally published in *The Art Bulletin,* the scholarly journal of our discipline's profes-sional organization, the College Art Associa-tion of America. The earliest of them, Kahr's "Delilah," was presented at a C.A.A. meeting in 1970 and published in *The Art Bulletin* in 1972; it was followed by Duncan's "Happy Mothers," read in 1972 and published in 1973; Broude's "Degas," read in 1975 and published in 1977; and Nochlin's "Lost and *Found,*" published in 1978.

In making our selections for this volume, some choices were obvious ones while others came harder, since feminist revisionist activ-ity has occurred with greater vigor in some historical periods than in others. Much to our regret, space limitations, and the desire to have a reasonably balanced coverage of major historical periods, prevented our including some excellent work that surely belongs in a collection of this kind.

By bringing together in one volume both new essays and many that have been pub-lished elsewhere, we hope to provide a con-text in which the individual importance of each essay may be better understood in rela-tion to the larger issue and task before us. As a compendium of important recent ideas on

the subject, the book will, we hope, be of use to scholars, students, and general readers un-familiar with the effect of feminist thinking on art history. Beyond that, however, we would like to see this collection stimulate more work in the same vein. Each of the es-says in the book is a ground-breaking effort, both for the historical period it addresses and for the specific ways in which its subject is reexamined. Many more artists, periods, and cultures deserve new critical scrutiny; the possibilities are infinite.

In planning and preparing this book for publication, we are fortunate to have had en-couragement and assistance from many quar-ters. First, we must acknowledge the invalu-able support that came from the Women's Caucus for Art in providing a continuing fo-rum for these ideas. In particular, we thank Judith K. Brodsky, who was president of the Caucus at the time of the first "Questioning the Litany" session, and who has been espe-cially encouraging from that time to now. We would also like to thank innumerable other friends in the Caucus and in the Coali-tion of Women's Art Organizations, whose enthusiasm for this project has helped to sus-tain us.

We are grateful for support from our own institution, The American University, and from the College of Arts and Sciences, which awarded us a Mellon Faculty Development Grant to facilitate this project. Among the friends and colleagues at the University who encouraged our project, we would particular-ly like to mention Ann Ferren, Kay Mussell, and Roberta Rubenstein. We have greatly appreciated the confidence and backing of the Art Department, and we are especially thankful for the continuous interest and en-thusiasm that has come from our students, our sharpest and most valued critics.

We would like to express special apprecia-tion to the contributors to this volume. They have all been marvelous to work with. The book has benefited in a variety of ways from

their suggestions and advice, and our own job as editors has been made much easier by their cheerful cooperation and patience.

We would like to thank Madlyn Millner Kahr and Cass Canfield, Jr., for believing in this book.

And, finally, we would like to express our gratitude to each other, for the qualities of intellectual stimulus, psychological complement, creative disagreement, and mutual appreciation that are the essence of a productive partnership, and of a whole that is more than the sum of its parts.

NOTES

1. Linda Nochlin, "Why Have There Been No Great Women Artists?", *Art News,* 69, no. 9, January 1971, pp. 22–39, 67–71. The papers read at Nochlin's C.A.A. session were published in *Woman as Sex Object, Studies in Erotic Art, 1730–1970,* ed. by Thomas B. Hess and Linda Nochlin, Art News Annual 38, Newsweek, Inc., New York, 1973. They include Nochlin's "Eroticism and Female Imagery in Nineteenth-Century Art," pp. 8–15.

2. A sampling of the theoretical literature from this period is found in Judy Loeb, ed., *Feminist Collage: Educating Women in the Visual Arts,* New York, 1979. See also Lise Vogel, "Fine Arts and Feminism: The Awakening Consciousness," *Feminist Studies,* 2, no. 1 (1974), pp. 3–37; and Carol Duncan, "When Greatness Is a Box of Wheaties," *Artforum,* 14, October 1975, pp. 60–64. For an overview and critical discussion of feminist art historical writing of the seventies, see the review essays by Gloria F. Orenstein, "Art History," *Signs: Journal of Women in Culture and Society,* 1, no. 2, Winter 1975, pp. 505–25; and H. Diane Russell, "Art History," *Signs: Journal of Women in Culture and Society,* 5, no. 3, Spring 1980, pp. 468–81.

Introduction:
Feminism and Art History

Norma Broude and Mary D. Garrard

The history of art, like other scholarly disciplines, has matured over the centuries by expanding its boundaries to include new ways of looking at its subject. After the rudimentary descriptions of Pliny the Elder came the biographies of Vasari, followed by the archaeological researches of Winckelmann, the historical insights of Burckhardt, and the archival investigations of Waagen and Milanesi. The frame of reference was further widened by the connoisseurship of Morelli and Berenson, the theoretical substructures of Riegl and Wölfflin, the formalism of Fry and Bell, the iconographic studies of the Warburg school, the psychological approaches of Kris and Gombrich, and the social approaches of Hauser, Antal, Baxandall, and others. In the course of its development, art history has drawn nourishment from intellectual advances made in other fields. Radically new perspectives on human experience—whether these involved archaeological discovery, the discovery of the subconscious mind, or of the behavior of social classes—have eventually had a broadening effect upon the way that art historians think.[1]

Feminism, or the historical discovery of women, has had in the past decade a comparably broadening effect upon art history. On the most basic and, to date, the most visible level, it has prompted the rediscovery and reevaluation of the achievements of women artists, both past and present. Thanks to the efforts of a growing number of scholars who are devoting their research skills to this area, we know a great deal today about the work of women artists who were almost lost to us little more than a decade ago, as a result of their exclusion from the standard histories.[2]

This book, however, is not about women artists. Feminism has raised other, even more fundamental questions for art history as a humanistic discipline, questions that are now affecting its functioning at all levels and that may ultimately lead to its redefinition. In its broadest terms, we would define the impact of feminism on art history as an adjustment of historical perspective, and, at the outset, an analogy may help us to establish this point.

Early in the fourteenth century, the Italian poet Petrarch walked through the streets of Rome with his friend Giovanni Colonna, talking of history. He surveyed the ancient ruins of the city with deep emotion, seeing in

them a silent and enduring witness to the greatness and splendor of ancient Rome. Petrarch was inspired by this vision to define as "ancient history" the period before the official Roman acceptance of Christianity, and to distinguish it from "modern history," which he described as a period of cultural darkness, without interest to himself and his contemporaries. Although Petrarch saw his own time as part of that "Dark Age," he could visualize and appeal for a revival of the Golden Age of the ancient past. He believed that his culture was on the brink of spiritual rebirth, which would put an end to the process of decline and bring about the beginning of a new era. What Petrarch called "modern" history, the humanists of the fifteenth century would call "medieval." It was his insight, nevertheless, that formed the cornerstone of the totally new view of history that was to be codified in the "Renaissance"—an age that saw itself as the legitimate heir to a past Golden Age, following an interim period of barbarism and ignorance.[3]

Just as Renaissance humanists were able to define the "Dark" or Middle Ages for the first time as a separate transitional age, bounded at either end by differing cultures, and could therefore understand it as a distinct period with cultural characteristics that were unique to it rather than universal, so feminists have named as "patriarchal" that period of more than five thousand years which reaches down to the present, and which began with the gradual replacement of a long-standing Goddess-worshipping culture by patrilineal and God-worshipping civilizations.[4] Beyond the diversity of this patriarchal period—a diversity with which its historians have been preoccupied—our new historical perspective allows us to see the steady, one-dimensional bias that has pervaded it. From the new historical vantagepoint afforded by feminism, the recorded history of Western civilization thus shrinks to a narrow account of the deeds and institutions of men and of

the monuments that have been erected to celebrate them.

For art historians, this new historical perspective has permitted for the first time a clear vision of the controlling part that sexual attitudes and assumptions have played both in the creation and naming of "Art" and in the writing of art history. We can see how persistently and insidiously low esteem for women has figured in the formation of value judgments, consigning to perpetual second-class status all aspects of art associated with femininity: the crafts and the so-called minor arts, historical styles such as *maniera* or the Rococo, and even art itself in the larger social order. We are for the first time in a position to ask whether the ethical and idealist values associated with heroic art of the past—from the Apollonian male nude to the prime-ranked history paintings of the academies—were in fact the universal values of "mankind," or the narrower values of men, that band of brothers who ran the cultural institutions. We are also now in a position to ask whether artistic images are reliable reflections of male and female roles and relationships in particular cultures, or whether the images may instead reflect the dream worlds or vested interests of male artists and their patrons. Conversely, we may ask whether an art might not occasionally tell a social truth about its culture, a truth overlooked or misinterpreted by historians who are steeped in the sexual mores of a later and different age.[5]

A recognition of the distortions that sexual bias has imposed both upon the creation and the interpretation of art in our culture has impelled each of the contributors to this volume to question in one way or another an art historical "litany." Prompted by this insight to reconsider the evidence, each has offered a more accurate or a more balanced understanding of a work of art, an artist, an iconographical theme, or a period. Individually, these essays represent a series of specific corrections to traditional art historical interpre-

tations. Collectively, however, they point to a new reading of history itself, and a new definition of the cultural and social uses of art.[6]

The first two essays in this collection, by Nancy Luomala and Vincent Scully, deal with the material evidence that attests to the historical reality of the ancient Great Goddess culture. Although archaeological and anthropological evidence has confirmed the existence of various forms of Goddess worship for a period of at least 20,000 years prior to the beginnings of Egyptian civilization, art historians often ignore the existence of the Goddess culture, even when they deal with the monuments that may reflect for us most clearly the character and the values of the pre-patriarchal period. Or, alternatively, they may sometimes misinterpret the physical remains of pre-patriarchal cultures to fit their own, more familiar, patriarchal conceptions of social organization.

The term "patriarchal" is used here to describe the social and religious structure of life in the Western world over the last five thousand years, but we are not suggesting that what preceded it was its mirror opposite, a matriarchy, in which roles were reversed, with social power and authority held by the females. For the model of a social order in which power is vested primarily in one sex is itself a patriarchal idea, and studies of ancient cultures suggest that these opposite extremes have not always been societies' only choices.

Both Egypt and Crete were transitional civilizations, and Luomala and Scully have each shown that we misunderstand these cultures when we ignore aspects of their imagery that reflect the previous civilizations out of which they come, paying attention only to the images of the emerging patriarchal world order. Luomala, for example, discusses the difficulty that art historians living in a patriculture have in dealing with the concept of matrilineal descent in Egyptian society. As anthropologists have long known, royal descent in Egypt was reckoned through the female line. The queen, though presented in art history textbooks as an insignificant adjunct to the pharaoh, was in reality the possessor of important powers, both mystical and real, to which the king had access only through marriage to a member of the female royal line. Luomala points to the perpetuation of the imagery and symbolism of Goddess-worshipping cultures in much of Egyptian art. She also demonstrates the links that existed between matrilineal descent in Egypt and the symbols that surrounded Egyptian royalty, suggesting further evidence regarding the real nature of the queen's role in ancient Egypt may be found in the images and monuments, awaiting unbiased reinterpretation.

In his discussion of the palace architecture of Minoan Crete, Vincent Scully dispels the myth that pre-Greek Aegean architecture lacked orderly or meaningful arrangement. In this essay, excerpted from his larger study of Greek sacred architecture, *The Earth, the Temple and the Gods* (first published in 1962), Scully looks beyond the orthodoxies of classicism, which have encouraged us to see formal structure only in the imposition of regular or mathematical forms upon the irregularities of the natural world. Instead, he sees in the siting and design of the palaces of Bronze Age Crete a persistent and deliberate use of other modes of spatial organization, which relate to the imagery and the symbols of the Stone Age Great Goddess. These include labyrinthine and serpentine paths of movement, and architectural forms that are open, hollow, non-monumental, and responsive to the sculptural forms of nature. This is architecture based on the principle foreign to academic classicism—though not originally to Minoan and Greek architecture itself—of a reciprocity between architecture and nature, in which, as Scully says, "the natural and the man-made create one ritual whole." Scully suggests that the consistent siting of Minoan palaces in an enclosed valley and in align-

ment with a double-peaked mountain was consciously chosen to evoke the form of horns, an ancient and pervasive symbol of the Great Goddess. In such a relationship with the earth, which was conceived in ancient times to be the sacred body of the Goddess, the palace could function as a conduit of the Goddess's power to the Minoan kings who exercised that power. Thus, both Scully and Luomala reveal to us the similar and sustaining religious principle that lay behind the power structures of societies as diverse as Egypt, Crete, and even Achaian Greece: though their rulers might be male, those rulers derived their right to rule as well as the power that they wielded from the female Goddess, history's most nearly universal deity, whose imagery may be found to have survived long after patriarchal social systems had taken root.

The Indo-European invasion and conquest of the Greek mainland shortly after 2000 B.C. brought to the Mediterranean world an aggressive and bellicose people, whose descendants, the Achaian and Dorian Greeks, were to found the Western world's first known heroic and patriarchal civilization. Whatever the actual position of ordinary women may have been in pre-Greek societies—and that is far from clear—it is certain, as Christine Mitchell Havelock shows, that ancient Greece, though regarded as a "Golden Age" by subsequent cultures, was deeply misogynist and deliberately repressive of women. In her essay, "Mourners on Greek Vases: Remarks on the Social History of Women," Havelock establishes the preeminence of male values and virtues in Greek myth and in public and monumental Greek art. She goes on, however, to define a role of continuing importance and dignity for women in rituals that pertained to the domestic realm and to the larger cycles of human life, such as the funerary rites that are represented on Geometric and post-Geometric vases. These ceremonial roles played by women in rituals of

birth and death in Greek society remind us of—and may be survivals of the customs of—those ancient cultures that worshipped a Mother Goddess who controlled procreation and death. Implicit in Havelock's discussion of these ceremonial roles assigned to women in Greek society, an assignment of role that suggests a continuing recognition of their superior powers of caring and assisting in the life process, is a reassessment of our own priorities when we deal with the social values held by the Greeks: is killing and dying heroically necessarily a greater human attainment than mourning the dead and comforting the living? And have we not further exaggerated the already imbalanced set of cultural values that existed in the Greek world by our own selective attention principally to the masculine and heroic imagery in Greek art?

In Havelock's analysis of the changing status of women in Greece, as in Natalie Kampen's discussion of Roman working women, artistic images are used as interpretive keys to the social position of women in a male-dominated culture. Kampen, too, sets out to rectify the art historical imbalance created by our own emphasis upon the monuments of Roman art that glorify the official side of Roman life, its empire-building and colonization, its wars and its victories. So thoroughly do we ourselves accept those official values of Roman culture that we have come to define its art almost exclusively in their terms, illustrating and studying as "typical" of the culture as a whole images that, in reality, pertain almost exclusively to the upper and ruling classes. In these images, women figure principally as personifications or as relatively idealized portraits of well-to-do ladies. Kampen's approach and her contribution is to focus instead upon images that reflect the unofficial side of Roman life and its "silent populations," whose lives are not adequately recorded in written history. By isolating a little-studied category of art—reliefs depicting working-class life and, specifically, the activi-

ties of saleswomen—Kampen pinpoints an unusual situation in Roman art in which male and female figures are treated with equal degrees of realism. Comparing these images with those representing other occupational groups, she graphically demonstrates the ways in which class and gender functioned, interdependently, to determine iconography in Roman images of working women.

With the gradual establishment of the power of the Christian Church during the centuries following its acceptance by the Roman Empire came a resurgence of misogynist attitudes toward women and a limiting of their social freedom, this time reinforced by theological argument.[7] In the essay entitled "Eve and Mary: Conflicting Images of Medieval Woman," drawn from his book *The Living Theatre of Medieval Art* (1967), Henry Kraus defines the Church's conception of Eve, who was, in the words of St. Bernard of Clairvaux, "the original cause of all evil, whose disgrace has come down to all other women." Kraus vividly shows the controlling use made in medieval monasteries of artistic images that reflected this identification of women with evil, vice, and the Devil himself. In direct contrast to the fallen Eve was her theological opposite, the pure and saintly Virgin Mary, who redeemed Eve's sins. The cult of the Virgin, which elevated Mary to queenly and revered status and which reached a peak of intensity in the thirteenth century, has frequently been adduced as effective refutation of the charge that the Church was misogynous. Kraus argues to the contrary, pointing to the carefully developed pairing of Eve and Mary as doctrinal complements in both literary and artistic images; and—in anticipation of the interpretations of recent feminist historians and theologians—he observes that the prototypical concepts of both Eve and Mary were equally extreme and inhuman, unrepresentative of and inaccessible to living women. Attentive to the underlying message of the visual images, and in

defiance of the standing litanies, Kraus recognizes and names as misogynous medieval attitudes toward women. He goes on to trace the gradual humanizing of the image of woman, both Mary and Eve, in later medieval art and theology, and to establish a parallel between the wane of misogynist attitudes and the rise in the economic and social status of women during the period of the Crusades. The complicated but not necessarily contradictory attitudes toward women, who were perceived simultaneously by the medieval Church as models of bestiality and purity, have been treated more fully by recent historians and theologians.[8] But rarely have art historians dealt with this subject more explicitly than Kraus, who has brought to his study of medieval art a zest for searching out answers in social history to art historical questions, questions described by Harry Bober as "not yet satisfactorily answered or not even asked before."[9]

Along with the dominance of a masculine value system in art and art history has often come a blindness to female experience, or, sometimes quite literally, to female existence, even when the reality of women's roles is well documented by the art of a given place or period. Among the writers in this volume who set out to rectify such omissions is Claire Richter Sherman. In her essay entitled "Taking a Second Look: Observations on the Iconography of a French Queen, Jeanne de Bourbon (1338–1378)," Sherman explains how a feminist perspective led her to reexamine a fourteenth-century French illuminated manuscript that had long been familiar to her in another context,[10] and to make, as a result of this fresh inquiry, some important observations and contributions to the neglected study of French medieval queenship. The manuscript in question, known as the *Coronation Book of Charles V of France*, contains a surprisingly extensive cycle of miniatures that relate to the coronation of the queen, Jeanne de Bourbon. Even though this cycle provides

for us the earliest extant illustrated account of the coronation of a French queen, it has held no interest for historians, who have apparently deemed it to be of little significance because of the diminished political position of French queens in the fourteenth century. Although a comparison of the queen's minatures with those of the king in this *Coronation Book* does in fact confirm the queen's lesser political status, Sherman's careful study of text and imagery reveals the important and acknowledged role that the queen played in the public life of the monarchy, where, like the Virgin Mary who was the Queen of Heaven, she was expected to embody the virtues of mercy, wisdom, charity, and justice. Citing the activities of French queens as founders of religious and civic institutions and as patrons of art and literature, Sherman urges us to reexamine the visual and historical documents of the period from a new perspective, so that we may come to recognize and reevaluate "the important cultural contributions of this influential group of women."

In blaming women for many of the weaknesses of human nature—especially uncontrolled sexuality—medieval theologians, priests, and artists created the prototypes for two of the most enduring themes in Western art and literature: the temptress and the fallen woman. Both have left a permanent imprint upon the Western imagination, as subsequent essays in this volume reveal. The story of Samson and Delilah, for example, has been used since the Middle Ages as an effective cautionary message to man, that he must resist the allure of woman, who will seduce, betray, humiliate, and destroy him. In her essay "Delilah," Madlyn Millner Kahr traces the evolution of this pervasive and influential theme in examples from the medieval, Renaissance and Baroque periods, from both northern and southern Europe. Beginning with the Freudian postulate that the fictive setting of art will foster the expression of unconscious sexual conflicts, Kahr examines the

Samson and Delilah theme from the viewpoint of the unconscious sexual attitudes that inform each culture's interpretation and use of it. In every example with which she deals, she probes "beneath the surface of the traditional narrative" for "intimations of psychological determinants that help to explain both the form of the image and its deep appeal." Thus Kahr is able to treat the Samson and Delilah theme in a more fully three-dimensional way than previous iconographers have done, not only because she supplements the more conventional methods of art historical inquiry with the component of psychological analysis, but also because she brings to bear upon her subject insights born of a feminist perspective. It is the historical distance this perspective provides that enables us to recognize the values and fears embedded in the Samson and Delilah story as nurtured attributes of specific cultures rather than as universal and eternal moral imperatives. Armed with this insight, Kahr goes well beyond conventional treatments of her subject, holding up for civilized reconsideration the "heroic" values traditionally associated with the Samson story, and revealing to us the role that misogyny has played both in the evolution and in the popularity of the Delilah theme.[11]

In "Artemisia and Susanna," Mary D. Garrard also examines the treatment in art of a particular theme, that of Susanna and the Elders. In this case, the author's goal is to define the unique character of the theme's handling in one particular early seventeenth-century painting, and thereby to solve the problem of that painting's attribution. The painting in question, though inscribed with the name of Artemisia Gentileschi, has been considered by several scholars to be the work of her father, Orazio. Garrard establishes the work as Artemisia's by distinguishing its uniquely sympathetic treatment of its subject—presented, unusually, from the viewpoint of the female protagonist—from the

way in which that subject was traditionally handled during the Renaissance and Baroque periods by male artists, who emphasized not Susanna's plight and victimization but rather the elders' anticipated pleasures. These interpretations, which blatantly distorted the biblical Susanna, nevertheless prevailed because most artists were men, instinctively drawn to identify with the male rather than the female protagonists of the stories with which they dealt. Artemisia, herself a victim of rape, brought a very different attitude to bear upon this and related subjects that she treated. Beyond the particular problem of attribution that is involved here, Garrard points the way toward the more general use of such feminist iconographical analysis as a valuable new tool for art historical connoisseurship. "The definitive assignment of sex roles in history," she writes, "has created fundamental differences between the sexes in their perception, experience and expectations of the world, differences that cannot help but have been carried over into the creative process, where they have sometimes left their tracks." If we are attentive—as she suggests we should be—to the personal voice and uniquely female perceptions that women artists of the past may have brought to their treatment of traditional themes, we may then be in a better position to define the lost *oeuvres* of many of these women, whose achievements were later partially subsumed, like Artemisia's, by the identities of their better known fathers and husbands.[12]

Judith Leyster, who was Artemisia Gentileschi's Dutch contemporary, was, like Artemisia, famous in her own lifetime but largely ignored in subsequent scholarly literature. In her essay "Judith Leyster's 'Proposition'—Between Virtue and Vice," Frima Fox Hofrichter examines a painting by Leyster in which the artist delivers a subtle personal critique of the traditional Dutch artistic theme of prostitution—rather than merely presenting an example of the theme, as had previously been thought. The central figure in the painting, a woman sewing, is shown by Hofrichter to be not the temptress-instigator of the sexual proposition, as was common in Northern art of the sixteenth and seventeenth centuries, but instead the "embarrassed victim" and "embodiment of domestic virtue," who steadily ignores the unwelcome and improper offer that is being made to her. Not only was Leyster's treatment of the theme, with its heroic female protagonist, unique in her own period and earlier; it may also have formed an important link between the Dutch genre painters of the early seventeenth century and those of the generation of Vermeer and Metsu. This essay, an early effort to concentrate on what is unique and innovative in the iconography of a woman artist, provides a useful model for further scholarship. Inasmuch as Hofrichter was a graduate student at the time her paper was written, it is appropriate to acknowledge here the stimulus and direction given her by her thesis adviser, Ann Sutherland Harris, whose important contributions to the literature on women artists are well known.[13]

The heroines treated by Kahr, Garrard, and Hofrichter resemble each other in that their fundamental identities as virtuous or heroic women (Delilah was, after all, the Judith of the Philistines) were in one way or another compromised or distorted in artistic imagery or art historical scholarship. As embodiments of female heroism in an androcentric culture, they share, too, the fact that each is defined almost exclusively in erotic terms. Whether typecast as temptress or saint, they are nevertheless, as Garrard writes in "Susanna," characterized primarily as "sexual creatures as a result of sexual acts imposed on them by others." No matter how fine the needlework with which the woman in Leyster's picture is absorbed, she is not defined for us in terms of her positive occupation; rather, like Susanna, she exists and will be remembered by us in terms of what she is choosing *not* to do, what

she is obliged to use her energies to resist. As we shall see in subsequent essays, this casting and conceiving of women in primarily sexual roles according to the medieval formula has continued in art, with rare exceptions, into the modern era, despite the reality of women's increasing participation in the diverse activities of the larger world.

In "Art History and Its Exclusions: The Example of Dutch Art," Svetlana Alpers sets out to reexamine from a feminist perspective nothing less than the larger values and methodological assumptions of art history itself. Claiming that "art history as a discipline has had a point of view, which involves choices and exclusions," Alpers observes that the methodology of the discipline has been narrowly based upon Italian Renaissance standards and values. Specifically, the Italian conception of the picture space as a window onto a world, whose boundaries are firmly defined by the picture frame, and which is seen in one-point perspective by a viewer in a fixed position, does not adequately describe Northern painting of the fifteenth through seventeenth centuries. For this is an art that projects the opposite qualities, of dispassionate acceptance of the world seen, and a taste for describing it rather than possessing or ordering it. Alpers points out that these different approaches to art and nature underwent sexual stereotyping as early as the Renaissance itself, when Northern painting was scorned by Italians as "an art for women." The same critical attitude, she argues, has infected even so-called objective art historical scholarship, making generations of Renaissance-trained scholars insensitive to qualities in Northern (or other) art that do not happen to fit the Italian mold.

Alpers leads us to see that the available metaphor of the polarity between the sexes has served to reinforce traditional value distinctions between Northern and Italian art, keeping Northern art in a permanent ancillary position relative to the Italian norm. In-

verting the value relationship, Alpers points to the art of Vermeer as the quintessential expression of the "female" way of experiencing the world, showing in an analysis of several of Vermeer's paintings the successful application of such alternative approaches as fragmentary perception, a non-possessive relation between artist/observer and female subject, and the pictorial presentation of monumental female figures, who in their exclusive attention to their own affairs are supremely "self-possessed." Noting that these images were painted by a man, not a woman, Alpers proposes that "it is not the gender of the makers, but the different modes of making that is at issue." To recognize and assign appropriate value to "modes of making" that have escaped the rigid net of Italianate-masculinist criticism is, she suggests, a major challenge now posed for the discipline of art history.[14]

The extent to which art has contributed to the process of sex-role socialization in our culture is explored for a particular historical period by Carol Duncan in her article of 1973, entitled "Happy Mothers and Other New Ideas in Eighteenth-Century French Art." In eighteenth-century France, she observes, the secular themes of happy motherhood and marital bliss became increasingly popular and fashionable as subjects for art and literature. In a world where aristocratic parents took little or no responsibility for the direct rearing or education of their children, and where the social norm was the arranged marriage, entered into for economic and dynastic convenience, these concepts of family life were wholly new and unfamiliar ones. Duncan studies the emergence of these new themes in French art during a crucial time of social and political transition, when the first model of the modern bourgois state was taking shape. Contrary to the current, traditionally accepted practice among the wealthy, who normally sought their personal pleasures and fulfillment outside their arranged mar-

riages, enlightened philosophers, educators, and social critics in eighteenth-century France advocated marriage and parenthood as the individual's path to personal happiness. Duncan shows us how art played a not insubstantial role in the Enlightenment's campaign to promote the new ideals of conjugal love and parental responsibility. Central to the success of the new family unit they espoused—and to the success of the emerging middle-class culture which that family would serve—was the ideal of the happy and beloved mother, who, contrary to what was then traditional practice, nursed her own children, raised them at home, and saw to their individualized education. It was an ideal that depended openly upon educating women from childhood on to be docile, submissive, and positively to want to organize their lives around the needs of their husbands and children—to educate women, in other words, to accept their "nature," as this was defined for them by the philosophers, educators, writers, and artists of the period.

Duncan goes on to outline the complex social, economic, and cultural factors that lay behind the growing campaign in eighteenth-century France to convince women that motherhood was indeed their only natural and only joyful role, showing us that what we see in the pictures of the period was not a reflection of what actually was, but of what Enlightenment philosophers felt ought to be. So successful was their campaign—and the similar ones, for similar purposes, that have followed it in modern society down to the present day—that we have come indeed to accept the social role the Enlightenment prescribed for women as the natural order of things. For the late twentieth-century reader, the issues, the arguments, and the strategies that were born of changing social conditions in eighteenth-century French society—a society on the brink of the modern age—will be chillingly familiar ones, and will serve as an important historical reminder of the extent to which the so-called "natural" in the modern social order of things has been, in fact, almost entirely man-made.[15]

The pendant to the virtuous wife and happy mother of eighteenth-century art was her moral opposite, the fallen woman, a type that held great fascination for artists, writers, and social critics, particularly in mid-nineteenth-century Victorian England. In "Lost and *Found:* Once More the Fallen Woman," Linda Nochlin examines a major example of this popular theme in mid-nineteenth-century English art: an unfinished work by Dante Gabriel Rossetti, entitled *Found.* In her essay, Nochlin explores not only the visual and symbolic structure of the picture and its personal meanings for the artist, but also its relationship to the broad range of fallen woman imagery in the nineteenth century, and to the social and moral issues that colored the subject both for the artist and his contemporaries. Unlike the more black-and-white view of venal corruption and its punishment that had been typical of eighteenth-century images of prostitution in England—for example, in the work of Hogarth—nineteenth-century artists and writers increasingly and sympathetically acknowledged the causal role of poverty and urban indifference to the sufferings of the poor when they dealt with the subject of corrupted innocence. As many pictures of the period made clear, for those few fallen souls of lower-class origins who managed to escape an ignominious end, redemption might be earned through a return to the family and a full acceptance of its humble social condition. But for the protected middle-class wife and mother, whose lapse was seen as a dangerous and intolerable threat to the stability of the home, that "bulwark of Victorian paternal authoritarianism," the hope of redemption was not as readily offered. Indeed, the permanent loss of the home and its warm security was the usual fate of the erring wife in nineteenth-century art. Thus, as artists of the eighteenth century had helped to

establish, those of the nineteenth century helped to protect the sanctity of the bourgeois home as the instrument and embodiment of nature's law.

In "Degas's 'Misogyny,'" Norma Broude examines the social biases and sex-stereotyped expectations that impelled art critics and writers in the late nineteenth century to regard Edgar Degas and his art as misogynist. She points to the survival of these same social attitudes and values in our own century as a root cause of modern-day art historians' uncritical acceptance of the notion of Degas's misogyny, and reveals the extent to which these biased expectations have distorted prevailing interpretations of many of Degas's works. While the imagery of Degas's paintings and the evidence of his life clearly contradict the standard accusation of misogyny, they reveal at the same time that Degas's attitudes toward women were atypical for his period, and that he challenged in many ways that period's artificial codes and "cherished myths" regarding the role and position of women in society. Looking at Degas's many portraits of women and his early history paintings, Broude points to the artist's sensitivity to nuances of relationship between the sexes, his generally sympathetic treatment of his female subjects, and his unusual emphasis, in presenting them, upon their independent identities and their creative powers ("intellectual and artistic rather than biological").

Degas's own personal friendships with many intelligent and creative women, and his professional encouragement of artists like Mary Cassatt and Suzanne Valadon, are treated as further indications of his unusual freedom from the conventional values held by most men of his period: men such as Renoir, whose interest in women seems to have been confined to their sexuality and their suitability as models, or Manet, whose behavior toward women was at best conventionally chivalric. These represented a norm of masculine behavior that Degas rejected in favor

of a personal standard which, ironically, modern-day feminists would be more inclined to relate to a universal and humanistic ideal. It was by the normative standard of his own period, however, that Degas was judged, both by his contemporaries and by art historians in our own century. By labeling Degas's iconoclasm as "misogynist"—the product of personal malevolence or maladjustment—his critics succeeded in containing and dismissing its threatening message. That their assessment has stood for so long is sobering testimony to the power, as Broude puts it, of "assumptions held by society at large" to "compromise scholarly objectivity." Her essay reveals, as does Alpers's, that in the writing of art history, it is not only women who have been the victims of sex-biased expectations.

At times in the history of art, an important shift in critical evaluation can be initiated by someone asking: "Have the values embodied in this art remained meaningful and universally significant?" Alessandra Comini begins her essay "Gender or Genius? The Women Artists of German Expressionism" with such a question concerning the Norwegian founding father of German Expressionism, Edvard Munch. Noting that the representation of specific personal emotions was the hallmark of Expressionist art, Comini reveals the element of egoistic self-pity that characterizes Munch's much vaunted expressions of personal anxiety, particularly in comparison with the work of his contemporary, the German printmaker and sculptor Käthe Kollwitz.

With tongue partly in cheek, Comini leads us through a critical comparison of the two artists, in which the usual stereotypes are reversed and the male artist shown to be the more subjective and personal, with the female the more profoundly universal. For Kollwitz, who responded very directly to the major wars and political upheavals of twentieth-century life, was an artist whose emotion and personal grief were channeled into art on

behalf of society and humanity in general. Comini holds up the powerfully moving and more broadly humanistic art of Kollwitz as equally representative of the age of Expressionism, and finds Kollwitz's virtual exclusion from the litanies of Expressionism to be a consequence principally of her being the "wrong" gender—there having been, she observes, a notable absence of "mothers" of artistic movements. "Many voices," Comini writes, "must sound to express an age. Munch's scream was not unique. If we ask, however, for whom did the bell toll, Munch's answer was 'for me,' Kollwitz's response was 'for thee and all mankind.'"

Turning to other women artists connected with the Expressionist movement, Comini examines the careers of Paula Modersohn-Becker and Gabriele Münter in their contemporary contexts and, in particular, in relation to the male artists Otto Modersohn and Wassily Kandinsky, respectively, with whom they were associated and by whom they were overshadowed during their lives. Comini finds in the work of these women, when juxtaposed with that of their male counterparts, artistic qualities that (we note with irony) are more typically thought of as "masculine"— strong, bold design rather than romantic nostalgia; and solid, gravity-rooted forms instead of floating, airy ones. Despite significant progressive and innovative qualities in their work, the achievements of Modersohn-Becker and Münter have suffered undue art historical neglect—a condition in part here remedied by Comini's contribution.

Comini's question, "Why have there been no mothers of German Expressionism?" finds an answer in Carol Duncan's ground-breaking article of 1973, here revised and expanded, entitled "Virility and Domination in Early Twentieth-Century Vanguard Painting." Duncan takes as her point of departure the pictures of women, and in particular of the female nude, that were painted in great numbers by the Fauves, Cubists, German Expressionists, and other vanguard artists in the decade before World War I. Although the male artists of this generation rejected the vampire/virgin dichotomies of Symbolist art,[16] they shared with their brethren of that previous generation the assumption that the relationship between the sexes, seen exclusively from the point of view of male experience, was a central issue of Life with which Art must deal. Their work abounds in images of powerless, often faceless nudes, sprawled as "passive, available flesh" before the artist-viewer, serving in various ways as proofs of and as witnesses to the artist's sexual virility and to his freedom from bourgeois restraint. This assertion of male virility and sexual dominance, which found its expression through images of female sexual subjugation in so much of early twentieth-century art, "effectively alienated women (artists)," Duncan writes, "from the collective, mutually supportive endeavor that was the avant garde." They were alienated and excluded too by the period's insistence (along with Freud) upon the idea that cultural creativity is a function of male libidinous energy, as well as by the reassertion of the age-old identification of woman with nature, as "an alien, amoral creature of passion and instinct, an antagonist to rather than a builder of human culture." Most of all, Duncan points out, the social and creative freedom that vanguard art was supposed to embody as a universal ideal was, in reality, a freedom for men only, a freedom that depended upon the domination of others. In an era when the suffragist movement was at its height, and when women were proclaiming themselves for the first time in patriarchal history to be the human equals of men in all spheres, the artistic vanguard, she writes, must be seen as a historically regressive and reactionary movement. The obsessive urgency with which these pictures reassert male sexual and cultural supremacy may be understood fully, she suggests, only within this larger context, as

"both responses to and attempts to deny the new possibilities history was unfolding."[17]

In "Miriam Schapiro and 'Femmage': Reflections on the Conflict Between Decoration and Abstraction in Twentieth-Century Art," Norma Broude reexamines a fundamental axiom of modernist theory: that serious abstract art is to be distinguished from the "merely" decorative by virtue of its significant content. Although abstract art drew both inspiration and vitality from the decorative and craft traditions, a clear distinction between the two modes was actively maintained by early twentieth-century artists like Matisse and Kandinsky, focused on here by Broude as artists who, early in their careers, had to grapple with "the lure and the stigma of decoration." Their attitudes, Broude observes, were supported by the traditional and ethically inflected dichotomy in French art theory between the "rational-masculine" currents and the somehow lesser, "sensory-feminine" ones (established as contrasts between artists, like Poussin and Rubens, or between movements, like Neoclassicism and Romanticism). Critical and art historical thinking have preserved the value structure imbedded in this polarization, and have also helped to sustain the supremacy of the fine arts tradition (now expanded to include twentieth-century abstraction) and its categoric difference from the applied and decorative arts, whose major exponents, of course, have been women. Broude underlines the artificiality of the high art/low art distinction by contrasting the competitive and self-assertive strategies of the male avant garde with those of a leading contemporary artist, Miriam Schapiro, whose art depends upon a fundamentally different principle: the creation of a deliberate continuity between her own work and women's traditional arts. Through her "joyous collaboration" and dialogue in her art with women artists and craft traditions of the past, Schapiro attempts to break down rather than to reinforce the conventional barriers between

the decorative and the abstract. Her feminist art functions, in her own words, to bring "women's experience into the world," while it simultaneously satisfies the modernist mainstream's demand for significant content. "What more powerful and meaningful embodiment of the human spirit...might we ask for," Broude writes, "than these artifacts, which express not only the lives and skills and tastes of women but also their undauntable will to create?" Feminist art like Schapiro's, Broude concludes, by virtue of both its political content and its profound human and social significance, can never be "merely decorative." Her essay points to the pressing need for a critical framework, freed of sexist hierarchies, that will accommodate both the fine and the traditional arts; it suggests, too, the ways in which feminist art may provide an important stimulus in helping us to establish this new framework.

But the issue of folk arts and the crafts and their association with women also poses a larger question for art historical revision. The creation of hierarchies of value in the arts, in which the so-called fine arts of painting, sculpture, and architecture are held to be more significant than the crafts and decorative arts, has been the work both of artists, who since the Renaissance have controlled the art academies and defined their values, and of subsequent historians, who have selected out and emphasized the achievements of those in positions of cultural authority (or those in self-conscious rebellion against that authority). The resulting devaluation of what are called the "minor arts" has led to the exclusion from our histories of such non-fine art activities as weaving, needlework, and quilt-making. But in the broadest historical sense, when the small trickle of "high art" activity that has occurred in a few centuries at our own end of the historical spectrum is measured against the millennia in which weaving and potmaking were among the world's principal forms of art-making, one may con-

clude that it is not the crafts and traditional arts, but the fine arts, that are history's aberration.

In "Quilts: The Great American Art," Patricia Mainardi makes a strong case for the art historical importance of quilting and other needlework arts, defined by her as "a universal female art, transcending race, class and national borders." Mainardi's article represents one of the earliest efforts to define quilts positively in relation to the "fine arts" tradition, both in terms of the values and conventions they share and of those that irrevocably separate them from one another. The conventional argument against the elevation to high art status of women's traditional arts is that they do not represent significant expressions of the human spirit, nor symbolize the highest ethical or philosophical values of a culture. Focusing upon quilts in the nineteenth-century American tradition, Mainardi shows that, far from being composed of attractive but arbitrary and meaningless decorative patterns, quilts had a rich iconography and a considerable range of symbolic and expressive meaning. Fixed generic types existed for different purposes, to celebrate and serve the ceremonial events that marked the major events and experiences of the individual's life within the community—birth, marriage, friendship, death. Quilts also served as a vehicle of political and social expression, both in the political symbolism of particular imagery and in the social events that surrounded quilt making. Central among these, of course, was the quilting bee, which provided an important forum for the exchange of ideas among women.

Quilting, furthermore, was both a personal and a communal art form. Although each quilt was communally assembled and expressive of communal values, each was also individually designed. Contrary to what historians and cataloguers have told us, women did not produce quilts in self-effacing anonymity; rather, like other artists, they often proudly included their signatures as part of the designs of their quilts, designs that were subject to an infinite number of individual variations within established genres. And in many parts of America, Mainardi reminds us, these greatly prized and carefully preserved beautiful objects, which were both utilitarian and commemorative in their function, were "likely to be the only art that most of the populace saw, certainly the only art most of them possessed." Mainardi dismisses as both narrow and ahistorical the current enthusiasm for quilts based on the resemblance between their bold geometric patterns and contemporary minimalist and color-field painting. A quilt may indeed be enjoyed simply for its aesthetic beauty. But to appreciate it in this way, Mainardi leads us to see, in isolation from its own context, is to rob it of an intrinsic part of its aesthetic meaning. For it must also be understood as an icon of a culture whose values are fundamentally different from those of the parallel culture that has produced avant-garde high art.

The question, then, it seems to us, building upon this last distinction, is not whether quilts should now be seen as fine art, or even whether the barrier between the fine arts and the crafts should be removed. It is, rather, whether the fine arts are necessarily "higher" in any important historical or social sense than the traditional arts and crafts. In women's traditional arts, as in almost all cultures that predate the invention of "fine arts," art is not conceived as something that is higher than, or separate from, life, but rather as a functional part of life itself. The desire to refine and improve, enrich and elaborate designs of useful things—whether quilts, cathedrals, earthenware bowls, or chalices—proceeds from a reverence for the dimension of life that these things serve and the impulse to enhance these experiences aesthetically, the better to celebrate them. Looked at from this point of view, the challenge that is posed for us as art historians by women's traditional

art is to expand our definitions of art to give a larger place to those forms of art that serve life in un-self-conscious ways, and to place in balanced perspective the contributions to and definitions of art that have been introduced, in Mainardi's words, by "white males over a five hundred-year period in a small section of the world."

Although most of the essays in this book were directly inspired by a feminist viewpoint, several of the pieces, most notably those by Scully and Kraus, were written before feminism was definable as an approach to art history. While all of the essays share an attention to social history—to the extent that all of art history must necessarily be concerned in some measure with social history—some of the authors, in particular Duncan and Kampen, offer us a look at their subjects that presupposes not only a feminist perspective but also a conscious concern for social history from an economic and class point of view. Kahr and Luomala have also drawn, as art historians have traditionally done, upon the methods and insights of other fields—psychology and anthropology, respectively—and have combined these with their feminist perspectives to open new doors in their own discipline.

Whatever the approach, in every case the test of the essays in this volume as contributions to a renewed and expanded history of art is the extent to which they can impel us to experience in a new way the images and objects of the old art historical litany. To experience these images and monuments freshly, from a feminist perspective, will mean in many cases to experience them more nearly as they were originally meant to be experienced, as in the examples of Egyptian and Minoan art discussed here, with our own cultural preconceptions about the structures of those societies and their values now removed. In other cases, it will involve a total rethinking of our responses to the question, "What

is art?," as women reject the traditional hierarchic distinctions between "high" and "low" art, or between the "meaningful" or "abstract" as opposed to the "merely decorative," challenging aesthetic values and bringing new tests of use, relevancy, and significance to bear upon our evaluation of what constitutes a work of art.

To reexperience art from a feminist perspective will also mean in many cases to divorce it from the ivory tower context of pure, aesthetic, and "universal" values, and to see it not as a passive reflector of social history but as a tool that can be and has been used in every historical period as a powerful social force. Several of the essays in this book reveal the extent to which art, through its imagery and associations and through its cultural status, has functioned as an instrument of sex-role socialization, helping to create and reinforce a norm of social behavior for women in a patriarchal world. This norm, which has remained remarkably stable throughout the patriarchal period—from the Working Women of Rome to the Eves and Marys of the Middle Ages, the Happy Mothers of eighteenth-century France and the Fallen Women of nineteenth-century England—has involved an emphasis upon women's sexual identity and upon their role within the home and the family, an emphasis that has effectively obscured the reality of their efforts, throughout history, to assume other than these prescribed and limited roles. The extent to which these exaggerated emblems that art presents to us of female virtue and vice have distorted the truth of actual female experience is revealed most forcefully when the traditional themes and types are seen and interpreted through the eyes of female artists, as in the works by Gentileschi and Leyster that are analyzed here. In every case, the stereotypes are exposed for what they are: ethical and interpretive categories devised by men and imposed upon women for social purposes that ultimately have little to do with our con-

ception of a "universal" art, an art through which we express and fulfill "our" highest aspirations.

Recognition of the ways in which peculiarly masculine interests have often been mistaken in our culture for universal concerns has prompted us as art historians to reexamine some of the basic premises of our discipline—for example, the importance that modern Western culture attaches to the ideas of individual artistic innovation on the one hand and to stylistic progression on the other, to name just two issues that emerge from a reading of the essays in this book. In "Virility and Domination," Duncan characterizes the exaggerated value attached to artistic freedom and the stylistic innovations of the avant garde as the culturally cherished proof of the existence of individual freedom *in general* in democratic societies. But, as Duncan points out, the institution of the avant garde—and its effectiveness in thus serving social ideology—depends upon the presumption that the psychic needs of society as a whole are identical with those of the *male* artists who are permitted to act out their own liberating fantasies in their art—fantasies of freedom and power that often depend, ironically, on the sexual and social subjugation of others.

Similarly, Alpers points to the pervasive art-historical idea of style progression as a hallmark of cultural achievement, and suggests that this idea, which originated in Renaissance Italy, has exerted a disproportionate influence on art-historical thinking. Certainly, it has affected our interpretation and evaluation of art traditions to which the ideal of artistic progress is simply not applicable, and whose development might better be described in metaphoric terms of continuity, enrichment and growth. Underlying both of these influential ideas— the mystique of the innovative avant garde and the paradigm of art history as a sequence of styles that vanquish and supersede each other—is the psychosexual model of heroic patricide, the competitive

revolt of the sons against the fathers, a model whose relevance both to art history in general and to women's art in particular is challenged in these two essays, and in those by Comini, Broude ("Femmage"), and Mainardi as well.[18]

Throughout its development, the discipline of art history, like every other scholarly pursuit, has been advanced by the correction of false beliefs. Greek sculpture was once erroneously thought to have been pure white. Medieval art was once thought to have had no style, and Renaissance art was once thought to have had no meaning. To these already recognized false beliefs, the authors of the essays in this book have shown that we may now add others—for example, the idea that Egyptian queens lacked power, that Minoan palace architecture lacked planned organization, or that Degas hated women. Like the ones that preceded them, these misconceptions have more often been the product of biased expectations than of innocent ignorance, so that in order to correct the misconceptions, we have had first to recognize and expose the biases that produced them. For the future, we cannot even imagine the number and scope of the art historical misconceptions that lie waiting to be exposed by feminist thinking. But for the present, one thing is clear: we have spotted the bias. And the task before us now is similar to that of our predecessors: to demythologize art history according to our new perspectives, questioning its litanies and reducing to lifesize those subjective judgments and partial viewpoints concerning men and women, masculine and feminine in art, that have stood too long as absolute articles of faith.

The uniquely creative act that feminist art historians, both male and female, can now perform is to seize their new historical understanding, and to complete art history by restoring its female half. Like Petrarch in the fourteenth century, we stand expectantly on the brink of a new age. And we may say in conclusion as he did, addressing himself to

the fruits of his literary labors:

My fate is to live amid varied and confusing
storms.
But for you perhaps, if as I hope and wish you
will live long after me, there will follow a
better age.

This sleep of forgetfulness will not last for ever.
When the darkness has been dispersed, our
descendants can come again in the former
pure radiance.

—*Africa*, IX, 451–57 [19]

Rome and Washington, D.C.
July and August 1981

NOTES

1. On the evolution of art history as a discipline,
see Kenneth Clark, "The Study of Art History,"
an address delivered at the Jubilee meeting of the
Historical Association in the Senate House, University of London, 4 January 1956, London, 1956
(reprinted from the *Universities Quarterly*, 10, 3,
May 1956); also, James S. Ackerman and Rhys
Carpenter, *Art and Archaeology*, Englewood
Cliffs, N.J., 1963, pp. 196–229; Rudolf Wittkower,
"Art History as a Discipline," *Winterthur Seminar
on Museum Operation and Connoisseurship*, 1959,
Winterthur, Del., 1961; and W. Eugene Kleinbauer, "Genres of Modern Scholarship," *Modern
Perspectives in Western Art History*, New York,
1971, pp. 37–105.

2. Contributions to the new literature on women artists include: Eleanor Tufts, *Our Hidden
Heritage: Five Centuries of Women Artists*, New
York and London, 1974; Cindy Nemser, *Art Talk:
Conversations with Twelve Women Artists*, New
York, 1975; Ann Sutherland Harris and Linda
Nochlin, *Women Artists: 1550–1950*, New York,
1976; Karen Petersen and J. J. Wilson, *Women
Artists: Recognition and Reappraisal, from the
Early Middle Ages to the Twentieth Century*,
New York, 1976; Elsa Honig Fine, *Women and
Art: A History of Women Painters and Sculptors
from the Renaissance to the Twentieth Century*,
Montclair, N.J., 1978; Germaine Greer, *The Obstacle Race: The Fortunes of Women Painters and
Their Work*, New York, 1979; and Eleanor
Munro, *Originals: American Women Artists*, New
York, 1979 (see the review of Greer and Munro by
N. Broude, *Art Journal*, Summer 1981, pp. 180–
83). For additional bibliography, see Donna G.
Bachmann and Sherry Piland, *Women Artists: An*

Historical, Contemporary and Feminist Bibliography, Metuchen, N.J., and London, 1978. On women and architecture, see Doris Cole, *From Tipi to
Skyscraper: A History of Women in Architecture*,
Boston, 1973; Susana Torre, ed., *Women in American Architecture: A Historic and Contemporary
Perspective*, New York, 1977; and Dolores Hayden, *The Grand Domestic Revolution: A History
of Feminist Designs for American Homes, Neighborhoods, and Cities*, Cambridge, Mass., 1981. On
the contributions of women as scholars, critics, and
museum professionals, see Claire Richter Sherman, with Adele M. Holcomb, eds., *Women as Interpreters of the Visual Arts, 1820–1979*, Westport, Conn., 1981.

3. See Theodor E. Mommsen, "Petrarch's Conception of 'The Dark Ages,'" *Speculum*, 17 (1942),
pp. 226–42.

4. On Goddess-worshipping cultures and their
influence, see J. J. Bachofen, *Das Mutterrecht*, first
German edn. 1861, trans. as *Myth, Religion and
Mother Right*, Princeton, N.J., 1967; Jane Harrison, *Prolegomena to the Study of Greek Religion*,
Cambridge, Engl., 1903; Robert Briffault, *The
Mothers*, 3 vols., London and New York, 1927;
Gertrude Rachel Levy, *The Gate of Horn: A
Study of the Religious Conceptions of the Stone
Age and Their Influence upon European Thought*,
London, 1948; E. O. James, *The Cult of the Mother Goddess*, London and New York, 1959; Sibylle
Cles-Reden, *The Realm of the Great Goddess*,
1962; James Mellaart, *Earliest Civilizations of the
Near East*, New York, 1965; and Evelyn Reed,
*Woman's Evolution: From Matriarchal Clan to
Patriarchal Family*, New York and Toronto, 1975.
For contemporary feminist responses to these

ideas, see "The Great Goddess" issue of *Heresies: A Feminist Publication on Art and Politics,* no. 5, Spring 1978.

5. See Mary D. Garrard, " 'Of Men, Women and Art': Some Historical Reflections," *Art Journal,* Summer 1976, pp. 324–29 (reprinted in *Feminist Collage: Educating Women in the Visual Arts,* ed. Judy Loeb, New York, 1979, pp. 138–55); also Mary D. Garrard, "Feminism: Has It Changed Art History?", in *Women Studies and the Arts,* eds. Lola B. Gellman and Elsa H. Fine, Women's Caucus for Art, 1978 (reprinted in *Heresies,* no. 4, Spring 1978, pp. 59–60). Other ideas in this paragraph were originally presented by Garrard in her introductory remarks to the first "Questioning the Litany" session, sponsored by the Women's Caucus for Art at the College Art Association Annual Meeting, New York, 1978.

6. For an excellent compilation of feminist historical studies, see *Becoming Visible: Women in European History,* ed. by Renate Bridenthal and Claudia Koonz, Boston, 1977; also, *Conceptual Frameworks for Studying Women's History* (four papers, by Marilyn Arthur, Renate Bridenthal, Joan Kelly-Gadol and Gerda Lerner, from a Sarah Lawrence College symposium, March 1975), Bronxville, N.Y., 1976.

7. Prominent among theological apologists for male superiority were St. Paul (first century A.D.), whose letters reinforced the traditional Judaic subordination of women (in contradistinction to Jesus's own teachings); St. Augustine (fifth century), who in *The City of God* classified women in the archetypal categories of evil temptress and blessed mother; and St. Thomas Aquinas (thirteenth century), who codified in the *Summa* the misogynous view of woman as defective male, an idea that comes originally from Aristotle. For relevant excerpts from their writings, see Rosemary Agonito, ed., *History of Ideas on Woman, A Source Book,* New York, 1977.

8. See, e.g., Rosemary Radford Ruether, ed., *Religion and Sexism: Images of Woman in the Jewish and Christian Traditions,* New York, 1974.

9. Harry Bober, "Foreword," *The Living The-*

atre of Medieval Art, Bloomington, Ind., 1967, p. xvii.

10. C. R. Sherman, *The Portraits of Charles V of France (1338–1380),* New York, 1969, and "Representations of Charles V of France (1338–1380) as a Wise Ruler," *Medievalia et Humanistica* n.s. 2 (1971), pp. 83–96.

11. See also Madlyn Millner Kahr, "Rembrandt and Delilah," *The Art Bulletin,* 55 June 1973, pp. 240–59.

12. For studies of other individual works by Artemisia Gentileschi, see Frima Fox Hofrichter, "Artemisia Gentileschi's Uffizi *Judith* and a Lost Rubens," *The Rutgers Art Review,* I, January 1980, pp. 9–15; and Mary D. Garrard, "Artemisia Gentileschi's Self-Portrait as the Allegory of Painting," The Art Bulletin, 62, March 1980, pp. 97–112.

13. See especially Harris and Nochlin, *Women Artists: 1550–1950,* New York, 1976.

14. See also Svetlana Alpers, "Is Art History?", *Daedalus,* I, Summer 1977, pp. 1–13.

15. For a more recent discussion by Carol Duncan of other aspects of the changing relationship in eighteenth-century France between authoritarian power in the family and in the state, see her "Fallen Fathers: Images of Authority in Pre-Revolutionary French Art," *Art History,* 4, June 1981, pp. 187–202.

16. See Alessandra Comini, "Vampires, Virgins and Voyeurs in Imperial Vienna," in *Woman as Sex Object,* ed. T. Hess and L. Nochlin, New York, 1972, pp. 206–21.

17. See also Carol Duncan, "Esthetics of Power," *Heresies,* 1 (1977), pp. 46–50; and Norma Broude, "Picasso: Artist of the Century (Late Nineteenth)," *Arts Magazine,* 55, October 1980, pp. 84–86.

18. For a discussion of the "killing-the-fathers" concept as it applies to English literature, see S. M. Gilbert and S. Gubar, *The Madwoman in the Attic: The Woman Writer and the Nineteenth-Century Imagination,* New Haven and London, 1979, especially chapters 1 and 2.

19. Trans. by Mommsen, *op. cit.,* p. 240.

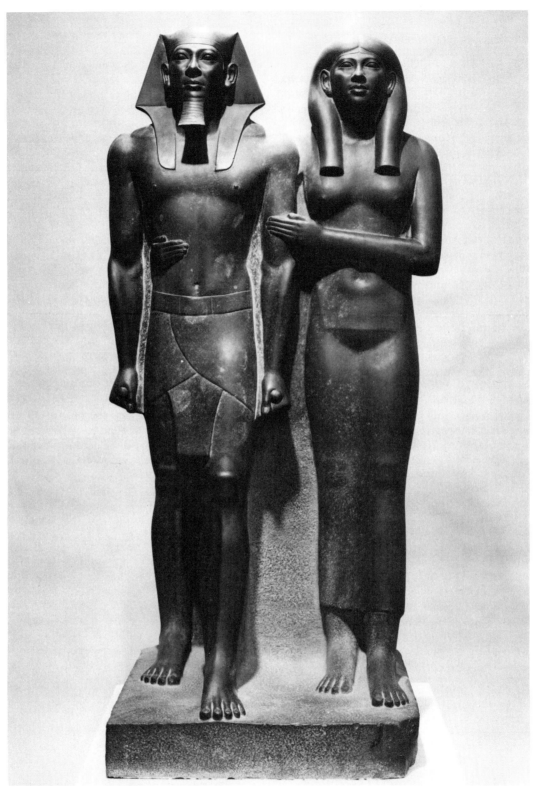

1. King Mycerinus and Queen Khamerernebty II, 4th Dynasty, ca. 2470 B.C.
Boston, Museum of Fine Arts (*Museum of Fine Arts*).

1
Matrilineal Reinterpretation
of Some Egyptian Sacred Cows

NANCY LUOMALA

In the late 1960s, we longtime feminists in the scholarly professions discovered that we were part of the women's movement. The 1970s have presented us with the challenge of applying our feminism to our scholarly or creative disciplines. Feminist scholars are learning to question the time-honored bromides provided by professors and textbooks that were carefully memorized during their education.

One area this teacher has questioned in the sacred art historical litany is the role of the queen as depicted in ancient Egyptian art. Anthropological literature states that Egyptian civilization retained its matrilineal order of descent in the royal family until Egypt was enveloped by the Roman Empire. Yet writers of art history textbooks consistently ignore this crucial piece of cultural information when they present and attempt to interpret the images and monuments of Egyptian art.

This essay was developed from a paper read at the Women's Caucus for Art session, "Questioning the Litany: Feminist Views of Art History," College Art Association Annual Meeting, New York, 1978. Copyright © 1982 by Nancy Luomala. By permission of the author.

This essay will describe how rulers of ancient Egypt traced descent matrilineally from queen to princess-daughter, and will show how this matriliny is reflected in the images of feminine primordial creation that surrounded Egyptian royalty.

Anthropological research presents a picture of women in ancient Egypt that is probably quite different from what you learned from your Art 100 professor. In her book entitled *Women's Evolution* (1975), the anthropologist Evelyn Reed refutes the widely held idea that brother-sister "marriages" in Egypt involved incest by describing the workings of matrilineal descent. Ancient Egyptians followed the Neolithic practice of reckoning descent and property inheritance through a woman and her daughters.[1] Although the king was the visible administrator of Egypt, he owed all his power and position to the queen. The throne of the land was inherited by the queen's eldest daughter.[2] The queen's daughter was a king-maker in two ways: while she was unmarried or separated from her husband, her brother could rule with her

Royal Succession In Ancient Egypt

Egyptians trace inheritance of property through the woman.

Pharaoh father

Queen mother
The throne passes from Queen to her princess-daughter.

Royal Princess
The Royal Princess is Queen from birth.

Royal Son
The Royal Son is a potential regent.

Commoner

Queen
The Queen's brother is Pharaoh-Regent while the Queen is unmarried or separated from her husband.

Brother Regent
The sister-brother ruling pair could each have consort(s) for sexual relations.

Commoner

Commoner
The Pharaoh may have other Queens and non-inheriting progeny.

Consort Pharaoh
The Queen's consort becomes Pharaoh upon marriage. He remains Pharaoh only while married to the Queen.

Queen

Matrilineal descent gives maternal uncles potential for regency through blood relationship to the Queen.

Non-inheriting Progeny

Royal Princess
The Royal Princess is Queen from birth.

Royal Son
The Royal Son may be trained as Regent.

©Nancy Luomala 1981

2. Royal succession in ancient Egypt (*Nancy Luomala*).

as regent; when she took a husband, the husband ruled as pharaoh [see 2]. As Reed explains:

The queen stood between two men, her brother and her husband. Both men, by virtue of their connection to the queen, were "kings," but in different ways. The queen's brother was king by right of birth and kinship to the queen, which made him undeposable. The queen's husband, on the other hand, as a "commoner," was king only as long as the marriage lasted; he was deposed if it was terminated by the queen.[3]

In either case—brother or husband—the queen was ceremonially "married" to the pharaoh, who served as her "man of business affairs," so that she might share with him the mystic and divine virtue that was attached to the royal inheritance. This point is amplified by Robert Briffault, author of the three-volume monumental anthropological study, *The Mothers* (1927). He writes:

The queen was not so much the wife of the king as the wife of the god; and it was as a temporary incarnation of the deity that the king was spouse to the queen....

The mysterious power, which was thus originally an attribute of the women of the royal family and not of the men, was not in its origin political or administrative, but was, as Sir James Frazer has shown, of a magical or magic-wielding nature; and it was that magical power which was transmitted by the women, or rather was primitively possessed exclusively by the women of the royal family. It was in view of the transmission of that magic power that so much importance was attached to legitimacy in the royal succession.[4]

There is no evidence that the queen would have sexual relations with her brother-king. The sister and brother of the ruling pair could each have a consort or consorts for sexual relations, but these spouses were not included in the possession and transmission of property. The queen did have intercourse with her consort-king, and the resulting female progeny constituted the royal line, earning the title of "Royal Mother" by right of

birth. As in any other matrifamily, the mother's brother or maternal uncle held a more important and permanent place than the husband. For example, Tutankhamon was king because he was married to one of Queen Nefertiti's daughters, Ankhesenamon. Since Ankhesenamon had no brother to rule as regent after Tutankhamon's death, and her plan to marry a Hittite prince was foiled, her uncle Ay succeeded as pharaoh because he was blood kin to her mother, Queen Nefertiti.[5]

A childless princess could not hold the throne unless married, although many queens ruled alone during the minority of their children. Continuity of the ancient female blood line had to be assured. Ruling power from predynastic times was transferred by Queen Niet-hotep (who bore the "*ka*" ruler name) to her consort King Mena to found the first historical dynasty under which Upper and Lower Egypt were united.[6]

Despite the anthropologically recognized importance of matrilineal descent in Egyptian culture, art historians continue to misinterpret Egyptian art and life by applying to it the familiar conventions of their own patriculture. For example, in the most recent edition of *Gardner's Art Through the Ages*, Hatshepsut was "a princess who became queen when there were no legitimate male heirs."[7] Another current text, discussing the paired statues of Prince Rahotep and "his" consort Nofert, describes Rahotep as "a son of Sneferu... also high priest of Heliopolis and a general. His intelligent and energetic face suggests that he owed his high offices to something more than kinship with the king."[8] A final example comes from a book entitled, ironically, *Gods, Men and Pharaohs: The Glory of Egyptian Art*, where we find the following commentary on the paired figures of King Mycerinus and his wife (i.e., the queen), Khamerernebty II [1]:

The fact that the king is portrayed in close conjunction with his consort does, however, indicate a

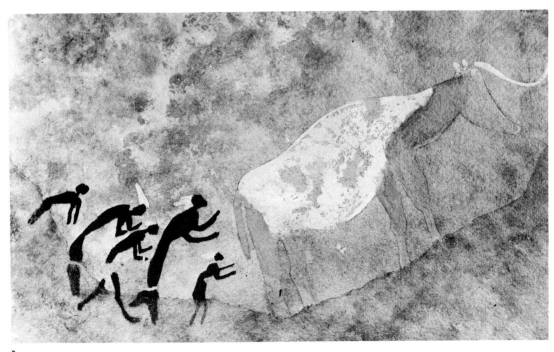

3

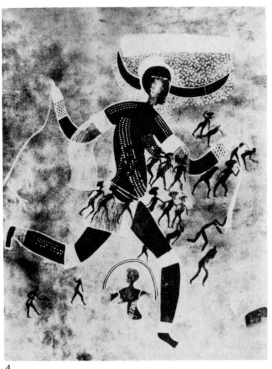

4

5

3. Human figures worshipping great cow. Saharan rock painting from Wadi Sora VI (Gilf Kebir), Libya, Cave E. Bovidian period, ca. 5000–1200 B.C. (*Frobenius Institute*).

4. *White Lady of Aouanret,* Tassili-N-Ajjer, North Africa, Bovidian period, ca. 5000–1200 B.C. (*after B. Brentjes,* African Rock Art, *New York, 1970, pl. 16*).

5. Nome goddess with upraised arms. Predynastic painted bowl of the Gerzean period. Chicago, Oriental Institute 10581 (*Oriental Institute*).

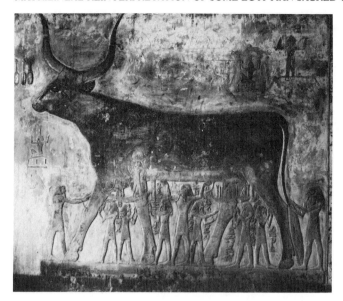

6. The sky-goddess Nut in the form of the Divine Cow, supported by the god of the air, Shou. Relief from the tomb of Sethos I, 19th Dynasty (*Hirmer*).

weakening of the concept of the pharaoh as an unapproachable being possessed of divine power. In the portrait of Mycerinus the expression of imperturbability and calm strength associated with the god-king is no longer given prominence; instead we can detect a physical and spiritual tension, the slight hint of a connection with the transient human world, of a diminution of the king's claim to divinity.[9]

In fact, what we see in the queen's embrace is more likely to be the opposite of what we have been told: not "a diminution of the king's claim to divinity," but the affirmation of it. In light of what we know about the Egyptian matrifamily and the founding of the historic dynasties, a queen's embrace in Egyptian art should be more properly read as a gesture that confers legitimacy, a symbol of her transfer of power to the pharaoh.

Like the Egyptian matrifamily, which was retained from the Egyptians' Neolithic ancestors, many of the symbols of power that surround Egyptian royalty also had their origin in North African Neolithic culture. Principal among these are the symbols of a cow deity, which became closely associated with major Egyptian goddesses and the queen in Egyptian art.

It is significant that the only major deity recognized in Saharan rock art during the bovidian or herding period (ca. 12000–5000 B.C.) is either a cow or a female figure with cow attributes [3]. The famous "White Lady of Aouanret" from Tassili-n-Ajjer in Algeria has a cow-horn headdress similar to those of the Egyptian goddesses Hathor and Isis [4]. A grain-field between the "White Lady's" horns shows her as a grain-giver; her Nile Valley successor Isis is remembered for substituting agricultural arts for Mesolithic cannibalism.[10]

The "White Lady's" pose with upraised arms, so common in later *nome* (principality) deities in pre-dynastic Egypt [5], is an attribute of the Great Mother Goddess worshipped throughout the ancient Mediterranean world. A pair of upraised arms also forms the Egyptian hieroglyph for *ka*—a person's spiritual double and also an ancient title for a ruler.[11] Sometimes the Saharan goddess is shown with curved lines arched above her upraised arms. This control of the arch of the sky parallels the function of the goddess Nut in Egypt, whose star-studded body stretches from horizon to horizon. Sometimes Nut is shown as a sycamore or a great cow [6], in-

7. The goddess Nut swallows and gives birth to the sun. Painted ceiling relief, Temple of Hathor at Dendera, Egypt, Roman period (*after E. Neumann,* The Great Mother, *New York, 1963, pl. 36*).

stead of a woman [7]. In the latter example she is shown swallowing the sun in the evening so that she may give birth to the sun from her womb in the morning.[12] Her body is covered with water, and milk flows from her breast toward the ground. At her feet, the double mound of Neith (also a throne symbol) cradles the image of Hathor.

Another role of the Goddess seen in the "White Lady" from Tassili-n-Ajjer is that of a bringer of water, suggested by the cascading lines from her elbow ornaments and the droplets around her head. Even in the southernmost regions of Africa where bovidian cultures and Bantu languages have spread, rain and cow-goddess imagery have survived. Bushman myth tells of the discovery and capture of the rain-cow; a Rhodesian painting illustrates the widespread myth of a tree of life growing from a virgin's body to the sky, where a Sky-Goddess sends rain [8].[13] In Egyptian creation traditions, the original mat-

ter of creation was water; it was called Nun and determined as feminine.[14] Moreover, the progenitor of all the paired gods in Egypt was the feminine Neith, who created herself from the primordial waters of the goddess Nun [9].

The control of the life-giving sun and the *ka*'s admission to rebirth in the underworld was given to goddesses who derived their insignia from the Great Cow: Hathor, Nut, and Isis. From the Cow-Goddess's prominent position on Narmer's palette of the first dynasty [10] to Hathor's cow-eared visage at her late Ptolemaic temple at Dendera, the cow is seen in Egyptian art as a chief deity, in charge of regeneration and sustenance.

From earliest times, the rulers of Egypt were identified with cows and cow imagery. Just as the sun was born of Nut, the Sky-Cow Goddess, so too the pharaoh, in his divine status as incarnation of the sun, became known from the Fifth Dynasty onward (ca. 2580 B.C.) as child of the Sky-Goddess. "As

8

9

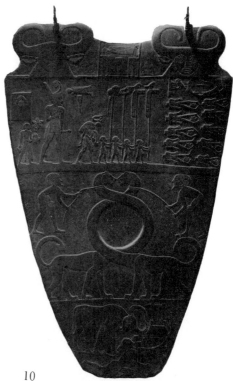

10

the Bull of Heaven he was the dominant male, the embodiment of virile fertility, and in this capacity he impregnated the queen, called 'The Cow that bore the Bull.' "[15] The queen therefore was equated with the great Sky-Cow Mother, alternately Nut or Hathor, who swallows the Sun (Re) to give birth to it anew. Like Neith, the Sky-Cow was self-generating, only needing the sun disk Re to impregnate her body "with the seed of the spirit that must be in her."[16] At death, the pharaoh is received into the body of Hathor as a mountain; through her body, as through the queen's body, the pharaoh can hope to be born anew.

The insignia of those goddesses who embodied the power of the Cow-Mother were the lyriform cow's horns and the sun disk. These elements are prominently displayed in the headdresses of queens from the New Kingdom on (after 1600 B.C.), suggesting a desire to reaffirm the queen's identity with the

8. Rain goddess legend. Rock painting from Rusape, Rhodesia, n.d. (*Frobenius Institute*).

9. Primordial mounds representing Neith emerging from the waters of Nun. Ceramic bowl. Egypt, predynastic Amratian period (*Piankoff*, Mythological Papyri, *1957, fig. 11*).

10. Victory pallette of King Narmer. Obverse with heads of the cow-goddess Hathor at top. Egypt, 1st Dynasty, ca. 3000 B.C. Cairo, Egyptian Museum (*Hirmer*).

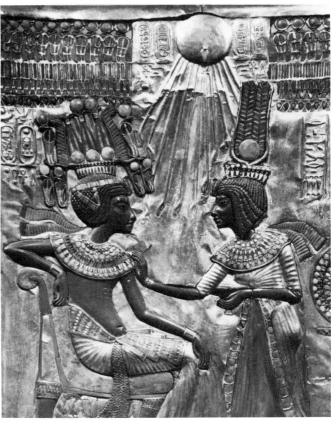

11

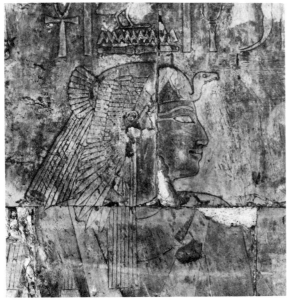

11. Queen Ankhesenamon wearing the lyriform cow's horns and sun disk of the cow-goddesses, with King Tutankhamon. Detail from the back of the throne of King Tutankhamon. 18th Dynasty, ca. 1347–1338 B.C. Cairo, Egyptian Museum (*Hirmer*).

12. Queen Ahmose, mother of Pharaoh Hatshepsut, wearing the Great Wife headdress of the vulture-goddess Nekhbet of Upper Egypt. Detail of relief from Hatshepsut's mortuary temple at Deir-el-Bahari. 18th Dynasty, 1504–1483 B.C. (*Hirmer*).

12

heavenly "Cow that bore the Bull." An example [11], on an inlaid throne from the tomb of Tutankhamon (1355–1342 B.C.), shows Queen Ankhesenamon wearing the lyriform cow's horns and sun disk of the cow-goddesses, as well as the uraeus of the cobra, Wadjet of Buto. The enraged female cobra, or uraeus, is another important female symbol of government that can be linked to the functions of the Great Goddess. It is the personified eye of the sun-god Re and is always present on royal crowns.

The cobra, Wadjet of Buto, was the tutelary goddess of North or Lower Egypt, and one of the earliest of royal insignia. It was in her sanctuary, the *per nu,* that the pharaoh sat at coronation to receive the Red Crown. The tutelary goddess of the South or Upper Egypt was the vulture Nekhbet, who similarly represented royal dominion. Her great house, the *per wer,* was likewise used in coronation and jubilee ceremonies to represent the White Crown. But Nekhbet had the special function of designating the person through whom the royal line was traced, and thus appears in the headdress of the Great Wife, the queen [12].

Old Kingdom and Middle Kingdom (2800–1700 B.C.) portrayals of princesses and queens often showed idealized women who are of equal size and importance to princes and pharaohs [see 1]. But these same periods saw the ascendancy of the pharaoh's power, which was paralleled by an increase in the importance of the solar deity Re and the vegetation-god Osiris over the cow-goddesses who had been so prominent on earlier monuments.[17] Pharaonic symbols of the hawk, scepter, flail, and pyramid were derived from the cults of these male deities. By the Eighteenth Dynasty, however, the arts reinstated the goddess symbols of horns, sun disk, uraeus snake, and vulture in depictions of female royalty. "From then onwards," as E. O. James has written, "royal heiresses became increasingly prominent in Egypt. Hereditary queens

bore the titles 'Royal Daughter,' 'Royal Sister,' 'Great Royal Wife,' 'Hereditary Princess,' 'Lady of the Two Lands,' as well as 'God's Wife.'"[18] The title of "Divine Wife," for example, was assumed by Queen Neferu of the Eleventh Dynasty (2100 B.C.); and Ahhotep, the mother of Ahmose I, who was founder of the Eighteenth Dynasty, was described as the "God's Wife." Thus the designation of the queen both as the wife of the pharaoh in the incarnation of Re, and as chief priestess of Re, was continued.

At least a half dozen female pharaohs have been recognized. Most famous of these is Queen Hatshepsut, who reigned for twenty-one years, from 1504 to 1483 B.C. Her mortuary temple at Deir-el-Bahari, which commemorates her reign, is a monument to a skillful and determined monarch who asserted her right to exercise the full powers of her throne.

Hatshepsut was the daughter of Queen Ahmose and King Thutmosis I. In Hatshepsut's temple, the god Amon-Re was shown taking the form of her father Thutmosis I in order to have intercourse with the queen. In the accompanying inscription, Amon declares: "Khenemet-Amon-Hatshepsut shall be the name of this my daughter, whom I have placed in thy body. . . . She shall exercise the excellent kingship in this whole land. My soul is hers, my [bounty] is hers, my crown [is hers,] that she may rule the Two Lands, that she may lead all the living. . . ."[19] Most scholars write as if these reliefs were an attempt to legitimize Hatshepsut's reign by showing her consecration by Thutmosis I.[20] In reality, the right to the throne was Hatshepsut's already. She ruled because, though married, she did not let her husbands govern. Her first husband, Thutmosis II, was a son of her father Thutmosis I by a minor wife who legitimized his claim to the throne by marrying her. After his death, she married again, but kept this husband, Thutmosis III, as an unimportant minion. Her "favorite," Senmut, became

13. Pharaoh Hatshepsut drinking from the udder of the Hathor-Cow. Detail of relief from Hatshepsut's temple at Deir-el-Bahari. 18th Dynasty, 1504–1483 B.C. (*Hirmer*).

her architect and built the mortuary temple for her. Senmut had some prestige, but not the throne; his reward for being Hatshepsut's intimate was the privilege of carving his image discreetly behind doors of the niches of some upper terrace chapels.[21]

At Deir-el-Bahari, the queen is shown suckling from Hathor's udder [13], assuming, in this ritual image, the role of the pharaoh. The goddess, whether in the form of the cow, Isis, or the sycamore, had traditionally been shown nurturing the pharaoh, her offspring, from her udder or breast [14]. As one scholar explains: "The suckling of the king by a goddess was a symbol of the entry of the king into the divine world. The king by this rite obtained a new and divine life which gave him the power to fulfill his royal mission on earth."[22] Images which show Queen Hatshepsut as a boy or with a beard are also part of the tradition of the pharaoh as the male procreative force of the land, since early times ritualized in the pharaoh's displays of physical prowess in the Heb-Sed jubilee, and in

his association with the heavenly bull and the ichthyphallic Min.[23] After her death, Hatshepsut's suppressed second husband, Thutmosis III, had every mention of her name and every image of her destroyed.[24]

Another example of spite against an active queen occurred a little over a century later, when the upstart military pharaoh Horemheb singled out Queen Nefertiti for special indignities. Early in her reign, Nefertiti had built a great open sun court in the Aten Temple at Karnak. It was a unique architectural monument to the female succession because every surface was carved with exclusively female figures, including, of course, the queen. Consecration by the queen must have been important enough in the Eighteenth Dynasty to require this special court in the Aten Temple, which showed Nefertiti's endorsement of Atenism. Later, when Horemheb succeeded Ay, he ordered the destruction of Nefertiti's sun court. The tops of the twenty-eight great pillars showing Nefertiti and her daughters worshipping Aten were laboriously turned

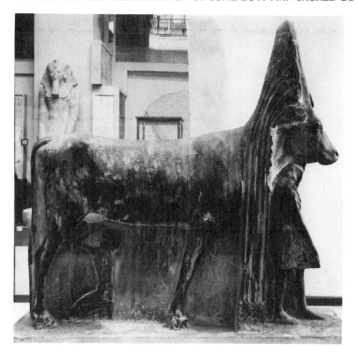

14. King Amenophis II drinking from the udder of the Hathor-Cow. Egypt, 18th Dynasty, ca. 1438–1412 B.C. Cairo, Egyptian Museum (*Hirmer*).

upside down; the faces, limbs, and fingers of each figure were defaced, and the blocks were buried inside the great second pylon at Karnak.[25] In each of these examples, the spiteful successor attempted eradication of the queen who represented a blood line to which he did not belong.

Continuance of matrilineal descent into the late period is clearly stated in royal titles, such as in this inscription on the statue of Amenertas:

The kindest and most amiable queen of upper and lower Egypts, the sister of the king, the ever living daughter of the deceased king, the wife of the divine one—Amenertas—may she live.[26]

This seventh-century queen did live for many years ruling Thebes, and her daughter transferred the sovereign rights of the throne to the following Saitic Dynasty (663–525 B.C.). A succession of five "God's Wives" followed, who ruled exclusively as governors. Their titles described them as "High Priestess" and "Mistress of Egypt."[27]

Female succession, brother-sister marriages, and dual kingship prevailed in Egypt until the reign of the last Ptolemy. The Cleopatra we know from Shakespeare was the seventh Macedonian princess of that name. She spoke the Egyptian language and adhered to Egyptian matrilineal custom.[28] Cleopatra, however, married and reportedly murdered her two regent-brothers in turn for the sake of her consort Marc Antony, thus committing what Evelyn Reed has described as the "crime of crimes, shedding the blood of the blood kin." After Octavius conquered Egypt, Cleopatra refused to accept him as her pharaoh. At the same time, the Roman patriculture which Octavius represented would not allow him to accept her daughter and two sons as heirs to the throne. Male supremacy won out in the end, but Cleopatra's suicide deprived the Roman Empire of the ancient tradition of the Cow-Queen.[29]

Matrilineal descent made it possible for men of talent to rise to the throne of Egypt, but even the most ambitious male ruler had to reckon with the Cow-Queen's power.

Egyptian princesses and queens could assert their power visibly, like Hatshepsut or Nefertiti, or elect to function as the "power behind the pharaoh." In either case, Egyptians knew, as many art historians will not, that the Great Wife made whomever she married into a living king, whether brother or commoner, just as the goddess Isis as Throne Woman gave birth to the living king. Thus, if we are to interpret Egyptian art accurately, we must reexamine our definitions of dynasty and succession in Egypt, and from now on, remember to couch our thinking about Egyptian art in matrilineal terms.

NOTES

1. Evelyn Reed, *Woman's Evolution, From Matriarchal Clan to Patriarchal Family.* New York, 1975, pp. 437–38.

2. This succession had ancient sanctification in the Delta goddess Isis of Sebennytes, who became the deified Throne Woman, giving birth to the prototype of the living king in his Horus capacity. (E. O. James, *Cult of the Mother Goddess.* London and Norwich, 1959, p. 55).

3. Reed, *op. cit.,* p. 439. This dual kingship is seldom recognized by scholars, who might mention one pharaoh and not the other.

4. Robert Briffault, *The Mothers: A Study of the Origin of Sentiments and Institutions.* New York, 1927, Vol. III, pp. 37, 44.

5. Edward Wente of the Oriental Institute of Chicago describes the aged Ay as a former overseer of the royal horses, with the title "God's Father." He cites similarities between Ay's titles and those of Yuya, father of Queen Teye, who was mother of Queen Nefertiti, as well as connections that both men had with the Upper Egyptian town of Akmin. Wente concludes that Ay may have been Nefertiti's father (see Edward F. Wente, "Tutankhamen and His World," *Treasures of Tutankhamen,* eds. Joan Holt and Sara Hudson. New York, 1976, pp. 23, 28–29, 31). This author, however, finds it more likely that Ay was an elder brother of Nefertiti, who would succeed to the throne after the exhaustion of her female progeny.

6. Briffault, *op. cit.,* vol. III, p. 38.

7. *Gardner's Art through the Ages,* 7th edn., revised by Horst de la Croix and Richard G. Tansey. New York, 1980, Vol. I, p. 77.

8. Wolfhart Westendorf, *The Painting, Sculpture and Architecture of Ancient Egypt.* New York, 1968, pp. 34–35.

9. Irmgard Woldering, *Gods, Men and Pharaohs: The Glory of Egyptian Art.* New York, 1967, p. 57.

10. See Reed, *op. cit.,* pp. 338–39.

11. Erich Neumann, *The Great Mother, An Analysis of the Archetype,* 2nd edn., Princeton, N.J., 1963, pp. 114–18. Neumann states that the "magical significance" of this posture was also retained for prayer. See also Briffault, *op. cit.,* Vol. III, p. 38.

12. Westendorf, *op. cit.,* pp. 2–3.

13. Burchard Brentjes, *African Rock Art,* trans. by Anthony Dent. New York, 1970, pp. 26–27.

14. Westendorf, *op. cit.,* p. 8.

15. James, *op. cit.,* p. 67.

16. *Ibid.,* p. 67.

17. I. E. S. Edwards, *The Pyramids of Egypt,* revised edn., Baltimore, 1961, pp. 24–26.

18. James, *op. cit,* p. 67.

19. James Henry Breasted, *Ancient Records of Egypt,* New York, 1962 (first edn., 1906), Vol. II: *The Eighteenth Dynasty,* paragraph 198. The Deir-el-Bahari inscriptions on the history of Hatshepsut are translated and described on pp. 75–86. An almost identical inscription at Luxor is used by Breasted to corroborate damaged segments. The relief showing the meeting between Queen Ahmose and Amon-Re (Scene III on the north colonnade of Hatshepsut's mortuary temple) is described in paragraph 195 as follows: "Amon and Queen Ahmose are seated facing each other; the god extends to her the symbols of life. They are

sitting upon the heavens, symbolic of the exalted character of the interview, supported by two female divinities who are seated upon a couch." For a similar image of such a "sacred marriage," see Westendorf, *op. cit.*, p. 4, fig. 4.

20. James, *op. cit.*, pp. 65–67.

21. Jean Yoyote, entries in *Dictionary of Egyptian Civilization,* ed. Georges Posener, New York, 1962, pp. 59, 118. On matriliny and the line of succession in the Eighteenth Dynasty, see Donald B. Redford, *History and Chronology of the Eighteenth Dynasty of Egypt: Seven Studies,* Toronto, 1967, pp. 71–73. On the issue of whether Senmut was Hatshepsut's lover, Evelyn Wells, author of *Hatshepsut* (Garden City, N.Y., 1969) does not take a stand. She quotes Senmut's inscriptions from his own tomb at Deir-el-Bahari: "I was one, whose steps were known in the palace, a real confidant of the king (Hatshepsut) his beloved.... I was the greatest of the great in the whole land; one who heard the hearing alone in the privy council...." and "I was one who entered in love, and came forth in favor, making glad the heart of the king every day, the companion, and master of the palace, Sennemut" (p. 194).

22. Serge Sauneron, "Milk," *Dictionary of Egyptian Civilization,* p. 170.

23. Edwards, *op. cit.*, pp. 65–67.

24. Yoyote, *op. cit.*, p. 118. See also Breasted, *op. cit.*, Vol. II, p. 77, paragraph 190, who says of the reliefs at Deir-el-Bahari that they "have suffered sadly from a twofold attack: by the triumphant Thutmose III who erased the figures and inscriptions of the queen; and by the Amon-hating Amenhotep IV, who did likewise for those of Amon."

25. Ray Winfield Smith, "Computer Helps Scholars Re-create Egyptian Temple," *National Geographic,* 138, November 1970, pp. 645–49. Horemheb had a long career as military commander, but he was a commoner from Middle Egypt. Nefertiti held the title of goddess early and prayers were addressed to her. Both as queen and goddess she used her power to consecrate the new religion.

26. From the lifesize alabaster statue of Queen Amenertas (seventh to sixth centuries B.C.), in the temple of Osiris at Karnak. She was the daughter of the Theban priestess-sovereign Shepenapt II, who shared the crown with her two brothers.

The inscription starts with a dedication—"This is an offering for the Theban Amon-Re of Apt, to the God Mentu-Re, the Lord of Thebes. May he grant everything that is good and pure, by which divine (nature) lives, all that heaven bestows and earth brings forth...."—and closes with a list of good deeds: "I was the wife of the divine one, a benefactress of her city, and a bounteous giver of land. I gave food to the hungry, drink to the thirsty, clothes to the naked."

27. James, *op. cit.*, pp. 68–69. When the Ethiopian dynasty came to an end about 663 B.C., its sovereign rights were carried over to the new Saitic rulers by Shepenart III, royal daughter of Pankhy II and Amenertas. At the accession of the Saitic king Psammetrichus I (663–609), his daughter Nitaquert was made legal heiress of Shepenart, the former queen.

28. Sauneron, "Cleopatra," in *Dictionary of Egyptian Civilization,* p. 44.

29. Reed, *op. cit.*, pp. 443–45.

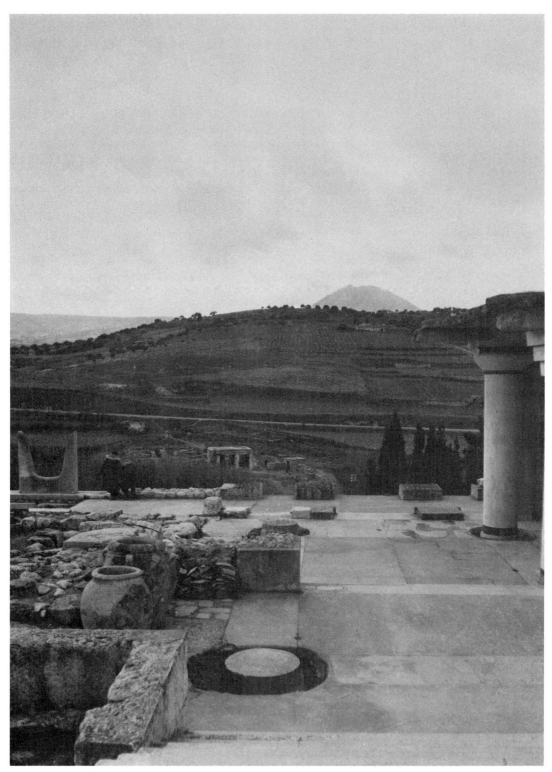

1. Knossos. South Propylaia with façade horns and Mt. Jouctas (*Vincent Scully*).

2

The Great Goddess and
the Palace Architecture of Crete

——————⟫ꞏⵗ ⵗꞏ⟪——————

VINCENT SCULLY

Long ago, the Mountain Mother
Of all the gods...
—Euripides, HELEN (Lattimore)[1]

The landscape of Greece is defined by clearly formed mountains of moderate size, which bound definite areas of valley and plain.[2] . . . Because of the ordered variety, clarity, and scale in the landscape, the human being is neither engulfed nor adrift in Greece. He can come close to the earth to experience either its comfort or its threat. . . .

Yet the hunters of the Old Stone Age apparently found little to attract them in this landscape. Its sea-bitten valleys and rugged mountains could hardly support the vast herds of grass-eating animals which they followed, as killers, across the northern plains. Only one small find of Paleolithic implements has been made in Greece, in a shallow cave by the shores of the ancient Lake Copais in Boeotia.[3] Others may come to light, but it seems apparent that the great formulations of

From Vincent Scully, *The Earth, the Temple and the Gods: Greek Sacred Architecture.* First edn. Yale University Press, 1962; rev. edns. Frederick A. Praeger, Inc., 1969, and Yale University Press, 1979. These excerpts, Chapter 2 ("The Great Goddess"), pp. 9–14, and Chapter 3 ("The Goddess and the Lords"), pp. 25–26. By permission of the author and Yale University Press.

Paleolithic art and religion were achieved elsewhere, as in the deep caves of southwestern France and the Pyrenees. The nature of those fundamental creations of the human consciousness has been studied by many scholars.[4] Briefly summarized, the essential belief seems to have been in the earth as a mother, especially as the mother of the herbivorous animals—all, except the horse, horned—upon whose continued presence human life depended. Therefore the deep caverns of the earth were holy places; upon their walls and ceilings the revered and desired beasts were painted or incised in the splendid movements of full life, and the earth was thus impregnated with them. The forms of the paintings themselves, which create an image of the living beast more persuasive and directly sympathetic than any later art has been able to do, seem to show that the necessary death of the animal, partly induced by magic, was dignified by human respect and admiration for the creature itself and even by human gratitude to it. The totemistic beliefs of later primitive peoples indicate that such was probably the case in fact, and that the Paleo-

lithic hunter was humble enough, or wise enough, to hope that an element of consent brought the quarry to his spear. Stone Age man thus focused his major attention upon objects outside himself. His own acts were of no consequence per se; meaning resided in the life of the animals which were the objects of those acts. He himself was simply one of the many creatures to whom the earth gave life and death. Later he aggrandized himself, but at first the animals were the gods, unchanging in their battalions, one with the earth, immortal.

Yet it now seems possible that a more complicated metaphysic was also embodied in the running, weapon-threatened, animal forms: one which developed balanced themes of fertility and death, movement and extinction. So, too, the caverns came to be conceived in spatial hierarchies, defined by certain species in various groupings and with critical areas indicated by abstract signs. Movement through the labyrinthine passages which led to the caverns seems also to have formed an

2. *Venus of Willendorf,* ca. 25,000–20,000 B.C. Vienna, Museum of Natural History (*Museum of Natural History*).

essential part of the ritual, and schematized representations of the labyrinth itself can be found in some of the caves. In these ways the arts formed themselves, founded upon wish fulfillment but infused with reverence and, through the very process of use and making whereby they were realized, with love. The path of the labyrinth became a dance and the natural architecture of twisting passageway and swelling cave a personalized, familiar setting, while the painted beasts began to lead their own huge and symbolic lives. In sculpture, the most ubiquitous objects extant are female figures, generally regarded as images of the earth mother and certainly, despite differences in style and possibly in intent, carved as the child knows the mother, all breasts, hips, and *mons Veneris,* full and round, with the head often inclined forward [2].

It is not necessary to trace here the images and symbols of the goddess, the labyrinth, and the horns through the art and religion of the Neolithic period and in the civilizations of the Near East and Crete. Levy has done so with considerable success.[5] Instead I should like to suggest that the siting, orientation, and design of the palace architecture of Bronze Age Crete clearly made conscious use of exactly those images, some of them derived from the forms of the landscape itself, others constructed. The Cretan palaces and their use of the site represent a late and full ritualization of the traditions of Stone and Bronze Age culture. From roughly 2000 B.C. onward, a clearly defined pattern of landscape use can be recognized at every palace site. More than this, each palace makes use, so far as possible, of the same landscape elements. These are as follows: first, an enclosed valley of varying size in which the palace is set; I should like to call this the "Natural Megaron"; second, a gently mounded or conical hill on axis with the palace to north or south; and lastly a higher, double-peaked or cleft mountain some distance beyond the hill but

3. Mt. Jouctas from ancient harbor of Knossos (*Vincent Scully*).

4. Sketch map: Crete (*Der Scutt*).

3

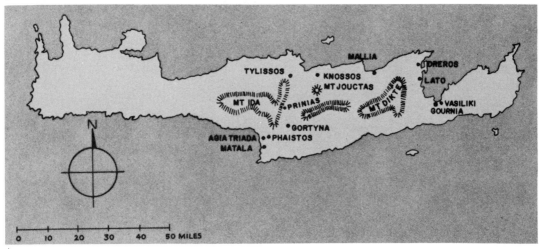

4

on the same axis. The mountain may have other characteristics of great sculptural force, such as rounded slopes, deep gullies, or a conical or pyramidal massing itself, but the double peaks or notched cleft seem essential to it. These features create a profile which is basically that of a pair of horns, but it may sometimes also suggest raised arms or wings, the female cleft, or even, at some sites, a pair of breasts. It forms in all cases a climactic shape which has the quality of causing the observer's eye to come to rest in its cup. Though there are many overlaps in shape and probably many unguessed complexities in their meanings, still the cone would appear to have been seen as the earth's motherly form, the horns as the symbol of its active power. All the landscape elements listed above are present at Knossos, Phaistos, Mallia, and Gournia, and in each case they them-

selves—and this point must be stressed—are the basic architecture of the palace complex. They define its space and focus it. Within that space the constructed elements take their form and create four complementary types of enclosure. These are: the labyrinthine passage, the open court, the columned pavilion, and the pillared cave. All these forms, both the natural and the constructed, can be shown to relate to what we otherwise know of Minoan religion and its dominant goddess, so that the natural and the man-made create one ritual whole, in which man's part is defined and directed by the sculptural masses of the land and is subordinate to their rhythms.

From the old harbor of Knossos, where the traveler of antiquity would have disembarked, the notched peak of conical Mount Jouctas can be seen rising directly to the south [3

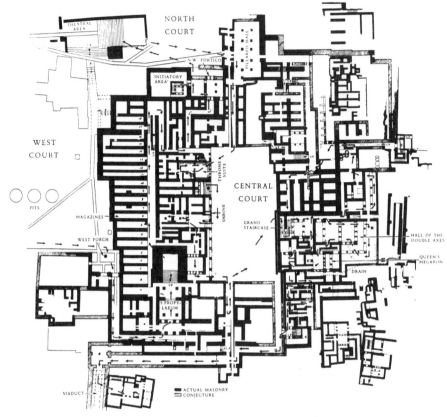

5

5. Knossos. Plan (*Pendlebury, Handbook to the Palace of Minos at Knossos, plan 9*).

6. Knossos. Central court and Jouctas from northern entrance (*Vincent Scully*).

6

and 4]. Upon it, in Minoan times, was a cave sanctuary of the goddess, in Greek times a sanctuary of Zeus which was supposed to mark the place where, in terms which are those of pre-Olympian religion, the god was buried.[6] Jouctas, then, was a holy mountain, like those of the Hebrews, the Mesopotamians, and the Hittites, like those, indeed, of all the religions of the Near East. Most of all, it existed in fact as a focus for ritual; it did not have to be constructed, like the Ziggurats of Mesopotamia.[7]

The way toward Knossos from its ancient harbor winds in a serpentine movement through the lower hills that lie between the palace and the sea. Finally the sea is left well behind; the valley widens and the hills on both sides rise up to define it clearly. Directly ahead, enclosed within the valley, and indeed pushed up close to the point where the valley itself is closed by a mounded hill, lies the palace and beyond it Mount Jouctas. The ceremonial entrance would seem to have been on the north [5]. Here are the doubled stairs of the so-called theatral area, approached along pavements marked by raised stone paths which are so narrow that they must be walked upon in single file. Thus a procession into the palace must have taken on something of the character of the ancient processions into the caverns of Paleolithic times: a long file following a narrow way. Perhaps spectators were massed upon the steps of the "theater" to watch the ritual approach, as they later stood upon similar steps inside the

Telesterion at Eleusis and at other mystery sites. The paths diverge at the steps. One moves east, enters a pillared hall, turns south, mounts a ramp, and comes into the open court at its north end. From here the eye travels directly down the long axis of the court and sees beyond it (though the lower part of this view might have been blocked by buildings in Minoan times) the mounded hill which closes the valley and the split peak of Jouctas in the distance [6]. The reason for the elongation of the court on a north-south axis now seems clear: it directs the eyes toward the sacred mountain of the goddess and emphasizes the natural order which derives from her. The sculptural solids are natural ones. The constructed palace opposes no counter sculptural presence to them. Instead it is essentially a hollow which receives and is controlled by their massive force.

Yet the court at Knossos is not precisely on axis with the mountain; in order to discover that axis the second, more labyrinthine ceremonial route must be followed. It moves south from the theatral area and directs its narrow path along the west flank of the palace with the mounded hill and Jouctas in view ahead. Arriving at an open space, the "west court," it divides again and is joined by a path from the west; in this area was an altar. Directly ahead was the west porch, with a single column enclosed between its walls. The cylindrical wooden column between walls was itself a symbol of the goddess' presence and a feature of her shrines [7].[8] It might

7. Knossos. Fresco, shrine. Reconstructed (*Herakleion Museum. Evans*).

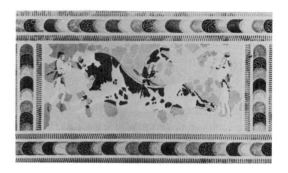

8. Knossos. Fresco, Bull Dance. Reconstructed (*Herakleion Museum. Evans*).

be argued that the column, thus enclosed, as later by lions at Mycenae, may have been considered especially expressive of the goddess since it joined to its tree symbolism a specific description of a female state of being. Thus the whole palace became her body, as the earth itself had been in the Stone Age. So, beyond the west porch at Knossos a corridor, narrowed down almost to the width of the footway and lined with processional frescoes, took the actual processions into a dark place; beyond it, in the light beyond the south terrace, the softly mounded hill and Mount Jouctas form the view. Here a ramp joined the façade at a lower level, bridging the ravine between the palace and the hill. Perhaps this façade of the palace was crowned by horns, as Evans thought.[9] The pair at present set up near the propylaia are his restoration based upon a rather small fragment [1]. With them in view, however, it can be understood how the Minoans could have seen Jouctas as horned and why it is probable that it was the epithet *keratos,* "of the horn," that Strabo used to describe Knossos as a whole.[10] The cave shrine of the goddess was upon the horned mountain, and her shrines— as we know from Minoan gems and frescoes, and from the altars with horns upon them at Knossos—were horned with what Evans has called the "Horns of Consecration."[11] Thus the horned mountain itself defined the consecrated site where the larger ritual of ceremonial kingship under the goddess could best be performed.

In any event, it is the propylaia which, at Knossos, is directly on axis with the mountain. Thus, turning left and left again, the processions had Jouctas directly to their back, passed through the propylaia on that axis, and mounted the stairs toward the shadowed volume of the main columnar hall. Beyond this a narrow stairway, divided below by another single column, led downward toward the east, and took the processions into the bright light of the court [5]. Here, as Graham has shown, the bull dance took place.[12] In it, the old Stone Age ceremonials achieved a new and beautiful form when, in the presence of horned Jouctas, the young men and girls, facing death in the bull, seized the horns sacred to the goddess and leaped, propelled by the power of the horns [8]. In this unilinear dance there was none of the complication of form and meaning to be found in the modern Spanish bullfight and its circular arena. The bull charges straight, down the long court designed for him as he embodies the mountain's force, and no baroque or spatially aggressive figures are made by a cape around him. Nor, though the bull was probably sacrificed to the goddess later, does there seem to have been any blood involved in the game itself except that shed by the dancers, surrogates for all mankind, if they failed to grasp the horns. The unilinear Minoan dance, therefore, did not dramatize subtle man making his own shapes around and finally killing the unreasoning power of nature but instead celebrated both men and women together as

accepting nature's law, adoring it, adding to their own power precisely insofar as they seized it close and adjusted their rhythms to its force. The love for the free movement of the beast which is demonstrated by the paintings of the Paleolithic caves now broadens its conceptual base and grasps the beauty of the movements of man and beast together and indeed of all creatures and things in the world. The final sacrifice of the bull to the goddess should itself also be seen, like the later sacrifices of the Greek world, as an act of reverence to the animal, since it dignified with ceremony and hallowed with gratitude the everyday deaths of his kind.

Turning right off the court at last, the processions might have entered the low, dark, cave-like shrine of the goddess with its enclosed stone pillars, flanked by offering pits and marked with the double axe. Therefore, the processional movement from light to dark to light and dark again—culminating as it does in the innermost cavern shrine where were found at once the hollow earth of the goddess and the pillar which both enters and supports the earth and is thus also hers— makes of the Minoan palace as a whole that ceremonial labyrinth around the secret place which the Greeks remembered in their myths. The space, though organized by rectangles, is fluid and moving, like the bull dances themselves and the frescoes on the walls. Through it ran the water which was the goddess' gift and which was collected in lustral basins wherever it found its level in her hollows. All is constant motion up and down around the central court, alike in the domestic apartments culminating in the Hall of the Double Axes as on the other side. There, movement is again labyrinthine, down lighted stairways to semi-cavernous apartments which open outward between pillars, first to columned porches and then to open courts. The exterior profiles of the palace, like its rubble, timber-tensioned structure, simply enclose that movement and shift in-

ward or outward with it. They are not required, for purposes of coherence, to define a clear exterior shape, precisely because they themselves are within a defining shape, that is, the valley as a whole. Thus Minoan planning, possibly owing something of its labyrinthine quality and its courtyard system to the East and the axial propylaia to Egypt, was still neither derivative nor incoherent, as some rather impatient contemporary critics would have it be.[13] Instead it would seem to have fulfilled its elaborate ceremonial function exactly and with deeply expressive power. It can make even the modern observer at least dimly perceive what it must have been like to feel wholly in harmony with nature and at peace with it.[14] In the Minoan palace itself harmony with the land was at once profoundly religious, knowing, and, one senses, even romantically conceived. The palace complex richly reorganized in new and communally satisfying ways what must have been the most ancient of traditions, as it directed its unilinear courtyard upon the landscape forms. It wove its dance of the labyrinth and the horns within the larger hollow of the protecting valley which was the goddess, and in view of the mounded hill which was her gentleness and of the horned mountain which was her splendor and her throne.

Yet once again we should beware of assuming that a form such as the horned mountain could have had only a single symbolic meaning. There is evidence, for example, that the V cleft was associated with the female parts of the goddess in Paleolithic and Neolithic times, and that the same V was a stylized form for horns.[15] One may therefore legitimately surmise that the cleft or horned mountain may sometimes have been seen as embodying the *mons Veneris* of the earth. This could especially have been so at Knossos, where Mount Jouctas is both conical and cleft [1]. No assumption of a personal preoccupation with sexual symbolism in the Freudian sense on the part of the Cretan people,

and no Jungian preoccupation with the concept of a collective unconscious on our own, is necessary for us to understand how they might have hoped to endow Earth, "mother of all," with such an essential attribute and to have believed that those sites dominated by it were closest to the center of life and ultimate power. The horned mountain would thus have been conceived of as the goddess' lap, like the lap of horned Isis upon which the Pharaohs sat [9], her symbolic throne for the king whose palace was focused upon it.[16] He, like the hollow courtyard of the palace, receives the earth power wholly and is subordinate to it although, bull-masked, he may wield it. His own throne at Knossos is set deep in the palace behind the goddess' crypt. It rises from its bucket seat to a high back

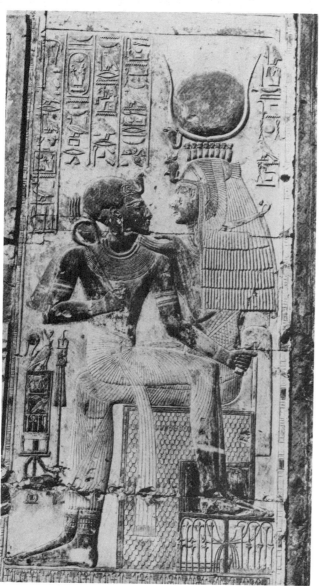

9. Isis with the Pharaoh. Temple of Seti I, Abydos. 19th Dynasty (*Neumann,* The Great Mother, *pl. 4*).

carved in undulations like those of an earth-quake tremor, and, like the propylaia, it faces exactly on axis toward the horned mountain from which those tremors came. . . .

The Indo-Europeans, speaking an early form of Greek, who moved down into the Greek peninsula shortly after 2000 B.C., were soon in contact with the culture of Crete, and they may have sacked Knossos about 1550 B.C. and conquered the island as a whole about 1400 B.C.[17] It now appears that there was no true break between Middle and Late Bronze Ages in Greece, although a rising pattern of aggressiveness seems to characterize the later centuries of the second period, whose culture is generally referred to as Mycenaean and whose later phases were directed by the most aggressive group of all, the Achaians. Yet it is clear that the warrior heroes who were first the chiefs of the Hellenic war bands and then the lords of the citadels were profoundly receptive to Minoan culture, and it would appear that they were either eager to see themselves or were anxious that their subjects should see them as ritual kings who ruled through the power and under the protection of the great goddess.[18] Their cousins, the Dorians, who eventually overthrew them, were clearly impatient of the power of the goddess and strove to curb it. But the earlier groups may even have brought her worship with them, and obvious similarities between their culture and that of the Hittites of Asia Minor, a stronghold of the goddess, serve to reinforce that supposition. The colossal, seated Hittite goddess, carved in the living rock high on the side of Mount Sipylos within the horned cleft of one of its ridges, indicates the importance of her worship in Asia Minor and the kind of natural formation which was felt to be her proper abode.[19] In any event, the Middle and Late Bronze Age settlements on the mainland of Greece begin to show a pattern of placement and orientation in relation to landscape formations, similar to those sacred on

Crete, which was to be developed further in later Greek sacred sites. At the same time, the tablets in Linear B characters from Pylos, Mycenae, and Knossos now tell us that, certainly after 1600 B.C. and probably earlier, many of the special Greek gods were already present.[20] Among these were Zeus, Hera, Poseidon, Athena, Artemis, Hermes and, it would now appear, Dionysos. Hephaistos is doubtful. Apollo as "Paiawon" (Paian) is probable; so too is Ares as "Enualios." The supreme deity, however, would seem to have been Potnia, so named the "Mistress," and invoked at Knossos as "Our Lady of the Labyrinth." At Pylos she was hailed as "Divine Mother," and most of the surviving dedications of offerings there are to her and Poseidon, apparently her consort and possibly identified with the living king himself. This curious anomaly, replete with creative tension for the future, of individual warrior chiefs whose Indo-European pantheon of gods was already in the making but who still worshiped the goddess of the earth and of peace as the dominant power, is amply demonstrated by their buildings and most of all by the sites where they placed them. These tell us why the Bronze Age lords were the hero ancestors of the later Greeks, daimonic intermediaries with the gods: first, because they made systematic contact with the sacred earth; second, because some of them were eventually forced, by their own necessity for action, to contest the goddess' earthly dominion with her and to seize her places of power for their own. Out of that tragic confrontation the richest fabric of Greek myth took form, and some of the greatest sites, like that of Mycenae itself, document it with their forms. Finally, the inevitable death of the heroes, defeated in the end by the earth, gave a new sanctity to the already sacred places where the terrible encounter had occurred. Having come to grips with the earth, they became—in return and though dead—the receptacles and transmittors of its powers.

NOTES

1. Euripides, *Helen,* 1301–1302, trans. by Richmond Lattimore, Vol. 3, Chicago, 1959.

2. For the geography of Greece, the work of Alfred Philippson is indispensable. A complete bibliography of his writing may be found in Ernst Kirstein, *Die griechische Polis als historisch— geographisches Problem des Mittelmeerraumes,* Colloquium Geographicum, Bd. 5, Bonn, 1956, pp. 15–25. There is now appearing under Philippson's editorship, together with E. Kirstein and H. Lehmann, an encyclopedia of Greek geography under the general title *Die griechischen Landschaften, eine Landeskunde,* Frankfort, 1950ff. Also: *Atlas of the Classical World,* Van der Heyden and Scullard, eds., London, 1959, pp. 9–90.

3. See Rudolph Stampfuss on Paleolithic finds in Boeotia, in *Zeitschrift für deutsche Vorgeschichte,* 34 (1942).

4. Notably by G. R. Levy in her brilliantly conceived work, *The Gate of Horn, A Study of the Religious Conceptions of the Stone Age, and Their Influence upon European Thought,* London, 1948. See now also Johannes Maringer, *The Gods of Prehistoric Man,* ed. and trans. by Mary Ilford, New York, 1960.

5. Levy, pp. 3–28, 54–63, 128–138, 213ff.

6. Sir Arthur J. Evans, *The Palace of Minos at Knossos,* 4 vols., London, 1921–36, Vol. I, pp. 151–63, and A. B. Cook, *Zeus, A Study in Ancient Religion,* 3 vols., Cambridge, Engl., 1914, Vol. I, pp. 157–63. For a conflicting opinion, see Martin P. Nilsson, *The Minoan—Mycenaean Religion and Its Survival in Greek Religion,* Lund, 1950, pp. 461–62.

7. Levy, *The Gate of Horn,* pp. 167–77. The recognition of this tradition by the Hebrews and the dialogue which takes place between it and their developing concept of Jehovah is well attested from the Bible, as in Psalm 121: "I will lift up mine eyes unto the hills: whence cometh my help? ... My help cometh from the Lord, which made heaven and earth." Also Jeremiah II: "Truly in vain is salvation hoped for from the hills, and from the multitude of mountains; truly in the Lord our God is the salvation of Israel."

8. Evans, *The Palace of Minos,* Vol. I, pp. 159–60.

9. *Ibid.,* Vol. 2, pp. 159–60. See also Nilsson, *The Minoan-Mycenaean Religion,* pp. 165–93.

10. Strabo, *Geography* 10.4.8, Loeb edn., trans. by H. L. Jones, 8 vols., London, 1917–32, Vol. 5, p. 128, n. 4. Knossos in earlier times was called καίρατος, but this was Casaubon's conjecture for κέρατος, "horned," in the actual text.

11. Evans, "Mycenaean Tree and Pillar Cult," *Journal of Hellenic Studies,* 21 (1901), pp. 135–38. And see W. Gaerte, "Die Bedeutung der kretisch-minoischen 'Horns of Consecration,'" *Archiv für Religionswissenschaft* 21 (1922), pp. 72–98.

12. Walter J. Graham, "The Central Court as the Minoan Bull-Ring," *American Journal of Archaeology,* 61 (1957), pp. 255–62. For an earlier opinion, see Nilsson, *The Minoan-Mycenaean Religion,* p. 374, and Nilsson, *The Mycenaean Origin of Greek Mythology,* Berkeley, Calif., 1932, p. 176.

13. Lawrence, *Greek Architecture,* p. 34.

14. Such harmony has been romantically sought by many writers and architects in one way or another since the beginning of the whole divorce from nature which marks modern times. It is for this reason, I think, that there is such a curiously close and triple relationship between the plan of the palace at Knossos as excavated, its details and frescoes as reconstructed by Evans, and the contemporary, early twentieth-century design of Art Nouveau architects or of Frank Lloyd Wright. I have elsewhere attempted to demonstrate Wright's use of Minoan and related orientations and forms for similar meanings. Eventually, like the peoples of the Ancient East, he even built his own sacred mountain in the Beth Sholem Synagogue, of 1959. This recalls the coned, horned altar of Artemis at Byblos, published by Evans. Vincent Scully, Jr., *Frank Lloyd Wright,* New York, 1960, pp. 28ff., figs. 96, 97, 102–20, 125–27.

15. Cf. Paolo Graziosi, *Palaeolithic Art,* New York and London, 1960, pp. 96–97. Reference is to schematization of ibex forms, viewed frontally, which, through a series of engravings on bone, can be seen to be progressively abstracted or reduced

to a system of V-shaped signs which stand for the horns. This V-shaped symbol for the horned animal may in turn be related to the V-shaped or triangular genital region of so many mother goddess figurines. Cf. plates 2, 4, 5, 9, 11, 12, (mother-goddess figurines); plate 82a (accentuated V-cleft); plate 99d–g (progressive schematization of ibex). Also refer to page 103, where mention is made of small, cone-shaped figurines decorated with V-signs and zig-zag lines, symmetrically placed, with a triangular mark near the base. These objects have been interpreted as phalli, as birds, and also schematized female figures. The latter interpretation is the most generally accepted. Graziosi cites the following: (1) Th. Volkov, "Nouvelles découvertes dans la station paléolithique de Mézine (Ukraine)," in *Congrès Internat. d'Anthrop. et d'Archéologie Préhistoriques*, XIVe session, Geneva, 1912, Vol. I, pp. 415–28. (2) P. P. Ephimenko, "Kamennije orudija paleoliticeskoi ctojanki v s. Mesine Cernigovskoi gub.," in *Èjegsdnik Pysskogo Antropologhiceskogo obscestva nri S.-Peterburskom universitete*, 4, St. Petersburg, 1913, pp. 67–102. These objects were found in the Ukraine. Photos originated in E. Golomshtok, "The Old Stone Age in European Russia," *Transactions of the American Philosophical Society*, n. s. 29, Part 2, March 1938, pp. 189–468. They are illustrated in Graziosi, pl. 101 a–j.

16. For the tradition of the goddess' lap as the king's throne, for the throne as mountain, and for female symbolism in general, albeit in rather cabalistic terms, cf. Erich Neumann, *The Great Mother*, trans. by Ralph Manheim, Bollingen Series XLVII, New York, 1955, esp. pp. 98–100, 273–92. For genital triangle as prominent symbol of the mother goddess: pls. 6–14, 16, 17, 23, 25; figs. 2, 10, 22, 23, 25. See also *ibid.*, pl. 4, where Seti I, XIX Dynasty, is shown sitting on the lap of horned Isis. In this connection it may be significant that the enclosed cup of the Valley of the Kings, used for pharaonic burial primarily during the second millennium, has a nippled pyramidal peak on one side and a pair of mountain horns on the other.

17. Evans, *Palace of Minos*, Vol. 1, pp. 27–28, and Vol. 2, pp. 344–46. R. W. Hutchinson, "Minoan Chronology Reviewed," *Antiquity*, 28 (1954), pp. 155–64.

18. Nilsson, *The Minoan-Mycenaean Religion*, pp. 485–91.

19. For the Hittite mother goddess carved in the rock, see O. R. Gurney, *The Hittites*, Harmondsworth, Middx., 1952, pp. 135–144. In general, see L. Franz, "Die Muttergötter im vorderen Orient und in Europa," *Der alte Orient*, 35, no. 3, Leipzig, 1937.

20. M. G. F. Ventris and J. Chadwick, *Documents in Mycenaean Greek; Three Hundred Selected Tablets from Knossos, Pylos and Mycenae* . . . Cambridge, Engl., 1956. The observations about Mycenaean divinities which follow derive generally from John Chadwick, *The Decipherment of Linear B*, Cambridge, Engl., 1958. This fundamental work has also been excerpted in *Natural History*, 70, March 1961, pp. 8ff., and April 1961, pp. 58ff.

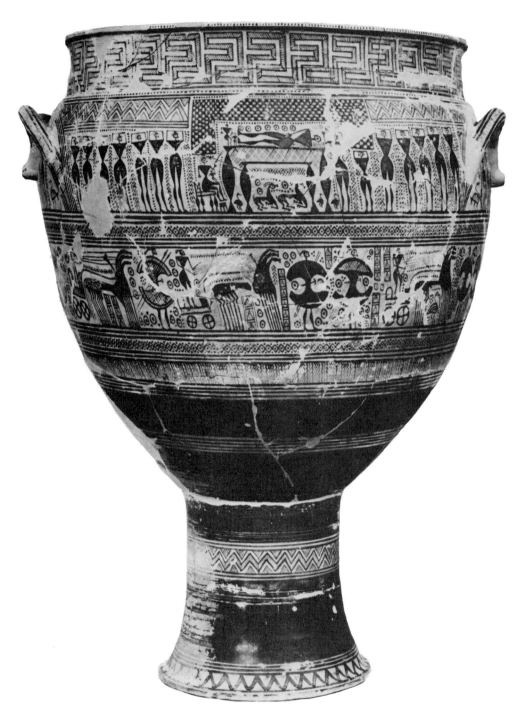

1. Dipylon Vase. Krater, probably by the Hirschfeld Painter, 8th century B.C.
New York, Metropolitan Museum of Art, Rogers Fund, 1914 (*Metropolitan Museum of Art*).

3

Mourners on Greek Vases:
Remarks on the Social History of Women

CHRISTINE MITCHELL HAVELOCK

It is now generally believed that a woman in ancient Greece was a creature not to be envied. There is a considerable body of evidence which points to the fact that, compared to a man, she was secondary, oppressed, restricted, disregarded and without identity.[1] It is not possible to be in such a situation without feeling deeply and darkly bitter. The words of Medea are some of the most eloquent in all Euripidean drama:

We women are the most unfortunate creatures.
Firstly, with an excess of wealth it is required
For us to buy a husband and take for our bodies
A master; for not to take one is even worse.

...I would very much rather stand
Three times in the front of battle than bear one
 child.[2]

Could any woman possibly react with pleasure when Hippolytus—that chaste young

man who spurned the advances of Queen Phaedra—is allowed to spit out the following:

...Curses on you!
I'll hate you women, hate and hate and hate you,
and never have enough of hating...
some say that I talk of this eternally,
yes, but eternal, too, is woman's wickedness.[3]

No doubt the males in the ancient audience were understanding if not delighted. Hipponax, an archaic poet from Ephesos, is recorded to have said: "The two days in a woman's life a man can best enjoy are when he marries her and when he carries her dead body to the grave."[4]

But lest it be argued that these quotations are drawn from the fantasies and inventions of the poetic mind, women's sorry lot can be objectively documented by other evidence. A series of legal measures beginning at the time of Solon and carrying through into the classical periods—roughly from 600 to 300 B.C.—directly affected women. As Sarah Pomeroy states in her book on women in classical antiquity, the thrust of Solon's legislation was "to keep them [women] out of sight and to limit their influence."[5] This no doubt applied especially to Athens among the Greek city

Christine Mitchell Havelock, "Mourners on Greek Vases: Remarks on the Social History of Women," *The Greek Vase: Papers based on lectures presented to a symposium held at Hudson Valley Community College at Troy, New York, in April of 1979*, ed. Stephen L. Hyatt. Latham, N.Y.: Hudson-Mohawk Association of Colleges and Universities, 1981, pp. 101–18. By permission of the author and the Trustees of Hudson Valley Community College, Troy, New York.

states. Women may have had more freedom in Ionia and they certainly did in Sparta. A woman in Athens could not own or dispose of property in her own right. A citizen woman was never allowed to marry for love or self alone, but as a consequence of a dowry which came with her. If she expected to have a husband—and she did for she was meaningless without one—she had to guarantee never to be a financial burden to him. Her father or the nearest male relative selected the husband, whom she may never have seen before. Once married her first duty was to procreate—but not too much since excess infants were destroyed. She had no autonomy or selfhood; as a person she was always defined in terms of a male protector or guardian. In the classical period it is not clear how much education she could or did receive, but it would seem to have been less than her brother. Athenian, unlike Spartan women, were not even allowed to exercise themselves in athletics.

But even beyond custom and law, Greek philosophical opinion further certified that women's secondary role was the inevitable consequence of her very nature. Plato, when he wrote the *Republic*,[6] thought otherwise, but the later philosophical tradition was hostile to women. This was the worst kind of charge: that women are ordained to be second rate because of some kind of cosmic program. It was Aristotle who finally set the seal permanently on this view: "... as between male and female the former is by nature superior and ruler, the latter inferior and subject."[7]

Thus the woman of ancient Greece, and of ancient Athens especially, listened and heard these unhappy utterances from the dramatists, the poets, the legislators and the philosophers. But she also had eyes, and there were occasions, perhaps during a festival or a theatrical performance, when she had an opportunity to observe how the city in which she lived celebrated its history and extolled its heroes, how in short, with unabashed forth-

rightness, male virtues reigned supreme.[8]

The most significant type of building in ancient Greece was the temple. Time and thought, money and labor were lavished upon its construction and decoration. Temples were normally conspicuous and frequently the largest buildings of a city or sanctuary and well situated. Thus their importance was made clear through sheer visibility. The sculptural decoration constantly sent messages to the spectator, and if we look at their range of subject we observe that the messages were directed primarily to men and not to women. This is because the overwhelming majority involved battle subjects. Indeed, it is difficult to think of a Greek temple which if decorated did not contain an *agon* or contest somewhere. To a Greek, war was a way of life and this is, it can be argued, a heroic, chauvinistic, male concept. The battle scenes might involve Greek struggling with Persian, with Trojan or with centaur. But the appeal of these struggles is to the young Greek man—who is invited to behave like a hero and to identify with those sculptured Greeks. Women are present in centauromachies but they are victims rather than contestants. In the west pediment of the temple of Zeus at Olympia, for instance, groups consisting of one Greek and one centaur quarrel viciously over one woman—as if she were a piece of property.

But what aroused the greatest pleasure and enjoyment in the young spectator—if we judge by the frequency of representation—were the conflicts of the mortal hero Herakles. In Greek art Herakles is the perpetual Man of the Year; he is featured abundantly in painting and in sculpture. From these various representations we can learn a lot about him. As a man, he led a full life: he hunted, he killed, he made love, he became a father, he liked food and wine, he suffered from fatigue and yet recovered. He was a complete person. All Greek youths, no matter where or when they lived, could be expected to find some

psychological link with him. He was, in short, a superb role model.

Yet we should be aware that there are some instances in Greek art where women are also courageous and physically powerful. I speak of the often dazzling Amazons. They rode horses, they were good shots with bow and arrow; when necessary they even managed a navy. They were thought to exhibit manly vigor and it is precisely this that made them so dangerous to the Greeks. They were women imitating men—a deep affront and a perversion. Therefore, very often in Greek art, whether in sculpture or painting, the Greeks confronted and defeated these agile and capable women who dared to straddle their horses like men. Such a subject is for men only. For a woman spectator there is only one message: behave like an Amazon and you will be overcome. Greek literature and art portray several other unappetizing women: Medusa, Pandora and the Harpies. Their main fault? They succeed, or nearly succeed, in disrupting mankind, which means "male" man.

But was there no female counterpart to Herakles? Who could young women look up to? The goddess of Athens, Athena, is a possible candidate. She was a very important Greek goddess; everyone loved her; she was represented in every medium and in all phases of Greek art. What kind of person was she? She had both brains and beauty, it is true. She was the favorite child of the supreme god Zeus. In fact, he insisted on giving birth to Athena himself; he would not allow her to be born of inferior woman. She was not only endowed with her father's intelligence, she also inherited his physical prowess. She is frequently represented as a warrior. On the other hand, Athena presided over some distinctly female pursuits—such as weaving and sewing; she had her sweet and compassionate side. Yet for all these achievements she paid a price. It was her own decision to remain a virgin and never to marry.

Thus Athena would not be the sort of woman a young girl in Greece could easily accept as a role model. She was too free, too accomplished and also far too conspicuous. She is really an invention of the male mind. In Aeschylus' drama the *Eumenides* Athena presides over the trial in which Orestes is exculpated for murdering his mother. In the course of it she gives this memorable description of herself:

For there is no mother who bore me;
and I approve the male in all things, short of accepting marriage,
with all my heart, and I belong altogether to my father.[9]

Another prominent female deity, Artemis, was a vigorous huntress and an extremely independent woman. However, in spite of her interest in childbirth, she herself resisted men and motherhood. She was not a suitable role model either.

While there is much negative evidence about woman's place and role in ancient Greece, there is also another side to the coin. Legal codes and philosophical writings are not the whole story. As for art: until now we have been considering official, public art, art commissioned by the ruling authority and which speaks for the political and religious values of the city-state. But in the realm of private art, we can focus more closely on women and the ordinary rather than the extraordinary woman. The situation will not seem so adverse to her interests. We can observe that while the female may have been restricted in her participation in society, she was not totally excluded. For example, a lovely votive relief, now in the National Museum in Athens, was privately dedicated and perhaps even individually commissioned by a woman. The woman, a mother, by the name of Xenocrateia, brings her young son into the presence of at least seven divinities [2].[10] One of the gods, perhaps Kephisos to whom the relief is dedicated, actually bends down to greet her. What we should realize is that this

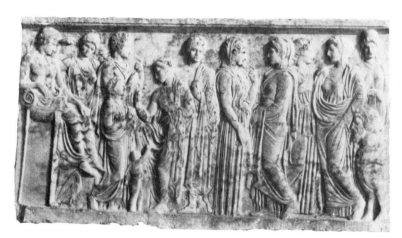

2. Votive relief dedicated by Xenocrateia, 5th century B.C. Athens, National Archaeological Museum (*after U. Hausmann,* Griechische Weilreliefs, *1960, fig. 33*).

woman, of the classical period in Athens, enjoyed or believed she enjoyed direct access to the gods, even without her husband. There is no male intermediary or associate. The mother of Christ could only enter the temple to present her child accompanied by Joseph.

But vase painting is the most informative visual source for the role of women in ancient Greece. Women are ubiquitous in black and red figure vases; they are featured prominently and delightfully in mythological scenes and in scenes from daily life. However in order to focus the discussion I will select a series of vases whose painted decoration depicts women as present and as functioning at events which are crucial to the functioning of human societies: that is, funerary ceremonies. Funerary vases, mainly but not entirely from Athens, may shed some light on the social history of women.

As background it is important to realize the significance of vases as such to Greek burials and funerary rituals. A grave dated in the Geometric period (about 740 B.C.) was recently excavated in Athens.[11] Down the center of the rectangular pit were the skeletal remains of a young woman lying on her back with her head tilted toward her right shoulder. She was surrounded by a sort of nimbus of vases [3]. Over forty were placed there,

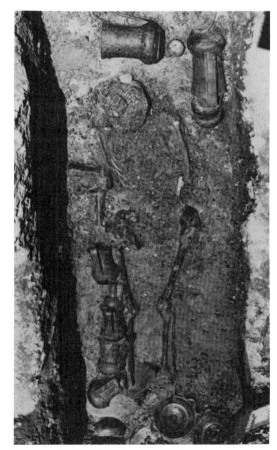

3. Grave pit with skeletal remains of woman surrounded by vases. Athens, ca. 740 B.C. (Mitteilungen des Deutschen Archäologischen Instituts, Athenische Abteilung, *89, 1974, pl. 1, 3*).

some even under her before the body was laid down. The vases are of different shapes and sizes and all are of high quality. In addition to the vases six brooches, two knives, one ivory seal and one amulet were distributed near the corpse. It would surely seem that this young woman was not likely to have been oppressed or neglected; she must have belonged to a wealthy family who, one could guess, adored her. They might also have feared her; in any case she was very important to them. They piled around her her own domestic pots and jewelry, tenderly making sure her head was uncrowded. The ivory seal suggests she had a certain responsibility for the economic affairs of her household. This particular grave is unusually rich, but it is not unique, and I am suggesting that even in these early Greek times feminine values, those derived from the dignity of the home and woman's place, were appreciated.

The magnificent larger krater which stands on its own pedestal in the Metropolitan Museum of Art in New York was made in Athens about the middle of the eighth century B.C. [1][12]. Originally it stood above a grave as a marker. On a tall zone at the widest part of the vase we are presented with a scene of major significance: it is a showing or display of the dead body, a *prothesis*.[13] Lying on a bier or couch is the corpse of a dead man turned up on his side, his head resting on a pillow [4]. He is probably nude. Above him a chessboard design, depicting a cover for the bier, is drawn vertically instead of horizontally. The figures nearest the corpse are probably the immediate members of his family: his wife, at the left, is seated with a footstool under her feet and with a child on her lap. She holds a branch, perhaps to swish away the flies. Two people, one an adult, the other perhaps a child, seem to stand at the foot of the bier. Another woman, also holding a branch, stands at the head of the bier. The closeness of these women to the actual body of the dead man and the role they play are very significant. Then beyond the bier on either side we observe a long parade of figures with their arms raised, all the same way, above their heads. In the secondary zone below and circulating around the vase is a procession of armed foot soldiers and charioteers drawn by three horses.

If we examine the figures in greater detail we can notice that the vase painter has, with supreme brevity, and almost imperceptibly,

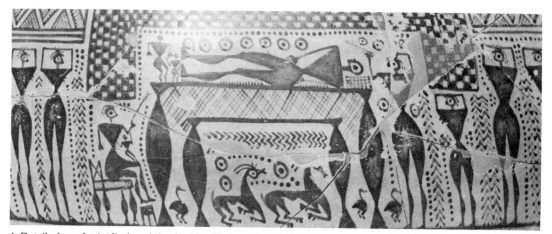

4. Detail of *prothesis* (display of the dead body), from the Dipylon Vase. Krater, probably by the Hirschfeld Painter. 8th century B.C. New York, Metropolitan Museum of Art, Rogers Fund, 1914 (*Metropolitan Museum of Art*).

distinguished the sex of his figures. Most of
the people in the wide zone are women: two
short brushstrokes indicate breasts showing
that the figures surrounding the bier are
women, and they are mourning and tearing
their hair with both hands. But in Geometric
vases taken as a whole group we cannot count
on gender differences being clarified in con-
spicuous physical terms.

After the corpse had been lying in state for
three days, it was taken away for burial.[14]
Pomp and ceremony were essential and were
expressed through a procession in which the
bier was hoisted up on a hearse and towed
along by two horses to the cemetery, accom-
panied by many mourners of both sexes. The
removal of the body to the cemetery (*ek-
phora*) is portrayed on a large Geometric
krater (about 740 B.C.) which is now in the
National Museum in Athens [5 and 6].[15] More
women than men mourn in this example; the
latter carry swords. It is possible that the
chariots or wagons below were also part of
the procession to the grave.

The funerary scenes on the Geometric
vases in New York and Athens, and on others
like them, might be described in condescend-
ing terms. It could be argued that the style of
the figures is primitive and incompetent and
that the artist could not draw the human
form. Perhaps he did not know enough to put

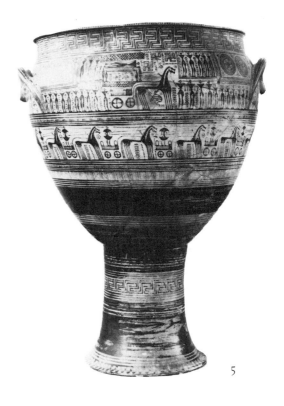

5

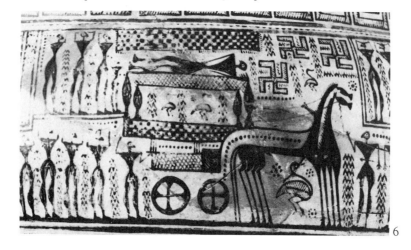

6

5. Krater by the Hirschfeld
Painter, ca. 740 B.C. Athens,
National Archaeological
Museum (*National
Archaeological Museum*).

6. Detail of *ekphora* (removal
of the body to the cemetery),
from #5 above (*National
Archaeological Museum*).

the wheels on the ground. But let us consider what the painter succeeds in telling us very well indeed. First of all he wants to assure us that these are big funerals, major public events. I also believe, as do others, that these scenes represent real contemporary funerals, not mythological ones. When these scenes are viewed you feel you are watching crowds of people—there are easily fifty persons on each vase—in a ceremony conducted probably in some public area in which the whole village or community is involved: not only the immediate family, the relatives, but the neighbors up and down the street as well. Men, women, children, warriors, old and young participate. The point is that women are very much a part of these events, they are not excluded. But more than that they are essential to the performance and to the ritual. They have a role to play, no more, no less than anyone else. They thus seem to be woven into the very fabric and texture of town life. One senses their integration, even their equality. This may be a primitive painting style, but I would submit that the painter is very socially aware and civilized.

As it happens Homer may have been composing the epic verses of the *Iliad* at just about the time these vases were being turned and painted in the potter's shop. This sense that an entire population can join in mourning is also present in the epic. In Book XXIV, after Hector's body had been dragged around Troy, and after his father had ransomed it, it was placed on a bier and brought home to the palace. The first person to see the corpse of Hector coming through the gate was a woman, his sister Cassandra:

She cried out then in sorrow and spoke to the
 entire city:
"Come, men of Troy and Trojan women; look
 upon Hektor." . . .
She spoke, and there was no man left there in all
 the city nor woman, but all were held in sorrow
 passing endurance.[16]

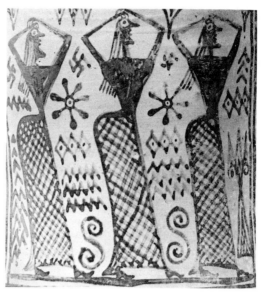

7. Detail of women mourners, from a late Geometric amphora, 8th century B.C. New York, Metropolitan Museum of Art, Rogers Fund, 1910 (*Metropolitan Museum of Art*).

The lament (*threnos*) for the dead[17] was performed primarily by women in antiquity. This we can learn from literary accounts, but certainly also from vases such as the two just discussed. The gesture of mourning, seen again in a detail [7] from an amphora in the Metropolitan Museum[18] of very late Geometric times, is very simple but amazingly effective. This is, of course, body language, an instinctive raising of the arms to our heads when we are unhappy—in order to replace the pain in the heart by a kind of self-wound, either by pulling our hair, or by digging our nails into our flesh. This is a universal, not a gender, response to sorrow and it is familiar in earlier Egyptian and Mycenaean painting as well.[19] In Greek art, two raised arms appear to signify female mourners, the single arm male mourners. Women could even be hired as mourners at funerals in antiquity. Why women? Is it because women have always been less inhibited than men in displaying emotion? And yet we might recall how

that mighty warrior Achilles laments for Patroklos. He falls to the earth, pours grimy dust over his head and face and tears his hair with his hands.[20] Even so, in later periods, for instance in the plays of Euripides, it is expected that women will do the weeping. In Plato's *Phaedo,* when Socrates' friends give way to grief as he lies on his death bed, Socrates himself says to them: "...I sent away the women mainly in order that they might not behave in this way..." and "his young friends, ashamed, stopped their crying."[21] The expression of such emotions was something that Plato condemned, as we know from other passages in his work. But his was not the popular attitude. My own suggestion is that women were and are not more prone to tears than men but that as part of the ritual which is properly due the dead and as a kind of division of labor, women in the distant past assumed the role of performing the lament and in time the emotion thus expressed began to take on a gender as well as a functional meaning. In their formal, repetitive and almost dance-like mourning gestures, women on Geometric vases are never hysterical or uncontrolled. Dignity and decorum are implied in every movement.

We may look at another aspect of the division of labor in some post-Geometric vases. When a person died, the women of the family washed the body and dressed it. Pomeroy points out the analogy with the care of infants: "the cycle of life takes us from the care of women and returns us to the care of women."[22] In other words, whenever we are helpless we need women. It is well to remember, however, that under normal circumstances this occurs at home; in the classical periods this is where the body was laid out for the neighbors to see.[23] A funerary plaque in black figure in the Metropolitan Museum[24] of about 500 B.C. shows a young man laid out on a bier with his head propped up on two pillows [8]. His sisters and maybe his mother come forward from the left. The women lament and mourn—with gestures which are now less stylized and more individual, but the men are also deeply moved, although they raise only one arm as if to say farewell. On a black figured hydria in the Louvre,[25] four nymphs bend over the draped form of dead Achilles

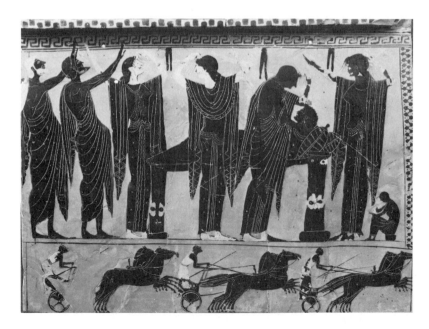

8. Black-figured funerary plaque, ca. 500 B.C. New York, Metropolitan Museum of Art, Rogers Fund, 1954 (*Metropolitan Museum of Art*).

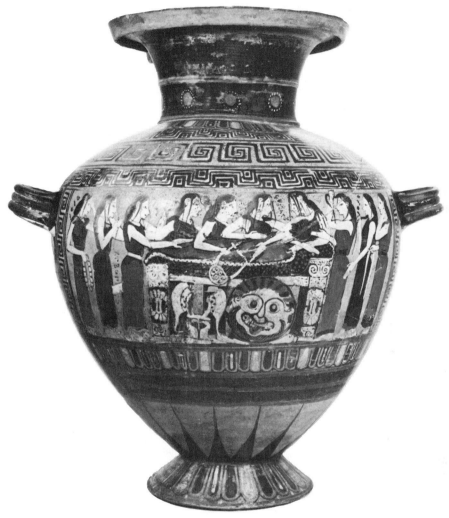

9. Mourning of Achilles. Black-figured hydria, ca. 550 B.C. Paris, Louvre (*Louvre*).

[9]. The nymphs are distraught—their hair streaming down like tears, yet as women they are affectionate and solicitous of their hero. They cannot, it would appear, keep their hands off him. Three other nymphs at each end of the bier express their grief by clutching their hair or by waving their arms despairingly. This is one of the most emotionally charged of all scenes of *prothesis* in Greek vase painting. The white paint applied to the flesh of the women emphasizes their gestures and their aliveness compared to the black stiff cadaver of the great warrior. One is reminded of a Lamentation by Giotto.

The display of the body is one way of honoring it. So far we have observed only the male corpse. But women too were so honored on vases, although apparently not nearly as

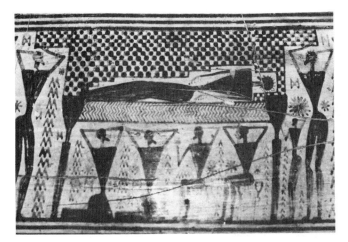

10. Detail of *prothesis,* from a
Geometric amphora by the Dipylon
Master, 8th century B.C. Athens,
National Archaeological Museum
(*National Archaeological Museum*).

often. On a Geometric amphora in Athens[26]
the long skirt worn by the recumbent figure
identifies it, more than likely, as female [10].
Both male and female mourners approach the
bier.[27] An exquisite detail from an Attic lou-
trophoros [11][28] a vase used at the ritual cere-
monies of weddings and funerals, also depicts
a dead woman. The vase, attributed to the
Painter of Bologna, was made during the clas-
sical period, about 460 B.C. We can compare
it to another loutrophoros of the same period
by the Kleophrades Painter which depicts a
young man lying in state [12 and 13].[29] There
is no difference in what is done for each sex
in death. As always the deceased faces left
and women fuss over the body. A special
touch is added by the old nurse who bemoans
her diademed mistress. The diadem may indi-
cate that the young woman, who was unmar-
ried, becomes a bride in death. Marriage and
death were frequently linked in Greek
thought.[30] One thinks specifically of the sto-
ries of Persephone or Antigone, or of funer-
ary epitaphs which mourn the maidens who
died before wedlock.[31]

Much has been written about the seclusion
of Greek women, especially Athenian women
of the upper class. Medea herself bitterly
draws the contrast between the man "who
goes out of the house" to see his friends or to
do battle and the wife who stays home.[32] If

women are depicted on Greek vases as party-
goers, they cannot really be respectable. Yet
a Greek woman was a veritable queen in her
own house; her power, her security, her emo-
tional ties were all there. The Deianera of
Sophocles, before she commits suicide, wan-
ders about the house from room to room,
touching her favorite objects, weeping.[33]

Moreover the *oikos* or household was the
center of gravity not just to women but to
men as well. After the death of his wife Al-
cestis, Admetus keeps saying:

Hateful is this
return, hateful the sight of this house
widowed, empty. Where shall I go?
Where shall I stay?

. . . I wish I had not
ever married her, lived with her in this house.[34]

It is not surprising, then, that the house
was the location of some of the most impor-
tant funerary services; home after all is where
the family gathers and home above all is
where the women are. Consider the domestic
aspects of funerary scenes: the bier is just a
plain bed or *kline,* one that might be found in
a well-appointed home. The dead person lies
on a comfortable mattress, on an embroidered
pillow. He or she is nicely tucked under an
ornamental cover, the body all cleaned and
perfumed. Thus, lamentations of the archaic

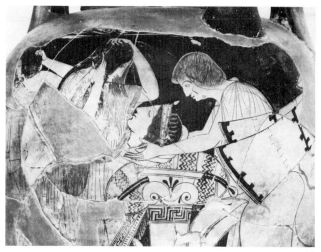

11

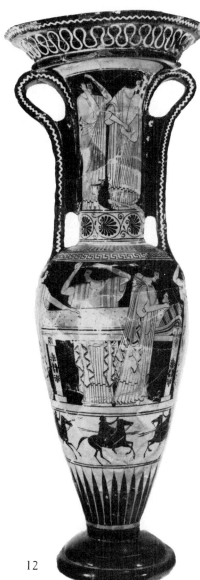

12

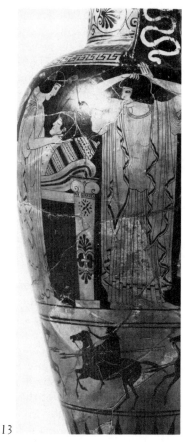

11. Detail from a red-figured loutrophoros by the Painter of Bologna, ca. 460 B.C. Athens, National Archaeological Museum (*National Archaeological Museum*).

12. Red-figured loutrophoros by the Kleophrades Painter, mid-5th century B.C. Paris, Louvre (*Louvre*).

13. Detail from #12 (*Hirmer*).

13

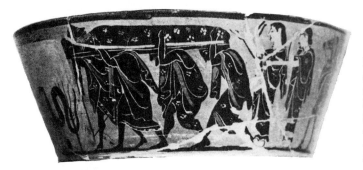

14. Transport of the corpse with female mourners. Black-figured cup. Early 5th century B.C. Paris, Bibliothèque Nationale, Cabinet des Médailles (Mitteilungen des Deutschen Archäologischen Instituts, Athenische Abteilung, *53, 1928, Beilage XV, fig. 91*).

and classical periods are performed with ordinary household furniture, and spread around is the work of woman's hand. Lamentations do not occur in commercial funeral parlors.

In contrast to the collective scenes of town life on Geometric vases, those of the fifth century capture the sense of private lives in the household, of family affection, even a sort of delight in the freshly washed body covered by familiar materials woven by the women who have lost their loved one.

As we have already noted, women could leave the house and join the procession which conveyed the corpse to the cemetery. On a black-figured cup in Paris, four men carry the bed on which the bearded dead man lies, while behind two women characteristically lament [14].[35] The body might be cremated or buried in the ground. In either case women participated until the very end. A vase by the Sappho Painter portrays a woman helping to lower the body into the coffin.[36] Libations of wine, oil, or perfume were poured on the grave, and when the ceremony was over, the family and relatives returned to the house for a funeral feast. Sources indicate that the bed and blankets came back too, and no doubt the women cooked the meal.

For the High Classical period the most characteristic funerary vase was the white lekythos.[37] These are small vases compared with the giant kraters of the Geometric period, and while originally the shape was made for domestic use, in time it became primarily

funereal. The mouth, neck and lower part were usually painted black; they contained oil or perhaps a perfumed scent, and they were often placed as offerings in or on the tomb. The technique involved drawing on a white ground, and then a matt color was added to give a soft fragile effect. The color will rather easily flake off. Occasionally *prothesis* scenes were depicted, but many of these vases show scenes in which two or three figures meet at a tomb. The outstanding feature is not their realism. Rather what is unforgettable is their economy of drawing and the mood or tone. Women are nearly always present.

For example, women are frequently paired on lekythoi. A vase of the 460s in Wisconsin by the Timokrates Painter [15] and one in Berlin by the Achilles Painter are typical.[38] In both cases the actions are unpretentious and unhistrionic. On the Wisconsin vase, two women have assembled their offerings in baskets and are now on their way to visit the grave. On the Berlin lekythos, two women play with a child. These are ordinary and quiet themes; it is not necessary to talk, and the women do not. This is the kind of thing that goes on in the home between women. Greek vases such as these, and also some stone grave reliefs of the classical period, are an excellent source to indicate that Greek females could bond and exhibit sisterhood. One seems to feel, partly because of the white background, that the women enjoy each other in immaculate and sunny interiors.

15. White-ground lekythos by the Timokrates Painter, ca. 460 B.C. University of Wisconsin-Madison, Elvehjem Museum of Art, Edna G. Dyar Fund and Fairchild Foundation Fund purchase (*Elvehjem Museum of Art*).

16. White-ground lekythos by the Painter of Athens, ca. 450–425 B.C. Athens, National Archaeological Museum (*National Archaeological Museum*).

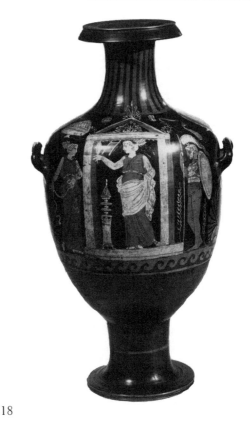

17

18

On a vase in Athens (450–425 B.C.) a woman sinks to her knees at the side of a tomb [16] while she beats her breast with her right hand.[39] In a similar fashion, from a vase in the Metropolitan Museum (about 425 B.C.) another woman clutches her head in the traditional mourning gesture.[40] These women are not part of a chorus or procession of mourners such as we have observed earlier; they are almost alone at the grave, so that it seems as if their actions are motivated more by personal and specific feeling than by formal ritualized occasion whereby a certain mode of behavior is required of them. On the other hand, their capitulation to sorrow and the uninhibited nature of their grief segregates them more strongly than ever from men who come to the tomb, often, but usually with self-control and restraint. The kind of emo-

tion which Plato's Socrates objected to and accused women of can be seen on some of these contemporary vases.

Another subject which is frequently depicted on vases also shows the contrast between male and female mourners. Clytemnestra and her lover Aegisthus conspired to murder Agamemnon. His two children were heartbroken. But it is only Electra who becomes paralyzed with sorrow in this painted version on a red-figured vase from South Italy now in the Louvre [17].[41] She sits dejectedly in a pose, also taken by other disconsolate women such as Penelope and Niobe, on the steps of her father's tomb. Her brother Orestes, at the left, and Hermes on the other side take appropriate ritual actions. The symmetry of this composition is part of the reason for its effectiveness, and the conjunction of Electra and

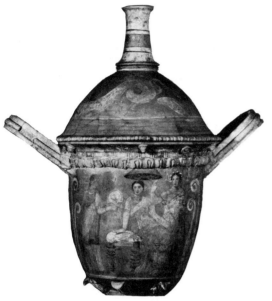

19

17. Red-figured pelike from South Italy, ca. 350 B.C. Paris, Louvre (*Louvre*).

18. Red-figured hydria from South Italy, ca. 325 B.C. Newark, N.J., Newark Museum (*Newark Museum*).

19. Polychrome vase from Centuripe, Catania, Sicily, 3rd century B.C. Catania, Institute of Classical Archaeology, University of Catania (*Hirmer*).

the tombstone on the central axis furnishes both the necessary focus and pathos.

In South Italian and Sicilian vases of the fourth and third centuries B.C., women seem to occupy a more important and elevated position than ever before. A red-figured hydria in the museum in Newark is dated about 325 B.C. [18].[42] As in many vases from Campania and other South Italian regions, its decoration refers to the cult of the dead. In this case the deceased, a woman, stands in a *naiskos* or shrine all by herself, like a heroine or a goddess as if she were worthy of worship. Down near her feet is a censer, at the top left is probably a xylophone, and she is looking at herself in a mirror. A young woman and a warrior approach reverently and respectfully from either side—are they her children? We might ask: what more could a woman want

than this? A fourth-century grave stele from Athens might also feature an enshrined woman, but perhaps with less regard for her vanity and ego.

However, Campanian vases are restrained compared to a group of vessels of the third century which have been discovered in the cemeteries at Centuripe in Sicily. In their decoration the majority show women. These vases are polychrome; pink backgrounds predominate, and in one typical example [19][43] a woman, probably deceased, sits on a fancy cushioned stool. One companion, her maid, holds a parasol over her and the woman at the left hands her mistress a white fan. The elegance of the scene is remarkable: pinks, blues and whites increase the aura of femininity. The paint was applied after firing and it has the quality of face powder.

The Centuripe vase was made in the Hellenistic period, a period in which, documents indicate, Greek women, no matter where they lived, enjoyed more rights and personal freedom than ever before. For instance, opportunities for education, political participation and property owning increased. But, oddly enough, the woman depicted on the Centuripe vase does not look capable of, or even interested in, any of those things; she is not a Cleopatra type who bargained hardheadedly with both Caesar and Octavian. She is rather a woman who sees herself (or is seen by the painter) as an erotic subject, unoccupied, at leisure, adorned and admired. In Geometric vases a woman was part of the warp and woof of life. But in this Hellenistic painting woman is a romantic idealized image and fabrication, such as we might also find in Apollonios' *Argonautica*. Something real about the female sex is understood perhaps in these later vases—her concern for personal appearance, for instance—but that reality also places her on a pedestal; it also equates femininity with eroticism. In either case woman is stripped of her function within society and removed from any significant role. Feminists might be gratified by the individuality and distinction conferred upon women represented in these later Greek vases. Yet we must at the same time recognize that such admiring attention may be accompanied by social isolation.

Regardless of how we interpret the femininity expressed on the Centuripe vase, we must admit that women depicted in funerary contexts on Greek vases, from the Geometric through the Hellenistic periods, were frequently viewed with sympathetic understanding. Neither their contributions nor special qualities were totally disregarded. For this reason, the vases of ancient Greece, and possibly other artistic evidence drawn from the private realm, can offer a needed corrective to the negative picture often presented by literary and legal sources. Generally speaking it would appear that the verbal and visual documentation for the situation of women in ancient Greece may be contradictory, and both must be carefully examined before final conclusions are drawn.[44]

NOTES

1. The most recent and comprehensive survey of women's situation in ancient Greece is to be found in Sarah B. Pomeroy, *Goddesses, Whores, Wives and Slaves: Women in Classical Antiquity,* New York, 1975.

2. Euripides, *Medea,* 231-34, 250-51. Trans. by Rex Warner, in D. Grene and R. Lattimore, eds., *The Complete Greek Tragedies,* 4 vols., Chicago, 1959, Vol. 3, p. 67.

3. Euripides, *Hippolytus,* 664-66. Trans. by David Grene, in *The Complete Greek Tragedies,* Vol. 3, p. 190.

4. M. R. Lefkowitz and M. B. Farb, *Women in Greece and Rome,* 1977, p. 18.

5. Pomeroy, *Goddesses, Whores, Wives and Slaves,* p. 57.

6. See especially *Republic,* book 5.

7. Aristotle, *Politics,* I, 5. Trans. by William Ellis in Everyman Library edn., London, 1948, p. 8.

8. I have earlier considered Greek art as communication in E. A. Havelock and J. P. Hershbell, eds., *Communication Arts in the Ancient World,* New York, 1978.

9. Aeschylus, *Eumenides,* 736-38. Trans. by H. Lloyd-Jones, in E. A. Havelock and M. Mack, eds., *Greek Drama Series,* Englewood Cliffs, N.J., 1970.

10. Athens, National Archaeological Museum 2756.

11. *Mitteilungen des Deutschen Archäologischen Instituts, Athenische Abteilung,* 89 (1974), pl. I, 3.

12. New York, Metropolitan Museum of Art 14.130.14.

13. For a thorough and well-illustrated discus-

sion of this type of scene, see G. Ahlberg, *Prothesis and Ekphora in Greek Geometric Art (Studies in Mediterranean Archaeology)*, Vol. 32, Göteborg, 1971.

14. Burial customs and procedures are considered by E. Rehde, *Psyche, The Cult of Souls and Belief in Immortality among the Greeks,* Trans. by W. B. Hillis, Tübingen, 1925, and by D. C. Kurtz and J. Boardman in *Greek Burial Customs,* London, 1971.

15. Athens, National Archaeological Museum 990.

16. Homer, *Iliad,* XXIV, 703–08. Trans. by Richmond Lattimore, in *The Iliad of Homer,* Chicago, 1951, pp. 493–94.

17. For recent discussion of the lament, see M. Alexiou, *The Ritual Lament in Greek Tradition,* Cambridge, Engl., 1964, and E. Vermeule, *Aspects of Death in Early Greek Art and Poetry,* Berkeley, Calif., 1979.

18. New York, Metropolitan Museum of Art 10.210.8.

19. Early mourners are discussed and illustrated in J. L. Benson, *Horse, Bird and Man, the Origins of Greek Painting,* Amherst, Mass., 1970.

20. Homer, *Iliad,* XVIII, 23–27. Lattimore, *op. cit.,* pp. 375–76.

21. Plato, *Phaedo.* Trans. by B. Jowett in *The Dialogues of Plato,* I, 1936, p. 501.

22. Pomeroy, *Goddesses, Whores, Wives and Slaves,* p. 44.

23. Whether the body was laid in the courtyard or inside the house cannot be determined. Cf. Alexiou, *Ritual Lament,* p. 5.

24. New York, Metropolitan Museum of Art 54.11.5.

25. Paris, Louvre E 643.

26. Athens, National Archaeological Museum 804. See Ahlberg, *Prothesis and Ekphora,* fig. 2a, b.

27. Ahlberg, *Prothesis and Ekphora,* p. 80.

28. Athens, National Archaeological Museum 1170.

29. Paris, Louvre CA 453.

30. See Alexiou, *The Ritual Lament,* p. 122.

31. R. Lattimore, *Themes in Greek and Latin Epitaphs,* Urbana, Ill., 1942, pp. 192–93.

32. Euripides, *Medea,* 245f. Trans. by Rex Warner in *Complete Greek Tragedies, op. cit.,* Vol. 3, p. 67.

33. Sophocles, *The Women of Trachis,* 905–11. In *Complete Greek Tragedies,* Vol. 2, p. 311.

34. Euripides, *Alcestis,* 861–64, 881–82. Trans. by R. Lattimore in *Complete Greek Tragedies,* Vol. 3, pp. 41–42.

35. Paris, Bibliothèque Nationale, Cabinet des Médailles 353.

36. Lausanne, Gillet Collection. See Kurtz and Boardman, *Greek Burial Customs,* pl. 37.

37. For a recent study of this type of vase, see D. Kurtz, *Athenian White Lekythoi,* Oxford, 1975.

38. Madison, Wisconsin, Elvehjem Museum of Art (University of Wisconsin) EAC 70.2; Berlin, Staatliche Museen 2443.

39. Athens, National Archaeological Museum 1934.

40. New York, Metropolitan Museum of Art 22.139.10. Illustrated in Kurtz, *Athenian White Lekythoi,* pl. 41, 2a.

41. Paris, Louvre K544, about 350 B.C. See A. D. Trendall and T. B. L. Webster, *Illustrations of Greek Drama,* London, 1971, p. 42.

42. Newark, Newark Museum, 50.330. See A. D. Trendall, *The Red-Figured Vases of Lucania, Campania, and Sicily,* Oxford, 1967, pl. 176, 1.

43. Catania, Institute of Classical Archaeology (University of Catania). For the polychromy, see C. M. Havelock, *Hellenistic Art,* Greenwich, Conn., 1971, colorplate 3.

44. An extremely interesting analysis of visual as opposed to verbal evidence was recently undertaken by Sheila McNally, "The Maenad in Early Greek Art," *Arethusa,* 2, nos. 1 and 2 (Spring and Fall 1978), pp. 101–35.

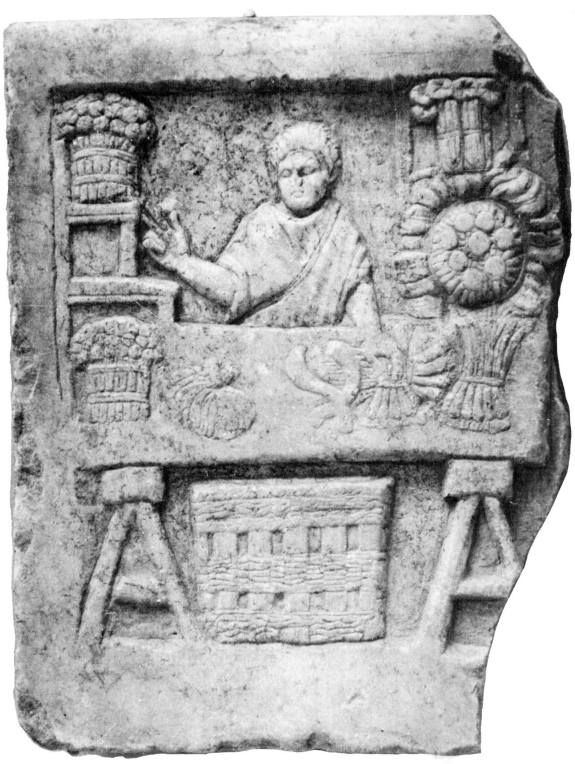

1. Vegetable vendor relief. Late 2nd or early 3rd century A.D. Ostia, Museo Ostiense (*Fototeca Unione*).

4

Social Status and Gender in Roman Art:
The Case of the Saleswoman

Natalie Boymel Kampen

One of the crucial issues in the women's movement of the late 1970s and early 1980s has been the relationship between social class and gender as determinants of women's condition in the world.[1] The argument over the primacy of capitalism or patriarchy as the factor most responsible for women's oppression is by no means a reductivist search for prime movers; the issue is one which not only provides a basis for political choice, but which affects the interpretation of history as well. As other essays in this volume indicate, the art historian can make some useful contributions to the question of the relationship between class and gender. Approaching the question from the point of view of non-verbal, visual language, the art historian can uncover valuable information about social position and attitudes of both patrons and protagonists of works of art. Particularly for social groups lacking substantial written documentation (and ancient women fit here be-

cause they so seldom speak for themselves), deductions from visual imagery may provide important links with silent populations.

The interaction of status with gender is a subject rarely investigated in the history of Roman art, and only recently has increased attention turned to this relationship in Roman history.[2] In this essay, I will explore the relation of gender and status for one group, Roman working people, and will show how gender and social status interacted as determinants of visual images along with such other variables as period, artist's or patron's taste, or function of the object. The hypothesis of this essay is that a woman's position in the social matrix of Roman life helped to determine her iconography in Roman art.

Roman society was both stratified and patriarchal, its codes of public and private behavior based on status and gender power relationships. Stratification meant that there were definable levels in society, recognizable sometimes even on the street by the clothing people wore, but that upward mobility was possible.[3] A slave could become a freedman or freedwoman (*libertus* or *liberta*); a *liberta*'s

This essay was developed from a paper read at the College Art Association Annual Meeting, Chicago, 1976. Copyright © 1982 by Natalie Boymel Kampen. By permission of the author.

children might grow up to be rich and their children to hold office beside men whose grandfathers had been great landowners and members of the highest group, the senatorial order. Birth, both in the slave system and in the class/order system, went along with wealth, service to the community, and nature of occupation, to place an individual in a social stratum. Unfortunately, the many strata of Roman society are not adequately described by our modern terms—upper class, *bourgeoisie,* or working class—and so the reader will find "class" as a concept less frequently used than "stratum." Stratum will refer to a recognizable level in Roman society, but it will not be synonymous with economic class.

Roman society was not only stratified, it was also patriarchal, in that public and private institutions supported an unequal power relationship between men and women which favored men. Position in the stratification system qualified these power relationships; a poor man would have had less power or privilege than a wealthy woman of the aristocracy, but the woman would have experienced these benefits of status *de facto* more often than *de jure.* Women could neither fight nor govern Rome (except through influence behind the scenes), and so stood outside the system of duties and honors open to the full (i.e., male) citizen. Although free Roman women in many parts of the Empire were unlike Athenian upper-class women in that they had considerable freedom of movement and were able to manage property and personal affairs with a measure of autonomy, they still remained legal dependents with little institutionalized power, even in their own houses.[4]

Roman women's experience of the world was thus conditioned by gender, by social status, and by lives led in a stratified and patriarchal society. To assess the influence of status and gender on one another as determinants of visual iconography, I shall present a group of images which shows working women and men. Some of these images, those illustrating working women selling foodstuffs to customers, represent an important sample for several reasons: they offer clear evidence of women at work; there are written parallels to the visual evidence; and images of male vendors exist for comparison. After analyzing the vendor images, I shall offer comparative images of other kinds of male and female workers whose status differed from that of the vendor. These comparisons will reveal the ways in which social status and gender affected a woman's visual image within the "working stratum" of the Roman Empire.

From Ostia, the port of ancient Rome, come two small marble reliefs of women selling foodstuffs. Both are now in the Museo Ostiense at Ostia, and both date from the late second or early third century A.D. The more complex of the two [2] was found in the Via della Foce, a street of shops and apartments; probably a shop decoration or sign, it shows a woman surrounded by poultry, produce and customers.[5] She stands in the center of the relief behind a counter made of rows of cages with rabbits and chickens. Around the saleswoman, creating a realistic clutter, are platters of fruits or vegetables, game hanging from a gibbet, a snail basket with a snail emblem on the wall nearby. Just behind the principal figure, a second person, perhaps an assistant, hovers almost out of sight, while on the right end of the counter sit two pet monkeys kept for the amusement of passers-by. Finally, three men, including a customer buying a piece of fruit, occupy the left third of the relief with their gesticulating conversation. The entire scene radiates a good-natured concern with the particulars of daily life.

The central focus on the seller recurs in the second Ostia relief [1].[6] There, a crudely carved seller in tunic and shawl stands behind a makeshift trestle counter displaying vegeta-

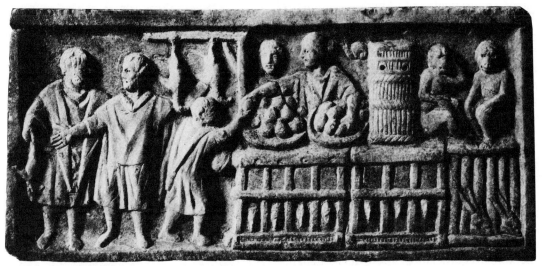

2. Poultry vendor relief. Late 2nd or early 3rd century A.D. Ostia, Museo Ostiense (*Fototeca Unione*).

bles. The scene is again filled with detail, from the counter with its zucchini and scallions to the speaking gesture of the vendor. Because the site where it was found is unknown, the function of this relief remains unclear, but it must have been either for a tomb or for a shop.

The two reliefs, both small in size and modest in technique, share a number of formal and iconographic characteristics which indicate the presence of a firmly established visual language for commercial scenes. In both cases, the vendors stand behind their impromptu counters; they are centrally placed and made clearly visible by frames of objects and people. In the case of the poultry vendor, placement above the other figures helps to make her noticeable as well. Pose and gesture also distinguish the seller from other people and identify her as a worker. Both vendors touch the goods they offer for sale, and in the poultry vendor relief the saleswoman is identified by the act of giving a piece of fruit to a customer, who is identifiable by his outdoor cloak and shopping bag. The vegetable vendor addresses her custom-

ers (us, the viewers) not by handing goods to us, but by raising her hand in the speaking gesture which Roman literature describes as a signal for attention.[7]

Along with placement, pose and gesture, costume serves to identify a vendor. The women wear simple tunics with or without shawls, their hair dressed simply in styles unrelated to the fashionable coiffures of the court. These vendors do not wear the *stola,* a long and elaborate dress which identified the upper-class matron. Rather, as can be seen in representations of other working women, they wear simple garments which were not associated with any special class.[8] Thus placement, pose, gesture, costume and hairstyle all function as ways of identifying female vendors and distinguishing them from customers or from women of higher classes.

The few existing funerary inscriptions made for saleswomen give the same careful attention to the identity of the vendor *qua* worker as do the Ostia reliefs. These inscriptions name the women and sometimes identify their relatives and—if they were *libertae,* freed slaves—their patrons, those who freed

them. For example, M. Abudius Luminaris made a funerary monument for Abudia Megiste, his wife and former slave,[9] and Aurelia Nais' inscription mentions her *libertus* patron.[10] Most clearly stated in both inscription and image is the woman's occupation, that which defines her role in the world. We learn what she sold and often where she sold it. Abudia Megiste sold grain at Rome's Middle Stairs, Aurelia Nais sold fish at the Warehouses of Galba, and Pollecla sold vegetables on the Via Nova.[11] Others in Rome and elsewhere in the Latin-speaking western Empire are commemorated as having sold seed, beans, dyes, nails and ointments.[12] This clear statement of commodities and occupations is the verbal equivalent of the evident delight in visually presenting objects and gestures to identify a woman's occupation in art; both stress her role in society.

The emphasis on role is equally present in representations of saleswomen from areas other than Ostia. Two female vendors appear in paintings from Pompeii, one from the Praedia Iulia Felix and the other from the dye shop of Verecundus. Among the many sales vignettes in the forum paintings which decorated the Praedia Iulia Felix (a building which may have had rental shops as well as living spaces) is one of a small female who stands beside a trestle counter covered with vegetables. She touches the greens as a youth approaches, presumably to buy.[13] The standard iconography of vendor and customer thus may have applied in a domestic context as well as in shops. On the left door post of the dye shop of Verecundus, on Pompeii's Via dell'Abbondanza, appears a depiction of a low table with indeciferable objects, perhaps shoes or things made of felt. Behind the table a woman sits and touches the objects, as a youth seated beside the table watches her.[14] This scene is a pendant to the image on the right door post, which shows the dyers at work and the proud Verecundus displaying a finished piece of cloth. In the context of a

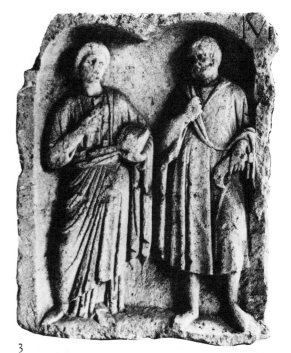

3

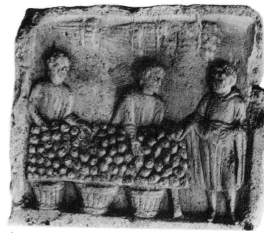

4

3. Pilier du Cultivateur, front. Late 2nd or 3rd century A.D. Arlon, Belgium, Musée Luxembourgeois (*Musée Luxembourgeois*).

4. Pilier du Cultivateur, upper left side. Late 2nd or 3rd century A.D. Arlon, Musée Luxembourgeois (*Musée Luxembourgeois*).

5. Altar of Atimetus, side. Late 1st century A.D. Vatican, Galleria Lapidaria (*Deutsches Archäologisches Institut*).

shop, these literally presented commercial scenes are undoubtedly a form of advertising, and the emphasis on role and occupation is completely appropriate.

The characteristic features of role images for women vendors in Ostia and Pompeii reappear in a large funerary monument called the Pilier du Cultivateur from Arlon, Belgium [3 and 4].[15] The Pilier is a tall oblong monument made of large blocks of local stone and carved with portraits and quasi-biographical images on three sides. It belongs to a group of funerary monuments from late second- and third-century Gallia Belgica, especially Arlon, Trier-Neumagen and Luxembourg.[16] The Pilier du Cultivateur is so named because, in addition to the portraits of a man and a woman on the front [3], its sides present four different scenes of agricultural life. On the right are a cart and driver above an image of a man displaying a tipped basket of fruit for another. On the left side, above a pair of men hoeing the earth, a sale scene occurs [4]. It contains many of the usual elements, from the trestle counter to the sellers' gestures. The customer, who may in this case be the estate owner inspecting the goods for sale, is distinguished from the vendors by his outdoor cloak and his position to the right of the counter. The vendors, a man handing some fruit to the customer and a woman at the left arranging fruit, wear simple indoor garments, stand behind the counter and touch the goods displayed. Although it is by no means clear whether these vendors are the same people as those who appear on the front of the Pilier or their employees/slaves, the roles are once again primary.

Three conclusions emerge from comparison of the Pilier du Cultivateur with the vendor images of Italy. First, the artists of Arlon used the same forms that appeared in Italy from the first through the third centuries; second, they applied the same visual language to a funerary monument as that which was appropriate for shop and domestic decora-

tion; and last, they permit us to see that the same visual conventions may apply to both male and female vendors. The visual language defines a common occupational and social role for both sexes, and this, as we shall see later, is limited to a recognizable social stratum.

The Arlon Pilier du Cultivateur is hardly unique in its use of the same visual language for male and female vendors. The attention-drawing placement of the vendor above and behind the sale counter appears in a Pompeian painting of a bakery or bread distribution from the Casa del Panettiere (first century A.D.),[17] and in the funerary monument with a wine shop from Dijon (second–third century A.D.).[18] Lucifer Aquatari, the water seller whose tomb of about A.D. 130 in Ostia's Isola Sacra Necropolis is decorated with small terracotta relief pendants, stands behind his counter and is further identified by plaques near him which give his name.[19] Pose and gesture identify salesmen as they did saleswomen. The cutlery vendor of the late first-century A.D. altar of Atimetus in the Vatican [5] stands next to a display of goods, with his

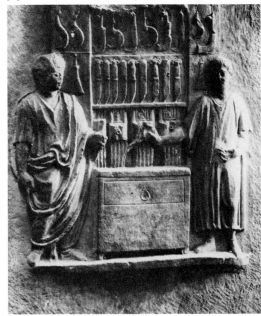

5

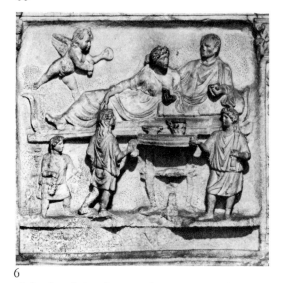

6

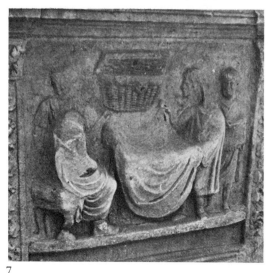

7

right hand in the speaking gesture familiar from the relief of the Ostia vegetable vendor.[20] In all these representations, the salesmen and saleswomen wear simple short or long tunics, while the customers wear either the *togae* and *stolae* of prosperous citizens (e.g., altar of Atimetus, where the *togatus* may be an owner, as in the Pilier du Cultivateur), or the outdoor cloak (Panettiere painting and Dijon monument). The basic elements which identify male and female vendors in the art of Italy and the northern provinces are the same, even though men's images outnumber those of women and the men sell a far greater variety of goods. In iconographic terms, then, role and social stratum are more important in determining vendor images than gender.

The question now to be asked is whether male and female workers are represented in similar ways in other occupations. This question will be put to images of three different occupations which are representative of several social levels: the rich merchant, the medical practitioner, and the artisan.[21]

The merchant differs from the vendor by owning a larger establishment, the scope of which extends beyond the neighborhood.

Rather than setting up a trestle counter in the marketplace, the merchant produces or moves goods in quantity and reaps larger profits. This is the person whom Cicero described in *De Officiis* as distributing goods in great volume to many without misrepresentation; he went on to say: "It [the merchant's occupation] even seems to deserve the highest respect if those who are engaged in it, satiated, or rather, I should say, satisfied with the fortunes they have made, make their way from the port to a country estate. . . ."[22] The rich merchant presumably dealt honestly with the public, took no part in retail sales (which Cicero thought involved lying for profit), and eventually invested his great income in land and respectable leisure. Although Cicero disparaged small retailers and hired laborers as vulgar, dishonest and unworthy, his conservative upper-class perspective allowed him to respect the tycoon for his potential absorption into the ranks of gentlemen.

Representations of wealthy merchants have a distinguishable language of their own, which communicates status by using the model of the customer rather than the vendor. The altar of Q. Socconius Felix in Rome shows a banquet with a reclining couple, Soc-

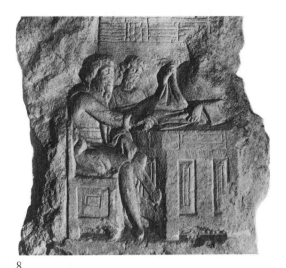

8

6. Altar of Q. Socconius Felix, front. Rome, Via Quattro Fontane, 15 (*Deutsches Archäologisches Institut*).

7. Altar of Q. Socconius Felix, back. Rome, Via Quattro Fontane, 15 (*from Goethert, pl. 2*).

8. Pilier du Marchand de Drap, side. Arlon, Musée Luxembourgeois (*Musée Luxembourgeois*).

conius Felix and his wife, on the front [6]; on the back, a man wearing a toga (again Socconius) sits in an elaborately carved chair and watches three men in workers' tunics display a large piece of cloth [7].[23] A similar image appears on two provincial funerary monuments, the Igel column near Trier[24] and the Pilier du Marchand de Drap from Arlon [8].[25] Both come from Gallia Belgica, which played a major role in the Roman cloth trade. In each one, a richly dressed man sits at a desk as fabric is displayed for him. That he is not a customer but the merchant himself is likely, in view of the presence of other scenes of this mercantile world on the monuments. The images clearly differentiate the status of the seated merchant, shown like a customer, from the employees who share iconography with vendors or attendants.

No comparable images of female merchants exist. This is not, however, because there were no such women, since inscriptions on bricks and lead pipes, as well as comments by writers about women who owned merchant ships, prove that women owned and operated businesses on a grand scale.[26] Nowhere do these women appear in art, nor do the women on the monuments of male merchants play any role in business. They stand for their portraits holding little dogs or spindles, or they sit quietly while their maids dress their hair.[27] In other words, they are presented as evidence of the wealth of their husbands in that they need do nothing but attend to their appearance and leisure.

Women with wealthy husbands or with enough wealth of their own to invest in business were given a traditional public image. As we have seen in Cicero, "gentlemen" might work at governing, fighting for Rome, or agriculture, but they did not work in "trade." Similarly, "ladies," Roman matrons, could run great households, manage huge businesses or carry on disreputable affairs with gladiators, but all clung to the *mores maiorum,* the ways of the ancestors, according to which all matrons were supposed to be at home, raising their children and working wool with their faithful slaves. The ideology of gender division of labor was firmly entrenched even when reality daily violated it.

In the aristocracy and the wealthy merchant/landowner stratum in Rome and the provinces, women were not shown at work even though they did sometimes work. Perhaps this was because the wealthy merchant stratum valued the *mores maiorum* as a public image or wished to appropriate it to gain

status. For men like the cloth merchants, a pampered wife could signal upward mobility; however, the source of their wealth in business still mattered enough for them to have it represented. They had not yet moved up into the stratum of gentlemen, whose values precluded mercantile work.

The case of medical workers is less clear than that of merchants because doctors and midwives offer less coherent evidence about the social strata to which they belonged. They are known to have been imported often as slaves from the Greek-speaking East, at least in the Republic. About half of the preserved inscriptions which document women doctors and midwives in Latin identify them as *libertae,* often associated with the households of the very wealthy.[28] There are, however, many inscriptions for male and female doctors which give no evidence of legal status and which sometimes suggest an independent practice with a definite location.[29] Furthermore, a certain amount of equality for male and female medical practitioners seems indicated by Ulpian, the jurist, when he states that obstetricians had the same status as doctors (male and female), regardless of the fact that they worked mainly with female patients.[30] (This would apply to medical professionals rather than to folk midwives and healers.) That status Cicero explained by saying that professions which benefit humanity, such as education and medicine, were not to be condemned as lowly and were respectable for those whose status they suited (!).[31] Thus medical workers stood outside the upper class but could have gained some status, even as slaves, through their occupation; that status, according to the written sources, could have been equal for women and men.

Although there are not many surviving images of male or female medical practitioners, we can nevertheless see a clear iconographic stereotype for male doctors which does not apply to midwives and female doctors. In virtually every case, the image of the male doc-

tor draws upon the iconography of either a Greek philosopher or the healing god Aesculapius [9]. The connection is made, for example, in a funerary stele of the Attic doctor Jason, here illustrated [10], as well as in a small and crudely executed terracotta relief which decorated tomb 100 in Ostia's Isola Sacra Necropolis, and even in elegantly carved gems (all of the second century A.D.).[32] All wear the Greek *himation,* are bearded, and sit examining or treating a patient who is often smaller than the doctor; all are presumably ennobled by the iconographic models they employ.

In contrast to male medical imagery, three examples of women doctors or midwives—which are all that survive for this period—present three very different iconographic schemes. The terracotta relief of a midwife-obstetrician birthing a baby, pendant with the doctor relief from the Isola Sacra cited above, is utterly simple and literal [11]. A Pompeian ivory plaque, probably from the first century A.D., shows the same childbirth composition, but with a landscape setting and attributes suggestive of some unknown myth.[33] The third example, a funerary stele from Metz (second–third century), eschews action of any kind and instead presents a standing woman with a box in her hand [12]. Only the fragmentary inscription, INI FII MEDICA, indicates her occupation.[34] This kind of standing portrait is traditional for women's funerary reliefs from late Republican Rome to late Imperial Gaul. It carries with it no associations with work, any more than do the representations of doctors on stelae from the Greek world, where women sit or stand with family or friends, and only inscriptions identify their profession.[35]

The small amount of evidence for the iconography of medical practitioners thus indicates that images of men and women did not share the same visual vocabulary, in spite of the equality described in the written sources. Women doctors may appear as matrons in portraits, or as idealized participants in myth,

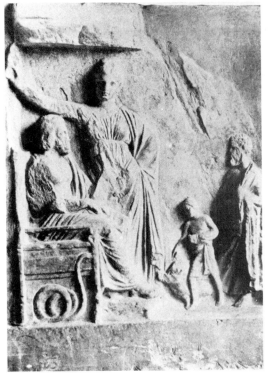

9

10

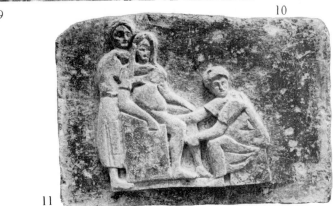

11

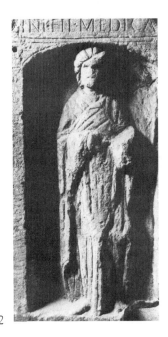

9. Detail of votive relief, Asklepios (Aesculapius) and Hygeia. From the Sanctuary of Asklepios, Athens (*from E. Holländer*, Plastik und Medizin, *1912, p. 113*).

10. Stele of doctor Jason, from Attica. 2nd century A.D. London, British Museum (*Trustees of the British Museum*).

11. Terracotta relief of a midwife-obstetrician. Ostia, Museo Ostiense (*Fototeca Unione*).

12. Stele of a doctor. 2nd or 3rd century A.D. Metz, Musée Archéologique (*Service photographique des Musées de Metz*).

12

13. Temple of Minerva, detail of frieze. Late 1st century A.D. Rome, Imperial Fora (*Deutsches Archäologisches Institut*).

but men are routinely presented as themselves, their specific identities reinforced by the status-enhancing association with Aesculapius or a philosopher. Iconographic differences depend on the gender of the protagonist as well as the content and function of the image.

Iconography again varies according to the worker's gender when men and women do artisan work. Not surprisingly, a large number of representations in paint and relief show men working at all kinds of artisan occupations; they are ship-builders, masons, smiths, perfumers, carpenters and the like.[36] In most instances, the representation of men at work documents them quite literally, as in the case of the ship-builder Longidienus of Classis, who is shown working on a boat.[37] No allegory, no mythological overlay interferes with communication of these men's identities as workers. Women artisans, much smaller in number, partake of a very different iconography, since with few exceptions they appear only in an allegorical or mythological context. The occupations are generally limited to fabric work: spinning, weaving, repairing cloth,

garland-making, and in one instance, perfume production.[38] In the Minerva and Arachne frieze of the Temple of Minerva in Rome's Imperial Fora, women are not human weavers and spinners but mythic parts of an allegory of the state [13].[39] Such images are by no means comparable in iconography or function to the small stelae and reliefs of male artisans from all over the western Roman Empire.

Despite the fact that inscriptions report a few women metalworkers (one a smith married to a smith), as well as weavers and garland makers, and in spite of the undoubted presence of some female slaves and family members in small production shops, the visual imagery offers little evidence for the existence of these women.[40] Although wool baskets and spindles appear on funerary reliefs from Gaul to Asia Minor, they denote women's feminine virtues rather than their moneymaking occupations.[41] By contrast, male artisans are both liberally and literally documented, not only because they were plentiful and visible, but also because they gained status within their own social stratum

through their work. By contrast, the work of a woman, whether in her own shop or that of her father, husband or owner, was either not recognized as conferring status or was actually considered to lower her status.

A few other occupations should be noted in passing, those which represent the least prosperous and least autonomous of workers. Hairdressers and nurses are invariably shown as women, not men, in scenes which subordinate their labor to the identity and status of the people they serve. Nurses on biographical and mythological sarcophagi [14], like hairdressers on Gallic funerary monuments [15], offer information about their mistresses and masters, but they are far too mythologized or conventional in type to tell much about

themselves.[42] This is hardly surprising in light of the texts and inscriptions which indicate that many, perhaps most, of the women in these jobs were slaves or *libertae* attached to wealthy households.[43] The monuments show us owners attended by faithful but ultimately anonymous retainers. Status and gender combine to deprive the hairdressers and nurses of personal autonomy in these images.

In all the occupations discussed in this section, women are differentiated iconographically from men. Merchants are always male, while hairdressers and nurses are always female. Although medical practitioners and artisans can be male or female, their iconographies differ radically. A quasi-divine model is invariably used for male doctors, whereas it

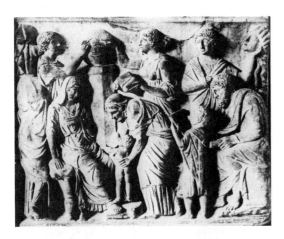

14. Biographical sarcophagus, side. Second half of the 2nd century A.D. Florence, Uffizi (*Deutsches Archäologisches Institut*).

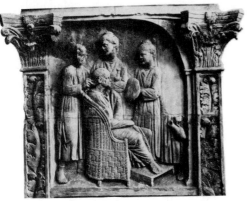

15. Monument of the parents (*Elternpaarpfeiler*), detail. First half of the 3rd century A.D. Trier, Landesmuseum (*Fototeca Unione*).

is never used at all for female doctors. Male artisans normally appear in a very literal form, one which emphasizes role and work, in contrast to female artisans, who become part of a mythologized scheme, their actual work rendered trivial or unreal.

The comparative documentation in this section demonstrates that men's work images are plentiful and popular at almost every stratum below the upper class. The images occur in a variety of types and frequently in large quantities for all occupations seen as acceptably male. The reasons for the popularity of male worker images are twofold: first, the images document a reality which was visible to the patron or public and which at the same time was acceptable, in the sense of fitting into the dominant ideological system of male behavior in a given social class. Second, these images enhanced the social status of the worker, as in the case of the merchant who looked like a customer, or the artisan who advertised himself through his role. Self-commemoration, employing iconographies which differed according to the status of the patrons or subjects, became role-commemoration.

Women workers might have their roles commemorated in their epitaphs, as did men, but those roles seldom took a literal visual form. Women's work tended to be either invisible or transformed for purposes other than literal documentation of role. When women held the same jobs as men, their imagery was based on different models and iconographies, generated by a combination of role, gender and status. To whatever extent the working roles of Roman men and women may have differed in real life, even more did their identities as workers diverge in their images in works of art.

Two questions remain to be considered. First, why is women's work so much more fully acknowledged in literature and inscriptions than in the visual arts? And second, what can we say, on the basis of the material considered here, about the relationship of gender and social status as variables which help to determine the iconographic structure of works of art?

The first step in answering both these questions is to describe two rather different constraints which applied in varying degrees to the different parts of Roman society. Art patrons of high class and status, or with aspirations to join that level of society, seem to have operated under an ideological constraint which held that work was unacceptable for women unless it was centered in their own households and executed for their own families. The ideology, based on traditional notions about the life and conduct of the old-fashioned Roman Republican matron, was, as we have seen, frequently divorced from the practical realities of life, from the first century B.C. on. This denial of experience helped to preserve in ideological form a gender division of labor while at the same time it negated the reality of the working lives of women—slaves and *libertae* especially—who violated the ideological norm. In theory, women stayed at home and cared for their particular domain, the place in which their status resided. Works of art which contradicted this principle had to show the female worker as mythological or entertaining, or as an adjunct to the patron's own status; otherwise she might not appear.

The second constraint applied to men and women of the lower classes, who possessed less wealth and status than those we have just been discussing and whose aspirations and daily experience are much less clearly understood. For them, financial constraint undoubtedly limited the purchase of work representations even more severely than it limited the purchase of commemorative inscriptions. (The greater number of inscriptions than work images for both men and women suggests that inscriptions cost less.) Such financial constraint may have especially affected women, who are likely to have

worked less often, for fewer years, and for lower wages, than men.

To ask why only vendors share a cross-gender iconography is in fact to confront the question of how often and to whom in the lower classes the ideological constraint applied. The answer is to be found in the special conditions of vendors' work, conditions which made them different from the other workers in the same social stratum.

The vendors for whom inscriptions and images remain inhabited a narrow stratum below the aristocracy and the rich merchants and gentry, but above the poorest members of the lower class. They had greater prosperity and autonomy than the anonymous slaves-of-all-work, field hands and mine workers, and they certainly enjoyed greater social status than the whores, waitresses and entertainers whose names were scribbled on barroom walls. They belonged instead to the upper working class/lower middle class, to that stratum which also included prosperous artisans, midwives and doctors, innkeepers, and perhaps even some skilled and valued household slaves; they could be freeborn, *liberti* and *libertae,* or slaves. Their attributes included skill, a degree of financial autonomy, social status within their immediate communities, or proximity to a benevolent owner-patron. These were the people who either had money to record their own work or whose work was so valued that others documented it. At the same time, they are people with enough pride in their work to want to give it public form, in writing or art.

Within this social stratum, the experience of women sometimes differed from that of men, and the differences were heightened in art. Women tended to be shown in jobs related to traditional female domestic occupations: fabric work, work with food, health and child care, and care for personal appearance, and this work often took place in private houses rather than public settings. The public saw women at work less often than it saw men,

and it saw women doing things they would do at home for no wages. This perception, further reinforced by art, was perhaps responsible for diminishing the public image of women as real workers, thus preserving the ideology of gender division of labor which kept the "ideal woman" at home at her loom.

The vendor is the most obvious exception to this rule. Both men and women worked as vendors, performing the same actions, using the same gestures, selling the same goods to the same people in the same setting. The occupation seems not to have had a traditional association with either sex, and may have granted the same degree of prosperity and independence to both sexes. Perhaps most important, however, is the fact that this was a public occupation which could not be mistaken for anything other than money-earning. It represented one of the very few instances when men and women were seen doing exactly the same work in circumstances which were undeniably the same—public and economically motivated. These conditions of work must, I believe, have caused the public to perceive male and female vendors as more similar than men and women in other jobs. It is this perception which allowed vendors to share an iconography in artistic images when other workers did not.

The works of art we have examined here reveal the existence of variations in social and gender experience within the lower classes of Rome as well as differences between upper- and lower-class values. For women as for men in the Roman world, gender experience changed from one social level to the next, even though the dominant and visible ideologies of the first, second and third centuries were aristocratic and patriarchal. To understand this interaction between class and gender and between ideology and material reality is to see more clearly some of the factors which determine the structure of both a work of art and a society.

NOTES

Author's note: This essay was written at the Penland School, Penland, North Carolina; I thank the people there for providing a wonderful working environment. I also wish to thank John Dunnigan, Dobie Snowber, and the editors of this volume, Norma Broude and Mary D. Garrard, for their helpful criticism.

1. L. Sargent, ed., *Women and Revolution,* Boston, 1981; and Z. Eisenstein, ed., *Capitalist Patriarchy and the Case for Socialist Feminism,* New York, 1978.

2. Very little work has yet been done on these issues; I mention a few of the most recent works here. On Roman working women, S. Treggiari, "Jobs for Women," *American Journal of Ancient History,* 1 (1976), pp. 76–104; and "Questions on Women Domestics in the Roman West," *Schiavitù, manomissione e classi dipendenti nel mondo antico:* Università degli studi di Padova, *Pubblicazioni dell'Istituto di Storia Antica,* 13 (Rome, 1979), pp. 185–201. My thanks to Sarah Pomeroy for bringing these articles to my attention. On worker imagery, B. M. Felletti Maj, *La Tradizione italica nell'arte romana,* Rome, 1977; and G. Zimmer, *Römische Handwerkdarstellungen,* Rome, in preparation. On class as a determinant of visual imagery, R. Brilliant, *Gesture and Rank in Roman Art,* New Haven, Conn., 1963; R. Bianchi-Bandinelli, "Arte plebea," *Dialoghi di Archeologia,* 1 (1967), pp. 7–19; and D. E. Kleiner, *Roman Group Portraiture,* New York, 1977. On class and gender, N. Kampen, *Image and Status,* Berlin, 1981.

3. J. Gagé, *Les classes sociales dans l'Empire romain,* Paris, 1965.

4. There were certain exceptions, e.g., women who had three or four children and were therefore exempt from the need for a male legal guardian through whom to conduct their business: *Gaius,* 1.194; and S. B. Pomeroy, *Goddesses, Whores, Wives, and Slaves: Women in Classical Antiquity,* New York, 1975, pp. 151–52.

5. Kampen, *op. cit.,* pp. 52–59; and R. Calza, *Scavi di Ostia, 9: I Ritratti,* 2, Rome, 1978, no. 48.

6. Kampen, *op. cit.,* pp. 59–64; and R. Calza and M. F. Squarciapino, *Museo Ostiense,* Rome, 1962, no. 12. The figure can be identified as female by her hairstyle, a type not seen in male images, and by her non-bearded face. In the Hadrianic period, in which this relief can securely be dated, virtually all males are shown as bearded.

7. Apuleius, *Metamorphoses,* 2. 21.

8. Figures 4, 11, 15.

9. *Corpus Inscriptionum latinarum* (Berlin, 1862 *et seq.*), VI. 9683. (Hereafter cited as *CIL.*)

10. *CIL,* VI. 9801.

11. E. Diehl, *Inscriptiones Latinae Christianae veteres,* Berlin, 1925–67, 685b.

12. *CIL,* XIV. 2850; III. 153; VI. 9846, 9848, 37820; V. 7023; VI. 10006, 333928; and X. 1965.

13. W. Helbig, *Wandgemälde der vom Vesuv verschütteten Städte Campaniens,* Leipzig, 1868 no. 1500.

14. V. Spinazzoli, *Pompei alla luce degli scavi nuovi di via dell'Abbondanza,* Rome, 1953, pp. 189–210, f. 237–38.

15. A. Bertrang, *Le Musée Luxembourgeois: Annales, Institut archéologique du Luxembourg,* 85 (Arlon, 1954), no. 10.

16. F. Drexel, "Die Belgisch-germanischen Pfeilergrabmäler," *Mitteilungen des deutschen archäologischen Instituts, Römische Abteilung,* 35 (1920), pp. 27–64; W. von Massow, *Die Grabmäler von Neumagen,* Berlin and Leipzig, 1932; and J. J. Hatt, *La Tombe gallo-romaine,* Paris, 1951.

17. Helbig, *op. cit.,* no. 1501.

18. E. Esperandieu, *Recueil général des bas-reliefs, statues et bustes de la Gaule romaine,* Paris, 1907–66, no. 3469.

19. M. F. Squarciapino, "Piccolo Corpus dei mattoni scolpiti ostiensi," *Bullettino della commissione archeologica comunale di Roma,* 76 (1956–58), pp. 192–99.

20. W. Helbig, *Führer durch die öffentlichen Sammlungen klassischer Altertümer in Rom* (4th edn., directed by H. Speier, Tübingen, 1969–72), I, no. 400.

21. These are hardly the only occupations possible; one could easily substitute shoemakers, wait-

ers and waitresses, or agricultural laborers, among others.

22. Cicero, *De Officiis*, 150-51.

23. F. W. Goethert, "Grabara des Q. Socconius Felix," *Antike Plastik*, 9. 1-7 (1969), pp. 79-86.

24. H. Dragendorff and E. Krueger, *Das Grabmal von Igel*, Trier, 1924.

25. Bertrang, *op. cit.*, no. 48.

26. E.g., *Notizie degli Scavi*, 7 (1953), 116, no. 27; and 174, no. 39. Suetonius, *Claudius*, 18-19.

27. Massow, *op. cit.*, no. 184-85.

28. Treggiari, "Jobs for Women," pp. 86-87; and Kampen, *op. cit.*, pp. 116-17.

29. E.g., *CIL*, VI. 9720 and 9477.

30. *Digest*, 50.13.1.2; and *Code of Justinian*, 6.43.3.1.

31. Cicero, *De Officiis*, 150.

32. Ostia relief: Kampen, *op. cit.*, no. 16. Jason stele: V. Zinserling, "Zum Menschenbild im klassischen attischen Grabrelief," *Klio*, 56 (1974), pp. 370-74. Gems: G. M. A. Richter, *Engraved Gems of the Romans*, London, 1971, no. 362.

33. Ostia relief: Kampen, *op. cit.*, pp. 69-72; and Naples, Museo Nazionale relief, inv. 109905: Kampen, *ibid.*, p. 70, n. 145.

34. Metz, Musée Archéologique, *La civilisation gallo-romaine dans la cité des Mediomatriques*, Metz, 1964, pp. x-xi.

35. E.g., N. Firatlı, *Les stèles funéraires de Byzance greco-romaine*, Paris, 1964, no. 139.

36. H. Gummerus, "Darstellungen aus dem Handwerk auf römischen Grab- und Votivsteinen," *Jahrbuch des deutschen archäologischen Instituts*, 28 (1913), pp. 63-126.

37. G. Mansuelli, *Le Stele romane del territorio ravennate e del Basso Po*, Ravenna, 1967, no. 12.

38. As psyches they make garlands or perfume in the House of the Vettii in Pompeii; A. Sogliano, *La Casa dei Vettii in Pompei*, Milan, 1898, pp. 233-388.

39. P. H. von Blanckenhagen, *Flavische Architektur und ihre Dekoration untersucht am Nervaforum*, Berlin, 1940.

40. *CIL*, V. 7044; VI. 6939, 9211; III. 2117; Treggiari, "Jobs for Women," pp. 82-84.

41. F. Noack, "Dorylaion: Grabreliefs," *Mitteilungen des deutschen archäologischen Instituts, Athenische Abteilung*, 19 (1894), pp. 315-34.

42. Hairdressers: Kampen, *op. cit.*, nos. 30-38; nurses: nos. 21-29.

43. Treggiari, "Jobs for Women," pp. 88.

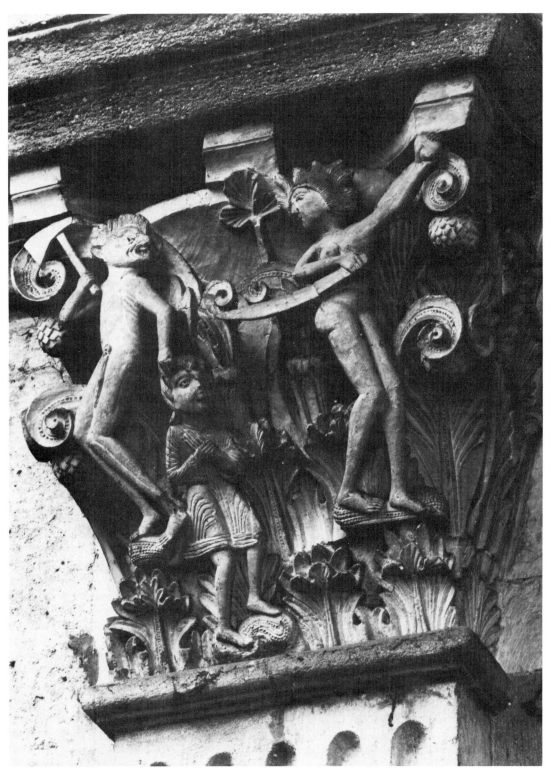

1. The Vice of Unchastity. Capital relief, Autun Cathedral, 12th century (*Marburg Bildarchiv*).

5
Eve and Mary:
Conflicting Images of Medieval Woman

HENRY KRAUS

Built during the papal occupancy, on the crest of the "new town" across the Rhone from Avignon, the Chartreuse-du-Val-de-Bénédiction has long been abandoned by the monks. There is neither furniture nor any other amenity of earlier habitation in the spacious, barren convent, nothing but the pale remnants of Italian frescoes which the homesick popes had painted in various places of their temporary abode.

One's eye is the more struck accordingly by the sculptured relief above the door inside one of the cells that line the old cloister. Suddenly, as one looks at it, the empty, echoing monastery seems to be peopled once again. There are certain art works that have this faculty of recall; yet what this one summons up is less the physical life than the very special order of ideas that once prevailed here.

The subject of the relief is wild and obscene, presenting a recumbent woman in a scabrous posture with a goat. "The old hag is

From Henry Kraus, *The Living Theatre of Medieval Art*, Bloomington, Ind.: Indiana University Press, 1967. This excerpt, Chapter III, pp. 41–62. By permission of the author and Indiana University Press.

letting the goat do to her," the concierge commented disgustedly [2].

His attitude toward the woman, one realized, was perhaps not much different from that of the early occupants of the cell, that vanished community for whom this revolting bit of sculpture had been carved.

Not aimed at the public but at single pairs of cloistered eyes, what could its message be other than a warning against woman's bestiality, meant to rally the monks' resistance at faltering moments? For the lives of the most saintly ascetics—St. Anthony's, for example—show that Satan reserved his most redoubtable trials for the cloistered brethren. And in the monks' catalogue of transformations the Devil might often assume a woman's guise.

By the fourteenth century, when the Chartreuse was built, the general view of woman had considerably softened so that this kind of treatment of her in art strikes one as rather anachronistic for its time. But the battles of the convent were abiding ones and the monastic attitude toward woman changed more slowly than did its secular counterpart. This

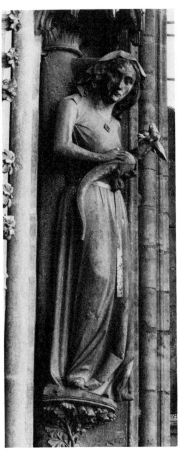

2. The Vice of Unchastity. Chartreuse-du-Val-de-Bénédiction, Villeneuve-les-Avignon, 14th century (*Daspet*).

3. Eve showing her fondness for the serpent. Reims Cathedral, 13th century (*Marburg*).

viewpoint regarded woman as the Daughter of Eve and by that descent still primarily responsible for man's fall. As St. Bernard expressed it in sermons addressed to his "sons" at Clairvaux, Eve was "the original cause of all evil, whose disgrace has come down to all other women."[1]

This view of woman inevitably influenced the manner of her presentation in church art of that time and continued now and then to break through into works of later periods. She might be shown as repellently ugly or hatefully seductive. The latter delineation is strik-

ingly illustrated in a capital relief at Autun representing the mortal Vice of Unchastity. A young man stands rapt before the naked body of his temptress, whose flaming hair associates her with the Devil. The latter is also present, his fingers coiled into the hapless youth's hair [1].

At Vézelay, on the other hand, it is the woman herself who is bewitched, supposedly by the "profane music" of a jongleur, under whose influence she permits herself to be caressed by a grimacing demon. But from the time of Eve woman was known to have this

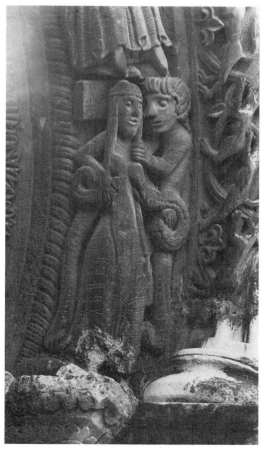

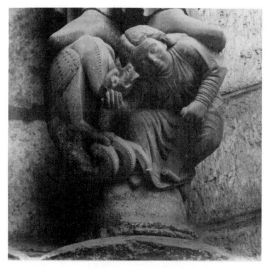

4. Potiphar's wife listening to the Devil's advice. Chartres Cathedral, north porch, 13th century (*Marburg*).

5. A woman, illustrating the Vice of Unchastity, shown with her lover, the Devil. Church of Sainte-Croix, Bordeaux, 12th century (*Marburg*).

denatured fondness for foul things, taking the serpent into her arms on occasion and stroking it adoringly [3]. In the case of Potiphar's wife, she is frankly a member of the Devil's team, listening confidently to his evil counsel while extending to him the eager intimacy of a co-conspirator [4].

Surely it is not without meaning that the sculptured presentation of the Vice of Unchastity which one finds on so many church facades of the twelfth century should invariably be a woman, suffering eternally in Hell. She is usually shown in a revolting posture, her naked body entwined by serpents which feed on her breasts and sexual organs. Sometimes, too, she is accompanied by the Devil, who assumes an intimate relationship to her [5].

The typical "male" Vice, on the other hand, is either Pride or Avarice, the former denoting the chief failing of the feudal nobles, the latter that of the middle class. There was a shift of emphasis from one mortal Vice to the other in the twelfth century, which one author has traced to the Church's increased concern with the rising clamor of the

burghers for communal rights. But the major female Vice as depicted in church art remained unaltered. Whatever her class, woman's characteristic corruption was still Unchastity.[2]

In any event, it is the cloister's accent on the baleful influence of woman on man that gives much twelfth-century sculpture a misogynous imprint. At its cruelest perhaps the viewpoint is expressed in the Expulsion from Paradise reliefs of Notre-Dame-du-Port, at Clermont-Ferrand [6]. Adam hurls wailing Eve to the ground, kicks her, and drags her by the hair in a series of realistic gestures that were inspired, it has been suggested, by the liturgical drama *Le Jeu d'Adam et Ève,* which was acted during the Middle Ages both inside and outside of many churches. The high climax of the play, whose verisimil-

itude was heightened by costumes and stage scenery, was reached when Adam, robbed of eternal bliss, cried out his fury and dismay:

> Oh, evil woman, full of treason. . . .
> Forever contrary to reason,
> Bringing no man good in any season:
> Our children's children to the end of time
> Will feel the cruel whiplash of your crime![3]

It was hardly the kind of teaching calculated to spread affection for the wives and mothers in the audience. But it did suit the Church's purpose of combating in behalf of its clergy woman's terrible attractiveness. How dangerous this was considered to be is shown by the action of one church council forbidding priests to visit their mothers and sisters.[4] And the monk, Bernard de Besse, warned his confreres against even touching

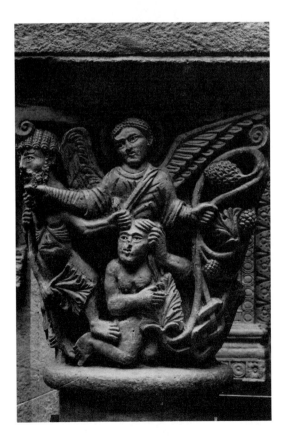

6. Adam and Eve driven from Paradise. Notre-Dame-du-Port, Clermont-Ferrand, 12th century (*Marburg*).

their baby sister's hands.[5] The rules of the Cistercian order held that the prohibition against contact with woman must not be breached even for the purpose of granting charity and that if a member of the feared sex penetrated by accident into the convent church, services must be suspended, the abbot deposed, and the monks put on bread and water.

These harsh regulations have been related to Gregory VII's struggle for Church reform.[6] As is known, moral regeneration of the religious community was only one phase of this campaign, which involved ultimately the political power of the Church, its independence of lay sovereigns, and the centralization of control at Rome. An indispensable part of this program was considered to be the prohibition of legal marriage or concubinage, both of which were widely practiced not only by the secular but by the regular (monastic) clergy as well.

The drive to tear the priests and monks from the arms of women continued to color the ecclesiastic attitude toward the female sex long after other circumstances had brought about important improvements in woman's social position. Into the late thirteenth and even the fourteenth century priests sermonized about the malice of women toward men. The wisest of males were helpless before their wiles. Reflections of this viewpoint are not lacking in art. Thus Aristotle and Virgil—those summits of genius among the ancients—are often portrayed in ignominious Boccaccio-like situations illustrating woman's perfidy. Aristotle is shown on all fours with the Indian courtesan Campaspe on his back, whose favors he seeks. And Virgil is left dangling in midair in a basket by a lady who had granted him an assignation, to be laughed at by the entire populace of Rome the following morning.[7]

It would be impossible to discount the great contributions of the Church over the centuries to the dignity of marriage and to

woman's position within it. As one author, otherwise critical of the Church, has put it, "from its origins Christianity has exalted marriage, proclaimed the equality of husband and wife, and in particular divided impartially between the two the rights conferred by society and nature on the children." But this writer goes on to document the Church's ambivalence on the question of woman's emancipation, pointing out that it rejected most other privileges for her, including the right of communal property.[8] Church apologists have admitted this disparaging attitude. One of them, while seeking to emphasize its role in improving woman's lot, nevertheless agrees that it considered her to be morally inferior, which was the formal basis, for example, for her exclusion from the priesthood.[9]

The Villeneuve-les-Avignon relief raises another disturbing question. How could one square this monkish execration of women with the universal apotheosis of Christ's mother, who already in the twelfth century had assumed a preponderant position in so much of church art? Even the most passionate of reformers, the Cistercians, who played a key role in the Church's moral-purification movement as well as in support of the papacy's political ambitions, had a most particular devotion for the Virgin. They dedicated all their churches to her and the mother-abbey at Cîteaux adopted as its device an image of Mary, under whose mantle the abbots of the order were shown kneeling while above the church portal verses in her honor were engraved. St. Bernard, whom Dante called "the knight of the Virgin," devoted a whole series of his homilies to the mother of Christ, that "strong woman" upon whom "Our salvation, the recovery of our innocence and the victory over our enemy [Satan] depends. . . ."[10]

However, a closer examination will show that there is actually no contradiction between the monks' adoration of Mary and their very low view of ordinary woman. The

relationship between the two stressed contrasts rather than similarities. In the glorification of the Virgin, it was the Woman-Without-Sin, the non-woman Woman, the anti-Eve that was revered. This distinction is often explicit in the art of the time, as at the church of Saint-Martin-d'Ainay, at Lyon, where sculptured versions of the Original Sin and—plainly antithetical—the Virgin of the Annunciation are placed side by side. That type of confrontation seemed, to subtle medieval minds, to be marvelously validated by the inversion of letters in the words "EVA" and "AVE." The exegetical spotlighting of this anagram was put into a Latin poem by Peter Damian, the great eleventh-century reformer:

> That angel who greets you with "Ave"
> Reverses sinful Eva's name.
> Lead us back, O holy Virgin,
> Whence the falling sinner came.

And the twelfth-century poet Wace, in his *La vie de la vierge Marie,* vowed that the anagram was meant

> To allow us all to recall
> From what high point Eve made us fall.[11]

In the doctrinal opposition of Mary and Eve, common woman was uncompromisingly associated with the latter. Even with Mary Magdalene and Mary the Egyptian, those sinners to whom she could feel most naturally drawn, the ordinary woman could hardly forget that their sainthood was sanctioned by a decision that she herself was not prepared to take: the abandonment of their sex. Her identification with their earlier transgressions could scarcely bring her solace for her continuing sins, as numerous representations in art were always prompt to remind her. A famous example, which unfortunately a prudish seventeenth-century priest suppressed, was a stained-glass medallion from a Parisian church showing Mary the Egyptian poised suggestively on the bridge deck of the ship taking her to Jaffa from Alexandria, with her

skirts raised up to her knees, prepared, as an inscription explained, to pay for her passage in trade. There was masculine malice in this portrayal but it was entirely consistent with the Church's view of woman: once fallen and forever after prone.

The glorification of Mary in the West had been a recent development. Unlike the Eastern Church, where her festival days had been celebrated from earliest times, they passed almost without notice in France. It was only toward the end of the tenth century that the cult of the Virgin as the "Mother of Mercy" was initiated by the order of Cluny, interpreted iconographically by Mary's taking her protégés under her ample cloak. This was, it has been suggested, possibly in response to the terror of the world's end that spread abroad with the approach of the Year Thousand.[12]

It was not until the twelfth century that the Church's cult of Mary came to full flower, when also the "amour courtois," that strange deviant among love poetries, began to be sung in all the feudal courts of Southern France. It used to be thought that the cult of the Virgin had inspired the origin of this courtly love poetry. But modern scholarship has rejected the hypothesis, arguing that the two are profoundly contradictory in essence, the frankly hedonistic nature of the one and the sex-denying emphasis of the other being only one phase of their antagonism.

However, though the erotic content of the courtly love poetry could not have failed to make it abhorrent to such men as St. Bernard and Hugues de Saint-Victor, it is curious nevertheless how their own literary style was influenced by it. In the former's sermons in praise of Mary he gives vent to a type of sexual symbolism that would give Freudian amateurs a field day. She was "the bush, the arc, the star, the flowering stalk, the fleece, the nuptial chamber, the door, the garden, the dawn, Jacob's ladder."[13] The celebrated Catholic encyclopedist, Honorius d'Autun (who wrote from 1090 to 1120), composed a

hymn in which Jesus praises the beauty of Mary. "He extols her freshness," an author paraphrases him, "her loose hair, her lovely throat, her brow which he likens to a tower, and her sparkling teeth. He gives each feature a moral sense and the poem, a mixture of voluptuous images and noble thoughts, shines with a kind of abstract passion."[14]

The Church's Mariolatry reached an intense stage in the thirteenth century, its widespread acceptance being fostered by prayers, hymns, liturgical drama, legends, and especially art. The lovely *Ave Maria* dates from this impulsion as does the beautiful name of "Notre Dame," a pure hand-over from the language of chivalry. The rhymed version of the *Miracles of Notre Dame,* by Gautier de Coincy, canon of Soissons, helped spread the idea of Mary's accessibility. Even the worst sinners could now touch her heart. She was known, for example, to have protected an adultress against the clamorous accusations of the woman whose husband she had seduced simply because the siren had honored daily in her prayers the Annunciation, considered to have been the Virgin's most pleasurable moment.[15]

Iconographically, Mary's image responded richly to these various influences. Earlier she had been so little estimated that she once was actually left out of the Nativity.[16] But in the twelfth and especially the thirteenth century she came into her own. Émile Mâle described this evolution admirably.[17] At first, he pointed out, the Virgin was never seen apart from her son. Then in such scenes as the Annunciation and the Visitation she began to appear alone. But even when with Jesus the artists would put the dramatic spotlight on her. The wide popularization of such a subject as the Adoration of the Magi, for example, was merely an excuse for presenting Mary. Shown in a kind of majesty and mounted on a throne, from this position she (along with her son) received the feudal reverence of kings.

This royal treatment came naturally to medieval artists, Mâle noted. "The Virgin of the twelfth century and of the beginning of the thirteenth is a queen."[18]

It was only somewhat later that the Magi were withdrawn and the Virgin appeared alone on church tympana—still bearing the infant Jesus on her knees, to be sure—in the same superb posture as before. This "daring innovation" was used at Chartres (among other places), it has been suggested, in order to give an impulsion to the great pilgrimage in the Virgin's honor that was directed toward that church in the first half of the twelfth century.[19] Soon after there began to appear the great chain of miracles associated with Mary that one can see effigied in so many churches of France and elsewhere. Then representations of the Death, Resurrection, and Assumption of the Virgin were appended to her plastic repertory, each adding further to her glory. And finally that ultimate scene of her triumph was invented: the Coronation. First shown as an already accomplished fact, then carried out by an angel in the presence of her Son, it is by Christ's own hands in the end that the crown is put on Mary's head.

Much of this elevated the Virgin to a position that tended to put her out of reach of the ordinary woman. But this overawing side of Mary was only one facet of her complex personality. There was another phase that began to evolve in the thirteenth century, which had the effect of popularizing her image. Simple, literate minds found Scripture altogether too meager as to detail and out of their desire to see the great gaps in Mary's life filled in, there arose a whole series of popular apocrypha, which eventually passed over, in part at least, into church liturgy and art.

Starting before Mary's birth, the legends early amplified the story of her parents, Anne and Joachim, going on to the Virgin's early years, her marriage, her relationship with her son at the different epochs of his life, which

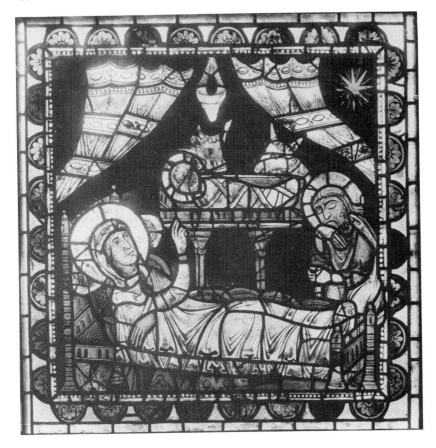

7. The Nativity. Stained-glass panel, Chartres Cathedral, 12th century (*Archives photographiques*).

the Bible had left so barren, and finally to Mary's life after the death of Christ. Even the already established elements of her story were in this manner completely transformed. In the early twelfth-century Nativity, for example, she is presented as overwhelmed by the event, hardly accepting her own role in it. She does not even dare look at the Infant, who is extended on a kind of altar, which is set above and at some distance from her [7].

But this austerity changes gradually, taking on one after another those gracious little touches we now normally associate with the subject—and all of them apocryphal. Even the ox and the ass had to be produced out of whole cloth, and the midwives. As the story goes, when the great moment drew near Jo-

seph ran distraught out of the stable looking for assistance. But he could find no one and when he returned Jesus was already born and there were the midwives quietly preparing his bath. The tendency of all this (before the mawkish exaggerations of the fourteenth and especially of later centuries) was to humanize Mary's story, making her a real girl, a real woman, a real mother.

Accompanying this trend, as we shall see, was a deep-going change in the social position of medieval woman. In art, besides what has been called the "feminization of the Divinity,"[20] which referred specifically to Mary, went a softening of attitude in the representation of other women. This tendency can be more readily seen in works covering Old Tes-

tament stories than in those of the Christian legend, which remained under stricter doctrinal control. Though material about the Hebrew prophets and other predecessors was rarely used in church art except to prefigure important elements of the dogma involving Christ and Mary (Abraham's offered sacrifice of Isaac symbolizing the Crucifixion; Habakkuk's feeding of Daniel in the lions' den without breaking the king's seal designating Christ's passage into and out of his mother's womb without marring her virginity; etc.), nevertheless there was less rigidity in the handling of details and characters in these accounts than in subjects drawn from the New Testament.

Thirteenth-century art is particularly inventive in this regard. Thus the Noah story often furnishes striking family scenes like those on the sculptured frieze of Bourges cathedral's west façade [8]. And at Amiens an incomparable series of small quatrefoils covering the entire base of the church front has most gracious material of this type, such as the story of the Queen of Sheba or of Hosea's harlot. The latter represents a medieval version of a theme which in modern times has

9. Hosea and the Harlot. Above, he pays fifteen pieces of silver, plus one and one-half homers of barley, for her; below, he marries her. Quatrefoil, Amiens Cathedral, 13th century (*Marburg*).

8. Noah's family going to the Ark. West façade frieze, Bourges Cathedral, 13th century (*Marburg*).

continued to be highly popular: the rehabilitation of a fallen woman by an honest man. In medieval art it had the added effect of alleviating the tragic heritage of Eve, whose descendant puts on a bourgeois hat to symbolize her reform [9].

As for Esther and Judith, both frequently found in thirteenth-century art, they were equally memorable for their patriotic and heroic roles. Psychologically they often represented a great advance in the handling of women, as illustrated by the beautiful carvings on the north porch at Chartres, where

10. Queen Esther at the feet of Ahasuerus. Chartres Cathedral, north porch, 13th century (*Henry Cohen, Paris*).

11. Judith, in prayer, covers her head with ashes before going out to kill Holofernes. Chartres Cathedral, north porch, 13th century (*Henry Cohen, Paris*).

Esther is shown pleading for her people at the feet of Ahasuerus [10] and Judith is seen piously pouring ashes on her head in preparation for her mission [11]. Such scenes are rarer in the twelfth century but they do exist, as in a capital relief at Vézelay, where Judith is shown returning from her perilous self-imposed task. She stands, magnificently conscious of her accomplishment, brandishing Holofernes' head before the astonished eyes of the men cowering on the city's walls [12].

Other important sources of stirring scenes involving women have been the *Golden Leg-* *end* and certain narrative sections of the Evangels, especially those occurring in the absence of Christ or Mary. The Massacre of the Innocents, for example, often furnishes affecting illustrations of motherly love, as in the tiny frieze that threads across the façade of Chartres cathedral, where the whole story of Christ is told in frequently exquisite images [13]. By extension, delineations of fatherly affection also begin to appear, seen in many representations of the return of the Prodigal Son [14] or in the marvelously touching scene of the Creation of Adam, on

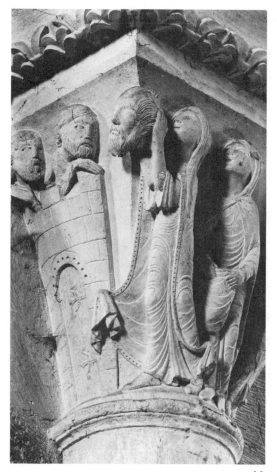

12

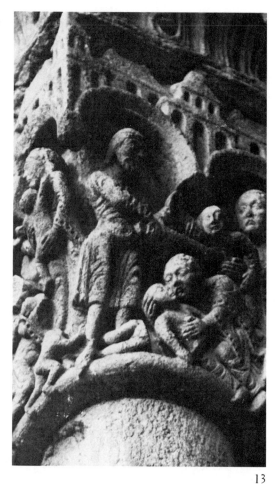

13

14

12. Judith returning with the head of Holofernes.
Capital relief, Church of La Madeleine, Vézelay, 12th
century (*Marburg*).

13. The Massacre of the Innocents. West façade frieze,
Chartres Cathedral, 12th century (*Dr. Mark Yanover*).

14. The Prodigal Son. Stained-glass window, Bourges
Cathedral, 13th century (*Archives photographiques*).

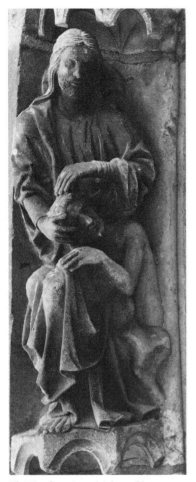

15. The Creation of Adam. Chartres Cathedral, north porch, 13th century (*Archives photographiques*).

16. Detail of the Judgment Day: The Rising Dead. Upper right, a man helps his wife out of the tomb. Amiens Cathedral, Porte du Sauveur, 13th century (*Archives photographiques*).

Chartres' north porch, where the love of God wells out of his gaze upon the still inert form of his firstborn, whose nodding head he embraces on his lap [15].

As the attitude toward woman improved, it was inevitable that the relationship between the sexes, as exemplified in art, should undergo a like alteration. Nowhere is this more movingly portrayed than in Judgment Day scenes, inescapably charged with the thought of eternal separations. But the artists at Saint-Trophime at Arles, at Notre-Dame de Paris, and at Amiens cathedral strike a reassuring note. Forgetful that associations by the flesh would cease after the Rising, they depict husband and wife as lovingly taking each other's hands [16]. The principle of human solidarity is extended at times to include the whole family of man, who are shown eagerly helping each other out of the grave.

In this manner likewise the thirteenth-century narrative of the Original Sin and its punishment was transformed, taking on a totally different character from the early misogynous one. The Devil retires into the background and Eve is no longer portrayed as the chief

17. The Original Sin. Reims Cathedral, 13th century (*Compagnie des arts photomécaniques*).

18. The Tempter and the Foolish Virgin. Strasbourg Cathedral, west façade, south portal, 13th century (*Marburg*).

instigator of disobedience but shares her guilt with Adam in an act of complete moral as well as artistic balance [17]. At times, regard for the sentiments of the unfortunate first couple overflows into an attempt to shield them from harrowing despair after the Expulsion. In the south rose at Lyon cathedral this is accomplished by accompanying the latter scene by a sort of flash-forward of Christ's Descent into Limbo, out of whose jaws he reclaims the repentant sinners, thus serving to reassure them (as well as their descendants) that they will not be abandoned for eternity.

Nor is the entry of Adam and Eve into mortality any longer treated in the thirteenth century as the ultimate calamity. The first couple fall to their labors with zest in the Genesis window at Tours, and when Eve pauses to have her baby, she proudly lifts it up to its father, who offers fervent prayers to God. But the ultimate in reverses is undoubtedly that amazing scene at Strasbourg, in which an elegant young seignior offers the fruit of temptation to the Unwise Virgin [18]. It is no longer Eve who is associated with the Devil but rather the male partner, the back of whose

cloak reveals a family of crawling things. And whereas Adam was formerly the pathetic dupe, it is now the giddy girl whose credulity is imposed upon—and she promptly begins to unclasp her robe.

Sexual love as such is no longer automatically covered by taboo or pictured in almost animalic terms, as in the famous vignette on the border of the Bayeux Tapestry. It can now be the subject of extraordinary finesse and even sympathy. A charming example is the young couple sculptured on the pendant of a stone console at Lyon. Each caresses his partner with one soft hand while holding his favorite pet in the other. It would be hard to find a good theological reason for including this scene on a church façade. The portrayal of Castor and Pollux had a firmer iconographic tradition but its manner of presentation sometimes went beyond prescription, showing the twins warmly embracing. This gracious treatment of men reveals the same humanizing trend that we find softening the artistic effigy of women. Indeed, the process developed to the point where a type of pure "genre" scene began to insert itself here and there amid the austerities of church art [19].

And startling is the representation of Herod's love for Salome in the famous Saint-Étienne relief, whose pathos inspired a whole library of literary comment. The tetrarch chucks his stepdaughter under the chin, a favorite gesture in the Middle Ages, but his sad, sad face displays a striking maturity in the description of this anomalous passion, whose purely human side effaces for the moment its calamitous consequences for St. John [20].

It is difficult to think that such complex changes in the artistic interpretation of women could have failed to have their social counterpart. As a matter of fact, woman's legal position was undergoing a great transformation during this period, the fundamental element being her acquisition of the right of inheritance.

Under the feudal fief the possession of land by a vassal was at first inseparable from the obligation of military service. But around the

19. A mother combing her child's hair. Church of La Madeleine, Vézelay, 12th century (*Marburg*).

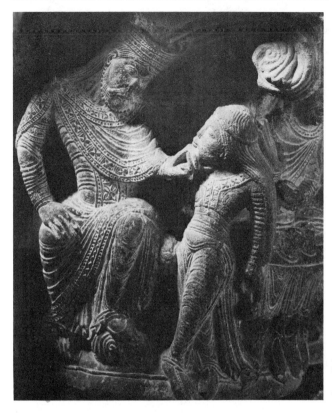

20. Herod and Salome. Capital relief, former Cloister of the Monastery of Saint-Étienne, 12th century. Now at the Musée des Augustins, Toulouse (*Marburg*).

tenth century a change began to establish itself, an inheriting son being required by civil law to indemnify his sister with a dowry at her marriage. But even if the young woman failed to wed she could, by the thirteenth century, acquire possession of up to one third of her parent's landed property.[21] Marriage itself was considered a strictly feudal service and choosing a mate without the seignior's consent was severely punishable. But eventually a rich heir could buy off this servitude and a woman, too, could pay to marry the man of her choice.

With the woman's acquisition of the right of inheritance went all the feudal privileges pertaining to it. Since land superseded the person under feudal law, as one author has pointed out, "the woman possessing fiefs had . . . all the rights of sovereignty, that of raising troops, coining money, conducting civil and criminal justice." To be sure, these prerogatives were not won without opposition, on the part of both the lay seigniors and the Church. The latter seemed to be particularly horrified by the trend and a synod at Nantes early denounced as a "barbaric" innovation the practice of allowing women to discuss public affairs with men: Let them return to their own quarters and gabble among themselves![22]

It was woman's assumption of the judge's mantle that particularly exercised the conservatives. Canonic law even prohibited them from serving as witnesses in court, their testimony being considered unworthy of trust.[23] But by the thirteenth century matters had developed to the point where Pope Innocent III was forced to concede that Queen Aliénor, though a woman, had full rights of justice as a feudal suzerain. The pope's deci-

21. Woman combing wool. Chartres Cathedral, 13th century (*Henry Cohen, Paris*).

sion came on an appeal by the order of Hospitalers, in a case in which the queen had claimed jurisdiction over the Knights, which they challenged.[24]

It is significant that in the middle class of the cities woman's social position was early characterized by almost complete equality with that of man. The burgher, who in the twelfth and even in the thirteenth century continued to carry various disabilities of his former serfdom, had even to fight for the right of endowing his children or any other heirs. His daughters were co-beneficiaries of the positive outcome of this struggle, and the equal division of his possessions between male and female descendants was a right that was written into most communal charters. As for the woman merchant, all legislation of the Middle Ages concurred in granting her full civil status, "even if married."[25] And the artisan's wife paid her own poll tax.

In some trades women had their own guilds ("corporations") and in thirteenth-century Paris they worked in the following categories: as embroiderers, seamstresses, spinners, wool combers, weavers, headdress makers ("coiffières"), hatters, dairywomen, retail food merchants, and female doctors.[26] Several of these occupations are beautifully illustrated in the sculptured series representing the "Active Life," on Chartres' north porch [21]. Silkmaking was almost exclusively a woman's trade and one of the great poetic bequests of the Middle Ages is Chrétien de Troyes' complaint of the women silk spinners:

> Forever weaving silken goods,
> But we ourselves so poorly dressed,
> Forever clothed in nakedness,
> Forever lacking drink and food . . .[27]

While it was through the elimination of the military service requirement that women finally obtained the right of inheritance and hence moved closer to equality with men, it was by no means unusual for them to fight during the Middle Ages, whether in tournaments or in wars. "Many women appeared in armor in the ranks of the Crusaders," one author reports.[28] Another has pointed out that the mortality of men in the Crusades was so high that women had to be used in the armies, where they were assigned special tasks such as filling moats during sieges and pulling artillery into position.[29] Their role in defending their homes has been consecrated in the romantic image of their standing guard at the barbicans, preparing to pour hot oil on the heads of the city's attackers.

The picture is hardly fictional, judging from chronicles of the great defensive battles fought by the people of Southwest France during the religious wars of the thirteenth century. Organized ostensibly to root out heresy but strongly animated also by a goal of political domination and absorption, the invasion by the Northern forces roused a great tide of patriotic resistance. Women often played heroic roles in accounts of this popular upsurge, as in the epic poem describing the death of the leader of the "crusaders," Simon de Montfort, outside the walls of Toulouse.

A projectile-thrower devised by a carpenter and mounted on the city ramparts was operated "by young girls and married women," the poet assures us. It hurled the stone that smashed Simon's head open, spilling eyes, brains, upper teeth, forehead, and jaw. The delighted populace lighted candles in all the city's churches, crying: "Joy! For God is merciful," while trumpets and drums, cymbals and bugles sounded throughout the grateful city.[30] The incident might well have been commemorated in one of those artistic monuments that were put up by the freedom-loving communities of Central Italy. But the course of the "crusade" soon after shifted again and the final subjection of the South would have made any such memorials historically anomalous. On the other hand, there is a relief in the church of Saint-Nazaire at Carcassonne which is supposed to be the story seen from the eventually winning side. The

fact that this church also has a tombal effigy of Simon tends to authenticate this assumption.[31]

There is evidence suggesting that the great Crusades played a significant part in the evolution of woman's improved social position. They occurred during that critical period when her legal right to inheritance was being slowly won, not without strong opposition as we have seen. But as the male seigniors were now called out to the holy wars, remaining away for years on end, the capacity of women—their wives—to conduct the affairs of the seigniories in their place was often given a kind of sharp laboratory test. Many thousands of these husbands never came home at all and although twelfth-century "chansons de geste" show Charlemagne, as prescribed by custom, marrying off the widows of his slain barons en masse upon the return home, a time must have come when there were no longer enough men to go around. And some women may have simply decided to remain unwed, intoxicated by the heady wine of their new-found freedom and importance.

That they could be competent administrators and at times tough ones is a well-documented fact. One of these "strong women," the Comtesse Catherine de Chartres, ran her husband's affairs while he was off to the Crusades. When he was killed, she retained the fief in her own hands as dowager. She had her court of justice, her marshal of the palace, and her provost and like any aggressive feudal lord conducted sharp jurisdictional battles with the cathedral canons. On one occasion she encouraged or even helped organize a mob which invaded and sacked the church and other chapter buildings, the conflict ultimately requiring the intervention of Philippe-Auguste.[32]

It is generally held today, despite the sharp contradictions between them, that courtly love poetry strongly influenced the cult of Mary, at least in the latter's code and trappings. That this should have been possible implies a sharing by the two, in part anyway, of important background influences. That the changed social position of women should be more clearly mirrored in the love poetry than in the cult of the Virgin (and, derivatively, in religious art) is understandable. The former was declamatorily predicated on the superiority of women while the Church was, if anything, misogynous.

The panegyrics of the court poets addressed to their paragons, usually married women, were formerly read at face value, from which was derived a strange notion of the feudal marital relationship. Certainly the nobles' morals were no better than might be expected. They are said to have populated the manors with their bastards. But that these egoistic and bellicose men should allow their wives a similar freedom strains credibility.[33]

Modern scholars have been able to find "internal evidence" in the courtly poetry pointing to an entirely different interpretation. The strong parallel between the postures assumed by the poet with regard to his lady and the feudal relationship has been singled out as particularly meaningful. He conducted himself toward her entirely in the manner of a vassal to his suzerain. "To be in love ... was like a knight taking an oath," declared the famed troubadour, Bernard de Ventadour: "With patience and discretion, I am your vassal and your servant."[34] One author, when discussing the allegedly biographical content of the troubadour's poetry, goes so far as to insist that "one could not find a single example of the dreams and beliefs of the courtly love being carried into practice."[35]

It could hardly be otherwise in the socially rigid Middle Ages. The poet most frequently belonged to a lower social class than the lady to whom he sang. As the authoritative writer on this subject, Eduard Wechssler, exhaustively demonstrated, it was indeed through his poetry that the troubadour hoped to get

advancement at the seigniorial court, over whose spiritual life (and often its physical one as well) his lady presided. Since it was known to all concerned that the favors he demanded were purely conventional, her good name remained unblemished. She could enjoy the luxury of being passionately and publicly craved—and often in excellent verse—without paying the usual price, unless, of course, inclination and opportunity combined toward that end.

The poet, on the other hand, had the strongest non-amatory motives for his songs. Often starting as a lowly jongleur, who had to travel from court to court to earn a precarious living, one can see him suddenly presented with the opportunity of stabilizing his position. He could ask for nothing better than to be "taken up" into his lady's household, which to him meant the nearest thing to security and social position attainable at the time. And the kiss he asked for was nothing else, Wechssler argued, than the token by which the pledge of vassalage was customarily sealed. (The vassal first kissed the lord's shoe, then was raised by him and given the accolade.)[36]

Nevertheless, as such things happen in the creative life of man, the poems that were meant as "bread and butter" pieces ended by acquiring an artistic independence and at times a depth and richness that have helped them retain their attractiveness over the centuries. Their remarkable originality consisted in the circumstance that for the first time in the West was sung the ennobling effect on man of his love for a superior woman. This emphasis contributed importantly to the spiritual position of the female sex and, in consequence, to the relationship between the sexes.

It is all the more surprising to find the greatest love epic of the time, the *Roman de la rose,* containing some of the most ferocious attacks on women in all literature. "There are fewer honest women than phoenixes," Jean de Meung sang, "fewer honest women than

white crows." And his is that truly bestial couplet:

> Either by act or in your hearts,
> You all are, were, or will be tarts![37]

It would almost seem from this savage misogyny that the poet was lined up with the monks. But the affinity is illusory. Actually there were light-years of difference between the two attitudes toward woman. Jean de Meung's poetry could never have been the inspiration of the atrocious relief at Villeneuve-les-Avignon [2]!

Jean de Meung's attacks on women have been interpreted as essentially an act of dissociation from the mawkishness and exaggerated self-abnegation of the courtly poetry in favor of a natural, candidly hedonistic relationship. That of Abélard and Héloïse, for example. Ah, there was a woman! "Never has her like been seen since," the poet sadly exulted. Freely and courageously she took the man she loved to her bed, mating him out of wedlock, by nature, as it were. It was only when they did marry, on Abélard's insistence, that tragedy ensued. For marriage was a hateful and treacherous state, the source of lies and villainy. The only true relationship between the sexes was honest sensuality, the poet insisted, ending his long epic with an amazingly graphic allegorical description of the sex act.

Héloïse herself was no shrinking violet when recalling their passionate affair to Abélard. She preferred, she admitted, the flat but "more expressive" word—"fornication"—to the ridiculous euphemism—"delights of love"—that was usually applied to the physical relationship. (It should be said, of course, that she could hardly have known that her burning letters to her lover would ever become public.) It is a significant fact, however, at a time when the positive feminine influence on man was beginning to be vaunted, as by Abélard himself who argued that women's prayers always had a special grace in Scrip-

ture, that it should have been this great and extraordinarily modern woman who acted the Devil's disciple. She forthrightly reasserted Eve's sinful role and countered her former lover's references by quoting from Gospel various instances where woman's influence had been pernicious. Even so, Héloïse declared, she had brought evil into Abélard's life, for which she would now atone by a lifetime of penance. But she would not lie either to God or herself by asserting that she was reformed. How could one talk of repentance when one's soul burned with the same passions as before?

"The delights of love which we enjoyed together were so sweet to me that their memory can neither displease me nor be effaced. Wherever I turn, they are present, reawakening the old desires. . . . Even at solemn mass . . . the licentious pictures of those passionate acts seize upon this miserable heart." She caught herself while asleep, she said, making motions that recalled their passion. The very places where they had embraced were indelibly imprinted on her mind. Do not ask for my prayers, she cried, for my chastity is nothing but hypocrisy. It is your prayers that I need since you have always been the first to me, coming even before God. To which Adam-Abélard replied, bitterly recriminating, blessing the mutilation that had put him beyond temptation's reach, finally succeeding in bringing his tormentor to reason.[38]

It has often been said that everything that medieval man has thought or felt or dreamed can be found in the art of the cathedrals. Unfortunately, this is a great exaggeration. Perhaps if the word "found" were changed to "alluded to," it would be closer to the truth for then manner would be left out of account.

And even so, there are whole areas and depths of the human soul revealed in the exchange of letters between Héloïse and Abélard with which nothing in the art of the time shows the slightest familiarity. The plastic presence, of course, has its own inimitable qualities, and with these we must be content.

It would be incongruous to think of church art as depicting the extraordinary relationship between these two amazing human beings. That Jean de Meung glorified them was largely due to the fact that they symbolized for him a defiance of church morality and of the false monastic advocacy of sexual abstinence, which he held to be a course of life that was against nature, hence repugnant. In this sense his ideas may be considered as a kind of reply to the Church's glorification of the Virgin and to the various corollaries of her cult. And even his ideas about women, violently abusive though they might be, tended to free them from inaccessible, saintly models and to substitute more natural prototypes.

But, strangely, this was also an accomplishment, though only obliquely to be sure, of the church art of the twelfth and thirteenth centuries. For this art, as we have seen, had its own notable share in the humanizing of woman's image. Through representations of Mary and the saints, the softening influence of art made itself more widely felt in the portrayal of all the Daughters of Eve and beyond them in the depiction of various human relationships. The altered attitude toward the female sex in church art may have been largely unintended. But it strikes us as inevitable today, ultimately responsive to important changes in woman's social situation.

NOTES

1. St. Bernard, *Textes choisis et présentés par Étienne Gilson,* Paris, 1949, p. 65.

2. Meyer Schapiro, "From Mozarabic to Romanesque in Silos," *The Art Bulletin,* 21 (1939), pp. 313–74.

3. *Le Jeu d'Adam et Ève.* Transposition littéraire de Gustave Cohen, Paris, 1936. I should like to take responsibility for the English translations of the several poetic passages in this chapter.

4. Lily Braun, *Le problème de la femme: son évolution historique, son aspect économique,* Paris, 1908, p. 43.

5. G. G. Coulton, *Ten Medieval Studies,* Cambridge, Engl., 1930, p. 52.

6. Émile Mâle, *L'art religieux du XIIe siècle en France,* Paris, 1922, p. 373.

7. Émile Mâle, *L'art religieux du XIIIe siècle en France,* Paris, 1925, pp. 337–38.

8. Alice Hurtrel, *La femme, sa condition sociale, depuis l'antiquité jusqu'à nos jours,* Paris, 1887, pp. 40, 43.

9. Albert R.-A. Lecoy de la Marche, *La chaire française au moyen-âge,* Paris, 1886, p. 430.

10. St. Bernard, pp. 66–67.

11. Both poems quoted by Pierre Jonin, *Les personnages féminins dans les romans français de Tristan au XIIe siècle,* Gap, 1958, p. 445 and note.

12. Mlle. Chatel, "Le culte de la vierge Marie en France, du Ve au XIIIe siècle," *Thèses-Sorbonne,* Paris, 1945, pp. 151–52.

13. Quoted by Mâle, *L'art religieux du XIIIe siècle,* pp. 273–74.

14. Mlle. Chatel, p. 220.

15. *Ibid.,* p. 203.

16. Marion Lawrence, "Maria Regina," *The Art Bulletin,* 7 (1935), pp. 150–61.

17. Mâle, *L'art religieux du XIIe siècle,* pp. 426–37.

18. Mâle, *L'art religieux du XIIIe siècle,* p. 276.

19. Mâle, *L'art religieux du XIIe siècle,* p. 431.

20. Gustave Cohen, Henri Focillon and Henri Pirenne, *La civilisation occidentale au moyen-âge du XIe au milieu du XVe siècle,* Paris, 1933, p. 231.

21. Édouard de Laboulaye, *Recherches sur la condition civile et politique des femmes, depuis les Romains jusqu'à nos jours,* Paris, 1843, p. 243.

22. *Ibid.,* p. 443.

23. Hurtrel, p. 43.

24. É. de Laboulaye, p. 444.

25. *Ibid.,* p. 441.

26. Edmond Faral, *La vie quotidienne au temps de Saint Louis,* Paris, 1942, p. 141.

27. Chrétien de Troyes, "Yvain ou le chevalier au lion," Verses 5298–5301, in Gustave Cohen, *Chrétien de Troyes: Oeuvres choisies,* Paris, 1936, p. 76.

28. "Women in the Middle Ages," *Blackwood's Magazine,* 102 (1867), pp. 613–34.

29. Auguste Bebel, *La femme et le socialisme,* Gand, 1911, p. 119.

30. *La chanson de la croisade albigeoise,* ed. Eugène Martin-Chabot, III, no. 35 (205), Nogent-le-Rotrou, 1931, Verses 121–29 and 145–56.

31. J. de Lahondès, "Église Saint-Nazaire (Carcassonne)," *Congrès Archéologiques,* 73 (1906), pp. 32–42.

32. E. de Lépinois, *Histoire de Chartres,* Chartres, 1854, p. 127.

33. Marc Bloch, *La société féodale,* Paris, 1940, p. 40.

34. Quoted in Joseph Anglade, *Les troubadours, leurs vies, leurs oeuvres, leur influence,* Paris, 1908, p. 77.

35. Gaston Paris, "Jaufré Rudel," *Revue Historique,* 53 (1893), pp. 223–56.

36. Eduard Wechssler, *Das Kultur-Problem des Minnesangs,* Halle a/S, 1909, pp. 72, 94, 95, 140, 182, 206, *passim.*

37. Guillaume de Lorris et Jean de Meung, *Le roman de la rose,* ed. Pierre Marteau, Orléans, 1878–79, Verses 9489–9490.

38. *Lettres complètes d'Abélard et d'Héloïse,* transl. from the Latin into French by Octave Gréard, Paris, 1886, pp. 81, 96, 98, 110, *passim.*

1. Donor Statue of Charles V, ca. 1370. Paris, Louvre (*Archives photographiques*).

2. Donor Statue of Jeanne de Bourbon, ca. 1370. Paris, Louvre (*Archives photographiques*).

6

Taking a Second Look: Observations on the Iconography of a French Queen, Jeanne de Bourbon (1338–1378)

> ⊃+ +⊂

CLAIRE RICHTER SHERMAN

In recent years, a new feminist perspective has led me to question my assumptions as an art historian. By a feminist perspective I simply mean an awareness that women have played much larger roles in history and art history than those traditionally assigned them by scholars of these subjects. More specifically, this "questioning the litany" resulted in a critical reappraisal of a manuscript long familiar to me. This analytical process also called for a method to solve a new set of problems about the manuscript that art history or history by themselves did not fully answer. In turn, this method proved to have wider application to the study of French medieval queenship, the broader subject of this essay.

From my publications on the library and iconography of King Charles V of France (1338–1380), I was well acquainted with images of his consort, Queen Jeanne de Bour-

bon (1338–1378).[1] In these studies, I had discussed sculptures, drawings, and manuscript illuminations in which the queen figured as examples of new naturalistic directions in late medieval portraiture. Yet I had never considered these images as sources for contemporary ideas about French queenship, as I had done with the iconography of Charles V and the tradition of kingship. Only when, fortified with a new feminist perspective, I began in 1972 to study anew an important and beautiful manuscript commissioned by Charles V, did the focus of my interest change. More specifically, my curiosity was aroused by the cycle of nine miniatures illustrating the coronation of a French queen in the manuscript now in the British Library (Cotton Tiberius B. VIII) known as the *Coronation Book of Charles V of France*.[2] The date 1365 forms part of an unusual colophon (to which I shall return) in the king's own hand stating that he had commissioned the book. The text of the manuscript, published in both French and English sources of the seventeenth century, was well known to modern historians.[3] A facsimile of the *Coronation Book* was printed in

This essay was developed from a paper read at the Women's Caucus for Art session, "Questioning the Litany: Feminist Views of Art History," College Art Association Annual Meeting, New York, 1978. Copyright © 1982 by Claire Richter Sherman. By permission of the author.

1899, and I had discussed the miniatures of the king in my book on Charles V's portraits.[4] Despite a concerted search, nowhere did I find any art historical or historical analysis of the nine (originally ten or eleven) miniatures of the queen's coronation in this manuscript.

I soon discovered why historians had neglected both the texts and illustrations of this part of the manuscript, apparently the first extant historically documented and illustrated account of the coronation of a French queen. Medievalists, interested in the political and constitutional aspects of the *Coronation Book,* believed that from these perspectives the coronation of the queen had little or no significance. They noted the important political position held by French queens after marriage to a reigning or future king in the later Carolingian and early Capetian periods. But as the institutions, power, and sacral character of the French monarchy developed, from the middle of the twelfth century the role of French queens became increasingly restricted to a ceremonial and symbolic sphere.[5] In the early fourteenth century, the crisis brought on by the inability of the last Capetian rulers to produce male heirs further weakened the positions of French queens. In 1316, after King Louis X and his infant son died, his only living child, the future Queen Jeanne II de Navarre, was passed over as successor to the crown in favor of the king's oldest brother. This choice marked the first step in excluding women from inheriting the French throne. The second stage came in 1328, when Louis X's second brother, the last Capetian king Charles IV, died without leaving a son. In order to prevent the English king Edward III from ascending the French throne (through his mother Isabelle, sister of Charles IV), an assembly of notables decreed that the succession could not pass through the female line. This denial of Edward III's claim, one of the prime causes of the Hundred Years' War between England and France, obviously dealt

an extremely severe blow to women's ambitions as independent rulers.[6] A new dynasty, the house of Valois headed by Philippe VI (ruled 1328–50), became hereditary monarchs of France.

Although the decline in the political positions of French queens in the fourteenth century explains the historians' lack of interest in the queen's cycle in the *Coronation Book,* my feminist perspective and my training as an art historian told me that this attitude was misleading. For one thing, I knew that such an extensive—and expensive—cycle of images surely had a substantial raison d'être. In other words, within the total program of illustration of the manuscript, this large group of miniatures representing the queen's coronation occupied such a prominent place that it must have some historical meaning. I began to look at the way the *Coronation Book* was put together in order to decipher this meaning. My approach to studying the manuscript is based on codicology. This term applies to a method of considering the medieval book as an integrated physical and aesthetic structure. The materials, writing, and decoration, as well as the type of text, patronage, and audience for the manuscript, all constitute evidence for evaluating its historical and wider cultural significance.[7] In particular, I concentrated on analyzing the function of the images in relationship to the text.

After I began studying the *Coronation Book* as a whole, I soon discovered that coronation texts as independent volumes were relatively new to the fourteenth century. Previously the texts of coronation orders had formed part of pontifical manuscripts, which contain various kinds of ecclesiastical ceremonies over which the clergy preside. The coronation ceremony itself, a typical medieval formula, blends secular protocol, liturgical elements, and mystical symbols that enunciate the spiritual and constitutional obligations and prerogatives of the ruler vis-à-vis the Church and people. The sequence of the

French ceremony in the Charles V coronation order has a preliminary section that includes the king's oath and an elaborate portion concerned with knightly symbolism. Then follow the king's consecration or anointing and the bestowal of the regalia, culminating in his enthronement. The procedure for the consecration and coronation of the queen involves the same sequence, minus the oath and knightly symbolism.[8]

Several earlier pontifical manuscripts also have extensive illustrations of the coronation ceremony. Yet as far as I know, the Charles V *Coronation Book,* commissioned by the king in the year following the ceremony held at Reims Cathedral on May 19, 1364, was the first French manuscript of this type with individualized portraits of both rulers. Although they are nowhere identified by name in the *Coronation Book,* the images of the royal couple accord with universally acknowledged images of Charles V and Jeanne de Bourbon, such as the donor figures originally placed on the façade of the Church of the Célestins in Paris around 1370 [1 and 2].[9] This portrait identification further suggests that the illustrations are based on the actual coronation of these rulers. The colophon on folio 74 of the *Coronation Book* written in Charles V's own hand states that he had taken an active role in the correction, arrangement, writing, and illustration of the text.

This information provided crucial clues in several directions. First, I observed that apart from the limited number of miniatures placed in the text, many others—including eight out of nine of the queen's cycle—had been set in the lower margins. This change in layout indicates that the king had desired a lavish, more detailed program of illustrations than may have originally been planned. Moreover, the design of the manuscript showed how the miniatures were meant to function. Interspersed with the liturgy and the oaths taken by the king written in black was a series of instructions in red. These rubrics actually form a set of directions on staging the different phases of the ceremony. Placed close to the rubrics, the illustrations serve as specific visual examples of these general directions given in the text. Although the twenty-eight miniatures of the king's ceremony (originally thirty) far outnumber the nine (formerly ten or eleven) devoted to the rites for the queen, the density of illustration in each cycle is comparable. Altogether this pictorial record serves as a souvenir album of the historical event.

After having discovered the function of the illustrations and noted the greatly expanded program of images in the coronation ceremonies for both king and queen, I decided to compare the texts to earlier coronation orders. The increased cycles of illumination in the *Coronation Book* are matched by a corresponding development of the text. In Charles V's case, the developments in both texts and images had the clear political motive of emphasizing certain powers of the monarch embodied in particular symbols of royal ceremonial. The intention of the elaborate coronation rites was to celebrate the accession of the third ruler of the Valois dynasty to the French throne at a crucial moment. Under the leadership of the first two Valois kings, the first phase of the Hundred Years' War and profound civil unrest had brought the fortunes of the country to a low ebb. The coronation and subsequent royal ceremonial were among the first steps taken by Charles V to bolster the shaky position of the monarchy.

Yet the expansion of the king's cycle in the *Coronation Book* did not necessarily call for a comparable increase in the length of the queen's ceremony, as she did not possess the political power of her husband. My examination of coronation orders for the queen dating from 980 showed, however, that the section in the *Coronation Book* had twice the number of prayers of any earlier example.[10] A prominent characteristic of three prayers in

3. Old Testament Figures, 1145–1155. Chartres Cathedral, west façade, central portal (*Marburg*).

the *Coronation Book* was the comparison of the queen to Old Testament women. The analogy of Christian to biblical rulers and personalities had a long history in medieval culture. A visual example of this parallel is found in the statue columns of the west façade of Chartres Cathedral [3], which honored French kings and queens in the guise of Old Testament rulers and heroines.[11]

Several *Coronation Book* prayers emphasize the fertility that God had bestowed on certain Old Testament women. A similar favor was requested for the queen: "And together with Sarah and Rebecca and Leah and Rachel, all blessed and revered women, may she be worthy of being made fruitful and rejoice in the fruit of her womb in order to rule and protect the glory of the whole kingdom and the state of the Holy Church."[12] This passage suggests that in the context of conse-

cration and coronation the anointing of the queen was viewed as a fertility charm that would assure her ability to fulfill the essential function of providing heirs to the kingdom. According to an eminent scholar, this tradition began in the Carolingian period, when the queen's coronation was linked to marriage vows and blessings.[13] A contemporary commentary commissioned by Charles V in 1374 shows that these ideas remained alive. In the second of two prayers addressed by the queen to God in Jean Golein's *Treatise on the Consecration,* she asks: "And today may I receive in such a way the blessing of the holy unction as to increase my virtues and destroy my sins, and so that I may by my lord have a line of descendants who will be ordained to serve you and the Holy Church."[14] These supplications, emphasized by the image of the queen's anointing in the *Coronation Book* [4], had particular urgency in the year of the coronation. In 1364, after fourteen years of marriage, Charles V and Jeanne de Bourbon had not yet produced a living heir. This situation was all the more damaging in view of the shaky position of the Valois dynasty. In this historical context, the connection between fertility and the anointing of the queen supplies a convincing rationale for the prominence of the cycle devoted to the consecration and coronation of Jeanne de Bourbon.

This method of studying the structure of the *Coronation Book,* especially the function of the illustrations and the relationship between text and image, brought encouraging results. But what do the miniatures representing the rite for Jeanne de Bourbon in the *Coronation Book* tell us about the queen's status at this time? In many respects the individual scenes and symbols confirm her lack of political power. For example, in the first miniature in which Jeanne de Bourbon enters Reims Cathedral, she comes through a side door, not the main entrance reserved for the reception of the king by the archbishop of Reims and a procession of clerics [5 and 6].

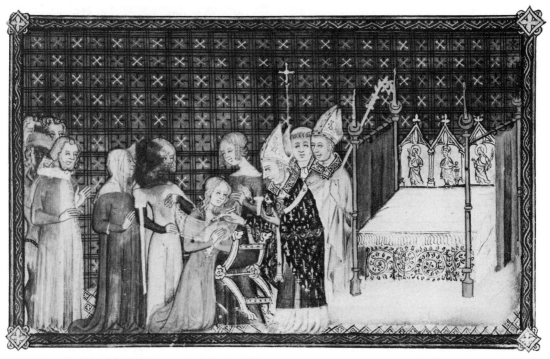

4

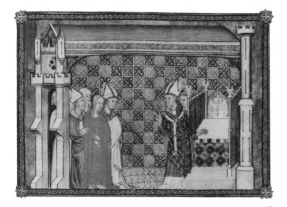

5

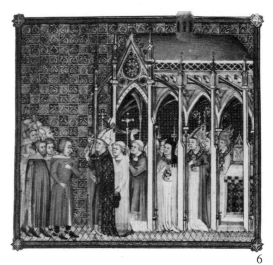

6

4. *The Anointing of Jeanne de Bourbon. The Coronation Book of Charles V of France,* 1365. London, British Library, MS Cotton Tiberius B. VIII, fol. 68 (*British Library Board*).

5. *Jeanne de Bourbon Enters Reims Cathedral. The Coronation Book of Charles V of France,* 1365. London, British Library, MS Cotton Tiberius B. VIII, fol. 66 (*British Library Board*).

6. *The Reception of Charles V at the West End of Reims Cathedral. The Coronation Book of Charles V of France,* 1365. London, British Library, MS Cotton Tiberius B. VIII, fol. 43 (*British Library Board*).

Unlike Charles V, who self-confidently receives the welcome accorded him, Jeanne de Bourbon, escorted by two bishops, seems almost to be pushed forward by them.

Although the queen's anointing had a particular significance relating to Jeanne de Bourbon's ability to bear a successor to the throne, the manner in which she received the unction reinforced her inferior political position. According to legend, the French king was anointed with a special balm kept in the Holy Vial at the abbey of Saint-Remi, also in Reims. The legend stated also that the balm came from heaven for the baptism in 496 of Clovis, the first king of the Franks converted to Christianity. From the French king's distinctive anointing derived his alleged thaumaturgic power to cure scrofula, his quasi-priestly status, and his superiority over rulers of other nations.[15] In contrast, the queen was anointed only with ordinary sanctified oil on chest [4] and head, while the king received a sevenfold unction.

Several other symbols associated with Jeanne de Bourbon's coronation emphasize her lack of sovereignty. Her scepter [7], symbol of temporal authority, was smaller than the king's. Her throne is also not as big as his;

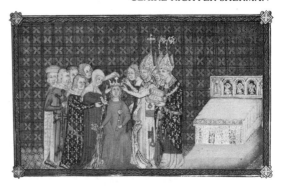

8. *The Crowning of Jeanne de Bourbon. The Coronation Book of Charles V of France*, 1365. London, British Library, MS Cotton Tiberius B. VIII, fol. 69 v. (*British Library Board*).

hers is placed in the left—the symbolically less desirable side—of the choir. In the scene that illustrates her crowning [8], she is attended by barons, not the peers of France who surround the king. Thus the miniatures representing the consecration and coronation of Jeanne de Bourbon confirm her political weakness. Yet these symbols of the queen's inferior status had particular significance in 1364. As I mentioned earlier, the French had denied English claims to the throne through the female line. Propagandist literature commissioned by Charles V did not hesitate to use any symbols of the queen's inability to rule to deny the English pretensions. In his *Treatise on the Consecration*, Jean Golein dwells especially on the anointing to make a crucial point:

No woman ever approaches so near the priestly order as to receive the royal unction, nor has a woman been entrusted with the healing of the said disease. Wherefore it appears that women cannot and certainly should not inherit in France, but it would be wrong for the realm. For by way of the hereditary succession the first king anointed laid down that unction from the Sainte Ampoule never appertains to a woman. *Ergo* no woman has the royal succession. . . .[16]

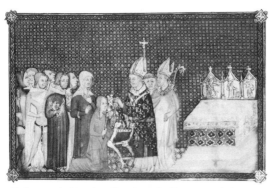

7. *Jeanne de Bourbon Receives the Scepter and the Rod. The Coronation Book of Charles V of France*, 1365. London, British Library, MS Cotton Tiberius B. VIII, fol. 69 (*British Library Board*).

Although the miniatures of the Jeanne de

Bourbon cycle in the *Coronation Book* undoubtedly confirm and even exploit the queen's lack of sovereignty, certain images in the manuscript, together with the relevant text passages, suggest that political power is not the sole measure of the social and cultural status of medieval French queens. For instance, when following her anointing Jeanne de Bourbon receives a ring [9], this traditional symbol of Christian faith stands for the queen's duty to the Church, her belief in the Holy Trinity, and her obligation to fight heresy. Although the queen's scepter is smaller than the king's, the rod she receives at the same time [7] is associated in the liturgy with the queen's spiritual and charitable responsibilities. Indeed, the relevant prayer in the text bids the queen to be "merciful and generous to the poor and to widows and orphans."[17] Likewise, the bestowal on the queen of the crown [8] called for the exercise of spiritual duties: "Thus just as you shine forth crowned with gold and gems, thus also may you strive to be decorated internally with the gold of wisdom and the gems of virtue." Another prayer enjoins her to be aware that she is "the consort of the kingdom" and that she must "always take favorable counsel

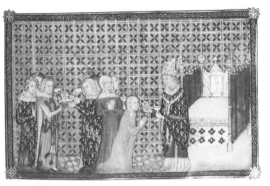

10. *Jeanne de Bourbon Receives Communion. The Coronation Book of Charles V of France,* 1365. London, British Library, MS Cotton Tiberius B. VIII, fol. 72 (*British Library Board*).

for the people." Furthermore, God is asked to send a wide range of virtues to aid the queen in discharging her obligations: "Authority of command, greatness of judgment, an abundance of wisdom, prudence, and understanding, a guardianship of religion and piety."[18] A further indication of the queen's high status as a royal person appears in the final illustration of the Jeanne de Bourbon cycle in the *Coronation Book* [10], in which she receives communion. At this period, the king and queen of France were virtually the only nonclerics to have this privilege. In short, the illustrations of the Jeanne de Bourbon cycle indicate that her participation in the most important ceremonial occasion in the life of the monarchy is not an insignificant index of her status at a time when such ritual was regarded as the symbolic enactment of invisible and ineffable truths.

The important role of the queen in the public life of the monarchy probably resulted from a blend of personal and political reasons. For one thing, evidence of a close and happy relationship between Charles V and Jeanne de Bourbon comes from various contemporary sources. Jeanne, member of a famous noble family, and Charles were cousins. Born in the same year, they knew one another from

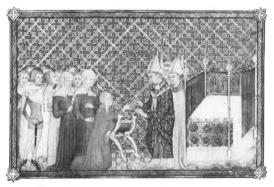

9. *Jeanne de Bourbon Receives the Ring. The Coronation Book of Charles V of France,* 1365. London, British Library, MS Cotton Tiberius B. VIII, fol. 68 v. (*British Library Board*).

11. *Charter with Charles V, Jeanne de Bourbon, and Their Children, and the Abbot Pierre and Monks of Royaumont*, 1374. Paris, Archives nationales, J. 465, no. 48 (*Archives nationales*).

early childhood. Charles's parents served as her godparents at her baptism, which took place at the same church as his. Indeed, before their marriage—a typical dynastic arrangement—could take place, it was necessary to secure a papal dispensation. Although three children were born to the couple between their marriage in 1350 and their coronation in 1364, none had survived. One sign of Charles V's loyalty to the queen was that he waited until 1368 before an heir to the throne was born.

Valuable as testimony of Jeanne de Bourbon's public life are the eyewitness reports of Christine de Pizan, the most famous female and feminist author of the Middle Ages. Christine grew up at Charles V's court and in 1404 wrote a biography of the late king. Stressing the elegance of the court, Christine speaks glowingly of the dignity and splendor of the queen and her attendants.[19] The inventories of the queen's possessions, including her own library of some twenty-three manuscripts, confirm that Jeanne de Bourbon lived in the regal style observed by Christine.[20] The lavish household of the queen formed part of Charles V's attempt to enhance the prestige of the monarchy, as well as to express his regard for Jeanne.

Visual records affirm the verbal evidence of the high esteem enjoyed by the queen. Among the most notable images of Jeanne de Bourbon is the statue dated about 1370 that shows her as donor of the Church of the Célestins, a pendant to the sculpture of Charles V [1 and 2]. Her homely and good-humored face, like that of her husband, is a landmark in the development of the naturalistic portrait. The presence of Jeanne on an equal basis with the king as donors of a newly founded church also accords with the responsibilities to the Church associated with the queen in the text of the *Coronation Book*.

A more specific public role was assigned to Jeanne de Bourbon in 1374, when she was appointed guardian of the royal children in the event of the king's death.[21] In belated fulfillment of the *Coronation Book* prayers, two boys and two girls had been born to the royal couple between 1368 and 1373. A drawing in a charter establishing an annual mass at Royaumont Abbey for Charles V and his family may well allude to Jeanne de Bourbon's official designation [11]. The queen

12

spreads her cloak protectively around her daughters in a gesture associated with the Madonna of Mercy. As a symbol of adoption, the spreading of the mantle originally had legal connotations. In an ingenious miniature illustrating the first copy of Aristotle's *Ethics* in French, commissioned by Charles V [12] and dated after 1372, the personification of Legal Justice in the top register shows another use in a secular context of the Madonna of Mercy pictorial formula.[22] Appropriately wearing a crown, the queen of virtues, Legal Justice, shelters her "daughter" virtues in the same manner as Jeanne de Bourbon in the Royaumont charter. A connecting link between these two images is the association of justice and mercy with the high moral standing of queenship. A second tie joins the moral virtue possessed both by Mary, Queen of Heaven, and the queen of France.

Allusions to Jeanne de Bourbon's official responsibility for her children's upbringing occur in two contemporary manuscript illuminations. In the frontispiece of the same copy of Aristotle's *Ethics* mentioned above, the queen apparently receives instructions from the king regarding their education [13].

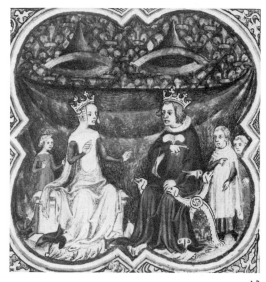

13

12. *Legal Justice and Other Virtues. Aristotle's Ethics in French,* after 1372. Brussels, Bibliothèque royale de Belgique, MS 9505–06, fol. 89 (*Copyright Bibliothèque royale Albert Ier*).

13. *Charles V and His Family. Aristotle's Ethics in French,* after 1372. Brussels, Bibliothèque royale de Belgique, MS 9505–06, fol. 2 v. (*Copyright Bibliothèque royale Albert Ier*).

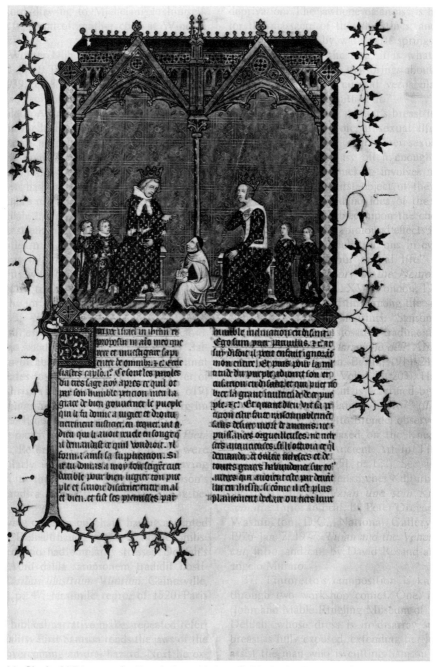

14. *Charles V Discusses the Translation with Jean Golein in the Presence of His Family.*
Rational des divins offices, 1374. Paris, Bibliothèque nationale, MS fr. 437, fol. 1
(*Bibliothèque nationale*).

This portion of the miniature refers to the importance of the education of the young, a recurrent theme of the *Ethics* and its companion volume, the *Politics*. Also pertinent is the frontispiece of the king's copy of Jean Golein's translation into French of the liturgical encyclopedia (*Order of the Divine Offices*), containing his *Treatise on the Consecration* dated 1374 [14]. In the presence of his family, Charles V commissions and discusses the work with Jean Golein. Jeanne de Bourbon's presence and gesture are prominent features of the right half of this large miniature. The motion of her hand in the direction of her daughters may well indicate the responsibilities entrusted to her as legal guardian of the royal children in Charles V's ordinance dated that year. Interestingly enough, as in the Royaumont charter—executed by the same master—the miniature of the Golein text links Jeanne de Bourbon more immediately with her daughters. The two boys, whose heraldic mantles identify their rank as heirs to the throne, remain either next to, or on the same side as, their father in these two images.

Jeanne de Bourbon's active participation in the public life of the monarchy receives emphasis in the portion of the official history dealing with the events of Charles V's reign, *Les grandes chroniques de France (Grand Chronicles of France)*. Written under the king's direction between 1375 and 1379 by someone in his own circle, this section of Charles V's copy of the manuscript is unusually rich in verbal and visual detail. Jeanne de Bourbon's featured role in the official social and ceremonial life of the reign is signaled by the attention given in the *Grand Chronicles* not only to her coronation but also to her separate *entrée* into Paris and the brilliant social events following them. This account also relates that in 1369 at the extraordinary session of the Parlement of Paris convened by Charles V to declare war against England, Jeanne de Bourbon sat at the king's right

hand. Her presence at this distinguished gathering was another sign of the high esteem she enjoyed.[23] Jeanne de Bourbon was also a focal point of a prominent incident during the climactic event of Charles V's reign: the visit of his uncle, the Holy Roman Emperor, Charles IV. The emphasis in the text on this state visit, which occurred at the end of 1377 and the beginning of 1378, is repeated in an elaborate cycle of illustrations unprecedented in earlier examples of the *Grand Chronicles*. The account of Charles IV's call on his niece, Jeanne de Bourbon, one of the fullest in this part of the manuscript, is accompanied by a miniature representing their meeting at the Hôtel Saint-Pol [15]. Also described is the long conversation the queen enjoyed with the emperor on the occasion of a second meeting,

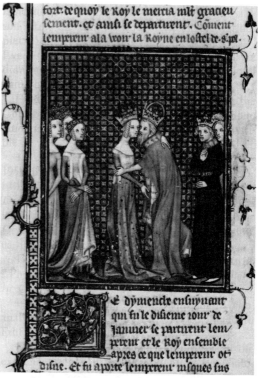

15. *The Meeting of the Emperor Charles IV and Jeanne de Bourbon. Les grandes chroniques de France*, 1375–79. Paris, Bibliothèque nationale MS fr. 2813, fol. 477 (*Bibliothèque nationale*).

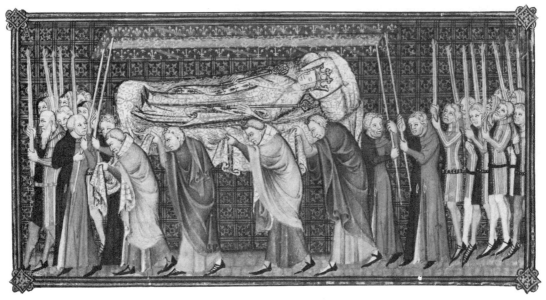

16. *The Funeral Procession of Jeanne de Bourbon. Les grandes chroniques de France,* 1375–79. Paris, Bibliothèque nationale MS fr. 2813, fol. 480 v. (*Bibliothèque nationale*).

during which she bestowed her own personal gift on Charles IV.

When, shortly after the emperor's visit, the queen died on February 6, 1378, from the effects of childbirth, the *Grand Chronicles* devoted four chapters to the elaborate funeral rites held for her. This lengthy narrative received further emphasis by an unusually large miniature depicting the funeral procession [16]. The miniature reinforces this expression both of the king's use of ceremonial for political purposes and his affection for the queen. A passage from the usually impersonal text states: "The said queen departed this world at the afore-mentioned Hôtel Saint-Pol, whose death greatly disturbed the king for a long time, as well as many other good people, for they loved one another as much as loyal spouses can."[24] In an eloquent passage from her biography of Charles V, Christine de Pizan sums up the relationship between the royal couple: "He was often in her company, and always with joyful face and pleasing

words, and she for her part, in bringing him the honor and reverence which pertained to his excellence, did similarly. And so the king in all respects kept her in sufficiency, love, unity, and peace."[25]

Early in his reign, Charles V had provided for the erection of a double tomb in the royal necropolis of Saint-Denis with effigies of the queen and himself united in one monument. Commissioned in 1365 from the well-known sculptor André Beauneveu, this monument was destroyed during the French Revolution except for the effigy of Charles V. A seventeenth-century drawing, however, reveals the elaborate nature of the tomb [17]. The placement of the figure of the queen next to that of the king offers further evidence of the high social status that Jeanne de Bourbon and other French queens enjoyed. The sculpture from a tomb for Jeanne de Bourbon's entrails, originally from the Church of the Célestins, now lies next to the Beauneveu sculpture in Saint-Denis [18].[26] Like other representations

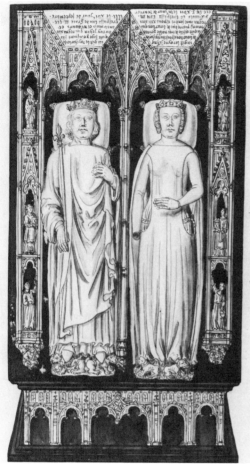

17

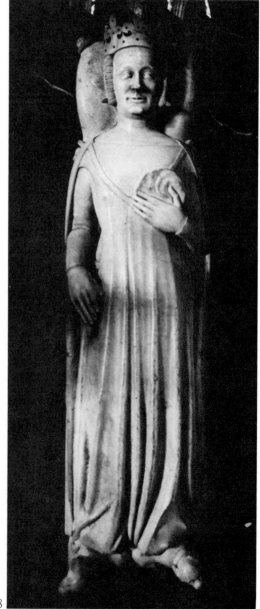

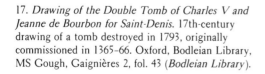

17. *Drawing of the Double Tomb of Charles V and Jeanne de Bourbon for Saint-Denis.* 17th-century drawing of a tomb destroyed in 1793, originally commissioned in 1365–66. Oxford, Bodleian Library, MS Gough, Gaignières 2, fol. 43 (*Bodleian Library*).

18. Sculpture from the tomb for Jeanne de Bourbon's entrails from the Church of the Célestins, after 1378. Paris, Saint-Denis (*Archives photographiques*).

18

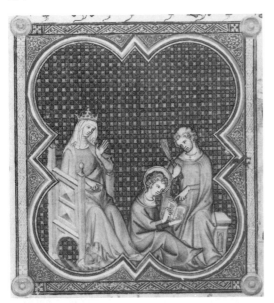

19. *Blanche de Castille Supervising the Education of Saint-Louis. Heures de Jeanne de Navarre,* after 1336. Paris, Bibliothèque nationale, MS N. a. latin 3145, fol. 85 v. (*Bibliothèque nationale*).

of Jeanne de Bourbon [2, 11, and 14], the tomb image of the queen does not idealize her plain features. Indeed, the attempt to represent her face in a naturalistic manner is another manifestation of her high standing. At this time individual portraits were limited to a very few who stood at the apex of the social pyramid.

This account of the cycle representing Jeanne de Bourbon in the *Coronation Book* and other examples of her iconography is intended to encourage further examination of the visual and verbal evidence regarding medieval French queens. An analysis of text-image relationships in manuscripts and the historical traditions underlying verbal and visual evidence can yield fresh insights about French queens based on criteria not limited to the direct exercise of political power. For example, Queen Blanche de Castille (1187–1252), mother of a future saint, King Louis IX (b. 1215; ruled 1226–70), could not rule in her own right after her husband's death. Yet as

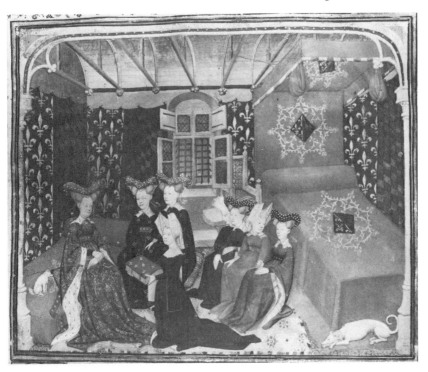

20. *Isabeau de Bavière Receiving the Book from the Author. Collected Writings of Christine de Pizan,* after 1410. London, British Library, MS Harley 4431, fol. 3 (*British Library Board*).

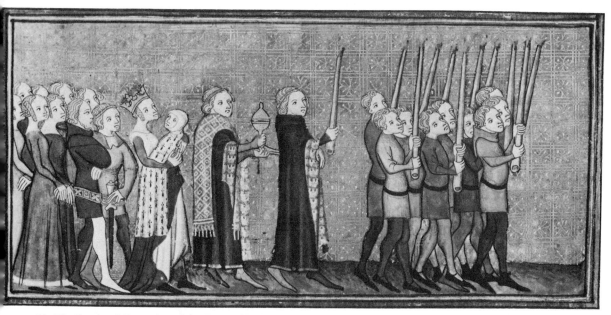

21. *The Baptismal Procession of the Future Charles VI of France. Les grandes chroniques de France,* 1375–79. Paris, Bibliothèque nationale, MS fr. 2813, fol. 466 v. (*Bibliothèque nationale*).

regent for her son at different times of his life, she had great political power. At the same time, her personal influence over Louis IX was profound and lasting. An image of Blanche de Castille supervising her son's education [19] typifies the moral and spiritual influence that French queens could bring to bear. They could look to a feminine model of the highest order in carrying out their moral and religious duties.[27] The Virgin Mary, who wore the crown of Queen of Heaven, was associated with mercy, wisdom, and concern for the poor, as was the queen of France in the coronation liturgy.[28]

The role of French queens as founders of religious and civic institutions that reflected their moral obligations deserves systematic study. Their patronage of art and literature also needs to be examined in order to determine what particular cultural traditions they fostered. An interesting example of a queen who commissioned works from a woman writer occurs in a miniature dated after 1410 showing Isabeau de Bavière (1371–1435), wife of King Charles VI (b. 1368; ruled 1380–1422), receiving the author's collected writings from Christine de Pizan in a highly unusual all-female court setting [20]. An earlier important patron of art was the dowager queen Jeanne d'Evreux (d. 1371), whose political influence continued long after the death in 1328 of her husband, the last Capetian king, Charles IV. She and her niece, another dowager queen, Blanche de Navarre (1331–1398), actively engaged in diplomatic efforts to bring peace between their close relatives, Charles the Bad, king of Navarre, and the future Charles V of France.[29] In 1368, Queen Jeanne d'Evreux was given the honor of carrying the heir so eagerly awaited by Charles V and Jeanne de Bourbon in the future Charles VI's baptismal procession [21]. These few examples illustrating the activities of late medieval French queens suggest that iconographic evidence, studied together with contemporary historical sources, can lead to a reevaluation of the important cultural contributions of this influential group of women.

NOTES

1. *The Portraits of Charles V of France (1338–1380),* Monographs on Archaeology and the Fine Arts Sponsored by the Archaeological Institute of America and the College Art Association of America, 20, New York, 1969. See also my "Representations of Charles V of France (1338–1380) as a Wise Ruler," *Medievalia et Humanistica,* n.s. 2 (1971), pp. 83–96.

2. For a full discussion of these questions, see my study—the basis of the present essay—"The Queen in Charles V's *Coronation Book:* Jeanne de Bourbon and the *Ordo ad reginam benedicendam,*" *Viator: Medieval and Renaissance Studies,* 8 (1977), pp. 255–97.

3. For the literature in French and German, see *ibid.,* ns. 1–3.

4. The facsimile publication is *The Coronation Book of Charles V of France* (Cottonian MS Tiberius B. VIII), Henry Bradshaw Society 16, ed. E. S. Dewick, London, 1899. The manuscript will be referred to as the *Coronation Book.* For my first discussion of the images in the manuscript, see Sherman, *Portraits,* pp. 34–37.

5. M. F. Facinger, "A Study of Medieval Queenship: Capetian France, 987–1237," *Studies in Medieval and Renaissance History,* 5 (1968), p. 4.

6. For a brief discussion of and literature about this controversy, see Sherman, "The Queen," p. 258 and n. 9.

7. For a discussion of the background of codicology, see A. Gruijs, "Codicology or the Archaeology of the Book? A False Dilemma," *Quaerendo,* 2 (1972), pp. 87–108.

8. For an account of the French coronation ceremony, and Charles V's in particular, see the popular history of A. Denieul-Cormier, *Wise and Foolish Kings: The First House of Valois, 1328–1498,* Garden City, N.Y., 1980, pp. 108–24.

9. For a recent discussion of the controversial provenance of these figures, see H. W. Janson, "Postures of Prayer—A Problem of Late Medieval Etiquette," *Jahrbuch der Hamburger Kunstsammlungen,* 17 (1972), pp. 13–22. Two other portraits

of comparable quality are the drawings on silk of the king and queen on the altar hanging in the Louvre known as the *Parement de Narbonne.* See Sherman, *Portraits,* pp. 50–51, pls. 42–44.

10. For a list of these orders, see Sherman, "The Queen," no. 7.

11. A. Katzenellenbogen, *The Sculptural Programs of Chartres Cathedral,* Baltimore, 1959, pp. 28–32.

12. Dewick, *Coronation Book,* fol. 67, col. 45. I have translated the passages from the Latin text.

13. E. H. Kantorowicz, "The Carolingian King in the *Bible of San Paolo fuori le mura,*" in *Selected Studies,* ed. R. E. Giesey and M. Cherniavsky, Locust Valley, N.Y., 1965, pp. 87–88.

14. "The *Traité du sacre* of Jean Golein," ed. R. A. Jackson, *Proceedings of the American Philosophical Society,* 113.4 (1969), p. 319. The translation is mine. The *Treatise* was inserted in Golein's French version of a Latin liturgical encyclopedia, *Rational des divins offices (Order of the Divine Offices).* I also quote excerpts from Golein's *Treatise* that appear in a translation by A. Goodman in M. Bloch, *The Royal Touch: Sacred Monarchy and Scrofula in England and France,* trans. by J. E. Anderson, London, 1973, pp. 275–82.

15. The classic discussion of this theme is found in Bloch, *The Royal Touch.* For the anointing of the queen, see F. Oppenheimer, *The Legend of the Ste. Ampoule,* London, 1953, Chs. 22–23.

16. Bloch, *Royal Touch,* p. 281.

17. Dewick, *Coronation Book,* fol. 69, col. 47.

18. *Ibid.,* fols. 69 v.–70, col. 48.

19. Christine de Pizan, *Le livre des fais et bonnes meurs du sage roy Charles V,* ed. S. Solente, 2 vols., Paris, 1936–40, Vol. I, pp. 53–57. For translations of relevant passages from this biography entitled in English *Deeds and Good Customs of King Charles V,* see Denieul-Cormier, *Wise and Foolish Kings,* pp. 136–37. For a narrative account of the queen's life and times, see "Reign of Charles V and Jeanne de Bourbon," in a romantic and popular history by C. Bearne, *Pictures of the*

Old French Court, New York, 1900, pp. 1–105.

20. Sherman, "The Queen," p. 290 and ns. 122–23.

21. For further details, see *ibid.,* p. 288 and n. 116.

22. For an interpretation of this miniature, see my article "Some Visual Definitions in the Illustrations of Aristotle's *Nicomachean Ethics* and *Politics* in the French Translations of Nicole Oresme," *The Art Bulletin,* 59 (1977), pp. 324–26.

23. For further documentation of this event, see Sherman "The Queen," ns. 114–15.

24. R. Delachenal, ed., *Les grandes chroniques de France: Chronique des règnes de Jean II et de Charles V,* 4 vols, Paris, 1910–20, Vol. 2, p. 278. The translation is mine.

25. The translation of this passage of Christine's biography comes from Denieul-Cormier, *Wise and Foolish Kings,* p. 137.

26. For the history of these monuments, see Sherman, *Portraits,* pp. 65–71. For additional images of Jeanne de Bourbon not mentioned here, see *ibid.,* p. 59 and pls. 21 and 29. See also Sherman, "The Queen," p. 291 and n. 128, and figs. 5, 7, 9, and 13.

27. For this analogy, see M. Warner, *Alone of All Her Sex: The Myth and the Cult of the Virgin Mary,* New York, 1976, p. 104.

28. In Golein's *Treatise on the Consecration,* the queen is twice identified with Mary. When the queen prays to the Virgin, she refers to Mary as one who was "anointed sovereign queen by the mystery of the Holy Spirit" (Jackson, ed., p. 318). Also, Golein claims the queen symbolically represents the Virgin during the offertory portion of the coronation ceremony—*ibid.,* p. 320.

29. C. Bearne's popular history, *Lives and Times of the Early Valois Queens,* London, 1899, devotes seven chapters to Blanche de Navarre and events that occurred during her lifetime. For the diplomatic activities of Blanche and her aunt Queen Jeanne d'Evreux, see *ibid.,* pp. 190–98 and 231–38.

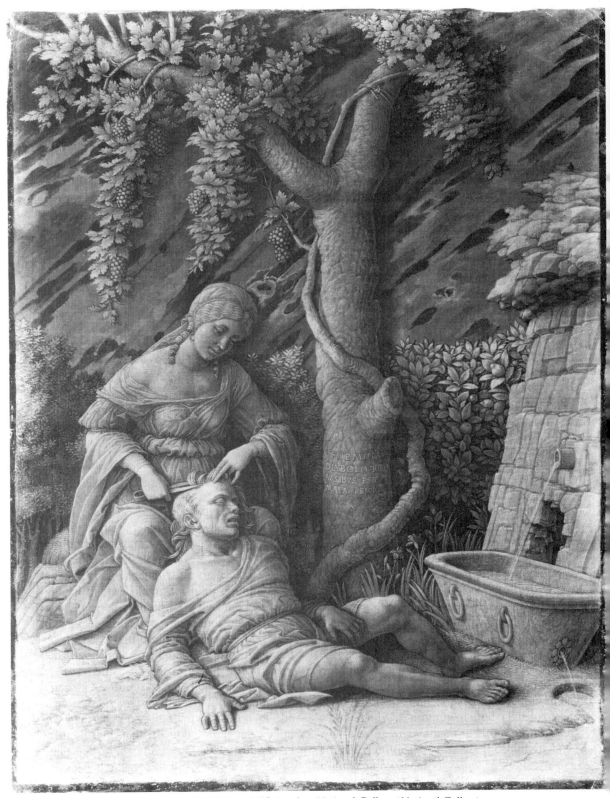

1. Andrea Mantegna, *Samson and Delilah,* ca. 1495. London, National Gallery (*National Gallery*).

7
Delilah

———◦†◦†◦———

MADLYN MILLNER KAHR

I will put enmities between thee and the woman
Genesis 3:15

Art historians sometimes find it useful to focus on the sphere of art as a world apart, thus tending to obscure the fact that art is nourished by the whole rich flow of human life. Art responds to cultural and individual determinants, and it serves social and psychological purposes. Alongside overt subject matter, it contains elements that were not consciously determined but reflect psychic forces of which the artist was unaware. Some of the emotional expressions rouse resonance in the audience of the artist's own time, and some stir other generations as well. If we look at the numerous representations of Delilah in works of widely diverse origins as part of this vital human enterprise, we can discern some features that are relatively invariable, some that can be associated with their specific time, place, and school of art, and some that appear to pertain to a particular artist. A comprehensive interpretation of any one of these pictures must attempt to take into ac-

count the deep inner drives that are vented, along with the cultural and formal constituents.

Samson loved Delilah, she betrayed him, and what is worse, she did it for money. That is virtually all the Bible tells us about Delilah (Judges 13: 16). It is enough to have made her name a byword for deadly female allure and to have brought her widespread attention in art and literature. About Samson we are told a good deal more. His actions reveal him as gullible, impulsive, brutal, and vengeful, as well as superhuman in strength. His exploits were directed against the Philistines, to whom his people were subject, but his behavior was not calculated to free the Jews. He was generally motivated by his lusty appetites and his determination to avenge himself for personal injuries, rather than by any larger purposes. How did figures so flawed in character and intellect—so repulsive by civilized standards—come to be a favored subject through six centuries of Western art?

Samson's claim to respect rested first of all on his extraordinary beginnings. An angel of God announced to the barren wife of Mano-

Madlyn Kahr, "Delilah," *The Art Bulletin*, 54, September 1972, pp. 282–299; with revisions by the author. By permission of the author and the College Art Association of America.

ah that she would conceive and bear a son "who shall be a Nazarite unto God from the womb to the day of his death"; "and he shall begin to deliver Israel out of the hand of the Philistines." That son, Samson, was thus consecrated to God from his conception. Linked to his special, divinely ordained role were certain prohibitions; he was forbidden to cut his hair and to drink wine or strong drink.[1] Both Jews and Christians accepted Samson as an instrument of the divine will, even though this was not easy to read into the story of his apparently unprincipled behavior. Philip Melanchthon, for instance, reports that he asked Martin Luther what the difference was between Samson and Caesar or some other man who was strong in body and mind. To this Luther replied: "The spirit of Samson was the Holy Spirit, who makes holy and who produces actions which are obedient to God and serve him." "I often wonder about the example of Samson," Melanchthon continues. "There must have been a strong forgiveness of sins in his case. Human strength could not do what he did."[2]

The earliest representations in art of the story of Samson were illustrations of the Old Testament narrative that were intended simply to make the sacred history clear and interesting. The eventful tale of Samson's exploits and his tragic fate provided ample material for visual presentation. The same episodes were repeated again and again in illuminations and later in prints. By the middle of the thirteenth century, the use of pictures as a kind of visual gloss to support typological interpretations had begun to supplant the purely narrative illustrations, as can be seen in the upper right segment of Figure 2, in which the gates of Gaza are crossed on Samson's shoulder as a clear reference to Christ Bearing the Cross.[3] From the beginning of the fourteenth century, with the *Biblia Pauperum*, which gave wide currency to typological meanings, the events of Samson's life were generally un-

derstood as parallels to the life of Christ. The annunciation by an angel that Manoah's wife was to conceive and bear a son moved by the Spirit of the Lord was recognized as a foretelling of the Annunciation to the Virgin Mary. Samson's Herculean feat of rending the jaws of a raging lion was equated with Christ's victory over Satan. In this exploit Samson is also represented as a personification of the cardinal virtue *Fortitudo,* just as Hercules is.[4] On the level of the narrative itself, and from the point of view of conventional ethics, this is the episode in Samson's life that shows him at his most admirable, an impressive example of courage and determination. The motif of the strong man overcoming the king of the beasts, so rich in references, is at the same time easy to depict clearly, which no doubt fostered its widespread use in art.

Most of Samson's story, however, demonstrates human weakness more than spiritual strength. His marriage to a Philistine woman ended before the seven-day wedding feast was over, when by weeping and wheedling she extracted from him a secret that her kinsmen promptly used against him. To this Samson reacted with his usual vengefulness, burning the crops of the Philistines. When the Philistines retaliated by burning to death Samson's wife and her father, Samson slaughtered great numbers of them. As was the case when he rent the roaring lion, "the Spirit of the Lord" came upon him to give him the strength for each of his successive deeds of violence, thus implying that a higher purpose was served by these savage acts, even though the biblical narrative always describes Samson's motives in personal terms.[5] In time Samson victorious over the Philistines became a symbol of patriotic valor.[6]

Again Samson's life was endangered by his indulgence of his sexual drives when he visited a harlot in Gaza. The men of Gaza lay in wait to kill him at the gates of the city, but Samson foiled this ambush by lifting the

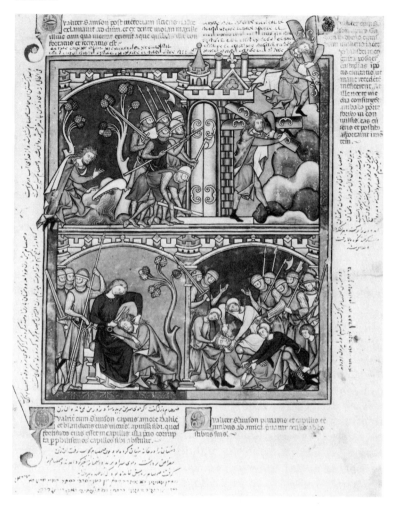

2. *The Story of Samson,* ca. 1250. New York, Pierpont Morgan Library, MS 638, fol. 15 (*Pierpont Morgan Library*).

gates and carrying them off. This episode, too, had its typological interpretations. In some instances, as in Figure 2, it was associated with the Bearing of the Cross, in others with the Resurrection, as Samson escaping from Gaza was related—inappropriate as it may seem—to Christ emerging from the tomb.

Next Samson fell in love with the Philistine woman Delilah; even this unwholesome situation had its typologic use, as referring to Christ's love for the Church. Delilah, thanks to her own persistence and Samson's cooperation, succeeded in destroying him. Bribed by the Philistine leaders, Delilah begged Samson to reveal to her the source of his strength. Three times he gave false replies, so that though she bound him, he was able to break his bonds each time and escape from the Philistines who were on hand to take him prisoner. The fourth time, despite this clear and repeated evidence of Delilah's malevolent intentions, he gave in to her entreaties. When she demanded the truth as proof of his love for her, Samson revealed to her that he would become weak if his hair were cut. Delilah informed the Philistines, who gave her the money they had promised. "And she

made him sleep upon her knees; and she called for a man, and she caused him to shave off the seven locks of his head;[7] and she began to afflict him, and his strength went from him.... And he wist not that the Lord was departed from him. But the Philistines took him and put out his eyes."[8] Nor was this the end of Samson's tragedy. The blind, captive Samson was humiliated by being forced to grind at the mill, an extreme insult because this was woman's work (typologically equated with the Derision of Christ).[9] Ultimately, as his strength returned with the growth of his hair, he died along with thousands of Philistines when he pulled down their temple.[10] Even in his final act of brave defiance, he was concerned only with vengeance for the loss of his eyes and not with any nobler goal. Yet typologic interpretations adapted these events to a didactic purpose. In the nielli in the floor of Jan van Eyck's *Annunciation in a Church* (Washington, National Gallery of Art), for instance, Samson Slaying the Philistines prefigures the triumph of Christ over sin, Samson and Delilah prefigure the Entombment, and the Death of Samson prefigures the Crucifixion.[11]

"That he let himself be ensnared by a woman must be imputed to human nature, which succumbs to sins," according to Josephus.[12] Today we would find psychological plausibility in the fate of Samson by recognizing, behind his active participation in his own downfall, not sin, but a sense of sin. Throughout his story runs the threat of punishment for his sexual drives. It is only through his own acquiescence that the punishment can take place. Milton has Samson say to Delilah: "I to myself was false e're thou to me." Samson refuses to learn from his experiences because, as Josephus says, "he must needs fall a victim to calamity." Like Oedipus, like Othello, Samson is a tragic hero who must fulfill his destiny, of which his own downfall is the climax. That is to say, in psychological terms, his feeling of guilt leads to a self-destructive urge.[13]

The story of Samson accords very well, of course, with Christian attitudes toward sensual pleasures. If, as St. Paul said, "It is good for a man not to touch a woman" (I Cor. 7:1), a story like Samson's can serve a useful didactic purpose.[14] Awareness that woman is dangerous may help to reinforce the avoidance of sin. Besides, men can more readily accept the notion of woman's duplicity than face their own guilty wishes.[15] As Samuel Beckett has been quoted as saying, "Self-perception is the most frightening of all human observations."[16]

Some Renaissance artists made it clear, through inscriptions and literary allusions, that they consciously intended the scene of Samson betrayed by Delilah to be a warning against women. Other meanings hidden behind this one emerge on closer scrutiny.

Next to St. Paul, Petrarch was the most effective propagandist against women in Christendom. A long series of illustrated manuscripts and, later, printed books spread his biases throughout western Europe for centuries. Since Petrarch was one of history's most publicly unfulfilled lovers, his ambivalence toward women set an influential pattern for representations in both literature and the visual arts. His *Trionfi* are particularly suitable for use in art because they are conceived as visual experiences. The poet *sees* the processions he describes. In the *Triumph of Love* he sees the triumphal chariot of Cupid accompanied by throngs of victims of love, some of whom he names. This poem provided the subject matter for works of art in various media, including a number of painted *deschi da parto*. For a Florentine mid-quattrocento *desco* [3], the painter—or perhaps the person who commissioned it—selected for special emphasis two among the many examples cited by Petrarch of those who suffered for love: Aristotle humiliated by Phyllis (sometimes called Campaspe) and Samson be-

3. *The Triumph of Love,*
Florentine *desco da parto,*
mid-15th century. London,
Victoria and Albert Museum,
on loan from the National
Gallery (*National Gallery*).

trayed by Delilah.[17] The triumph of love, it is clear, means the degradation of even the wisest of men, Aristotle, and the ruin of even the strongest of men, Samson. Samson's nude loins are girded by vine leaves, a reference to drunkenness as a condition of his downfall. As a Nazarite Samson was forbidden all wine and strong drink. The Bible does not indicate in any way that he failed to respect this prohibition, but Josephus says he did. As we shall see, artists have included various references to wine in the scene of Samson's haircut. This may reflect the traditional association of wine with the vice *Luxuria* (Licentiousness), which the story of Samson and Delilah exemplifies. Wine may also convey a more positive hortatory message, for the fruit of the vine symbolizes the life-giving doctrine of Christ.

Surely it was with conscious irony that the subject of woman's inhumanity to man was chosen to decorate this gift to a woman on the occasion of the birth of her child. It seems to have been a standard subject for *deschi da parto.* Another tray, slightly later than this one, shows the same subject matter (but without Samson's vine-leaf girdle), along with two additional examples of men humiliated by women: Hercules spinning while Omphale

brandishes his club, and Virgil suspended in a basket by the emperor's daughter.[18] These were among the tricks of women often included in the *Weibermacht* cycles that were popular in Northern prints.[19] The first bad example in these series was usually Eve, the first mother, whose offer of the apple (equated with the breast) led to the Fall of Man.[20] Her counterpart was Mary, the New Eve, who represents restitution by the Good Mother. One of the earliest images of the Virgin—and one which was widely represented in medieval art and continued to be painted even as late as the seventeenth century—depicted her as a nursing mother. The deep significance of the nourishment that the Good Mother provides for her child is underlined in pictures of the Day of Judgment in which Mary is shown displaying her breast as a reminder to Christ as she intercedes with him for mercy for mankind.

The relationship of motherhood to the power of women for good or evil is weighted on the cautionary side in the Petrarchan and *Weibermacht* representations. The intent of individual works of art is not always so obvious. For example, the prominent German engraver known as the Master E.S. produced a print around 1460 that at first glance might

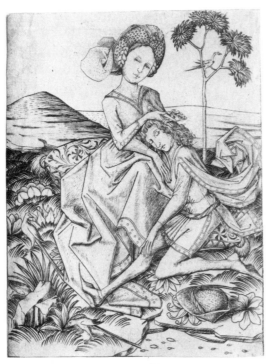

4. Master E. S., *Samson and Delilah*, engraving, ca. 1460. New York, The Metropolitan Museum of Art, Harris Brisbane Dick Fund, 1922 (*Metropolitan Museum of Art*).

seem to belong to the genre of Late Gothic scenes of courtly love (Lehrs 6) [4].[21] A young man sleeps with his head on the knees of a fashionable lady who sits on a cushion in a meadow under a highly decorative tree. Birds and plants add to the charm of their situation. The fact that the lady is cutting her companion's hair would hardly appear alarming—if we did not know the story of Samson and Delilah. In the light of this story, however, we interpret the scene as a representation of Delilah's betrayal of Samson, solely on the basis of the scissors in the lady's right hand. Having come this far, we recognize that the disparity in scale between the two figures—not usual in the work of Master E.S.—is also meaningful. The woman is large and firmly in command of events, while her male companion is physically far from the image of the

superman Samson. Indeed, he is so frail and relatively small that he might be a child napping on his mother's knee. Once again there have crept in, beneath the surface of the traditional narrative, intimations of psychological determinants that help to explain both the form of the image and its deep appeal.

Familiarity with the story of Samson and Delilah must be assumed for many generatons, on the evidence of pictures, sculpture, and literature that made use of this subject matter. In the book of *Der Ritter vom Turn von den Exempeln der Gottsforcht und Erberkeit,* which was published in Basel in 1493 by Michael Furter, Delilah's betrayal of Samson provided one example among a series written more than a century earlier by Geoffroy de la Tour Landry for the moral instruction of his daughters. The text points out the parallel between Delilah's mercenary treachery and Judas's betrayal of Christ. The young Dürer designed the woodcut to illustrate this story [5], which shows Delilah herself cutting Samson's hair, as did the earlier examples we have considered. According to the Bible, "she called for a man" to cut his hair, while Jose-

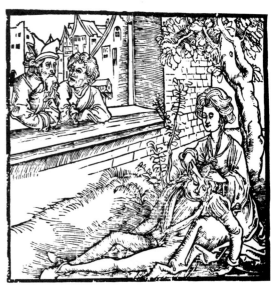

5. Albrecht Dürer, *Samson and Delilah*, woodcut for *Der Ritter vom Turn*, Basel, 1493.

phus says "she reft him of his locks." Representations in which Delilah is shown wielding the scissors may reflect Josephus's version, or they may merely resort to a convenient, though uncanonical, simplification. However this may be, the effect of the image of Delilah personally depriving the man of the source of his strength is vivid exposure of the woman's culpability.

The fool who could not keep a secret, in Sebastian Brant's *Narrenschyff,* is, appropriately enough, Samson. The woodcut in the first edition [6], published in Basel in 1494 by Johann Bergmann von Olpe, closely followed Dürer's woodcut for the *Ritter vom Turn.* It was repeated through many editions of this immensely influential book. In the edition published in Amsterdam in 1635, the basic motif remains the same, but a wine jug and a glass are placed beside the couple.

Mantegna's small monochrome painting [1], a feigned marble relief, generally accepted as a late work, ca. 1495, shows striking similarities to the woodcut that was published in the *Ritter vom Turn* in 1493. Dürer had not yet been in Italy at this time, and it is highly unlikely that he would have been familiar with Mantegna's composition. It is not at all unlikely, on the other hand, that Mantegna may have seen and been impressed by the handsomely illustrated book. Would a mature Italian master deign to borrow from a young—and Northern—artist? This is certainly not out of the question, and it seems the most plausible explanation for a similitude too detailed to be accounted for by coincidence, unless a common model, which I have been unable to discover, should be found. Not only is the motif of the two figures remarkably close, including such details as Delilah's gesture and her wide sleeves, but in the painting, as in the woodcut, they are seated outdoors, under a tree beside a wall.

In the Mantegna, however, the tree is dead, and it supports a vine heavy-laden with grapes, and water flows from the wall into an

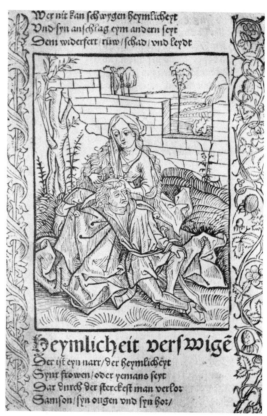

6. *Heymlicheit verswigen,* woodcut for Sebastian Brandt's *Narrenschyff,* Basel, 1494.

antique basin and thence onto the ground. Professor Julius S. Held suggests that, since all these elements must have meaning in the context of the scene, the vine that twines around the tree may symbolize the lethal woman, while the amputated limb of the tree may relate to the symbolic castration that Samson is undergoing at the hands of Delilah.[22] It seems to me that Held has correctly perceived the bearing of these details on the central emotional theme of Mantegna's conception. The grapes, which may be a female symbol with allusion to the breast, imply that Samson drank before falling into a sleep so profound that Delilah could cut his hair without disturbing him. At the same time, the grapes and the fountain were traditional symbols of the Fountain of Living Waters and

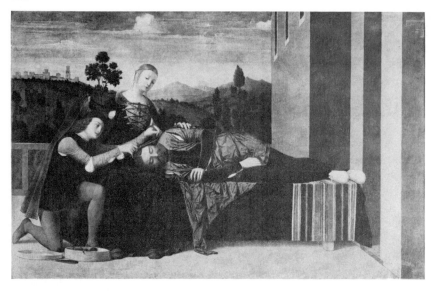

7. Francesco Morone,
Samson and Delilah,
early 16th century.
Milan, Poldi-Pezzoli
Museum (*Alinari*).

the Mystic Wine Press, and thus referred to the Passion of Christ, as did the iris and the lemon trees visible at the right of the tree trunk.[23] The pose of Samson reflects that of an antique river god, and the fact that he is seated on the ground, beside a stream, emphasizes this identification. The vice *Luxuria* is often represented by a pair of lovers,[24] and the motif of a couple beside a fountain, frequently found in medieval art, connotes the dangers of concupiscence.[25] The tragedy of Samson was a well-known instance of the evil of unbridled sexual appetites.

Along with intimations of danger and death, Mantegna provided promise of rebirth and salvation, for the vine that clings to the dead tree flourishes and bears abundant fruit. "The difference between good and evil has, for ages past, been illustrated by the parable of two contrasted trees... sometimes by a withered and a fruitful tree."[26] The dead tree may refer to the Synagogue, the living vine to the Church. And Samson himself, it must not be forgotten, typifies the Redeemer.

In this richly symbolistic composition, however, it is the inscription on the tree trunk that makes the intended message perfectly clear: "Foemina diabolo tribus assibus est mala peior" ("A bad woman is three times worse than the Devil"). As Erica Tietze-Conrat pointed out, "the idea and even the wording of this inscription occur repeatedly in medieval proverbs and fairy tales."[27] The duplicity of Delilah is used to illustrate a warning against bad women in general.

In the following generation there appeared another Italian version of Samson and Delilah that exceeded Mantegna's in both idyllic atmosphere and classical stability.[28] This is the panel by Francesco Morone of Verona [7], in which the setting is a terrace at the entrance to a building, with the figures, in their dignified costumes, seen against a serene landscape. Samson lies asleep on his side on a bench parallel with the picture plane, with his head in Delilah's lap. Kneeling at her other side is a Philistine engaged in cutting Samson's hair, which he collects in a round box at his feet. Delilah looks on calmly, while she impartially shelters the Philistine under her cloak with her right hand and embraces Samson with her left. As in the Mantegna, Delilah's expression is calm, benevolent, even tender.

It was mainly in Germany and the Netherlands that representations of Delilah outwit-

ting Samson appeared in the sixteenth century. The great Dutch graphic artist Lucas van Leyden, for instance, depicted this subject three times, to our knowledge. The earliest representation is the engraving dating from about 1508 [8]. Lucas's interpretation introduces several significant novelties. Samson wears armor but has laid his shield and halberd on the ground beside him; this stresses his defenselessness as he sleeps in Delilah's lap. His feet are bare; he has no hope for flight, any more than for self-defense. As in the previous examples, the action takes place in a landscape setting, with trees and a rocky outcropping. But into this scene are now introduced fully armed soldiers who lurk in the background, ready to spring forward at Delilah's signal that she has cut Samson's hair. Within the next decade Lucas made two woodcuts of this subject, both of which show in the background a throng of soldiers guarding the bound and captive Samson, which is the situation that follows after that depicted in the central scene. This adherence to the medieval mode of depicting simultaneously events that in the narrative take place successively continued even into the seventeenth century in the Netherlands in prints and occasionally in paintings as well.

In Lucas van Leyden's woodcut of about 1517–18 [9], Samson's weapon is not a halberd but a spiked war-club, perhaps intended as an allusion to a more primitive time, or perhaps a reference to the club of Hercules. The simi-

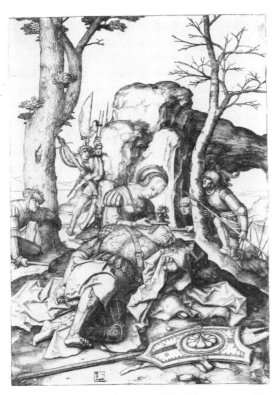

8. Lucas van Leyden, *Samson and Delilah*, engraving (B. 25), ca. 1508. New York, The Metropolitan Museum of Art, Harris Brisbane Dick Fund, 1924 (*Metropolitan Museum of Art*).

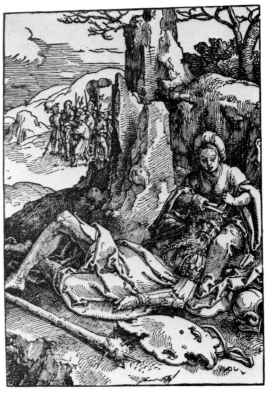

9. Lucas van Leyden, *Samson and Delilah*, woodcut (B. 5), ca. 1517–18. New York, The Metropolitan Museum of Art, Harris Brisbane Dick Fund, 1925 (*Metropolitan Museum of Art*).

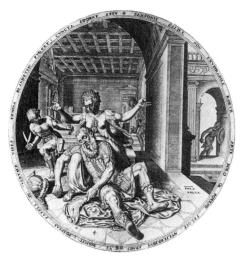

10. After Maerten van Heemskerck, *Samson and Delilah,* engraving. Leiden, Rijksuniversiteit, Prentenkabinet (*Prentenkabinet*).

larities between this design and the Mantegna painting ([1], Delilah's pose and costume, especially the wide flowing sleeves; Samson's position, with his head resting between Delilah's knees, his farther knee bent, his near forearm flat on the ground) suggest, if not a direct relationship, a common ancestor. But Lucas has endowed the situation with a military aspect utterly lacking in the conception of Mantegna, whose Samson and Delilah in *déshabillé* bring the sensual elements of the story to the fore. The confrontation as Lucas portrays it is no longer solely that between a man and a woman, but between a man and his enemies. It would be a mistake to conclude from this, however, that the perniciousness of woman was not the main idea behind these prints, for both of the woodcuts belonged to *Weibermacht* series.[29]

Maerten van Heemskerck included Delilah's betrayal of Samson in a series of drawings of famous women of the Old Testament.[30] They were engraved by Philippe Galle, with each tondo bordered by an inscription. The scene depicting the moment after Samson's hair has been cut, as the soldiers rush forward to take him prisoner [10],

stresses verbally the feminine wiles and trickery that brought about his ruin: "Samsonis Dalile non exupirabile robur arte doloque potens fregit. Muliebribus armis ut didicit positas fatali in vertice vires, faemina blanditiis pugnat cuncta edomat astu."[31]

Heemskerck also drew a series illustrating the whole story of Samson (as he did of many other biblical stories). The sleeping Samson and, to a lesser degree, the Delilah of the hair-cutting scene of this series [11] are similar in pose to those in Mantegna's painting [1].[32] This engraving dated 155(1?), published by Hieronymus Cock, also carries its own explanation in the form of an inscription: "Dalila detonsis Sampsoni capillis, accepta pecunia, tradit Philistinis,"[33] which emphasizes the fact that Delilah betrayed Samson for money, doubtless a more vile act than those of other Old Testament man-killing females, who were motivated by principle. In the background is the scene of Samson dying in the wreckage of the temple of Dagon, while the feigned reliefs on the wall at the right show two of Samson's earlier exploits: massacring Philistines with the jawbone of an ass and, below, overcoming the lion.

In another series illustrating the story of Samson, (engraved by Philippe Galle, published first by H. Cock and later by Theodor Galle), Heemskerck depicted Samson and Delilah once again [12], showing Samson with his right arm flung over Delilah's thigh in a pose that originated with Dürer's Samson. Unlike Dürer, however, Heemskerck explicitly accents both the erotic components and the sense of peril to a degree not seen earlier, though they were always implicit in the story. The threatening presence of the Philistine soldiers, included by some medieval artists as well as by Lucas van Leyden, stresses the terrible fate in store for Samson. Setting the action in the vicinity of a bed, and showing Samson disrobed and suggestively close to a carafe and glass, Heemskerck makes clear the part that drunkenness and lust play in the

11. After Maerten van Heemskerck, *Samson and Delilah,* engraving, 155(1?). Leiden, Rijksuniversiteit, Prentenkabinet (*Prentenkabinet*).

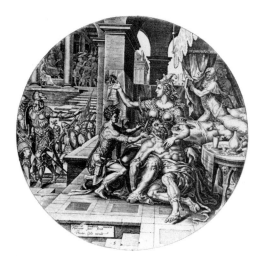

12. After Maerten van Heemskerck, *Samson and Delilah,* engraving. Leiden, Rijksuniversiteit, Prentenkabinet (*Prentenkabinet*).

tragedy. While a soldier does the actual cutting, Delilah triumphantly brandishes a lock of Samson's hair as a trophy of her victory. In all his versions of the scene, Heemskerck devised costumes for Delilah that emphasized her breasts. In this one he managed to expose and frame the breasts in a fantasy-costume of extreme originality, in keeping with the Mannerist taste for erotic themes. This selective nudity also suggests the oral aspect of the relationship between Samson and Delilah, only one of the many oral references in Samson's strange story.[34] Again a second episode is included in the background, this time the blinding of Samson.

Thus Heemskerck revealed, in the guise of illustrations of the familiar biblical story, some of the latent concerns that sparked the interest of artists in this story and aroused a response in observers of their pictures. The attachment to the mother and the fear of

punishment for the strivings it stimulates, which are ordinarily excluded from consciousness, are acceptable in this disguised form.[35] As Oedipus had to blind himself as a punishment for incest, so Samson had to be blinded in retribution for forbidden impulses, impulses which in the realm of fantasy exist for all men, and for which all feel guilty. The punishment allays the guilt.

The pose of Heemskerck's Delilah with head in profile and shoulders parallel to the picture plane [12] depends on the Delilah in Titian's design for a woodcut by Nicolo Boldrini [13] (Passavant VI.223.5).[36] Titian's powerful composition belongs in style to his works of the early 1540s. Heemskerck depicted the moment when Delilah signals to the Philistines that Samson's hair has been cut and he is at their mercy, whereas Titian had focused on the following event in the story, when Samson, roused from his sleep, is taken prisoner. In contrast with the calm of Mantegna's and Morone's compositions, the excitement of dramatic conflict dominates the conceptions of Titian and Heemskerck. This dissimilarity is characteristic of the general tendencies in art of the different periods these works exemplify; it demonstrates the adaptability of the same narrative material to differing aesthetic goals.

Between Titian and Heemskerck there are also significant differences. Whereas Heemskerck emphasizes the instability of the situation by multiplying spatial complexities and busy details, the action in Titian's frieze-like scene is set in a limited foreground space parallel to the picture plane and is stabilized by the architectural elements. The thrust of the three soldiers rushing in from the left and the pair taking Samson prisoner is contained by the impregnable verticals of the group at the right with spear and shield. Standing beside Delilah, who holds the shears and Samson's severed locks away from her as if to dissociate herself from the tragedy she watches so intently, there is a second woman whom Titian has introduced into the situation. Her role is equivocal, for the hands with which she holds Samson could be providing either restraint or support. It is as if she acts in place of Delilah, expressing the conflicting emotions that characterize Delilah's relations with Samson.

It is not surprising that the large and masterly woodcut after Titian's design impressed other artists. Tintoretto translated Titian's Delilah into the figure of the Virgin Annunciate he painted for the ground floor of the Scuola di San Rocco. When he painted Delilah, however, he placed her in a three-quarter frontal pose better adapted to his composition of the cutting of Samson's hair, the more traditional scene that he chose to depict.[37] But he followed Titian in including Delilah's

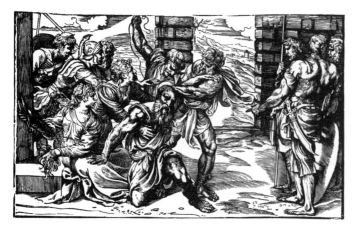

13. Nicolo Boldrini, after Titian, *Samson Taken Prisoner,* woodcut, early 1540s. Amsterdam, Rijksmuseum (*Rijksmuseum*).

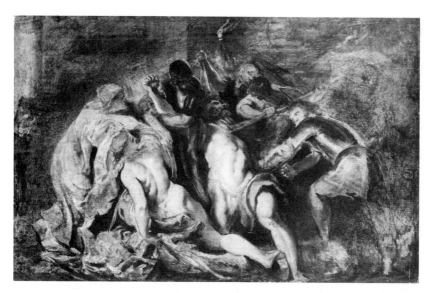

14. Peter Paul Rubens, *Samson Taken Prisoner,* oil sketch, ca. 1609. Baron Thyssen-Bornemisza Collection, Lugano-Castagnola.

maid in the scene. A number of later painters were likewise to include a female accomplice. Titian's contribution of Delilah's confederate to the iconography of Samson and Delilah was to have enduring significance, for in seventeenth-century paintings of this subject she introduced clear associations to brothel scenes, with their implied castigation of the dangerous combination of venality and lasciviousness. Rubens was preeminent in giving this image currency.

All of the oil sketches and drawings known to us in which Rubens dealt with the betrayal of Samson were, in my opinion, in preparation for the important painting he made soon after his return to Antwerp from Italy, which was intended to hang in the home of his patron, the Burgomaster Nicolaes Rockox. The earliest of the surviving projects is, I believe, a dramatic oil sketch, which is now in the collection of Baron Thyssen-Bornemisza in Lugano-Castagnola [14].[38] From the start, then, Rubens envisaged a night scene, spangled with the flickering light of torches and candles. The Samson is based directly on the Laocoon, which Rubens had so thoroughly studied in Rome.[39] The Delilah reflects his drawing of the upper part of the Laocoon

seen from the back; Rubens used this pose again some ten years later for a female figure in the *Rape of the Daughters of Leucippus* in Munich. The pose of Delilah may have been inspired by the figure on the left in Tintoretto's *Mercury and the Three Graces* of 1578 (Sala dell' Anticollegio, Palazzo Ducale). A powerful tension is set up between the two contorted figures, Samson struggling against his tormentors as he is dragged back into the depth of the picture space, Delilah straining in the opposite direction. They are locked into place by a compact pyramidal group closed, as if by a pair of parentheses, at the left by the old woman, at the right by the soldier in armor. The soldier with the dagger in his upraised hand aimed at Samson's eye is reminiscent of the Philistine in a similar position in the Titian design, who holds a rope in his upraised hand. Clearly Rubens's Samson too owes something to Titian's conception. It is noteworthy, however, that while Titian's Samson huddles helplessly, Rubens always depicts Samson as a powerful, gigantic figure. Even when he is pinioned by the Philistines, as he is here, he never ceases to battle against his doom.

With all its merit, the dynamic sketch in

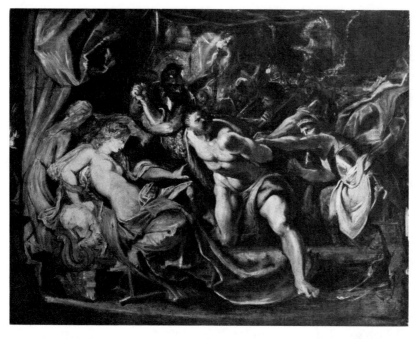

15. Rubens, *Samson Taken Prisoner*, oil sketch, 1609–10. Art Institute of Chicago (*Art Institute*).

the Thyssen-Bornemisza Collection falls short as illustration, particularly in failing to describe the role of Delilah. It seems reasonable to suppose that this was why Rubens tried again, producing the brilliant oil sketch now in the collection of the Art Institute of Chicago [15].[40] It is again a night scene, with visible sources of artificial light. The old woman and the Philistines are retained essentially as they appear in the Lugano sketch. Samson again reflects Titian's Samson, but this time the upper part of his body is based on Rubens's studies of the Belvedere Torso, as Held has pointed out.[41] Delilah, however, is totally transformed, and it is clear that Rubens found it necessary to revise the pose of Samson in response to the compositional demands of this new element. This Delilah is based on Michelangelo's *Notte* on the tomb of Giuliano de' Medici in San Lorenzo, Florence. In drawing several views of this sculpture [16], Rubens probably used a small plaster cast of the original marble, as Burchard and d'Hulst suggested.[42] The Chicago Delilah appears to be the same figure seen from a

viewpoint slightly different from that represented by the central figure in this drawing. For the oil sketch, Rubens reversed the figure and changed the angle of inclination. He also altered the left arm (incomplete in Michelangelo's sculpture) so that Delilah reaches out toward Samson and at the same time fends him off.

The moment in the story that Rubens initially illustrated, to which he was evidently attracted by Titian's rendition of it, is the climactic point when Samson's strength has been shorn away and he has been awakened by Delilah's cry, "The Philistines are upon thee, Samson." The Philistines take Samson captive before he is able to leave Delilah's bed. The erotic essence of the situation is emphasized by the nudity of the two protagonists; both are only minimally draped. The eerie light of torches and mysterious shadows press the point that the betrayal takes place in the dark of the night. We have come a long way from the setting in fields and woods that was characteristic of medieval and Early Renaissance conceptions of Samson and Deli-

lah. Even the overtly erotic Mannerist exam-
ples were placed where a bed was visible but
not occupied. Here the bed is the locus of the
clash by night. In the Lugano sketch, the
emotions of both Delilah and Samson are ex-
pressed mainly through their bodily postures,
but in the Chicago composition their faces
also speak eloquently. Samson twists away
from Delilah with a ferociously angry look.
Delilah's stare bespeaks rapt fascination. The
surface of the picture is shot with streaks of
lurid light that emerge restlessly from the in-
scrutable darkness, adding to the sinister at-
mosphere.

The nocturnal scene of sex and violence in
the Chicago panel has a counterpart in real
life in childhood fantasy about happenings in
the parents' bedroom. Excluded from con-
sciousness, the child's speculations may find
their way back through a painting,[43] with
Samson and Delilah serving as substitutes for
the participants in the primal scene. Feelings
which neither the artist nor those who re-
spond to his work can consciously acknowl-
edge are thus communicated through art.
"Art is a conventionally accepted reality in
which, thanks to artistic illusion, symbols and
substitutes are able to provoke real emotions.
Thus art constitutes a region halfway be-
tween a reality which frustrates wishes and

17. Rubens, *Samson and Delilah*, drawing, ca. 1609–10.
Amsterdam, J. Q. van Regteren-Altena Collection
(*A.C.L., Brussels*).

the wish-fulfilling world of the imagination—
a region in which, as it were, primitive man's
strivings for omnipotence are still in full
force."[44]

Perhaps the Chicago oil sketch proved to
be too frank for Rubens—or for his patron. In
any case, the next step was a pen-and-wash
drawing [17] that replaced the emotional ex-
citement of the Chicago scene of *Samson
Taken Prisoner* with a more conventional
treatment of the preceding moment in the
Old Testament narrative, the cutting of Sam-
son's hair. Delilah remains as in the Chicago
picture, except that she is now clothed but
bare breasted. Her extended left hand now
rests—tenderly, it seems—on Samson's shoul-
der as he sleeps with his head on his right
hand cradled in her lap. The old woman who
stands behind Delilah now holds a candle. A
man leans forward to cut Samson's hair, in a
pose similar to that of the barber in Tintoret-
to's *Samson and Delilah*. Waiting soldiers
look on through a door in the right back-
ground. These features are all embodied in

16. Rubens, *"La Notte" of Michelangelo*, drawing, ca.
1600–1603. Paris, Fondation Custodia (coll. F. Lugt),
Institut Néerlandais (*A. Dingjan, The Hague*).

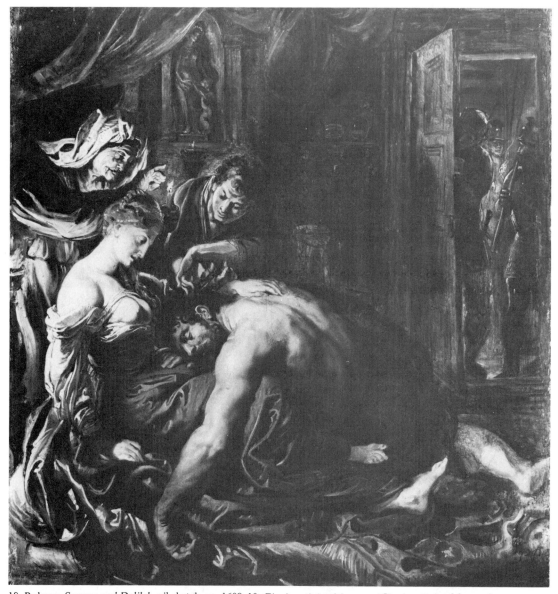

18. Rubens, *Samson and Delilah,* oil sketch, ca. 1609–10. Cincinnati Art Museum (*Cincinnati Art Museum*).

an oil sketch [18, Cincinnati Art Museum] that is much more detailed and finished than the two earlier ones.[45] This sketch is such a faithful preview of the final monumental painting that it may well have served as a *modello* for the patron's approval (or for the engraving by Jacob Matham, as the sale catalogue suggests).

In the drawing in Amsterdam, the man who cuts Samson's hair crosses his arms in an odd way as he lifts a lock of hair with his left hand and shears it with his right. This conspicuously unnatural gesture, which is even more noticeable in the Cincinnati oil sketch, must have been a deliberate vehicle for a specific meaning. As Wolfgang Stechow has so

clearly demonstrated, the crossing of Jacob's hands as he blesses the sons of Joseph has had a long history in art as a reference to the crucifixion of Christ.[46] Thus there are grounds for supposing that the crossed hands involved in the betrayal of Samson likewise are intended as a reference to the betrayal of Christ. In the oil sketch, but not in the drawing, Delilah's legs are crossed, a change that does not seem to be accounted for by any formal consideration and which may therefore be assumed to relate to the content. It suggests the slang term for treachery: double-cross.[47]

In addition to the burning lamp at the left edge of the picture, which is present in the series of Rubens drawings and oil sketches from the start, the Cincinnati oil sketch includes three other visible sources of light: the candle held by the old woman, the torchlight that illuminates the waiting soldiers, and the lamp that burns at the feet of the statue of Venus. The major figures, however, are sharply lighted from the front in a way that is not accounted for. Both the play of light sources within the picture and the arbitrary use of light for dramatic focus on the figures remind us of Rubens's interest in the Caravaggist innovations. That in meaning as well Rubens's *Samson and Delilah* is related to the brothel scenes favored especially by Northern printmakers in the sixteenth century and followers of Caravaggio in the seventeenth is suggested by the fact (pointed out by H. G. Evers) that "Delilah's lap," meaning involvement with whores, is the road straight to Hell, according to verses in Johan de Brune's *Emblemata*.[48] This book was published in Amsterdam in 1624, but it is not unlikely that representations of Delilah were understood in this sense well before it found its way into print. "Door lichte Vrouwen worden veel verdorven" was the gloss accompanying Van Mander's advice to young artists about visiting Italy, in his *Schilder-Boeck* published in Haarlem in 1604,[49] attesting to open concern about the dangers of involvement with loose

women. Josephus referred to Delilah as a harlot, and that Rubens too thought of her in these terms is suggested by the presence of the old woman whom he associates with her in every instance. This crone is the procuress type introduced in moralizing Netherlandish pictures in the sixteenth century and familiar to us especially in Dutch paintings of the seventeenth century. She is an embodiment of the debasement of sex for mercenary motives, and as such she has been a standard character in literature at least since the time when Ovid reviled Dipsas.[50] La Vieille in the *Roman de la Rose* is a well-known example of this type of degraded old woman in medieval literature.[51] Her appearance in sixteenth-century literature and art is frequent enough to elucidate the associations that would have prompted Rubens to make her Delilah's inseparable companion. With her close at hand, no one can ignore the proof that woman is faithless.

In the Cincinnati oil sketch Rubens included some details of the setting that were to go unchanged into the painting for Rockox.[52] Chief among these is the sculpture of Venus and Cupid set in a niche, which forms the apex of the pyramidal group made up of the three major figures. The Goddess of Love and her son (with his mouth bound!) are the household divinities. Thus in one brilliant stroke Antiquity is given due prominence in terms of both form and meaning. Delilah's bemused expression and the light touch of her hand on Samson's bare shoulder reveal her amorous attachment even at the moment of her duplicity—a mirror-image of the conflicting emotions that provoke the man's anxiety.

Rubens's series of interpretations of the betrayal of Samson by Delilah culminated—less than two years after it had begun—in the masterpiece he completed around 1610 [19].[53] He had apparently solved the problems to his own and his patron's satisfaction in the third oil sketch [18], which in its essentials was re-

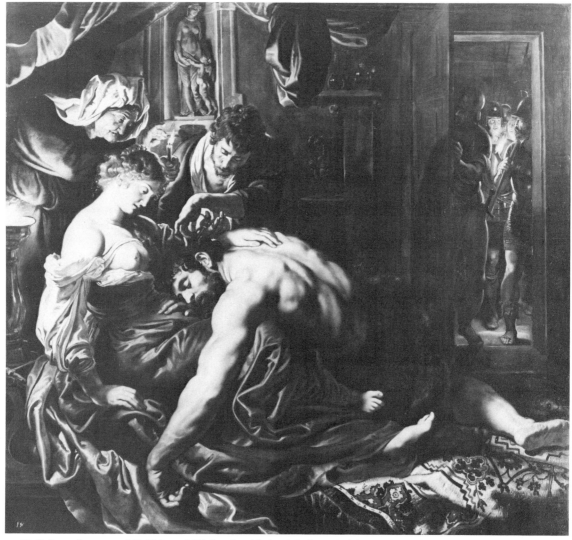

19. Rubens, *Samson and Delilah*, ca. 1610. London, National Gallery (*Ralph Kleinhempel*).

peated on a much larger scale in the final painting. While his Italian experience was still fresh, he had undertaken this project in which ultimately he ingeniously integrated into his composition of the unlikely subject of *Delilah Betraying Samson* a tribute to ancient art, as well as flattering references to some works of the more recent past.[54] He made it the occasion for a worthy expression not only of his great gifts for design and color but also

of his extensive learning and extraordinary visual memory. His painting is characteristic of the advanced art of its period, while at the same time it reveals both the personal preferences of its author and the timeless concerns he shared with all mankind. The chief motif takes its place in a long visual tradition. Samson, sleeping with his head on his bent right arm resting on Delilah's lap, and his left arm hanging diagonally forward, calls to mind the

print by the Master E. S. [4] of some 150 years earlier. All the more striking, in the light of this comparison, is the direct access to intense feelings provided by Rubens's painting.

Through the prominence of Delilah's bared breasts Rubens calls attention to the oral component in Samson's involvement with her, as Heemskerck had also done. Samson thus serves to epitomize the primitive, ambivalent ideas rooted in the complex of erotic and hostile feelings aroused by the infantile oral attachment to the mother which may underlie men's hostility toward women and concomitant fear of them. The bond be-

tween the dependent infant and the mother who sustains his life is crucial.[55] In a sense, the fears as well as the positive feelings engendered by this attachment are never fully outgrown. In greater or lesser degree they play a part in the adult man's relations with women. Samson deprived of his strength, the pride of his masculinity, is the ready image of the victim of such a dependent relationship. A Flemish Mannerist drawing of the late sixteenth century, by or very close to Maerten de Vos [20, New York, Pierpont Morgan Library], expresses this psychological involvement graphically (quite apart from the emblematic content that was its consciously

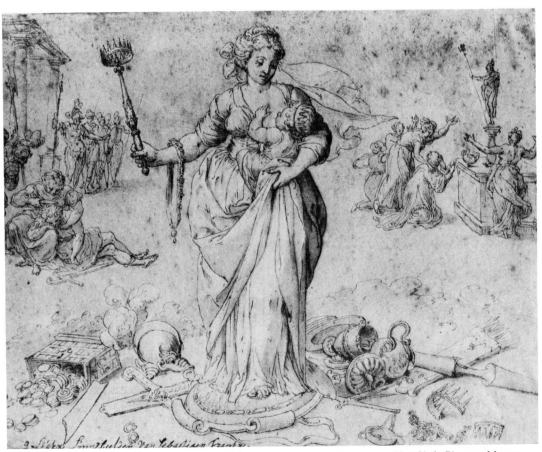

20. Maerten de Vos (?), *Allegory of the Power of Women,* drawing, late 16th century. New York, Pierpont Morgan Library (*Pierpont Morgan Library*).

intended message). The nursing mother holds the royal scepter and golden chain. All the symbols of worldly power and wealth are broken at her feet. The child at the breast is a princeling, because his mother has placed him there. And what does the woman do with the sovereignty she possesses? She persuades the man to worship false gods, like King Solomon in the upper right, or she robs him of his strength, as Delilah does to Samson in the upper left. Like the Florentine *desco da parto* [3], this drawing asserts that woman wields a power over man against which neither wisdom nor strength can prevail. An unconscious conflict can be expressed openly when it appears thus under fictitious conditions. To both the artist and his audience such anxiety-provoking ideas are tolerable in the guise of art, not life.[56] Presenting such ideas in acceptable terms is one of the achievements of art. Taking into account the biological basis of the psychological conflict under consideration, it seems reasonable to suggest that the need to master such conflicts is one of the wellsprings of art.

That Delilah divested Samson of his strength, and ultimately his life, by cutting his hair connects this story with a broad stream of superstitions and legends about the hair of the head. In the Old Testament, Elisha was mocked by the little children of Bethel because he was bald, and for this he called down on them a ruthless punishment (2 Kings, 2:23). During recent conflicts, sympathizers with the Irish Republican Army cropped the hair of women suspected of consorting with British soldiers in Northern Ireland. How the intended insult of head-shaving was turned to positive use through the institution of the tonsure was explained in the thirteenth century by Jacobus de Voragine in the *Golden Legend*.[57]

Belief that a man's strength resides in his hair arose independently in so many unrelated cultures that it must be associated with

concerns of general, if not universal, interest. The version from classical antiquity best known to us in both literature and art is the story of Scylla and her father Nisus, King of Megara.[58] Having fallen in love with Minos, who was leading the Cretan forces besieging Megara, Scylla cut her father's purple lock of hair, on which his life depended, thus betraying the city to the enemy. Folklore and legend provide many similar stories.[59] Not long ago hair was again a live issue. "Hair became the most controversial word of the sixties," the *New York Times* stated in one of the articles with which it summarized the past decade as 1969 came to an end.[60] The passions that marked the controversy over male hair styles reflected the depth of emotional involvement on the part of both the long-hairs and the short-hairs. Though it sounded frightfully current, the battle of the hair was really old hat. In London in 1654, Thomas Hall published a diatribe titled *The Loathsomnesse of Long Haire,* quoting Scripture to prove that the Cavaliers indulged in wicked hair styles. A principal point of his argument rested on biblical indications that God did not want men and women to look alike,[61] a point that seems still to be at issue in modern attitudes toward coiffure.

Conflict over hair styles serves ulterior purposes well because the hair is valued as a symbol by those who would deprive others of it as much as it is by those who insist on their right to let it grow. Behind this emotional investment in the hair is the tendency to equate the hair with other parts of the body and to fear its loss as the loss of the most valued attribute. A relationship between baldness and decreased virility is not only secretly feared but scientifically studied even in our time.[62] In this as in other instances, the scientific age is still bound to folklore, for folklore reflects deep-seated psychological concerns.[63] A man's fear of losing his hair and the strength that it represents, as happened to Samson, gives to the story of Samson's be-

trayal by Delilah an emotional impact that helps to explain its long life in literature and art.

The ubiquitous psychological forces that find expression in the story of Samson's emasculation at the hands of a woman were reinforced by other considerations at various times.[64] As sacred history the narrative was illustrated and widely circulated for centuries. Christological values enhanced its preceptive power; the parallel with Christ, whose death is not the end but the beginning of man's redemption, lends moral significance even to the episodes of degradation. The story of Samson was also used to represent heroic patriotism as a model for action. Along with these positive references, its negative aspects had powerful appeal. It was widely understood as derogation of the vice *Luxuria,* and in this context it supported a position of hostility to women based on fear. Contradictory implications abound, not only among the different paintings but even within a single example. Much that is not consciously determined participates in the generation of a work of art, and ideas that would be mutually exclusive in rational discourse can and do coexist in art.

A study of the many representations in the visual arts of Samson and Delilah clearly demonstrates the inextricable interweaving of the aspects that for convenience in discussion we speak of as "form" with those we call "content." In tracing the survival and revival of specific motifs, as is possible in a study focused on a single subject, we can see in strong relief the function of formal elements in the meaning of the picture. The contributions of tradition on the one hand and innovation on the other to the successive conceptions and styles of different schools and individual masters also become evident.

Whatever else may vary in the representations of Delilah's treachery, one undeviating factor remains: Delilah is the embodiment of men's deep-rooted fear of the danger threatened by erotic involvement with a woman.

NOTES

1. Samson was the earliest Nazarite on record. The rules for Nazarites (Numbers 6) also prohibit contact with the dead, but this is not specified in relation to Samson (Judges 13:4-7).

2. "Table Talk," Spring 1533, no. 473, in Luther's *Works,* Vol. LIV, Philadelphia, 1967, p. 79.

3. The subjects shown in the MS page are: Samson drinking water that God caused to flow from the jawbone of an ass; the men of Gaza lying in wait for Samson at the gates of the city; Samson taking up the gates and carrying them to the top of the hill before Hebron; three Philistine soldiers waiting to take Samson prisoner as Delilah cuts his hair; Philistines putting out Samson's eyes. Other parts of the Samson story are illustrated on fols. 14r, 14v, and 15v. This is not an illustrated Bible but a picture book illustrating the Old Testament from the Creation to the story of David, painted around 1250, probably by Parisian artists, to which Latin descriptions were added perhaps fifty years later. See Sydney C. Cockerell, *Old Testament Miniatures,* New York (first edn. 1927), n.d. (1970).

4. "We will transform Hercules into Samson," Dürer wrote, in discussing the intention of Christian artists to endow their sacred personages with the beautiful forms that the artists of antiquity had visualized for their false gods (K. Lange and F. Fuhse, *Dürers schriftlicher Nachlass,* Halle a/S, 1893, p. 316). For an amusing example of the confusion of Hercules with Samson, see the engraving by Albrecht Altdorfer (B. 27) reproduced in Holl-

stein I.176.32 with the title "Hercules Bearing the Columns of Gaza."

On Francesco Barberino's proposal to represent "virtue in general" by a "Samson-or-Hercules-like figure rending a lion," see Erwin Panofsky, *Studies in Iconology,* New York, 1962, p. 157, n.97. The fact that King David, ancestor and prototype of Christ, also triumphed over a lion doubtless contributed to the connotation of this motif. In medieval art the distinction between Samson's triumph over the lion and David's became blurred. See for instance the late fifteenth-century miniature in the *Hours of Engelbert of Nassau* (Oxford, Bodleian Library, MS Douce 219–20, fol. 184), in which the lion that David fights has its forepaws on a beehive, which belongs to the story of Samson (reproduced in J. J. G. Alexander, *The Master of Mary of Burgundy: A Book of Hours for Engelbert of Nassau,* New York, 1970, pl.94).

5. It has been suggested that the discrepancies are probably due to the transformation of a pagan hero into an agent of Jehovah. C. F. Burney, *The Book of Judges,* London, 1930, p. 338.

6. The most prominent example of this usage was the statue of Samson with two Philistines at his feet which Michelangelo planned to place at the entrance to the Palazzo Vecchio, along with his *David,* to exemplify civic virtue. Though the Samson was never erected, its composition was widely known from small models and drawings.

7. The symbolic uses of the number seven are too numerous for discussion here.

8. Judges 16:19–21.

9. Ernest Jones, *On the Nightmare,* New York, 1949 (first edn. 1931), p. 280f. notes that "to grind, from classical myths to modern slang, has always been a symbol for sexual intercourse." Jones quotes F. Nork as follows: "Samson when robbed of his strength by Delilah has to grind in the mill, on which passage the Talmud comments as follows: by the phrase 'grinding corn' one has always to understand the sin of carnal intercourse. This is why all the mills had to stand still in Rome at the festival of the Chaste Vesta" (F. Nork, *Mythologie der Volkssagen und Volksmärchen,* 1848, p. 301f.).

10. St. Augustine specifically exempted Samson from the divine law against suicide: "Samson, who drew down the house on himself and his foes together, is justified only on this ground, that the Spirit who wrought wonders by him had given

him secret instructions to do this" (*The City of God,* 1, 21; New York, 1950, p. 27).

11. Erwin Panofsky, *Early Netherlandish Painting,* Cambridge, Mass., 1953, Vol. 1, p. 138 and n. 1.

12. *Jewish Antiquities,* V, 317; Loeb edn., New York, 1900, p. 143.

13. See Otto Rank, *Das Inzest-Motiv in Dichtung und Sage,* Leipzig and Vienna, 1912.

14. Non-Christian cultures as well have stressed women's evil propensities. "Probably all religions, and notably the Christian religion, represent solutions of the masculine Oedipus complex and are worked out by men with this unconscious end in view, the problems of women being a secondary matter.... The one thing that would be more intolerable than anything else would be indications of sexual desires on the part of women.... It is only considerations such as these that render at all comprehensible the inhuman and barbaric attitude of the Christian Church towards women.... The behavior of the Church in ascribing all manner of unworthy traits to women, and even debating whether she had a soul at all or was merely a beast, was without question due to its degrading attitude towards sexuality in general, and was a manifestation of a morbid misogynous revulsion produced by extreme repression"—Ernest Jones, *On the Nightmare,* p. 222.

15. "Always, everywhere, the man strives to rid himself of his dread of women by objectifying it: 'It is not,' he says, 'that I dread her: it is that she herself is malignant, capable of any crime.... She is the very personification of what is sinister.' May not this be one of the principal roots of the whole masculine impulse to creative work—the never-ending conflict between the man's longing for the woman and his dread of her?" Karen Horney, "The Dread of Woman: Observations on a Specific Difference in the Dread Felt by Men and by Women Respectively for the Opposite Sex," *International Journal of Psychoanalysis,* 13 (1932), p. 349.

16. Interview by John Gruen, *Vogue,* December 1969, p. 210.

17. "Poco dinanzi allei vedi Sansone/Vie piu forte che saggio: che per ciance/In grembo alla nimica il capo pone," *Triomphi di messer Francesco Petrarcha,* Florence, 1499, for Pietro Facini; "Del Triompho dello Amore," Cap. II, fol. 5v.

18. Both are in London, Victoria and Albert Museum, on loan from the National Gallery.

19. Ebria Feinblatt, "Two Prints by Lucas van Leyden," *Los Angeles County Museum of Art Bulletin,* XVII (1965), no. 2, pp. 9–15, discusses some *Weibermacht* cycles. So does Jane Campbell Hutchison, "The Housebook Master and the Folly of the Wise Man," *The Art Bulletin,* 48 (1966), pp. 73–78.

20. Lucas Cranach the Elder illustrated the equation of apples with the breast of the nursing mother in his painting of *Caritas* (Weimar, Schlossmuseum; repr. Max J. Friedländer and Jakob Rosenberg, *Die Gemälde von Lucas Cranach,* Berlin, 1932, no. 326). Several other versions also exist, the most interesting in this connection being the one in Hamburg, Kunsthalle (Cat. 1930, no. 299). Representations of the apple tree as the Tree of Life reflect this association (see Adolph Katzenellenbogen, *Allegories of the Virtues and Vices in Mediaeval Art,* New York, 1964, p. 63, n. 1).

21. In an earlier, smaller version, the Master E.S. placed the same motif of Delilah cutting Samson's hair on a paved, walled terrace, with a landscape background (Lehrs 5; *Late Gothic Engravings of Germany and the Netherlands: 682 Copperplates from the "Kritischer Katalog" by Max Lehrs,* New York [Dover], 1969, fig. 194). A man reclining with his head on his lady's lap, not unlike the traditional Samson and Delilah motif, was among the lovers depicted by the perhaps slightly earlier Rhenish engraver known as the "Master of the Gardens of Love" in his *Small Garden of Love (ibid.* fig. 101).

22. I am deeply grateful to Professor Held, who read a preliminary draft of this study, made a number of valuable suggestions, and lent me several photographs.

23. A grapevine supported by a dead tree is the illustration for the emblem "Amicitia etiam post mortem durans" in Andrea Alciati's *Emblematum libellus (ed. prin.,* Augsburg, 1531; Paris, 1542, 40, reprinted Darmstadt, 1967). Frans Hals adapted this emblematic image in his *Portrait of a Married Couple,* ca. 1622, presumably with reference to the dependence of the wife on the husband, by having the vine wind around a flourishing tree instead of a dead one. See E. de Jongh and P. J. Vinken, "Frans Hals als voortzetter van een emblematische traditie. Bij het Huwelijksportret van Isaac Massa en Beatrix van der Laen," *Oud Holland,* 76 (1961), pp. 117–52.

In Lucas Cranach's painting of *Samson and Delilah* (Augsburg, Maximiliansmuseum), dated 1529, the couple are seated in a wood under a lemon tree, in poses that reflect the design by the Master E. S. Philistine soldiers hide behind the trees, a feature that was introduced by Lucas van Leyden in his engraving of 1508, from which Cranach might also have picked up the notion of dressing Samson in armor.

24. E.g., in Amiens and Chartres. See Katzenellenbogen, *Allegories,* p. 76, n.3.

25. E.g., Alart du Hameel's engraving, *A Pair of Lovers and a Fool at a Fountain,* in which a grape vine is also prominent (Lehrs 8; reproduced in *Late Gothic Engravings . . . ,* New York, 1969, fig. 493).

26. Katzenellenbogen, *Allegories,* pp. 63ff.

27. Erica Tietze-Conrat, *Mantegna: Paintings, Drawings, Engravings,* London, 1955, p. 184.

28. Bernard Berenson, *Drawings of the Florentine Painters,* Chicago, 1938, p. 238, Cat. no. 1718, suggests that "to grasp the difference between the idyllic and heroic, the romantic and the classic spirits," one should compare the Morone painting with the drawing by Michelangelo or a follower (Oxford, Ashmolean Museum, no. 55) of a nude female mounted upon a nude male, whose scale is gigantic relative to hers. The composition of the drawing has nothing in common with the visual tradition of Samson and Delilah or with the particulars of their story. According to Berenson, "The moment chosen is when, having cut his hair, she, while still dallying with him, turns around, no doubt to call the Philistines lying in wait." Berenson considers the drawing to be by a follower of Michelangelo, done "almost certainly in his studio," probably 1530. Johannes Wilde refers to the drawing at Oxford as Michelangelo's original, of which the version in the British Museum "seems to be a contemporary copy by a not very experienced hand" (*Italian Drawings in the Department of Prints and Drawings in the British Museum: Michelangelo and his Studio,* London, 1953, Cat. no. 90, pl. CXLII). In the British Museum sheet the male figure's head appears to be totally bald or shaven, which might have suggested the identification with Samson. The identification does not seem to me well founded, nor does the attribution

of the Oxford drawing to Michelangelo himself. There is a fragment of another copy at Windsor (Cat. no. 425 v.).

29. See Wouter Nijhoff, *Nederlandsche Houtsneden* 1500–1550, The Hague, 1933–36, and Supplement, 1939, pp. 88ff.

30. The subjects of this series were: (1) Eve giving the apple to Adam; (2) Lot's daughters offering him wine and seducing him; (3) Jael pounding the nail into Sisera's head; (4) Delilah cutting Samson's hair; (5) The woman inducing Solomon to worship false gods; (6) Judith beheading Holofernes. What these women had in common was their alarming ability to injure men.

31. "Delilah, having power over him, broke the insuperable strength of Samson by a clever trick. In order to learn by her feminine powers that his strength was fatefully placed on his head, the woman fights with blandishments and overcomes everything by trickery." I am grateful to Joan Casper Kahr for help with translations from the Latin.

The motif, especially the pose of Delilah, closely reflects a woodcut *Lamentation* by Hans Baldung Grien of about 1515 (B. 5), which Helmut Perseke relates to a charcoal drawing by Dürer of a Dead Christ (Lippmann 718, Panofsky 619) (*Hans Baldungs Schaffen in Freiburg,* Freiburg im Breisgau, 1941, no. 12).

32. The motif resembles Michelangelo's *Pietà* (Rome, St. Peter's). Samson and Delilah were posed similarly in Cornelis Massys's engraving dated 1537, in which Delilah herself cuts Samson's hair and hands a lock of it to a man standing beside her.

33. "Having cut Samson's hair, having accepted the money, Delilah hands him over to the Philistines." Boccaccio had similarly stressed Delilah's venality: "Auro dalila sampsonem tradidit hostibus" (*de Casibus Illustrium Virorum,* Gainesville, Fla., 1962, p. 47; facsimile repro. of 1520 Paris edn.).

34. The biblical narrative makes repeated references to orality. First Samson rends the jaws of the lion, thus overcoming an oral hazard. Next he examines the lion and finds honey in the carcass; he gives the honey to his parents to eat, a symbolic reversal of the role of the dependent child. To retaliate against the Philistines for keeping his wife from him, he destroys their food supply, an oral

deprivation. The jawbone of an ass is his weapon for the massacre of the Philistines, and later his thirst is assuaged by water that springs from this same jawbone. In the end, it is what could be called his oral problem that brings about his downfall, because, in the current vernacular, he just couldn't "keep his mouth shut."

35. "Sucking at the mother's breast is the starting-point of the whole of sexual life, the unmatched prototype of every later sexual satisfaction, to which phantasy often enough recurs in times of need. This sucking involves making the mother's breast the first object of the sexual instinct. I can give you no idea of the important bearing of this first object upon the choice of every later object, of the profound effects it has in its transformations and substitutions in even the remotest regions of our sexual life"—Sigmund Freud, *General Theory of the Neuroses* (1917), Standard Edition, Vol. XVI, London, 1963, p. 314.

36. Ridolfi included this among the subjects Titian drew especially for prints: "Sansone preso da Filistei con Dalida fastosa del tradimento co' recifi crini in mano" (*Le Maraviglie dell' Arte,* ed. prin. 1648, ed. Von Hadeln, Berlin, 1914–24, reprinted Rome, 1965, 2 vols., Vol. I, p. 203). Hans Tietze noted that the woodcut is "certified by Lampsonius in his letter of March 13, 1567" (*Titian,* London, 1950, p. 406). Otto Brendel observed that Titian's Samson was based on the Kneeling Gaul ("Borrowings from Ancient Art in Titian," *The Art Bulletin,* 37 [1955], p. 122). See also: Berlin, Staatliche Museen Preussischer Kulturbesitz, Kupferstichkabinett, *Tizian und sein Kreis: Holzschnitte,* Intro. and cat. by Peter Dreyer (n.d.), and Washington, D.C., National Gallery, Oct. 30, 1976–Jan. 2, 1977, *Titian and the Venetian Woodcut,* Intro. and cat. by David Rosand and Michelangelo Muraro.

37. Tintoretto's composition is known to us through two workshop copies. One, in Sarasota (John and Mable Ringling Museum of Art), shows Delilah, whose dress is in disarray so that one breast is fully exposed, extending her left hand to assist the man who is cutting Samson's hair and, like an elegant hairdresser, flourishing a comb. Between them a ghostly remnant of Delilah's maid can be seen. The second, with the same motif of Samson, Delilah, and the barber, with Delilah's maid clearly visible and with added figures and

background details, is in Chatsworth, Duke of Devonshire Collection. Detlev Baron von Hadeln believed that the "smaller, more concentrated version" in Sarasota was an autograph work by Tintoretto, "one of the finest examples of his last, freest manner" ("Tintoretto's *Samson and Delilah*," *Burlington Magazine*, 52 [1928], p. 21). It is in fact impossible to judge in its present state. Erich von der Bercken, who published a reproduction of the Sarasota picture in a much retouched state, accepted it as by Tintoretto (*Die Gemälde des Jacopo Tintoretto*, Munich, 1942, Cat. no. 306, fig. 210) and mentioned the Chatsworth picture as a workshop variant of it (Cat. no. 61). Hans Tietze did not reproduce either of the versions and stated that he had not seen the original (*Tintoretto: Gemälde und Zeichnungen*, London, 1948, pp. 348 and 359). A painting of totally different composition that was included in an exhibition under the title *Samson and Delilah* and erroneously attributed to Tintoretto may originally have represented some other subject (New York, Wildenstein, "The Painter as Historian," Nov. 15–Dec. 31, 1962, no. 8, repro. p. 35).

38. Robert von Hirsch very kindly supplied the photograph while the picture was in his possession. At the sale of his art collection in 1978, after his death, this Rubens oil sketch was purchased by Baron Thyssen-Bornemisza. Earlier it had been published as by Van Dyck in an exhibition catalogue: Frankfurt, Staedel Institute, *Zweite Veröffentlichung des Städelschen Kunstinstituts herausgegeben von Georg Swarzenski: Ausstellung von Meisterwerken alter Malerei aus Privatbesitz,* Summer 1925, Frankfurt-am-Main, 1926, no. 60. Erica Tietze-Conrat attributed it to Rubens in "Van Dyck's Samson and Delilah," *Burlington Magazine,* 61 (1932), p. 246. Frits Lugt believed that this oil sketch and a drawing in the Louvre after it were both by Van Dyck (*Louvre, École flamande,* Vol. I, 1949, no. 605). Hans Gerhard Evers considered the Louvre drawing to be by Rubens (*Rubens und sein Werk: Neue Forschungen,* Brussels, 1943, p. 164). Julius S. Held convincingly explains that the Louvre drawing is a copy by another hand after the Rubens oil sketch (*The Oil Sketches of Peter Paul Rubens: A Critical Catalogue,* Princeton, N.J., 1980, Vol. I, p. 434f.).

In this masterly two-volume work, Held presents a view of the sequence of Rubens's depic-

tions of Samson and Delilah that differs from mine. He believes that the three oil sketches were in preparation not for one, but for two different paintings (Cat. nos. 312–314 and pls. 309–311. Colorplate 2 is an excellent reproduction of the oil sketch now in Cincinnati).

39. See Giorgio Fubini and Julius S. Held, "Padre Resta's Rubens Drawings after Ancient Sculpture," *Master Drawings,* Vol. II, 1964, pls. 2–4.

40. Formerly attributed to Van Dyck, the Chicago oil sketch has been indubitably attributed to Rubens and dated between 1609 and 1610 by David Rosen and Julius S. Held, "A Rubens Discovery in Chicago," *Journal of the Walters Art Gallery,* 13–14 (1950–51), pp. 77–91. As to the chronology of Rubens's works depicting Samson and Delilah, these authors state (p. 89): "We are inclined to follow Evers, who considered 'The Cutting of the Hair,' and its sketch in the collection of van Regteren-Altena, earlier than the studies in which Rubens dealt with the more dramatic incidents of the 'Capture' and 'Blinding of Samson.' Yet, the time interval between the various pieces of this group can not have been great." Evers (1943, p. 163) had described the Louvre drawing as "not only a capture, but a *blinding* of Samson."

Held (1980, Vol. I, p. 433) points out that the Chicago oil sketch was painted over an incomplete *Adoration of the Magi,* part of which is still visible.

41. *Rubens: Selected Drawings,* New York, 1959, p. 104.

42. L. Burchard and R.-A. d'Hulst, *Rubens Drawings,* Brussels, 1963, Vol. I, p. 35. Rubens used this figure again for the Venus in his *Sine Cerere et Baccho Friget Venus* (Cassel, Museum, ca. 1612–15).

43. Or through a story. See Marie Bonaparte, "The Murders in the Rue Morgue," *Psychoanalytic Quarterly,* 4 (1935), pp. 259–93.

44. Sigmund Freud, "The Claims of Psychoanalysis to Scientific Interest," (1913), Standard Edition, Vol. XIII, p. 188.

45. Professor Julius S. Held informed me of the existence of this oil sketch and lent me the photograph of it. Sale, Christies', Nov. 25, 1966 (66). In his 1980 book (Vol. I, p. 432), Held suggests that narrow strips have been removed on both sides.

46. "'Jacob Blessing the Sons of Joseph,' from

Early Christian Times to Rembrandt," *Gazette des Beaux-Arts,* ser. 6, 23 (1943), pp. 193–208; and "'Jacob Blessing the Sons of Joseph,' from Rembrandt to Cornelius," *Festschrift Ulrich Middeldorf,* Berlin, 1968, pp. 460–65.

47. Evers (1943, p. 152) noted: "Die verkreuzten Füsse Delilas und die verkreuzten Hände des Philisters sind wie ein Ausdruck des Verrates, der vor sich geht."

48. *Rubens und sein Werk, Neue Forschungen,* Brussels, 1943, p. 231.

49. Fol. 7r.

50. *The Art of Love,* New York, 1959, pp. 17ff. (Elegy VIII).

51. See John V. Fleming, *The "Roman de la Rose": A Study in Allegory and Iconography,* Princeton, N.J., 1969, esp. pp. 171ff.

52. I am grateful to Frau Margret Köser, the previous owner, who kindly provided the photograph and gave me the opportunity to study the painting in her home in Hamburg. This painting was lost from sight for almost three hundred years following Rockox's death in 1640, at which time it was mentioned in his inventory. It was known through the engraving by Jacob Matham and the painting by Franz Francken of the Kunstkamer of Burgomaster Rockox (Munich, Alte Pinakothek), in which it appears over the fireplace (reproduced in Evers, 1943, fig. 62). The engraving by Matham after Rubens's painting, which was made about 1613, is dedicated to Rockox in an inscription which states that the painting was then to be seen in Rockox's home; this has led to the assumption that it was commissioned by Rockox.

53.. In addition to the works depicting Samson and Delilah which I consider to be autograph pictures by Rubens, all of which I discuss in the text, there are a number of others that were produced by artists in the Rubens circle. Van Dyck's large painting of the *Capture of Samson* (Vienna, Kunsthistorisches Museum) closely follows Rubens's Chicago oil sketch (which was formerly attributed to Van Dyck). Van Dyck, however, tones down both the violence and the sensuality of Rubens's conception; he shows Samson turning beseechingly toward the relatively modestly clad Delilah, while she gestures toward him as if in an effort to comfort him. Another painting by Van Dyck (Dulwich College Picture Gallery), which depicts the cutting of Samson's hair, is based on Rubens's painting now in the National Gallery, London (or Rubens's preparatory sketch for this painting). Numerous workshop replicas and copies of the various Rubens and Van Dyck "Samson and Delilah" paintings exist, as do drawings related to them.

54. Rudolf Oldenbourg, *Peter Paul Rubens,* Munich and Berlin, 1922, pp. 82ff., proposed Tintoretto's *Samson and Delilah* as Rubens's model. See also H. G. Evers (1943), fig. 52, an engraving of *Jupiter and Callisto* after Perino del Vaga, which Evers believed was reflected in Rubens's composition. The relationship of Rubens's conceptions of Samson and Delilah to either the Tintoretto or the Perino seems to me tenuous at best; Titian and Michelangelo left clearer traces on his works.

55. "It is clearly the mother on and with whom the most important problems of separation and individuation must be played out. At first the breast is the most important part of her, satisfying not only feeding needs, but offering a soft, warm cushion which may blur the sense of separateness; and in offering so comfortable a spot it becomes the germinal center of tender love"—Phyllis Greenacre, "The Fetish and the Transitional Object," *The Psychoanalytic Study of the Child,* 24 (1969), p. 156.

56. "The illicit has become licit" by common consent. See Ernst Kris, *Psychoanalytic Explorations in Art,* New York, 1952, p. 38.

57. Letting the hair grow as penance or sacrifice has also been a widespread practice. According to Tacitus, for instance, the Batavians vowed not to cut their hair until they had conquered the enemy (*Histories,* IV, p. 61). Rembrandt may have had this in mind when he depicted the Batavians with long hair in the *Oath of Julius Civilis* (Stockholm, National Museum).

58. Aeschylus mentioned this story as a well-known example of the pernicious woman. Among the numerous literary references to it, those in Ovid and Petrarch may have been the sources used by artists. The subject appeared in Roman wall paintings. Sebastiano del Piombo illustrated it in one of the fresco lunettes in the Farnesina (repr. Venturi, *Storia,* IX, 5, (1932), p. 22). His composition is not unlike that of Morone's *Samson and Delilah* [7].

59. See H. Bächtold-Stäubli, *Handwörterbuch des deutschen Aberglaubens,* III, Berlin and Leipzig, 1930–31, col. 1239–87, s.v. *Haar.* Also T. H. Gaster, *Myth, Legend, and Custom in the Old Testament,* New York and Evanston, Ill., 1969, pp. 436ff. and 517f. Further, W. Robertson Smith, *The Religion of the Semites* (first edn., 1889), New York, 1957, p. 483f.

60. Dec. 31, 1969, p. 29.

61. Hall stated this exception: "In extraordinary cases that may be lawfull which in an ordinary way is unlawfull; thus the Nazarites might weare *Long Haire* because thay had Gods speciall command for it" (p. 8).

62. *The New York Times* of Oct. 23, 1969, in an article datelined London, cites *Focus,* the Consumer Council's Magazine, on this subject.

63. See Charles Berg, *The Unconscious Significance of Hair,* London, 1951.

64. The long succession of pictures representing Samson and Delilah by no means ended with Rubens and his circle. Indeed, interest in this subject displayed a new vitality in seventeenth-century Dutch painting, particularly in works by Rembrandt. I dealt with these developments in an article titled "Rembrandt and Delilah," *The Art Bulletin,* 55 (1973), pp. 240–59.

On Jan. 29, 1970, I read a condensed report of my study of Delilah in art at the Annual Meeting of the College Art Association in Washington.

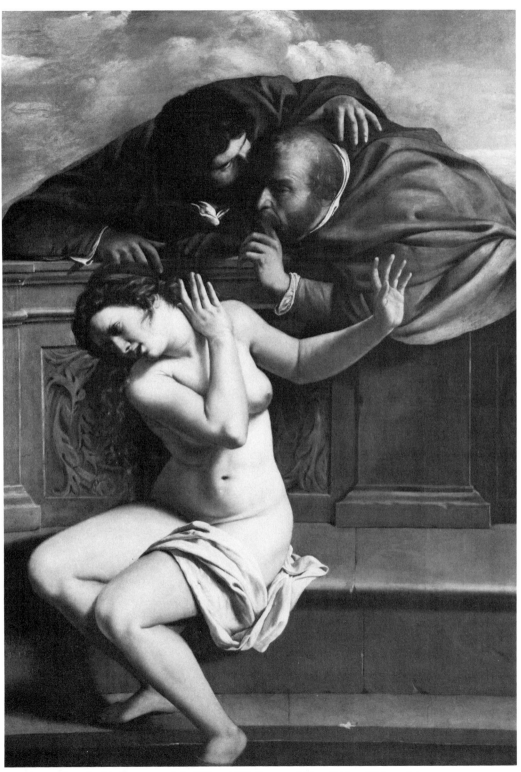

1. Artemisia Gentileschi, *Susanna and the Elders,* 1610. Pommersfelden, Schloss Weissenstein, Collection Dr. Karl Graf von Schönborn (*Brooklyn Museum*).

8
Artemisia and Susanna

———————⇒✦✦⟵———————

MARY D. GARRARD

When the large exhibition *Women Artists, 1550-1950* was seen in several American cities in 1977,[1] American viewers were treated to the spectacle of six paintings by Artemisia Gentileschi, more than are normally found in any single city in the world. The rarest sight among these for Gentileschi scholars was the painting of *Susanna and the Elders* [1], a work long hidden from the public eye in a private collection in Pommersfelden, Germany, and a problematic picture in the Gentileschi *oeuvre*.[2] In response to the stimulus of the exhibition, I have attempted here to resolve the attribution and dating problems connected with this painting, offering new evidence in support of Artemisia's authorship. I shall demonstrate as well that part of that evidence, namely, the painting's unorthodox interpretation of the biblical theme of Susanna and the Elders, is of wider significance, for both Artemisia's art and her life.

Although the painting bears the prominent inscription "ARTEMITIA/GENTILESCHI F./1610" on the step at the lower left [2], scholars have been divided in their attribution of the work between Artemisia and her father Orazio Gentileschi. Orazio was proposed as the artist, first by Longhi, then by others,[3] on the grounds that 1610 was impossibly early for the daughter, who was presumed to have been only thirteen years old in that year. In 1968, Ward Bissell established Artemisia's correct birthdate as 1593 rather than 1597, and sustained the attribution of the *Susanna* to her on stylistic grounds.[4] He suggested, however, following an idea earlier advanced by Voss,[5] that the date on the canvas should be read as 1619, when Artemisia's artistic maturity would have more nearly matched the technical sophistication of the painting. In her catalogue entry of the Los Angeles exhibition, Ann Sutherland Harris supported the attribution to Artemisia and reaffirmed the probable date as 1610, following a reading of the inscription offered by the curator of the collection.[6] When the painting arrived in Los Angeles in January 1977, and was available in the original for the first time to Artemisia scholars, close inspection confirmed that the date indeed reads 1610.

Still, the possibility remained that the signature and/or date had been altered or added

2. Gentileschi, *Susanna and the Elders,* detail. Pommersfelden, Schloss Weissenstein, Collection Dr. Karl Graf von Schönborn (*Brooklyn Museum*).

later. When the exhibition moved to the Brooklyn Museum in October 1977, I took the opportunity to consult the museum's chief conservator, Susanne P. Sack, who, with the generous cooperation of the owner, Dr. Karl G. Schönborn, subjected to laboratory analysis the inscribed portion of the painting [2]. Ultraviolet photography revealed no overpainting of a previous date or signature, and in Mrs. Sack's opinion, the character of the pigment, the structure of the lettering and its conformity with the internal lighting of the painting, and the craquelure of the surface all strongly indicate that the signature and date formed an original part of the picture.[7] All technical evidence points, therefore, to the authenticity of the signature and date, and consequently, to the authenticity of the *Susanna and the Elders* as the earliest preserved painting of Artemisia Gentileschi.

Even with the advancing of Artemisia's age from thirteen to seventeen, however, the picture still confronts us with an unusually accomplished technical performance by a young artist who in 1610 had, by her father's account, only been painting about a year.[8] A logical explanation, one advanced by Moir,[9] is that Orazio helped his daughter-pupil exten-

sively in the planning and execution of the work. This view differs only in degree from Longhi's opinion that Orazio essentially painted the picture and put Artemisia's name on it.[10] From an exclusively stylistic point of view, this is an irrefutable argument, since the early works of Artemisia are very similar to those of Orazio in formal conception and color harmony. On the other hand, if we take into account the expressive character of the painting, we can distinguish between the two artists even at this early point in Artemisia's career. Surprisingly, no scholarly attention has yet been devoted to the single most exceptional aspect of this painting, which is its treatment of the theme.

Like most versions of the Susanna theme, the Schönborn painting presents the central confrontation between the principal characters, the moment when the two Elders return to Joachim's garden to seduce Joachim's wife Susanna. As Ann Sutherland Harris has noted, the Gentileschi *Susanna* belongs in the general context of a group of Susanna paintings and prints from the Carracci circle, a group that includes Annibale's print of ca. 1590 [3], and a painting by Annibale of around 1601–02, now lost but known in a copy or variant by another artist, who was probably Domenichino [4].[11] Yet granting a family resemblance among these works, a direct comparison of them with the Schönborn picture serves principally to establish its essential difference from the others. While Susanna's legs correspond generally in pose with those in Annibale's print, the position of the arms has been decisively changed, and her image accordingly revised, from that of a sexually available and responsive female to an emotionally distressed young women, whose vulnerability is emphasized in the awkward twisting of her body. The artist has also eliminated the sexually allusive garden setting, replacing the lush foliage, spurting fountain and sculptured satyr heads that appear in the Carracci circle works with an austere rec-

tilinear stone balustrade that subtly reinforces
our sense of Susanna's discomfort. The ex
pressive core of this picture is the heroine's
plight, not the villains' anticipated pleasure.
And while one might well expect this to be
the case, since Susanna's chastity and moral
rectitude were, after all, the point of the
Apocryphal story, it is in fact the Carracci
circle pictures, and not Artemisia's work, that
represent the more usual treatment of the Su-
sanna theme in Western art.

Few artistic themes have offered so satisfy-
ing an opportunity for legitimized voyeurism
as Susanna and the Elders. The subject was
taken up with relish by artists from the six-
teenth through eighteenth centuries[12] as an
opportunity to display the female nude, in
much the same spirit that such themes as
Danae or Lucretia were approached, but with
the added advantage that the nude's erotic

3. Annibale Carracci, *Susanna and the Elders*, etching,
ca. 1590. Washington, D.C., National Gallery of Art,
Ailsa Mellon Bruce Fund (*National Gallery*).

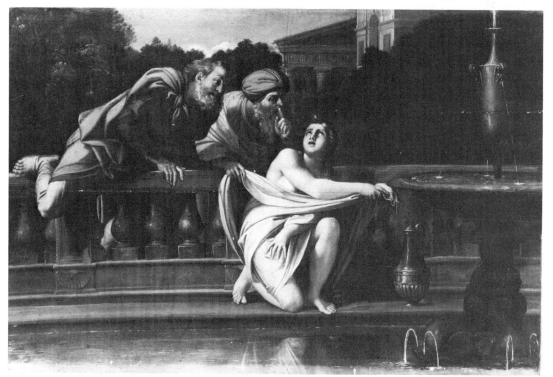

4. Domenichino (?), *Susanna and the Elders*. Rome, Palazzo Doria-Pamphilj (*Gabinetto Fotografico Nazionale*).

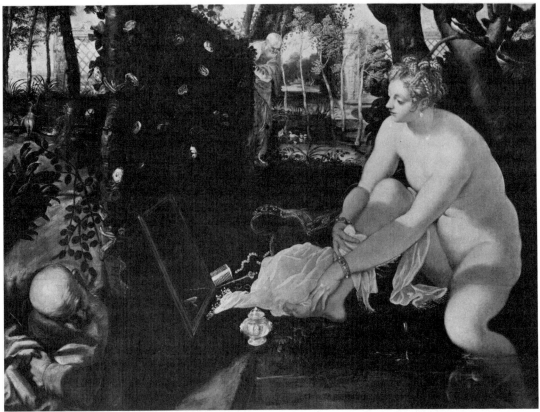

5. Tintoretto, *Susanna and the Elders*, 1555–56. Vienna, Kunsthistorisches Museum (*Kunsthistorisches Museum*).

appeal could be heightened by the presence of two lecherous old men, whose inclusion was both iconographically justified and pornographically effective. It is a remarkable testament to the indomitable male ego that a biblical theme holding forth an exemplum of female chastity should have become in painting a celebration of sexual opportunity, or, as Max Rooses enthusiastically described Rubens's version, a "gallant enterprise mounted by two bold adventurers."[13] Tintoretto, whose adventurers stage their advance in a manner more sneaky than bold [5], nonetheless offers a representative depiction of the theme in his emphasis upon Susanna's voluptuous body and upon the Elders' ingenuity in getting a closer look at it. Even when a painter attempted to convey some rhetorical dis-

tress on Susanna's part, as did the eighteenth-century Dutch painter Adriaan van der Berg [6], he was apt to offset it with a graceful pose whose chief effect was the display of a beautiful nude. Because the Susanna theme was particularly prevalent in Venice, two Venetian examples, one an anonymous painting of the early sixteenth century [7], and the other of the eighteenth century, by Sebastiano Ricci [8], may suffice to demonstrate that the prevailing pictorial treatment of the theme typically included an erotically suggestive garden setting and a partly nude Susanna, whose body is prominent and alluring, and whose expressive range runs from protest of a largely rhetorical nature to the hint of outright acquiescence.

In the sense that the imagined consequence

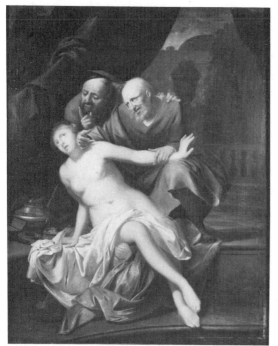

6. Adriaan van der Burg, *Susanna and the Elders,* 18th century. Toulouse, Musée des Augustins (*Courtauld Institute*).

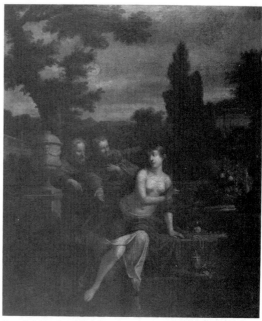

7. Anonymous artist, *Susanna and the Elders,* early 16th century. The Trustees of the Chatsworth Settlement, Devonshire Collection (*Courtauld Institute*).

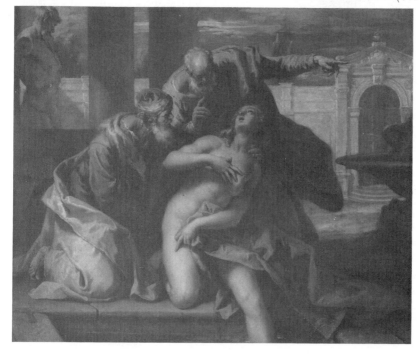

8. Sebastiano Ricci, *Susanna and the Elders.* The Trustees of the Chatsworth Settlement, Devonshire Collection (*Courtauld Institute*).

of the action is possession of a woman who has firmly said "No," the covert subject of the Susanna theme in Western art is not seduction but rape, imagined by artists—and presumably also by their patrons and customers—as a daring and noble adventure. That rape should have been glorified in art is not surprising, considering the heroic position it has occupied in mythic tradition, serving as the pivotal event in such epics of colonization as the rape of Helen by Paris or the rape of the Sabines, not to mention the inventively diverse forms of sexual conquest performed by Zeus and Apollo, all inevitably sanitized in description as "abductions."[14] And yet "abduction," a word defined as the taking away of women, "with or without their consent," is precisely accurate. Language has conveniently not distinguished between willing and unwilling women, since it is not at all clear what were the attitudes of Europa, Io, Helen, or the Daughters of Leucippus toward their abductors. Those artists who have glamorized the act of rape, deemphasizing or leaving undeveloped the reaction of the victim, have at least acted in consonance with the masculine bias of the creators of the Greek myths.[15] Susanna, however, as a potential rape victim who emphatically halted the proceedings, is a rare heroine in biblical mythology—her extremism in defense of virtue is topped only by that of Lucretia—and Susanna's unusually well-defined resistance throws into bold relief the extent to which she has been distorted into a half-willing participant in post-Renaissance art.

The biblical Susanna was distorted in a different direction in the patristic literature of the Early Christian Church. A recent writer, Mark Leach, has described the exegetical comparisons between the temptation of Susanna and the temptation of Eve that were drawn by Hippolytus, the third-century bishop and martyr; St. John Chrysostom; and the fourth-century bishop St. Asterius of Amasus.[16] Hippolytus explains: "For as of old the

Devil was concealed in the serpent in the garden, so now too, the Devil, concealed in the Elders, fired them with his own lust that he might a second time corrupt Eve."[17] Rubens alludes to this tradition in his Munich *Susanna* [9], as Leach has shown, by including an apple tree in the garden instead of the oak or mastic called for in the story. Susanna, who is also associated for Hippolytus with the Church, successfully resists this "supreme temptation involving the essence of human volition" (Leach's phrase), and thus prefigures the Church's redemption of original sin. But the extraordinary underlying assumption on the part of both Hippolytus and Leach is that Susanna-Eve should have found the pair of old lechers as tempting as they found her! Indeed, the Apocryphal account of Susanna and the Elders effectively eliminates the potentially distracting issue of mutual temptation by casting the male assailants as Elders, thus rendering their lust reprehensible and Susanna's voluntary acquiescence unthinkable, in order to concentrate dramatic attention upon the story's climax and denouement, in which Daniel successfully differentiates between her true account and their false ones.[18]

As an Old Testament parable, the Susanna story represents a contest between good and evil, or virtue and vice, mediated by wise judgment. Susanna herself is a personification of the good Israelite wife, whose sexuality was her husband's exclusive property,[19] and Susanna's total fidelity to Joachim is demonstrated in her willingness to accept death rather than dishonor him by yielding to the Elders. Her resistance is heroic because she faces danger; it is not complicated by any conflict of feeling toward her oppressors, and she is crucial to the story, flat character that she is, in the absoluteness of her resolve, her virtue and her honesty. Renaissance and Baroque artists, however, like the early church fathers, ignored the fundamental moral point concerning the discovery of truth and the ex-

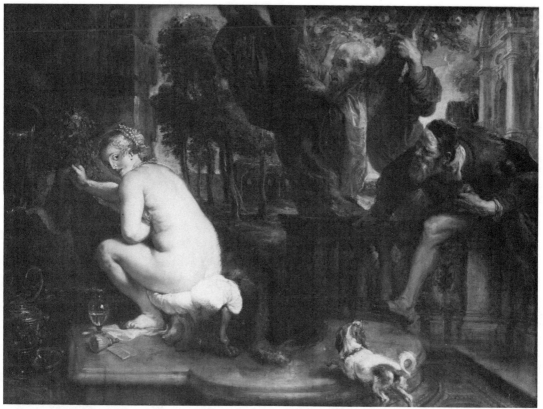

9. Peter Paul Rubens, *Susanna and the Elders,* 1636–40. Munich, Alte Pinakothek (*Bayerischen Staatsgemäldesammlungen*).

ecution of justice, to focus instead upon the secondary plot devices of temptation, seduction, and the erotic escapades of the Elders. (Tellingly, many more depictions of Susanna and the Elders exist than of either the Judgment of Daniel or the Stoning of the Elders.)[20] Both the patristic and the artistic conceptions of Susanna, whether as an Eve triumphant over her own impulses or as a voluptuous sex object who may not bother to resist, are linked by the same erroneous assumption: that Susanna's dilemma was whether or not to give in to her sexual instincts. In art, a sexually exploitative and morally meaningless interpretation of the theme has prevailed, most simply, because most artists and patrons have been men,

drawn by instinct to identify more with the villains than with the heroine.

There have appeared occasionally versions of the Susanna theme that place some emphasis upon her character and her personal anguish. In Rembrandt's *Susanna* of 1647 in Berlin [10], one of the most sympathetic treatments of the biblical heroine, we find a concern with her youth, innocence, and vulnerability that is thoroughly characteristic of the artist. Yet even Rembrandt implants in the pose of Susanna, whose arms reach to cover her breasts and genitals, the memory of the Medici Venus, a classical model that was virtually synonymous with female sexuality.[21] In the Carracci, Domenichino and Rubens *Susannas,* the classical model is the crouching

10. Rembrandt, *Susanna and the Elders,* 1647. Berlin (West), Staatliche Museen Preussischer Kulturbesitz (*Jörg P. Anders*).

Venus Anadyomene, a type known in numerous variants, whose association with the bath connects her with Susanna on a luxurious and erotic level.[22] The frequent echo of these antique prototypes in paintings of the Susanna theme underlines their use as a device to evoke erotic recollections, in the classic formulation of having it both ways: adhering superficially to the requirement that Susanna be chaste, while appealing subliminally to the memory of the Venus archetype, whose gestures of modesty call attention to what she conceals.

In the Gentileschi *Susanna,* the Venus model has been conspicuously avoided. Instead, the artist, evidently as aware as the Carracci circle artists of the possibilities of *double entendre* through classical allusion, replaces the crouching Venus with an unmistakable reference to a different antique prototype. The dramatic defensive gesture of Susanna's upper body is taken from a figure on a Roman Orestes sarcophagus, the figure of Orestes' nurse [11], who memorably conveys the anguished response of Orestes to the advent of the Furies. This sarcophagus was

11

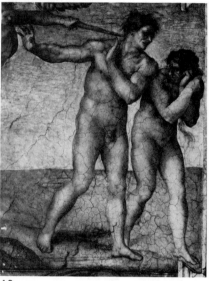

11. Roman sarcophagus, *Orestes Slaying Clytemnestra and Aegisthus*, detail. Rome, Museo Profano Lateranense (*Alinari*).

12. Michelangelo, *Expulsion of Adam and Eve*, 1508–11. Rome, Vatican Palace, Sistine Chapel ceiling (*Alinari*).

12

known in Rome in at least three variant versions, in the Lateran, the Vatican and the Giustiniani Palace, and was the source of numerous borrowings by artists in the Renaissance.[23] One of the most prominent quotations of the nurse's pose is found on the Sistine Ceiling, where it is used in reverse by Michelangelo for the figure of Adam in the *Expulsion* [12].[24] The artist of the Schönborn painting, by incorporating a gesture that carried associations with antique and Renaissance works of epic proportions and tragic overtones, restored to the Susanna theme the

tone of high seriousness that it surely deserves.[25]

The Schönborn *Susanna* carries over from its antique prototype the suggestion that a sympathetic character is being hounded on a psychological level, and the painting differs in this respect from the *Expulsion of Adam and Eve,* where the relationship between the punished Adam and the moral authority, Gabriel, is direct and physical. At the same time, and unlike Michelangelo's straightforward narrative, the painter of the *Susanna* sustains a certain ambiguity about guilt and

punishment, right and wrong, that is present in the relief as well. Orestes' action was not a clear-cut instance either of just vengeance or of unjustified murder, and the figure of the nurse effectively sets the expressive tone in the relief; through her gesture of pushing away a thing she cannot face, she establishes a psychological dimension that indirectly recalls the complexity of Orestes' feelings about the deed.[26] Similarly, if we read the Gentileschi picture naively, the figure of Susanna appears, in her position and gestural response, to react to some judgment from the two men who loom high over her. Such ambiguity is brilliantly suited to the Susanna theme, reminding the viewer simultaneously of the Elders' false accusation of the woman and their threat to expose and punish her,

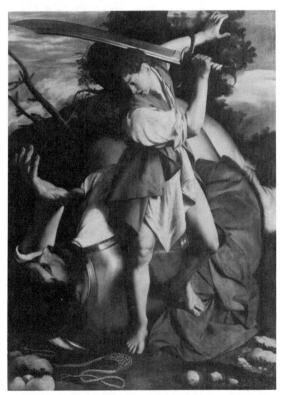

13. Orazio Gentileschi, *David and Goliath*, ca. 1605–10. Dublin, National Gallery of Ireland (*National Gallery of Ireland*).

and—a subtler echo—of the just punishment that came to the Elders when their own genuine guilt was exposed by Daniel.

The painter of *Susanna and the Elders,* then, rejected traditional allusions to Venus and drew an alternative expressive vocabulary from the Orestes sarcophagus to suggest both the anguish of the heroine and the punitive consequences of the event. Certainly by now, the reader will have anticipated the conclusion that it must have been the female Artemisia Gentileschi, rather than the male Orazio, who made such an artistic decision. While I believe that the evidence of the sarcophagus quotation does support that conclusion, the problem is complicated by the fact that Orazio Gentileschi also borrowed from the Orestes sarcophagus a pose for the figure of David in his Dublin *David and Goliath* [13], a picture that is close in date to the *Susanna*.[27] Does this mean that Orazio, who unquestionably painted the *David,* must also have painted the *Susanna?* Or that he brought the sarcophagus to the attention of his daughter who, in incorporating a pose from it in her *Susanna,* was reflecting her father's interests rather than her own? Neither, I think, if we examine closely the nature of the borrowing in each case. Evidently, the swashbuckling pose of the male hero, Orestes, and his interaction with fallen bodies, were the elements that interested Orazio and shaped his conception of this active version of the David theme, a version that is sharply contrasted with the contemplative *Davids* (Spada, Berlin-Dahlem) of the same period, which were built upon different classical prototypes.[28] In the Dublin *David,* Orazio incorporated part of the nurse's gesture in the hero's left hand, in order to develop a more energetic and gracefully balanced figure than the Orestes of the sarcophagus. This transplanted gesture differs markedly from its counterpart in the *Susanna,* where it is what we might call functional rather than decorative, serving by its pivotal placement to inter-

14. Artemisia Gentileschi, *Susanna and the Elders,* detail. Pommersfelden, Schloss Weissenstein, Collection Dr. Karl Graf von Schönborn- Wiesentheid (*Brooklyn Museum*).

rupt the compositional flow and to convey intense inner feeling.

It is very unlikely that Orazio would make of a single antique prototype two such entirely different expressive uses as are made of the nurse in the *Susanna* and the Dublin *David,* and particularly not during a single brief period of his career. Orazio's use of the Orestes sarcophagus may have directed Artemisia's attention to it, but the difference between the pictorial derivations establishes beyond doubt that it is Artemisia's creative imagination we see at work in the *Susanna.* Looking at the sarcophagus with different eyes, female eyes, she saw the gesture of the nurse as of central, not peripheral, importance, and chose it to form the expressive core of the *Susanna.*

The conception of the figure of Susanna involves, of course, more than a fortuitous classical quotation, since the rudimentary gesture has been developed into a fully realized fe-

male nude, and set in a new pictorial context. As an almost totally nude figure, Susanna would not be a complete anomaly in either artist's work, but another point in favor of Artemisia's authorship is the figure's uncompromising naturalism, since as a woman she had access only to female nude models, while male artists in general during the sixteenth and seventeenth centuries usually worked from male models, improvising their transformation into women where required.[29] Susanna's body is persuasively composed of flesh; it is articulated by specific touches of realism that are unflattering by conventional standards of beauty, such as the groin wrinkle, the crow's foot wrinkles at the top of her right arm, and the lines in her neck [14]. The naturalistically pendant breast, the recognizably feminine abdomen, and the awkwardly proportioned legs further attest that this figure was closely studied from life. By contrast, Orazio Gentileschi's relatively rare nude and

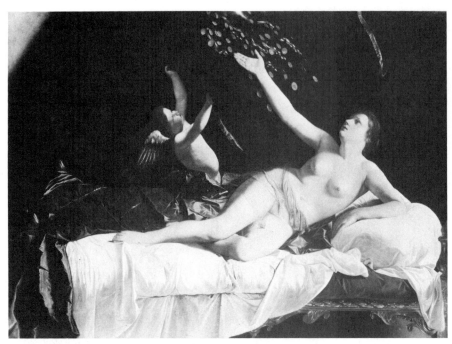

15

partly nude females, for example, his *Danae* [15] in Cleveland of 1621–22, and his Vienna *Magdalene* of the late 1620s, are more idealized, with inorganic, molded breasts and little anatomical articulation.

The difference between Artemisia's and Orazio's treatment of female figures is more fundamental, however, than their approaches to anatomical drawing. While women figure prominently in Orazio's paintings, in such themes as Judith and Holofernes, Lot and His Daughters, the Rest on the Flight into Egypt, or St. Cecilia (perhaps significantly, no Susannas are known), their range of expression is basically passive. Orazio, whose general preference was for quiet and meditative themes, portrayed even his most active female characters, Judith and her maidservant [16], in a moment of watching and waiting, suggesting through the women's anxious glances in two directions the existence of a pervasive outside force more powerful than the heroines. By contrast, Artemisia's Detroit and Pitti *Judiths* [17] react to a specific danger from a single

direction, indicating that the threat is both life-sized and local.[30]

The Schönborn Susanna behaves more like Artemisia's Judiths than Orazio's, in her physically active resistance of her oppressors and in her expressive intensity. She conveys through her awkward pose and her nudity the full range of feelings of anxiety, fear and shame felt by a victimized woman faced with a choice between rape and slanderous public denouncement. As a pictorial conception, Susanna presents an image rare in art, of a three-dimensional female character who is heroic in the classical sense. For in her struggle against forces ultimately beyond her control, she exhibits a spectrum of human emotions that move us, as with Oedipus or Achilles, both to pity and to awe.

The uniqueness of Artemisia's interpretation is further confirmed by the existence of two examples of the Susanna theme that are based in part upon her version. The first [18] is a painting by Simone Cantarini in the Pinacoteca, Bologna, dating from 1640–42.[31]

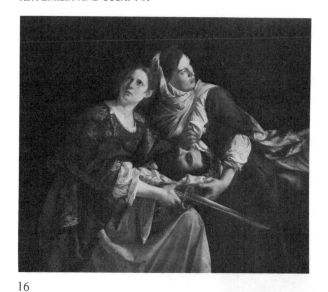

16

15. Orazio Gentileschi, *Danae,* 1621–22. The Cleveland Museum of Art, Purchase, Leonard C. Hanna, Jr. Bequest (photo: *Cleveland Museum of Art*).

16. Orazio Gentileschi, *Judith and Her Maidservant,* ca. 1610–12. Hartford, Wadsworth Atheneum (*Wadsworth Atheneum*).

17. Artemisia Gentileschi, *Judith and Her Maidservant,* ca. 1625. The Detroit Institute of Arts (*Detroit Institute*).

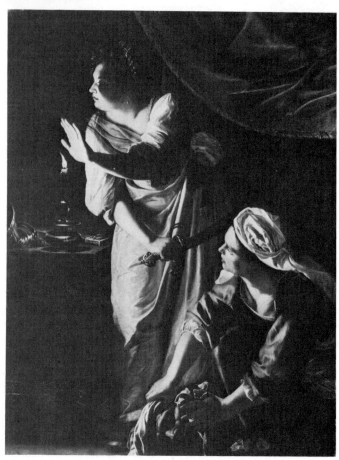

17

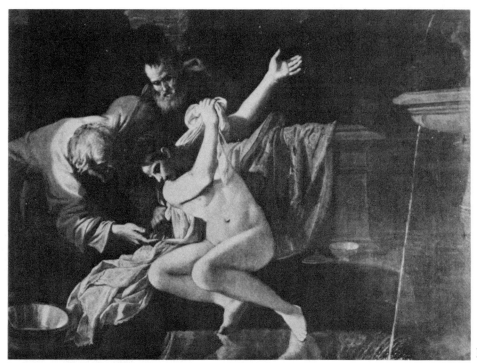

18

Susanna in this picture repeats Artemisia's pose histrionically and without inner motivation, while the relocation of the Elders makes Susanna's gesture pointless. The picture is a classic instance of an artist borrowing a pose without understanding its expressive function. The second picture, in the Palazzo Corsini, Rome [19], by an anonymous Bolognese artist of the seventeenth century, presents a Susanna whose gesture is more faithful in spirit both to Artemisia and the Orestes sarcophagus, with a more dignified sense of measure and of physical bulk than is seen in Cantarini's flyaway figure. Yet here too the sympathetic treatment of the Elders and the subliminal sexual message suggested through the spotlighted earring betray an essentially masculine conception of the theme. Through their own internal inconsistencies, these paintings reveal their derivative nature, and they demonstrate as well that a portrayal of Susanna from the heroine's viewpoint was a rare achievement indeed in Renaissance and

Baroque art, unattainable even by imitators of such a model.

One must acknowledge that in differentiating between Orazio and Artemisia Gentileschi, and then between Artemisia and her male imitators, on the grounds of their respective treatments of a female character, one runs the risk of oversimplification. Yet it is rare that we know anything so categoric about two artists' psyches as we do about Artemisia and her father, distinguished as they are by sex, and consequently by attitude and experience. Particularly in view of what we today would call the feminist cast of much of Artemisia's subsequent work,[32] it is reasonable to propose in this instance that the consideration of temperamental probability may be as valid as connoisseurship of style in solving the attribution problem.

And the Susanna problem is not an isolated one. Women artists in history are now being rediscovered in increasing numbers, and because their artistic identities have so often

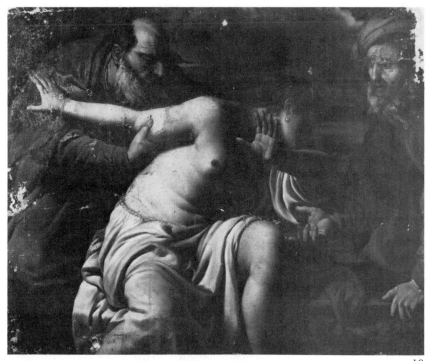

18. Simone Cantarini,
Susanna and the Elders,
1640–42. Bologna,
Pinacoteca (*Frick Art
Reference Library*).

19. Anonymous artist,
Susanna and the Elders,
17th century. Rome,
Palazzo Corsini
(*Gabinetto Fotografico
Nazionale*).

19

been subsumed under the names of their fathers and husbands, it is important to have reliable bases for distinguishing the women's work. Stylistic considerations are often of limited value since, as we have seen with Artemisia and Orazio, the pupil was usually an eager disciple in the master's style. Yet if Morelli's hypothesis may be applied here, the artist functioning on an unconscious level betrays personal traits—traits in this case happily more interesting than Morellian earlobes and fingernails—that offer rich evidence for discovering his or her identity. This is not to insist that all art by women bears some inevitable stamp of femininity; women have been as talented as men in learning the common denominators of style and expression in specific cultures. It is, however, to suggest that the definitive assignment of sex roles in history has created fundamental differences between the sexes in their perception, experience and expectations of the world, differences that cannot help but have been

carried over into the creative process, where they have sometimes left their tracks. We need not decide whether sex-role differentiation has been a good thing, or whether art has been the richer or poorer for it, to observe that the sow's ear of sexism has given us at least one silk purse: an art historical tool for distinguishing between male and female artistic identities.

These considerations apply in the case of another *Susanna and the Elders* that has been connected with the Gentileschi. A picture in the collection of the Marquess of Exeter, at Burghley House [20], was formerly exhibited as a work of Orazio and is presently ascribed to Artemisia.[33] No scholar has vigorously defended the Artemisia attribution; Bissell and Harris both merely consider it "possible," with Harris suggesting a date in the 1620s.[34] If Artemisia were the artist, the concreteness of detail, the firmness of contour and the large scale of figures in relation to format would indeed mandate a dating in the 1620s or early

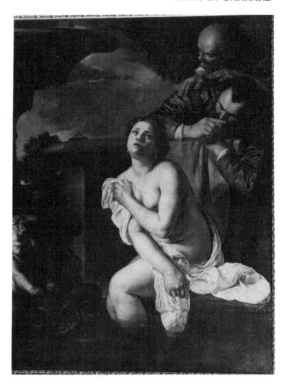

20. Anonymous artist, *Susanna and the Elders,* 17th century. Burghley House, Collection of the Marquess of Exeter (*Courtauld Institute*).

1630s, since Artemisia's later paintings of the 1640s differ appreciably in style from the Burghley House picture, offering smaller, more fluidly painted, and less solid figures. Yet this English *Susanna* is totally inconsistent with Artemisia's treatment of female characters in the earlier period. The work shows no interpretative continuity with the Schönborn picture, but reverts instead to the Carracci and Domenichino prototypes, reintroducing a seductive, Venus pudica pose and upturned eyes, and an environment swelling with Cupids and spurting fountains. It is inconceivable that the Burghley House *Susanna,* as an Artemisia Gentileschi, could be contemporary with the heroic and anti-romantic *Judith and Holofernes* in Detroit. Other typological differences, such as the broad noses of the three characters in this picture that contrast markedly with Artemisia's preferred narrow, pointed nose type, merely serve to confirm one's instinctive reaction to reject

this attribution because its expressive character would have been alien to the young Artemisia. But while we should also reject Orazio as the artist on similar formal grounds—the faces and the female anatomy, in particular, do not correspond to his usual types—it would be difficult to assert with the same confidence as with Artemisia that the nature of expression is sharply out of character for the artist.

The simple fact that Artemisia Gentileschi was female is sufficient to explain her uniquely sympathetic treatment of the Susanna theme. Yet one important event in Artemisia's personal history provides a parallel between art and life that is too extraordinary to be passed over. In the spring of 1611 Artemisia was allegedly raped by Agostino Tassi, Orazio's colleague whom Orazio had hired to teach Artemisia perspective. Orazio brought suit, and after a trial that lasted five months, Tassi, who had earlier been convicted of ar-

ranging his wife's murder, was sentenced to eight months in prison. He was subsequently acquitted, while Artemisia, whose testimony was put to the test of torture by thumbscrew, acquired a reputation as a licentious woman that has persisted to this day. Not only does the Susanna theme correspond to the real incident in its components of sexual assault, public trial, conflicting testimony and punishment, but this particular picture corresponds as well in its emphasis upon the girl's personal anguish, and in certain telling details.

In no other version of the subject known to me are the Elders shown whispering to one another. The motif heightens the conspiratorial character of their act, and suggests allusively the whispering campaign that was the Elders' specific threat, to ruin Susanna's reputation through slander. Artemisia's reputation figured prominently in her rape experience, a fact attested by Orazio's speedy arrangement of her marriage to a Florentine shortly after the trial to spare her the glare of publicity in Rome.[35] Artemisia, moreover, like Susanna, had two assailants. Orazio mentioned in the proceedings of the trial that Tassi had an accomplice, a certain Cosimo Quorli, who joined him in the rape; Orazio's statement was corroborated by Tutia, Artemisia's guardian, who independently implicated Quorli in the affair.[36] With exact biographic correspondences such as these, one is tempted to interpret as an echo of personal experience the peculiarly concrete Elder on the left [14], whose depiction as a thick-haired younger man is, as far as I can determine, completely unique in Susanna pictures.

The most logical explanation for the unusual iconographic character of the Schönborn *Susanna* is that it reflects the real situation in which the young Artemisia found herself. Yet the date, now authenticated, clearly reads 1610, while the rape occurred a few days after Easter, 1611.[37] But can the manifest connections between the painting and Artemisia's experience really be coinci-

dental? In order to understand what happened, we must look more closely at the circumstances surrounding the rape, an event which has remained controversial despite the fact that Tassi was convicted of the crime.

The truth of Orazio's testimony at the trial has consistently been doubted by the scholars, predominantly male, who have touched on the subject of Artemisia's rape. For them, her innocence is compromised by the fact that while Orazio claimed at the trial that she was a minor when the rape occurred, she was actually seventeen at the time; and they also see as contradictory and incriminating his claim that she had been raped "many, many times."[38] A fuller consideration of rape reminds us, however, that sexual coercion can take a range of forms. Artemisia was very clear in her own trial testimony about her experience and her subsequent expectations. She alleged that Tassi had planned to seduce her, but instead took an opportunity when she was painting alone to assault her sexually, an assault she resisted vigorously, to the point of wounding him.[39] After the rape, Tassi promised to marry her to quiet her. For that reason, she said, she considered herself subsequently to be his wife, but when he didn't keep his word, she revealed the incident to her father, who then filed charges against Tassi. That marriage was the expected outcome is further illustrated in Artemisia's gallows-humor outburst at Tassi when she was tortured with thumbscrews: "This is the ring you give me, and these the promises!"[40]

Implicit in Artemisia's admission that she thought of herself as Tassi's wife following the rape is the probability that she continued to have sexual relations with him, but the reality of this experience must be understood in the context of law and custom. In seventeenth-century Italy, as in biblical times, and in Sicily even today, a raped woman was considered damaged property, spoiled for marriage to anyone other than her violator.[41] Hence there was strong social pressure for

the rapist to marry her. After being raped, Artemisia's best chance for salvaging her honor would have been to go along with the sexual demands of the rapist, since that would have been her only leverage for getting him to marry her. Orazio's accusation, that Tassi raped her many times, was perhaps not far off the mark.

Tassi's gambit for escaping his obligation was to cloud the issue of who had deflowered Artemisia. His erstwhile friend G. B. Stiattesi testified on March 24 that while Tassi loved Artemisia, he could not marry her because Cosimo Quorli had already taken advantage of her.[42] Five days after that, Tassi accused Stiattesi of having raped her himself, then added two days later that a Modenese painter Gironimo had raped her, and that he (Tassi) had helped to beat him up.[43] All of this "evidence" is too patently self-serving to the cause of the accused Tassi to be taken seriously, yet it exposes the underlying issue in the trial, which was to determine whether or not Tassi was personally guilty of having damaged the legal property of Orazio Gentileschi. Orazio himself made this explicit in his initial appeal, describing the rape as an ugly act which brought grave and enormous damage to—none other than himself, the "povero oratore."[44]

Artemisia's personal sexual feelings were no more relevant to these strictly legal proceedings than were Susanna's toward the Elders, yet historians have dealt with Artemisia in the same way that Susanna was treated by artists and theologians: she has been the butt of one long historical dirty joke. R. Ward Bissell and Richard Spear, scholars who have written perceptively and objectively about Artemisia's life, nevertheless have each inserted a note of irrelevant skepticism by putting the word "rape" in quotation marks.[45] In his popularized Lives of the Painters, John Canaday speaks of the "unsavory—or savory, as you wish—lawsuit," and, hinting broadly that Artemisia's experience with Tassi may

not have been "introductory," offers the gratuitous information that "she demonstrated until her death . . . an enduring enthusiasm for the art of love that paralleled her very great talent as a painter."[46] Although Artemisia's reputation as a sexual libertine flourished in the eighteenth century, when she was described by an English commentator as "famous all over Europe for her amours as for her painting,"[47] this legend appears to have been based upon little other than Tassi's self-protective charge of her promiscuity and the scandal of the trial.[48] Wittkower caught the bitter irony of the fact that Tassi, whose "escapades" included "rape, incest, sodomy, lechery, and possibly homicide," was remembered by biographers as a competent painter liked for his good humor and wit, who eventually even made up with his old friend Orazio Gentileschi.[49] Yet Wittkower parallels this observation with the extraordinary description of Artemisia as "a lascivious and precocious girl," levying once again upon Artemisia the undeserved defamation of character that Tassi undeservingly escaped. If twentieth-century scholars can unthinkingly perpetuate such chauvinist attitudes, one can only imagine what Artemisia's male contemporaries had to say. Orazio may have redeemed her honor through the arranged marriage, but he could not protect her ultimate reputation from the undying masculine assumption that, if a woman is raped, she must have asked for it.

Looked at from this perspective, the painting of Susanna and the Elders may literally document Artemisia's innocence and honest testimony in the trial. Susanna, like Artemisia, endured sexual persecution at the hands of two men for the sake of preserving her respectability. As it turned out, Artemisia's protestation of innocence, like Susanna's, was not accepted at face value, and it took a trial to establish that she had indeed been assaulted. And while each woman was eventually vindicated, both were permanently stig-

matized as primarily sexual creatures as a result of sexual acts imposed upon them by others. Artemisia's choice of the Susanna theme and her unorthodox treatment of it formed a perfect vehicle for the expression of the sexual victim's point of view, even though she may well have carried out such a personal statement on a deeply unconscious level.

But how are we to account for the discrepancy between the date on the painting, 1610, and the date of the rape, 1611? One possible explanation is that the picture was painted shortly after the rape, but falsely inscribed with the date 1610, a decision that would undoubtedly have been that of Orazio, for the dual purpose of establishing his daughter's early competence as a painter—which he is known to have wanted to do[50]—and of concealing the direct and potentially embarrassing relation between the picture's content and the artist's personal trauma. Such a purpose would have been served by the conspicuous addition of the earlier date beneath Artemisia's name. Moreover, if Orazio were willing to falsify her age at the trial, one presumes he would not have hesitated to falsify a date on a painting.

A more likely solution, however, is one that does not call for the hypothesis of a deception. Artemisia may well have experienced sexual harassment for some time before the rape actually occurred. She suggests as much in her trial testimony, in which she describes the efforts of Tassi to seduce her.[51] Tassi, who had come to Rome in 1610, and whose friendship with Orazio must have developed in that year,[52] was a frequent visitor to the Gentileschi household. According to Artemisia's testimony, Tassi and his friend Cosimo Quorli pressured her for sexual favors with the taunt that she had already given them to a household servant. Although Artemisia fixed the period of Tassi's attentions to her as shortly before the rape itself— that is, in the spring of 1611—it is by no means certain from the trial evidence exactly when Tassi's acquaintance with Artemisia began. Moreover, the innuendoes about her promiscuity made by Tassi and Quorli, and her defensive responses to them, suggest that the question of her sexual availability had been of interest to several men in her immediate environment, perhaps for a long while.

What the painting gives us then is a reflection, not of the rape itself, but rather of how the young woman artist felt about her own sexual vulnerability in the year 1610. It is significant that the *Susanna* does not express the violence of rape, but the intimidating pressure of the threat of rape. Artemisia's response to the rape itself is expressed in the dark and bloody *Judith Decapitating Holofernes* in the Uffizi [21] painted shortly after her marriage and move to Florence, in which—as even the most conservative writers have realized—Judith's decapitation of Holofernes appears to provide a pictorial equivalent for the punishment of Agostino Tassi. Once we acknowledge, as we must, that Artemisia Gentileschi's early pictures are vehicles of personal expression to an extraordinary degree, we can trace the progress of her experience, first as the victim of sexual intimidation, and then of rape—two phases of a continuous sequence that find their pictorial counterparts in the *Susanna* and the Uffizi *Judith* respectively.

Artemisia's continuing personal interest in the Susanna theme is measured by the fact that, the Burghley House picture aside, there are four other recorded paintings of Susanna and the Elders by her.[53] One of these, painted the year before the artist died, is likely to have been her last picture,[54] and thus the subject effectively brackets her entire career. The late dates of these paintings suggest that none is likely to have equaled the Schönborn picture in originality and in the intensity of personal expression. Rather, Artemisia's incipient social challenge represented in her earliest known picture was developed in the sequence of *Judiths* of the late teens and

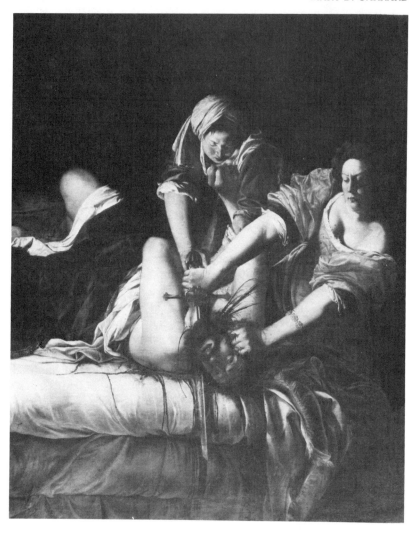

21. Artemisia
Gentileschi, *Judith
Decapitating Holofernes,*
ca. 1614–20. Florence,
Uffizi (*Alinari*).

twenties. Ironically, Artemisia's *Judiths* are routinely characterized as "castrating" and "violent," while the early *Susanna* has, we may assume from critical silence, been regarded as expressively benign. Writers and lecturers who respond with acute sensitivity to a scene in which violence is done to men, have passed over a picture that gives full expression to an equivalent female fear, the menace of rape, an event that is no less menacing because the act is not shown.[55] Seen metaphorically, Artemisia's *Susanna and the*

Elders differs significantly from her *Judiths,* however, in offering not one woman's fantasy revenge, but a sober expression of the broader situation which gives rise to that extreme solution: the reality of women's confined and vulnerable position in a society whose rules are made by men.

Manifestly, a seventeen-year-old girl brought up in an unquestioned patriarchal world could not have consciously intended all this. But as all great artists are those who can convert unconscious emotions into palpable

form without intervention of the socialized brain—and we accept this in a Michelangelo, a Rembrandt or a Goya as the explanation for their articulation of more deeply human values than those espoused by the cultures in which they functioned—it is more than possible that the young Artemisia Gentileschi, the victim of a traumatic sexual experience and the later-to-be defiant advocate of female capability, should have drawn subconsciously from the wellspring of her female identity and experience to humanize the treatment of a biblical theme that men had distorted almost beyond recognition.

NOTES

Author's note: I am grateful to the American Association of University Women Educational Foundation for a fellowship awarded me in 1978–79, which made it possible for me to write this essay during that academic year. Special thanks are also due to Norma Broude, whose incisive suggestions helped to strengthen this study in many ways.

1. See Ann Sutherland Harris and Linda Nochlin, *Women Artists: 1550–1950,* Los Angeles County Museum of Art; New York, 1976. The exhibition opened in Los Angeles, December 1976, and traveled to Austin, Texas; Pittsburgh; and Brooklyn.

2. The painting has been in the family collection of Dr. Karl Graf von Schönborn, Pommersfelden, Schloss Weissenstein, at least since the early eighteenth century. A reference of 1715 in the family archive mentions the painting of *Susanna* as a work of Orazio Gentileschi. I am grateful to Dr. Schönborn for generously supplying information on the picture. The *Susanna and the Elders* measures 67 by 47⅝ inches and is painted in oil on canvas.

3. R. Longhi, "Ultimi studi sul Caravaggio e la sua cerchia," *Proporzioni,* I (1943), p. 47, n. 38. See also A. Emiliani, "Orazio Gentileschi: nuove proposte per il viaggio marchigiano," *Paragone,* 9, no. 102 (1958), p. 42.

4. R. Ward Bissell, "Artemisia Gentileschi—A New Documented Chronology," *The Art Bulletin,* 50, June 1968, pp. 153ff., especially p. 157.

5. H. Voss, *Die Malerei des Barock in Rom,* Berlin, 1925, p. 463.

6. Harris and Nochlin, p. 120.

7. The conservator pointed out that the white highlights visible on the left portion of the signature fade as the inscription passes into the shadow cast by Susanna's right leg, a carefully thought-out detail that appears to have been part of the original conception. Some damages in this passage have been repaired by restorers, but these are easily distinguished from the original pigment. Mrs. Sack confirmed that surface cracks run through the lettering, and this can be seen indistinctly in Figure 2. In her opinion, the picture is in unusually good condition, with much of the freshness of the original color still preserved.

8. In a deposition of 1612, Orazio declared that Artemisia had been painting for three years. See Bissell, p. 154. By this, Orazio probably meant (as Norma Broude suggested to me) that she had been painting independently for three years, since her apprenticeship would undoubtedly have begun before the age of sixteen.

9. A. Moir, *The Italian Followers of Caravaggio,* Cambridge, Mass., 1967, Vol. I, p. 100.

10. Longhi, p. 47, no. 38. Bissell, in his doctoral dissertation (*The Baroque Painter Orazio Gentileschi: His Career in Italy,* University of Michigan, 1966, Vol. II, p. 262), aptly questions why Orazio would have wanted the name of his young daughter on one of his own paintings.

11. The *Susanna* in the Doria-Pamphilj Gallery is thought to be by Domenichino by Richard Spear (*Caravaggio and His Followers,* Cleveland, 1967, p. 54) and by Ann Harris (Harris and Nochlin, p. 120). D. Posner, *Annibale Carracci: A Study in the Reform of Italian Painting Around 1590,* London, 1971, Vol. II, nos. 57 and 131A, has published the painting as possibly by Lanfranco, after Annibale's lost original. For literature on Annibale's print of ca. 1590, see D. Bohlin, *Prints and Related Drawings by the Carracci Family,* Nation-

al Gallery of Art, Washington, D.C., 1979, p. 444.

12. Most versions of the Susanna theme date from this period, with only occasional examples from before the sixteenth century and after the eighteenth. See L. Reau, *L'iconographie de l'art chrétien,* Paris, 1957, Vol. II, pp. 393ff., and A. Pigler, *Barockthemen,* Budapest, 1956, Vol. I, pp. 218ff.

13. Speaking of Rubens's several depictions of the Susanna theme, Rooses remarks: "Il est permis de croire que, pour lui, le charme du sujet n'était pas tant la chasteté de l'héroïne biblique que l'occasion de montrer une belle femme nue, deux audacieux qui tentent une enterprise galante et les émotions fort diverses qui en résultent pour chacun des personnages"—M. Rooses, *L'Oeuvre de P. P. Rubens,* Antwerp, 1886, Vol. I, p. 171.

14. In her recent study of rape, Susan Brownmiller offers a graphic parallel from military history. Examining rape as an acceptable corollary of wartime conquest, she observes that in a situation in which killing is viewed as "heroic behavior sanctioned by one's government or cause," other forms of violence acquire part of that heroic luster—S. Brownmiller, *Against Our Will: Men, Women and Rape,* New York, 1975, pp. 31ff.

15. S. B. Pomeroy, in *Goddesses, Whores, Wives and Slaves: Women in Classical Antiquity,* New York, 1975, p. 12, comments upon the "passivity of the woman [who] never enticed or seduced the god but was instead the victim of his spontaneous lust," in the "endless catalogue of rape in Greek myth."

16. M. C. Leach, "Rubens' *Susanna and the Elders* in Munich and Some Early Copies," *Print Review,* 5 (1976), pp. 120–27, especially p. 125. Useful further bibliography on the Susanna theme is given by Leach, p. 121, n. 8. Despite its theological popularity, the Susanna theme was only rarely treated in medieval art; see K. Künstle, *Ikonographie der Christlichen Kunst,* Freiburg-im-Breisgau, 1928, Vol. I, pp. 302–03, and Reau, *L'iconographie,* Vol. II, p. 395, for a few examples.

17. Leach, p. 125.

18. The story of Susanna and the Elders is believed by some scholars to have been based upon a legend that symbolized a struggle between the Pharisees and Saducees over laws concerning false accusation and false testimony, the Pharisees having instituted as reforms over laxer Saducee prac-

tices the thorough examination of witnesses and the severe punishment of false witnesses. See W. O. E. Oesterley, *The Books of the Apocrypha,* London, 1915, pp. 391ff. An alternative view is represented by scholars who argued that the Susanna story derives from a combination of folklore and myth. See P. F. Casey, *The Susanna Theme in German Literature,* Bonn, 1976, pp. 21ff. Scholars generally agree that the story was written in Hebrew during the reign of Alexander Jannaeus (102–75 B.C.). The story was appended to the Book of Daniel, although the two Daniels are historically unrelated, and acquired its present position as chapter 13 in that book in 1547, as decreed by the Council of Trent.

19. See Phyllis Bird, "Images of Women in the Old Testament," in *Religion and Sexism,* ed. by Rosemary R. Ruether, New York, 1974, pp. 48ff., especially p. 51.

20. Reau, *L'iconographie,* vol. II, pp. 396–98, lists as many Susannas at the Bath as he does Stonings or Judgments combined; Pigler, *Barockthemen,* pp. 218ff., gives nearly eight times as many Susannas at the Bath as Judgments, and lists no Stonings.

21. A study in the Louvre connects Rembrandt's Berlin *Susanna* with a painting of 1614 by Pieter Lastman that is also in the Dahlem Museum (see H. Gerson, *Rembrandt Paintings,* Amsterdam, 1968, illus. p. 94 and fig. a, p. 327), but Rembrandt deviates from Lastman in repeating the Medici Venus pose for Susanna that he used in his 1637 *Susanna* in The Hague.

22. The connection between Rubens's Susanna figure and the famous antique model has been observed by a number of writers; see Leach, p. 123, n. 14. Leach himself attempts to distinguish the expressive character of Rubens's Susanna in the Munich painting from that seen in several copies of the picture by other artists, suggesting that the copyists mistakenly converted a "carefully selected gesture of modesty" into a "coy and inviting gesture." In my view, Leach attaches too much importance to an inconspicuous detail added by the copyists, Susanna's grasping of a lock of her hair (surely an Aphrodite Anadyomene reference with its bath-sea-fertility associations, and not a Vanitas, as Leach suggests), and too little importance to the overtly seductive facial expression in Rubens's original *Susanna*—an expression that surpasses the

copies in coyness (not fear), and countermands whatever modesty the "closed-composition" pose may convey.

23. See C. Robert, *Die Antike Sarcophagreliefs im auftrage des kaiserlich deutschen archaeologischen Instituts,* Berlin, 1890–1919, Vol. II, pp. 155, 157, and 171. Raphael drew a number of the figures seen in the Loggia frescoes from this sarcophagus, as Robert notes. Titian also used poses taken from the Orestes sarcophagus, e.g., the figure of Bacchus in the London *Bacchus and Ariadne,* which is based upon Orestes, and the figure of Goliath in the S. M. della Salute *David and Goliath,* which is based upon the fallen Aegisthus. See O. Brendel, "Borrowings from Ancient Art in Titian," *The Art Bulletin,* 37 (1955), p. 118 and n. 19, and p. 121. The defensive gesture of the nurse also appears in Sebastiano del Piombo's *Raising of Lazarus* (National Gallery, London), in the Giulio/Raphael *Repulse of Attila* in the Vatican Sala di Costantino, and in the eighteenth century in Fuseli's *Oedipus Curses his Son Polynices* (Paul Mellon Collection).

24. See C. de Tolnay, *Michelangelo,* Princeton, N.J., 1945, Vol. II, p. 134, and fig. 304, which illustrates the Orestes sarcophagus in reverse. Tolnay credits Walther Horn for first observing the connection between Adam's gesture and the Orestes sarcophagus.

25. It is unlikely that the specific subject of the Orestes sarcophagus was known in either Michelangelo's or Artemisia's time, inasmuch as two learned early writers betrayed their own ignorance of the theme in their descriptions of the sarcophagi. In his Naples diary, Cassiano dal Pozzo identified a sarcophagus in the house of the Duke of Bracciano as having the same theme as the Vatican and Giustiniani sarcophagi with the note that a certain painter, Micheli, who worked for the duke had some information about what its subject might be (T. Schreiber, ed., *Unedirte römische Fundberichte aus italiënischen Archiven und Bibliotheken,* Leipzig, 1885, Vol. III, p. 37, no. 54). And when the Giustiniani sarcophagus was published in P. S. Bartoli's *Admiranda Romanorum antiquitatum* of 1693, Bellori, who wrote the notes that accompanied the engravings, resorted to a literal description of the action without identifying the characters, although nearly every other monument in the album is named by subject. Montfau-

con, in the eighteenth century, supposed that the relief commemorated one of the grandest deeds of antiquity, but admitted he did not know which one. It was apparently Winckelmann who first identified the subject of these celebrated sarcophagi as the story of Orestes avenging his father's death by slaying his mother Clytemnestra and her lover Aegisthus (J. J. Winckelmann, *Monuments inédits de l'antiquité,* Paris, 1809, Vol. III, pp. 26ff.; see also Robert, Vol. II, p. 130).

But if the early writers could not pinpoint the relief's theme, some at least understood the action generally to involve punishment. This is made explicit in a description of the Giustiniani sarcophagus written in 1550 by Fabricius, who names it as "this image in which some figures are punished...." ("servilium suppliciorum (simulachra) in quibus alii capite plectuntur, aliis brachium saxo impositum alio saxo frangitur...," G. Fabricius, *Roma,* 1550, p. 177, in J. Lipsius, *Roma illustrata sive Antiquitatum romanarum breviarium,* Amsterdam, 1689).

26. It may suffice to recall the intricate interplay of moral forces in Aeschylus' *Oresteia* through one critic's observation that while Orestes in the Odyssey kills his father's assassins "without a qualm of conscience" and is "completely successful and completely in the right," Aeschylus' Orestes is "right and wrong, his father's avenger and a guilty matricide and more, the vortex where the Furies and the gods converge with fresh intensity and effect"—W. B. Stanford, intro., *Aeschylus: The Oresteia,* trans. by R. Fagles, London, 1976, p. 42.

27. Bissell, *Orazio Gentileschi,* Vol. II, pp. 77ff., dates this *David* in the period between 1605–10. Moir, p. 70, places the picture in the second decade.

28. The pose assumed by Orazio's contemplative Davids is a familiar one in antique art, seen in depictions of the contest between Poseidon and Athena (e.g., the cameo in Naples upon which one of the fifteenth-century relief tondos in the Medici Palace cortile is based; see *Il tesoro di Lorenzo il Magnifico,* eds. N. Dacos, A. Giuliano, and U. Pannuti, Florence, 1973, Vol I, pl. ix, fig. 81, and cat. 6), and seen also in the *Odysseus Before Telemachus* in the Villa Albani; see Winckelmann, *Monuments inédits de l'antiquité,* Paris, 1809, Vol. III, no. 157.

29. In a paper delivered in a recent symposium,

The Carracci and Italian Art around 1600, National Gallery of Art, Washington, D.C., April 7, 1979, Carl Goldstein observed that the use of a female studio model was rare before the nineteenth century, as a result of the prevalent attitude that women had uglier bodies than men. Occasional specific mention of female models in contemporary descriptions of seventeenth-century Roman art academies indicates that these were unusual practices; see N. Pevsner, *Academies of Art, Past and Present,* Cambridge, Engl., 1940, pp. 73 and 77.

30. The Detroit *Judith* dates from the mid-1620s. See Bissell, *Orazio Gentileschi,* Vol. II, pp. 95ff. and 102ff., for a clarifying discussion of the several versions of the Judith theme by Orazio and Artemisia. See also Bissell's recent monograph, *Orazio Gentileschi and the Poetic Tradition in Caravaggesque Painting,* University Park, Pa., 1981, pp. 153–56.

31. See the exhibition catalogue compiled by C. Gnudi, *Nuove Acquisizioni per i Musei dello Stato, 1966–71,* Palazzo dell'Archiginnasio, Bologna, Sept. 28–Oct. 24, 1971, pp. 62–63. In his catalogue entry, Andrea Emiliani suggests these dates for the painting, connecting it with Cantarini's Roman journey. Emiliani considers Cantarini's *Susanna* to be a development of an idea first stated by the artist in a drawing of Ariadne (Brera, inv. 509). While I have not seen this drawing, Emiliani's statement that it shows the influence of Annibale Carracci's print of 1592 suggests that Ariadne's pose may not be especially similar to that of Cantarini's *Susanna.*

32. Although a thorough iconographic study of Artemisia's heroic female characters remains to be made, Ann Sutherland Harris has briefly discussed the artist's proto-feminist statements and has emphasized her preference for subjects with heroines; see Harris and Nochlin, pp. 118ff. See also M. D. Garrard, "Artemisia Gentileschi's Self-Portrait as the Allegory of Painting," *The Art Bulletin,* 62, March 1980, pp. 97–112.

33. See Bissell, p. 167.

34. Harris and Nochlin, p. 121, n. 18; Harris sees the influence of Guercino in the background and the color scheme.

35. See Bissell, p. 154, for a fuller account of Artemisia's marriage to Pietro Antonio di Vincenzo Stiattesi, who may, as Moir suggests (p. 99,

n. 101), have been related to the G. B. Stiattesi who testified on Tassi's behalf at the trial.

36. A. Bertolotti, "Agostino Tasso; suoi scolari e compagni pittori in Roma," *Giornale di Erudizione Artistica,* V. fasc. VII and VIII, July–August 1876, p. 200. Bertolotti's article contains a reduced transcription of the trial proceedings that are preserved in the Archivio di Stato, Rome. See Bissell, p. 153, no. 2, and p. 155.

37. Bissell, p. 154. In 1611, Easter fell on April 3.

38. See, for example, Bissell, p. 153, and also T. Pugliatti, *Agostino Tassi fra conformismo e libertà,* Rome, 1977, pp. 24 and 167.

39. Bertolotti, p. 201.

40. Bertolotti, p. 195, quoting from Passeri's biography of Tassi.

41. I am grateful to Malcolm Campbell for calling to my attention the modern vestiges of older practices concerning rape. On the traditions under which rape was seen as an offense against property, see in particular P. Bird, "Images of Women in the Old Testament," in *Religion and Sexism,* R. R. Reuther, ed., New York, 1974, pp. 51–52; and L. M. G. Clark and D. J. Lewis, *Rape: the Price of Coercive Sexuality,* Toronto, 1977, pp. 115ff.

42. Bertolotti, p. 202. See also Moir, p. 99, n. 101.

43. Bertolotti, p. 203. See also R. Wittkower, *Born Under Saturn,* New York, 1963, p. 163.

44. Bertolotti, p. 201.

45. Bissell, p. 153; Spear, p. 96.

46. J. Canaday, *The Lives of the Painters,* London, 1969, Vol. II, pp. 364 and 366.

47. From an anonymous note on Artemisia added to the English edition of Roger de Piles's *The Art of Painting,* London, 1754, p. 376.

48. Moir, Vol. I, p. 100, observes that these were the chief factors that conditioned reports of her reputation, mentioning in addition two scarcely damning bits of information: one, that she may have had some relationship with one of her roomers, and, two, that she had a reputation for writing good love letters. That Artemisia was defined in sexual terms even when not specifically accused of promiscuity is also shown in Baldinucci's anecdote concerning the portrait painted of her by G. F. Romanelli and the subsequent jealousy of his wife (F. Baldinucci, *Delle Notizie de' Professori del Disegno,* Florence, 1772, Vol. XII, pp. 9–13). Em-

phasis upon the artist's love life was sustained in a fictional romance about her, *Artemisia,* by Lucia Longhi Lopresti (pseud. Anna Banti), Florence, 1947.

49. Wittkower, p. 164.

50. Evidence that Orazio was anxious to publicize his daughter's precociousness is given by Bissell, p. 154. In any event, the picture would not have been painted later than 1614, since by then Artemisia was settled in Florence and consistently signed pictures with her Tuscan family name, Lomi. Also, the light and color arrangement of the Susanna, with its somewhat Venetian combination of blue, violet, red and olive green, is close to Orazio's color of the first decade, and differs markedly from the more intense chiaroscuro in the paintings of the early twenties.

51. Bertolotti, p. 201. The full text of the trial, which has just been published, came into my hands too late for me to be able to include sections of it here. See *Artemisia Gentileschi/Agostino Tassi: Atti di un processo per stupro,* E. Menzio, ed., Milan, 1981.

52. T. Pugliatti, *Agostino Tassi fra conformismo e libertà,* Rome, 1977, p. 19.

53. These include (1) a painting in England in the collection of Charles I, mentioned in Van der Doort's inventory as being in Henrietta Maria's chamber at Whitehall (*Walpole Society,* 37 [1960], p. 177); (2) a *Susanna* of the 1640s in the house of Dott. Luigi Romeo, Baron of S. Luigi, Naples, said to have been a pendant to the *Bathsheba* in Columbus, Ohio (see Bissell, p. 163, n. 82); (3) a signed *Susanna* in Brünn, Czechoslovakia, a heavily damaged and overpainted work, whose design, however, is said to resemble that of the Schönborn *Susanna* (see Bissell, p. 164); and (4) a *Susanna* signed and dated 1652, known only from the citations of Da Morrona and Lanzi that it was in the collection of Averardo de' Medici (see Bissell, p. 164). In addition to these, Longhi, *L'Arte,* 19 (1916), p. 299, attributed to Artemisia a *Susanna* in the Pinacoteca, Naples, that was previously ascribed to Stanzioni, and more recently, to F. Guarino.

54. See note 53 above, item (4), and Bissell, p. 164.

55. Cf. Germaine Greer: "The fear of sexual assault is a special fear: its intensity in women can best be likened to the male fear of castration"—G. Greer, "Seduction Is a Four Letter Word," in L. G. Schultz, ed., *Rape Victimology,* Springfield, Ill., 1975, p. 376. See also Greer's sound treatment of Artemisia Gentileschi in general and her discussion of the *Susanna* in particular in *The Obstacle Race: The Fortunes of Women Painters and Their Work,* New York, 1979, especially pp. 191–93. Greer's conclusions, published after this essay was written, accord with my own in several points.

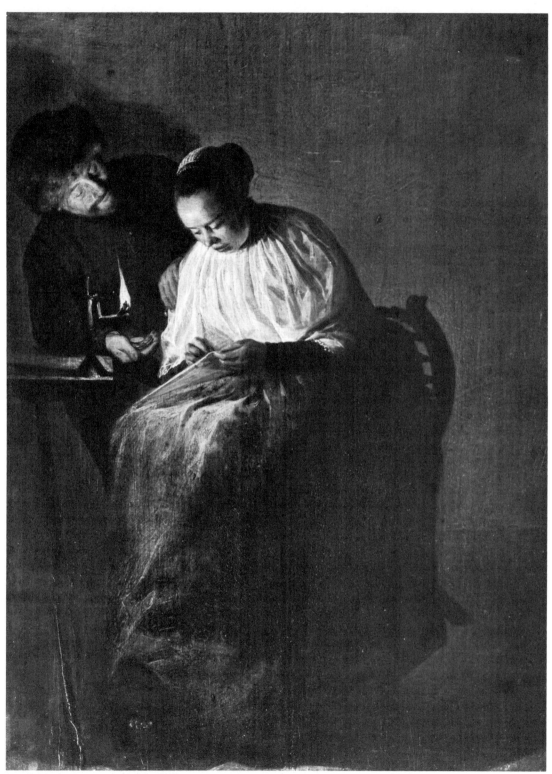

1. Judith Leyster, *The Proposition*, 1631. The Hague, Mauritshuis (*Mauritshuis*).

9

Judith Leyster's
Proposition—Between Virtue and Vice

�ký

FRIMA FOX HOFRICHTER

It has been three centuries since the death of the versatile Dutch genre, portrait, and still-life painter Judith Leyster (1609–1660), but it was only during the last women's movement that the pioneer study of her works was finally made. In 1927, Juliane Harms discussed Leyster's life, arranged her works in chronological order, and provided the first (and as yet only) published *catalogue raisonné* of her paintings.[1] Within six years after the appearance of these articles in *Oud-Holland,* other art historians added information to, or disputed points in, Harms's thesis. But from the mid-1930s until the present, there has been very little written about this artist.

Yet during her own lifetime, Leyster had been praised twice in the histories of the city of Haarlem (where she was born), once in 1627 by Samuel Ampzing in *Beschrijvinge ende lof der stadt Haerlem* when she was only eighteen,[2] and again in 1648 by Theodore Shrevel, who, punning on her last name,

called Leyster a "leading star in art."[3] She was admitted to the St. Luke's Guild in Haarlem in 1633, and is known to have had several students (documents concerning at least three students exist).[4] She married another Haarlem painter, Jan Miense Molenaer, in 1636, bore three children, and died in Heemstede, near Haarlem, in 1660.

During her fifty-one years, Judith Leyster worked in Haarlem, Utrecht, and Amsterdam; presumably she knew the masters of each school, including Hals, Honthorst and Terbrugghen, and Rembrandt, respectively. Her familiarity with the subjects and with the lighting and compositional techniques of each school is evident in her works. Indeed, her work was often attributed to the other masters because of certain similarities and was praised for this affinity; on the other hand, however, Leyster was condemned for this same reason—and more severely so for those works which show Frans Hals's influence. Even in current art historical literature on Dutch art, she is often quickly dismissed as a "clever" imitator of his. However, because of Leyster's training in Utrecht, as well as in

Frima Fox Hofrichter, "Judith Leyster's *Proposition*— Between Virtue and Vice," *The Feminist Art Journal,* Fall 1975, pp. 22–26. By permission of the author and *The Feminist Art Journal.*

Haarlem, many of her paintings actually owe little to Hals.

The *Proposition* [1][5] in the Mauritshuis, The Hague, confirms this view. This small panel painting is 12.2 inches high by 9.5 inches wide, bears her monogram, and is dated 1631. In the choice of subject, and the dark setting, lit only by an oil lamp, the influence of the Utrecht Caravaggisti is clear.

The proposition is initiated by the man as he leans over the woman's shoulder, with one hand on her upper arm and his other extended forward full of coins. She, without noticeable reaction, or perhaps with determined disinterest, sits in a chair with her feet propped on a footwarmer, concentrating on the sewing which she holds in her lap. Leyster is openly and clearly depicting a sexual proposition (the man is not offering the woman payment for the sewing!). However, it is not the subject, but rather Leyster's attitude toward this popular theme, which is our main concern.

The theme of propositions, prostitution, procuresses, and brothels, including seventeenth-century scenes of the Prodigal Son, was common in Northern art. Pigler, in his *Barockthemen*,[6] cites seventy-two scenes of ill-matched lovers and twenty-five others of love gardens, and this listing could easily be expanded. The popularity of the theme may be explained in part because the subject was common enough in life in seventeenth-century Holland. Despite the influence of Calvinism in the latter half of the sixteenth century, or perhaps because of it, there was a resurgence of brothels in the seventeenth century. Such paintings were probably appealing both as depictions of forbidden, but commonplace, pleasures and as works with moralizing intent.

The woman who is the recipient of a proposition or who is shown as an active member of a brothel is generally depicted as a more than willing participant.[7] The subject already appears in fifteenth-century engravings and

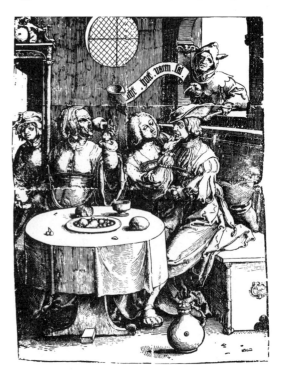

2. Lucas van Leyden, *The Prodigal Son*, woodcut, 1519 (*from Hollstein*, Dutch and Flemish Engravers, *vol. X, p. 217*).

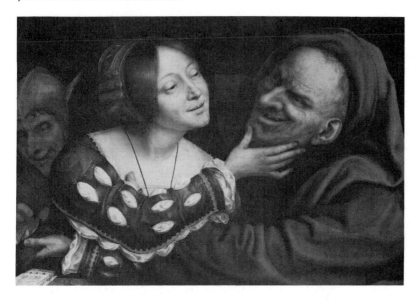

3. Quentin Metsys, *Ill-Matched Lovers*, ca. 1520. Washington, D.C., National Gallery of Art, Ailsa Mellon Bruce Fund, 1971 (*National Gallery*).

becomes even more popular in the sixteenth century. Especially popular are scenes of the Prodigal Son "wasting his life with riotous living" (Luke 15:31) and "devouring [his] life with harlots" (Luke 15:30), as in the print of 1519 by Lucas van Leyden [2], where the young woman in the center is seducing the "son" at the right, while, at the same time and unbeknownst to him, she is picking his pocket.[8]

This view of the theme is similar to that of Quentin Metsys's *Ill-Matched Lovers* of about 1520 [3],[9] and others of the same type, where money is used to compensate for the age of the elder participant (hence, an admission that they are ill-matched). The exchange of love, or sex, for money is quite clear, although the money is often being stolen by the woman rather than being given willingly by the man. Money—an essential element in prostitution—is, however, not seen in the "Merry Company" paintings of the 1630s, such as those of Jacob Duck and Dirck Hals. This type shows boisterous musical parties set in brothels, with much drinking and good times. Money may not have been necessary in these works because the activity is so obvi-

ous; it is, however, indicated in the scenes of ill-matched lovers or of procuresses so that the action depicted in those paintings may be clearly understood.

The procuress theme was particularly popular in Utrecht and is well illustrated by Baburen's *Procuress* of 1622 [4]. The entire cast is present: the old procuress at the right, the customer in the center, and the prostitute on the left. Each is a stereotype for a clearly defined role, and all are shown as bold, jocular, and certainly willing participants in this exchange of services for money.

However, Leyster's attitude toward the subject and her treatment of it differ from those of the Utrecht masters and from those of her contemporaries in general. Her *Proposition*, painted just one and a half years after she left the Utrecht area (she lived in Vreeland, near Utrecht, from 1628 to September 1629), recalls the Caravaggesque spirit in theme, time (a night scene), and light source (an oil lamp). But it is these similarities which serve to accent its differences. Leyster's work may, in fact, be considered a critical response to the paintings of her predecessors. Her depiction of the scene is contrary to the accept-

4. Dirck van Baburen, *The Procuress,* 1622. Boston, Museum of Fine Arts (*Boston Museum of Fine Arts*).

ed role assigned women in the paintings from the fifteenth to the seventeenth centuries, previously mentioned, in which they "fleece" men, pick their pockets, steal their money, seduce them, abuse them, and generally make fools of them.[10] The theme of prostitution exploits the idea of women using their wiles to degrade men and lead them to sin. Leyster's painting does not foster this image.

In her *Proposition,* the mood is not one of

carousing but of quiet intimacy. The woman, usually depicted as a willing participant in the adventure if not its instigator, is not shown that way here. She is not entertaining the leering cavalier who offers her money; she is neither playing a lute, nor drinking, nor wearing a low-cut dress[11]—nor is she accepting his offer. The embodiment of domestic virtue, she continues her sewing. Rather than encouraging the man's intentions, she be-

comes the embarrassed victim. The room is silent as we wait for her response. Leyster's woman is no harlot: she is an ordinary woman being propositioned—not an extraordinary circumstance. The difference in approach is unprecedented: it surely represents, to some degree, Leyster's viewpoint as a woman.

Leyster's *Proposition* is her only treatment of this subject. She did, however, paint two other pictures of women sewing, both night scenes and both with oil lamps: one of a woman alone, which was recorded in the G. Stein Collection, Paris, 1937, and the other of a woman with her two children, in the National Gallery of Ireland. Both of these works can be dated about 1633 and share with the picture in The Hague a sympathetic attitude toward women's domestic roles. But Leyster, in the Hague *Proposition,* is able to integrate the domestic and the erotic in a rare combination which still upholds the virtue of the woman.

This hypothesis becomes even more plausi-ble when we compare the *Proposition* with a copy of Leyster's work by an anonymous artist [5], sold from the Amédée Prouvost Collection, June 20, 1928. Along with other small changes,[12] this copy includes a wineglass on the table. Presumably, the copyist "correct-ed" the apparent ambiguity of Leyster's work by introducing the glass in order to explain, in the traditional way, what was really going on. The figures are put back in the roles as-signed to them through the years—once again, the reason for the offer of money is un-derstood only through seeing the woman as a temptress.

Additional evidence that Leyster's woman will not cooperate is suggested by Leyster's use of a footwarmer, propped beneath the woman's feet. A footwarmer is illustrated un-der the title "Favorite of Women,"[13] in Roemer Visscher's emblem book, *Sinne-Pop-pen* (1614); the epigram suggests, perhaps only half-jokingly, that because the footwarmer is such a prized possession in the

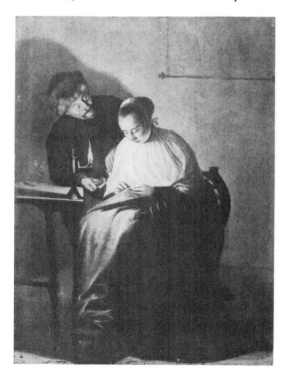

5. Anonymous, copy after Judith Leyster, *Proposition* (*Frima Fox Hofrichter*).

cold of winter—and even more so during the night—a man would really have to impress a woman to get her to move from it, a step Leyster's woman does not seem ready to take.

The intimate and restrained mood used by Leyster for the usually bawdy subject of propositions is not found again until the generation of Gerard Ter Borch, twenty-five years later. Ter Borch's numerous paintings of propositions are also quiet, intimate scenes, such as the so-called *Gallant Officer* [6] of

about 1665. As in Leyster's, one almost has to look twice to realize what is happening in these works. In fact, Ter Borch may even have seen Leyster's *Proposition* when he visited Haarlem in 1634, just three years after her painting was completed, and he may have remembered it when painting the same subject many years later. But Ter Borch's elegant setting and the quiet mood do not change the attitude of the artist or the intention of the officer here, who declares his

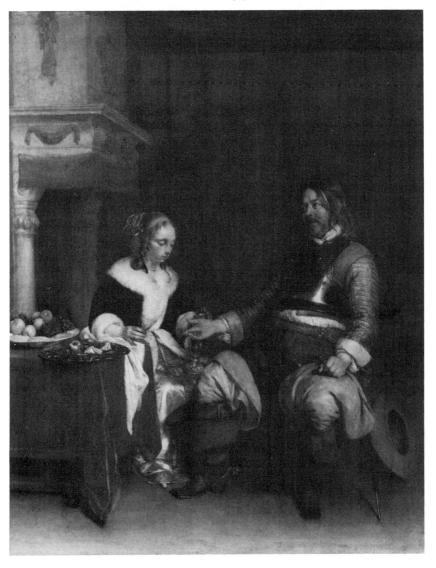

6. Gerard Ter Borch, *The Gallant Officer*, ca. 1665. Paris, Louvre (*Service de documentation photographique, Musées nationaux*).

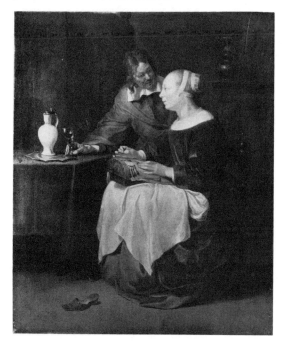

7. Gabriel Metsu, *An Offer of Wine*, ca. 1650. Vienna, Kunsthistorisches Museum (*Kunsthistorisches Museum*).

needs to the young woman with his open legs and his open palm filled with coins. For even in Ter Borch's intimate scenes, the men are entertained by the women who are clearly courtesans serving luscious fruit and wine. And although his work is a far cry from the blatant Caravaggesque procuresses, Ter Borch nevertheless does not concern himself with the circumstances or victimization of woman, but sees her only as the vehicle to fulfill the sexual relationship.

A painting which is closer in subject and composition, as well as mood, to Leyster's work is Gabriel Metsu's[14] *An Offer of Wine* [7] of the 1650s. Although here, unlike Leyster's, there is wine on the table, which supports the interpretation that this is a proposition, the action of the people and their placement is so close to hers as to suggest that the artist may have seen Leyster's work or a copy of it. Although there are earlier examples of a similar subject, Metsu's work here and in general is too close to Leyster's for the similarities to be coincidental. Frank-

lin W. Robinson, in his new monograph on Metsu, notes that a recurrent theme in Metsu's work is the sensitive woman victimized by the coarser man.[15] He cites Leyster's *Proposition* as a prototype for this theme. And Lawrence Gowing, in his book *Vermeer*, uses Metsu's painting to illustrate the idea of the interrupted moment (specifically, men interrupting women at their work), a theme he credits to the school of Frans Hals. In particular, Gowing cites Judith Leyster and her *Proposition* as a possible source for this continuing theme in both Metsu and Vermeer.[16] Thus, a link between two generations of genre painters is established, if only in this instance, through the work of Judith Leyster.

Even in recent studies of seventeenth-century Dutch painting, the genre painters are viewed in terms of two separate generations: one of the twenties and thirties and the other of the late fifties and sixties, with the former thought to exercise no influence upon the latter. Certainly, in the theme of prostitution, procuresses, brothels, and prodigal sons,

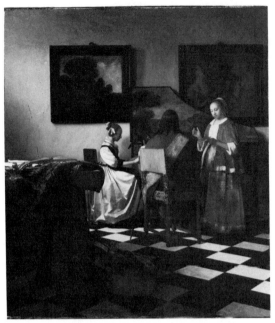

8. Jan Vermeer, *The Concert,* ca. 1660. Boston, Isabella Stewart Gardner Museum (*Isabella Stewart Gardner Museum*).

alone, one can see a continuum of this subject through the century. Yet there are, for example, deliberate allusions to the past in some of Vermeer's paintings of the 1660s. In one of them, *The Concert* [8], no doubt itself a brothel scene, hanging on the wall at the right is an earlier, blatant example of the procuress type, Baburen's *Procuress* of 1622, which has already been discussed [see 4].

Therefore, that the first generation of seventeenth-century genre painters exerted an influence on the later ones, or were in some way reflected in their work, can be seen in an evaluation of this subject matter. That the work of Metsu and Ter Borch was influenced by the intimate proposition scene of Judith Leyster is certainly possible. Her work may have inspired the quieter mood in genre painting of the proposition theme. Certainly, if Judith Leyster was not their direct influence, she was, at the very least, their unrecognized forerunner.

NOTES

Author's note: This essay was presented in a slightly different form as a paper for the College Art Association in January 1975. I should like to thank Professor Ann Sutherland Harris for first introducing me to the works of Judith Leyster. Her unwavering support and genuine enthusiasm for this work and her continued encouragement throughout the writing of my M.A. thesis, *Judith Leyster: A Preliminary Catalogue* (Hunter College), has meant a great deal to me. I would also like to thank Professor Martin Eidelberg for his prodding criticism and quiet encouragement during the writing of this essay and the C.A.A. paper—and to thank him most of all for his patience.

1. Juliane Harms, "Judith Leyster: Ihr Leben und ihr Werk," *Oud Holland,* 44 (1927), pp. 88–

96, 113–26, 145–54, 221–42, 275–79. The base of Harms's research was Cornelius Hofstede de Groot's discovery, in 1893, of Leyster's monogram on *The Happy Couple,* now in the Louvre in Paris. The painting had just been sold as a Frans Hals, and Hofstede de Groot's discovery resulted in a law suit. He also cited six other monogrammed works by Leyster which he had found (C. Hofstede de Groot, "Judith Leyster," *Jahrbuch der Königlich Preussischen Kunstsammlungen,* Vol. XIV, 1893, pp. 190–98, 232). It is noteworthy too that the eighteenth-century biographer Arnold Houbraken, in his *De Groote Schouburgh der nederlantsche konstschilders en schilderessen* (1718), did not include Leyster, although he did include almost two dozen other women artists (among them, Maria van Oosterwyck, Maria de Grebber, and

Anna Maria van Schuurmans), as well as Leyster's husband, Jan Miense Molenaer.

2. Harms, "Judith Leyster," p. 90.

3. Hofstede de Groot, *Jahrbuch,* p. 192. Leyster, too, played a word game of her own in her monogram, which is a connected J, L, and a star.

4. A. Bredius, "Een Conflect tusschen Frans Hals en Judith Leyster," *Oud-Holland,* 35 (1917), pp. 71–77.

5. The title *Proposition* is used here, although the painting has borne several other titles in the past. It has been called both *The Tempting Offer* (the implications of which are too obviously sexist for elaboration) and *The Rejected Offer,* although the actual rejection has not yet taken place. And the nineteenth-century title, *The Seamstress,* gives far too little information to be of any value.

6. Andor Pigler, *Barockthemen,* Vol. II, 1956, pp. 529, 544–46.

7. One notable exception is Baburen's *Procuress* of 1623, in the Residenz, Würzburg, which has been described as follows: " . . . the girl is unwilling, the old procuress is firm, and the soldier demanding"—Leonard J. Slatkes, *Dirck van Baburen (c. 1595–1624): A Dutch Painter in Utrecht and Rome,* Utrecht, 1969, p. 78.

8. Perhaps the earliest example of a woman reaching for the man's purse as she is being kissed is *Flora and Fauntius* (?), from Boccaccio, *De claris mulieribus,* New York Public Library, Spencer Collection, MS33 (second half of the fifteenth century). See Julius Held, "Flora, Goddess and Courtesan," *Essays in Honor of Erwin Panofsky,* New York, 1961, pp. 201–18.

9. Many examples of the theme of ill-matched lovers exist. To list just a few of the artists who have dealt with it: Quentin Metsys, Lucas Cranach, Jan Lys, Frans van Mieris, Jan van Bylert, Hendrick Terbrugghen. Furthermore, there are also many engravings of the theme by: Albrecht Dürer (Bartsch 7-103-93), Jacob Matham after Hendrick Goltzius (Bartsch 3-204-302, 303), and Jacob Goltzius (Bartsch 3-122-2,3).

10. The theme of men being victimized by women is well illustrated in Philip Gallen's engraving after Maerten van Heemskerck's *The Might of the Woman,* where women of the Old Testament are shown, in six scenes, in the process of maiming or trying to destroy a man, leading to his downfall. For further discussion, see two articles by Madlyn Kahr: "Delilah," here reprinted at p. 119, and "Rembrandt and Delilah," *The Art Bulletin,* 55, June 1973, pp. 240–59.

11. Seymour Slive notes that "care must be taken not to jump to hasty conclusions about the character of a woman upon the basis of the clothes she wears." He cites the engraving of "Fair Alice," a courtesan in Crispin van de Passe's *A Looking Glass of the Most Beautiful Courtesans of these Times* (1630), who is dressed in the height of fashion: a mill stone ruff, a stiff bodice, and a cap—Slive, *Frans Hals,* Vol. I, London, 1971, pp. 92–93.

12. There are changes in proportion, background, space, and the addition of a map and a wineglass. The 1935 French edition of the Mauritshuis catalogue (The Hague, Royal Picture Gallery, *Musée Royal de Tableaux Mauritshuis à la Haye, Catalogue Raisonné de Tableaux et Sculptures*) indicates that another version of this painting, including a cat and a globe and the monogram P M B, was in the Porgès Collection in Paris. A suggestion is also made that Hals #142B (seamstress with old man) in the Hofstede de Groot catalogue (*Beschreibendes und Kritisches Verzeichnis der Werke der hervorragendsten hollandischen Maler des XVII Jahrhunderts,* Vol. III, Paris, 1910; English trans. E.G. Hawke, London, 1910) may be the Leyster in question.

13. The text reads: "Favorite of Women. A footwarmer with fire in it is a beloved jewel with our Dutch women, especially when the snowflakes fall and the hail and the frost chase the leaves from the trees. The man who wants to win attention in second place with women (first place goes to the footwarmer) has to push himself to serve her with sweet, funny small talk, avoiding all clumsiness and rudeness, without reprimanding her chatter and never making fun of her frilly clothes. But if he praises what she does and how she looks, then he will be praised in her company as a perfect gentlemen (courtier)" (translation mine).

14. The painting is now held to be a work "after" Metsu. See Franklin W. Robinson, *Gabriel Metsu (1629–1667): A Study of His Place in Dutch Genre Painting of the Golden Age,* New York, 1974, p. 70.

15. *Ibid.,* pp. 19–20.

16. Lawrence Gowing, *Vermeer,* London, 1970, p. 115.

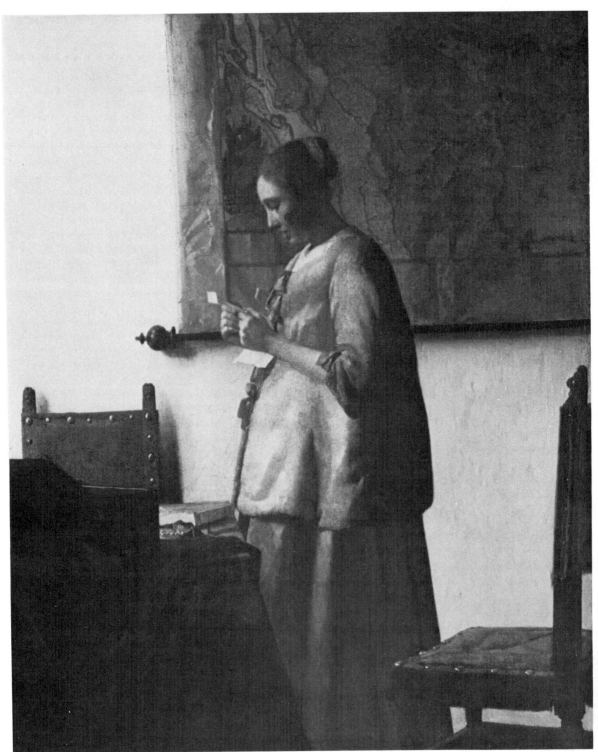

1. Jan Vermeer, *The Letter-Reader*, 1660–65. Amsterdam, Rijksmuseum (*Svetlana Alpers*).

10
Art History and Its Exclusions:
The Example of Dutch Art

>+ +<

SVETLANA ALPERS

It has been an assumption of feminist students of art history that their task is nothing less than to rewrite the history of art. The question, of course, is how it is done. What does it entail? A major part of this task so far has been unearthing, naming, and making visible the works of women artists of the past. The landmark exhibition *Women Artists: 1550–1950*,[1] organized in 1976 by Linda Nochlin and Ann Sutherland Harris, movingly bore witness to those many women painters not mentioned in our books and not hung in our museums. It provided predecessors and precedence for women as artists today, and new figures for our studies. For all that, I must admit to having been disappointed by it. First of all, as the compilers of the catalogue themselves admit, there is the puzzling problem that with few exceptions the paintings did not look distinctly different from examples by their male counterparts. In gener-

al, for example, two women painting in the seventeenth century, one painting still-lifes in Holland and the other figural compositions in Italy, have more in common with their fellow countrymen than with each other as women. But of more importance, far from *rewriting* art history, the exhibition served to *confirm* it in its present state, and in effect demanded that a place be made for women. It did this first in the historical coverage and the kind of works selected: only painting, and only from the Renaissance until today—the backbone, that is, of traditional art history. Where were the illuminated manuscripts both earlier and contemporary, the tapestries and other things normally relegated to the category of minor arts? Secondly, it presented a sequence of individual masterpieces making contributions to a definable stylistic sequence which is another assumption of traditional art history.

Let us contrast this confirmation of established art history with the status of women's art today. Perhaps the first conscious feminist questioning about art was Nochlin's "Why Have There Been No Great Women Artists?"[2] The question was posed with a good

This essay was developed from a paper read at the Women's Caucus for Art session, "Questioning the Litany: Feminist Views of Art History," College Art Association Annual Meeting, New York, 1978. Copyright © 1982 by Svetlana Alpers. By permission of the author.

deal of irony and mixed wit with its passion. Nochlin answered it in essentially two ways: (1) There have been none because of disabling social circumstances; (2) the whole thrust of what we mean by greatness suggests a certain notion of art, its production and its function in society. The demystification of the notion of the great master and the great work proposed by Nochlin has indeed played a significant role in the world of women artists today: in their subject matter, working materials and manner of execution, their gallery organization, and in their resistance as makers and as perceivers to the imposition of preestablished critical categories. There is a sense of openness here to different modes of making what we call art, even though the problem of a female style remains much debated.

Let me now juxtapose two statements made about women's art and its study:

My intention was to treat women artists as if they were artists and as such subject to the same methodology and argument as anybody else.[3]

The answer to the question of whether indeed there is something definable as a female aesthetic is ultimately less important than the fact that the issue has been raised for it means that contemporary women are taking art history into their own hands and molding it to suit their image.[4]

Each of these statements seems to me to suffer from admitting nothing else but its own position. But what distinguishes them is that the woman, the second writer I quoted, admits to the partisanship of her position, while the man retreats behind the claimed neutrality of the methodology of his field.

The admission of having a point of view is, I think, something that women's studies, be they literary, historical, or art historical, can truly make a claim for. It is something that we can learn from and I think it helps supply an answer to the way in which art history can begin to be rewritten. I do not want to argue that a woman's point of view, along with its art, has been left out, but rather to point to what art history has been alert to and what it has not. A starting point is to see that art history as a discipline has had a point of view which involves choices and exclusions despite its usual claim to scholarly objectivity.

My own understanding of this issue came about not through women's art but through my own field, the art of northern Europe from Van Eyck to Vermeer. The methodology that I was taught prepared me to deal with Italian art, but not with this. The rhetoric, the very language with which we talk about a painting and its history is, I would claim, Italian born and bred. This is a truth that art historians are in danger of ignoring in the

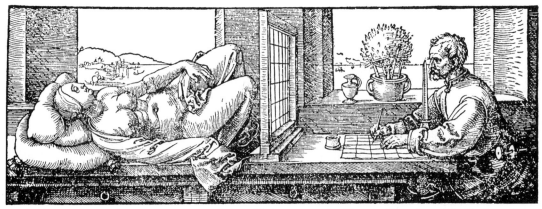

2. Albrecht Dürer, *Draughtsman Drawing a Nude,* from *Underweysung der Messung,*Nuremberg,1538 (*Svetlana Alpers*).

3. Johan van Beverwyck, *Schat der Ongesontheyt*, Amsterdam, 1664 (*Svetlana Alpers*).

present rush to diversify the objects and the nature of their studies. Italian art and the rhetorical evocation of it has not only determined the study of works, it has defined the practice of the central tradition of Western artists. This definition of art was internalized by artists and finally installed in the program of the Academy. This was the tradition to equal (or to dispute) well into the nineteenth century. It was the tradition which produced Vasari, who was the first art historian and the first writer to formulate an autonomous history of art. A notable sequence of artists in the West and a central body of writing on art can be understood in these Italian terms. Since the institutionalization of art history as an academic discipline, the major analytic strategies by which we have been taught to interpret images—style as proposed by Wölfflin and iconography by Panofsky—were developed in reference to the Italian tradition.

When I refer to the notion of art in the Italian Renaissance, I have in mind the definition of the picture first put into words by Alberti. Though this dates from the fifteenth century, it remained, through what we have come to think of as several changes of style, the dominant notion of the picture in the West until the present century. Painting, and

beyond that the fresco, is the ideal form. It is a unique, unreplicable creation as contrasted, for example, with prints. It is conceived of as a window onto a second world. The viewer, rather than the world seen, has priority. Alberti's picture originates with a viewer who is actively looking out at objects—preferably human figures—in space. Their appearance is a function of their distance from the viewer. We can let Dürer's rendering of perspective practice represent the making of the Albertian picture [2]. Though he was a northerner, Dürer's ambition here was to re-present the practice of the Italians he so admired. It is Alberti who instructed the artist to lay down a rectangle on the model of the window frame. The picture is the artist's construct, an expression in paint, as Alberti says, of the intersection of the visual plane at a given distance from the observer.[5] It could be argued that Alberti's greatest invention was this picture itself. The framed rectangle on the wall which became the basis of the art of painting in the West is distinct from the painted walls of Egypt, the scrolls of China, the pages of India or even the panels of Byzantium. The frame has priority in the ordering of the image which thus lends itself to formal (stylistic) analysis in its relation to its rectangular sur-

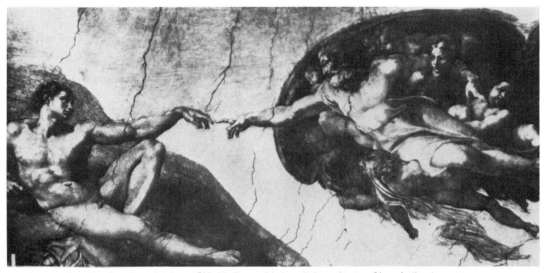

4. Michelangelo, *The Creation of Adam*, 1508–11. Rome, Vatican Palace, Sistine Chapel (*Svetlana Alpers*).

5. Roelant Savery, *Paradise*. Vienna, Kunsthistorisches Museum (*Svetlana Alpers*).

round. Sight or vision is defined geometrically in this art. It concerns our measured relationship to objects in space rather than the glow of light and color. Finally, human figures are central. They dominate the world and, in the case of a Michelangelo at least, they exclude all other phenomena [4]. Creation in such art is of man, not of the world as it is represented in the flora and fauna which crowd a Garden of Eden by the Flemish artist Roelant Savery [5].

The highest aim of such painting is to be like poetry. Artists elevated themselves from their craft status by allying themselves with privileged modes of knowledge: with mathematics on the one hand and with literature on the other. Iconography as a way of analyzing pictorial meaning, like the art itself, trusts basically to texts as a basis for all meaning. We look through the pictorial surface to the deeper meaning of the text. It is verbal meaning or the narration of stories that we take away from such pictures. In both the art and the analysis of it, completed composition is asserted over the craft and process of making, and meaning dominates over representation and its functions. In its ordering of the world and in its possession of meaning, such an art, like the analysis art historians have devoted to it, asserts that the power of art over life is real. Many aspects of Renaissance culture—its painting, its literature, its historiography—are born of this active confidence in human powers. Dürer's woodcut tellingly reveals it in the relationship of the male artist to the female observed who offers her naked body to him to draw. The attitude toward women in this art—toward the central image of the female nude in particular—is part and parcel of a commanding attitude taken toward the possession of the world.

Of course this tradition does not account for all that was going on pictorially in Italy at the time: chests were being decorated, tapestries woven, pottery painted, and books illustrated. Artists such as Pisanello were engaged in making an encyclopedic account of the myriad things in the world. But these kinds of making were pushed aside by Alberti's definition of the painting.[6] They have not been treated as central to what we call the history of art.

Now let us turn to the North. Though my remarks are largely based on seventeenth-century images, their pictorial mode is grounded also in earlier images in the North. It is commonly said that Northern art represents a different way of perceiving or looking at the world. But I want to emphasize that it constitutes also a different relationship to the world, a different mode of art. As an appropriate contrast to Dürer's artist demonstrating how to make a picture in the Italian manner, let us take two men observing the image made by a camera obscura as the model of Northern picture making [3].[7] The men are in a dark room which is equipped with a lighthole fitted with a lens. They hold out a surface, a piece of paper perhaps, on which is cast the image of the landscape beyond. People, trees, boats on a canal are all brought inside, re-presented for their delectation. In the place of an artist who frames the world to picture it, the world produces its own image without a frame. Rather than a man possessing through his art the female he observes, the men attend to the prior world, the world as it existed before them. While Dürer's woodcut recalls the engagement of Italian art with the monumental female nude, the Northern image calls to mind Vermeer's *View of Delft* [6]. In Vermeer's painting, Delft seems neither ordered nor possessed, it is just there for the looking. It is as if visual phenomena are present without the intervention of a human maker.

The Dutch offer their pictures as descriptions of the world seen, rather than as imitations of human figures engaged in significant actions. It is the world, not the maker or viewer, which has priority. A pictorial image is not a window, but rather a mirror, or a map

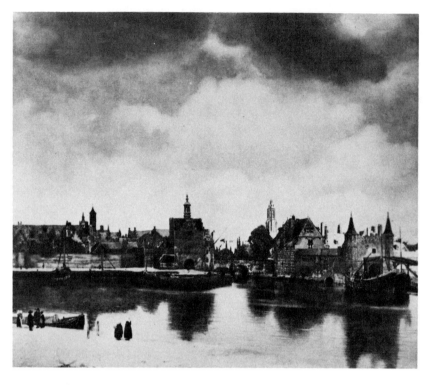

6. Vermeer, *View of Delft*, ca. 1660. The Hague, Mauritshuis (*Svetlana Alpers*).

laid out on a flat surface. The maker is not posited prior to the painted world but is himself of the world. On rare (and telling) occasions, as in some still-lifes by Van Beyeren, he is even captured on a mirroring surface in the picture and seen as but one of many objects in the world [7 and 8]. Related to this anonymous maker, eyes fixed on the world, is the fact that this is an art of replication and of repetition. Multiples are the normal condition of Dutch pictures. Bound up with this is the fact that it is hard to trace much stylistic development, as we usually call it, in the work of Dutch artists. Even the most naive viewer can see much continuity, not to say repetition, in Northern art from Van Eyck to Vermeer. But as yet no history on the developmental model of Vasari has been written, nor do I think it could be. This is because the art did not constitute itself as a progressive tradition, it did not make a history in the sense that it did in Italy. For art to have a history in this Italian sense is the exception, not the rule. Most artistic traditions mark what persists and is sustaining, not what is changing, in culture.

Northern artists not only depicted landscapes but also served as mapmakers, executed topographical views and made maplike landscapes. The distinction between an image functioning as a map and one which we would be more likely to consider a work of art is not easily made. This is related to the fact that the painter remained a craftsman who insisted on the role of craft in his representation. It is no accident that the rise in the price of paintings in Holland in the mid-seventeenth century was not due to a claim of unique inventions, but rather to the exercise of craft. The so-called fine painters, among whom we include Vermeer, simply took a much longer time to produce a finished work.

Because we are heir to the Italian tradition and the interpretive methods that go with it,

7. Abraham van Beyeren, *Still-Life.* The Cleveland Museum of Art (*Cleveland Museum of Art*).

8. Van Beyeren, *Still-Life,* detail. The Cleveland Museum of Art (*Cleveland Museum of Art*).

9. Pieter Bruegel the Elder, *View of Naples,* ca. 1562–63. Rome, Galleria Doria (*Svetlana Alpers*).

we have so far, for example, not been able to comprehend Bruegel's trip to Italy. All the attempts to ferret out some influence of Italy on his subsequent figurative art miss the fact that the trip was probably in effect made to see the world, not for the art. A picture like Pieter Bruegel's *View of Naples* [9] fits into the category of topographical harbor views or mappings that would have been of so much interest to his friend the cartographer Ortelius. Ruisdael's views of Haarlem in the seventeenth century belong to the same tradition and also employ a maplike format [10].

Such dedication to descriptive function and the priority of the world seen or mapped produces works in which the maker-viewer has no privileged position. It is impossible to say where the viewer is located in relation to a map or to a panoramic landscape. These are works in which the frame or edge is arbitrary. Since they start with the world seen and laid out onto a flat pictorial surface, rather than with the viewer and the window frame, the edge of the image comes last and is as arbitrary as is the edge of a map. This is acknowledged in the use of doors opening up to lead the eye into further rooms, or the land spreading out almost beyond what we can see. Dutch pictures seem to expand their bounds as if the frames were only an afterthought. Dutch peep-boxes have this point built into their construction. They do away with the frame entirely and make everything that is seen dependent on the viewer's eye, which is separated from his body and placed at the viewing hole. If a painter wishes to mark off a fragment of the world with a frame, as Dou does, he paints a frame into a picture. It is a decisive act.

If the descriptive function provides the manner of Dutch works, it also provides their meaning. Let us look at two paintings by Dirck Hals of women with letters (a very popular subject in Dutch art). One is tearing up her letter, the other is just holding hers [11 and 12]. On the wall behind each hangs a pic-

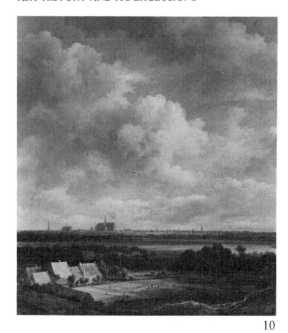

10

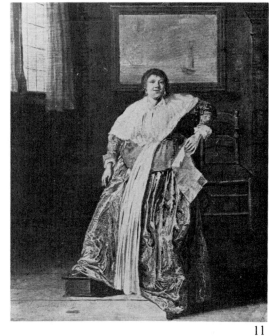

11

12

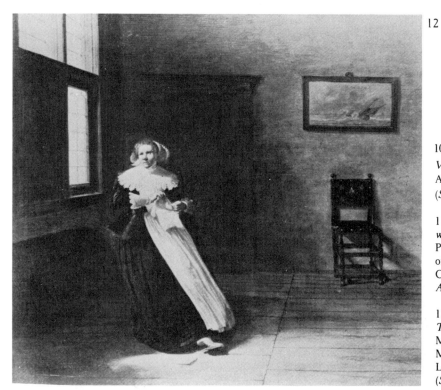

10. Jacob van Ruisdael,
View of Haarlem, ca.1670.
Amsterdam, Rijksmuseum
(*Svetlana Alpers*).

11. Dirck Hals, *Woman
with a Letter.* The
Philadelphia Museum
of Art, John G. Johnson
Collection (*Svetlana
Alpers*).

12. Hals, *Woman
Tearing Up a Letter.*
Mainz,
Mittelrheinisches
Landesmuseum
(*Svetlana Alpers*).

Al zijt ghy vert,, noyt uyt het Hert.

DE ongebonde Zee, vol spooreloose baren,
Doet tusschen hoop en vrees, mijn lievend' herte
varen:
De liefd' is als een Zee, een Minnaer als een schip,
V gonst de haven lief, u af-keer is een Klip;
Indien het schip vervalt (door af-keer) komt te stran-
den,
Soo is de hoop te niet van veyligh te belanden:
De haven u wes gonst, my toont by liefdens baeck,
Op dat ick uyt de Zee van liefdens vreese raeck.

13. Jan Hermanszoon Krul, *Minnebeelden*, Amsterdam, 1664 (*Svetlana Alpers*).

ture: a storm-tossed boat behind the woman who tears up her letter; a boat on a calm sea behind the other. Now look at a page from a contemporary emblem book [13]. A motto, a picture and a verse expound the wisdom that a lover is like a ship on the sea of love—it comes to harbor with the lover's favor, or hits a reef with a lover's rejection. The two letter paintings represent women as happy or sad in love. We know the women in terms of the state of their love made visible in the handling of the letters and the pictures-within-pictures. It is now the fashion to accommodate all such Dutch painting to the signifying mode of iconography.[8] But far from hiding meaning beneath the pictorial surface, Dutch emblematic pictures such as these demonstrate rather that what we know is visible.

The texts of the emblems are characteristically proverbial and descriptive, like the Dutch language itself. Dutch paintings of this kind are indeed like painted engravings that have been removed from the book page where they first shared a common surface with a visible text. The issue, even in viewing human lives, is not reading and interpretation, but seeing and knowing. In other works, words take their place not as textual sources or deeper meanings, but as visible inscription. They appear either beside printed images or, like mottoes on virginals or inscriptions on tombstones, on objects that are depicted in paintings. While this notion of how pictures convey meaning is satisfactory as a presentation of landscapes, or flowers, or even human portraits, it meets its limits

when an attempt is made to deal with human feelings. It is one of the characteristics of Dutch art (Rembrandt excepted) that it seeks to taxonomize or to map human behavior even as it does the items in a still-life or the lay of the land.

Finally, in the absence of the prior viewer, we lose that scale or proportion of figures in the work which is basic to Italian perspectival picture making. Without a human figure providing prior measure, the entire epistemological issue of how we know or how we relate to the world is made uncertain. A symptom of this is the extraordinary juxtaposition of different figural scales in Northern art. In Pieter Bruegel's *Road to Calvary,* for example [14], we look down and across a landscape filled with small, compact and singularly dispassionate figures of the common people, among which is Christ himself. Then in the foreground, on an elevated plot of ground, stand tall figures, elaborately mourning, which are quoted from a Passion as it was staged in fifteenth-century art. There are two body sizes, two ways of responding to the death of Christ, neither of which is clearly like ours. How do we respond to the Passion? The event is part and parcel of the modes of presentation and the question is left unresolved, perhaps, Bruegel suggests, unresolvable.

What in the sixteenth century is put in terms of a quandary in faith, in the seventeenth is put in terms of a quandary about perception or seeing. The Dutch positively

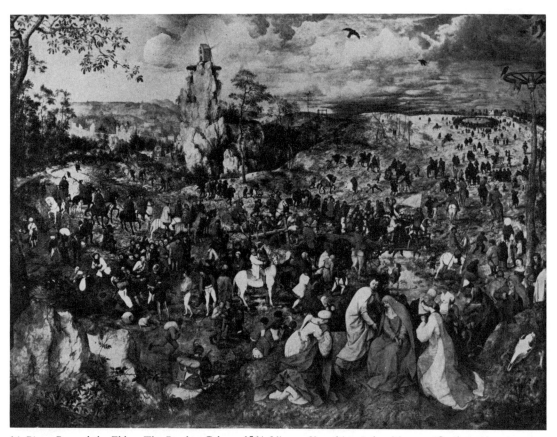

14. Pieter Bruegel the Elder, *The Road to Calvary,* 1564. Vienna, Kunsthistorisches Museum (*Svetlana Alpers*).

15. Paulus Potter, *The Young Bull.* The Hague, Mauritshuis (*Svetlana Alpers*).

reveled in the dislocation that resulted when the new technology of the lens brought to men's eyes the minutest of living things beside the largest and most distant star. Consider Paulus Potter's *The Young Bull,* in which the animal looms large against a dwarfed church tower and sports, on its extensive flank, a tiny fly [15]. Along with style and meaning, space and scale are sacrificed to the interest in the seen presence. But to say sacrificed is once again to assume the Italian notion of art to be the principal one and to treat art history as basically definitive of only one mode of art among many. The problem is that we do not have ready at hand the method or the words to deal easily with the Northern mode of art.

The problem is hardly new. The Italians in the Renaissance had difficulty dealing with Northern art and, significantly, one way in which they expressed it was to dub Northern art an art for women. Keeping in mind all that we have just seen about the difference between Northern and Southern modes of picturing, let us look once again at the oft-cited passage attributed by Francisco de Hollanda to none other than Michelangelo himself:

Flemish painting . . . will . . . please the devout better than any painting of Italy. It will appeal to women, especially to the very old and the very young, and also to monks and nuns and to certain noblemen who have no sense of true harmony. In Flanders they paint with a view to external exactness or such things as may cheer you and of which you cannot speak ill, as for example saints and prophets. They paint stuffs and masonry, the green grass of the fields, the shadow of trees, and rivers and bridges, which they call landscapes, with many figures on this side and many figures on that. And all this, though it please some persons, is done without reason or art, without symmetry or proportion, without skilful choice or boldness and, finally, without substance or vigour.[9]

While reason and art and the difficulty involved in copying the perfection of God are on the side of Italy, only landscape, external exactness and the attempt to do too many things well belong to the North. The contrast is between the central and definitive Italian concern with the representation of the human body and the Northern concern with representing everything else in nature, exactly and unselectively. Northern art is an art for women because it lacks all reason and proportion. It lacks the human figure as a prior module or measure for the harmonious pictured

world. The implication is clearly that Italian art is for men because it is reasoned and proportioned. But why cite women? As a gloss to this, we can turn to a fifteenth-century Italian handbook on painting, written by Cennino Cennini:

Before going any farther I will give you the exact proportion of a man. Those of a woman I will disregard for she does not have any set proportion. . . . I will not tell you about irrational animals because you will never discover any system of proportion in them. Copy them and draw as much as you can from nature.[10]

To say an art is for women is to reiterate that it displays not measure or order but rather, to Italian eyes at least, a flood of observed, unmediated details drawn from nature. The lack of female proportion or order in a moral sense is a familiar sentiment from this time. What is suggested by de Hollanda is its analogue in a particular mode of art—an art not like ideal beautiful women but like ordinary, immeasurable ones.

Is it a fault not to be ordered, as the Italians claim, or is it simply the way things in the world are, as Dutch art seems to claim? How do we relate to this presence of the prior world seen? It is in the meditative works of Jan Vermeer that this basic problem of a descriptive art is faced. It is, fittingly, in his repeated images of women that Vermeer places before us the ungraspable nature of the world seen. In his depiction of women, Vermeer thematizes the problem of the Dutch painter's relationship to the world seen and turns it to extraordinary psychological account.

At the heart of most of Vermeer's works, a man, either explicitly within the painting or implicitly observing from without, is attendant upon and dependent on a woman. In the Buckingham Palace *Music Lesson* [16], Vermeer's familiar man is attendant on a woman, his pupil, who is standing at the virginal. A mirror on the wall beyond reflects the room and her face turned slightly (as it is not in "actuality") toward him. On the wall to the

right we see a piece of a picture which depicts the scene of the "Roman Charity"; a bound male prisoner leaning forward to suck for sustenance at the breasts of a charitable woman, his daughter. An inscription on the virginal reads: "Music, the companion of joy, the medicine of sadness." Vermeer demonstrates four ways of representing, but also four different versions of the relationship between a man and a woman. Significantly, each one is presented as partial, not just in respect to the others, but also in respect to the viewer. Each is cut off from total view: the woman's face turns away from us, the mirror shows only her face, the picture on the wall is sliced by the frame, the inscription interrupted by the woman's body. This is how the world is known: incompletely, and in pieces. To the certain grasp of his fellow Dutch painters, Vermeer responds with a deep uncertainty.

An essential part of this uncertainty for Vermeer is revealed in the account he gives

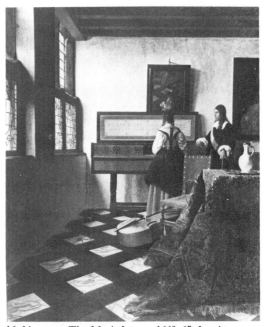

16. Vermeer, *The Music Lesson*, 1660–65. London, Buckingham Palace (*Svetlana Alpers*).

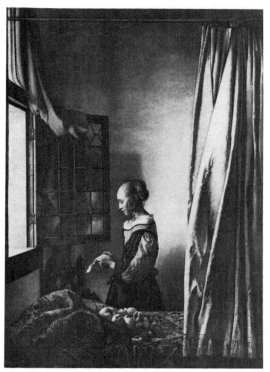

17. Vermeer, *The Letter-Reader,* 1655–60. Dresden, Staatliche Kunstsammlungen (*Svetlana Alpers*).

us of the artist's role. We have seen that a feature of the image in the North is the lack of a prior viewer. The *View of Delft,* in which the city presents itself to our eyes like the image cast by the camera obscura in the darkened chamber, is paradigmatic of this aspect of Northern images [6]. In his two great paintings of letter-readers, however, Vermeer acknowledges that the eye of the artist taking in the world is like a voyeur with the woman as the object on which he spies [17,1]. In contrast to the women of Dirck Hals, Vermeer's women with letters do not reveal their feelings. The letters are not defined for us as either happy or sad. Vermeer in fact uses them to draw our attention to the elusiveness of the women. In the Dresden picture [17], the reader seems less to be looking at the letter than to be absorbed in it, even as she is absorbed in herself. We note the distinctive an-

gle of her head and her slightly parted lips. Her elusiveness is further played out by Vermeer in the invention of the reflection of her face in the surface of the open window. The window that we would expect to be able to look through instead reflects back. It makes another surface of the woman's face visible without offering us any further insight into her. The carefully constructed foreground—a curtain partially drawing back, the barrier of the rug on the table with its offering of fruit—bars our entry even as it confirms our presence. We cannot approach her or enter into her world or feelings, try as we might. Vermeer represents what he perceives as a complex and uncertain relationship between the artist as male observer and the female observed. The contrast between this and the image of the naked woman exposing her body for the perspective draughtsman in Dürer's woodcut [2] could not be greater.

In *The Letter-Reader* in Amsterdam, a later work, Vermeer resolves the tensions of this picture [1]. The monumental figure of the woman, poised in her absorption in the letter, is now dominant. She assembles the world of the picture around herself. Her ample figure reveals, by comparison, the slightness of the Dresden letter-reader, whose small figure was pressed in on by objects on every side. No longer a product of the tension between male viewer and woman viewed, the woman's elusiveness is now simply granted her as her own. It is a sign of her self-possession. For all their presence, Vermeer's women are a world apart, inviolate, self-contained, but more significantly, self-possessed. These are works in which the quality of the paint (that intangible nature of the painted points of light) and the quality of rendering (the poise of the weighty figures) engage human implications that are rare in Dutch art. Vermeer recognizes the world present in these women as something that is other than himself, and with a kind of passionate detachment he lets it, through them, be.

Lawrence Gowing in his incomparable study of Vermeer has put the central quality of his art in the following way:

Vermeer stands outside our convention [of art, he means, which we can read as Italian art] because he cannot share its great sustaining fantasy, the illusion that the power of style over life is real. However an artist love the world, however seize on it, in truth he can never make it his own. Whatever bold show his eye may make of subduing and devouring, the real forms of life remain untouched.[11]

Vermeer, in other words, disputes the claims on which the dominant mode of Western art is based.

It is in this realm, and by these very means, that Vermeer in another work locates the nature of justice. Vermeer rejects the raising of the sword, the embattled gesture through which justice traditionally achieved its end of separating the saved from the damned. He acknowledges the human attraction for conflict and battle, but he relegates it to the painting of the *Last Judgment* which hangs on the wall in his *Woman Holding a Balance* [18]. It seems to me odd to claim, as recent interpretation has it, that this picture of such considered perfection is a representation of vanity. Is vanity intended by a mirror not looked at, or pride by jewels displayed but left untouched on the table? We note the care with which the woman's hand steadies the weight

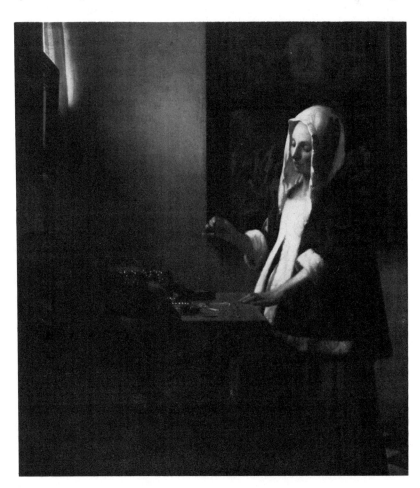

18. Vermeer, *Woman Holding a Balance*, 1664. Washington, D.C., National Gallery of Art, Widener Collection, 1942 (*National Gallery*).

of her body and the grace with which her glance attends to the hand so delicately balancing the scales. Is Vermeer's still, subtly balanced figure intended as an image of radical imbalance and thus of sin? The basis of the current interpretation is not only the traditionally vain act of weighing valuables, but also the painting of the *Last Judgment* on the wall, which has been understood as rendering a judgment on the woman. But her action—testing the accuracy or balance of the scales, not weighing valuables—and the order of the composition suggest that she herself is a just judge. A woman holding scales is a common image of justice. The Christ in the painting on the wall, on the other hand, is represented with the other traditional image of justice, the raised sword. Far from judging this woman, the painting on the wall would appear to assist us to see the woman herself as an alternative: the kind of justice (justness) desirable on this earth, in the Dutch home, of the woman. To view this or any work we must understand and accept *its* mode.

I am aware that there are familiar psychological terms in which we might confirm the female label that the Italian commentators put on northern European art, and by extension we could place a male label on Italian art. It is part of our Western culture to find this kind of patient contemplation, this giving in and adapting to the world rather than seizing it and making it one's own, to be weak, not strong; feminine, not masculine. To want to possess meaning is masculine, to experience presence is feminine. This sexual designation is, however, not biologically determined but rather a matter of culture. And in

the makings of art—these marvelous, gentle, loving, strangely detached works by Vermeer, for example—we find a demonstration that the engagement of such modes of being is open to either sex. It is not the gender of makers, but the different modes of making that is at issue.

There is something more important than calling this or that feminine or masculine. It seems to me that the lesson we can draw from looking at Northern art as we have is that there are different modes of art which require different ways of looking and of understanding. We are today in the midst of a demystification of the definition and of the making of art. All kinds of activities and all kinds of functions for images are now being taken seriously. But it is time that we also demystify our methods of our history to let more in, to allow us to deal fully and intelligently with more ways of picturing and seeing. To offer another example: in the current storm of rhetoric rising about photography, I often feel that those who wish to deny its status as art come closer to the mark than do those who simply want to absorb it into the flow of art history as we know it. An attack on photography such as Susan Sontag's, which defines it as a totally different kind of image from painting, at least has the virtue of allowing and encouraging distinctions to be made and the positions from which we make such distinctions to be acknowledged.[12] The strategy I would recommend, therefore, is not just to insist that women be written into art history, but that art history itself—specifically its notions of what a work of art is, how it functions in society, and how we understand it—be rewritten.

NOTES

Author's note: This essay was originally written more than four years ago. In spite of new work done in the meantime both by myself and others, I

have decided to let it stand essentially as it was written with only a few additions. It records the moment when my own work and thinking benefit-

ed most from the challenge presented by the new feminist views of art and its history.

1. Ann Sutherland Harris and Linda Nochlin, *Women Artists: 1550–1950* (New York, 1976).

2. Linda Nochlin, "Why Have There Been No Great Women Artists?" in *Art and Sexual Politics,* ed. Thomas B. Hess and Elizabeth C. Baker, New York, 1973, pp. 1–39.

3. Lawrence Alloway, "Issues and Commentary," *Art in America,* November–December 1976, p. 23.

4. Gloria Feman Orenstein, "Review Essay: Art History," *Signs: Journal of Women in Culture and Society,* 1, Winter 1975, p. 521.

5. Leon Battista Alberti, *On Painting,* trans. by Cecil Grayson, London, 1972, p. 49.

6. Michael Baxandall has pointed out that prior to Alberti, the language of the humanists was most suited to praise and expound an artist such as Pisanello. See Michael Baxandall, *Giotto and the Orators,* London, 1971, pp. 89–120.

7. The engraving is taken from a chapter on diseases of the eye in a leading Dutch medical handbook in which the camera obscura was offered as a model for the eye. See Johann van Beverwyck, *Schat der Ongesontheyt,* p. 87, in *Wercken der Genees-Konste,* Amsterdam, 1664.

8. The pioneer work in the study of the relationship of Dutch pictures to emblems was E. de Jongh, *Zinne-en minnebeelden in de schilderkunst van de zeventiende eeuw,* Amsterdam, 1967. A convenient account of this method of interpretation in English is found in Christopher Brown's exhibition catalogue, *Dutch Genre Painting,* The National Gallery, London, 1978.

9. Francisco de Hollanda, *Four Dialogues on Painting,* trans. by Aubrey F. G. Bell, London, 1928, pp. 15–16.

10. Cennino d'Andrea Cennini, *The Craftsman's Handbook,* trans. by Daniel V. Thompson, Jr., New York, n.d., pp. 48–49.

11. Lawrence Gowing, *Vermeer,* 2nd edn., New York, 1970, p. 66.

12. I am referring of course to Susan Sontag, *On Photography,* New York, 1977. As examples of studies which accommodate photography to the established history of painting, I have in mind Kirk Varnedoe, "The Artifice of Candor: Impressionism and Photography Reconsidered," *Art in America,* January 1980, pp. 66–78, and Peter Galassi, *Before Photography,* New York, 1981. In contrast, Rosalind Krauss, who is so at odds with Sontag in her evaluation of photography, shares with her the aim of defining its distinctive mode.

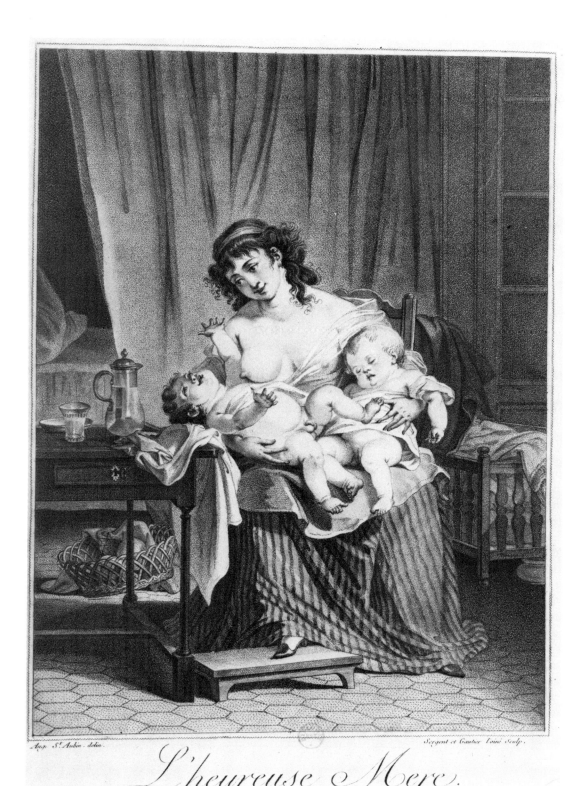

L'heureuse Mere.

1. After Augustin de Saint-Aubin, *The Happy Mother (L'Heureuse mère)*, engraved by A. F. Sergent-Marceau. Paris, Bibliothèque nationale (*Bibliothèque nationale*).

11
Happy Mothers and Other New Ideas in Eighteenth-Century French Art

Carol Duncan

In the late eighteenth century, French artists and writers became enamored of a set of characters whose virtues and attractions were still new to the public. These characters, the happy or good mother and the loving father, appear fully developed in Greuze's *The Beloved Mother* [2], one of the most popular attractions at the Salon of 1765. To the twentieth-century viewer, Greuze's painting has many features suggesting not only earlier French and Dutch genre scenes and family portraits but Holy Families as well. To his French contemporaries, however, Greuze was saying something fresh and new. As Diderot so tirelessly repeated, Greuze's pictures were not simply pleasant to look at, they also spoke to present vital moral issues. Indeed, the very forms of *The Beloved Mother* energetically signal the presence of a message; gesturing figures, dramatic lights and shadows and busy, bunched-up masses of people and drapery promise the eye a drama. What

Previously published as Carol Duncan, "Happy Mothers and Other New Ideas in French Art," *The Art Bulletin,* 55, December 1973, pp. 570–83. By permission of the author and the College Art Association of America.

occasions such excited form and moves these characters to such emotional display? Nothing more than the fact of the family, for the scene represents a most commonplace event: the entrance of a farmer into his own home where he beholds his own wife and six children. Yet the content of this work was far from commonplace in 1765.

Mothers, fathers and their children were hardly new to secular art. Nor were scenes portraying the peace or the charm of simple domestic life. Chardin's *Saying Grace* [3], painted around 1740, is such a scene. Compared to the highly detailed naturalism of Greuze's figures, however, this mother and her children seem almost doll-like, their expressions merely pert. The modest subject was not original and struck no one as especially significant. What made Chardin's reputation was not *what* he painted, but *how* he painted. He was famous not for any ideas he conveyed but for his mastery of color and light effects, his ability to suggest real atmosphere and his artful balance of volumes and voids. Chardin was appreciated as a master, but only within the confines of genre paint-

2

2. Jean Baptiste Greuze, *The Beloved Mother* (*La Mère bien-aimée*), 1765. Paris, De Laborde Collection (from Gazette des Beaux-Arts, *LVI, 1960*).

3. Jean Baptiste Chardin, *Saying Grace* (*Le Bénédicité*), ca. 1740. Paris, Louvre (*Service de Documentation photographique de la Réunion des Musées nationaux*).

ing, a field where no one thought to find any but the most limited concepts.[1]

In Greuze, on the other hand, the eighteenth century recognized a moralist, a brilliant observer of human nature and behavior. His art, wrote Diderot, is "dramatic poetry that touches our feelings, instructs us, improves us and invites us to virtuous action."[2] The difference between *Saying Grace* and *The Beloved Mother* confirms Diderot's judgment. Although *Saying Grace* is based on the assumption that domestic life is pleasant, *The Beloved Mother* emphatically states that it is blissful. In almost magnified detail, it examines the very emotions of family relationships themselves (as Greuze conceived them, that is), namely, the joy of being a husband and father and the delicious contentment of being a mother so well beloved by her husband and six children. Even the grandmother and, it appears, the dogs, too, are visibly stirred by the spectacle of family love. What is new here are a mother and a father who are consciously and ecstatically happy about simply *being* a mother and a father, a husband and a wife. The parents of neither gods, saints nor kings, they exemplify a new idea: simple motherhood and fatherhood in blissful conjugal union.[3] Thus wrote Diderot of this

3

painting: "It says to all men of feeling and sensibility: 'Keep your family comfortable ... give [your wife] as many [children] as you can ... and be assured of being happy at home.'"[4]

Even more than Greuze, Fragonard devoted his art to the ideal of the happy family.[5] In *The Return Home* [4], he suggests the

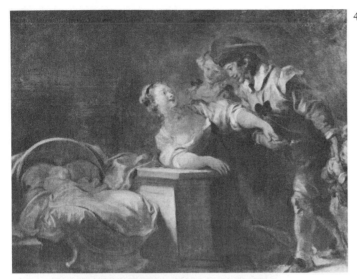

4

4. Jean-Honoré Fragonard, *The Return Home* (*Le Retour au Logis,* or *La Réconciliation*), ca 1770s. Paris, Arthur Veil-Picard Collection (*from G. Wildenstein,* Fragonard).

5. After Moreau le jeune, *The Delights of Motherhood* (*Les Délices de la maternité*), 1777, engraved by Helman. Paris, Bibliothèque nationale (*Bibliothèque nationale*).

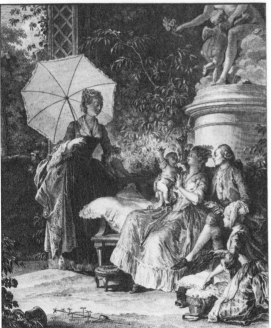

5

who gaze lovingly into each other's eyes and tenderly touch hands. It is this strong suggestion of sexual gratification that most distinguishes this work from traditional Holy Families, which it resembles in so many other ways.[6]

The association of motherhood with sexual satisfaction was frequent in eighteenth-century imagery. In 1766, the poet André Sabatier published an ode to mothers in which he describes "a tender and jealous mother rocking her baby—token of her fires. . . . It is Venus who charms and caresses Cupid."[7] The same conceit enlivens a witty engraving by Moreau le jeune, *The Delights of Motherhood,* 1777 [5]. In a verdant park, a conventional setting for amorous encounters, a husband and wife play with their baby beneath a statue of Venus and Cupid. Like his counterpart above, the child reaches for an enticing object; but it is his father, not his mother, who imitates the Venus overhead. Although more playful than the Fragonard and perhaps with tongue in cheek, this print, too, portrays marriage as a state that satisfies both sexual instincts and social demands for stability and order.[8] Greuze's painting also carries this message, although it is less overtly stated. A sketch for the mother's figure alone struck

warmth and intimacy of conjugal life. Bathed in golden, glowing light, father, mother and infant are compositionally bound into a harmonious unit, an arrangement that stresses not only the mother's position as a living, mediating link between father and child, but also the special closeness of the parents alone,

Diderot as disturbingly erotic. He observed that without "the accessories of motherhood"—as he referred to the children—her smile appears voluptuous and her languid, exposed body wanton.[9]

What these images of happy families and contented mothers reflect is not the social reality of the eighteenth century, nor even commonly accepted ideals. Rather, they give expression to a new concept of the family that challenged long-established attitudes and customs.[10] Traditionally, the "family" meant the "line," the chain of descendants who each in turn held title to estates, properties and privileges in the family name. Marriage was a legal contract negotiated between heads of families, whether kings or wealthy peasants, not between the bridal couple. The contract itemized in detail what each family would settle on the new bride and on her husband. The lowest classes, those with title to nothing, did not marry legally. Even in the propertied classes, only the few married, and those who did were rarely consulted about the choice of their mates. Marriage was normally expected only of the oldest son, usually the sole heir, upon whom parents lavished all their interest and centered their pride. The marriage of a daughter required a dowry and would be arranged only in the absence of male heirs or when her father judged such an alliance to be in the interests of the family.

Households were rarely limited to the immediate family. From the large estate of the aristocrat to the homestead of the wealthy peasant or artisan, the domicile swarmed with unwed relatives, apprentices, servants and retainers, all of whom were under the rule and protection of the father or legal male head. In these busy, crowded, domestic societies, human relations were largely determined by one's relative rank or status within the household hierarchy. Rules of decorum guided individual behavior in every rank. Relationships between husbands and wives and

parents and children were no exception; according to later notions, these were decidedly cool and distant. However, people generally did not expect emotional rewards in conjugal and parental relationships. Fathers and husbands stood for authority, not companionship. Especially in bourgeois and peasant families, where paternal authority was absolute, the father was a severe figure. He ruled his wife—and her property—and decided the fates of his children with full legal sanction. Veneration and obedience, not love and affection, were his traditional due.

Marriage was rarely thought of as a means to personal happiness. Rather, its purpose was to perpetuate the life and identity of the family group and its holdings. This is not to say that married couples did not sometimes develop cordial relationships and even a measure of companionship—the family could engender strong bonds between its members. A seventeenth-century group portrait by Antoine Le Nain [6] represents a convivial-looking family group. It is, however, a portrait of an old household, not the modern conjugal family of Fragonard's *Return Home.* Seated on the right are the old father and his wife, above whom stands either an unmarried daughter or a female relative. On the left stands the next generation, the son (or son-in-law), who will be the next head of the household, and his wife and children. Seated near them is a young boy playing a pipe, an apprentice or a servant and as such a member of this wealthy bourgeois household. If this painting has a voice, it is that of the old father, whose will is the will of the group. It speaks of family pride and loyalty, of prosperity and orderly succession. It also appears to speak with respect and affection of the wife. However, neither patron nor artist intended to suggest individual happiness or conjugal love, concepts that were not available to them. Even so, the work expresses what in the seventeenth century was a progressive bourgeois ideal in that it finds conscious,

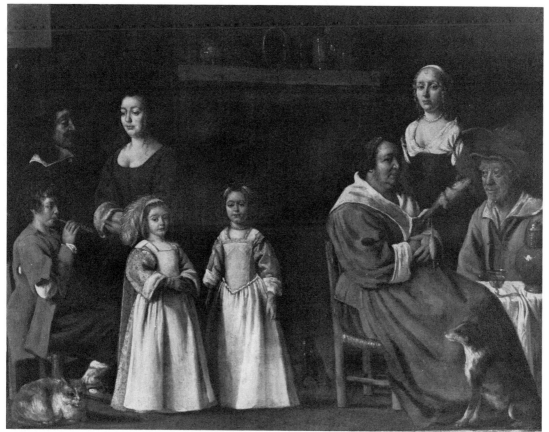

6. Antoine Le Nain, *Portraits in an Interior,* 1649. Paris, Louvre (*Service de Documentation photographique de la Réunion des Musées nationaux*).

positive values in marriage and the family society.[11]

The more widespread view of the marital relationship in both the seventeenth and eighteenth centuries was negative.[12] The figure of the husband was a popular butt of jokes and mockery, and wives were generally thought of as deceptive, crafty and willful: the cuckolded husband and his faithless spouse were stock characters in stories and prints. Among the wealthy, bachelorhood was often a chosen state. Even in the later eighteenth century, when forced or arranged marriages were under increasing attack by moralists, parents persistently opposed marriages of love and continued to arrange the traditional,

"sensible" match that furthered family interests without regard to the individual emotional and sexual needs of their children. The right of parents to choose the mates of their children could be ignored only rarely. At the risk of disinheritance, couples occasionally managed elopements, but the more popular—and acceptable—alternative was adultery. Especially in the cities and among the rich, women felt little compunction about breaking life-long vows that had been forced upon them. Their husbands, who did exactly the same thing, had neither the grounds nor the inclination to complain. For the fashionable woman, marriage in effect meant independence. After presenting her husband with

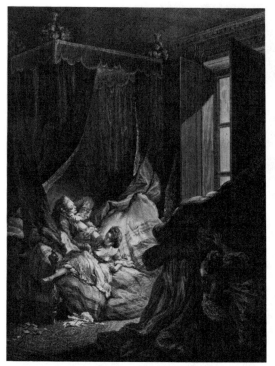

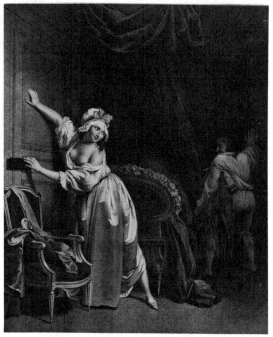

7. After Baudouin, *The Indiscreet Wife* (*L'Epouse indiscrète*), engraved by Delaunay in 1771. Paris, Bibliothèque nationale (*Bibliothèque nationale*).

8. After Boilly, *The Favored Lover* (*L'Amant favorisé*), engraved by A. Chaponnier, ca. 1780s. Paris, Bibliothèque nationale (*Bibliothèque nationale*).

one or two children, she had ample leave to pursue her own pleasures. So-called natural children were produced in abundance—and often acknowledged—at all levels of society.

Illicit love was openly celebrated in French eighteenth-century art, often by the same artists who illustrated the joys of conjugal love. In fact, in the second half of the eighteenth century, both libertine and moralizing subjects enjoyed a marked—and equal—increase in popularity.[13] Baudouin's *The Indiscreet Wife* [7], engraved in 1771, and L. L. Boilly's *The Favored Lover* [8], executed in the more sober forms of the 1790s, are typical of these *scènes galantes,* in which only forbidden pleasures are pursued and enjoyed. The charming adulteresses and soubrettes who abound in these scenes were not banished from the stalls and shops of printsellers by pictures of happy mothers and beloved wives. The com-

peting views of individual happiness that these two kinds of scenes present had at least one thing in common: directly or indirectly, they both opposed the conventional eighteenth-century marriage that at best ignored individual needs and at worst frustrated them.[14]

The new ideal of the family also challenged popular notions of children and child-rearing. The modern view of infancy and early childhood as attractive and important stages of life is an Enlightenment discovery that was still new in the eighteenth century.[15] It had yet to overcome vestiges of older attitudes that regarded small children sometimes as greedy and willful creatures in need of severe constraints, sometimes as defective adults, and sometimes as charming little pets to be spoiled or ignored as one pleased. Babies and very young children were still received with a

certain measure of indifference, if not hostility. Through most of the eighteenth century, the tasks of nursing and caring for babies were regarded by both men and women as debilitating, obnoxious and coarsening. The arrival of an heir brought honor to the mother, but tending to its infant needs and earliest education was the work of servants. French families with any means at all customarily handed their infants to peasant wet nurses, popularly regarded as disreputable, who kept them for about four years.[16] At this point children entered their homes for the first time, often to an indifferent reception. At seven, they were put into adult clothes and—if they were boys—sent away to school or an apprenticeship. Children could grow up barely knowing their parents. These attitudes and customs were still sufficiently alive at the end of the century to draw angry words from Bernardin de Saint-Pierre, the follower of Rousseau:

If, with us [as opposed to wise and gentle savages], fathers beat their children, it is because they love them not; if they send them abroad to nurse as soon as they come into the world, it is because they love them not; if they place them as soon as they have acquired a little growth in boarding schools and colleges, it is because they love them not ... if they keep them at a distance from themselves at every epoch of life, it must undoubtedly be because they look upon them as their heirs.[17]

Authoritarian or libertine, these traditional family relationships increasingly struck the eighteenth century as rigid, immoral and against the laws of nature. As the century wore on, and as enlightened segments of the bourgeoisie and then the aristocracy adopted the new ideal of the family, the old ways were increasingly rejected or attacked. Many parents, remembering the coldness of their childhood homes, developed more affectionate relations with their children, kept them at home longer and took more pains to find them compatible mates in marriage. After at

least two centuries of ridicule, marriage began to enjoy a degree of popularity.[18] Enlightened thinkers of the eighteenth century— men such as Buffon, Holbach, Rousseau and the Encyclopedists—almost unanimously regarded marriage as the happiest, the most civilized and the most natural of states, the institution that could best satisfy and conciliate social and individual needs. They generally agreed that in the marital relationship husbands should have final authority, but they also believed that only relationships based on mutual consent could work. Accordingly, the more they praised marriage the more they attacked the tyranny of greedy fathers who forced their children into unhappy marriages or threw their daughters into convents rather than give them dowries. To the material interests of the family they opposed the rights of the individual to personal happiness.[19] Their greatest anger, however, was reserved for the indifference and severity with which children of all classes were treated.

French philosophers, doctors and educators of the eighteenth century advanced concepts of child care and education that radically reversed common notions and practices. Profoundly influenced by Locke and English philosophy, they argued that the moral and psychological make-up of the adult is largely if not wholly shaped by his childhood environment.[20] Fénélon, Buffon, Rousseau and other French thinkers popularized the idea that the nature of childhood is essentially different from that of the adult. Since children cannot reason, they explained, rules, constraints and punishment can actually harm them; rather, good education flows from an understanding of the nature of children and the way their minds work. They advised parents to build upon and channel a child's need for affection and approval, his natural tendency to learn by imitating and his love of free play and movement. The custom of favoring the oldest son and heir while neglecting the other children was vehemently denounced.

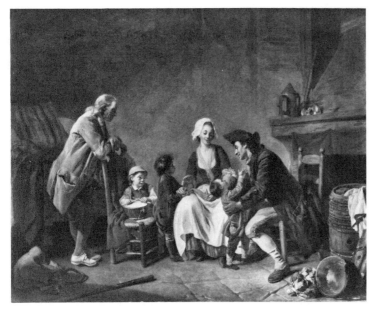

9. Etienne Aubry, *Fatherly Love*
(*L'Amour paternel*), 1775.
Birmingham, The Barber
Institute of Fine Arts, University
of Birmingham (*Barber Institute*).

Above all, they attacked the custom of sending babies off to wet nurses for the first few years of their lives as immoral and unnatural; only loving parents and especially nursing mothers could provide the kind of care and environment in which a healthy and virtuous child could grow. They promised the parents who would adopt these innovations a rich reward; awaiting them were pleasures and emotional satisfactions without parallel in other human relationships.

The promotion of these new ideas—the idea of childhood as a unique phase of human growth and that of the family as an intimate and harmonious social unit—became a major activity, a veritable cause, of Enlightenment writers.[21] In novels, on the stage and in educational, medical and philosophical treatises, the new ideals of the happy and healthy family were dramatized and explained. Rousseau's *Julie, or Nouvelle Heloïse* and his *Emile,* published in 1761 and 1762, respectively, lyrically plead them and probably did more to popularize them than any other works. Diderot's *Salons,* Greuze's *The Beloved Mother* and Fragonard's *The Return*

Home equally belong to this Enlightenment campaign.

Artists other than Greuze and Fragonard also gave expression to the new ideas—some from personal conviction, some with an eye to the market. The painter Etienne Aubry (1745–1781) won critical praise from moralists when he took up these issues in the 1770s.[22] His scenes of family life explore questions of child-rearing with seriousness and dignity. They are rendered with a graceful naturalism that was influenced by Greuze's style but relies less on dramatic devices. His *Fatherly Love,* 1775 [9], sold as a Greuze in 1961, shows a gentle, rustic father about to pick up his youngest son. His own father and wife watch with pleased and approving smiles. Here is an ideal environment for the young, where adults of both sexes show love and affection to all of their children. In his portrayal of the paternal role, Aubry was more advanced than Greuze, whose noble old patriarchs (as in *The Ungrateful Son*) are apologies for the traditional, authoritarian father.[23] In another painting, *Farewell to the Nurse,* 1776 [10], Aubry again argues for fatherly

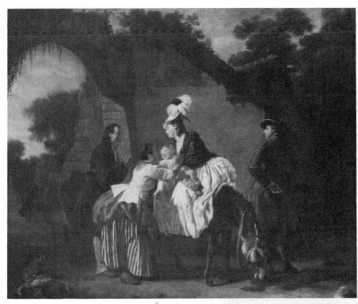

10. Aubry, *Farewell to the Nurse*
(*Les Adieux à la nourrice*), 1776.
Williamstown, Sterling and Francine
Clark Art Institute (*Sterling and
Francine Clark Art Institute*).

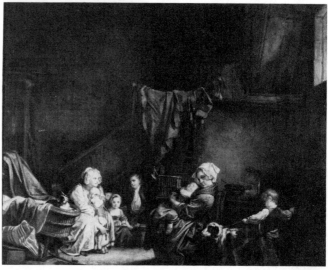

11. Greuze, *The Nursemaids,* Kansas
City, Nelson Gallery–Atkins Museum,
Nelson Fund (*Nelson Gallery–Atkins
Museum*).

love and close ties between parents and chil-
dren. On the right a wealthy father who has
left his baby with peasants holds himself
apart and aloof from the moving scene before
him. He stands in marked contrast to the
peasant, who openly expresses his paternal at-
tachment to the baby. Meanwhile, the un-
happy baby squirms to get out of the arms of
his natural mother and into those of his wet
nurse. Aubry teaches that environment and

social behavior mean more than simple blood
ties and that good parents nurse and keep
their children at home.

In *The Nursemaids* [11], Greuze gave the
same lesson, but with a more conventional ar-
gument and without his usual sympathy for
rustics. Unlike Aubry's good peasant woman,
this is a slovenly, crabby-looking nurse, sur-
rounded by ill-behaved children. Neither she
nor her companion seem to care about the

children in their charge, some of whom must be their own. The point again is that the environment makes the child and the child makes the man. These badly behaved youngsters can only become morally weak adults. Rousseau had stressed this idea in *Emile,* where he claimed that the whole moral order of France had degenerated because the wealthy refused to nurse and raise their own children.[24]

Although the exemplary parents of eighteenth-century art were usually represented as rustics, artists also explored the rewards of parenthood among the more affluent, as in a set of colored engravings by Debucourt [12 and 13], executed in the late 1780s. Here, good parents have become happy grandparents, and the fuss they make over their grandchildren is thoroughly modern. *Grandmother's Birthday* was dedicated to mothers, while *New Year's Visit* was dedicated to fathers, who traditionally blessed their families on January 1.

Commissioned portraits of real families increasingly reflected the new concept of conjugal love and family harmony. A family portrait by Drouais [14], dated 1756 when these ideas were still relatively novel in France, goes to some lengths to assert them. The aristocratic couple who commissioned this work and who unquestionably suggested or approved its every detail had a very exacting idea of how they wanted themselves represented. It is their conjugal relationship, their affection for each other, and not their separate identities or ranks that they chose to emphasize. The prominent clock tells the late morning hour and the scene is set in the wife's dressing room, an hour and a place usually reserved for intimates. An inscription gives the date as April 1, a sort of Valentine's Day on which gifts and love letters were exchanged—the paper in the husband's hand must be such a letter. Like the family in Fragonard's *Return Home,* the mother is situated in the center of the gracefully related

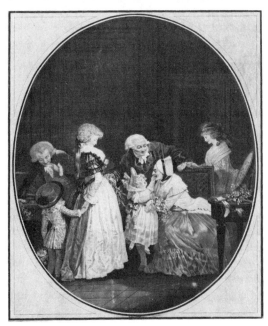

12. Debucourt, *Grandmother's Birthday* (Les Bouquets, ou la fête de la grand-maman), 1788, colored print. Paris, Bibliothèque nationale (*Bibliothèque nationale*).

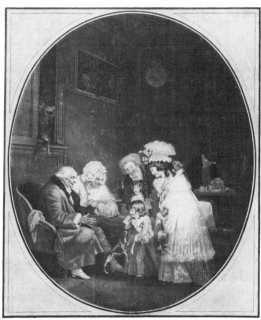

13. Debucourt, *New Year's Visit* (Les Compliments, ou La matinée du jour l'an), 1787, colored print. Paris, Bibliothèque nationale (*Bibliothèque nationale*).

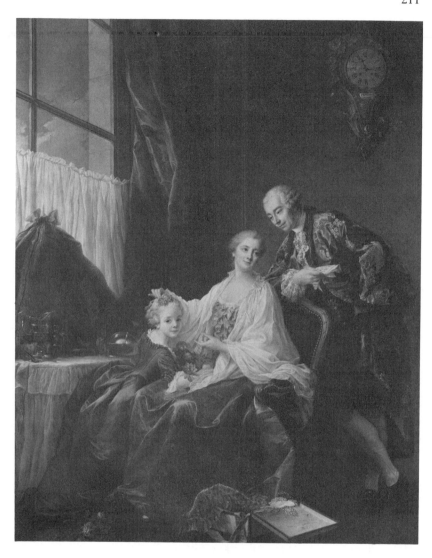

14. F.-H. Drouais,
Group Portrait, 1756.
Washington, D.C.,
National Gallery of
Art, Samuel H. Kress
Collection (*National
Gallery*).

group—between her attentive husband, toward whom she inclines her head, and her daughter, over whom she leans and fusses. Thus did bourgeois concepts penetrate aristocratic culture. Increasingly, women of noble rank would have themselves painted in their roles as mothers and wives.

Even the prestigious heights of art, the realm of mythology, responded to the new interest in conjugal love, letting this essentially middle-class idea enter through the front door of aristocratic culture. In the late eighteenth century, Hymen, the god of marriage, enjoyed a new popularity and increasingly joined Venus and Cupid in pictorial representations. Prud'hon's *Venus, Hymen and Cupid* [15] reverses the logic of conventional wisdom. Tradition taught that love, because it blinds and impairs the judgment, is the enemy of sound, advantageous marriage. But in

Prud'hon's painting, the three divinities smile in happy accord. The very classicism of their forms seems to confer upon their union the sanction of antiquity. Moreau's *Delights of Motherhood* [5], with its reference to Venus, conveys the same idea—that sexual gratification, marriage and parenthood come in a single package suitable for elevated tastes. A verse by Helvétius, published in 1772, went even further. It argued that sexual desire is heightened when Hymen and Cupid work as partners:

Enchained to both Hymen and Cupid,
Happy loving couple, what a blessing is ours ...
I was scorched by Cupid who was consuming
 my soul;
Hymen, far from quenching the flames, fanned
 them up.[25]

The educational and psychological functions of the new family help to explain its profound appeal to the feelings and imagination of the eighteenth century. For it appeared as a forceful idea just when modern bourgeois culture was beginning to take shape, and it answered particular needs which that culture created. The commercial, financial and professional activity of the *ancien régime,* although limited to a small sector of the population, was expanding enough to change people's life expectations and experience. As economic opportunities increased, it made sense to more people to limit the size of their families and to educate more of their children for higher positions in the world than the ones to which they were born.[26] The large traditional family was not geared to the new society; its logic presupposed stable social and economic conditions. Accordingly, it passed on its means intact to a single heir and taught its members family, not individual, identity, collective, not personal, ambitions. In contrast, the new family, a small and harmonious social group, could direct its unified energies toward all its children's futures. More child-centered, it was better organized

15. Pierre Paul Prud'hon, *Venus, Hymen and Cupid,* Paris, Louvre (*Service de Documentation photographique de la Réunion des Musées nationaux*).

to equip its sons with the mental skills and psychological strengths of the new man—the independent, mobile, reasoning citizen of the enlightened age. Rousseau, arguing the necessity of modern education, wrote: "If no one could be dislodged from his present station, then existing modes of education would, in some respects, be sound; a child would be brought up for his station, he would never leave it and he would never be exposed to the difficulties of any other. But we [must] consider the instability of human affairs [and] the restless and changeful spirit of the age, which reverses everything with each new generation."[27] And again: "In the case of the rustic we think only of the class; each member does the same as the rest. ... In the case of men living in civilized communities, we think of the individuals; we add to each everything that he can possess over and above that possessed by his fellows; we let him go as far as he can to become the greatest man alive."[28]

The new family, more intimate than the old, also served the psychological needs of adults. The emerging world of business was less personal and more active than the old and affected the quality of daily life. People developed a new consciousness of private versus public life, and a pressing new need for a secure and tranquil sanctuary removed from the impersonal and competitive relations that increasingly marked commercial and civic affairs. The home, the family, came to be looked upon as a haven, a place of intimacy, warmth and personal well-being opposed to the harsher world outside.[29] These associations helped to make the new ideal of the family such an attractive and emotionally resonant subject for the eighteenth century, even though—or perhaps because—most people still lived in traditionally arranged domestic situations.

The unifying element of the new family was the wife-mother. From her primarily was to flow that warmth and tranquility that Enlightenment bachelors like Diderot so ardently eulogized as the central attraction of family life. She is Rousseau's Julie and Sophie, the happy mother of Fragonard and Greuze and the virtuous wife of numerous eighteenth-century playwrights and novelists. Pretty, modest and blushing, her happiness consists in making her husband happy and in serving the needs of her children. Indeed, everything in her make-up, including her personality, is determined by her situation in the conjugal family, a situation from which eighteenth-century writers deduced the "nature" of woman. She is coquettish for her husband, whose physical and emotional needs she fulfills and to whose will she gladly submits; she is thrifty, skilled in the domestic arts, and a good mother and nurse to her children. She is the traditional bourgeois wife, but with a difference: she has been educated to find personal and emotional fulfillment in the execution of her duties. This is the difference between the good wife of old and the happy

mother of eighteenth-century art and literature. The latter is psychologically trained to *want* to do the very things she *must* do in a middle-class family society. According to Rousseau, this is the goal of women's education: since it is their natural lot to be subject to the will of men, girls should become accustomed from the first to restrictions and constraints. Their own fancies must be crushed in infancy so that they will become habitually docile and feel that they were "made" to obey.[30] Needless to say, in the eyes of Rousseau and his followers, the aristocratic woman, who organized her life around her own pleasures rather than around the needs of her husband and children, violated the laws of nature. So did the intellectual woman, the *femme-philosophe*. Wrote Rousseau: "From the lofty elevation of her genius, she despises all the duties of a woman and always begins to play the man. . . . [She] has left her natural state."[31]

Julie, the heroine of *La Nouvelle Heloïse*, is the perfect embodiment of the new feminine ideal. Although she married a man she was not in love with (out of love and duty to her parents), she is a contented wife and mother. Her husband is enlightened to the laws of nature, and Julie finds pleasure in winning his approval. She organizes her life largely around the needs of her children, nurses and personally cares for her own infants, and undertakes the complete education of her daughter, who by imitation will become like Julie. The education of her son, however, is another matter; when he reaches the age of reason he is handed over to his father. "I nurse children," says Julie, "but I am not presumptuous enough to wish to train men. . . . More worthy hands will be charged with this noble task. I am a woman and a mother and I know how to keep my proper sphere."[32] Thus does Julie contribute to two major functions of the conjugal family: the creation of active, independent males and of submissive, service-oriented females.[33]

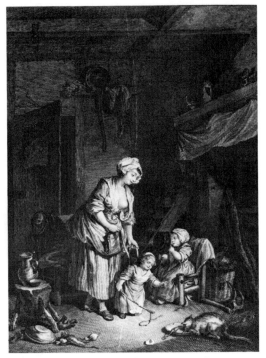

16. After Freudeberg, *The Contentments of Motherhood* (*La Complaisance maternelle*), ca. 1777, engraved by Delaunay. Paris, Bibliothèque nationale (*Bibliothèque nationale*).

The image of the mother fulfilling herself as she tends to the needs of her children was a compelling one to eighteenth-century writers. Indeed, the cult of motherhood conquered male writers before it significantly changed the lives of women. The joys of maternity became a fashionable literary theme, its every aspect eloquently told in prose and poetry, from the sensual rewards of breast feeding to the unequaled pleasure of receiving a child's caresses and kisses.[34] Even pregnancy was exalted. As one writer declared in 1772: "A woman is almost always annoyed at being pregnant, [but] this state should be regarded by women as the most beautiful moment in their lives."[35] The notion that motherhood is the *only* emotionally fulfilling role for a woman was fully developed. As another of these male authorities assured his readers: "The sensations experienced by a woman

when she becomes a mother are of a kind superior to anything she feels in other circumstances."[36]

Among the favorite arguments for motherhood advanced in this literature was the appeal to Nature, whose laws could be read in the mores of peasant or exotic cultures, or in more virtuous eras of the past.[37] French women were exhorted to imitate happy rustic mothers, noble savage mothers or the mothers of antiquity, all of whom nurse or nursed their own young. The campaign for motherhood, however, found its most urgent voice when it turned to the population problem. Frenchmen in the eighteenth century mistakenly but fervently believed that the French

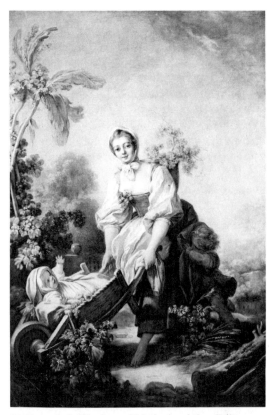

17. Fragonard, *The Joys of Motherhood* (*Les Délices maternelles*). New York, Wildenstein Collection (*Wildenstein and Company*).

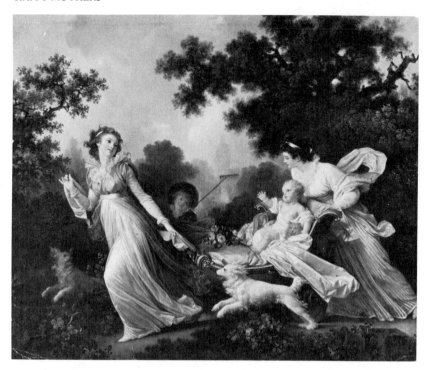

18. Fragonard and Marguerite Gérard, *The Beloved Child* (*L'Enfant chéri*). New York, Charles Dunlap Collection (*Wildenstein and Company*).

population was shrinking and in danger of extinction.[38] At the same time, the use of contraceptive practices was becoming widespread among middle- and upper-class women, whose subculture was bent on avoiding the debilitating physical effects and the economic burden of the large, biological family. Although evidence indicates that some fathers privately welcomed this trend, male public opinion was scandalized. The idea that women might exercise choice in this area, that they might choose to limit or avoid childbirth, alarmed respectable men of letters, who produced a torrent of pamphlets extolling the joys of motherhood, proclaiming it the only natural state for women and condemning the immorality and selfishness of those who would deprive the state of its population.[39] In this light, Diderot's verbal paraphrase of Greuze's *The Beloved Mother,* addressed as it is to men only, deserves to be quoted more fully: "It preaches population, and portrays with profound feeling the happi-

ness and the inestimable rewards of domestic tranquility. It says to all men of feeling and sensibility: 'Keep your family comfortable, give your wife children; give her as many as you can; give them only to her and be assured of being happy at home.'"[40]

The call to motherhood, however, probably had deeper roots in the psychological needs of the time than in concerns for population size. In any case, artists portrayed it more frequently than they did the theme of the larger family. Along with the writers, they explored its every facet. Young rustic mothers, their nursing breasts virtuously exposed, became a staple of the printseller; Freudeberg's *The Contentments of Motherhood* [16] is typical. From Fragonard's atelier came a whole series of happy and good mothers. Two of these, *The Joys of Motherhood* [17] and *The Beloved Child* [18], celebrate with Rococo exuberance the pleasures of a peasant and a fashionable mother respectively. *The Beloved Child* is probably in large

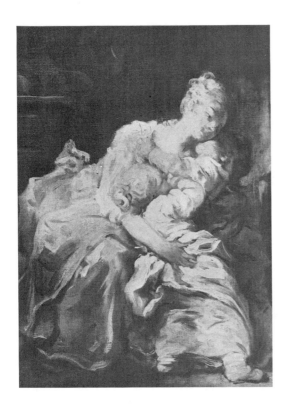

19. Fragonard, *Mother's Kisses* (*Les Baisers maternels*), ca. 1777. Preguy, Baron Edmond de Rothschild Collection (*Wildenstein,* Fragonard).

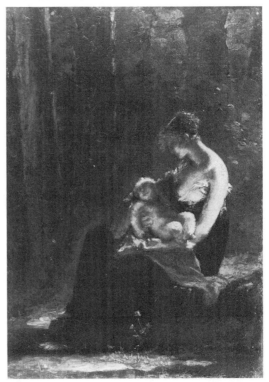

20. Prud'hon, *The Happy Mother,* sketch, ca. 1810. London, Wallace Collection (*Trustees of the Wallace Collection*).

part the work of Marguerite Gérard, Fragonard's student and sister-in-law and a specialist in this genre. Another Fragonard, *Mother's Kisses* [19], painted in his boldest, most spontaneous style, treats a theme that writers also liked: the joys of a mother who receives the fervent embraces of her children, an experience, claimed the moralists, justly denied to women who ship their infants off to be tended by others.

The image of the happy nursing mother—an image of generosity and charity with a long history in religious art—was also popular. Among the paintings that David sent to the Salon of 1781 was *A Woman Nursing Her Infant* (now lost), which was duly praised by Diderot.[41] In Prud'hon's *The Happy Mother* [20], the theme is treated with unusual subtlety. In a still, shadowy wood, a hazy light picks out the motionless figures of a nursing mother and her infant. The child asleep, the mother watching him, each seems to experience a perfect contentment and tranquility. The dark shadows, the simple, harmonious composition, the highlighted bare flesh—everything in this work suggests feelings of intimacy and sensual satisfaction shared by mother and child. In contrast to Prud'hon's poetry is a print by Augustin de Saint-Aubin of exactly the same subject, *The Happy Mother* [1], executed around the turn of the century. This extraordinary mother, who apparently can nurse two infants at a time, displays her maternal attributes with the clarity and the frontality of an archaic goddess. The message that motherhood is happiness is nowhere more blatantly stated.

With images such as these, the cult of motherhood and the concept of the conjugal family found vehicles of popularization. Expressions of a new, child-centered culture—still a minority culture in 1800—they would become familiar ideals throughout French society in the course of the following century.

NOTES

1. G. Wildenstein, *Chardin,* Manesse, 1963, pp. 17–20.

2. D. Diderot, *Salons,* ed. J. Seznec and J. Adhémar, Oxford, 1957, Vol. I, p. 233.

3. That Greuze took this rustic mother's smile from the face of Marie de Médicis as Rubens portrayed her in *The Birth of Louis XIII* (Diderot, *op. cit.,* Vol. II, pp. 35–36) only underscores the novel content of this eighteenth-century work. Marie's is the smile of a queen mother who has just given birth to a dauphin, heir to the throne by divine right. The work is officially addressed to subjects of that throne. *The Beloved Mother,* on the other hand, is theoretically addressed to humankind in general and embodies more purely secular ideas. It asserts that family relationships as such can be the sources of a happiness that is generically human.

4. *Ibid.,* Vol. II, p. 155.

5. Like Greuze, Fragonard also learned from the precedents of Dutch and Flemish art. Rubens's *Helena Fourment and Her Children* is a notable example of the kind of art that anticipated and informed Fragonard's paintings of women and children. *Mother's Kisses* [19] appears to have borrowed directly from it.

6. Rembrandt's Holy Families are especially called to mind. Fragonard loved the work of this artist.

No hard and fast line can be drawn between the older imagery of the Holy Family and that of the secular, eighteenth-century one. The suggestion of conjugal love—one of the main features of the latter—is not unusual in representations of the Holy Family, and both kinds of families supplied images of exemplary mothers, fathers and children. Philippe Ariès discusses this aspect of Christian imagery in Renaissance and post-Renaissance art in *Centuries of Childhood,* New York, 1962, pp. 339–64. In seventeenth-century France, for example, Le Brun's *Saying Grace (Le Bénédicité)* was thought to be a picture of the Holy Family, which, in turn, was regarded as a model family (*ibid.,* pp.

360–62). However, by their nature, pictures of the Holy Family are to some degree devotional. The image of the child around whom this family is organized cannot be entirely disassociated from his unique and extraordinary mission. The idea of the family that Fragonard painted, on the other hand, whatever it borrows from older, religious art, is completely secular. In contrast to the transcendent purposes of the Holy Family, the exclusive concern of this family is the individual happiness and well-being of its members. The image of the Holy Family, insofar as it is a picture of a family, could suggest this Enlightenment idea, but only to a point, beyond which it risked loss of its traditional Christian content. At the same time, the complete expression of the new ideal demanded ordinarily conceived human beings without special destinies: man in general. The terms of the new ideal were in fact those of eighteenth-century secular philosophy, and the iconography of the happy family thus reflects the contemporary secularization of French culture.

7. In R. Mercier, *L'Enfant dans la société du XVIII^e siècle (avant l'Emile)*, Dakar, 1961, p. 101.

8. The print, which appeared in the album *Monument du costume*, is part of a series of prints illustrating the life of a fashionable woman. A few scenes later she has tired of the delights of motherhood and is pursuing those of adultery.

9. Diderot, *Salons*, Vol. II, p. 151. The model for this figure was Mme Greuze, whose adulterous affairs were a source of continual vexation for her husband.

10. The traditional attitudes and family relationships to which I refer, sketched in this and following paragraphs, generally date from the seventeenth century and persisted through most of the eighteenth century. Moreover, this picture of family life is drawn from French society primarily. It will not necessarily hold for either the rest of Europe or for earlier periods in France. I have relied mainly on the following sources: Philippe Ariès's pioneering book *Centuries of Childhood*, which largely inspired the present essay, treats the Middle Ages to the eighteenth century, with emphasis on the seventeenth century; D. Hunt, *Parents and Children in History, The Psychology of Family Life in Early Modern France*, New York, 1970; W. D. Camp, *Marriage and the Family in France Since the Revolution*, New York, 1961; L. Del-

zons, *La Famille française et son évolution*, Paris, 1913; G. Duplessis, *Les Mariages en France*, Paris, 1954, pp. 1–27; J. Hajnal, "European Marriage Patterns in Perspective," in *Population in History: Essays in Historical Demography*, ed. D. V. Glass and D. Eversley, London and Chicago, 1965, pp. 101–43; Mercier, *L'Enfant*; Pilon, *La Vie de famille au XVIII^e siècle*, Paris, 1941; and R. Prigent, ed., *Renouveau des idées sur la famille* (Institut national d'études démographiques, XIV), Paris, 1954, pp. 27–49 and 111–18.

11. This progressive attitude is the subject of Ariès, *Centuries*, pp. 339–404.

12. See especially Hunt, *Parents*, pp. 68–74; and Pilon, *La Vie*, pp. 55–69.

13. E. Dacier, *La Gravure en France au XVIII^e siècle; La Gravure de genre et de moeurs*, Paris and Brussels, 1925, p. 33; J. Adhémar, *La Gravure originale au XVIII^e siècle*, Paris, 1963, p. 158; and L. Hautecoeur, *Les Peintres de la vie familiale*, p. 45f.

14. Both the thesis and the antithesis—that a woman's happiness lies in marriage, motherhood and sexual fidelity on the one hand and in libertinism and illicit love on the other—continued to delight the fashionable public well into the nineteenth century. See M. Melot, "'La Mauvaise Mère,' Étude d'un thème Romantique dans l'estampe et la littérature," *Gazette des Beaux-Arts*, ser. 6; 79 (1972), pp. 167–76, for an analysis of how nineteenth-century art struggled with the contradictions raised by these conflicting feminine ideals. Romantic continuers of eighteenth-century *éstampes galantes* and the absorption of aristocratic tastes and social patterns into nineteenth-century bourgeois culture are major themes in my *The Pursuit of Pleasure: The Rococo Revival in French Romantic Art*, New York and London, 1976.

15. Ariès, *Centuries*, pp. 15–49; and Hunt, *Parents*, Chs. 6 and 7.

16. See especially Hunt, *Parents*, pp. 100–09; and Mercier, *L'Enfant*, pp. 31–37.

17. Bernardin de Saint-Pierre, *Studies of Nature (Études de la nature)*, trans. by H. Hunter, Philadelphia, 1808, p. 413.

18. Prigent, *Renouveau*, pp. 34–49; and Duplessis, *Les Mariages*, pp. 14–15.

19. This issue was dramatically developed at the end of the century. The Revolutionary National

Assembly, carried away by liberal idealism, swept the old marriage laws off the books and legislated new ones, favoring consensual matches, restricting paternal authority and allowing for easy divorce. Napoleon's Civil Code of 1804 reversed almost all of these laws—laws that ran counter to the traditional interests of the bourgeois family—and reinstituted marriage along the old lines (Delzons, *La Famille*, pp. 1–26).

20. See especially Mercier's study, *L'Enfant*, for eighteenth-century theories of child-rearing.

21. Prigent, *Renouveau*, pp. 34–49; and Mercier, *L'Enfant*, pp. 145–61.

22. Florence Ingersoll-Smouse, "Quelques tableaux de genre inédits par Etienne Aubry (1745–1781)," *Gazette des Beaux-Arts*, ser. 5; 11[1] (1925), pp. 77–86; and Diderot, *Salons*, Vol. IV, pp. 260–61 and 291.

23. This ennobling of authoritarian fathers is a conservative element in the art of Greuze and a response to contemporary criticism of the traditional paternalistic role. David's *Oath of the Horatii*, 1784, and *Brutus*, 1789, similarly idealize the traditional authoritarian father and husband. While the women in these pictures are shown to be ruled by their emotions and family feelings alone, male virtue consists in conquering these sentiments with the aid of reason, a faculty women were thought to lack. See my "Fallen Fathers: Images of Authority in Pre-Revolutionary French Art," *Art History*, 4, June 1981, pp. 186–202.

24. R. L. Archer, ed., *Jean-Jacques Rousseau, His Educational Theories Selected from Emile, Julie and Other Writings*, Woodbury, N. Y., 1964, p. 73.

25. In Prigent, *Renouveau*, p. 37.

26. Ariès, *Centuries*, p. 404; Camp, *Marriage*, pp. 99 and 126; Prigent, *Renouveau*, pp. 111–14; and H. Bergues, P. Ariès and others, *La Prévention des naissances dans la famille, ses origines dans les temps modernes* (Institut national d'études démographiques, XXXV), Paris, 1960, pp. 311–27.

27. Archer, ed., *Rousseau*, p. 63.

28. *Ibid.*, p. 34.

29. Ariès, *Centuries*, pp. 398–400 and 404–06.

30. Archer, ed., *Rousseau*, pp. 218–27.

31. *Ibid.*, p. 253.

32. *Ibid.*, p. 46.

33. It should be noted, however, that the virtuous ideal embodied in Julie was in some ways a step up for women, whose capacity for virtue of any kind was still widely doubted and whose contribution to society was largely ignored (see Hunt, *Parents*, pp. 72–73). Moreover, at least in principle if not in substance, Julie demonstrated that individual happiness was a female as well as a male pursuit.

34. Mercier, *L'Enfant*, pp. 97–105.

35. In Bergues, *La Prévention*, p. 283.

36. In *ibid.*, p. 282.

37. Mercier, *L'Enfant*, pp. 118–22.

38. Bergues, *La Prévention*, pp. 311–27. In fact, the population of France was growing. See W. L. Langer, "Checks on Population Growth: 1750-1850," *Scientific American*, 226, February 1972, pp. 92–99.

39. See Bergues, *La Prévention*, pp. 253–307, for a collection of these texts.

40. Diderot, *Salons*, Vol. II, p. 155.

41. *Ibid.*, Vol. IV, p. 378.

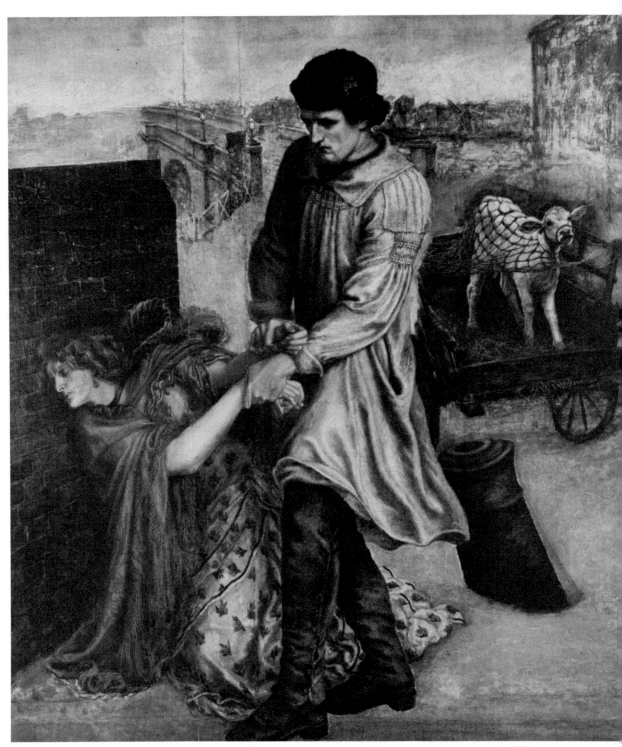

1. Dante Gabriel Rossetti, *Found,* begun 1854. Delaware Art Museum, Samuel and Mary R. Bancroft Collection (*Delaware Art Museum*).

Lost and *Found:*
Once More the Fallen Woman

LINDA NOCHLIN

"It's a queer thing," muses a young woman in one of Rose Macaulay's novels, written shortly after the first World War, "how 'fallen' in the masculine means killed in the war, and in the feminine given over to a particular kind of vice." The sexual asymmetry peculiar to the notion of falling is worth considering, especially in the nineteenth century, when both aspects were taken more seriously than they are today. In art, fallen in the masculine tended to inspire, for the most part, rather boring sculptural monuments and sarcophagi. Fallen in the feminine, however—understood as any sort of sexual activity on the part of women out of wedlock, whether or not for gain—exerted a peculiar fascination on the imagination of nineteenth-century artists, not to speak of writers, social critics and uplifters, an interest that reached its peak in England in the middle years of the nineteenth century, and that perhaps received its characteristic formulation in the circle of the Pre-

Raphaelites and their friends. Certainly the theme of the fallen woman may be said to have interested Dante Gabriel Rossetti almost to the point of obsession. Not only did he devote a number of poems and pictorial works to the subject, but his one painting to deal with a contemporary subject in an unaccustomed realistic mode was devoted to the theme. This painting, *Found* [1], significantly unfinished, occupied him on and off from at least as early as 1853 [2] until the year before his death: it was obviously a work he could never fully resolve nor definitely put aside.[1]

Rossetti's description of the picture in a letter to Holman Hunt of January 30, 1855, seems straightforward enough:

The picture represents a London street at dawn, with the lamps still lighted along a bridge which forms the distant background. A drover has left his cart standing in the middle of the road (in which, i.e., the cart, stands baa-ing a calf tied on its way to market), and has run a little way after a girl who has passed him, wandering in the streets. He had just come up with her and she, recognizing him, has sunk under her shame upon her knees, against the wall of a raised churchyard in the foreground,

Linda Nochlin, "Lost and *Found:* Once More the Fallen Woman," *The Art Bulletin,* 60, March 1978, pp. 139–53. By permission of the author and the College Art Association of America.

2. Rossetti, *Found,* Pen and brown ink and brown wash, dated 1853. London, British Museum.

while he stands holding her hands as he seized them, half in bewilderment and half guarding her from doing herself a hurt. These are the chief things in the picture which is to be called "Found" and for which my sister Maria has found me a most lovely motto from Jeremiah: "I remember Thee, the kindness of thy youth, the love of thine espousals." . . .[2]

Yet the complete significance of the work, and its multiple implications and relationships, are anything but straightforward—are highly problematic, in fact—and can best be illuminated by examining it in a variety of perspectives. First of all, setting *Found* within the context of a whole range of nineteenth-century attempts to invent a secular pictorial imagery of the fallen woman, a pressing social and moral, as well as often personal, contemporary issue, helps to reveal the unconscious, or what might be termed the ideological assumptions Rossetti makes about his subject, as well as the vividly personal aspects of his

inflection of it. Second, *Found* will be examined in relation to another Pre-Raphaelite's interpretation of the fallen-woman theme, Holman Hunt's *Awakening Conscience,* to which Rossetti's painting may be considered in some ways a paradoxically contradictory pendant, and for which I believe another work of Rossetti's supplied at least part of the inspiration. Third, the sources and the formulation of the pictorial structure of *Found* will be examined. Fourth, the work will be considered in relation to the meanings it may have had in the artist's personal history. And finally, I will demonstrate that the fact that Rossetti was a poet as well as a painter, and dealt with the theme of the fallen woman in verse as well as in pictures, has little or no relevance to the major features of structure or expression—as opposed to the mere "story" or the iconographic details—of *Found.* Indeed, the fact that Rossetti was inspired by his own "Jenny," turned to William Bell Scott's poetry for subject matter or for details of symbolism, and in turn looked to his own painting for inspiration in his later sonnet, "Found," seems to me in no way to imply that poems and pictures do more than simply explicate one another, or that they are locked together semantically or syntactically. Millais's *Ophelia* was not "semantically or syntactically locked" to the verses of Shakespeare's *Hamlet,* which inspired it and which it so faithfully reproduces, any more than Keats's "Ode on a Grecian Urn" was structurally or syntactically related to the principles of Greek vase painting. On the contrary, I should say that in *Found,* above all his other paintings, Rossetti's strategies are those of the painters of his time. He directs his attention firmly to suitable pictorial precedents for his composition, and to the task—a relatively conventional one in the nineteenth century and one that preoccupied the majority of artists of the period, from Delacroix or Couture to Hunt or Millais—of creating a suitable visual imagery, a meaningful pictorial struc-

ture, for relatively complex ideas or issues or narratives. It is a pictorial mode that has often been called "literary" since the time of Fry and Bell (although in actuality it is no more literary than film, which also attempts to do some of the same things by means of visual images rather than words). In other words, I think that there is nothing particularly "poetic" or even literary about *Found,* or indeed anything about it that particularly marks it off from any number of other similar narrative or morally meaningful nineteenth century works as being the work of a painter who is also a poet.

First, let us consider the general context of "fallen-woman" imagery, which I believe is critical to a reading of the painting. In the background, for any English artist of the nineteenth century turning to the subject of the prostitute—and especially for the Pre-Raphaelites, who were conscious of being both English and moral at the same time— lay the visual precedent of Hogarth; and for Rossetti especially lay the precedent of Blake, like himself a poet and a painter; and more particularly, in the case of *Found,* Blake's "London."[3] Yet already in the later eighteenth and earlier nineteenth centuries, Hogarth's brisk setting forth of the inexorable working of natural law to punish folly and sensuality, as well as Blake's apocalyptic vision of innocence as inexorably corrupted by greed and the great city, had been considerably softened by sentimentality and humanitarianism. By the nineteenth century, it was readily conceded that a woman might fall as much through need as through greed, and that she might redeem herself through repentance and subsequent reintegration into the family. Indeed, the institution of the family plays an increasingly important role, either as a foil to rehabilitation or as the instrument of it, in the imagery of the fallen woman in the nineteenth century. As early as 1789, George Morland, in his *Laetitia* series (engraved by John Raphael Smith), which demonstrated

the downfall of an innocent country girl, had substituted a happy ending for Hogarth's grim finale. In *The Fair Penitent* [3] the heroine, still fallen—and literal fall seems a sine qua non of this imagery—but more in confusion than depravity, is welcomed back into the bosom of the family. The setting of innocence here is pointedly rural, as opposed to the equally pointed urbanism of the setting of sin in the same series. The theme of redemption through a return to the family and native village, of rehabilitation through rural felicity and the acceptance of the country girl's "natural" humble position in society, had considerable currency in French popular imagery of the early nineteenth century. Merging with the more traditional serial *images populaires* of the Prodigal Son, this theme emerged as the *topos* of the *fille coupable"*—the guilty daughter—in a wide range of variations. In

3. George Morland, *The Fair Penitent,* 1789, engraved by John Raphael Smith. Plate 6 from *Laetitia.*

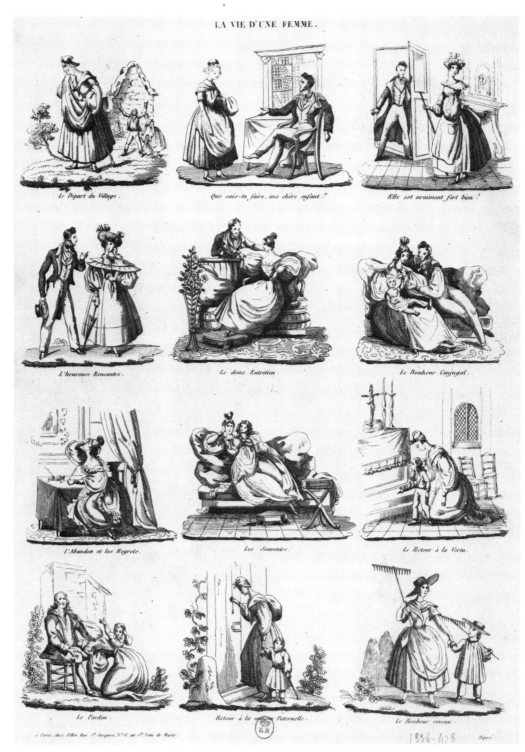

4. *La Vie d'une femme,* wood engraving, *chez* Pillot, 1836. Paris, Bibliothèque nationale (*Bibliothèque nationale*).

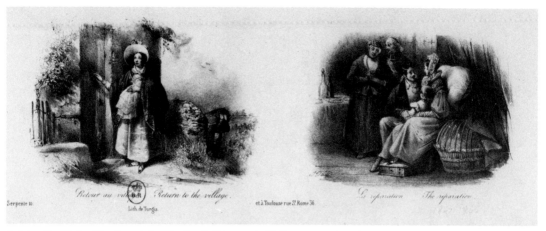

5. Jules David, *La Vie d'une jolie fille*, detail, lithograph, 1847. Paris, Bibliothèque nationale (*Bibliothèque nationale*).

La Vie d'une femme of 1836 [4], an anonymous wood engraving from *chez* Pillot in Paris, the kneeling pose generally associated with falling in the feminine is reserved for prayer or penitence. The more sophisticated lithograph series, *La Vie d'une jolie fille* of 1847 [5], pendant to *La Vie d'un joli garçon* by Jules David, is more obvious in its filiation from Hogarth, and clearly intended for a more worldly clientele, both French and English; there are many other examples, all of which stress return to the family as the "solution" to the fall. Lurking behind most of the fallen-woman imagery of the nineteenth century is the sometimes explicit but more often unspoken assumption that the only honorable position for a young woman is her role within the family: the role of daughter, wife and mother. Speaking figuratively, one might say that behind every crouched figure of a fallen woman there stands the eminently upright one of the angel in the house.

This conventional contrast is used several times to good effect by William Bell Scott in his long poem on the fallen-woman theme, "Rosabell," one of Rossetti's presumptive sources for the subject of *Found*.[4] In section 11 of "Rosabell," the prostitute's hard fate is contrasted with the domestic felicity of the good, humble woman whom her childhood sweetheart married instead: their cosy domestic interior—the husband doffing his shoes before the fire, the child sleeping, the wife "sewing tiny frills that it shall wear," the "window and curtain and the light"[5]—is pointedly contrasted with the cold, rainy, outdoor setting chosen for the description of fallen Rosabell in verses that follow:

Down the wet pavement gleam the lamps,
While the cold wind whistles past;
A distant heel rings hurrying home,
It lessens into stillness now,
And she is left alone again. . . .[6]

The implicit loss of domestic happiness, the irrevocable exclusion from the joys of the family, is signified in quite subtle pictorial terms by Rossetti, in the contrast he creates between the group in the left foreground foiled by wall and graveyard and the shuttered house—home as seen from the vantage point of the pariah—as well as the nest-building sparrows to the right.

The connection between the opposing terms of family and fallen woman and the sinister threat that woman's unregulated sexual activity was felt to offer the bulwark of Victorian paternal authoritarianism—the

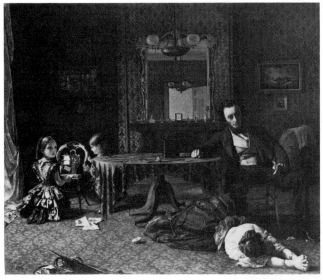

6. Augustus Leopold Egg, *Past and Present, No. 1,* 1858. London, Tate Gallery (*Tate Gallery*).

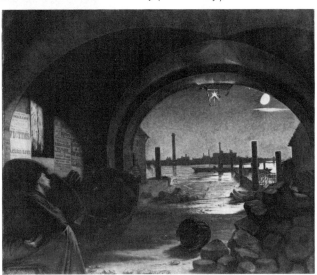

7. Egg, *Past and Present, No. 3,* 1858. London, Tate Gallery (*Tate Gallery*).

home—is nowhere given more explicit visual expression than in Augustus Egg's three-part painting entitled (probably erroneously) *Past and Present,* which was exhibited at the Royal Academy in 1858 [6].[7] Here, in No. 1, the fall is literally enacted in a middle-class domestic interior—a setting with ironic reminiscences of the *Arnolfini Wedding Portrait;* the impact of the fall, emphasized by the half-eaten apple on the table, is re-echoed in the tumbling of the children's house of cards. The awfulness of the wife's lapse is given added emphasis by the space chosen for the unfolding of the tragedy, the parlor, cella of that domestic temple which it is woman's natural duty to guard. The wife and mother's adultery shatters the order of nature: the sacred place is profaned: this is perhaps the most serious order of transgression in the canon of bourgeois morality. Indeed, there is no

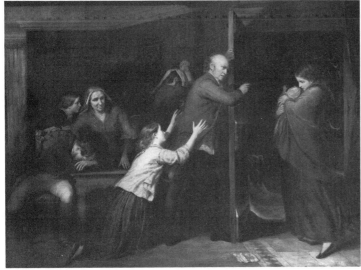

8

8. Richard Redgrave, *The Outcast,* 1851. London, The Royal Academy of Arts (*Royal Academy*).

9. Nikolai Alexandrovitch Iaroshenko, *Thrown Out (At the Station),* 1883. Tashkent, Uzbeki Museum of Fine Art.

9

place for the erring wife to go but out; she must be sent forth from the parlor-paradise, an eventuality suggested by the open door in the background and reiterated by the print of the Expulsion on the wall behind the fallen figure.

The outside, the city exterior, becomes the literal as well as the metaphoric place of the fallen woman in the third painting of Egg's trilogy [7]: here the fallen wife, who has obvi-

ously lost her money and her position in the world along with her virtue, clasping the fruit of her sin in her arms and still crouching, looks wistfully but hopelessly back at her former home from beneath a dry arch, an outside-inside dichotomy that was suggested by the first painting in the series and, in less obvious form, in Rossetti's painting as well, where outsideness, with its threats, its very contradiction of being at home in the world,

and the city setting are seen as the natural space of the fallen woman.

Indeed, the fallen woman thrust from home is the explicit theme of at least two paintings of the period: the English Richard Redgrave's melodramatic *The Outcast* of 1851 [8], and the more sober, realistic, and restrained Russian work, representing a pregnant girl forced out of her lodgings, *Thrown Out (At the Station)* of 1883 [9], by Nikolai Alexandrovitch Iaroshenko (1846-1899).[8]

At the same time that the fate of the fallen woman was tellingly contrasted with the sa-

cred security of home and family in nineteenth-century imagery of erring womanhood, a realistic account began to be taken of the economic factors involved in women's fall from virtue, with the sympathetic, often sentimental setting forth of the tragic consequences of sheer, desperate need. One of the most striking of such representations is George Frederic Watts's *Found Drowned* [10], painted in about 1848-50—brief years of social radicalism on the part of the artist as well as for Europe as a whole—one of four paintings Watts dedicated at the time to the

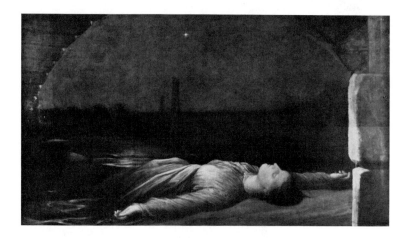

10. George Watts, *Found Drowned*, ca. 1848-50. The Trustees of the Watts Gallery.

11. Vassily Grigorievitch Perov, *The Drowned Woman*, 1867. Moscow, Tretyakov Gallery.

depiction of the helpless suffering of the poor, and of poor women especially. *Found Drowned* represents a suicide washed up under the arch of Waterloo Bridge. The interpretation of the causes of the young woman's suicide would seem obvious to the nineteenth-century viewer, and were manifestly connected with Thomas Hood's widely known poem on the subject, "The Bridge of Sighs" of 1844, which is closely related. The victim was understood to have done away with herself because of poverty and consequent falling, for some women still a fate worse than death. Watts, like Hood, means to arouse feelings of sympathy and compassion rather than condemnation; his painting may be considered a visual equivalent of Hood's admonition to

> Take her up instantly,
> Loving not loathing.
> Touch her not scornfully;
> Think of her mournfully,
> Gently and humanly;
> Not of the stains of her,
> All that remains of her
> Now is pure womanly. . . .[9]

Vassily Grigorievitch Perov's *The Drowned Woman* [11] of 1867 seems strikingly related to Watts's work (or Hood's poem), but is far more explicit in its ironic contrast between the pathos of the young girl's suicide and the indifference of society, implied by the presence of the constable who smokes his pipe phlegmatically to the right of the young victim; and Perov is far more concerned to specify the working-class origins of the drowned girl in details of dress and setting. Obviously in this case an unjust and indifferent social order, rather than the poor fallen woman, is meant to be the object of censure.

Certainly the economic determinants of prostitution were openly discussed and strongly deplored in England in the decade of the fifties. A long, well-documented, and by no means pussyfooting article on the subject

by William Rathbone Greg appeared in the *Westminster Review* in 1850. Citing the Bible of prostitution research, A. J. B. Parent-Duchâtelet's *De la prostitution dans la ville de Paris* (first published in 1836 and issued in new editions for years), and the results of the current investigations into the lives of the London poor by Henry Mayhew, then appearing in the form of letters to the *Morning Chronicle,* Greg states unequivocally that "poverty is the chief determining cause which drives women into prostitution in England as in France."[10] A small sepia drawing from Rossetti's own circle, John Millais's *Virtue and Vice* [12], signed and dated 1853—the year of the earliest dated compositional study for *Found*—could almost serve as an illustration to Mayhew or Greg's vivid testimony about the situation of women "slop-workers" (piece workers), whose wages were so pitifully low that they were forced to sell their bod-

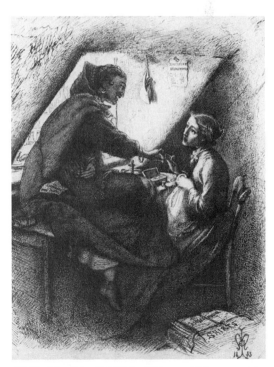

12. Sir John Everett Millais, *Virtue and Vice,* pen and sepia ink, 1853. Collection of Raoul Millais, Esq.

ies to keep themselves, or at times their children, from starving. Millais, despite the symbolic dramatization of the momentous choice, which transforms the temptress at the left into a kind of female Satan, has realistically rendered the bleakness of the garret and the thinness and exhaustion of the young slop-worker, and has underlined the grim factor of the economic determination of falling by the parcel of shirts on the floor to the right and the notice near the window headed "distressed needlewoman." It is perhaps relevant to point out that in the earliest version of *Found* [2], which, like Millais's work, originated in 1853, the young woman fallen to the pavement is thin and shabby-looking rather than tawdry and voluptuous; like Millais's seamstress, she is dressed poorly and modestly, suggesting that she too had been driven to

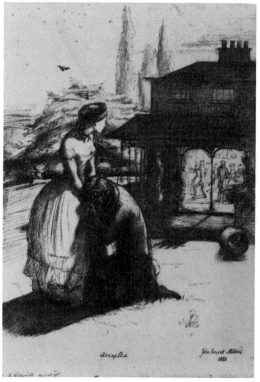

13. Millais, *Accepted,* pen and sepia ink, 1853. New Haven, Yale Center for British Art.

her fate rather than freely choosing it. Millais has also provided an obvious compositional parallel with Rossetti's original conception of *Found* in his own pen and ink drawing of the same year, *Accepted* [13], as well as a kind of moral counterweight to Rossetti's drawing. *Accepted,* like *Found,* had a basis in a disturbing personal relationship with the opposite sex: it is one of a series of drawings dealing with the troubled interaction between a man and a woman dating from the period of Millais's courtship of Effie Ruskin.

Yet perhaps no work is more closely intertwined with Rossetti's *Found* and his very conception of the fallen woman than Holman Hunt's *Awakening Conscience* [14], signed and dated 1853, and exhibited at the Royal Academy in 1854. Despite their striking differences of interpretation and structure—or perhaps because of them—one can see these works as pendants, opposing visions of a single moral issue: rising versus falling, salvation versus damnation, Christian optimism versus Christian or crypto-Christian despair, the larger oppositions in both cases growing out of intimate personal experience, probably involving Annie Miller, and couched in the pictorial language of realism. Like Rossetti, Hunt reinforces the credibility of his painstaking visual realism with an equally painstaking scaffolding of symbolic incident: at the crucial instant of conscience awakening, a cat releases a bird beneath the table, and light—reflected in the mirror in the background—quite literally dawns in the unspoiled garden outside the St. John's Wood sitting room. That parlor's unsavoriness is attested to by such elements as the print of *Christ and the Woman Taken in Adultery* on the wall, the dozing cupids on the clock, the birds stealing grapes in the wall design, as well as by what Ruskin admiringly described as the "fatal newness" of the furniture. The volume of Noel Humphrey's *The Origin and Progress of the Art of Writing* on the table may be a covert reference to Hunt's educational pro-

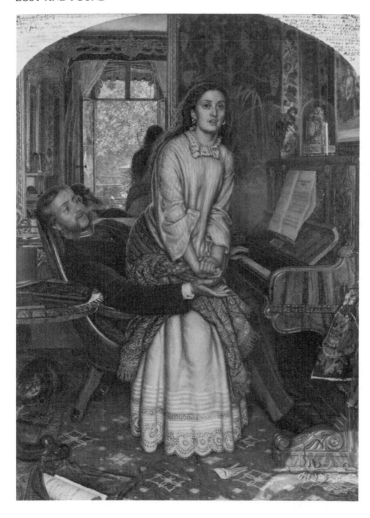

14. Holman Hunt, *Awakening Conscience*, 1853. London, Tate Gallery (*Tate Gallery*).

gram for his "fiancée," Annie Miller, the original model for the painting. Certainly it is no accident that the young woman experiencing the moral epiphany has rings on every finger *but* the third finger of her left hand.

Like Rossetti's, Hunt's work was no doubt originally based on a creative misunderstanding of Hogarth: perhaps of *The Lady's Last Stake,* as John Duncan MacMillan recently suggested;[11] probably by Hogarth's paired engravings, *Before* and *After,* with their emphatic lap-sitting, rising, and falling in an *intérieur moralisé;*[12] and doubtless by *The*

Harlot's Progress with the hopeful ending of nineteenth-century sentimentality substituted for the original one. Like Rossetti—as we shall see—Hunt turned to the precedent of Jan van Eyck, specifically to the *Arnolfini Portrait* in the National Gallery, London, for his inspiration in the setting and perhaps for a certain validation of Pre-Raphaelite authenticity, for a reassuringly primitive freshness of feeling, as well as a sincerity of execution, although he, like Rossetti, drew on more conventionally sophisticated sources as well. In Hunt's case, it would seem likely that he

made use of an engraving after Charles Le Brun's *Repentant Magdalene Renouncing All the Vanities of the World* [15] for the relatively rare motif of upward mobility on the part of the fallen woman.[13]

Rossetti, too, could not fail to associate contemporary fall with the precedent of the Bible: both his elaborate drawing and his sonnet "Mary Magdalene at the Door of Simon the Pharisee" of 1858, are obviously related to the theme of *Found*. Like Rossetti, Hunt, according to his own account, had been moved to pictorial action by literary incident. When considering his subject, Hunt said, he had been touched by the description of Peggotty's search for the outcast Emily in *David Copperfield*, first published in 1849–50.[14] Yet more likely, as in Rossetti's case, the more di-

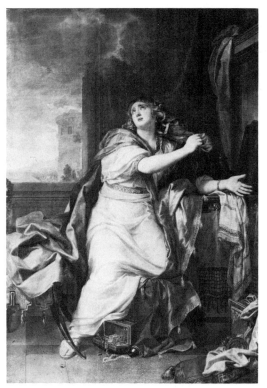

15. Charles Le Brun, *The Repentant Magdalene Renouncing All the Vanities of the World,* 1656–57. Paris, Louvre (*Giraudon*).

rect inspiration for the *Awakening Conscience* had been visual rather than literary, in this instance Phiz's (Hablot Knight Browne's) well-known illustration of 1849, an illustration not of the search for Emily but of the finding of the prostitute Martha in the same novel. Topoi from both Rossetti's and Hunt's paintings of fallen women seem to find echoes in the work of a later artist obsessed with problematic sexuality, Edvard Munch. *The Cry* of 1893, now in the Oslo Municipal Collection, seems an intensification of the implications of the lonely figure on the bridge behind the main incident in *Found;* and the adolescent girl in *Puberty* of 1894, now in the National Gallery, Oslo, repeats (with changed and ominous emphasis) the protective, traditional gesture of *pudeur* suggested by the protagonist of the *Awakening Conscience*, a gesture perhaps transmitted through an etching by Félicien Rops of 1886.[15]

The fallen-woman imagery of Hunt and Rossetti may have an even more specific connection: indeed, Hunt's painting may be directly dependent upon a Rossettian prototype for its most characteristic features. In the letter to Hunt of January 30, 1855, describing *Found,* Rossetti prefaces his description with the following remark:

The subject had been sometime designed before you left England [that is, before January 16, 1854, when Hunt started off for the Holy Land via Paris and Alexandria] and will be thought, by anyone who sees it when (and if) finished, to follow in the wake of your "Awakened Conscience," but not by yourself, as you know I had long had in view subjects taking the same direction as my present one.[16]

Despite the frequency of Pre-Raphaelite squabbles over precedence, and the incontrovertible fact that the *terminus ante quem* for the *Awakening Conscience* is 1853, the year of the earliest dated complete project for *Found*, it is significant that Hunt, who had originally, in the 1905 edition of his *Pre-Raphaelitism,* dated *his* first thoughts for the

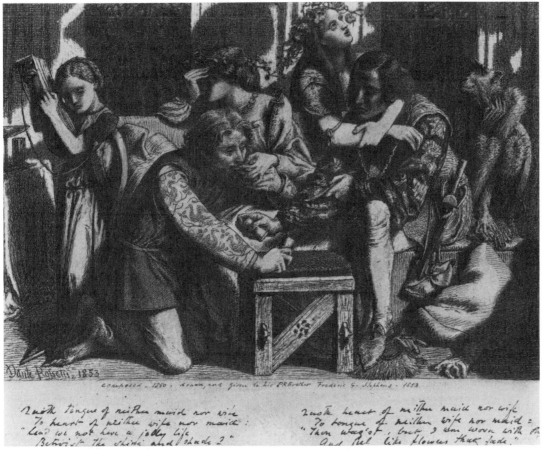

composed - 1850 - drawn, and given to his PRBrother Frederic G. Stephens - 1853.

16. Rossetti, *Hesterna Rosa*, 1853. London, Tate Gallery (*Tate Gallery*).

Awakening Conscience to 1851, revised this date to 1853 in the edition of 1913.[17] But there is more substantial evidence that Rossetti provided the pictorial inspiration for the basic conception as well as many of the characteristic details of the *Awakening Conscience.* The evidence is Rossetti's small pen and ink drawing—similar in its moral, if not modern, subject—*Hesterna Rosa* [16]. This little drawing (which Rossetti reworked as a watercolor in 1865),[18] although signed and dated in the lower left corner "1853," is nevertheless confusingly inscribed at its foot: "composed—1850—drawn, and given to his P. R. Brother Frederic G. Stephens—1853," which suggests an earlier origin. It is certainly

not a contemporary subject. (The drawing was intended as an illustration of Elena's song from Sir Henry Taylor's play *Philip van Artevelde,* the verses of which are inscribed at the bottom of the Tate drawing.) Nevertheless, *Hesterna Rosa* proposes the major themes of Hunt's fallen-woman painting. Like the *Awakening Conscience,* it demonstrates the power of music, an art traditionally associated with erotic temptation,[19] to awaken conscience by recalling childlike innocence, personified by the little girl playing and listening to the lute at the left. She is the embodiment of the memories of childhood innocence and subsequent "holy resolve" aroused by the playing of "Oft in the Stilly Night" in Hunt's

painting. In *Hesterna Rosa,* too, the con-science-striken woman is, like Hunt's, entangled with an uncaring, shallow male companion, who, continuing his play, provides a foil for her sudden change of heart. The contrast of inside and outside, the crowded, body-packed realm of sin opposed to the pure realm of nature outside the windows, is present in both works, although much further developed in Hunt's, as is the symbolic significance of animals—the ape in Rossetti's picture, the cat in Hunt's. Even the tell-tale symptom of a moral as well as physical carelessness in the dropped gloves appears in both works. *Hesterna Rosa,* then, may have been what Rossetti had in mind when he alerted Hunt at the beginning of 1855 to subjects "long had in view" that took the same direction as *Found.*

And what of *Found* itself, or, more specifically, the drawings for it of 1853 [2] and ca. 1855 [17]? These provide us with information about Rossetti's intentions, of which the incompleteness of the painting deprives us. Of course, the carefully described brickwork in the oil version, the later substitution of Fanny Cornforth for the original model (possibly Annie Miller, [18]),[20] and the deliberate change in the skirt and smock from chaste, "primitive" restraint to emotionally charged baroque surge, flow, and flutter, all have a significance of their own in the interpretation of the imaginative evolution of the theme. Yet in neither the earlier nor the later versions do I think that the structure of *Found* is significantly bound to Rossetti's strategies as a poet when dealing with the theme of the fallen woman.

True, *Found* is related to poetic precedent in some of its details, and first of all to that of William Bell Scott's "Rosabell." During the course of a visit Rossetti made to Newcastle in the summer of 1853, Scott evidently retitled his poem "Mary Ann," a name Rossetti felt was more indicative of the humble rank of the heroine. "Rosabell," which Rossetti claimed to have altered substantially in conjunction with its author,[21] may indeed have suggested the general idea of rural innocence corrupted by the temptations of the city, the

17

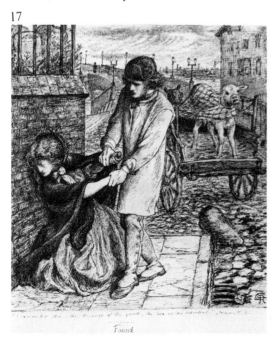

Found

18

17. Rossetti, *Found,* pen and ink, ca. 1855. Birmingham City Museum and Art Gallery (*City of Birmingham*).

18. Rossetti, Study for *Found,* pen and ink and slight ink-wash, ca. 1856–61? Birmingham City Museum and Art Gallery (*City of Birmingham*).

abandoned farmer-boy sweetheart, and the cold, isolated outdoor setting of *Found.* But Scott's poem did not include a meeting of the erring woman with her former sweetheart, although Rossetti evidently suggested that Scott alter his poem to include this incident. Portions of Scott's long narrative poem could even more easily be related to themes in Millais's or Hunt's paintings of fallen women than to *Found.* Rather than *Found,* Rossetti's watercolor of 1857, *The Gate of Memory* [19], depicting a prostitute standing under an archway watching a group of dancing children who remind her of her own lost innocence, must be considered the work most closely related to Scott's poem. Indeed, the watercolor is an illustration of a specific scene described in the poem.[22] Nor do I think that there is any substantive structural relation between *Found* and Rossetti's poem on the fallen-woman theme, "Jenny," which was first begun in 1847–48 (when it was engagingly awkward, openly indebted to Blake, and unabashedly sexy), published in greatly modified form in the 1870 edition of the *Poems,* and reworked as late as the edition of 1881.[23]

Certain descriptive features of the poem do appear in the pictorial work—the "long drooping throat" attributed to Jenny (but then again, to what Rossetti female would it *not* be attributed?) and visible in the heroine of the painting; the symbolic rose-patterning of the fallen woman's dress (in the painting, to be sure, not the earlier drawings); the early wagon and the London sparrows (which would, in the drawing, appear to be engaged in nest-building rather than merely "clamouring," as in the poem). Despite these parallels, however, the poem "Jenny" is remarkably different, both literally and figuratively, from its supposed visual equivalent, *Found.*[24] What is lacking in the painting is the complexity of attitude, as well as the multiplicity of viewpoints of the poem—an ambivalence severely criticized by Ruskin when Rossetti showed him "Jenny" in 1859[25]—the complex-

19. Rossetti, *The Gate of Memory,* watercolor, 1857, repainted 1864. Collection Mrs. Janet Camp Troxell.

ity created by the fact that in the poem, the theme of the fallen woman is mediated through the consciousness of the young male narrator whose interior monologue the poem purports to be.

If the poem "Jenny" may be said to be "about" any one thing, it is less about the fate of a young prostitute—who here never encounters her childhood sweetheart—than about the inner life of the sophisticated young narrator, certainly identifiable with the poet himself, and his meditations upon sex, sin, men and women, the paradoxical contrast between the "good" woman and the "bad one," the nature of time and the nature of atonement. Indeed, so subjective, even egocentric, is the poem, that at the critical point the actual Jenny fades from view, becoming, in rapid succession, a "cipher of man's changeless sum of lust," a riddle, and, finally and most daringly, serving as the stimulus for

a simile in which lust is likened to "a toad within a stone."[26] The striking freedom of association, compounded equally of psychological flow and sharp disjunctions of tone and mood, the shifts of distance and vantage point, the ambivalence of the attitude, compounded of compassion and condescension (strategies at least partly inspired by Browning, whom Rossetti still greatly admired at the time)[27]—all these are completely foreign to the painting. So is the crucial sense of being *within* the flexible space of an individual subjectivity—a possibility, after all, not completely unavailable to painting—instead of being situated at a fixed distance from an external event, which is the spatial assumption of *Found.* And certainly, if we compare *Found* with the later sonnet in which, we may speculate, Rossetti attempted to articulate more fully the implications of the painting he was never able to finish, we find that, on the contrary, Rossetti has chosen to simplify and exclude much that is suggested by the painting. Further, by emphasizing the contrast between light and dark as a moral metaphor of despair, he makes the sonnet sound far more forceful and unequivocal in its pessimism than the picture for which it exists as a kind of late-life gloss. In cutting off the fallen woman from possible redemption, the final line, "Leave me—I do not know you—go away,"[28] is absolute in a way that the painting is not, with its brightening dawn suggesting "peace with forgiveness. . . ," to borrow the description of F. G. Stephens.[29]

In short, I do not believe that Rossetti's poems on the fallen woman and the visual imagery of *Found* exhibit any of those essential structural analogies that, for example, Roman Jakobson has demonstrated to exist in related verse and pictures in the case of three other poet-painters, Blake, the Douanier Rousseau, and Paul Klee.[30] In *Found,* on the contrary, Rossetti, like most other painters of the nineteenth century and before, attempted to body forth moral meaning and personal feeling, to create a structure of space rich in significance and implicit temporality, by means of the most effective visual signifiers possible—that is, in pictorial, not in poetic language. To achieve this end, he turned to suitable pictorial precedents and to the direct study of nature, a practice strongly recommended by Ruskin, whose opinion certainly counted for something with Rossetti at the time, and one followed assiduously by his fellow Pre-Raphaelites, especially during the early fifties. Although such scrupulous realism is not usual in Rossetti's *oeuvre,* in the case of *Found,* he took the view of Blackfriars Bridge from his own window at Chatham Place; struggled with the brick wall—brick by brick—at Chiswick; and painted the calf and cart, "like Albert Dürer, hair by hair," as Ford Madox Brown impatiently remarked, while staying with the Browns at Finchley in 1854, a prolonged bout of painting that strained the friendship almost to the breaking point.[31]

If *Found* is full of messages, stuffed with narrative implications, it is no more so than innumerable other paintings of its time and place. Even the inscription of a pointed biblical text on the completed drawing, which might suggest an essential connection between words and picture—"I remember thee;/ The kindness of thy youth, the love of thy betrothal"—is by no means unique to the poet Rossetti. Hunt, for example, whose major literary achievement is the voluminous and certainly far from poetic *Pre-Raphaelitism and the Pre-Raphaelite Brotherhood,* inscribed the *Awakening Conscience* with a similarly apposite biblical tag on the frame.[32] Indeed, with respect to the structure of *Found,* one might say that Rossetti is less constrained by poetry, or by his conception of the poetic or the "musical" (i.e., the decorative), than he is in most of his other pictorial works.

As is true of so many other nineteenth-century paintings, perspective—or more spe-

cifically the pictorial suggestion of deep space—is deployed to suggest moral and temporal factors impossible to convey more literally on the static, two-dimensional surface of the canvas. In a manner analogous, although in no way similar, to that in which Couture, for instance, suggests a morally purer past by means of a perspective vista in his *Romans of the Decadence* of 1847, or Goya the *via crucis*-like progression from the everyday to the horrific by the deeply shadowed perspective of his *Execution of the Madrileños,* so Rossetti has deployed the turning vista of Blackfriars Bridge to suggest the past and the future, the moral meaning and the painful consequences of falling in the feminine. Spatial divisions are the meaningful indexes of moral and spiritual temperature throughout [2]: the churchyard wall, separating upright from fallen; the bollard, separating purity (the symbolic, sacrificial white calf) from corruption; the geometric blocks of the pavement separating the spiritually problematic group in the foreground from the simple, old irregularities of the cobblestones in the middle distance, a separation emphasized by the prominence of the bollard—a threatening boundary, suggestive of both phallus and gravestone in its conformation; the sharp orthogonal border dividing pavement from gutter, to which falling is materially related; the bars of the graveyard, separating death from life, yet suggesting the immanence of mortality, just as the mesh of the white calf's net suggests that life is enmeshed by death, that innocence is doomed to destruction. Perhaps most important of all is the bridge dividing city from country, virginal past from fallen present—the bridge whose significance is further heightened, not in the unfinished painting but in the complete drawings, by the moving presence of an isolated, anonymous female figure. This figure on the bridge is an emblem too of the future alienation of the fallen woman that carries an implication of contemplated suicide: the little figure seems

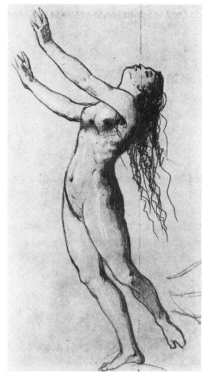

20. Perov, Study of *a Woman Throwing Herself into the Moscow River,* pencil, ca. 1867. Moscow, Tretyakov Gallery.

to be walking close to the stairway leading down to the river, and would produce ominous reverberations in viewers familiar with the precedents of Hood and Watts. Coincidentally, the Russian painter Vassily Grigorievitch Perov, creator of *The Drowned Woman* of 1867 [11], actually executed a study of *A Woman Throwing Herself into the Moscow River* [20], of about the same date, a work that seems a fulfillment of the suggestion offered by Rossetti's painting; and Rossetti himself dealt with the theme of the betrayed woman who commits suicide by throwing herself and her baby into the river in a poem of 1871, "The River's Record."[33]

In quite idiosyncratic ways, Rossetti has called on past pictorial precedents in envi-

sioning his modern subject, precedents that he radically alters to his purposes, or in the case of the central illumination offered by Hogarth's *Harlot's Progress* [21], that were inevitably altered by the pressures of nineteenth-century compassion, sentimentality, and doubts about the inevitable workings of natural law—in short, by the basic assumptions of nineteenth-century ideology itself. In *Found,* Rossetti has compressed the narrative sequence of Hogarth's serial morality—the "progress"—into a single pregnant image, substituting evocative spatial expansion for brisk narrative sequentiality, or, in other words, suggestive depth for explicit succession in time. And he has substituted a reduced range of symbolic reference for Ho-

garth's burgeoning richness of descriptive detail. The rural origins of the harlot, for example, specified in Hogarth by the fact of her arrival on the stagecoach in the first plate of the series, is simply suggested in Rossetti by the calf and the bridge, as well as by the country dress of her would-be rescuer. The inevitable downfall and death of the harlot, spelled out with considerable circumstantial detail and social concreteness, stage by stage, in Hogarth's work, is simply implied in Rossetti's, by the pose, the expression of shame or even anguish in the head in the oil version (modeled by Fanny Cornforth in a bit of "ironic typecasting")[34] of the woman on the bridge; and, most explicitly, by the graveyard, which, in the earlier drawing, reveals a tomb-

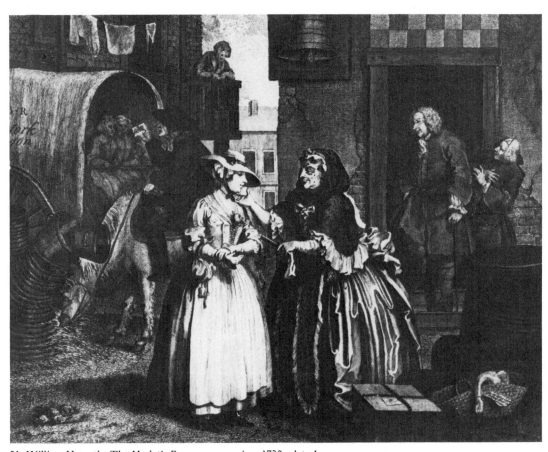

21. William Hogarth, *The Harlot's Progress,* engraving, 1732, plate I.

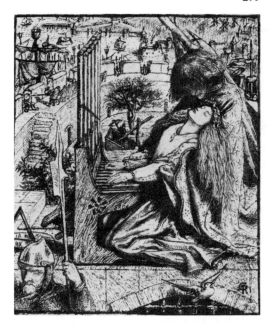

22. Rossetti, *St. Cecilia and the Angel,* pen and brown ink, 1856–57. Birmingham City Museum and Art Gallery (*City of Birmingham*).

stone in the corner with the inscription just legible: "There is joy . . . the Angels in he . . . one sinner that . . ."—a message of faint hope that, contradicting Hogarth's moral, perhaps softens the sense of spiritual as well as physical death suggested by the graveyard itself. Even the precedent for symbolic animals is found in Hogarth, although with the typical difference that it is the silly goose, the lecherous monkey, and the sensual cat that are depicted, rather than the innocent and pathetic netted calf.

For the specific setting of two large foreground figures against a city vista with a bridge in the background, Rossetti probably turned to the entirely appropriate Pre-Raphaelite precedent of Jan van Eyck, whose *Madonna and the Chancellor Rolin* he had admired when he had visited Paris with Hunt in 1849,[35] and which probably served again as an inspiration for his illustration of *St. Cecilia and the Angel* for "The Palace of Art" in the Moxon *Tennyson* of 1857 [22].[36]

For the two foreground figures of *Found* he turned, perhaps unconsciously, to a very

different pictorial source from the same European trip of 1849: Ingres's *Roger Rescuing Angelica* of 1819 [23], then in the Musée du Luxembourg. The painting had impressed him sufficiently so that he sent home two sonnets about it—"Last Visit to the Luxembourg"—in a letter to his brother;[37] the sonnets on Ingres's *Roger Rescuing Angelica* were later published in the *Germ* and reprinted in the *Poems* of 1870.[38]

Ingres's painting seems almost calculated to satisfy the contradictory urges of chivalrous purity and sexual lust burning in the breast of the young artist; it provides rich food for erotic fantasy. The poems Rossetti dedicated to it seem, to modern understanding anyway, unequivocal in their sensual relish of Ingres's titillating vision. The impulse behind the imagery is clear: sex is the tenor of every metaphoric expression in the sonnets, from "the spear's lithe stem" to the beast whose "evil length of body chafes at halt," contrasted with the passive but succulent offering of fettered nakedness, "flesh which has the colour of fine pearl," "with

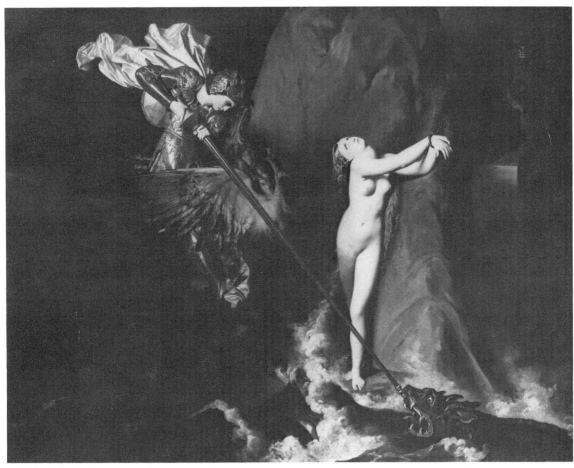

23. Jean-Auguste-Dominique Ingres, *Roger Rescuing Angelica,* 1819. Paris, Louvre (*Bulloz*).

loose hair/And throat let back and heartsick trail of limb,"[39] a description that is not far from the pose of the heroine of *Found* herself. One might almost say that, from one point of view, *Found* is a metamorphosed *Roger Rescuing Angelica* in modern dress, although the outcome is certainly more equivocal. Yet in the earlier versions, where the fallen woman is less flashy, sensual, and fancily attired, the abortive outcome of the drover's chivalrous and compassionate gesture is not as clearly articulated as it becomes in the final version, where the conflict between the two is more heightened and active; and of course, the impossibility of the harlot's being saved is made clear in the later sonnet, "Found."

Different though *Found* may be in many ways from *Roger Rescuing Angelica,* in both, desirable young women are the prisoners of sex—one a real prisoner of a metaphorical monster sex; the other a metaphorical prisoner of real sexual enslavement. Ultimately, it is the fallen woman's heart, rather than merely her body, that is "locked," in Rossetti's final reinterpretation of the theme in the sonnet "Found"; and for this sort of imprisonment there would seem to be no possible rescue in the form of man's good will or chivalric impulse. In a sense, *Found* is finally seen as a

sort of dark Annunciation, a perverse revision of *Ecce Ancilla Domini* [24]! There also a cowering female is set in opposition to a towering male figure; but in this instance the fallen woman refuses to "know" the messenger and sends him away instead of receiving glad tidings.

Found, then, is a palimpsest of motifs and motivations: it exists as an image that evolved over time, and it is possible that Rossetti's own interpretations of it were multiple. Certainly, on one level, Rossetti meant to imply that salvation for the fallen woman could only take place in distant biblical times, through the intervention of Christ, and that no possibility of redemption is possible for the modern prostitute. This interpretation is clearly suggested by a comparison of *Found* and its accompanying sonnet with the 1858 sonnet and drawing of *Mary Magdalene at the Door of Simon the Pharisee* of 1848.[40] Such an attitude was a morally convenient one for Rossetti, as it was for many men of his time, in that it exempts actual human beings—mere sensual men—from any responsibility in the situation: falling in the feminine is considered a metaphysical absolute rather than a social and ethical issue that might be dealt with and changed by means of human effort and action. The term "fallen" is not reversible; the attitude producing it ends as helpless pity or contempt, at best, as the protectiveness of a superior being for an inferior one. Yet, on another level, it would be a mistake to read the fallen woman in this painting simply as an emblem of Rossetti's attitude toward women; on a deeper level, perhaps, it also reflects his attitude toward himself. Seen at the end of his life, *Found* may be understood as a paradigm of Rossetti's own conflict-ridden existence, beginning with an idea of himself as the "preux chevalier," dedicated to rescue and the highest sort of artistic achievement, the most ideal way of life, and ending with despair and disillusion. In this light, the fallen "fair woman" might be con-

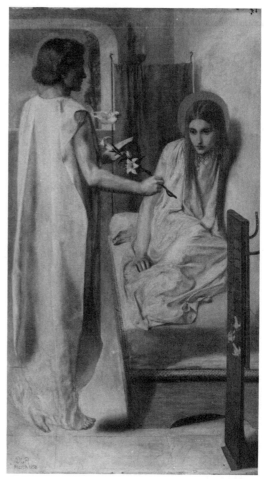

24. Rossetti, *Ecce Ancilla Domini* (*The Annunciation*), 1850. London, Tate Gallery (*Tate Gallery*).

sidered not merely as Jenny or Rosabell or Annie Miller or Fanny Cornforth, but as an aspect of the artist himself—his *anima*, a subject he depicted in a drawing of 1880 flying triumphantly with her fourteen-stringed harp,[41] here fallen and drooping.

If a woman has indeed figured as "Rossetti's icon for the artistic soul in the act of creation,"[42] then the figure of a woman could also be an image of his despair, his sense of the self—more specifically, the creative self—shut off from the possibility of help or redemption. Indeed, his attitude toward his

own work was strangely ambiguous, and especially toward his painting, which he tended to look down on in comparison with his poetry. "... I wish one could live by writing poetry. I think I'd see painting d—d if one could," he wrote to Ford Madox Brown in 1871.[43] Later in life, Rossetti had increasing recourse to "replicas" to raise money quickly; increasingly, he lost respect for his art, referring to *The Blessed Damozel,* once the very symbol of his moral and erotic idealism, as the "Blasted Damdozel," the "Blowed Damozel," or even more crudely as the "Bdy Dam."[44] In a letter to Frederic James Shields of 1869, he declares that he has now begun to rate his poetry above his painting, describing it as the art "in which I have done no potboiling at any rate. So," he continues, "I am grateful to that art and nourish against the other that base grudge which we bear against those whom we have treated shabbily."[45]

Rossetti had certainly treated *Found* shabbily, complaining about it, boasting of the new patrons he had seduced into making down payments for it, never completing it: indeed, his attitude toward the painting began to resemble the attitude he might have had toward an ill-treated woman. The painting of the fallen woman can almost be seen as a synecdoche of Rossetti's disillusion with painting itself and with himself as a painter. Rossetti in fact made the analogy between being an artist and being a prostitute explicit in a letter to Ford Madox Brown of 1873: "I have often said," he stated, "that to be an artist is just the same thing as to be a whore, as far as dependence on the whims and fancies of individuals is concerned."[46]

Not only, then, might Rossetti in later years feel deep sexual conflict and guilt, feel himself to be in some way "fallen": he was an exemplary *"homme de mauvaise foi"* in Sartrean terms, as a nineteenth-century man of strong sensuality who at the same time believed fervently in some kind of ideal of goodness but could rarely bring himself to act upon this belief. But he also might feel identified with the image of the fallen woman in *Found* in still another way. To return to the verbal analysis with which this discussion opened, "to prostitute oneself," like "to fall," is also an irreversible verbal form: for a man to prostitute himself means not to sell sex for money, as it does in the case of a woman, but rather—the fate worse than death in the masculine, for the artist above all—to debase one's art for money, to sell one's talent, to "sell out." Surely this sense of moral failure, of "selling out," or perhaps of "overselling," hangs over the troubled history of *Found* and at least in part accounts for its unfinished state. Although Rossetti claimed in a letter of 1881 that the "eternal *Found* picture is really getting done:—the figures close upon finish. ...," it passed unfinished into the possession of William Graham after the artist's death, whereupon Burne-Jones and possibly Dunn did further work on it.[47]

Sick, suffering, and miserable, in 1881 Rossetti seems to have sensed the nothingness lying in wait beyond the palace of art, behind the dreams of love and creation, and he turned backward to memory, still undecided: "Is Memory most of miseries miserable, or the one flower of ease in bitterest hell?" he asked.[48] His answer, the painting *Mnemosyne* (Bancroft Collection, Delaware Art Museum), fails to resolve the question, but simply replies with another kind of mystery. In a sense, *Found* should be considered less a key to Rossetti's ultimate feelings about sex, women, salvation, or the self than as evidence of the deep-seated conflicts and contradictions he experienced about all of them. It should perhaps be judged less as a work of art than as a document of unfulfilled aspirations.

NOTES

Author's note: This article was originally present-
ed at a Rossetti symposium at Yale University in
1976. I am grateful to the participants in the sym-
posium for their suggestions, and especially to Pro-
fessor George Hersey.

1. For a good summary of the history of *Found*,
see Virginia Surtees, *The Paintings and Drawings
of Dante Gabriel Rossetti (1828–1882): A Cata-
logue Raisonné,* Oxford, 1971, Vol I, no. 64. Relat-
ed preparatory studies are discussed by the same
author, nos. 64A to 64R. For illustrations of most
of these works, see Surtees, Vol. II, pls. 65–76. For
further information about the history of the paint-
ings and related works, see *Dante Gabriel Rosset-
ti, 1828–1882,* exh. cat., Laing Art Gallery, New-
castle-upon-Tyne, England, 1971, introd. A.
Grieve, no. 17, as well as *Dante Gabriel Rossetti:
Painter and Poet,* exh. cat., Royal Academy of Art,
London, 1973, no. 70 and nos. 71–84.

2. Cited in Surtees, Vol. I. p. 28.

3. The specific relation to "London" was sug-
gested by A. Grieve, *op. cit.,* p. 5.

4. William Bell Scott, "Rosabell: Recitative
with Songs," in W. Minto, ed., *Autobiographical
Notes of William Bell Scott,* New York, 1892, Vol.
I, pp. 135–52.

5. Scott, p. 147.

6. *Ibid.,* p. 148.

7. Anne J. d'Harnoncourt remarks: "The title
'Past and Present' may be the result of misreading
Ruskin's Academy notes for 1858, in which a dis-
cussion of no. 428, *Past and Present* by Miss A.
Blunden, follows immediately after the remarks on
Egg's triptych which is given no title"—Anne J.
d'Harnoncourt, *"The Awakening Conscience:* A
Study of Moral Subject Matter in Pre-Raphaelite
Paintings, with a Catalogue of Pictures in the Tate
Gallery," M.A. thesis, London, Courtauld Institute
of Art, University of London, 1967, Cat. nos. 3278,
3279, 3280.

8. I am grateful to Alison Hilton for this infor-
mation.

9. Thomas Hood, "The Bridge of Sighs," *The

Complete Poetical Works of Thomas Hood,* New
York, 1869, Vol. I, p. 27. For Watts's painting, see
G. F. Watts, a Nineteenth-Century Phenomenon,
exh. cat., Whitechapel Art Gallery, London, 1974,
no. 12. There is a smaller replica of the original in
the Watts Gallery at the Walter Art Gallery,
Liverpool.

10. [William Rathbone Greg], "Prostitution,"
Westminster Review, Vol. 53, 1850, p. 461, re-
printed in *Prostitution in the Victorian Age: De-
bates on the Issue from 19th-Century Critical
Journals,* ed. K. Nield, Westmead, Farnborough,
England, 1973, p. 461.

11. John Duncan MacMillan, "Holman Hunt's
Hireling Shepherd: Some Reflections on a Victori-
an Pastoral," *The Art Bulletin,* 54, June 1972, p.
195, and Fig. 7, p. 197.

12. For Hogarth's paintings, *Before* (indoor
scene) and *After* (indoor scene) ca. 1731?, now in
the J. Paul Getty Collection, Art Properties, Inc.,
see Ronald Paulson, *Hogarth: His Life, Art and
Times,* New Haven and London, 1971, Vol. I, pls.
89 and 90. For the more richly detailed engraved
versions of 1736, see Ronald Paulson, *Hogarth's
Graphic Works,* New Haven and London, 1965,
Vol. I, nos. 141 and 142, pp. 171–72, and Vol. II,
pls. 152 and 153.

13. This was perhaps Le Brun's best-known
painting, thanks to an engraving after it by Ede-
linck. See *Charles Le Brun, 1619–1690,* Château
de Versailles, 1963, no. 25, p. 67.

14. *William Holman Hunt,* Walker Art Gallery,
Liverpool, 1969, intro. M. Bennett, no. 27, p. 35.

15. Erika Klüsener has suggested the relation-
ship between Munch's *Puberty* and Hunt's *Awak-
ening Conscience,* as well as the intermediary of
Félicien Rops's etching *Le plus bel amour de Don
Juan* of 1886, in her article "Das erwachende
Bewusstsein: Zur Ikonographie der Malerei des 19.
Jahrhunderts," *Das Münster,* Vol. 28, 1975, pp.
149–52.

16. Cited in Surtees, Vol. I, p. 28.

17. *William Holman Hunt,* Liverpool, 1969, no.
27, p. 35.

18. There is another version of the 1853 drawing in pen and sepia in the collection of Mrs. Robin Carver, as well as the watercolor, dated 1865, an enlarged replica, in the Bancroft Collection, Wilmington Society of Fine Arts, Delaware. See Surtees, Vol. I, nos. 57, 57A, and R.1.

19. For a discussion of the relation of musicmaking to eroticism in the imagery of seventeenth-century Dutch painting especially, see A. P. de Mirimonde, "La Musique dans les allégories de l'amour," *Gazette des Beaux-Arts,* ser. 6; 68, November 1966, pp. 265–90; 69, May 1967, pp. 319–46.

20. For the most detailed information about Annie Miller, mainly in the context of her relation to W. Holman Hunt, see Diana Holman-Hunt, *My Grandfather, His Wives and Loves,* London, 1969. The precise date of the substitution of Fanny Cornforth for the original model of the woman in *Found* is uncertain. Paul Franklin Baum, for instance, in his introduction to *Dante Gabriel Rossetti's Letters to Fanny Cornforth* (Baltimore, 1940, pp. 3–7), tends to support Fanny's own contention that she and Rossetti met in 1856, that she went to his studio the day after their meeting, and, in what are purported to be her own words, "he put my head against the wall and drew it for the head in the calf picture" (p. 4), although Baum admits there are certain inconsistencies in this account. Surtees, however, would seem to argue for the substitution of the Cornforth head in ca. 1859–61 (see nos. 64M and 64N), although the date suggested in the catalogue *Dante Gabriel Rossetti: Painter and Poet* (Royal Academy of Arts, London, 1973) for the Birmingham study for the head of the woman modeled by Cornforth (no. 82) is given as ca. 1855–61. Oswald Doughty, in his *Dante Gabriel Rossetti: A Victorian Romantic* (New Haven, 1949, p. 251), maintains that "of the two dates, 1856 and 1859, that Fanny herself gave in her two mutually contradictory accounts of her first meeting with Rossetti one is demonstrably a little late." But he does not postulate an exact date for the studies based on Cornforth or the substitution of her head in the oil version of *Found.*

21. In a letter to his mother of July 1, 1853; Oswald Doughty and John Robert Wahl, eds., *Letters of Dante Gabriel Rossetti,* Oxford, 1965, Vol. I, no. 116, p. 147. Scott later changed the title back to its original one *(Autobiographical Notes,* Vol. I, pp. 135ff.).

22. See William Bell Scott, "Rosabell," Part 13, lines 16–42, in *Autobiographical Notes,* Vol. I, pp. 149–50.

23. The manuscript of the early draft of "Jenny," of 1847–48, is in the collection of the Delaware Art Museum. Rossetti evidently revised and enlarged the poem upon meeting Fanny Cornforth (David Sonstroem, *Rossetti and the Fair Lady,* Middletown, Conn., 1970, p. 64). William Clyde De Vane ("The Harlot and the Thoughtful Young Man," *Studies in Philology,* 29, 1932, p. 468) asserts that Rossetti kept the poem beside him for twenty-three years, writing and rewriting.

24. For a perceptive analysis of the use of similar iconographic details in "Jenny" and *Found,* see Susan Ball Bandelin, " 'Allegorizing on One's Own Hook': Works before 1863," *Dante Gabriel Rossetti and the Double Work of Art,* exh. cat., Yale University Art Gallery, New Haven, 1976, pp. 44–45.

25. William M. Rossetti, ed., *Ruskin: Rossetti: Preraphaelitism: Papers 1854 to 1862,* London, 1899, p. 234. The letter in which Ruskin criticizes "Jenny" is dated ca. 1859 by Sonstroem, *op. cit.,* p. 231, n. 1.

26. "Jenny" in Dante Gabriel Rossetti, *Poems,* ed. Oswald Doughty, London, 1957, pp. 63–72, especially lines 276–97. (I have been unable to obtain the 1911 edition of Rossetti's *Works* edited by William M. Rossetti.)

27. De Vane, *Studies in Philology,* pp. 468–69.

28. Rossetti, *Poems,* p. 258.

29. F. G. Stephens, *The Portfolio,* May 1894, p. 38.

30. Roman Jakobson, "On the Verbal Art of William Blake and Other Poet-Painters," *Linguistic Inquiry,* I (1970), no. 1, pp. 3–23.

31. Surtees, Vol. I, no. 64, p. 27.

32. *William Holman Hunt,* Liverpool, 1969, no. 27, p. 35. The further Scriptural passages in the Royal Academy Catalogue of 1854, however, were later disclaimed by Hunt, as Allen Staley kindly informed me.

33. "The River's Record," written in 1871, was published under the title "Down Stream" in the 1881 edition of the *Poems.* See Doughty, *Dante Gabriel Rossetti,* p. 478.

34. Susan Casteras, "The Double Vision in Portraiture," *Rossetti,* New Haven, 1976, p. 13.

35. D. G. Rossetti, letter to William Michael

Rossetti, 1849, *Letters,* Vol. I, no. 47, p. 64.

36. The drawing for the illustration, now in the Birmingham City Museum and Art Gallery, is published by Surtees, Vol. I, no. 83, and Vol. II, pl. 108.

37. D. G. Rossetti, *Letters,* Vol. I, no. 49, p. 74.

38. Rossetti's interest in Ingres continued, or revived, in two pencil studies for *The Question* of 1875, a subject clearly inspired by Ingres's *Oedipus and the Sphinx,* which Rossetti may have seen in the Exposition Universelle of 1855 in Paris. For the connection between these late drawings and Ingres's work, see Carl A. Peterson, "Rossetti and the Sphinx," *Apollo,* 85, January 1967, pp. 48–53.

39. The lines are cited from the 1849 version of the sonnets on "Roger Rescuing Angelica" (see note 37 above). For the version included in the 1870 edition of the *Poems* and there entitled "For 'Ruggiero and Angelica' by Ingres," see Dante Gabriel Rossetti, *Poems,* 1957, pp. 138–39.

40. See Bandelin, "Allegorizing," in *Rossetti,* New Haven, 1976, pp. 45–47.

41. For a related drawing, *The Sonnet,* of 1880, and its accompanying sonnet, see *Rossetti,* New Haven, 1976, no. 55, and p. 103. For a discussion of the lost drawing portraying a winged female figure labeled "Anima" of 1880, see Jane Bayard, " 'Lustral Rites and Dire Portents': Works from 1872 to 1882," *ibid.,* p. 95.

42. Bayard, " 'Lustral Rites,' " in *Rossetti,* New Haven, 1976, p. 97.

43. August 31, 1871. *Letters,* Vol. III, no. 1158, p. 906.

44. "Leyland was here today and seems likely to buy the Blasted Damdozel. . . ." Letter to Frederic James Shields, January 30, 1881, *Letters,* Vol. IV, no. 2401, p. 1842. The reference to the "Blowed Damozel" appears in a letter to Ford Madox Brown of May 1873 (*Letters,* Vol. III, no. 1335, p. 1166). For a discussion of Rossetti's artistic demoralization and reference to "Bdy Dam," see Doughty, *Dante Gabriel Rossetti,* pp. 607–08.

45. Letter to Frederic James Shields, August, 27, 1869, *Letters,* Vol. II (1965), no. 862, p. 729. The same thought is expressed in a letter to Thomas Gordon Hake of April 21, 1870: ". . . The bread-and-cheese question has led to a good deal of my painting being pot-boiling and no more—whereas my verse, being nonprofitable, has remained (as much as I have found time for) unprostituted"—*Letters,* Vol. II, no. 992, p. 850.

46. May 28, 1873, *Letters,* Vol. III, no. 1345, p. 1175.

47. Surtees, Vol. I, no. 64, p. 27.

48. Cited by Bayard, " 'Lustral Rites,' " in *Rossetti,* New Haven, 1976, p. 102.

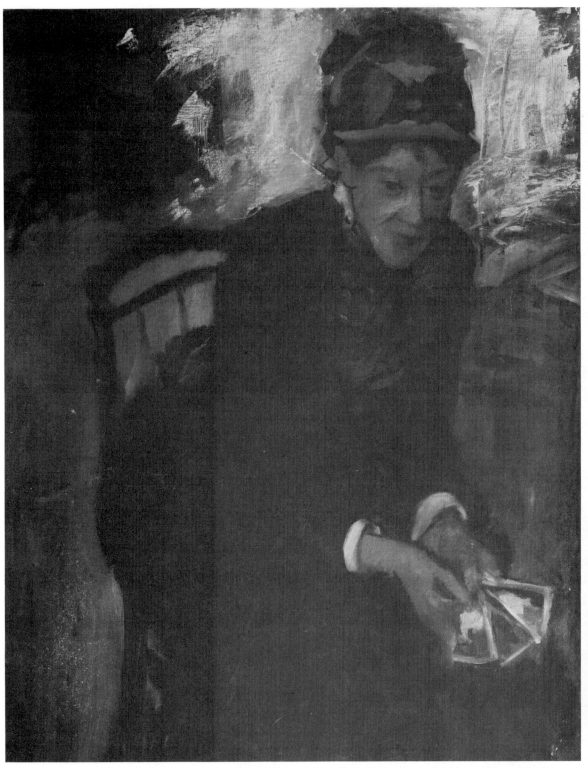

1. Edgar Degas, *Portrait of Mary Cassatt,* ca. 1880–84. Formerly New York, Collection André Meyer (*Durand-Ruel*).

13
Degas's "Misogyny"

NORMA BROUDE

In response to a series of nudes at their toilette, pastels exhibited by Degas at the Eighth Impressionist Exhibition in 1886 [e.g., 2], the contemporary novelist and critic J.-K. Huysmans initiated what has since become an established convention in the Degas literature: that of seeing personal malevolence as the unavoidable implication of Degas's rejection of feminine stereotypes. Although he was not unsympathetic to the iconoclasm that had impelled Degas to substitute "real, living, denuded flesh" for "the smooth and slippery flesh of ever nude goddesses," Huysmans could see no other motivation for this iconoclasm than a personal desire on the artist's part to "humiliate" and "debase" his subjects. Degas, he maintained, had "brought an attentive cruelty and a patient hatred to bear upon his studies of nudes."[1]

Since the notion of Degas's "misogyny" was thus given its classic literary formulation in the late nineteenth century by writers like Huysmans and Paul Valéry,[2] few scholars have expressed discomfort with this label,

and none has stopped to evaluate its sources or to question directly its validity. In 1962, for example, the appearance of Jean Sutherland Boggs's perceptive study of Degas's portraits revealed aspects of this artist's response to women, both in his art and in his life, that should have cast serious doubt upon the old accusation of "misogyny." Although certainly preparing the way for a reevaluation of this entire question, Boggs herself refrained from attacking the issue directly, permitting herself only the somewhat tentative comment that Degas, in his portraits of women, "could be enchanted, affectionate, perceptive in a way that suggests that his reputed misogyny was an affectation."[3] Nor have the implications of Boggs's observations been taken up elsewhere, and despite the recognition that her book received, the pro-misogyny literature continued to flourish throughout the 1960s and 1970s. Thus, for example, in 1963, Benedict Nicolson was still troubled by the old misogyny question. In a reappraisal of Degas's difficult and complex personality—a reappraisal that was on the whole sensitive and sympathetic—Nicolson strove to avoid the one-sided approach that has been traditionally used in dealing with the question of De-

Norma Broude, "Degas's 'Misogyny,'" *The Art Bulletin* 59, March 1977, pp. 97–107. By permission of the author and the College Art Association of America.

gas's attitudes toward women. In the end, however, Nicolson accepted the convention that our social norms have helped to establish in the art historical literature: "Even from Degas's pictures," he wrote, "a bewildering indifference to the grace of women emerges. . . . It is not that he treats a woman as though she were a horse: he treats her with more savagery."[4] Two years later, in 1965, the misogyny theme was revived with a vengeance by Quentin Bell in his interpretation of Degas's *Le Viol;*[5] and, as late as 1972, Theodore Reff published an important study on this same painting, a study in which the assumption of Degas's misogyny continued to play a key role.[6]

Thus, the late nineteenth-century idea of Degas's personal dislike for women has achieved, in our own century, the status of a commonplace. Fed and apparently supported by contemporary accounts of the artist's irascible temper and unpredictable social behavior, it has been seized upon by critics and historians and applied as an interpretive key to a great number of his works. Almost invariably, the reasoning that has been invoked has been circular: Degas's misogyny has been assumed, his paintings have been interpreted accordingly, and they have then been held up as proof of the original assumption. As a result, many of Degas's pictures have presented perplexing problems in interpretation to art historians, all too many of whom seem inadvertently to be approaching these works as though they were Rorschach tests. For example, a picture of the early 1870s, the so-called *Bouderie,* which means "Pouting" or "Sulking" [3, L. 335], was first described in print in the 1890s as a portrait grouping, "a scene of affectionate intimacy." In 1910, the critic G. Lecomte gave it the unfortunate title under which it has labored ever since, and in 1923 Meier-Graefe decided that what the picture really represented was a husband who was angry with his wife.[7] Similar methods of interpretation have plagued a painting that De-

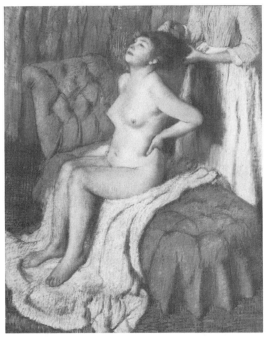

2. Degas, *La Toilette,* ca. 1885. Metropolitan Museum of Art, Havemeyer Collection (*Metropolitan Museum of Art*).

gas himself reportedly referred to in neutral terms as "Scène d'Intérieur" or "mon tableau de genre," but to which subsequent writers have preferred to attach a more explicit and melodramatic title, *Le Viol,* interpreting the scene as the aftermath of a violent rape [4, L. 348]. Recently, efforts to find a literary source for Degas's *Scène d'Intérieur* have culminated in Theodore Reff's suggestion of Emile Zola's novel *Thérèse Raquin.* Described by Reff as the "depiction of a married yet utterly estranged couple, doomed to live together closely yet without intimacy," this is a story in which Degas, we are told, "would have seen projected powerfully his deepest, most disturbing feelings about marriage and the relations of the sexes."[8]

Thus, the *fin de siècle* "attentive cruelty" and "patient hatred" attributed to Degas by Huysmans have taken on, in the twentieth century, predictably Freudian overtones to become, instead, a general "fear and suspi-

cion of women" that writers have endeavored to connect with Degas's formative experiences. Reff has written in this vein: "Significantly, the first marriage he had been able to observe closely, his mother having died when he was young, was the singularly unhappy one of an aunt and an uncle whom he portrayed in 1860, after living in their household." The painting here referred to, *La Famille Bellelli* [5, L. 79], is further associated by Reff, as a seminal work, with a group of five other pictures also of the 1860s and the early 1870s. This group is composed not only of the *Scène d'Intérieur* [4], but also a second *Scène d'Intérieur* [L. 41], *Bouderie* [3], the *Petites filles spartiates provoquant des garçons* [11, L. 70] and *Les Malheurs de la ville d'Orléans* [10, L. 124]. These pictures are said to depict situations of alienation or aggression between the sexes, expressive of or in some way dependent upon the artist's own alleged "fear and suspicion" of the opposite sex.[9]

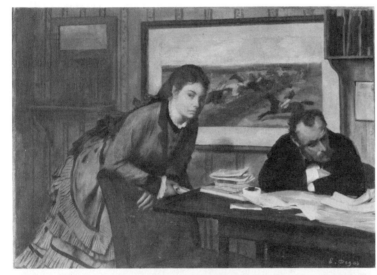

3. Degas, *Bouderie,* ca. 1871. New York, Metropolitan Museum of Art, Havemeyer Collection (*Metropolitan Museum of Art*).

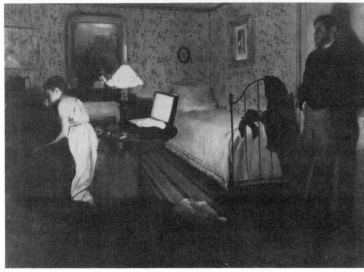

4. Degas, *Scène d' Intérieur (Le Viol),* ca. 1868–70. Philadelphia, Collection Henry P. McIlhenny (*Philadelphia Museum of Art*).

According to the earlier analysis of Quentin Bell, which is accepted and enlarged upon by Reff, these pictures share not only a common theme but also the same "psychomorphic design" that gives visual form to the artist's perhaps "unconscious" expressive intent. "In all of these pictures," Bell writes, "the left is, so to speak, the female side to the canvas—it is separated from the right by a central element, across which Degas sets a unifying diagonal." Speaking in particular of the *Petites filles spartiates, Bouderie* and *Les Malheurs,* he writes: "In these three paintings, the element of hostility between the sexes is apparent." Of the three, however, he holds *Les Malheurs* to be the most revealing because it is the most "explicit." "Protected," Bell writes, "by the conventions of academic art, Degas shows his hand, for this is unashamedly a scene of murder, torture and rape."[10]

In the discussion that follows, we will reexamine some of these widely held critical attitudes by taking a fresh look at a number of the works involved, considering them anew within their social and personal contexts as well as from the point of view of the art historical traditions to which they belong. For once we have made an effort to approach these works freshly, without allowing the preconception of misogynistic motivation to limit and guide our responses, a very different picture from the one commonly presented will emerge, not only of Degas's attitudes and motives but also of his art.

Such an effort at reinterpretation, despite the foundation laid by Boggs, is long overdue in the Degas literature. And it is well worth making, for upon it hinges not only our understanding of a major *oeuvre* but an important problem in methodology as well. The dual nature of this problem, which is sociological as well as art historical, is perhaps best suggested at the outset by considering an observation made by one of Degas's own contemporaries, Georges Rivière, who met the artist around 1875 and who was also a good friend of Renoir's. Commenting upon the complexity of Degas's character, Rivière pointed to something that struck *him* as a perplexing contradiction, but that we can perhaps now recognize may not be a contradiction at all. Degas, wrote Rivière, was an artist who depicted women without flattery. Yet, to his own surprise, Rivière felt compelled to observe:

Degas enjoyed the company of women! He, who often depicted them with real cruelty, derived great pleasure from being with them, enjoyed their conversation and produced pleasing phrases for them. This attitude presented a curious contrast to that of Renoir. The latter, though he painted women seductively, endowing with charm even those who did not possess it, generally experienced little pleasure from the things they valued. He was interested in women, with few exceptions, only if they were likely to become his models.[11]

Unlike Renoir, Degas, with his uncompromisingly contemporary images of women—seen at their toilette or at their work in theaters, laundries, millinery shops or brothels—stripped away idealized conventions, thereby challenging some of the most cherished myths of his society. It is not surprising that that society would have been, at the very least, unsettled by this "cruel" and threatening iconoclasm, and inclined to dismiss it, defensively, as the product of some personal maladjustment or malevolence on the artist's part. It is instructive for us to recall in this regard that during the nineteenth century the playwright Ibsen was also called a misogynist by his contemporaries. But while our colleagues in literary criticism have long since reexamined this label and set it into its historical context, the analogous accusation in the Degas literature has never been directly challenged. The reluctance of art historians in our own century to reconsider this accusation of misogyny as a function of the social conventions and biases of Degas's period is puzzling. But it may well result from the fact

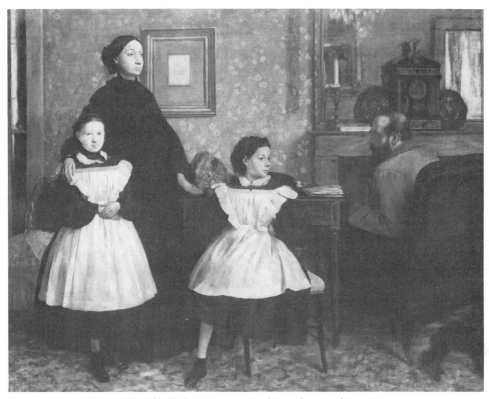

5. Degas, *La Famille Bellelli,* 1858–60. Paris, Louvre (*Archives photographiques*).

that these conventions and biases are ones that our own society to some extent still shares and endeavors to perpetuate. Thus, from the point of view of the methodology of our discipline, the problem of Degas's "reputed misogyny" may offer us a sobering example of how assumptions held by society at large can compromise scholarly objectivity, obscuring from us, in this instance, the intentions and perceptions of a major artist and distorting our assessment of a significant aspect of his work.

Although Degas's mother died in 1847 when he was thirteen years old, his large family provided a number of female figures to whom he could relate in his youth and whom he seems to have observed with extraordinary sympathy and understanding. These female relatives, including two sisters and several aunts and cousins, were the sitters for many of Degas's early portraits, works of great psychological acumen which often convey the peculiar tensions and problems of personality that might have resulted, either directly or indirectly, from the sitters' positions as women in their society.

The formidable yet singularly poignant figure of Degas's aunt Laura, for example, dominates the group portrait that is among the most ambitious and important of his early works, *La Famille Bellelli* [5], a painting not completed until late in 1860 but begun by Degas during the nearly nine months that he spent in Florence as the guest of his aunt and uncle, from August of 1858 to early April of 1859.[12] For this still naive and romantic young man, who confided to his travel diary just days before arriving in Florence his dream of one day finding "une bonne petite femme simple, tranquille, qui comprenne

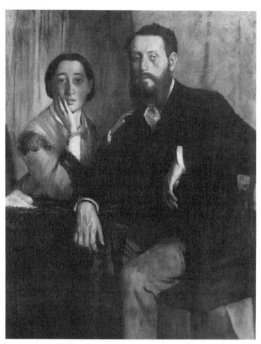

6. Degas, *Edmond and Thérèse Morbilli,* ca. 1865.
Boston, Museum of Fine Arts (*Boston Museum of Fine Arts*).

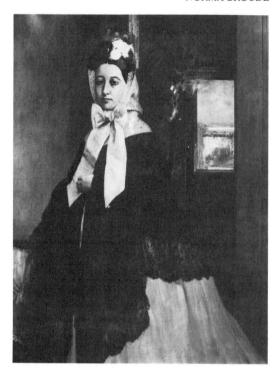

7. Degas, *Thérèse de Gas* (later Morbilli), ca. 1863.
Paris, Louvre (*Archives photographiques*).

mes folies d'esprit et avec qui je passe une vie modeste dans le travail,"[13] the experience of living as an intimate in the strained and unhappy household of the Bellellis would indeed have provided a sobering revelation. Degas's awareness of his relatives' marital difficulties is established not only by documents,[14] but also by the portrait that he painted of them with their two daughters—a work that reveals his remarkable sensitivity to the subtle pressures and tensions existing within this family unit.[15] If we are to believe, however, that the example of this difficult relationship had upon Degas the effects that have been claimed for it—helping to induce in him a permanent "fear and suspicion of women" in general—then we would be forced to assume that in painting the Bellelli family portrait, Degas himself personally identified in some way with the recessive and isolated figure of his uncle. But while the compositional

arrangement of the picture does effectively communicate Degas's perception of his aunt and uncle's emotional estrangement, there is really nothing in the portrait itself that might tell us conclusively, and objectively, on which side Degas's own sympathies lay—if, indeed, he did take sides. Certainly, the more complete of the two characterizations is that of the baroness, Degas's aunt on his father's side, of whom, reportedly, he was very fond.[16] Proud and severe, she is shown here pregnant and in mourning for her own recently deceased father, spatially and emotionally isolated from the husband whose life of nomadic political exile she had for many years shared.[17]

Further insight into the effects that marriages in his own family may have had upon Degas in his youth is provided by still another portrait of a married couple which the artist painted a few years later, in 1865. This

is the double portrait of Degas's own sister, Thérèse, and her husband, Edmond Morbilli, the Italian cousin whom she had married in 1863 [6, L. 164]. Here, as a young man, Degas had an opportunity to observe close up the complexities of yet another type of marital relationship, and this time, his concern for the effects that that relationship may have had upon the personality of the woman involved is unmistakable. As Jean Boggs has observed, we know very little about Thérèse De Gas beyond what her brother's portraits may tell us of her. But these, and, in particular, the double portrait of 1865, tell us a remarkable amount. The position which is assigned to Thérèse in this grouping, seated behind her husband with one hand placed tentatively upon his shoulder, immediately suggests the dependent nature of her relationship to him. At the same time, the startled, almost frightened expression imparted to her face by the staring, widened eyes and the defensive placement of her hand before her slightly parted lips bespeak her timidity in relation to the outside world, a world from which she literally seeks to shield herself by retreating physically behind the imposing and self-assured figure of her protective husband.

In a slightly earlier portrait of his sister by Degas, which was probably painted just before her marriage [7, L. 109], Thérèse is seen as a far more imposing and stable figure. Her posture and facial expression convey, relatively speaking, a measure of dignity and composure. And although her latent shyness may be suggested, as Boggs notes, by a detail like the hand that emerges tentatively from her voluminous shawl, this aspect of her personality is not stressed. It is fully revealed to us for the first time, grown now manifestly into a state of almost pitiable timidity and uncertainty—as it was perhaps first fully revealed to her brother as well—by the marital relationship that forms the real subject of the 1865 double portrait.[18]

In the same year, 1865, Degas painted an-

other striking family portrait, this one of his American aunt, Mme Michel Musson, and her two daughters, Désirée and Estelle [8].[19] Relatives of the artist on his mother's side, they had left their home in New Orleans in 1862 to take refuge in Paris during the American Civil War. Degas's intimate and revealing portrait study conveys with remarkable poignancy the unhappiness and listless inertia of these three women. It conveys as well his sympathetic response to their loneliness and their plight—in particular, the plight of his cousin Estelle, a war widow with a posthumous child. His special and life-long compassion for this sad, dependent figure is already suggested in this grouping, where she is distinguished from the other two women both by her frontal placement and by her darker mourning costume. It is conveyed more directly by the individual portrait that Degas

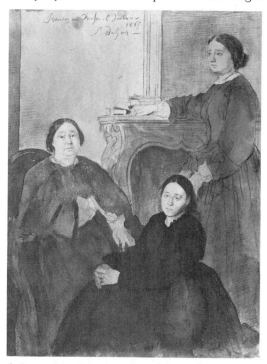

8. Degas, *Mme Musson and Her Two Daughters,* watercolor, dated January 6, 1865. Chicago, Art Institute, Gift of Tiffany and Margaret Blake (*Art Institute*).

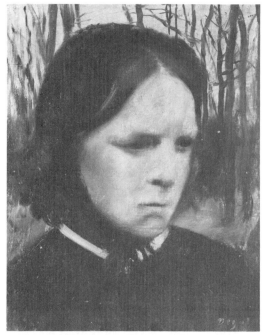

9. Degas, *Estelle Musson Balfour,* ca. 1865. Baltimore, Walters Art Gallery (*Walters Art Gallery*).

painted of his cousin at about the same time, a portrait in which he focuses close-up on her small and bewildered face, made even more "movingly lonely," as Boggs has observed, "by the background of barren trees" that rise beyond [9].[20]

The sensitivity and sympathy manifested by Degas's early portraits of his female relatives, so oddly at variance with the misogynistic impulse later attributed to him, are qualities that are no less apparent in the traditional subject pictures to which Degas devoted much of his effort during this same period, the 1850s and early 1860s.

A work of major interest in this regard—and, to date, the most problematic of all of Degas's early history paintings—is the picture exhibited at the Salon of 1865 under the title *Scène de guerre au Moyen Age* [10]. Even though subjects of the sort Degas depicted here were common coin in the nineteenth century among the Salon history painters whose ranks the young artist then as-

pired to join, nevertheless, the sufferings and maltreatment of the women and the cruelty of the men in this scene have often been emphasized by modern writers in the light of Degas's misogynistic reputation.[21] The subject of the painting, however, has long been a matter for debate. Although exhibited in 1865 as *Scène de guerre au Moyen Age,* the painting, which remained in Degas's studio until his death, was listed in the catalogue of the first studio sale under a different title, *Les Malheurs de la ville d'Orléans.* The meaning of this second title, its origins and Degas's intent, are questions that have long mystified scholars, who have been unable to find in the history of the city of Orléans any event that might explain or justify the scene that Degas depicts.[22] Recently, however, Hélène Adhémar has presented a hypothesis that convincingly dispels many of these problems and sheds important light for us upon the question of Degas's motivation.[23] She has pointed first of all to the fact, revealed by X-rays, that the picture was repainted in several areas and that, originally, the horsemen wore hairstyles of a different historical period, suggesting that even though Degas first exhibited the picture as a medieval scene, he did not necessarily conceive it as that initially. She contends, further, that the puzzling title by which the picture is known today—*Les Malheurs de la ville d'Orléans*—may well have resulted from a misreading of a document in Degas's studio identifying the picture as *Les Malheurs de la Nlle Orléans,* with the letters *Nlle* used as an abbreviation for the word *Nouvelle*—as they were in fact often similarly used in Degas's letters. If the hypothesis proffered by Mme Adhémar is correct—and the evidence she presents seems to weigh strongly in its favor—then the cruelties depicted by Degas in this scene would not have been the gratuitous inventions of a misogynistic imagination, as writers imply. They would have been, rather, a specific response on Degas's part to a bit of contemporary his-

tory that personally involved and apparently deeply upset him: the historically verifiable atrocities to which the female population of the city of New Orleans had been subjected for a period during the American Civil War. These are, of course, events of which Degas would have had very immediate and disturbing first-hand reports, for they are the events that seem to have prompted the flight from New Orleans of his aunt and two cousins late in the year 1862.

Thus, although Degas's motives for painting *Les Malheurs* may have been in part personal ones, they turn out to have been, in all probability, of a far different order from what has previously and generally been supposed. A bias similar to the one that has for so long helped to conceal this possibility from us has also affected and quite probably distorted the accepted art historical interpretation of yet another of Degas's early history paintings, a work of 1860, which the artist sent to the Fifth Impressionist Exhibition in 1880 with the title *Petites filles spartiates provoquant des garçons (Spartan Girls Challenging the Boys)* [11].[24] Here, once again, thematic choices can reveal to us much about the nature of Degas's early response to women that has hitherto been obscured—in this instance, not only by our uncritical acceptance of the notion of Degas's misogyny, but also by the culturally conditioned expectations that have helped to form and to limit our responses to the unusual subject with which Degas chose to deal.

The *Petites filles spartiates* is a picture to which the phrase "war of the sexes" has been applied by modern writers, who are wont to

10. Degas, *Scène de guerre au Moyen Age (Les Malheurs de la ville d' Orléans)*, Salon of 1865. Paris, Louvre (*Agraci*).

see in the work an unhealthy hostility between the sexes, reflecting what is supposed to be the artist's insecurity and fear of women.[25] For the precise action that Degas has depicted, however, no exact source has been identified, either in literature or in painting, that might help us to clarify the artist's intent. A clue, nevertheless, to the nature of the challenge that is being issued in the picture is offered to us by a notation in one of Degas's early notebooks, in which he referred to a scene of Spartan girls and boys wrestling together in a classical setting.[26] The theme in general, of course, is one that derives from the ancients, and Degas, who was well versed in the classics, is said to have read about it in Plutarch.[27] But although several classical as well as contemporary authors did in fact describe—and, what is more, praise—the Spartan custom of encouraging young girls to exercise and wrestle among themselves in the sight of all the citizens including the young boys, none spoke of the particular action that Degas illustrated: the girls challenging the boys to wrestle. Nor does such a scene occur in the relatively few earlier pictorial treatments of this subject, where, normally, young Spartans of the same sex are shown exercising together.[28]

The action presented in Degas's painting, then, would seem to have been largely of his own invention. And it is interesting that, drawn for his subject to an ancient society that, atypically, did not encourage passivity in young women, Degas chose for his painting a grouping that can suggest a situation of equality between the sexes and a confrontation that underscores—in what may well be

11. Degas, *Petites filles spartiates provoquant des garçons*, ca. 1860. London, National Gallery, Courtauld Collection (*National Gallery*).

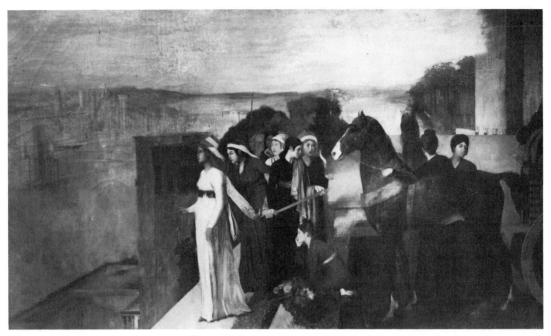

12. Degas, *Sémiramis construisant une ville,* ca. 1861. Paris, Louvre (*Archives photographiques*).

interpreted as a perfectly natural and positive way—the aggressive and competitive spirit of these young girls. Given the limitations of the data available to us, such an interpretation of the *Petites filles spartiates* is certainly as defensible as the one that currently prevails in the literature on this painting, and the fact that no previous writer has chosen to suggest or to entertain it is revealing. For the contention that the action depicted here is a threatening or a hostile one, we have, in point of fact, only the word of subsequent art historians, whose interpretation in this instance may tell us far more about the art historians themselves—about their own social conditioning and sex-role expectations—than it does about either the artist or his subject.

That Degas himself was capable of entertaining a positive attitude toward the kind of action he depicted in the *Petites filles spartiates* may be suggested by another of his early history paintings, the *Sémiramis construisant une ville,* upon which he stopped work

around 1861 [12, L. 82]. Here, as in the *Petites filles spartiates,* Degas dealt with a subject that was without pictorial precedent and that seems to have depended instead upon his own interpretation of original written sources.[29]

In approaching the subject of Semiramis, Degas, we should note, had two distinct historical traditions from which to choose. While most classical sources had described Semiramis as a beneficent empress and founder of Babylon, praising her for her brilliant military exploits and her building activities throughout the Empire, by the fifth century the Christian historian Orosius had discarded this view, presenting instead the image of an evil and licentious conqueror, a *femme fatale,* who finally met her ruin when she attempted to marry her own son.[30] The latter view of Semiramis was of course the one that prevailed throughout the Middle Ages, and it was predictably popular too throughout the Romantic period. In the late

eighteenth century it informed the popular tragedy by Voltaire, which, in turn, inspired the libretto for the well-known opera by Rossini. This opera, *Semiramide,* with libretto by Rossi, was produced in Paris in 1858, and again in 1860 as *Sémiramis,* with the Rossi libretto translated by Méry into French.[31]

Though certainly current, then, and readily available to Degas, the view of Semiramis as evil seductress is, significantly, not the one that interested Degas when he painted his own image of the queen, whom he shows standing with her retinue on a terrace above a river, serenely contemplating the panoramic cityscape below. Degas's image belongs to the tradition of Semiramis as builder, a tradition derived from the writings of the classical authors, particularly Herodotus and Diodorus of Sicily. Diodorus, who called Semiramis "the most renowned of all women of whom we have any record," and who devoted seventeen chapters in his *Bibliotheca historica* to her, is our most important source and probably Degas's as well. His detailed description of the building of Babylon contains one passage in particular which may have stirred Degas's pictorial imagination. Semiramis, he wrote, "built two palaces on the very banks of the river, one at each end of the bridge, her intention being that from them she might be able to look down over the entire city and to have the keys as it were to its most important sections." Her desire to found the great city of Babylon is ascribed by Diodorus to her "nature," which, he says, "made her eager for great exploits and ambitious to surpass the fame of her predecessor."[32] All in all, the character he evokes—a character apparently attractive and congenial to Degas—is that of a great woman, who was a strong and beneficent ruler, a creator and builder who shaped places as well as events, and who left her mark for the general good upon a world over which she exercised control.

In both the *Petites filles spartiates* and the *Sémiramis,* Degas, as a young man, dealt thematically with aspects of behavior and personality in women that were normally not encouraged for them in his society. He presented, in historical terms, possibilities for female independence, and he extolled the creative powers of women—intellectual and artistic rather than biological. The attitudes which these pictures suggest—attitudes that already in his youth would have marked Degas as unusual—are attitudes that seem to have survived as he grew older, for Degas, in later years, apparently continued to value independence of spirit and creative accomplishment in women, and he was most likely to establish his own relationships with them on a basis of intellectual equality.

Of the women in his own social circle whom Degas chose to paint, many were well known among their friends for both their intelligence and their creative talent. Mme Camus, for example, whom Degas painted twice in the late 1860s [L. 207, 271], was an accom-

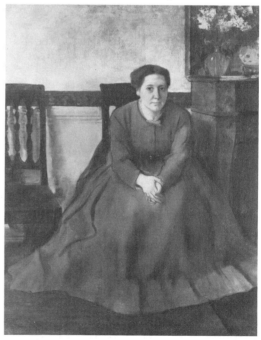

13. Degas, *Mlle Dubourg* (later Mme Fantin-Latour), 1866. Toledo, Toledo Museum of Art, Gift of Mr. and Mrs. William E. Levis (*Toledo Museum of Art*).

plished musician. Degas later wrote admiringly of her that she was a woman of great "energy," who "makes decisions in the most forceful manner."[33] Another talented female friend whom Degas painted in the late 1860s was Mlle Marie Dihau [L. 172, 263], a professional musician and singer, whose brother, Désiré, was bassoonist at the Paris Opéra.[34] And in 1866, Degas painted the portrait of Victoria Dubourg, another woman whom he appears to have admired and whom he interpreted pictorially in a remarkably straightforward and sympathetic way [13, L. 137]. Daughter of a painter, and herself a painter (largely of floral still lives), Victoria Dubourg exhibited from time to time at the Salon from 1869 on, and, according to a contemporary, Georges Rivière, she was noted for her intelligence among the artists and writers in whose circle she moved.[35] Boggs writes that "Degas painted her as sturdily built, uncomplicated in her movements, sensibly and for 1866 conservatively dressed in dull greenish brown, her hair simple, her face intelligent and wholesome." In a portrait conspicuously lacking in the conventional trappings of feminine coquetry and grace, she leans forward naturally in her chair with her hands clasped firmly in front of her and her forearms resting solidly upon her thighs, her posture informal, her gaze direct. In later years, Victoria Dubourg was also painted by her husband, Fantin-Latour, whom she married in 1876. And, as Boggs further points out, Degas's portrait presents us with "a far warmer and healthier image of her than the wan impression Fantin gave in painting her" during the years of their marriage that followed.[36]

Among Degas's small circle of friends, the woman with whom he seems to have enjoyed the closest and most durable friendship was of course Mary Cassatt. Cassatt could apparently withstand Degas's abrasive wit far better than most women—or, for that matter, most men—of his acquaintance. She was a person with whom he could debate the na-

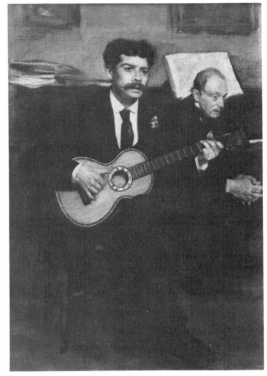

14. Degas, *De Gas Père Listening to Pagans,* ca. 1869. Paris, Louvre (*Archives photographiques*).

ture of "style," and she was an artist whose draughtsmanship he praised and admired. In the early 1880s, Degas painted a portrait of Mary Cassatt [1, L. 796], in a pose that is once again conspicuously lacking in conventional grace, a pose very similar to the one he had chosen many years earlier for his portrait of Victoria Dubourg—another woman of intelligence and spirit who was a painter. The expression here, however, is withdrawn and pensive, so that in depth and quality of feeling as well as in pose this portrait of Mary Cassatt is far more reminiscent of another earlier portrait by Degas, in this instance of a person very close to him: his aging father, whom he had painted around 1869 listening intently to the music of his friend Pagans [14, L. 256]. It is a formal echo that may in part be interpreted as an indication of the artist's af-

fection and high regard for his sitter, a woman whose outspoken manner and decisive opinions reportedly held great appeal for him and whose work he openly admired.[37]

Degas, we should observe at this juncture, played a notable and active role in encouraging women who were artists and in bringing them into the Impressionist circle. It was Degas who, after noticing and responding favorably to the work of Cassatt at the Salon of 1874, invited her three years later to exhibit with the Impressionists (which she did for the first time in 1879).[38] In addition to Cassatt, who was unquestionably the most distinguished of his recruits, Mme Marie Bracquemond, wife of the engraver Félix, also participated in some of the group exhibitions and received Degas's support and encouragement.[39] And in later years Degas took considerable interest in the work of Suzanne Valadon. According to his own report, he had one of her drawings hanging in his dining room, and in a series of short notes sent to her thoughout the 1890s he repeatedly praised her talent, admonishing her to address herself to her drawing and to visit him more often with new samples of her work. "Think of nothing but work," he urged, "of utilizing the rare talent that I am proud to see in you. . . ."[40] Degas scholars, it is interesting to note, have thus far been able to see little more in this correspondence than a symptom of the artist's approaching senility or the sign of an earlier but otherwise unsubstantiated love affair between the two.[41]

With Berthe Morisot, Degas seems always to have been, at least superficially, on fairly good social terms, although his attitude toward her as an artist is not entirely clear. He is reported to have said of her, disparagingly, that "she made pictures the way one would make hats."[42] Yet he is also reported to have said that behind "her rather airy painting is hidden a most assured drawing."[43] And, significantly, it was Degas who helped Morisot's husband and daughter to organize the

posthumous exhibition of her work that was held at Durand-Ruel's in 1896.[44]

Although she found his manner perplexing and often exasperating, Morisot clearly admired Degas. She mentioned and quoted him frequently in her letters, commenting on his activities and conversation as well as on his work. In a social sense, however, she far preferred the more conventionally congenial company of her brother-in-law, Manet, with whom her relationship was apparently a courtly one. Manet was a man who was reportedly attractive to women, and Morisot, it would seem, was a woman who appreciated and enjoyed the conventional forms of male social attentiveness.[45] Given their apparently greater acceptance of gender-defined social roles, it is not surprising, then, that Manet and Morisot should have been disturbed and even occasionally offended by Degas's frankness toward women and by his frequent rejection of many of the "appropriate" patterns of social response and behavior. A good example of this is provided by Degas's reported response to Berthe Morisot's expectation that, as a woman, she should and would be courted, an expectation that Degas apparently mocked and was not above playfully thwarting: "He came and sat beside me," Morisot reported to her sister in a letter of 1869, "pretending that he was going to court me, but this courting was confined to a long commentary on Solomon's proverb, 'Woman is the desolation of the righteous.'"[46] Degas's perverse yet extraordinarily self-aware and gently playful effort to undermine Morisot's conventionally feminine social posture in this exchange reveals values and social expectations on his part that were clearly very different from hers—and that were most certainly atypical for his period—but that were not necessarily misogynistic. The obvious difference in point of view that this exchange reveals, moreover, must prompt us to question the objectivity as well as the usefulness of many of Morisot's comments about Degas. It

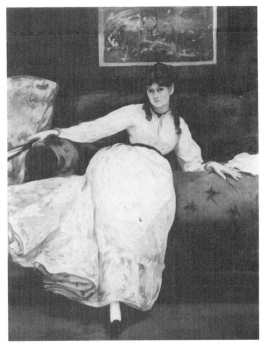

15. Edouard Manet, *Le Repos* (Portrait of Berthe Morisot), 1869–70, Salon of 1873. Providence, R.I., Rhode Island School of Design, Museum of Art, Edith Stuyvesant Vanderbilt Gerry Bequest (*Museum of Art*).

earlier portrait by Manet of Berthe Morisot [15]. The latter, painted in the winter of 1869–70 and exhibited at the Salon of 1873 under the title *Le Repos,* presents Morisot softly attired in billowing white, reclining languidly upon a sofa. No matter how unconventional and displeasing the style of this picture may have seemed to Manet's contemporaries,[48] as an interpretation of the female sitter, it is revealed by comparison with Degas's work as surprisingly conventional—the image of a dainty and appealing feminine object. That this, fundamentally, was the way in which Manet regarded Berthe Morisot is further suggested by Manet's jocular but nonetheless revealing comment on the Morisot sisters in a letter of 1868 to Fantin-Latour: "I agree with you," he wrote, "the demoiselles Morisot are charming. What a pity they aren't men. Still, as women, they might be able to serve the cause of painting by each of them marrying an academician and sowing discord in the camp of those old dotards. But that would be to ask of them an excess of self-sacrifice."[49] In an undated letter to the Comte Lepic, on the other hand, Degas asked his friend—who was a breeder of fine dogs as well as a painter and engraver—to find a dog for Miss Cassatt. In a postscript to the letter, he described Cassatt as "this distinguished person whose friendship I honor as you would in my place," adding: "I also believe it unnecessary to give you any other information about the applicant, whom you know to be a good painter, at the moment given to studies of reflection and shadows on flesh or dresses, for which she has the greatest feeling and understanding."[50]

In portraiture, then, Degas did not paint women as stereotyped feminine objects but as distinct human beings, emphasizing neither charm nor grace nor prettiness, but, rather, individual character. This fact often put off his contemporaries, and helps us to explain the less than enthusiastic response that Degas's portraits sometimes elicited—even from

should help, too, to shed some light for us upon Morisot's willingness to accept and to repeat Manet's assessment of the sexual and sentimental nature of their mutual friend, an assessment that, subsequently, has been often quoted without sufficient critical qualification. "He lacks spontaneity," Manet told her of Degas; "he isn't capable of loving a woman, much less of telling her that he does or of doing anything about it."[47]

Some indication of the fundamentally different ways in which Manet and Degas regarded women may be derived from a comparison of the portraits they painted of women, who, like themselves, were professionally active as artists. It is particularly instructive in this regard to consider Degas's portrait of Mary Cassatt [1] in relation to an

sitters and observers who should have known better. Thus, Berthe Morisot's ambivalent comment on Degas's austere and exquisitely refined portrait of Mme Gaujelin [L. 165], which she saw at the Salon of 1869 and with which, according to her own somewhat bemused report, Degas himself "seemed very pleased." She pronounced it to be "a very pretty little portrait of a very ugly woman in black...."[51] Berthe's sister, Yves, reacting to the portrait that Degas had done of her, commented ambiguously that it was "franc et fin tout à la fois."[52] Manet, of course, was so greatly displeased with the portrait of his wife in Degas's double portrait of the pair—painted around 1865 and showing Manet on a sofa listening to his wife at the piano [16, L. 127]—that he cut the canvas in two, provoking considerable ill-feeling between himself and his friend. Even Mary Cassatt, later in life, developed a strong dislike for the tender and sympathetic (but nonetheless unconventional) portrait that Degas had painted of her some three decades earlier [1]. Late in the year 1912, she wrote to her dealer, Durand-Ruel: "I don't want to leave this portrait by Degas to my family as one of me. It has some qualities as a work of art but it is so painful and represents me as such a repugnant person that I would not want anyone to know that I posed for it."[53] To understand what it was that Cassatt found objectionable in this portrait, one must compare it to another portrait, contemporary with Degas's, that Cassatt painted of herself [17]. As Boggs observes, Degas's portrait seems to us "to have a stronger and happier character than the charming portrait [that Cassatt] painted of herself."[54] And in those two words, "stronger" as opposed to "charming," lies the essential difference. Both portraits are designed to appear informal. But the informality of the self-portrait—communicated by the posture, the gaze, the appealing inclination of the head—is still conventionally "feminine" in its range of allusion and in its broader message.

Degas's refusal to flatter his female sitters is, of course, no proof of misogyny, even though some of his contemporaries, and ours as well, would have been inclined to interpret it as such. As the portrait of Manet, from the remains of the mutilated double portrait of

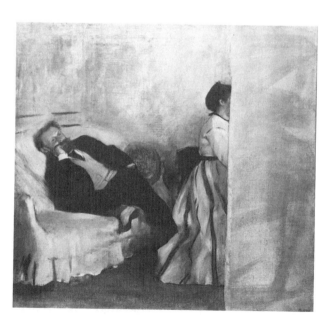

16. Degas, *Manet Listening to His Wife Play the Piano*, ca. 1865. Whereabouts unknown (*Archives photographiques*).

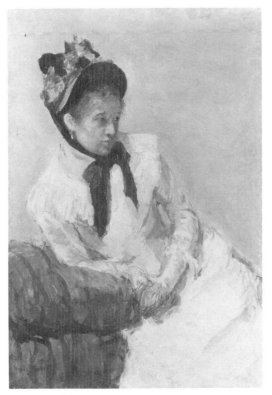

17. Mary Cassatt, *Self-Portrait,* gouache, ca. 1878. New York, Metropolitan Museum of Art, Edith H. Proskauer Bequest, 1975 (*Art Institute of Chicago*).

the artist and his wife [16], itself serves to demonstrate, Degas, throughout his career, was as physically realistic in painting men as he was in painting women—just as few people of his acquaintance, no matter what their gender, were ever spared entirely from the effects of his biting wit and irascible temper, especially as he grew older. A good case in point is the Italian critic Diego Martelli, whom Degas painted in 1879 in all his rotundity [18, L. 519], and who wrote in a letter at about this time that he feared, as he put it, that he "ran the risk" of becoming Degas's friend![55] Degas's portrait of Martelli, like his portrait of Cassatt, is informal, but not without dignity. It is an image that is in some ways physically unflattering, but that reveals, nevertheless, the character, the intelligence and the individuality of the sitter.

Although Degas avoided stereotypes when he painted portraits of particular women, who were usually members of his own social circle and class, he was far more inclined to reduce his subjects to types when he dealt with women of the lower working class. Yet even here, the formal prototypes upon which he drew and the iconographical associations

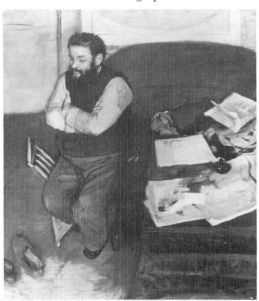

18. Degas, *Diego Martelli,* 1879, Edinburgh, National Galleries of Scotland (*National Galleries of Scotland*).

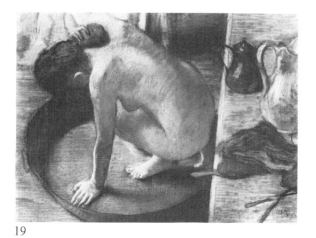

19

20

19. Degas, *Le Tub*, pastel, dated 1886. Paris, Louvre (*Archives photographiques*).

20. After Doidalsas, *Crouching Aphrodite*, ca. 250–240 B.C. Paris, Louvre (*Giraudon*).

that he chose to summon up can often suggest an intention far different from the purely negative one often inferred, both by his contemporaries and ours. Thus, behind the crouching bather [19, L. 872], whom Degas, according to Huysmans, had shown "debased in her tub, in the humiliating posture of intimate care,"[56] there lies the formal prototype of the Hellenistic *Crouching Aphrodite* [20], a Roman copy of which is in the Louvre. And behind Degas's many studies, both sculptured and painted, of dancers adjusting their shoes [e.g., 21]—those hardworking, determined, street-urchin ballerinas whose social origins Degas never lets us forget[57]—there lies a tradition that can be traced back to a relief from the Temple of Athena Nike, the goddess of Victory [22]. Nor can we ignore the implications of the fact that Degas's interest in the formal movement of Michelangelo's *Slave,* studied from the posed model as well as from the statue itself in the Louvre [23], eventually bore fruit in the figure of the exhausted laundress, who stretches as she pauses in her work—the contemporary female slave, whom the social system exploits [24, L. 785].[58] Although the formal patterns presented by

these traditional figure types may have appealed to Degas visually, there is something in the content of these figural prototypes as well that endows the artist's choice with additional significance, enriching his formal allusion and in part justifying it.

No examination of Degas's "misogyny" would be complete without consideration of his "failure to marry," a fact of the artist's personal life to which a disproportionate amount of significance has been attached in the literature. In addition to "misogyny," the theories that have been adduced to explain his single state have run the gamut from "natural timidity" to the equally unsupported speculation that he may have been "a repressed homosexual."[59] We know, certainly, that Degas's solitary existence, especially as he approached middle age, was not without its moments of loneliness and regret. Upon occasion, the example of the happy family life enjoyed by many of his relatives and friends prompted him to express his own longings for the joys of home and family and to speculate upon the possibilities of a similar sort of existence for himself.[60] Yet despite this conscious and occasionally bitter sense of deprivation,

21

22

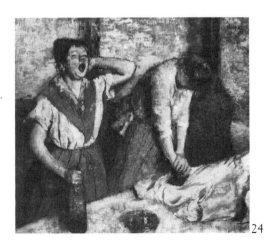

23

24

21. Degas, *Dancer Looking at the Sole of Her Foot,* bronze. New York, Metropolitan Museum of Art, Havemeyer Collection (*Metropolitan Museum of Art*).

22. *Nike Fixing Her Sandal,* marble relief from the Temple of Athena Nike, 421–415 B.C. Athens, Acropolis Museum (*Alinari*).

23. Degas, drawings, left: from model; right: after Michelangelo's *Slave.*

24. Degas, *Les Repasseuses,* ca. 1884. Paris, Louvre (*Archives photographiques*).

he seems to have been ruled, nevertheless, as one writer has put it, by "some deeper urge towards non-involvement,"[61] a position that the artist's contemporary, Georges Rivière, perceptively—and matter-of-factly—summed up in the following way:

He was unhappy about living alone, but at the same time, he realized that, given the conditions under which he lived, he was simply not cut out for the annoyances of family life. He envied, he said, the lot of some of his friends, surrounded by a happy family, but his imagination would raise a hundred objections against any inclination toward marriage, if ever his thoughts were to stray beyond a vague sadness over being deprived of joys that were not made for him.[62]

By interpreting Degas's bachelorhood as a sure sign of serious maladjustment, we have been responding, clearly, to a cultural bias: we have been confusing what may simply have been a distaste for certain role-defined

patterns of behavior and the kind of life they impose with distaste in general for all of the members of the opposite sex. For even though Degas may ultimately have rejected conventional domesticity as either unsuitable or impracticable for himself, he was not necessarily a man who feared or disliked women. To establish this, one need but glance without prejudice through the artist's correspondence, that record of his social relationships wherein is revealed not only his ability to relate to women, but also the important role that they played for him—actresses, dancers, painters, musicians, friends and the wives of friends—both socially and intellectually, throughout his life. His sympathetic response to them and his remarkably clear-sighted perception of their social condition in nearly every walk of life are qualities that pervade his career and leave a distinctive stamp upon almost every aspect of his art.

NOTES

Author's note: This essay grew out of a paper that was delivered at the Annual Meeting of the College Art Association in Washington, D.C., in January 1975.

1. J.-K. Huysmans, *Certains,* Paris, 1908, pp. 22–27 (1st edn. 1889); trans. by M. L. Landa, in P. Cabanne, *Edgar Degas,* Paris and New York, 1958, p. 120. A former naturalist and follower of Zola, Huysmans was the author of the influential "decadent" novel *À Rebours,* published in 1884. The attitude with which he subsequently approached Degas's art must be seen in part as a function of this recently adopted literary stance.

For examples of the pictures that prompted Huysman's commentary, see nos. 816, 847 [2], 872 [19 below], and 875 in the four-volume catalogue of Degas's work by P.-A. Lemoisne, *Degas et son oeuvre,* Paris, 1946–49. Works herein catalogued will be cited below as L., with number.

2. Valéry, who met Degas in the early 1890s, described the artist's gift for mimicry, citing his particularly vivid imitation upon one occasion of a woman whom he had observed going through the fussy and repetitive ritual of getting herself settled on a tram. "He was charmed with it," Valéry reported, adding: "There was an element of misogyny in his enjoyment"—P. Valéry, "Degas, Dance, Drawing," *The Complete Works of Paul Valéry,* Vol. XII, trans. by D. Paul, New York, 1960, p. 56.

3. J. S. Boggs, *Portraits by Degas,* Berkeley and Los Angeles, 1962, p. 31. Prompted by a similar intuition, Eugenia Janis later wrote: "Denis Rouart (*Monotypes,* 1948, pp. 1–10) and Camille Mauclair (*Degas,* Heinemann, London, pp. 15–16), have emphasized the beast-like qualities of Degas's prostitutes and have seen in them examples of Degas's supposed misogyny. They seem to have missed the humor in these women, who are ugly creatures, but comic, waiting for or administering to their cli-

ents. Even at their most obscene, they are carica-tures of obscenity"—E. P. Janis, *Degas Mono-types,* Fogg Art Museum, Boston, 1968, p. xx.

4. B. Nicholson, "Degas as a Human Being," *Burlington Magazine,* 105, June 1963, p. 239.

5. Q. Bell, *Degas: Le Viol* (Charlton Lectures on Art), Newcastle-upon-Tyne, England, 1965.

6. T. Reff, "Degas's 'Tableau de Genre,'" *The Art Bulletin,* 54, September 1972, pp. 316-37.

7. See the review of the literature on this paint-ing compiled by C. Sterling and M. M. Salinger, *French Paintings, A Catalogue of the Collection of the Metropolitan Museum of Art,* Vol. III (nine-teenth-twentieth centuries), Greenwich, Conn., 1967, pp. 72-73.

8. Reff, "Degas's 'Tableau de Genre,'" p. 324.

9. The phrases quoted are Reff's, *ibid.,* pp. 324 and 326.

10. Bell, *Degas: Le Viol,* unpaginated [12-14].

11. "Contradiction encore: Degas aimait la so-ciété des femmes. Lui qui les a représentées sou-vent avec une réelle cruauté, se plaisait auprès d'elles, s'amusait de leurs papotages, trouvait pour elles des mots flatteurs. Cette attitude formait un curieux contraste avec celle de Renoir. Celui-ci qui, cependant, peignant les femmes sous un as-pect séduisant et, dans ses tableaux, donnait du charme a celles qui n'en avaient pas, n'éprouvait généralement aucun plaisir aux propos qu'elles tenaient. Il n'aimait les femmes, à quelques excep-tions près, que si elles étaient susceptibles de de-venir ses modeles"—G. Rivière, *Mr. Degas, Bour-geois de Paris,* Paris, 1935, p. 18.

12. See J. S. Boggs, "Edgar Degas and the Bel-lellis," *The Art Bulletin,* 37, June 1955, p. 128.

13. Lemoisne, Vol. 1, p. 25.

14. See the letters quoted by T. Reff, "The Pic-tures within Degas's Pictures," *Metropolitan Mu-seum Journal,* I (1968), p. 129.

15. The psychological complexities of the por-trait and the expressive impact of its pictorial ar-rangement are discussed by Boggs, *Portraits,* pp. 14-15.

16. Lemoisne, Vol. I, p. 29.

17. A supporter of Cavour, the Baron Bellelli had been exiled from Naples because of his activi-ties during the Revolution of 1848. He settled first in France, from 1849 to 1853, and then in Flor-ence. See R. Raimondi, *Degas e la sua famiglia in Napoli, 1793-1917,* Naples, 1958, pp. 224-44.

18. See Boggs, *Portraits,* p. 17.

19. See J. S. Boggs, "'Mme Musson and Her Two Daughters,' by Edgar Degas," *Art Quarterly,* 21, Spring 1958, pp. 60-64; also Boggs, *Portraits,* p. 21.

20. Boggs, *Portraits,* p. 21. On Degas's later portraits of Estelle, see *ibid.,* pp. 40-41. And on the American branch of Degas's family, see J. Rewald, "Degas and His Family in New Orleans," *Gazette des Beaux-Arts,* 30, August 1946, pp. 105-26.

21. See, e.g., Bell, *Degas: Le Viol* [13-14]; Reff, "Degas' 'Tableau de Genre,'" p. 326; and Werner Hofmann, *The Earthly Paradise, Art in the Nine-teenth Century,* London, 1961, pp. 275-76.

22. See P. Cabanne, "Degas et 'Les Malheurs de la ville d'Orléans,'" *Gazette des Beaux-Arts,* 59, May 1962, pp. 363-66; and P. Pool, "The His-tory Pictures of Degas and Their Background," *Apollo,* 80, October 1964, p. 311.

23. H. Adhémar, "Edgar Degas et la 'Scène de Guerre au Moyen Age,'" *Gazette des Beaux-Arts,* 70, November 1967, pp. 295-98.

24. No. 33 in the *Catalogue de la 5e exposition de peinture... April 1-30, 1880.* See L. Venturi, *Archives de l'impressionnisme,* Paris and New York, 1939, Vol. II, p. 264.

25. The phrase "war of the sexes" is Bell's, *De-gas: Le Viol* [13]; see also Pool, "The History Pic-tures of Degas," p. 310.

26. "Jeunes filles et jeunes gens luttant dans le Plataniste sous les yeux de Lycurgue vieux à côté des mères." Quoted by Lemoisne, Vol. I, p. 230, and J. S. Boggs, "Degas Notebooks at the Biblio-thèque Nationale," *Burlington Magazine,* 100, June 1958, p. 202.

27. Daniel Halévy, *Degas parle,* Paris and Ge-neva, 1961, p. 183.

28. For a review of the possible literary sources and a description of earlier pictorial treatments of the theme, see M. Davies, *Catalogue of the French School, London, National Gallery,* London, 1957, pp. 70-72 and 71, n.7; also M. Sykes, "Two Degas Historical Paintings: 'Les jeunes spartiates s'exercent à la lutte,' and 'Les Malheurs de la ville d'Orléans,'" Master's thesis, New York, Columbia University, 1964, pp. 11-13, 14-16, and 33-34, notes 43-55.

29. On the sources of Degas's *Sémiramis,* see J. Kunin, "Degas's Near Eastern History Paintings,"

Master's thesis, New York, Columbia University, 1965, pp. 23–30, from which the following discussion is drawn.

30. See Irene Samuel, "Semiramis in the Middle Ages: The History of a Legend," *Medievalia et Humanistica,* Vol. II, 1944, pp. 32–44. Summarized by Kunin, p. 26.

31. Kunin, p. 25. Kunin convincingly challenges the often repeated contention of Lillian Browse that Degas's picture simply reproduces a scene from the current production of the Rossini-Méry *Sémiramis,* specifically, the scene at the beginning of the second act where Semiramis and a chorus of women await the arrival of Arsaces (L. Browse, *Degas Dancers,* New York, 1949, pp. 20, 50). With the aid of the libretto, Kunin points out that not only is the charged and dramatic mood of this scene out of keeping with the contemplative mood of Degas's picture but in the description of the setting for the scene (specified in the libretto as the Hanging Gardens), no mention is made of the river and cityscape that figure so prominently in Degas's composition (Kunin, pp. 23–25).

32. Diodorus of Sicily, *Bibliotheca historica,* trans. by C. H. Oldfather, London, 1933, Vol. I, p. 377 (Bk. II, 8), and Vol. I, p. 371 (Bk. II, 7). Cited by Kunin, p. 29.

33. Letter from Degas, upon the occasion of the death of Dr. Camus, in Jeanne Fevre, *Mon Oncle Degas,* ed. P. Borel, Geneva, 1949, p. 98. On Mme Camus and Degas's portraits of her, see Boggs, *Portraits,* pp. 26, 111.

34. Mlle Dihau sang regularly in Paris at the Colonne and Lamoureux concerts, where Degas and his father frequently heard her perform. See Lemoisne, Vol. II, p. 88; also M. Guérin, ed., *Degas Letters,* trans. by M. Kay, London, 1947, p. 260; and Sterling and Salinger, *French Paintings,* Vol. III, pp. 61–62.

35. Rivière, *Mr. Degas,* pp. 116, 121.

36. Boggs, *Portraits,* p. 31.

37. On the relationship between Degas and Cassatt, see Achille Segard, *Mary Cassatt, un peintre des enfants et des mères,* Paris, 1913, pp. 184–85; F. Sweet, *Miss Mary Cassatt, Impressionist from Pennsylvania,* University of Oklahoma Press, 1966, p. 33; and Julia M. H. Carson, *Mary Cassatt,* New York, 1966, pp. 32–36. On the personal significance for Degas of the portrait of his father and Pagans, see Cabanne, *Degas,* p. 108.

38. In response to Cassatt's work at the Salon of 1874, Degas is reported to have said to his friend Tourny: "C'est vrai. Voilà quelqu'un qui sent comme moi"—Segard, *Mary Cassatt,* p. 35.

39. See Degas's letters to Bracquemond and his wife, in Guérin, ed., *Degas Letters,* pp. 49–51; also J. Rewald, *The History of Impressionism,* New York, 1961, p. 448.

40. Letter of 1901 to Suzanne Valadon, in Guérin, ed., *Degas Letters,* p. 218, and undated letter [1897] to Suzanne Valadon, *ibid.,* p. 204. For other letters in this vein, see pp. 189–213; also the note on sources, p. 270.

41. See Cabanne, *Degas,* p. 81.

42. Sweet, *Miss Mary Cassatt,* p. 33.

43. In regard to Morisot's exhibition at Boussod et Valadon in 1892, Denis Rouart reports that Degas "lui fait le plus grand plaisir qu'il pouvait lui faire en lui disant que sa peinture un peu vaporeuse cache un dessin les plus sûrs"—D. Rouart, ed., *Correspondance de Berthe Morisot,* Paris, 1950, p. 169, quoted by Cabanne, *Degas,* p. 78.

44. See Degas's letter of 1896 to Julie Manet, in Guérin, ed., *Degas Letters,* p. 196.

45. See Boggs, *Portraits,* pp. 24 and 31.

46. "Il est venu s'asseoir auprès de moi prétendant qu'il allait me faire la cour, mais cette cour s'est bornée à un long commentaire du proverbe de Salomon: 'Le femme est la désolation du juste'"—Rouart, *Correspondance de Berthe Morisot,* p. 23; Eng. trans. by B. W. Hubbard, *The Correspondence of Berthe Morisot,* ed. D. Rouart, London, 1957, p. 27.

47. In a letter of May 1869, Berthe wrote to her sister Edma: "Quant à ton ami Degas, je ne lui trouve pas décidément une nature attrayante; il a de l'esprit, et rien de plus. Manet me disait hier très drôlement: 'Il manque de naturel; il n'est pas capable d'aimer une femme, même de le lui dire, ni de rien faire'"—Rouart, *Correspondance,* p. 31; Eng. trans. in *The Correspondence,* p. 35.

48. On contemporary reactions to the painting, see G. H. Hamilton, *Manet and His Critics,* New Haven, 1954, pp. 163–66, 169.

49. "Je suis de votre avis: les demoiselles Morisot sont charmantes. C'est fâcheux qu'elles ne soient pas des hommes. Cependant, elles pourraient, commes femmes, servir la cause de la peinture en épousant chacun un académicien et en mettant la discorde dans le camp de ces gâteux.

Mais c'est leur demander bien du dévouement"—
E. Moreau-Nélaton, *Manet raconté par lui–même*,
2 vols, Paris, 1926, Vol. I, p. 103.

50. Cited and trans. by Boggs, *Portraits*, p. 50.

51. *The Correspondence of Berthe Morisot*, pp.
27, 30–31, cited by Boggs, *Portraits*, p. 30.

52. *Correspondance de Berthe Morisot*, p. 32.

53. Venturi, *Les Archives de l'impression-
nisme*, Vol. II, p. 129; cited by Boggs, *Portraits*, p.
51.

54. Boggs, *Portraits*, p. 51.

55. For Martelli's interesting comments on his
developing friendship with Degas, see B. M. Bacci,
Diego Martelli, l'amico dei Macchiaioli, Florence,
1952, p. 67.

56. Huysmans, *Certains*, p. 23, trans. by M. L.
Landa, in Cabanne, *Degas*, p. 120.

57. See Degas's sonnets on this theme, in *Huit
Sonnets d'Edgar Degas*, preface by Jean Nepveu
Degas, Paris and New York, 1946, trans. in Ca-
banne, *Degas*, pp. 70–71.

58. See John Walker, "Degas et les maîtres an-
ciens," *Gazette des Beaux-Arts*, 10, September

1933, pp. 175 and 179.

59. See Nicolson, "Degas as a Human Being,"
pp. 239–40.

60. See, e.g., his letter to Henri Rouart, Decem-
ber 5, 1872, prompted by his visit with his broth-
er's family in New Orleans, Guérin, ed., *Degas
Letters*, p. 26. See also Degas's letter to Henri Le-
rolle, August 21, 1884, and his letter to Bartho-
lomé, December 19, 1884, in *ibid.*, pp. 81 and 99.

61. Nicolson, "Degas as a Human Being," p.
240.

62. "Il s'irritait de vivre seul et, en même
temps, il se rendait compte qu'il n'était point fait
pour les tracas de la vie familiale, en raison des
conditions dans lesquelles il vivait. Il enviait, dis-
ait-il, le sort de quelques-uns de ses amis, entourés
d'une heureuse famille, mais son imagination de-
vait soulever cent objections contre toute velléité
de mariage, si jamais la pensée de l'artiste allait
plus loin qu'une vague tristesse d'être privé de
joies qui n'étaient pas faites pour lui"—Rivière,
Mr. Degas, p. 18.

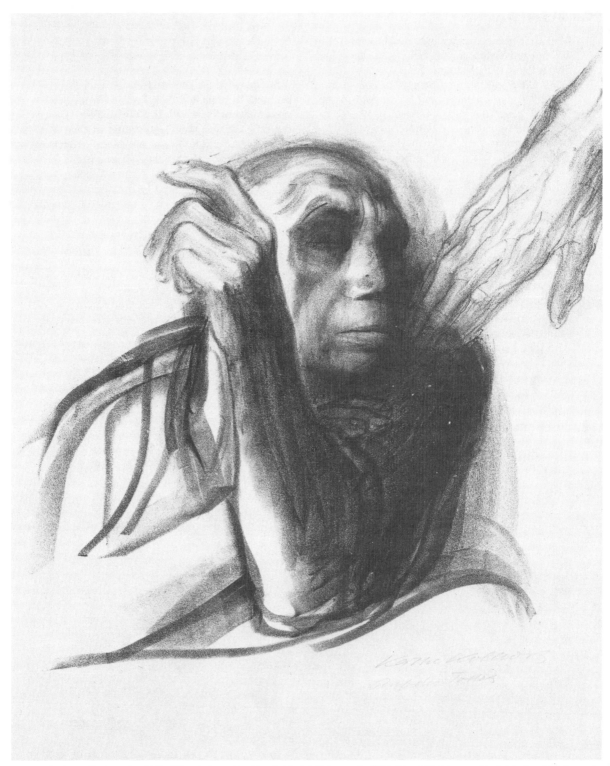

1. Käthe Kollwitz, *The Call of Death* (from the *Death Cycle*), lithograph, 1934–35. Washington, D.C., National Gallery of Art, Rosenwald Collection (*National Gallery*).

14
Gender or Genius?
The Women Artists of German Expressionism

ALESSANDRA COMINI

Expressionism—that primarily "German intuition"—had female as well as male practitioners in all its cultural manifestations: art, music, literature, theater, dance, and cinema. And yet much of the art history of the past seventy-five years after the fact has seen, exhibited, and explained German Expressionism primarily through one-gender glasses—masculine.

Is it perhaps a question of quality? Were women Expressionist artists just not as *good* as their colleagues of the opposite sex? (Take Marianne von Werefkin for example: her work really does not measure up to that of her fellow Russians Alexei Jawlensky and Wassily Kandinsky.) Or is it that despite fine technique, females simply weren't as "expressive" as their male counterparts, and hence their justifiable omission from the Land of German Expressionism?

Portions of this essay have appeared as "For Whom the Bell Tolls: Private Versus Universal Grief in the Work of Edvard Munch and Käthe Kollwitz," *Arts Magazine*, March 1977, p. 142; and "State of the Field 1980: The Women Artists of German Expressionism," *Arts Magazine*, November 1980, pp. 147–53. By permission of the author and *Arts Magazine*.

Or could the trouble lie with our discipline's standard definition of Expressionism—a definition which seems to take relish in contemplating and recontemplating the "revolt of the sons against the fathers"? (No room for daughters here.) Is it logical, I wonder, to demand Oedipal odysseys as entrance criteria for card-carrying Expressionists? Why for instance have critics been ambivalent about assigning equal value to the work of Käthe Kollwitz and Ernst Barlach? Why are we always told severely that Kollwitz tended to favor "social" themes, as if this weakened or negated the power of her poignancy? Concern with society, the very feature that characterizes the communionist mission of Expressionism's playwrights, would seem to tarnish Kollwitz's candidacy as a full-fledged Expressionist. Adolf Hitler was surer about Kollwitz's place in art history than many art historians have been: he specified that her works be included in the notorious Degenerate Art exhibition of 1937—possibly the greatest retrospective of modern art ever held.

According to the litany, the birth of Ger-

man Expressionism has repeatedly been traced back through an assortment of foreign midwives (Rodin, Gauguin, Van Gogh, and Minne) to a Norwegian father, Edvard Munch. During the 1970s several major retrospective exhibitions confirmed Munch as master of pessimistic determinism. But the cumulative impact of his frozen imagery also suggested a previously unthinkable question: Was life really that grim? Or did Munch's very real personal anxiety truly reflect the viewpoint of his time? We have always presumed the answer to be yes, and certainly the need to represent specific emotions in intense doses links Munch with the later centers of Expressionism—Dresden/Berlin, Munich, and Vienna. Certainly also Munch's parade of somnambulistic individuals in the grip of passion continues the close focus of Baude-

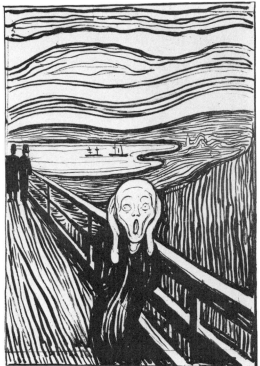

2. Edvard Munch, *The Scream,* lithograph, 1895. Washington, D.C., National Gallery of Art, Rosenwald Collection (*National Gallery*).

laire's *culte-de-moi,* parallels D'Annunzio's self-absorption, and culminates in Expressionism's probing of inner essence. But was this luxury of wallowing in the self *representative* of the 1890s, that decade of the crystallization of so much of Munch's imagery?

It is true that exploration of the psyche and inner realities dominated the analytical literature and painting of pre-World War I Europe, but such scrutiny was violently interrupted at Sarajevo on June 28, 1914, and the meditation was not resumed until the rise of cultural narcissism in the America of the mid-1970s. Demands for social justice compelled international attention after 1914, and the spotlight of individualism was dimmed by the glare of collective issues. But were these not also concerns *before* World War I? The answer is a resounding yes. Voices of the 1890s dealt insistently with social themes: Ibsen and Bjornson, objectively; Brandes, Strindberg, and Przybyszewski, subjectively. If Ibsen was too socially preoccupied, Knut Hamsun's reactionary emphasis on the unconscious sphere of the mind was nevertheless increasingly predicated upon the impact of society upon the individual.

Here is perhaps a key to the Expressionist-engendering epoch of which Munch has always been seen as an extreme but primary example. The theme of the time was the individual in society; its meaning was, according to the interpreter, objectively or subjectively rendered; its applications either universal or private. Determinism seemed a universal fate, pessimism or stubborn faith the only qualifiers.

Munch was fifty years old when the shot at Sarajevo rang round the world. His own shot—the great lithograph of 1895, *The Scream* [2]—had already touched off universal repercussions as an embodiment of pre-World War I anxiety. But, *was* Munch's scream wholly representative of his times, I wonder? And if so, for whom was he screaming? Was his problem, summed up in the re-

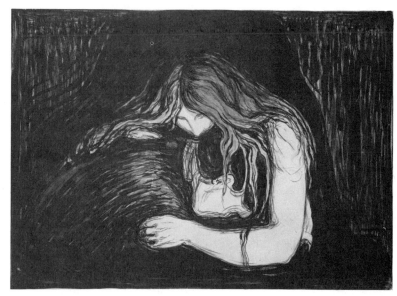

3. Munch, *Vampire*, lithograph, 1895. Washington, D.C., National Gallery of Art, Rosenwald Collection (*National Gallery*).

curring image of the blood-thirsty *femme fatale* [3], everybody's problem? Was everyone theatened by vampiric or harpy-like creatures? Or did this apply only to fellow creators such as Strindberg and Przybyszewski?

Let us look at just one of Munch's contemporaries, and let us stipulate that this fellow artist be concerned with the spectacle of human existence, as was Munch, be effective in the graphic media, as was Munch, and live during the exact same eight decades that Munch did, witnessing, as did Munch, not one but two world wars. Which artist shall we choose?

I propose Käthe Kollwitz [1 and 4]. Not because German Expressionism lacks a mother (which, according to the litany, it does), but because Kollwitz fulfills the rather stringent requirements just cited. Oh! But Kollwitz is so grim, so depressing, so socially involved. Always the same themes: poverty, dying mothers or children, war, and death. Is she the right artist to compare with Munch, who is so grim, so depressing, and always picturing the same themes: dying mothers or children, jealousy, aggression, and death? All

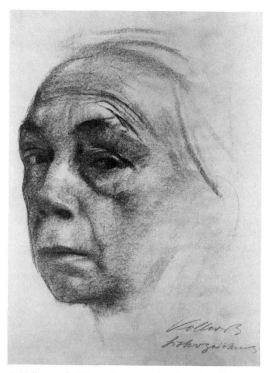

4. Kollwitz, *Self-Portrait*, crayon drawing (transfer drawing for lithograph K. 198), 1924. Washington, D.C., National Gallery of Art, Rosenwald Collection (*National Gallery*).

right, let's take Kollwitz. Because if the quality of grief can be measured, Kollwitz's pain was surely equal to that of Munch—in both melancholic intensity and lifelong duration. She too screamed aloud her fears through the etched or lithographic print. She too lived eight long decades, witnessing, as did Munch, two world wars. She too was a northern European, born in the East Prussian capital of Königsberg in 1867, just three and a half years after Munch. She survived him by only a year: Munch died at the age of eighty in 1944; Kollwitz died in 1945 in her seventy-ninth year. But what justifies this pairing of the Prussian pacifist with our Norwegian neurotic? Is this a feminist attempt to give German Expressionism a mother? (But the litany has told us that mothers are not neces-

sary for the delivery of new art movements.) No. I propose the unlikely but *revisionist* pairing of Kollwitz and Munch because the *objects* of their suffering were so very different. Munch grieved for himself—even picturing himself once as a cadaver-like patient at the mercy of a miracleworking doctor [5]. Kollwitz, especially through the medium of poster art, grieved for humanity: *Vienna Is Dying! Save Its Children!* [6]. Together this disparate pair of superb image-makers represents the polarities of their epoch. Their poignant syntheses of the drama of life and death convey several dimensions of the anguish of this period, whether hoarded as personal trauma, as with Munch, or expended as universal wound, as with Kollwitz.

Munch spoke for many disturbed souls

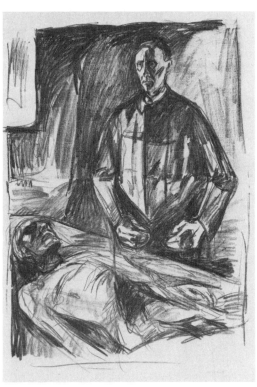

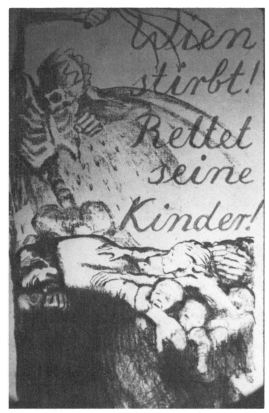

5. Munch, *Professor Schreiner as Anatomist,* lithograph, 1930. Oslo, Munch-Museet (*Munch-Museet*).

6. Kollwitz, *Vienna Is Dying! Save Its Children!,* lithograph, 1920 (*Alessandra Comini*).

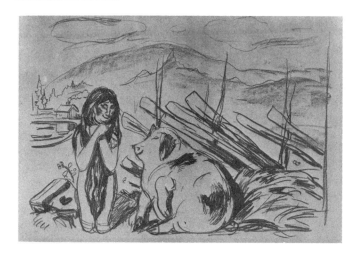

7. Munch, *Omega and the Swine* (from *Alpha and Omega*), lithograph, 1908–09. Oslo, Munch-Museet (*Munch-Museet*).

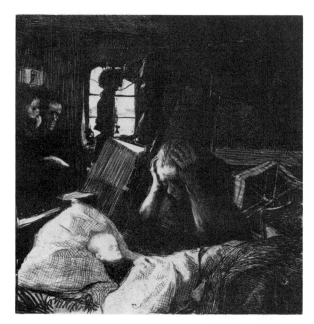

8. Kollwitz, *Poverty* (from *The Revolt of the Weavers*), lithograph, 1897. Washington, D.C., National Gallery of Art, Rosenwald Collection (*National Gallery*).

when he wrote and illustrated his own mythology of the pitfalls of love, *Alpha and Omega,* in which the panerotic Omega makes love to every sort of animal [7], finally abandoning a very Munch-like Alpha to his gloom and a bevy of bastard children who insist on calling him father. But Kollwitz spoke as strongly for as many souls when—in response

to Gerhard Hauptmann's play—she produced her six-print cycle *Revolt of the Weavers* [8], a sympathetic comment on the dreadful state of the German working class which earned her the active enmity of Kaiser Wilhelm II.

The phenomenon of the *femme fatale—* Art Nouveau's thematic legacy to Expressionism—was not, in spite of all that has been

written, the exclusive preoccupation of the *fin de siècle*. For every devouring woman in Munch's febrile imagination there was a supportive wife or nurturing mother in Kollwitz's world mirror [9]. The word "war" triggered different pictorial responses from the two: for Munch it meant a death battle between the sexes; for Kollwitz it meant the armed conflict of nations and the senseless destruction of family. After World War I, while Kollwitz was at work sculpting a war memorial to her son who had fallen in Flanders, Munch marked his own close bout with death in a painting entitled *Self-Portrait After the Spanish Influenza*. We do not reprove Matisse for not having painted a *Guernica*, nor do we point out the social concern of Kollwitz's work to imply any condemnation of Munch. But we can suggest that the

pessimism of Munch's sexual determinism and the obdurate pacifism of Kollwitz's *Never Again War!* [10] were equally representative of their times. Many voices must sound to express an age. Munch's scream was not unique. If we ask, however, for whom did the bell toll, Munch's answer was "for me," Kollwitz's response was "for thee and all mankind."

Both artists lived to hear their messages and their art pronounced "degenerate" by the Nazi regime. Both were shaken personally and artistically by the spectacle of illness and death. Both increasingly longed for death. The impotence of the individual before great forces had been personified as sexual and erotic by Munch; specified as political and social by Kollwitz. But if the age of Munch and Kollwitz was indeed characterized by pessi-

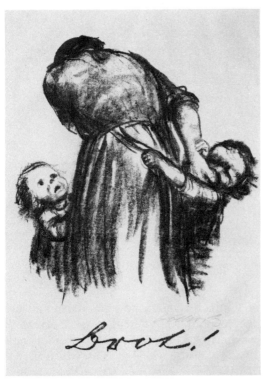

9. Kollwitz, *Bread!*, lithograph, 1924. Washington, D.C., National Gallery of Art, Rosenwald Collection (*National Gallery*).

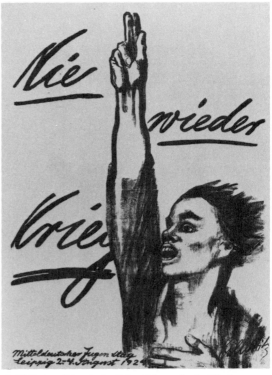

10. Kollwitz, *Nie wieder Krieg!* (Never Again War!), lithograph and drawing, 1924 (*after C. Zigrosser*, Kaethe Kollwitz, *1946, pl. 39*).

mism, its grief was both personal and universal. How curious that in the case of these two artists of genius who functioned before, during, and after German Expressionism, only one—Munch—has hitherto been singled out by art historians for apposite consanguinity.

The litany has denied Kollwitz a place as the mother of Expressionism because of the social content of her work. This same litany, in citing the all-male membership of German Social Realism of the 1920s and 1930s (including such relatively unknown artists as Carl Grossberg, Karl Hubbuch, Christian Schad, Rudolf Schlichter, and Georg Scholz), has also excluded Kollwitz from the roll call because of her expressionist reduction of form.

Would dying young have helped nominate Kollwitz for admission into Expressionist ranks? Certainly this tragic circumstance—death at the age of twenty-eight—has enhanced the historical standing of Egon Schiele (1890–1918) within the Viennese cell of German Expressionism, whereas the ninety-three-year terrestrial sojourn of Oskar Kokoschka (1886–1980) saw an appreciable dimming of the initial fiery luminosity of his Expressionist trajectory. Genius cut short by suicide has proved an intriguing factor in the recent reevaluation of the Viennese painter Richard Gerstl (1883–1908), whose spectral, splotchy group portraits and high-voltage autoscopy of mental deterioration are now recognized as foreshadowing the deformation and intensity of Expressionism.

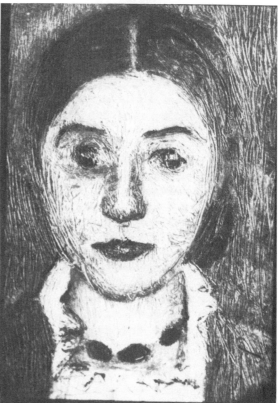

If an artist of exceptional merit whose *oeuvre* expressly anticipated Expressionism were to die a premature death, would not the works left behind qualify for consideration in any historian's search for stylistic precursors? Apparently not always. Not if the genius is of the "wrong" gender. Take the case of Paula Modersohn-Becker [11 and 12], who died at the age of thirty-one in 1907. The hard-won childlike simplifications of her archetypal forms in nature presaged the self-conscious primitivism of the Brücke and anticipated the

11. Photograph of Paula Modersohn-Becker (1876–1907), ca. 1900. (*after Rolf Hetsch*, Paula Modersohn-Becker: Ein Buch der Freundschaft).

12. Paula Modersohn-Becker, *Self-Portrait with Necklace*, oil on pasteboard, ca. 1903. Bremen, Kunsthalle (*from Hetsch*, Paula Modersohn-Becker).

instinctive abstractions of the Blue Rider. And yet she has suffered the same historical derailment from the main track of art history as has Kollwitz. Although Modersohn-Becker's diaries and letters went through several posthumous German editions, it was not until the year 1980, almost three quarters of a century after her death, that a translation of her writings and a treatment of her life appeared in English.[1] The neglect of her proto-Expressionist *oeuvre* by the academic world is extraordinary in light of the fact that the bulk of her paintings can be seen on permanent display under one roof in the museum dedicated to the artist on Bremen's famous Böttcherstrasse.

Was it possibly the remoteness of Modersohn-Becker's choice of residence that so delayed recognition of her painterly achievements? To visit Paula Modersohn-Becker Country means to travel some twenty miles north of the ancient Hanseatic town of Bremen and into the moody, low-lying North German moors where the tiny village of Worpswede nestles discreetly between pea green canals and gleaming white birches. But surely this bucolic retreat—already popular in the nineteenth century as an artists' colony—is no more remote than Emil Nolde's isolated Seebüll hideaway on the moors of Schleswig-Holstein, or the spooky country house at Zwickledt near Linz where the Austrian Expressionist Alfred Kubin lived out a hermit-like existence for some fifty-three years. Nolde and Kubin lived as prominent individuals in these obscure places and they maintained an active business correspondence with their gallery contacts in the big cities. Paula Modersohn-Becker on the other hand joined a group of older and established "nature" painters who lived and worked in Worpswede and whose picturesque landscapes and village scenes were referred to as the "Old Worpswede" style. The trouble with Modersohn-Becker was not that she lived off the beaten track but that, increasing-

ly, the pictures she painted did not fit in with the prevailing Worpswede penchant for the decorative and the nostalgic. Her purposeful primitivism was out of step with Old Worpswede, very much in step with the newer stimulus of Van Gogh, Gauguin, and Cézanne, whose works she had seen and admired on trips to Paris.

The personae of Modersohn-Becker's Worpswede life are presented in a winsome outdoor ensemble painted in 1905 by the Symbolist artist Heinrich Vogeler.[2] Modersohn-Becker is shown in profile to the far left, her somewhat frail physique a bit idealized in Vogeler's sympathetic rendition. Seated across from her, facing us with a serious, meditative gaze, is her close friend the sculptor Clara Westhoff, square of jaw and resolute of temperament, who lived to the age of seventy-six, dying in 1954. Her long life and interesting marriage are unusual enough for us to pause for a moment and take note of whom she married, and in this case the verb "marry" should be put in the active voice, for this calm, Amazonian woman was the temporary haven for the fragile, wandering poet Rainer Maria Rilke—just back from a stormy trip to Russia at the hem of that great real-life *femme fatale* Lou Salome, famed in her younger days for keeping even Nietzsche in line. Rilke and Westhoff were married in April of 1901. This union between poet and sculptor left the courtship field open for painters and a long-time Worpswede resident, Otto Modersohn, had already entered the scene: in Vogeler's group portrait he is shown standing between the two women, his kindly eyes directed toward the painter. Recently widowed and with a very young daughter to care for, he quietly pursued Paula Becker, whose personality and painting he admired in equal measure, and they were married in May of 1901, less than a month after the Rilkes. Paula was eleven years Otto's junior, and it soon became clear to her that marriage should not and could not dis-

13. Modersohn-Becker, *Barn at Worpswede,* ca. 1900. Cologne, Wallraf-Richartz Museum (*Alessandra Comini*).

14. Otto Modersohn, *Barn on the Teufelsmoor,* ca. 1900. Worpswede, Grosse Kunstschau (*Alessandra Comini*).

14

place the study trips she felt obligated to make to Paris. The sophistication and artistic richness of the *Weltstadt* was a magnet pulling her away from the serene complacency of provincial Worpswede. None of the other Old Worpswede painters, including Otto, felt this need to commute between the macrocosm and the microcosm. To them Worpswede was a *Weltdorf,* a "world village," whose unspoiled natural vistas and folk ways were humbling. For Modersohn-Becker, the intimacy and "Biblical simplicity" of the village constituted a challenge to discover visual equivalents of appropriate and monumental universality.

Given this profound difference in artistic aims, it becomes of keen interest to compare the works of our professional wife/husband team—Becker and Modersohn. In examining two characteristic landscape views by the two artists, *Barn at Worpswede* [13] and *Barn on the Teufelsmoor* [14], we find certain elements in common: the typical thatch-roofed farm buildings, birch trees, and cloud puffs. But the picturesque quality of *Barn at Worpswede* is marred somewhat, a contemporary critic might have mused, through the abrupt dissection of the barn motif by the wavering birches, which are themselves unceremoniously cut off in places at top and bottom. The compositional integrity of the farm building is "flawed" as a result; it's not picturesque. And it's not by Otto Modersohn. But is it fair to see with such certainty a dif-

15. Modersohn, *Peasant Girl Under a Willow Tree*, 1895. Bremen, Kunsthalle (*Alessandra Comini*).

16. Modersohn-Becker, *Single Birch Tree*, 1902. Bremen, Paula-Becker-Modersohn-Haus (*Alessandra Comini*).

ference in hands on the basis of just one comparison?

Let's look at another juxtaposition: Otto Modersohn's *Peasant Girl Under a Willow Tree* [15] and Paula Modersohn-Becker's *Single Birch Tree* [16]. If picturesqueness is our criterion, Paula Modersohn-Becker fails again. The mood of Otto Modersohn's picture, with its single waiting figure and meticulously rendered undulating tree silhouettes, is certainly far more "romantic" and "pleasing" than is his wife's less precisely articulated and empty meadow scene, in which a single gray and white birch trunk twists and throws the amorphous shadow of its branches against the grass with crude energy. We do not need more comparisons to realize that Paula Modersohn-Becker had a pictorial goal that was different from that of her husband. She was not interested in concocting pleasing compositions in the Old Worpswede manner, but rather in simplifying. She was in search of expression rather than nostalgia—expression through a primitivizing line. Just how successful she was in extracting line and form from visual data in order to create effective images can be seen in her portraiture: here, through what she termed "the naive in line," monumental human verticals [17] are articulated with elemental immediacy. In her intensity, the artist eschews traditional distance to bring her subjects into intimate, subjective focus, boldly patterning her human and plant forms into friezelike icons.

Otto watched this single-minded process with admiration, exclaiming in his diary: "She is really a great painter. She already paints better today than Vogeler.... She has something quite rare. In her intimacy she is monumental."[3] He also wrote: "No one knows her, no one esteems her,"[4] and this complaint seems justified when we consider that Rainer Maria Rilke's rhapsodic monograph of 1903 eulogizing Worpswede dealt exclusively with the leading *male* artists of the colony: Fritz Mackensen, Otto Moder-

sohn, Fritz Overbeck, Hans am Ende, and Heinrich Vogeler. No Paula Modersohn-Becker, not even his own Clara Westoff-Rilke. How ironic that within the litany of modern art history the cant of mainstreamism does not contain the name of even one of these male Worpswede artists—art critic Rilke notwithstanding. The prognosis is different for Paula Modersohn-Becker. The painter who looked briefly but intensely at life's riddle is now herself being scrutinized by revisionist historians as a quite remarkable and significant precursor of German Expressionism.

An exclusionist, one-gender litany has—almost successfully—designated Munch as "father" of Expressionism while ignoring Kollwitz as possible "mother," and has proposed precursors such as Rodin, Gauguin, Van Gogh, and Minne while bypassing the North German Modersohn-Becker. But how has this separatist policy coped with women artists who were indisputably on the scene as German Expressionists? (I wonder, by the way, why we never say "man" in front of the word "artist," as in: "Lavinia Fontana was the greatest artist of Bologna in the year 1600, while the man artist Ludovico Carracci was not without repute in the same city.") Let us take the case of Gabriele Münter [18 and 19], one of the original founding members of the Munich Blue Rider group. Born in Berlin in 1877 to German parents who had met and married in America, she lived eighty-five years, producing a sizeable *oeuvre* of oil paintings, reverse glass paintings, etchings, woodcuts, and lithographs. Here is how one prominent scholar recently summed up her career: "Gabriele Münter (1877–1962) was a pupil of Kandinsky, with whom she lived from 1904–1916. On the occasion of her eightieth birthday in 1957, she donated to the Städtische Galerie in Munich 139 paintings, 282 watercolors and drawings, and innumerable prints that Kandinsky had left with her in 1914."[5] From pupil to patron in two sen-

17. Modersohn-Becker, *Elsbeth,* July 1902. Bremen, Ludwig Roselius Collection, Bötcherstrasse (*Alessandra Comini*).

tences and eighty-five years with nary a word about the artist's paintings!

Why have Münter's paintings been ignored or given short shrift in so many of the exhibitions and histories of German Expressionism? The answer is, I fear, the primacy of biographical drama over artistic achievement. For fifteen years, from 1902 to 1917, Münter was intimately associated with and overshadowed by Kandinsky, both on a personal and an artistic level. Initially their relationship was that of student and—older by eleven years—teacher. Münter studied briefly in 1902 with Kandinsky at Munich's Phalanx School and they became secretly engaged the following year. Kandinsky was planning to

18. Photograph of Gabriele Münter (1877–1962), 1905 (*from Johannes Eichner,* Kandinsky und Gabriele Munter).

19. Gabriele Münter, *Self-Portrait,* 1910. Beverly Hills, California, The Robert Gore Rifkind Collection (*Jann and John Thomson*).

dissolve a ten-year marriage to his first wife, a Russian, who had been unprepared for the transformation of her lawyer-husband into a painter. Later, when divorce proceedings were under way, Kandinsky would introduce his new German companion as "my wife, Gabriele Münter."[6] The tension-fraught engagement between the uncomplicated Münter and the complex Kandinsky remained just that: a marriage never took place. For years Kandinsky tortured both himself and his fiancée with indecision.[7] But just as Kandinsky could not be compelled to marry Münter, so also he could not be constrained to break off their relation by facing the truth that the woman in whom he had invested so much time was not the right woman.

Two years later, after the war had begun, he wrote ruefully of the wrong he had done Münter and of the lengths to which he was willing to go for her:

Sometimes when I think of you my heart is ready to burst and I would gladly give my blood for you. You must never forget and you must constantly feel that I, who have spoiled your life, am really ready to shed my blood for you. These are not exaggerated, not petty words, you dear, dear, good, sweet Ella. [March 11, 1915][8]

But neither restitution nor blood-letting were in store for this mismatched couple. They spent their last Christmas together in Stockholm, their thoughts preoccupied by the war. As an alien in Germany, Kandinsky had fled to Russia at the outbreak of hostilities and his reunion with Münter in Stockholm only lasted three months. In March of 1916, promising to return, he left again for Russia. His letters arrived less and less frequently and on June 12, 1917, the fifty-one-year-old Kandinsky abruptly informed his German fiancée that he had just married the teenage daughter of a Russian general. The news shattered Münter. She stopped painting and began a restless journeying that took her from city to city for a full decade. These are the dramatic biographical events in Münter's as-

sociation with Kandinsky that have tended to obscure appreciation of Münter's attainments as an artist.

The hiatus in her creative production and the fact that in their early years together Münter seemed to be very much the creature of Kandinsky's making (he forbade her to dance, asked her to dress in black, and sometimes designed her clothes) have seemed to weight the student-teacher balance of their professional affiliation with greater importance than I think is due. When Münter first came to Munich for art instruction, she was a young girl, yes, but by no means an inexperienced provincial. She had already studied art in Düsseldorf and in Bonn, and at the age of twenty-one she had sailed across the Atlantic to visit America. Now much has been made, and rightly so, of Kandinsky's Russian roots, and dissertations will continue to be written about the impact of this heritage upon his art; but why has the litany ignored, and we revisionist-feminists waited so long to examine, seriously, the early formative experiences of Münter? After all, she spent *two* years in the United States, from 1898 to 1900, visiting relatives in Missouri, Arkansas, and Texas. We know of sketches done of the Texas relatives (the Ware and Donohoo families in Plainview)—executed with a remarkably fine and sure sense of line and composition—and we have the fascinating images Münter recorded with her new Kodak of "*typische*" American rural and city scenes.[9] She even appears in some of these photographs, dressed suitably for the occasion in pristine Sunday elegance or practical country frock. One of the photographs inadvertently includes the photographer's own top-knotted, tightly corseted lithe shadow—a curious phantasmagorical precursor of her painted presence in the Murnau pictures by Kandinsky.

Why has no art historian bothered to retrace Münter's extensive American odyssey? What might we expect to find if we did travel to one of the small towns the artist visited at the turn of this century? Certainly nothing now of Münter, but perhaps something of what Münter herself saw and experienced. This is indeed the case with Marshall, Texas (present population 23,000), situated in the primeval woodland lake district of the state near the Louisiana border. Settled in 1839, the town became an important stop on that "gateway to the West," the Texas and Pacific transcontinental railroad. Oscar Wilde had passed through this unavoidable junction to lecture in nearby Jefferson in 1882. In the same decade the actor Maurice Barrymore was shot and one of his troupe killed in front of Marshall's railway station. Two years before Fräulein Münter was destined to alight in front of this same dramatic backdrop, an enterprising businessman completed the construction of a luxurious Victorian establishment just opposite the railway station on the other side of the tracks, the Ginocchio Hotel and Restaurant. Here, a modern historical marker on the building informs us, four hundred meals a day were served to hungry transcontinental passengers. The ground-floor restaurant part of the building has been refurbished (contemporary chili is featured), and even though the second floor is no longer in operation for overnight guests, many of the original hotel furnishings are preserved *in situ*. A great hand-carved curly pine staircase and somnolently stagnating stag's head reveal today what appealed to Marshall's interior decorators at the turn of the century. And decorating the walls of the individual bedrooms on the second floor is a real surprise for German Expressionist enthusiasts: small nineteenth-century anonymous reverse paintings on glass. Romantic mountain landscapes rather than religious imagery, their presence in Marshall (and in much of nineteenth-century America and Europe) does remind us that the popular tradition of painting in oil on glass existed outside and beyond the confines of Bavaria—art history's traditional assignment point for the Blue Rid-

20. Münter, *Kandinsky
Painting a Landscape,*
1903. Munich, Städtische
Galerie im Lenbachhaus
(*Alessandra Comini*).

er group's first encounter with *Hinterglasma-
lerei.*

This is not to discredit or diminish the au-
thenticity or the impact of Münter's, Kan-
dinsky's, and Jawlensky's discovery of Bavar-
ian folk painting. But the multiplicity of
sources and stimuli in every artist's life can-
not be discounted. And who is to say whether
or not Münter's artistic sensibilities (like
those of Kandinsky for Russian peasant art
after his trip into the Volgoda) might not
have been quickened by the humble reverse
glass decorations of Marshall, Texas?

Let us return to Bavaria now and consider
that body of works produced by Münter dur-
ing her fifteen years with Kandinsky. Her
natural talent for drawing, so evident in the
unforced work she produced in Kandinsky's
painting class at the Phalanx School, soon
caused him to declare to her: "You are hope-
less as a student. One can't teach you any-
thing. You can only do what you have inside
you. You have everything instinctively. All I
can do for you is protect and cultivate your
talent so that nothing false supervenes."[10]
This he did, in Munich and in Murnau—
their summer retreat from 1908—and on the

painting trips they made across Europe dur-
ing the next ten years. Because their early
canvases frequently depicted the same motifs
in similar styles, the litany's easy judgment
that Kandinsky greatly influenced Münter
has received full credence.[11]

What about the question of influence ver-
sus individuality? We have Kandinsky's com-
ment as reported by Münter—that she was
"hopeless" as a student—and we have Kan-
dinsky's written judgment of 1916:

She is bound by the contemplative, immediate,
one is tempted to say, by the innocent feeling for
nature and the world. Gabriele Münter was recep-
tive to every artistic influence and understood not
only French art, but also that of other countries
and epochs, but in spite of this understanding she
has remained herself, and her work is quite unmis-
takable.[12]

But let's look for ourselves, and if we are
open to the thought that not all artists fol-
lowed the same paths toward Expressionism
(witness Kirchner versus Nolde, Marc versus
Kandinksy, Macke versus Klee), perhaps our
concept and definition of Expressionism can
be expanded.

21. Wassily Kandinsky, *Münter Painting in Kallmünz*, 1903. Munich, Städtische Galerie im Lenbachhaus (*Alessandra Comini*).

What can we say of any differences between student and teacher? Of any lags or superiorities in technique? Two portraits Münter and Kandinsky made of each other at work [20 and 21] provide us with an interesting juxtaposition. Both pictures date from 1903, and both pictures show the artists out of doors, painting directly on small canvases. Kandinsky sits, with that familiar, straight-backed, aristocratic posture of his, and Münter stands, her easel placed in the protective shade of a huge parasol. Differences in brushstroke seem minimal: thick horizontal dabs enliven both surfaces. Perhaps the dabs and palette knife strokes are a bit more varied in pressure and duration in Kandinsky's picture. Certainly the difference in vantage-point, if consistent in other comparisons, might constitute an early distinguishing characteristic—Münter apparently works closer to her subject than does Kandinsky, who includes in his painting what the artist herself is viewing and recording.

Now let us move ahead to the summer of 1908 when, after a criss-crossing exploration of the many enchanting villages dotting the foothills of the Bavarian Alps below Munich, the two painters discovered the old market town of Murnau. Murnau was gloriously situated at the base of a saw-toothed range of snow-capped mountains and between two small lakes, the Riegsee and the Staffelsee. It was here that, the following year, Münter bought the house where they would come to paint and garden from then on every summer until the outbreak of World War I. (Ironically, most histories of the Blue Rider attribute the ownership of the house to Kandinsky.) It is a spacious, four-story, cozy house that can still be visited today. It came to be known as the *Russenhaus* by the villagers because not only Kandinsky came to work there in the summers but also his compatriots Werefkin and Jawlensky. Both Münter and Kandinsky made pictorial records of the visits. Kandinsky painted an interior scene showing the two women seated in conversation on a couch, the prepossessing Russian guest on the right and her diminutive German hostess on the left, her hair done up in the customary topknot. Three brightly colored small paintings hang on the wall behind them and a side table to the right holds two blooming potted plants.

Münter painted the Russian visitors both indoors and outdoors, and at a closer vantage-point. At least three of her works record a boat ride on the nearby lake; in one of them [22] Münter includes a self-portrait, with herself doing the rowing, Werefkin to the right sporting a truly Gargantuan sun hat, Jawlensky's young son Andreas to the left, and, standing up in the boat like a latter-day George Washington, the fearless Admiral Kandinsky. Another Münter canvas of the same period, now in the Städtische Galerie im Lenbachhaus in Munich, shows Werefkin and Jawlensky reclining on a grassy hill slope, both wearing cheerful summer hats; and a third memento, also in the same museum, is an arrestingly simplified indoor portrait of Jawlensky alone, slouching like a great banana (the curve of which is repeated by a real banana on the table before him) behind an oil lamp, while, his face an expectant question mark, he "listens" to the expoundings of an unpictured Kandinsky. The painting is in fact titled *The Listener* and is a revealing example of Münter's interest in fixing sudden impressions rather than laboring for portrait exactitude. For instance, the artist's enchanting 1913 portrait of Paul Klee, titled simply *Man in Armchair,* and done in the Munich Ainmillerstrasse apartment she shared with Kandinsky, was similarly inspired by the force of a visual impression. Münter has explained that on one of the first warm days of the year, Klee, who lived just a few houses away, paid a call dressed in white slacks. As he sat in Münter's big armchair talking to Kandinsky, the artist was suddenly struck by the pure picturesqueness of the rectangle that his torso and long white legs made with her chair and the picture on the wall behind. Unnoticed by the two men, she quickly sketched the scene in a notebook and this became the "study" for the painting.[18]

It was Münter, not Kandinsky, who first began to collect local examples of Bavarian glass painting, incorporating them as quota-

22. Münter, *Boat Ride*, 1910. Milwaukee Art Center Collection, Gift of Mrs. Harry Lynde Bradley (*Bradley Family Foundation, Inc.*).

tions in her own work and then, with growing seriousness, imitating their brilliant colors and thick black lines. One of the local Murnau artists, Heinrich Rambold, demonstrated the ancient technique for Münter, and she and Kandinsky each tried painting with pure colors on the back side of plates of glass: the results were lambent and liberating. Comparison of their efforts bears out the difference in preferred vantagepoints already noted, with Münter interested in simplification rather than scope, patternization rather than diversity. She was not, apparently, tak-

ing the same route toward Expressionism as was Kandinsky.

If in fact Münter's preference for closer focus and bold planar simplification (features she shared with Modersohn-Becker) is close to any of the Blue Rider visitors at Murnau, it is to Jawlensky. Only familiarity with Jawlensky's regular saw-tooth application of paint aids us in distinguishing some of his Murnau landscapes from ones by Münter. The heavy black contour separating planes of luminous color is a hallmark of both artists during this early period of Expressionism; because of her previous work in woodcuts, Münter may have realized her stressed silhouette approach slightly before Jawlensky. At any rate she certainly took umbrage when, some four decades later, a German critic reviewed her work as that of a typical student of Jawlensky. In a heavy pen script quivering with indignation she set the record straight in a letter addressed to the critic, dated November 20, 1953:

Just now I ran across by chance your review of the exhibition of the Munich Art Association. In it you called me a typical student of Jawlensky. Surely you would like to know that one should rather call me a student of Kandinsky, *if this would not be misleading too* [italics mine]. In 1902 I entered the Munich Phalanx School where Kandinsky held classes in still life, portraiture, landscape, and an evening class in life-drawing. He soon gave up considering me as a student because he saw and appreciated the individuality in my work. With Jawlensky we spent a lot of time from 1908–11.... Jawlensky, our amiable colleague, stimulated me a lot through his own efforts and his theorizing and his appreciative enthusiasm for my studies.... At that time a truly fruitful work relationship existed between the three of us. Some of Kandinsky's studies moved in a similar direction to my own and also to Jawlensky's. Later we went our individual ways. The meetings and the departures, working together and yet expressing your own ideas— all this does not get expressed when my person and my work are mentioned under the catchword "Jawlensky-student." Since you have given friend-

ly recognition to my work previously, this little historical reference will surely be welcomed by you.

<div align="right">Sincerely, G. Münter[14]</div>

Münter was seventy-six years old when she penned this "little historical reference!" Her anger is justifiable and points up the gratuitous limbo-of-influence to which women artists of the past have so frequently been assigned by shallow art criticism.

If we reexamine the—by definition—one-sided student-teacher notion in regard to Münter and Kandinsky, we see, as Kandinsky perceived quite early, that Münter was essentially her own teacher. Her progress from the streaky, textured multiplicity of the early heavy-impasto "Impressionism" practiced by both Kandinsky and herself during their sum-

23. Münter, *Flower Pots and Bird Cage,* colored paper collage, 1910. Private collection (*from Leonard Hutton,* An Exhibition of Unknown Work by Gabriele Münter: "Hinterglasmalerei").

mer trips through Europe before 1908 to the flatly rendered selectivity of her work after 1908 is astonishing, and yet still does not prepare us for the drastic reduction achieved in her cut colored paper collages of 1910 [23]— some thirty-seven years *before* Matisse's *Jazz* cutouts of 1947.

By 1910 the Murnau motifs handled in common by Münter and Kandinsky exhibit impressively different interests. Let us immerse ourselves for a moment, as they did for many summers, in just one of the most recurrent Murnau images: the village church [24], which could be seen clearly from the Russian House. Every day Münter and Kandinsky walked from the Russian House across the railroad tracks at the bottom of their garden and into town for supplies, passing the little white church with its onion-bulb steeple. For both of them, the flowers, trees, town buildings, and ever-present Alpine range became part of their pictorial impression of the church. And yet how very differently these

ingredients add up to make the same whole: Münter's *Sunflowers with Church*[15] [25] and Kandinsky's *Church in Murnau* [26], both painted in 1910. Münter's objects are firmly rooted to one swelling spot; Kandinsky contends with several gravities simultaneously. Münter is bulgy and full, where Kandinsky is space-streaked and airy. Münter regulates with rhythmic sweeps of the brush, while Kandinsky experiments with multiple strokes and pressures. Münter's giant sunflowers loom; Kandinsky's avenue of trees floats. Münter's church squats; Kandinsky's church flies. This is not a competition. Neither is it a battle between the sexes. We are contrasting not different genders, but different artists. And we are identifying quite different approaches to painting. The intimate versus the cosmos; the deliberately primitive versus the soaringly lyrical. These characteristics were the two different but equal routes toward Expressionism which Münter and Kandinsky chose to follow. "Different," as Kandinsky would have said, "from inner necessity."

There is no doubt that Kandinsky's sudden rejection of his Murnau companion for a Russian wife in 1917 severely afflicted Münter for many years.[16] Her European odyssey ended in 1931, when she returned at last to Murnau to retire permanently in the Russian House. She began painting again and produced woodcuts, lithographs, and etchings as well. A traveling retrospective of her works culled from five decades and including some sixty paintings and thirty graphics was shown in twenty-two German cities during the years 1949 to 1953. (The presence on the scene of art critic Adolf Hitler, who knew a German Expressionist when he saw one, accounts for Münter's lack of shows during most of the 1930s and 1940s.) During the 1950s her works were hung with increasing frequency in group shows of German Expressionism across Europe, and in 1957 Munich's Städtische Galerie celebrated her eightieth birthday with a retrospective exhibition. She outlived Kan-

24. Photograph of church in Murnau, 1976 (*Alessandra Comini*).

25. Münter, *Sunflowers with Church*, 1910. Private collection (*Alessandra Comini*).

dinsky by eighteen years and died a peaceful death in 1962, secure in the knowledge that she would be buried beside the white onion-bulbed church she had painted so often from her house. Today her grave can indeed be found next to the church, and if we look carefully we can just see the Russian House where so much future German Expressionism was nurtured by the warm Bavarian summer sun.

Not the least of the German Expressionist artists then was Gabriele Münter: pupil of Kandinsky, yes, but also a rare, copious talent in the bud. She takes her rightful place in the new history of modern art alongside Kollwitz and Modersohn-Becker. And in the future, when we think of German Expressionism, perhaps we shall not think, teach, and exhibit exclusively in terms of Munch, or Kirchner, or Kandinsky, but rather expand our scope to embrace the individual and fascinating qualities of Münter and her co-travelers, Kollwitz and Modersohn-Becker, in their different routes toward Expressionism.

26. Kandinsky, *Church in Murnau*, 1910. Munich, Städtische Galerie im Lenbachhaus (*Städtische Galerie*).

NOTES

1. See J. Diane Radycki, translator and annotator, *The Letters and Journals of Paula Modersohn-Becker,* Metuchen, N.J., 1980; and Gillian Perry, *Paula Modersohn-Becker: Her Life and Work,* New York, 1980.

2. The painting is reproduced in Perry, *Modersohn-Becker,* p.15, fig. 6.

3. Paula Modersohn-Becker, *Briefe und Tagebuchblätter,* Berlin, 1920, Appendix diary entry of Otto Modersohn for March 11, 1902, p. 249. (This and all following translations mine.)

4. *Ibid,* Appendix diary entry of Otto Modersohn for June 15, 1903, p. 250. With great faith in his wife's work, Otto added the following line: "Someday things will be different."

5. Hans Konrad Roethel, *Kandinsky,* New York, 1979, p. 168. This cursory treatment of Münter by Roethel is strange indeed in light of the fact that Roethel became the director of the Gabriele Münter Foundation. Earlier, in 1957, Roethel had been on hand in Munich as director of the Städtische Galerie im Lenbachhaus when Münter was wooed into donating to that institution the treasure trove she possessed of Kandinsky drawings, watercolors, prints, and paintings (numbering some 500 objects).

6. As reported by Johannes Eichner (Münter's biographer and lifelong companion after 1927) in *Kandinsky und Gabriele Münter: von Ursprüngen Moderner Kunst,* Munich, 1957, p. 42.

7. For relevant passages from Kandinsky letters to Münter written between the years 1903 and 1905, see Eichner, *Kandinsky und Gabriele Münter,* pp. 163–64. A fuller discussion of the Kandinsky-Münter correspondence is found in A. Comini, "State of the Field 1980: The Women Artists of German Expressionism," *Arts Magazine,* November 1980, pp. 147–53.

8. Eichner, *Kandinsky und Gabriele Münter,* p. 178.

9. Three of these photographs are reproduced in the excellent exhibition catalogue by Anne Mochon, *Gabriele Münter: Between Munich and Murnau,* Cambridge, Mass., 1980, p. 14. This informative catalogue accompanied the first Münter retrospective ever to be held in an American museum. Organized by Anne Mochon, the show opened at the Busch-Reisinger Museum in Cambridge (Sept. 25–Nov. 8, 1980) and then went on to the Princeton University Art Museum (Nov. 22, 1980–Jan. 18, 1981). The American gallery world recognized Münter's artistic importance much earlier. Pioneering Leonard Hutton has been a Münter champion since 1961, when his exhibition of forty-five of her works attracted the notice of *Time* magazine. He included nine of her works in his Blue Rider exhibit of 1963, and in 1966 presented a fifty-year retrospective of seventy-two paintings. In 1966–67 he showed forty-three of Münter's *Hinterglasmalerei,* as well as woodcuts, etchings, lithographs, and collages by her. On the West Coast, the Dalzell Hatfield Galleries of Los Angeles sponsored important Münter shows in 1960 and 1963.

10. Eichner, *Kandinsky und Gabriele Münter,* p. 38.

11. This opinion was formed during the Blue Rider years when Münter and Kandinsky were openly living together in the Munich Ainmillerstrasse 36 apartment. August Macke wrote Franz Marc in a letter dated September 1, 1911: "I am of the opinion that Kandinsky is so much the intellectual stimulus of her [Münter's] painting as well, that I can as little agree with her notion that she works altogether personally, as I can conceive of myself without powerful French influence"— Wolfgang Macke, ed., *August Macke-Franz Marc Briefwechsel,* Cologne, 1964, p. 70.

12. Kandinsky, manuscript written in German for a brochure published in Stockholm in 1916, "Om Konstnaeren," Blaue Reiter Archives, Städtische Galerie im Lenbachhaus, Munich; English trans. published in Leonard Hutton Galleries, *An Exhibition of Unknown Works by Gabriele Münter, "Hinterglasmalerei,"* exh. cat., New York, December 1966–January 1967, p. 13.

13. See Eichner, *Kandinsky und Gabriele Münter,* p. 155.

14. Copy of the original letter included in Brigitte Cole, "Gabriele Münter and the Development of Her Early Murnau Style," Master's thesis, Southern Methodist University, 1980, Appendix.

(Original is in the Gabriele Münter-Johannes Eichner Stiftung in the Städtische Galerie im Lenbachhaus, Munich.)

15. Cole points out the importance of Münter's title *Sunflowers with Church,* and not vice versa, in her detailed analysis of the painting, *ibid,* pp. 59–62.

16. Five years after Kandinsky married Nina Andreewsky, he wrote Münter a final "explanatory" letter, addressing his former common-law wife of fifteen years in the formal "Sie": "...our life together was a constant torture for both of us. We are both guilty, insofar as a person is guilty because his character is one way and not another. ...My guilt is that I broke my promise to marry you ['Sie'!] in a civil service....I had always hoped that we would meet one day in England in order to—as agreed upon—get married there and immediately get divorced...."—Letter of July 27, 1922, quoted in Eichner, *Kandinsky und Gabriele Münter,* p. 178. We may wonder how much comfort Münter found in this summary of their history. It certainly deserves a place among the Lesser Litanies of Literary Letdowns.

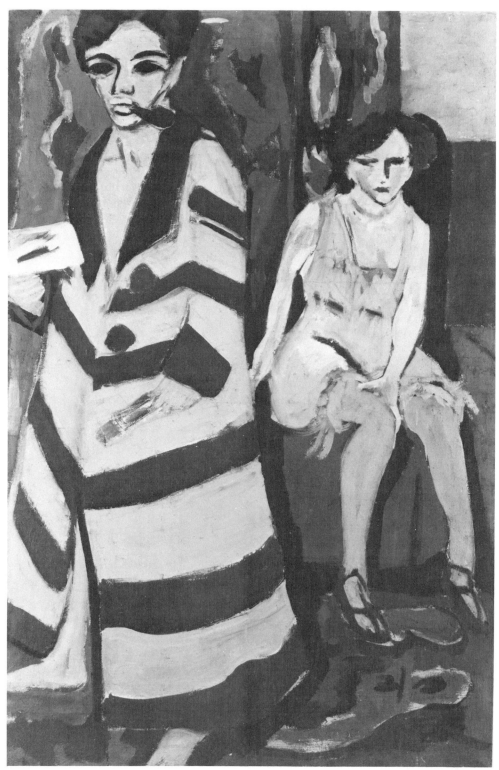

1. Ernst Ludwig Kirchner, *Self-Portrait with Model*, 1910. Hamburg, Kunsthalle (*Kunsthalle*).

15
Virility and Domination
in Early Twentieth-Century Vanguard Painting

—————————⊃⊱ ⊰⊂—————————

CAROL DUNCAN

In the decade before World War I, a number of European artists began painting pictures with a similar and distinctive content. In both imagery and style, these paintings forcefully assert the virile, vigorous and uninhibited sexual appetite of the artist. I am referring to the hundreds of pictures of nudes and women produced by the Fauves, Cubists, German Expressionists and other vanguard artists. As we shall see, these paintings often portray women as powerless, sexually subjugated beings. By portraying them thus, the artist makes visible his own claim as a sexually dominating presence, even if he himself does not appear in the picture.

This concern with virility—the need to assert it in one's art—is hardly unique to artists of this period. Much of what I am going to say here is equally relevant to later twentieth-century as well as some nineteenth-century art.[1] But the assertion of virility and sexual

domination appears with such force and frequency in the decade before World War I, and colors the work of so many different artists, that we must look there first to understand it. It is also relevant to ask whether these artists sought or achieved such relationships in reality, whether their lives contradict or accord with the claims of their art. But that is not the question I am asking here. My concern is with the nature and implications of those claims as they appear in the art and as they entered the mythology of vanguard culture. In this I am treating the artists in question not as unique individuals, but as men whose inner needs and desires were rooted in a shared historical experience— even if the language in which they expressed themselves was understood by only a handful of their contemporaries.

The material I explore inevitably touches on a larger issue—the role of avant-garde culture in our society. Avant-garde art has become the official art of our time. It occupies this place because, like any official art, it is ideologically useful. But to be so used, its meaning must be constantly and carefully

Carol Duncan, "Virility and Domination in Early 20th-Century Vanguard Painting," *Artforum,* December 1973, pp. 30–39. Revised by the author for this edition. By permission of the author and *Artforum,* copyright © 1973 *Artforum.*

mediated. That task is the specialty of art historians, who explain, defend and promote its value. The exhibitions, courses, articles, films and books produced by art historians not only keep vanguard art in view, they also limit and construct our experience of it.

In ever new ways, art history consistently stresses certain of its qualities. One idea in particular is always emphasized: that avant-garde art consists of so many moments of individual artistic freedom, a freedom evidenced in the artist's capacity for innovation. Accounts of modern art history are often exclusively, even obsessively, concerned with documenting and explicating evidence of innovation—the formal inventiveness of this or that work, the uniqueness of its iconography, its distinctive use of symbols or unconventional materials. The presence of innovation makes a work ideologically useful because it demonstrates the artist's individual freedom as an artist; and *that* freedom implies and comes to stand for human freedom in general. By celebrating artistic freedom, our cultural institutions "prove" that ours is a society in which all freedom is cherished and protected, since, in our society, all freedom is conceived as individual freedom. Thus vanguard paintings, as celebrated instances of freedom, function as icons of individualism, objects that silently turn the abstractions of liberal ideology into visible and concrete experience.

Early vanguard paintings, including many of the works I shall discuss, are especially revered as icons of this kind. According to all accounts, the decade before World War I was the heroic age of avant-garde art. In that period, the "old masters" of modernism—Picasso, Matisse, the Expressionists—created a new language and a new set of possibilities that became the foundation for all that is vital in later twentieth-century art. Accordingly, art history regards these first examples of vanguardism as preeminent emblems of freedom.

The essay that follows looks critically at this myth of the avant garde. In examining early vanguard painting, I shall be looking not for evidence of innovation (although there is plenty of that), but rather for what these works say about the social relations between the sexes. Once we raise this question—and it is a question that takes us outside the constructs of official art history—a most striking aspect of the avant garde immediately becomes visible: however innovative, the art produced by many of its early heroes hardly preaches freedom, at least not the universal human freedom it has come to symbolize. Nor are the values projected there necessarily "ours," let alone our highest. The paintings I shall look at speak not of universal aspirations but of the fantasies and fears of middle-class men living in a changing world. Because we are heirs to that world, because we still live its troubled social relations, the task of looking critically, not only at vanguard art but also at the mechanisms that mystify it, remains urgent.

I

Already in the late nineteenth century, European high culture was disposed to regard the male-female relationship as the central problem of human existence. The art and literature of the time is marked by an extraordinary preoccupation with the character of love and the nature of sexual desire. But while a progressive literature and theater gave expression to feminist voices, vanguard painting continued to be largely a male preserve. In Symbolist art, men alone proclaimed their deepest desires, thoughts and fears about the opposite sex. In the painting of Moreau, Gauguin, Munch and other end-of-the-century artists, the human predicament—what for Ibsen was a man-woman problem—was defined exclusively as a male predicament, the woman problem. As such, it was for men alone to resolve, transcend or cope with. Already there was an understanding that serious and

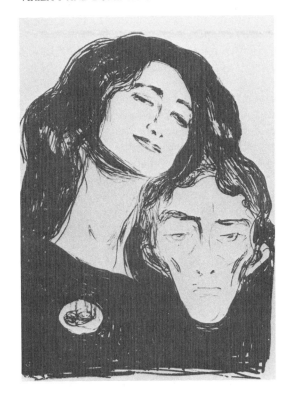

2. Edvard Munch, *Salome,* lithograph, 1903 (*Carol Duncan*).

profound art—and not simply erotic art—is likely to be about what men think of women.

Symbolist artists usually portrayed not women but one or two universal types of woman.[2] These types are often lethal to man. They are always more driven by instincts and closer to nature than man, more subject to its mysterious forces. They are often possessed by dark or enigmatic souls. They usually act out one or another archetypal myth—Eve, Salome, the Sphinx, the Madonna [2].

Young artists in the next avant-garde generation—those maturing around 1905—began rejecting these archetypes just as they dropped the muted colors, the langorous rhythms and the self-searching artist-types that Symbolism implied. The Symbolist artist, as he appears through his art, was a creature of dreams and barely perceptible intuitions, a refined, hypersensitive receiver of tiny sensations and cosmic vibrations. The new vanguardists, especially the Fauves and the Brücke, were youth and health cultists who liked noisy colors and wanted to paint their direct experience of mountains, flags, sunshine and naked girls. Above all, they wanted their art to communicate the immediacy of their own vivid feelings and sensations before the things of this world. In almost every detail, their images of nudes sharply contrast to the virgins and vampires of the 1890s. Yet these younger artists shared certain assumptions with the previous generation. They, too, believed that authentic art speaks of the central problems of existence, and they, too, defined Life in terms of a male situation—specifically the situation of the middle-class male struggling against the strictures of modern, bourgeois society.

Kirchner was the leader and most renowned member of the original Brücke, the group of young German artists who worked

and exhibited together in Dresden and then Berlin between 1905 and 1913. His *Girl Under a Japanese Umbrella* (ca. 1909) asserts the artistic and sexual ideals of this generation with characteristic boldness [3]. The artist seems to attack his subject, a naked woman, with barely controlled energy. His painterly gestures are large, spontaneous, sometimes vehement, and his colors intense, raw and strident. These features proclaim his unhesitant and uninhibited response to sexual and sensual experience. Leaning directly over his model, the artist fastens his attention mainly to her head, breasts and buttocks, the latter violently twisted toward him. The garish tints of the face, suggesting both primitive body paint and modern cosmetics, are repeated and magnified in the colorful burst of the exotic Japanese umbrella. Above the model is another Brücke painting, or perhaps a primi-

tive or Oriental work, in which crude shapes dance on a jungle-green ground.

Van Dongen's *Reclining Nude* (1905–06), a Fauve work, is similar in content [4]. Here, too, the artist reduces a woman to so much animal flesh, a headless body whose extremities trail off into ill-defined hands and feet. And here, too, the image reflects the no-nonsense sexuality of the artist. The artist's eye is a hyper-male lens that ruthlessly filters out everything irrelevant to the most basic genital urge. A lustful brush swiftly shapes the volume of a thigh, the mass of the belly, the fall of a breast.

Such images are almost exact inversions of the *femmes fatales* of the previous generation. Those vampires of the 1890s loom up over their male victims or viewers, fixing them with hypnotic stares. In Munch's paintings and prints, females engulf males with

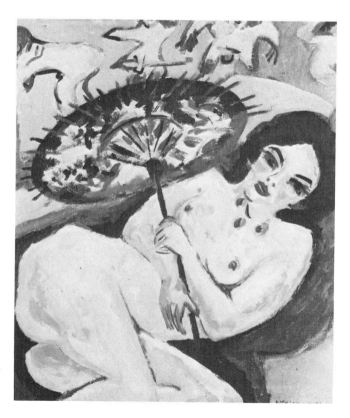

3. Kirchner, *Girl Under a Japanese Umbrella*, ca. 1909. Düsseldorf, Kunstsammlung Nordrhein-Westfalen (*Kunstsammlung*).

4. Kees Van Dongen, *Reclining Nude,*
1904–05. Monaco, private collection (*Carol Duncan*).

5. Munch, *Reclining Nude,* watercolor,
1905. Hamburg, Kunsthalle (*Carol Duncan*).

their steaming robes and hair. The male, whether depicted or simply understood as the viewer-artist, is passive, helpless or fearful before this irresistibly seductive force which threatens to absorb his very will. Now, in these nudes by Kirchner and Van Dongen, the artist reverses the relationship and stands above the supine woman. Reduced to flesh, she is sprawled powerlessly before him, her body contorted according to the dictates of his erotic will. Instead of the consuming *femme fatale,* one sees an obedient animal. The artist, in asserting his own sexual will, has annihilated all that is human in his opponent. In doing so, he also limits his own possibilities. Like conquered animals, these women seem incapable of recognizing in him anything beyond a sexually demanding and controlling presence. The assertion of that presence—the assertion of the artist's sexual domination—is in large part what these paintings are about.

In the new century, even Munch felt the need to see himself thus reflected. His *Reclining Nude* [5], a watercolor of 1905, is a remarkable reversal of his earlier *femmes fa-*

tales. Both literally and symbolically, Munch has laid low those powerful spirits along with the anxieties they created in him. This nude, her head buried in her arms, lies at his disposal, while he explores and translates into free, unrestrained touches the impact of thighs, belly and breasts on his senses and feelings.

Most images of female nudity imply the presence (in the artist and/or the viewer) of a male sexual appetite. What distinguishes these pictures and others in this period from most previous nudes is the compulsion with which women are reduced to objects of pure flesh, and the lengths to which the artist goes in denying their humanity. Not all nudes from this decade are as brutal as Van Don-

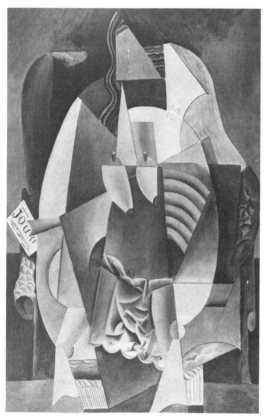

6. Pablo Picasso, *Woman in an Armchair,* 1913. New York, Collection Mr. and Mrs. Victor W. Ganz (*Carol Duncan*).

gen's, but the same dehumanizing approach is affirmed again and again. Nudes by Braque, Manguin, Puy and other Fauves are among scores of such images. They also occur in the work of such artists as Jules Pascin, the Belgian Realist Rik Wouters and the Swiss Félix Vallotton (*The Sleep,* 1908). *Nude in a Hammock* (1912), by Othon Friesz, is a Cubistic version of this same basic type of sleeping or faceless nude. So is Picasso's more formalistically radical *Woman in an Armchair* (1913) [6], where all the wit and virtuoso manipulation of form are lavished only upon the body, its literally hanging breasts, the suggestive folds of its underwear, etc. Indeed, Picasso's Cubist paintings maintain the same distinction between men and women as other artists of this decade did—only more relentlessly; many of these other artists painted portraits of women as authentic people in addition to nudes. Max Kozloff observed the striking difference between Picasso's depictions of men and women in the Cubist period:

The import of *Girl With a Mandolin* perhaps becomes clearer if it is compared with such contemporary male subjects as Picasso's *Portrait of Ambroise Vollard.* The artist hardly ever creates the image of a woman as portrait during this period. He reserved the mode almost entirely for men. . . . In other words, a woman can be typed, shown as a nude body or abstracted almost out of recognition, as in *Ma Jolie,* where the gender of the subject plays hardly any role, but she is not accorded the particularity and, it should be added, the dignity of one-to-one, formalized contact furnished by a portrait. More significant is the fact that Vollard is presented as an individual of phenomenal power and massive, ennobled presence, while the female type often gangles like a simian, is cantilevered uncomfortably in space, or is given bowed appendages.[3]

The artistic output of the Brücke abounded in images of powerless women. In Heckel's *Nude on a Sofa* (1909) [7] and his *Crystal Day* (1913) [8], women exist only in reference to— or rather, as witnesses to—the artist's frank

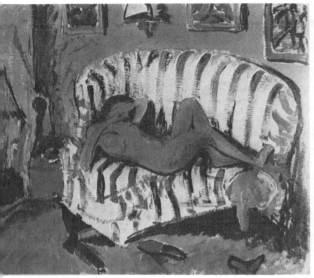

7. Erich Heckel, *Nude on a Sofa,* 1909. Munich, Bayerischen Staatsgemäldesammlungen (*Carol Duncan*).

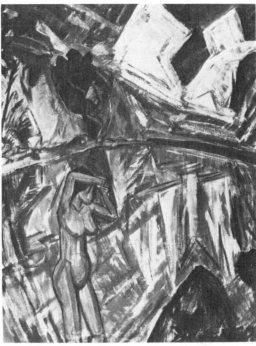

8. Heckel, *Crystal Day,* 1913. Berlin, private collection (*Carol Duncan*).

sexual interests. In one, the woman is sprawled in a disheveled setting; in the other, she is knee-deep in water—in the passive, arms-up, exhibitionist pose that occurs so frequently in the art of this period. The nude in *Crystal Day* is literally without features (although her nipples are meticulously detailed), while the figure in the other work covers her face, a combination of bodily self-offering and spiritual self-defacement that characterizes these male assertions of sexual power. In Kirchner's *Tower Room, Self-Portrait with Erna* (1913) [9], another faceless nude stands obediently before the artist, whose intense desire may be read in the erect and flaming object before him. In a less strident voice, Manguin's *Nude* (1905) [10] makes the same point. In the mirror behind the bed, the nude is visible a second time, and now one sees the tall, commanding figure of the artist standing above her.

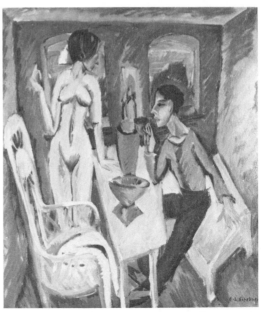

9. Kirchner, *Tower Room, Self-Portrait with Erna,* 1913. Columbus, Ohio, Collection Dr. and Mrs. Howard D. Sirak (*Collection Dr. and Mrs. Howard D. Sirak*).

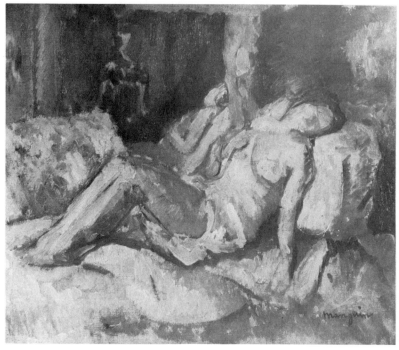

10

The artists of this decade were obsessed with such confrontations. In a curious woodcut, published as *The Brothel* (ca. 1906) [11], the French Fauve Vlaminck played with the tension inherent in that confrontation. What activates the three women in this print is not clear, but the central nude raises her arms in ambiguous gesture, suggesting both protest and self-defense. In either case, the movement is well contained in the upper portion of the print and does not prevent the artist from freely seizing the proffered, voluptuous body. Evidently, he has enjoyed the struggle and purposely leaves traces of it in the final image.

Matisse's painting of these years revolves around this kind of contest almost exclusively, exploring its tensions and seeking its resolution. Rarely does he indulge in the open, sexual boasting of these other artists. Matisse is more *galant,* more bourgeois. A look, an expression, a hint of personality often mitigate the insistent fact of passive, available flesh. In

the nice, funny face of *The Gypsy* (1905–06), one senses some human involvement on the part of the artist, even as he bent the lines of the model's face to rhyme with the shape of her breasts. Matisse is also more willing to admit his own intimidation before the nude. In *Carmelina* (1903) [12], a powerfully built model coolly stares him down—or, rather, into—a small corner of the mirror behind her. The image in that mirror, the little Matisse beneath the awesome Carmelina, makes none of the overt sexual claims of Manguin's *Nude* [10] or Kirchner's *Tower Room* [9]. But the artful Matisse has more subtle weapons. From his corner of the mirror, he blazes forth in brilliant red—the only red in this somber composition—fully alert and at the controls. The artist, if not the man, masters the situation—and also Carmelina, whose dominant role as a *femme fatale* is reversed by the mirror image. Nor is the assertion of virility direct and open in other paintings by Matisse, where the models sleep or lack faces. Ex-

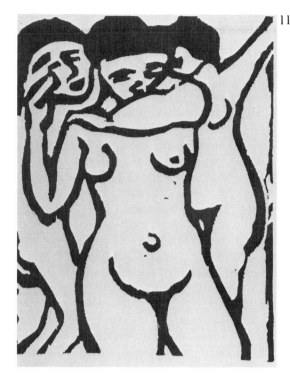

11

10. Henri-Charles Manguin, *Nude,* 1905. Paris, Collection Mme Lucile Manguin (*Carol Duncan*).

11. Maurice Vlaminck, *The Brothel,* woodcut, ca. 1906. Zurich, Collection Dr. Sigmond Pollag (*Carol Duncan*).

12. Henri Matisse, *Carmelina,* 1903. Boston, Museum of Fine Arts, Tompkins Collection, Arthur Gordon Tompkins Residuary Fund (*Museum of Fine Arts*).

treme reductions and distortions of form and color, all highly deliberated, self-evident "aesthetic" choices, transpose the sexual conflict onto the "higher" plane of art. Again, the assertion of virility becomes sublimated, metamorphosed into a demonstration of artistic control, and all evidence of aggression is obliterated. As he wrote in "Notes of a Painter" (1908), "I try to put serenity into my pictures. . . ."[4]

The vogue for virility in early twentieth-century art is but one aspect of a total social, cultural and economic situation that women artists had to overcome. It was, however, a particularly pernicious aspect. As an ethos communicated in a hundred insidious ways, but never overtly, it effectively alienated women from the collective, mutually supportive endeavor that was the avant garde. (Gertrude Stein, independently wealthy and, as a lesbian, sexually unavailable to men, is the grand exception.) Like most of their male counterparts, women artists came primarily

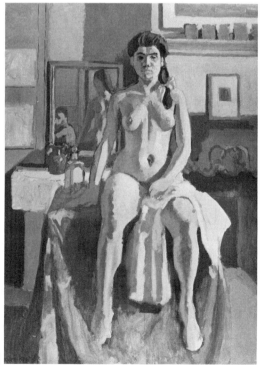

12

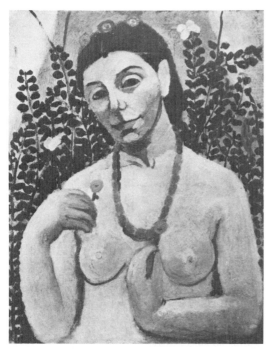

13. Paula Modersohn-Becker, *Self-Portrait,* 1906. Basel, Kunstmuseum (*Carol Duncan*).

from the middle classes. It is hardly conceivable that they would flaunt a desire for purely physical sex, even in private and even if they were capable of thinking it. To do so would result in social suicide and would require breaking deeply internalized taboos. In any case, it was not sexuality per se that was valued, but male sexuality. The problem for women—and the main thrust of women's emancipation—was not to invert the existing social-sexual order, not to replace it with the domination of women; the new woman was struggling for her own autonomy as a psychological, social and political being. Her problem was also the woman problem. Her task was also to master her own image.

Accordingly, the German artist Paula Modersohn-Becker confronted female nudity—her own—in a *Self-Portrait* of 1906 [13]. Fashioned out of the same Post-Impressionist heritage as Brücke art and Fauvism, this picture

is startling to see next to the defaced beings her fellow artists so often devised. Above the naked female flesh are the detailed features of a powerful and determined human being. Rare is the image of a naked woman whose head so outweighs her body. Rare, that is, in male art. Suzanne Valadon, Sonia Delaunay-Terk and other women of this period often painted fully human female beings, young and old, naked and clothed. Among male artists, only Manet in the *Olympia* comes close. But there the image-viewer relationship is socially specified. Olympia is literally flesh for sale, and in that context, her self-assertiveness appears willful and brash—a contradiction to the usual modesty of the nude. As a comment on bourgeois male-female relationships, the *Olympia* is both subversive and antisexist; it is, however, consciously posed as male experience and aimed, with deadly accuracy, at the smug and sexist male bourgeoisie. Modersohn-Becker, on the other hand, is addressing herself, not as commodity and not even as an artist but as a woman. Her effort is to resolve the contradiction Manet so brilliantly posed, to put herself back together as a fully conscious and fully sexual human being. To attempt this, with grace and strength to boot, speaks of profound humanism and conviction, even while the generalized treatment of the body and its constrained, hesitant gestures admit the difficulty.

II

Earlier, I suggested that the powerless, defaced nude of the twentieth century is an inversion of the Symbolist *femme fatale.* Beneath this apparent opposition, however, is the same supporting structure of thought.[5] In the new imagery, woman is still treated as a universal type, and this type, like the Sphinxes and Eves of the previous generation, is depicted as a being essentially different from man. In the eyes of both generations of artists, woman's mode of existence—her rela-

tionship to nature and to culture—is categorically different from man's. More dominated by the processes of human reproduction than men, and, by situation, more involved in nurturing tasks, she appears to be more *of nature* than man, less in opposition to it both physically and mentally. As the anthropologist Sherry Ortner has argued, men see themselves more closely identified with culture, "the means by which humanity transcends the givens of natural existence, bends them to its purposes, controls them in its interests." Man/culture tends to be one term in a dichotomy of which woman/nature is the other: "Even if woman is not equated with nature, she is still seen as representing a lower order of being, less transcendental of nature than men."[6]

However different from the Symbolists, these younger artists continued to regard confrontations with women as real or symbolic confrontations with nature. Not surprisingly, the nude-in-nature theme, so important to nineteenth-century artists, continued to haunt them. And like the older artists, they, too, imagined women as more at home there than men. Placid, naked women appear as natural features of the landscape in such works as Heckel's *Crystal Day* [8], Friesz's *Nude in a Hammock* and numerous bathers by Vlaminck, Derain, Mueller, Pechstein and other artists. The bacchante or the possessed, frenzied dancer is the active variant of the bather and frequently appears in the art of this period. Nolde's *Dancers with Candles* (1912) and Derain's *The Dance* (ca. 1905) equally represent women as a race apart from men, controlled by nature rather than in control of it.

Myths cultivated by artists would seem to contradict this dichotomy. Since the nineteenth century, it was fashionable for male artists to claim a unique capacity to respond to the realm of nature. But while they claimed for themselves a special intuition or imagination, a "feminine principle," as they often called it, they could not recognize in women a "masculine principle." The pictures of women produced in this epoch affirm this difference as much as Symbolist art. Women are depicted with none of the sense of self, none of the transcendent, spiritual autonomy that the men themselves experienced (and that Modersohn-Becker so insisted upon). The headless, faceless nudes, the dreamy looks of Gauguin's girls, the glaring mask of Kirchner's *Girl Under a Japanese Umbrella* [3], the somnambulism of the *femmes fatales*—all of these equally deny the presence of a human consciousness that knows itself as separate from and opposed to the natural and biological world.

The dichotomy that identifies women with nature and men with culture is one of the most ancient ideas ever devised by men and appears with greater or lesser strength in virtually all cultures. However, beginning in the eighteenth century, Western bourgeois culture increasingly recognized the real and important role of women in domestic, economic and social life. While the basic sexual dichotomy was maintained and people still insisted on the difference between male and female spheres, women's greater participation in culture was acknowledged. In the nineteenth century the bourgeoisie educated their daughters more than ever before, depended on their social and economic cooperation and valued their human companionship.

What is striking—and for modern Western culture unusual—about so many nineteenth- and twentieth-century vanguard nudes is the absoluteness with which women were pushed back to the extremity of the nature side of the dichotomy, and the insistence with which they were ranked in total opposition to all that is civilized and human. In this light, the attachment of vanguard artists to classical and biblical themes and their quest for folk and ethnographic material takes on special meaning. These ancient and primitive cultural materials enabled them to reassert the

woman/nature–man/culture dichotomy in its harshest forms. In Eve, Salome, the Orpheus myth and the primitive dancer, they found Woman as they wanted to see her—an alien, amoral creature of passion and instinct, an antagonist to rather than a builder of human culture. The vanguard protested modern bourgeois male-female relationships; but that protest, as it was expressed in these themes, must be recognized as culturally regressive and historically reactionary. The point needs to be emphasized only because we are told so often that vanguard tradition embodies our most progressive, liberal ideals.

The two generations of artists also shared a deep ambivalence toward the realm of woman/nature. The Symbolists were at once attracted to and repelled by its claims on them. Munch's art of the nineties is in large part a protest against this male predicament. From his island of consciousness, he surveys the surrounding world of woman/nature with both dread and desire. In paintings by Gauguin, Hodler and Klimt (especially his "Life and Death" series), woman's closeness to nature, her effortless biological cooperation with it, is enviable and inviting. She beckons one to enter a poetic, non-rational mode of experience—that side of life that advanced bourgeois civilization suppresses. Yet, while the realm of woman is valued, it is valued *as* an alien experience. The artist contemplates it, but prefers to remain outside, with all the consciousness of the outside world. For to enter it fully means not only loss of social identity, but also loss of autonomy and of the power to control one's world.

The same ambivalence marks the twentieth-century work I have been discussing, especially the many paintings of nudes in nature. In these images, too, the realm of woman/nature invites the male to escape rationalized experience and to know the world through his senses, instincts or imagination. Yet here, too, while the painter contemplates his own excited feelings, he hesitates to enter

that woman/nature realm of unconscious flesh, to imagine himself *there*. He prefers to know his instincts through the objects of his desire. Rarely do these artists depict naked men in nature. When they do, they are almost never inactive. To be sure, there are some naked, idle males in Kirchner's bathing scenes, but they are clearly uncomfortable and self-conscious-looking. More commonly, figures of men in nature are clothed, both literally and metaphorically, with social identities and cultural projects. They are shepherds, hunters, artists. Even in Fauve or Brücke bathing scenes where naked males appear, they are modern men going swimming. Unlike the female bather, they actively engage in culturally defined recreation, located in historical time and space. Nowhere do these men enter nature—and leave culture—on the same terms as women. Now as in the 1890s, to enter that world naked and inactive is to sink into a state of female powerlessness and anonymity.

Matisse's *Joy of Life* (*Bonheur de vivre*) of 1905–06 seems to be an exception [14]. In this sun-drenched fantasy, all the figures relate to nature, to each other and to their own bodies in harmony and freedom. No one bends to a force outside oneself. Yet, even in this Arcadia, Matisse hesitates to admit men. Except for the shepherd, all the figures with visible sexual characteristics are women. Maleness is suggested rather than explicitly stated. Nor is the woman/nature–man/culture dichotomy absent: culturally defined activities (music-making and animal husbandry) are male endeavors, while women simply exist as sensual beings or abandon themselves to spontaneous and artless self-expression.

No painting of this decade better articulates the male-female dichotomy and the ambivalence men experience before it than Picasso's *Demoiselles d'Avignon* of 1905–06 [15]. What is so remarkable about this work is the way it manifests the structural foundation underlying both the *femme fatale* and the

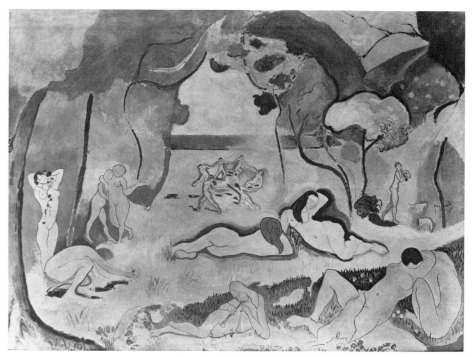

14. Matisse, *Joy of Life (Bonheur de vivre)*, 1905–06. Merion, Pennsylvania, The Barnes Foundation (*Copyright 1982 The Barnes Foundation*).

new, primitive woman. Picasso did not merely combine these into one horrible image; he dredged up from his psyche the terrifying and fascinating beast that gave birth to both of them. The *Demoiselles* prismatically mirrors her many opposing faces: whore and deity, decadent and savage, tempting and repelling, awesome and obscene, looming and crouching, masked and naked, threatening and powerless. In that jungle-brothel is womankind in all her past and present metamorphoses, concealing and revealing herself before the male. With sham and real reverence, Picasso presents her in the form of a desecrated icon already slashed and torn to bits.

If the *Demoiselles* is haunted by the nudes of Ingres, Delacroix, Cézanne and others,[7] it is because they, too, proceed from this Goddess-beast and because Picasso used them as beacons by which to excavate its root form. The quotations from ancient and non-Western art serve the same purpose. The *Demoiselles* pursues and recapitulates the Western European history of the woman/nature phantom back to her historical and primal sisters in Egypt, ancient Europe and Africa in order to reveal their oneness. Only in primitive art is woman as sub- and superhuman as this.[8] Many later works by Picasso, Miró or de Kooning would recall this primal mother-whore. But no other modern work reveals more of the rock foundation of sexist antihumanism or goes further and deeper to justify and celebrate the domination of woman by man.

Although few of Picasso's vanguard contemporaries could bear the full impact of the *Demoiselles* (Picasso himself would never again go quite as far), they upheld its essential meaning. They, too, advocated the otherness of woman, and asserted with all their artistic might the old idea that culture in its

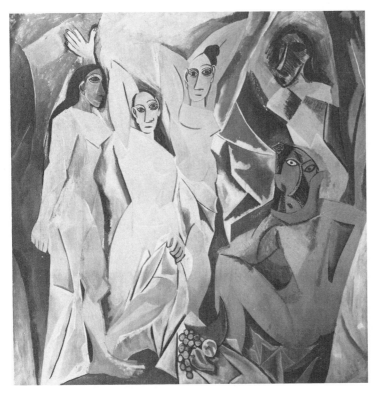

15. Picasso, *Les Demoiselles d'Avignon,* 1906-07. New York, The Museum of Modern Art, Lillie P. Bliss Bequest (*Museum of Modern Art*).

highest sense is an inherently male endeavor. Moreover, with Picasso, they perpetuated it in a distinctly modern form, refining and distilling it to a pure essence: from this decade dates the notion that the wellsprings of authentic art are fed by the streams of male libidinous energy. Certainly artists and critics did not consciously expound this idea. But there was no need to argue an assumption so deeply felt, so little questioned and so frequently demonstrated in art. I refer not merely to the assumption that erotic art is oriented to the male sexual appetite, but to the expectation that significant and vital content in *all* art presupposes the presence of male erotic energy.

The nudes of the period announce it with the most directness; but landscapes and other subjects might confirm it as well, especially when the artist invokes aggressive and bold feeling, when he "seizes" his subject with decisiveness, or demonstrates other supposedly masculine qualities. Vlaminck, although primarily a landscape painter, could still identify his paintbrush with his penis: "I try to paint with my heart and my loins, not bothering with style."[9] But the celebration of male sexual drives was more forcefully expressed in images of women. More than any other theme, the nude could demonstrate that art originates in and is sustained by male erotic energy. This is why so many "seminal" works of the period are nudes. When an artist had some new or major artistic statement to make, when he wanted to authenticate to himself or others his identity as an artist, or when he wanted to get back to "basics," he turned to the nude. The presence of small nude figures in so many landscapes and studio interiors—settings that might seem sufficient in themselves for a painting—also attests to the primal erotic motive of the artist's creative urge.

Kirchner's *Naked Girl Behind a Curtain*

16. Matisse, *The Red Studio*, 1911. New York, The Museum of Modern Art, Mrs. Simon Guggenheim Fund (*Museum of Modern Art*).

(dated 1907) makes just this connection with its juxtaposition of a nude, a work of primitive art and what appears to be a modern Brücke painting. The *Demoiselles,* with its many references to art of varied cultures, states the thesis with even more documentation. And, from the civilized walls of Matisse's *Red Studio* (1911) [16] comes the same idea, now softly whispered. There, eight of the eleven recognizable art objects represent female nudes. These literally surround another canvas, *The Young Sailor* (1906), as tough and "male" a character as Matisse ever painted. Next to the *Sailor* and forming the

vertical axis of the painting is a tall, phallic grandfather clock. The same configuration—a macho male surrounded by a group of nude women—also appears in the preparatory drawings for the *Demoiselles,* where a fully clothed sailor is encircled by a group of posing and posturing nudes. Picasso eventually deleted him but retained his red drinking vessel (on the foreground table) and made its erect spout a pivotal point in the composition.[10] Another phallocentric composition is Kirchner's much-reproduced *Self-Portrait with Model* (1907) [1]. In the center, Kirchner himself brandishes a large, thick, red-tipped

paintbrush at groin level, while behind him cringes a girl wearing only lingerie.

That such content—the linking of art and male sexuality—should appear in painting at precisely the moment when Freud was developing its theoretical and scientific base indicates not the source of these ideas but the common ground from which both artist and scientist sprang. By justifying scientifically the source of creativity in male sexuality,[11] Freud acted in concert with young, avant-garde artists, giving new ideological shape and force to traditional sexist biases. The reason for this cross-cultural cooperation is not difficult to find. The same era that produced Freud, Picasso and D. H. Lawrence—the era that took Nietzsche's superman to heart— was also defending itself from the first significant feminist challenge in history (the suffragist movement was then at its height). Never before had technological and social conditions been so favorable to the idea of extending democratic and liberal-humanistic ideals to women. Never before were so many women and men declaring the female sex to be the human equals of men, culturally, politically and individually. The intensified and often desperate reassertions of male cultural supremacy that permeate so much early twentieth-century culture, as illustrated in the vanguard's cult of the penis, are both responses to and attempts to deny the new possibilities history was unfolding. They were born in the midst of this critical moment of male-female history, and as such, gave voice to one of the most reactionary phases in the history of modern sexism.

Certainly the sexist reaction was not the only force shaping art in the early twentieth century. But without acknowledging its presence and the still uncharted shock waves that feminism sent through the feelings and imaginations of men and women, these paintings lose much of their urgency and meaning. Moreover, those other historical and cultural forces affecting art, the ones we already know

something about—industrialization, anarchism, the legacy of past art, the quest for freer and more self-expressive forms, primitivism, the dynamics of avant-garde art-politics itself, and so on—our understanding of these must inevitably be qualified as we learn more about their relationship to feminism and the sexist reaction.

Indeed, these more familiar issues often become rationalizations for the presence of sexism in art. In the literature of twentieth-century art, the sexist bias, itself unmentionable, is covered up and silently approved by the insistence on these other meanings. Our view of it is blocked by innocent-sounding generalizations about an artist's formal courageousness, his creative prowess or his progressive, humanistic values. But while we are told about the universal, genderless aspirations of art, a deeper level of consciousness, fed directly by the powerful images themselves, comprehends that this "general" truth arises from male experience alone. We are also taught to keep such suspicions suppressed, thus preserving the illusion that the "real" meanings of art are universal, beyond the interests of any one class or sex. In this way we have been schooled to cherish vanguardism as the embodiment of "our" most progressive values.

III

Our understanding of the social meanings of the art I have been considering—what these artists imply about society and their relationship to it—especially needs reevaluation. Much avant-garde painting of the early twentieth century is seen as a continuation of the nineteenth-century traditions of Romantic and Realist protest. Most of the artists whose names appear here were indeed heirs to this tradition and its central theme of liberation. Like others before them, they wished for a world in which man might live, think and feel, not according to the dictates of ra-

tionalized, capitalist society, but according to his own needs as an emotionally and sensually free human being.

The Fauves and the Brücke artists especially associated themselves with the cause of liberation, although in different national contexts. The French artistic bohemia in which the Fauves matured enjoyed a long tradition of sympathy and identification with vanguard politics.[12] In the first decade of the century, the anarchist ideas that so many Neo-Impressionists had rallied to in the previous generation were still nurtured. (Picasso, too, moved in anarchist circles in Barcelona before he settled in Paris.) The heyday of the artist bomb-thrower was over, but the art-ideology of the avant garde still interpreted flamboyant, unconventional styles of art and behavior as expressions of anarchist sentiments. The young Fauves understood this, and most of them enjoyed (at least for a time) being publicized as wild anarchists out to tear down the establishment. Germany, on the other hand, more recently organized as a modern, bourgeois state, had only begun to see artist-activists; traditionally, dissident German artists and intellectuals withdrew from society and sought solace in transcendental philosophies. In accord with this tradition, Brücke artists were programatically more hostile to cities than the Fauves, and more fervent nature-lovers.[13] They were also more organized and cohesive as a group. In a Dresden shop, they established a communal studio where they worked and lived together in what we would call today an alternative lifestyle. Yet, however distinct from the Fauves, they embraced many of the same ideals. At the outset, they announced their opposition to the rationalism and authoritarianism of modern industrial life. The banner they waved was for free, individual self-expression and the rehabilitation of the flesh.

The two groups shared both an optimism about the future of society and the conviction that art and artists had a role to play in the creation of a new and freer world. For them, as for so many of their vanguard contemporaries and successors, the mission of art was liberation—individual, not political. Liberal idealists at heart, they believed that artists could effect change simply by existing as individual authentic artists. In their eyes, to exercise and express one's unfettered instinctual powers was to strike a blow against, to subvert, the established order. The idea was to awaken, liberate and unleash in others creative-instinctual desires by holding up visions of reality born of liberated consciousness. That only an educated, leisured and relatively non-oppressed few were prepared to respond to their necessarily unconventional and avant-garde language was generally ignored.

The artist, then, exemplified the liberated individual *par excellence,* and the content of his art defined the nature of liberated experience itself. Such ideas were already present in the nineteenth century, but in that decade before World War I, young European painters took to them with new energy and excitement. More than anything else, the art of this decade depicts and glorifies what is unique in the life of the artist—his studio, his vanguard friends, his special perceptions of nature, the streets he walked, the cafés he frequented. Collectively, early vanguard art defines a new artist type: the earthy but poetic male, whose life is organized around his instinctual needs. Although he owes much to the nineteenth century, he is more consciously anti-intellectual—more hostile to reason and theory—and more aggressive than any of his predecessors. The new artist not only paints with heart and loins, he seizes the world with them and wrenches it out of shape. And he not only experiences his instinctual nature with more intensity than those trapped in the conventional guilt-ridden world; his bohemian life offers him more opportunities to gratify his purely physical needs.

According to the paintings of the period, sexually cooperative women are everywhere

available in the artist's environment, especially in his studio. Although they were sometimes depicted as professional models posing for their hourly wage, they usually appear as personal possessions of the artist, part of his specific studio and objects of his particular gratification. Indeed, pictures of studios, the *inner sanctum* of the art world, reinforce more than any other genre the *social* expectation that "the artist" is categorically a male who is more consciously in touch with his libido than other men and satisfies its purely physical demands more frequently. The nudes of Van Dongen, Kirchner and Modigliani often read as blatant pre- or postcoital personal experiences, and, according to much Brücke art, that communal studio in Dresden was overrun by naked, idle girls.

However selective these views of bohemia are, some social reality filters in—enough to identify the nameless, faceless women who congregate there in such numbers and offer their bodies with such total submission. Their social identity is precisely their availability as sex objects. We see them through the eyes of the artist, and the artist, despite his unconventional means, looked at them with the same eyes and the same class prejudices as other bourgeois men. Whatever the class situation of the actual models, they appear in these pictures as lower-class women who live off their bodies. Unlike generalized, classical nudes, they recline in the specified studio of the artist and take off contemporary—and often shabby—clothes. The audience of that time would instantly recognize in them the whole population of tarty, interchangeable and *socially* faceless women who are produced in quantity in modern, industrialized societies: mistresses of poor artists drawn from the hand-to-mouth street world of bohemia, whores, models (usually semi-professional whores), and an assortment of low-life entertainers and bar-flies. Whatever their dubious callings, they are not presented as respectable middle-class women. Indeed,

17. André Derain, *Woman in Chemise*, 1906. Copenhagen, Statens Museum for Kunst (*Carol Duncan*).

by emphasizing their lower-class identity, by celebrating them as mere sexual objects, these artists forcefully reject the modesty and sexual inhibitedness of middle-class women as well as the social demands their position entitles them to make. Thus the "liberated" artist defined his liberation by stressing the social plight of his models and his own willingness to exploit them sexually.

For, despite the antibourgeois stance of these artists and their quest for a liberated vision, they rarely saw the social oppression before them, particularly that yoke which the bourgeoisie imposed upon womankind at large and on poor women in particular. The women that Toulouse-Lautrec painted and sketched were surely no better off socially than the women in these pictures. But where he could look through class differences and sordid situations, and still see sympathetic human beings, these young men usually saw

only sexually available objects. Usually but not always. Two paintings of the same cabaret dancer, painted by Derain and Vlaminck on the same day, make a significant contrast. The woman in Derain's work, *Woman in Chemise* (1906) [17], looks uncomfortable and unsure of herself before the gaze of the artist. Her awkward, bony body is self-consciously drawn together, and a red, ungainly hand, exaggerated by the artist, hovers nervously at her side. The artist's social superiority and the model's shabbiness are acknowledged, but not enjoyed or celebrated. Despite her dyed hair and make-up, the woman is seen as an authentic subjective presence who commands serious attention, unbeautiful but human. In Vlaminck's *Dancer at the "Rat Mort"* (1906) [18], the same woman in the same pose is a brassy, inviting tart, a mascara-eyed sexual challenge. Set against a pointillist burst of color—those dots that were so beloved by the previous generation of anarchists—she is all black stockings, red hair, white flesh and a cool, come-on look. Vlaminck, the avowed anarchist, is as thrilled by her tawdry allure as any bourgeois out for an evening of low life.

The socially radical claims of a Vlaminck, a Van Dongen or a Kirchner are thus contradicted. According to their paintings, the liberation of the artist means the domination of others; his freedom requires their unfreedom. Far from contesting the established social order, the male-female relationship that these paintings imply—the drastic reduction of women to objects of specialized male interests—embodies on a sexual level the basic class relationships of capitalist society. In fact, such images are splendid metaphors for what the wealthy collectors who eventually acquired them did to those beneath them in the social as well as the sexual hierarchy.

However, if the artist is willing to regard women as merely a means to his own ends, if he exploits them to achieve his boast of virility, he in his turn must merchandise and sell

himself, or an illusion of himself and his intimate life, on the open avant-garde market. He must promote (or get dealers and critic friends to promote) the value of his special credo, the authenticity of his special vision, and—most importantly—the genuineness of his antibourgeois antagonism. Ultimately, he must be dependent on and serve the pleasure of the very bourgeois world (or enlightened segments of it) that his art and life appear to contest.[14] Here he lives a moral-social contradiction that is the corollary to his psychological dilemma before the sphere of woman/nature. The artist wants to but cannot escape the real world of rationalized bourgeois society. He is as tied to it economically as he is bound within its cultural and psychological constructs.

The enlightened art collector who purchased these works, then as now, entered a

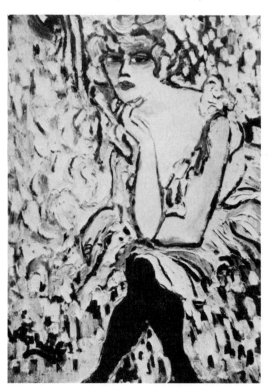

18. Vlaminck, *Dancer at the "Rat Mort,"* 1906. Paris, private collection (*Carol Duncan*).

complex relationship with both the object he purchased and the artist who made it. On the most obvious level, he acquired ownership of a unique and—if he had taste—valuable and even beautiful object. He also probably enjoyed giving support and encouragement to the artist, whose idealism he might genuinely admire. At the same time, he purchased a special service from the artist, one that is peculiarly modern. In the sixteenth, seventeenth and eighteenth centuries, the wealthy patron often owned outright both the object he purchased and its erotic content. Frequently he specified its subject and even designated its model, whose services he might also own. The work bore witness not to the artist's sexual fantasies or libertine lifestyle (the artist could hardly afford such luxuries), but to the patron's. The erotic works commissioned by famous eighteenth-century courtesans were equally addressed to their male benefactors. In these twentieth-century images of nudes, however, the willfully assertive presence of the artist stands between the patron and the erotic situation represented. It is clearly the artist's life situation that is depicted; it is for him that these women disrobe and recline. And the image itself, rendered in a deliberately individual and spontaneous style, is saturated with the artist's unique personality. The collector, in fact, is acquiring or sharing another man's sexual-aesthetic experience. His relationship to the nude is mediated by another man's virility, much to the benefit of his own sense of sexual identity and superiority. For these nudes are not merely high-culture versions of pornography or popular erotica. Often distorted and bestial, they are not always very erotic, and they may appeal to homosexual males as much as to heterosexuals. They are more about power than pleasure.

The relationship between the collector and the artist may be read in the monographs that art historians and connoisseurs so often write about painters of nudes. These usually praise the artist's frank eroticism, his forthright honesty and his healthy, down-to-earth sensuality. Often there are allusions to his correspondingly free sex life. The better writers give close and detailed analyses of individual works, reliving the artist's experience before the nude. At some point, higher, more significant meanings are invoked, things about the human condition, freedom, art and creativity—or, if the writer is a formalist, about the artist's coloristic advances, his stylistic precocity or his technical innovations. It is the moment of rationalization, the moment to back away and put abstractions between oneself and the real content of the paintings.

The collector could enjoy the same closeness to and the same distance from that content. What ensues in that collapsing and expanding space is a symbolic transference of male sexual mana from bohemian to bourgeois and also from lower to upper classes. The process began with the artist, who adopted or cultivated the aggressive, presumably unsocialized sexual stance of the sailor or laborer. The content of his art—his choice of nameless, lower-class women and his purely physical approach to them—established the illusion of his non-bourgeois sexual character. In acquiring or admiring such images, the respectable bourgeois identifies himself with this stance. Consciously or unconsciously, he affirms to himself and others the naked fact of male domination and sees that fact sanctified in the ritual of high culture. Without risking the dangers that such behavior on his own part would bring, he can appropriate the artist's experience and still live peacefully at home. For he cannot afford, and probably does not want, to treat his wife as an object. He needs and values her social cooperation and emotional presence, and to have these, he must respect her body and soul.

What the painting on the wall meant to that wife can only be imagined. A Van Dongen or a Kirchner was scandalous stuff, and few matrons were prepared to accept such

works on their aesthetic merits. But no doubt there were women who, proud of their modernity, could value them as emblems of their own progressive attitudes and daring lack of prudery. Finally, we can speculate that some women, frightened by suffragist and emancipation movements, needed to reaffirm—not

contest—their situation. The nude on the wall, however uncomfortable it may have been in some respects, could be reassuring to the wife as well as the husband. Although it condoned libertinism, it also drew a veil over the deeper question of emancipation and the frightening thought of freedom.

NOTES

1. See my "Esthetics of Power," *Heresies,* 1 (1977), pp. 46–50.

2. For the iconography of late nineteenth-century painting, I consulted A. Comini, "Vampires, Virgins and Voyeurs in Imperial Vienna," in *Woman as Sex Object,* ed. L. Nochlin, New York, 1972, pp. 206–21; M. Kingsbury, "The Femme Fatale and Her Sisters," in *ibid.,* pp. 182–205; R. A. Heller, "The Iconography of Edvard Munch's *Sphinx,*" *Artforum,* January 1970, pp. 56–62; and W. Anderson, *Gauguin's Paradise Lost,* New York, 1971.

3. M. Kozloff, *Cubism and Futurism,* New York, 1973, p. 91.

4. Matisse, in H. Chipp, *Theories of Modern Art,* Berkeley, Los Angeles, London, 1970, pp. 132–33.

5. S. Ortner, "Is Female to Male as Nature Is to Culture?" *Feminist Studies,* Fall 1972, pp. 5–31.

6. *Ibid.,* p. 10.

7. R. Rosenblum, "The 'Demoiselles d'Avignon' Revisited," *Art News,* April 1973, pp. 45–48.

8. The crouching woman at the lower right, especially as Picasso rendered her in preparatory studies, is a familiar figure in primitive and archaic art. See Douglas Fraser, "The Heraldic Woman: A Study in Diffusion," *The Many Faces of Primitive Art,* ed. D. Fraser, Englewood Cliffs, N.J., 1966, pp. 36–99. Anyone familiar with these symmetrical, knees-up, legs-spread figures can have little doubt that Picasso's woman was inspired by one of them. Grotesque deities with complex meanings,

they are often in the act of childbirth, and in primitive villages they frequently occupied the place above the door to the men's lodge, the center of culture and power. Often, they were meant to frighten enemies and were considered dangerous to look at. They surely functioned ideologically, reinforcing views of women as the "other." Picasso intuitively grasped their meaning.

9. Vlaminck, in Chipp, *Theories,* p. 144.

10. Leo Steinberg discusses the phallic meaning of this object in "The Philosophical Brothel, Part I," *Art News,* September 1972, pp. 25–26. The juxtaposition of the phallus and the squatting nude especially recalls the self-displaying figures Fraser studies (see note 8), since they were sometimes flanked by phalli.

11. Philip Rieff, *Freud: The Mind of the Moralist,* New York, 1959, Ch. 5.

12. F. Nora, "The Neo-Impressionist Avant-garde," in *Avant-garde Art,* New York, 1968, pp. 53–63; and E. Oppler, *Fauvism Re-examined,* New York and London, 1976, pp. 183–95.

13. B. Myers, *The German Expressionists,* New York, 1957; and C. S. Kessler, "Sun Worship and Anxiety: Nature, Nakedness and Nihilism in German Expressionist Painting," *Magazine of Art,* November 1952, pp. 304–12.

14. R. Poggioli, "The Artist in the Modern World," in M. Albrecht, J. Barnett, and M. Griff, eds., *The Sociology of Art and Literature: A Reader,* New York, 1970, pp. 669–86.

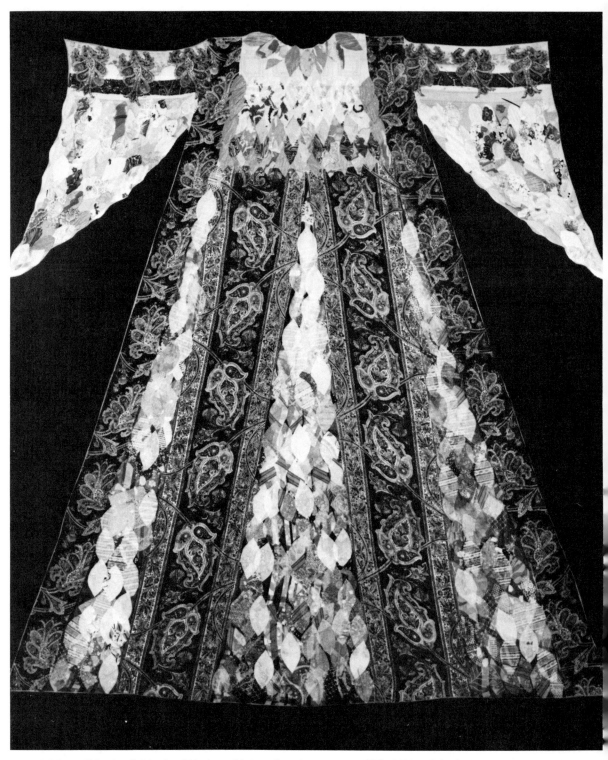

1. Miriam Schapiro, *Paisley/Leaf Vestiture*, fabric and acrylic on canvas, 1979 (*Miriam Schapiro*).

16

Miriam Schapiro and "Femmage": Reflections on the Conflict Between Decoration and Abstraction in Twentieth-Century Art

——————⇒╀ ╀⇐——————

Norma Broude

As art in the twentieth century became increasingly abstract, artists and critics struggled to create a clear distinction between the abstract and the "merely" decorative. In order to define and maintain the position of abstract art as "high" art, its supporters and apologists have been obliged literally to fight off the taint of association with so-called low art, variously defined as the decorative and often domestic handicraft productions of commercial artists, women, peasants and savages. The literature of modern art abounds with pompous—and sometimes overtly sexist—assertions of this supposed dichotomy. An example is the statement made in 1918 by Le Corbusier and Amédée Ozenfant: "There is a hierarchy in the arts: decorative art at the bottom, and the human form at the top. Because we are men!"[1]

Norma Broude, "Miriam Schapiro and 'Femmage': Reflections on the Conflict Between Decoration and Abstraction in Twentieth-Century Art," *Arts Magazine*, February 1980, pp. 83–87; reprinted in *Miriam Schapiro, A Retrospective: 1953–1980*, exhibition catalogue, Wooster, Ohio, The College of Wooster, 1980, pp. 32–38. By permission of *Arts Magazine*.

But despite such efforts to deny or to circumvent the connection, art historians of late have become increasingly aware of the crucial role that decorative art and decorative impulses have played in the formation and emergence of some of the major modernist styles of the early twentieth century. It is now generally recognized, for example, that Art Nouveau and the Jugendstil arts and crafts movement, with their basis in late nineteenth-century Symbolist thought, acted as important liberating catalysts for major artists like Henri Matisse and Wassily Kandinsky, as well as for that entire segment of twentieth-century art which seeks to convey content and meaning through abstract and non-objective forms.[2] It is to this tradition, I would suggest, that many of our most important feminist artists today are heir. Among the strongest, in my view, is Miriam Schapiro [1], and it is her work that provides the immediate inspiration for these reflections. Schapiro's feminist art was born, in part, in reaction to the 1950s and 1960s formalist dialectic of the New York School. But in rejecting the stifling rhetoric of Greenbergian reductivism,

Schapiro was not setting herself apart from the mainstream of modernism. Instead, she was resuming, on a far more meaningful level, an essential dialogue with that tradition. It is instructive to compare her work and ideological motivation with that of artists like Matisse and Kandinsky—earlier artists in our century who grappled with the lure and the stigma of "decoration"—not only so that we may reintegrate her work with the broader tradition that surely supports it, but so that we may recognize more fully the ways in which feminism and feminist art are now enriching and extending that vital modernist tradition.

Around the turn of the century, Art Nouveau and the international arts and crafts movement created a climate for young artists in Europe that nurtured and, in the view of some art historians, made almost inevitable the emergence of abstraction. Wassily Kandinsky arrived in Munich in 1896 during the first flowering of the Jugendstil decorative style. By 1904, he had become an active member of the Society for Applied Art and a close friend of such prime movers in the German arts and crafts movement as Peter Behrens, director of the Düsseldorf Arts and Crafts School, and Hermann Obrist. Obrist, a

prominent artist-designer, had exhibited a group of monumental embroideries, of his own design though not of his own hand, in a Munich gallery in 1896, thereby attracting international attention and striking an important early blow at traditional distinctions between the crafts and the fine arts [2].[3]

Kandinsky, too, was directly engaged in the decorative arts and crafts, designing items as diverse as dresses and handbags, jewelry, furniture and embroidered wall hangings [3 and 4].[4] It was the woodcut, however, then still regarded as a "craft" activity, that served—in the words of the Kandinsky scholar Peg Weiss—"as the bridge over which Kandinsky was able to *advance* [italics mine] from 'decorative' art to abstraction." For woodcuts, as Weiss explains, were not only "decorative"; they were "significant": "They were capable of suggesting profound meaning in much the same way as poetry, by means of a condensed image."[5]

The decorative crafts, then, combined with the prevailing Jugendstil taste for curvilinear design, encouraged Kandinsky's early experiments with pattern and plane, and eventually led him, as a painter, in the direction of total abstraction. Yet Kandinsky was always careful to maintain a clear distinction between these two poles of his activity, relegating the

2. Hermann Obrist, *Cyclamen Wall Hanging: The Whiplash*, 1895. Munich, Münchner Stadtmuseum (*Münchner Stadtmuseum*).

3

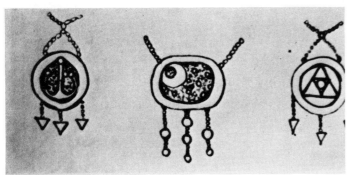

4 4

decorative arts, through a series of sophistic theoretical manipulations, to a clearly lower plane. In his book *Über das Geistige in der Kunst (Concerning the Spiritual in Art)*, Kandinsky wrote in 1912:

If we begin at once to break the bonds that bind us to nature and to devote ourselves purely to combinations of pure color and independent form, we shall produce works which are mere geometric decoration, resembling something like a necktie or a carpet. Beauty of form and color is no sufficient aim by itself.... The nerve vibrations are there (as we feel when confronted by applied art), but they get no further than the nerves because the corresponding vibrations of the spirit which they call forth are weak.[6]

To be art, then, according to Kandinsky, nonrepresentational forms had to have meaning. They had to call forth "vibrations of the spirit," or risk deterioration into what he called "mere decoration." As Peg Weiss again has put it, in support of this cardinal distinction of the modernist litany: "It was [Kandinsky's] particular genius to transform the merely decorative into the significantly abstract, and *Jugendstil* marked the way."[7]

For Henri Matisse, too, the path toward abstraction was marked, in part, by the deco-

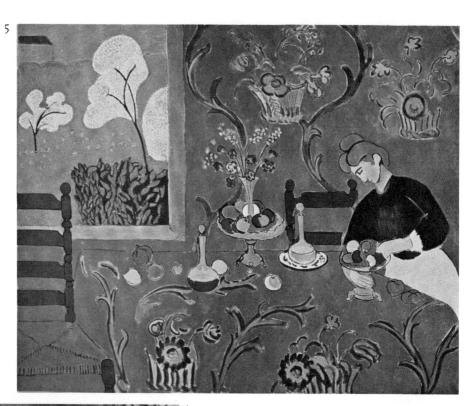

5. Henri Matisse, *Harmony in Red,* 1908-09. Moscow, Museum of Western Art (*after A. Barr, Jr.,* Matisse, *1951, p. 345*).

6. Victor Horta, Tassel House, Brussels, interior, 1892–93 (*Bildarchiv Foto Marburg*).

rative crafts and by Art Nouveau. Frank Anderson Trapp has already pointed to similarities in taste and character between Art Nouveau interiors and many of Matisse's paintings of interiors during the years around 1910 [5 and 6]. And he has related Matisse's enduring taste for curvilinear rhythms, all-over patterns and decorative arrangements of flattened shapes to the character of the fabrics, tapestries and embroidered wall hangings that were designed by artists associated with the international arts and crafts movement around the turn of the century.[8] The continuing appeal of the decorative arts for Matisse is evidenced by his frequent use of decorative objects, like rugs, screens and tapestries, as motifs in his paintings throughout his career [7], and also by his recurring interest in large, decorative mural paintings (e.g., the Shchukin murals, 1909–10, and the Barnes murals, 1931–33). It is made manifest particularly in his late work by the cut and pasted paper compositions that were specifically intended for a variety of decorative purposes. At first he used the technique as a study aid and on a small scale, to design posters, tapestries, rugs, covers for exhibit catalogues, periodicals and the like. Gradually, he extricated the technique from its utilitarian origins; and in the cut and pasted paper mural decorations of his last years, he established it as a valid "high art" medium in its own right [8].

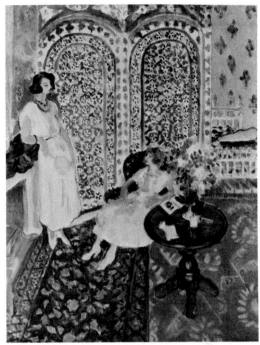

7. Matisse, *The Moorish Screen,* 1922. Philadelphia Museum of Art, Lisa Norris Elkins Bequest (*Philadelphia Museum of Art*).

8. Matisse, *Large Composition with Masks,* paper on canvas, 139¼ x 392¼ inches, 1953. Washington, D.C., National Gallery of Art, Ailsa Mellon Bruce Fund (*National Gallery*).

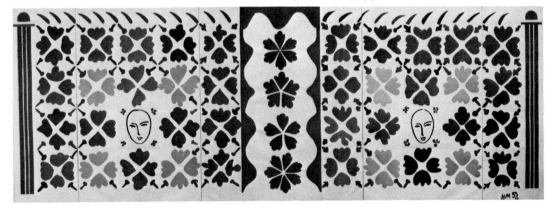

Like Kandinsky, then, Matisse was an artist who learned and borrowed from the decorative arts. He did so, however, without ever really raising them from their lowly status, and without ever allowing his own stature to be diminished because of his association with them. For in the works of both these artists, the influences of decoration are submerged and transformed by virtue of their placement within another context, through translation into the traditional high art methods and materials of paint on canvas or—in the case of Matisse's late works—cut and pasted papers that might imitate the look but never the materials or procedures of the despised and lowly crafts. Both of these major twentieth-century artists borrowed from the decorative and applied arts in order to create yet another form of high art, a form which by virtue of its very existence serves to reaffirm the separate and inferior status of its source.

Like Kandinsky, and like so many of the male artists of our century who have gravitated instinctively toward the decorative, Matisse too has sought to excuse and to justify his tastes by creating around them a dialectic that artificially supports the high art versus low art distinction. In the case of Matisse, however, it must be admitted that critics and historians have been far more responsible than the artist himself for establishing this approach. They have worked heroically to raise Matisse's art from the "merely decorative" to the "significantly abstract," a difficult and heroic task indeed if one considers that Matisse was the artist who said: "What I seek above all is expression"—but then went on to limit the range of that expression to an art that would act as "a soothing, calming influence on the mind, something like a good armchair," in which the tired businessman might rest his mind and spirit after his day's exertions.[9] The levels of absurdity that have been reached in critical attempts to deliver Matisse from the stigma of decoration are illustrated by the circumlocutions set to paper in 1952 and 1961 by Clement Greenberg in order to arrive at the conclusion that Matisse's cutouts are "more truly pictorial than decorative, in spite of the fact that Matisse intended several of them to serve mainly decorative ends."[10] Or the more recent but no less forced attempt by John Russell to make of Matisse's art something suitably problematic. "One of the more demanding of human activities," he wrote, "is to look long and concentratedly at a major painting by Henri Matisse," for that painting, he says, is "likely to be dense and complex beyond all elucidation."[11]

Let us turn now, not only for contrast but also for continuity, to the feminist art of Miriam Schapiro and, in particular, to her recent work with "femmage." "Femmage" is the witty and apt term that Schapiro has devised as a variant on "collage." "Collage" is defined by her and by her collaborator, Melissa Meyer, as "pictures assembled from assorted materials." It is a high art term, a word, they say, that was "invented in the twentieth century to describe an activity with an ancient history." As "femmage," this activity has been practiced for centuries by women, who used traditional craft techniques like sewing, piecing, hooking, quilting and appliquéing. The extensive use of fabric swatches, patchwork and embroidery, as both formal and iconographical elements in Schapiro's femmage, is part of her conscious effort to reestablish her connections with this older and—from the feminist point of view—more authentic tradition with which she, as an artist, identifies [9].[12]

Like Matisse and Kandinsky before her, Schapiro has taken the product of craft and transported it, through contextual change, into the realm of high art. But with one crucial difference. For when Schapiro incorporates craft into a high art context, as in the etchings from her suite, "Anonymous Was a Woman" [10 and 11], she does not treat her

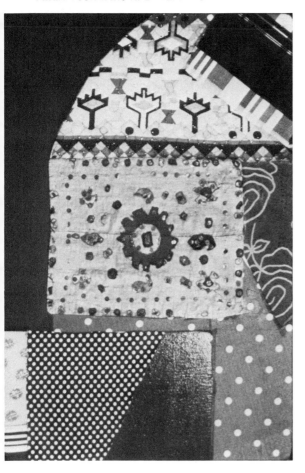
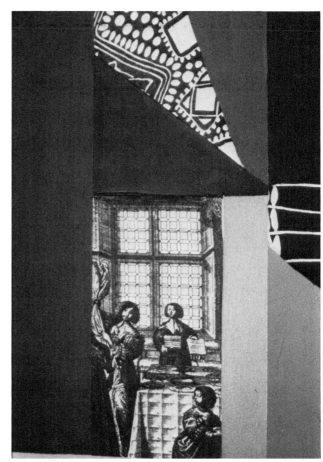

9. Schapiro, *Anatomy of a Kimono,* three details, fabric and acrylic on canvas, 1976. Zurich, Collection Bruno Bischofberger (*Miriam Schapiro*).

10. Schapiro, *Anonymous Was a Woman: Bread*, etching, 1977 (*D. James Dee*).

11. Schapiro, *Anonymous Was a Woman: Collar*, etching, 1977 (*Miriam Schapiro*).

sources as borrowings to be transformed. Unlike Matisse and Kandinsky, she does not transform her materials in an effort to efface their original character. Rather, she *reveals* them—perhaps fully for the first time—as objects of aesthetic value and expressive significance. What more powerful and meaningful embodiment of the human spirit (to borrow the language of Kandinsky) might we ask for than these artifacts, which express not only the lives and skills and tastes of women but also their undauntable will to create?[13] It is this that Schapiro reveals to us through femmage and through her joyous collaboration in her work with other women, women who are or who have been artists, both within the mainstream of art history and in the craft traditions outside of it. In "Notes from a Conversation on Art, Feminism and Work," Schapiro has said:

In my paintings—and less directly in my lecturing, teaching, organizing and publishing—I try to acknowledge and to underscore the realities of women's lives. In a new series of collages, I have glued in a painting by Mary Cassatt. I collaborate with women out of the past, as I do with the women I actually work with, to bring women's experience to the world.[14]

While such a collaborative dialogue is not an unfamiliar strategy in the history of twentieth-century art, its feminist aim and effect now, in Schapiro's art, are wholly new. For the spirit of celebration and continuity with which Miriam Schapiro approached her collaboration with Mary Cassatt [12] is very different indeed from the mocking, and ultimately competitive, nihilism with which Marcel Duchamp approached his "collaboration" with Leonardo da Vinci [13].

It is this positive spirit, then, of collaboration and revelation that marks and defines Schapiro's feminist art, while it simultaneously presents us, on the art historical level, with an ironic paradox. For through this blatant, and therefore consciously politicized, display of the despised and decorative products of the women's handicraft tradition, Schapiro has inadvertently and unavoidably separated her works from that tradition, allying them to some extent with the modernist mainstream. She does this, in essence, by satisfying the mainstream's demand for significance. For surely—to borrow once again the language of the mainstream itself—the works of Miriam Schapiro, with their social and political as well as aesthetic message, surely these works are "significant abstractions" and not "mere decorations"!

12

13

12. Schapiro, *Collaboration Series: Me and Mary Cassatt,* watercolor and photo/fabric femmage, 1976. New York, Collection Dorothy Seiberling (*Miriam Schapiro*).

13. Marcel Duchamp, *L.H.O.O.Q.,* assisted readymade, 1919. New York, private collection (*after R. Lebel, Duchamp, 1959, pl. 90*).

When one looks comparatively at the works of Schapiro next to works by Kandinsky and Matisse in the same vein [14–18], their sometimes rigid and sterile exercises in transforming the "decorative" into the "meaningful" contrast sharply with the genuine meaning and the genuine content of her work. And this is further underscored on the formal level when one contrasts their relative timidity in handling the elements of decoration with the exploding vitality of Schapiro's fabrics and patterns, which she harmonizes within a lucid structural order. In a purely speculative vein, one wonders if this is not the kind of vision that earlier artists, like Matisse and Kandinsky, might also have reached out for, had they not been prevented from freely exploring their natural impulses by the sexual politics of a society that would undoubtedly have branded them as less than men—and less than artists—had they fully followed those instincts.

Of the two, it is certainly Matisse who came closest to an honest and constructive acceptance of his natural aesthetic bent. As early as 1908, Matisse had isolated and defined as his highest artistic goal what he called "a condensation of sensations"[15]—a

14

14. Kandinsky, *Succession,* oil on canvas, 1935. Washington, D.C., The Phillips Collection (*Phillips Collection*).

15. Matisse, maquettes for *Red Chasuble,* paper cutout, 50½ x 78¼ inches, ca. 1950. New York, Museum of Modern Art, Lillie P. Bliss Bequest (*Museum of Modern Art*).

16. Schapiro, *Anatomy of a Kimono,* ten panels, 80 inches x 52 feet, fabric and acrylic on canvas, 1976. Installation view at André Emmerich Gallery, New York, September 1976 (*Eeva-Inkeri*).

15

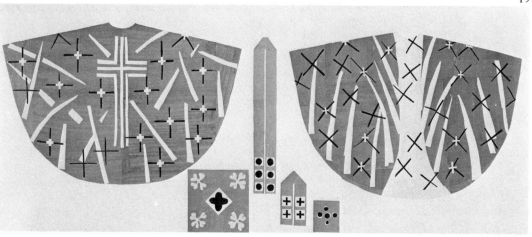

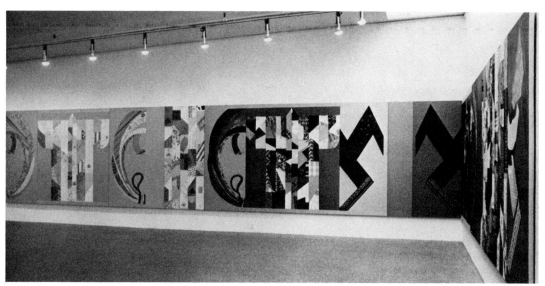

16

harmony, in essence, between those two traditional poles in Western cultural thought: the Dionysiac and the Apollonian, decoration and structure, sensation and thought, color and line. This polarization of values, which is fraught with ethical as well as artistic implications, has long been congenial to the French mind. It dates back to the *Poussinistes-Rubénistes* debates of the seventeenth-century French Academy, and persists, as Walter Friedlaender has noted, in the rivalries (e.g., Ingres versus Delacroix) and the alternating ascendancies in later French art of these opposing tendencies (e.g., the "femininity" of the Rococo succeeded by the "masculinity" of Neo-classicism).[16] In Matisse, this familiar French philosophical and aesthetic preoccupation has been restated and crystallized for the twentieth century in the work of a single artist, who, atypically, has attempted to achieve a reconciliation rather than a further polarization between these values: a critical balance between the sensory and the cerebral, which he acknowledges as two equally valid, rather than conflicting, demands of his artistic sensibility.

By aiming in his art for a "condensation of sensations," Matisse was pointing the way toward an aesthetic that would reject the traditional hierarchies of male as superior to female in our culture, while he was recognizing and affirming the natural and perhaps androgynous harmony between these two facets of which all of humanity is composed.

It is that conception of androgynous harmony that Miriam Schapiro's "femmage" most fully affirms. And nowhere in her work is that harmony better exemplified than in her monumental *Anatomy of a Kimono* [16], a 50-foot-wide painting/femmage, in which Schapiro uses scale—as Courbet used it for his *Burial at Ornans* and Monet for his *plein air Déjeuner sur l'herbe*—to precipitate ideological confrontation and to heroize that which has previously been categorized and dismissed as modest. The work, which consists of ten panels, takes as its principal motif the Japanese kimono, simple and stylized in form, yet exuberant and sensuous in surface patterning and texture. Three of them are flanked by the obi and the "kick" [17]—forms chosen by Schapiro because they satisfied, she said, her need for "two alternative forms," one that had to be "geometric," the

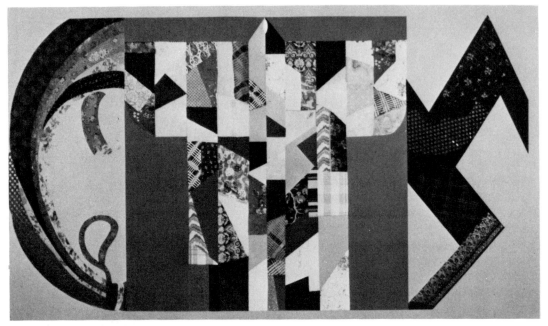

17. Schapiro, *Anatomy of a Kimono,* fabric and acrylic on canvas, 1976.
Detail: obi, kimono and kick.

other "curvilinear." The "Anatomy" section [18], in which the outline of the kimono is eliminated, is, in the artist's words, "the explosion of the fabrics themselves," followed at the far right by the final "kick," chosen to end the painting with a "red crescendo," so that it "would walk or strut its way into the 1980s." Originally, Schapiro had intended to address this statement only to women. But as she worked on it, its message changed and deepened for her. She wrote:

I wanted to speak directly to women—I chose the kimono as a ceremonial robe for the new woman. I wanted her to be dressed with the power of her own office, her inner strength . . . I wanted the robes to be clear, but also I wanted them to be a surrogate for me, for others. Later I remembered that men also wore kimonos, and so the piece eventually had an androgynous quality. Nice. The painting gave me a gift.[17]

It is in terms, then, of a dialogue with an older tradition of modernism, one that has its roots in both Symbolism and the decorative arts and crafts movements of the turn of the century, that the art of Miriam Schapiro is most properly understood. It is neither well served nor illuminated, in my view, by the short-sightedness of contemporary criticism, which insists upon classifying it with the work of a variety of other artists who nowadays describe their art as "decorative." These artists, who are all admittedly very different from one another, have nevertheless been packaged together in group exhibitions and critical analyses on the grounds that they "can all be said to work in a definite anti-Minimalist style"—an approach that echoes once again the swinging pendulum game of traditional aesthetic criticism.[18] These new "decorative" artists have been grouped together and distinguished, moreover, on the grounds that they all display an ability to invest the decorative with significant content, content that may be, but that is not necessarily, feminist in its orientation. As Jeff Perrone

puts it: "... the forms, which may strike us as neutralized, can be filled with any kind of meaning, for example, as reference to other decoration, as a feminist statement, as a diaristic accumulation of experience, as a pun on modernist painting, or even as a diagram of the 'fourth dimension.'"[19]

What is involved here, one feels, is a strange contradiction in terms. For such criticism merely engages us once again in the fruitless, and now dated, exercise of attempting to elevate the "decorative" to the "abstract" by endowing it with arcane and self-referential meanings. By so doing, of course, it continues to deny to the decorative the right to exist as art on its own terms. John Perreault seems inadvertently to fall into this same trap when he declares: "... there is obviously no good reason why a painting cannot

be both decorative and meaningful. The decorative is not necessarily the ornamental, and it may indeed have content."[20] Perreault has created here still another category, "the ornamental," which stands, one presumes, for what "the decorative" used to stand for, while the decorative has been redefined and elevated to the abstract. The unfortunate result of this semantic juggling is simply to preserve the old hierarchy of value and to reinforce the cultural bias that it reflects.

Such criticism continues to ignore and disguise the real nature of the aesthetic and ideological struggle that is at stake here, a struggle in which feminist art has played a central role. By finally exposing the sexist bias of the position that has assigned to the decorative a lowly status in twentieth-century art, Miriam Schapiro's "femmage" has ad-

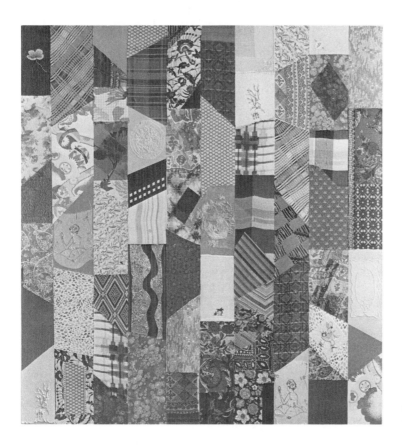

18. Schapiro, *Anatomy of a Kimono,* fabric and acrylic on canvas, 1976. Detail: "Anatomy" panel (*Kunié*).

dressed the real issue. Speaking in a language that is comprehensible to the mainstream, she has broken down the artificial barriers that sexism has raised between the decorative and the abstract in the art of our century. As a result, she may ultimately have cleared the path for the historical validation of the work of "decorative" artists, both male and female, in other periods as well as our own. Her own work, however, cannot be satisfactorily cate-

gorized with theirs. For feminist art, by definition—by virtue of its profound human, social and political significance—can never be "merely decorative." It is, ironically, the very *content* of Schapiro's art that may someday secure for other artists their right to be "merely decorative," and to produce a "high art" that is free to eschew significance other than the "merely" visual.

NOTES

Author's note: This essay grew out of a paper entitled "The Decorative versus the Abstract in Twentieth-Century Art: Questioning the Litanies," which was read at a joint session of the Women's Caucus for Art and the College Art Association of America, Washington, D.C., February 1979. My thanks go to Miriam Schapiro, who generously gave me access to her studio and to a variety of materials that have been invaluable to me in the final preparation of this essay. I am grateful, too, to my colleague, Mary D. Garrard, who read and discussed the original manuscript with me at several stages in its progress.

1. Le Corbusier (Charles Edouard Jeanneret) and Amédée Ozenfant, "On Cubism," 1918. For an eye-opening compendium that includes this as well as similar statements, see Valerie Jaudon and Joyce Kozloff, "Art Hysterical Notions of Progress and Culture," *Heresies: A Feminist Publication on Art and Politics,* no. 4, Winter 1978, pp. 38–42.

2. For the definitive statements of this position, see Frank Anderson Trapp, "Art Nouveau Aspects of Early Matisse," *Art Journal,* 26, no. 1, Fall 1966, pp. 2–8 (in particular, pp. 4–5); and Peg Weiss, "Kandinsky and the 'Jugendstil' Arts and Crafts Movement," *Burlington Magazine,* 117, no. 866, May 1975, pp. 270–79 (in particular, pp. 270, 279).

3. Weiss, *op. cit.,* pp. 270–71, and Mary Logan, "Hermann Obrist's Embroidered Decorations," *Studio,* 9, no. 44, November 1896, pp. 98–105 (cited by Weiss, *op. cit.,* p. 270, n. 3).

4. Weiss, *op. cit.,* pp. 271, 272, 275.

5. *Ibid.,* p. 279.

6. Wassily Kandinsky, *Concerning the Spiritual in Art,* New York, 1947, pp. 67–68.

7. Weiss, *op. cit.,* p. 279.

8. Trapp, *op. cit.,* pp. 6–8.

9. Henri Matisse, "Notes of a Painter" (1908), in *Matisse on Art,* ed. Jack Flam, London, 1973, p. 38.

10. Clement Greenberg, "*Partisan Review* 'Art Chronicle': 1952," in *Art and Culture,* Boston, 1961, pp. 148 and 148, note 1.

11. John Russell, "A Monumental Show of Matisse's Work," *The New York Times,* Sunday, Dec. 3, 1978, Section 2, p. 35.

12. See Melissa Meyer and Miriam Schapiro, "Waste Not/Want Not: Femmage," *Heresies: A Feminist Publication on Art and Politics,* no. 4, Winter 1978, pp. 66–69. For a brilliant and pioneering study of Schapiro's use of collage within a historical context, see Linda Nochlin, "Miriam Schapiro: Recent Work," *Arts Magazine,* 48, no. 2, November 1973, pp. 38–41 (revised and reprinted in *Miriam Schapiro: The Shrine, The Computer and The Dollhouse,* catalogue of an exhibition at the Mandeville Art Gallery, University of California, San Diego, April 1–27, 1975, pp. 2–7, and in *Miriam Schapiro, A Retrospective: 1953–1980,* exh. cat., Wooster, Ohio, The College of Wooster, 1980, pp. 19–24).

13. For a discussion of the overlooked sociological as well as aesthetic value of textiles and needlework, see Rachel Maines, "Fancywork: The Archaeology of Lives," *The Feminist Art Journal,* Winter 1974–75, pp. 1 and 3.

14. Miriam Schapiro, "Notes from a Conversation on Art, Feminism and Work," *Working It Out: Twenty-three Women Writers, Artists, Scientists and Scholars Talk About their Lives and Work,* eds. Sara Ruddick and Pamela Daniels, New York, 1977, p. 300.

15. Matisse, "Notes of a Painter," in Flam, *op. cit.,* p. 36.

16. Walter Friedlaender, *David to Delacroix,* trans. by Robert Goldwater, Cambridge, Mass., 1952, pp. 1–5.

17. All statements quoted here by Schapiro on the *Anatomy of a Kimono* come from her "How Did I Happen to Make the Painting *Anatomy of A Kimono?*" written on March 12, 1978, and published as a pamphlet by the Reed College Gallery, Portland, Oregon, in connection with its exhibition of the *Anatomy of a Kimono,* April 1–30, 1978.

18. See Jeff Perrone, "Approaching the Decorative" (review of "Ten Approaches to the Decorative," a show at the Allesandra Gallery, Sept. 25–Oct. 29, 1976), *Artforum,* 15, December 1976, p. 26. A more recent group exhibition of this type, which included Schapiro's work with that of seven other artists, was held in Brussels, at the Palais des Beaux-Arts, under the title *Patterning Painting* (catalogue with introductory essay by John Perreault), Jan. 19–Feb. 18, 1979. Perreault's insistence upon classifying Schapiro as a "pattern" painter—with "pattern" defined by him as "the systematic repetition of a motif or motifs used to cover a surface uniformly"—is an oversimplification that is easily disproved by looking closely at Schapiro's work. (See John Perreault, "Issues in Pattern Painting," *Artforum,* 16, no. 3, November 1977, p. 36.)

19. Perrone, "Approaching the Decorative," p. 26.

20. Perreault, "Issues in Pattern Painting," p. 34.

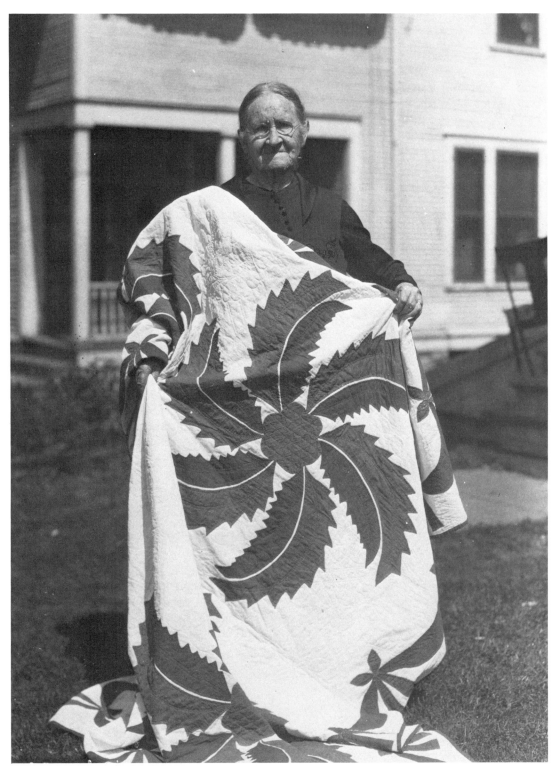

1. Woman and prize-winning quilt, Minnesota State Fair, 1926 (*Minnesota Historical Society*).

17

Quilts: The Great American Art

➤╪╪◅

PATRICIA MAINARDI

Flowers, Plants and Fishes
Beasts, Birds, Flyes and Bees
Hills, Dales, Plains, Pastures
Skies, Seas, Rivers, Trees
There's nothing near at hand or farthest sought
But with the needle may be wrought.
　　　　　　　　　　—From an old sampler[1]

Women have always made art. But for most women, the arts highest valued by male society have been closed to them for just that reason. They have put their creativity instead into the needlework arts, which exist in fantastic variety wherever there are women, and which in fact are a universal female art, transcending race, class and national borders. Needlework is the one art in which women controlled the education of their daughters, the production of the art, and were also the audience and critics. Needlework is therefore so important to women's culture that a study of the various textile and needlework arts should occupy the same position in Women's Studies that African art occupies in Black Studies—it is our cultural heritage. Because quilt making is so indisputably women's art, many of the issues women artists are attempting to clarify now—questions of feminine sensibility, of originality and tradition, of in-dividuality versus collectivity, of content and values in art—can be illuminated by a study of this art form, its relation to the lives of the artists, and how it has been dealt with in art history. The contrast between the utilitarian necessity of patching and quilting and the beautiful works of art which women made of it, and the contrast between the traditions of patchwork and quilting as brought to America and the quilts made here from colonial times to the present, give ample evidence that quilts are The Great American Art.

Although quilts had a functional purpose as bed coverings, they had another purpose equally important to their makers, and that is display. Early bedrooms frequently possessed only one piece of furniture, namely, the bed; and the quilt displayed on the bed was the central motif. Women exhibited their quilts, and still do, at state and county fairs, churches and grange halls, much as our contemporary "fine" art is exhibited in museums and with much the same results [1]. Good quilt makers were known and envied throughout their area, the exhibition of exceptionally fine craftswomanship and design

Patricia Mainardi, "Quilts: The Great American Art," *The Feminist Art Journal,* 2, no. 1, Winter 1973, pp. 1, 18-23; reprinted under the same title in an enlarged, illustrated edition published by Miles and Weir Ltd., San Pedro, Calif., 1978. By permission of the author, the publisher and *The Feminist Art Journal.*

influenced other women who returned home stimulated to do even finer work, and ideas of color and design were disseminated from one area to another causing recognizable historic and geographic trends [2].

Moreover, the women who made quilts knew and valued what they were doing: frequently quilts were signed and dated by the maker, listed in her will with specific instructions as to who should inherit them, and treated with all the care that a fine piece of art deserves. Women reserved their "best" quilt for guests of honor or special occasions, and when it was on the bed drew the curtains to prevent fading. Many of the most beautiful quilts were actually used so infrequently that they have come down to us without ever having been laundered. Women even made special "quilt cases" to store them in. Even in their choice of material women quilt makers behaved similarly to other artists. They wanted to use only the most permanent materials, and the popularity of two colors, indigo and turkey red (an alizarin dye), was the result of

their ability to withstand much use without fading.

In sharp contradiction to the truth about these women artists is the fabric of lies that has been spread over their work—the distortion of the purpose of the "quilting bee" into the false idea that quilts were "collective art" instead of the work of individual women, and, even more importantly, the lies about their anonymity. For example, the catalogue for the *American Pieced Quilts* exhibition at the Smithsonian Institution, Washington, D.C., bears a cover reproduction of a quilt signed "E. S. Reitz" in large letters, clearly visible. The quilt is identified in the catalogue as to title, place, date, material and size, *but the artist's name is not given*. Jonathan Holstein then dedicates the catalogue to "those anonymous women whose skilled hands and eyes created the American pieced quilt."[2] These women did not choose anonymity. Rather it has been forced on them. The great pains taken by art historians to identify all work of male artists, even if only by conjecture, cou-

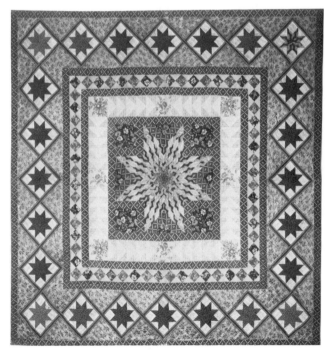

2. Sofonisba Anguissola Peale, *Star Medallion* or *Star of Bethlehem*, ca. 1850. Philadelphia Museum of Art (*Philadelphia Museum of Art*).

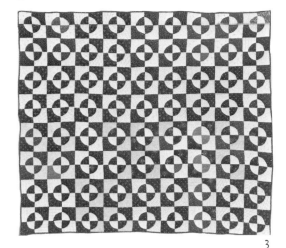

3

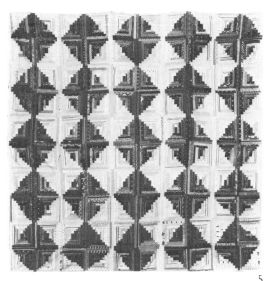

5

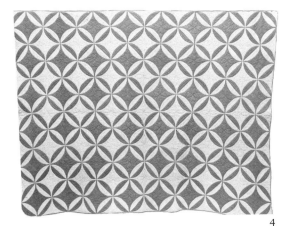

4

3. Elizabeth Ann Cline, *Steeplechase,* pieced quilt. Denver, Colorado, The Denver Art Museum (*Denver Art Museum*).

4. Unknown woman, *Robbing Peter to Pay Paul* (design also known as *Orange Peel*), red and white pieced quilt; quilting: hearts and ellipses, 19th century. New York, The Brooklyn Museum, Gift of Mrs. E. G. Bennett (*Brooklyn Museum*).

5. Unknown woman, *Log Cabin Quilt,* pieced, 19th century. New York, The Brooklyn Museum (*Brooklyn Museum*).

pled with the intentional omission of the names of those women artists, *even when they signed their work,* makes mockery of all pretensions that male "scholarship" is anything but a tool of sexist oppression.

Although women made quilts of wool and silk, the first for warmth, the second for beauty, most quilts were made of launderable fabrics called wash goods, primarily chintz and calico. Too much has been made of the fact that the fashions of a period were used in quilts, thus implying that women were the passive agents between fashions and quilts. Aside from the fact that this is not the whole truth (women also dyed and traded fabric), no

such interpretation has been given to the work of male painters, whose art has also been influenced by the mediums and pigments "in style" during that period. Quilts were made in three ways: pieced, appliqué, or by the use of quilting stitches alone on a solid color background. The majority of them were "pieced" for economic reasons; small pieces of fabric were joined edge to edge to make up a top of a single layer of fabric [3 and 4]. The process of piecing makes curved designs very difficult as the fabric has to be joined on the bias and tends to pucker, so most pieced quilts have straight edge designs founded on squares, triangles or diamonds [5]. Appliqué

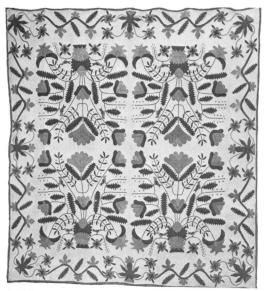

6. Unknown woman, *Little Birds* (variation of Tree of Life motif), yellow, brown, and green appliqué on homespun linen, Ohio, 1830. Shelburne, Vermont, The Shelburne Museum (*Shelburne Museum*).

quilts are actually called "patchwork," but since this word has also been used as a general term for all quilts, I'll use the more specific word "appliqué." They were designed by laying the cut out shapes of fabric on a base of new fabric and hemming them down [6], thus making a double layer of fabric—a clear extravagance and one which accounted for the fact that appliqué didn't come into wide use for quilts until approximately 1750 when fabric wasn't so scarce, although pieced quilts were made by the first female immigrants. Women quilt makers preferred their appliqué quilts to their pieced ones because hemming down allowed them greater freedom of design than piecing, and because the additional expense of the extra fabric for appliqué called for their very best needlework and design. These are the ones that women considered their "best" quilts, and which, although many fewer of them were made, have survived in larger number because of their "show," rather than "everyday," use. Because

of the greater freedom of the appliqué technique, women created hundreds of new designs, most based on natural forms, especially the flowers they loved. Solid-color quilts, usually white, were designed only in stitchery called quilting. Their beauty comes from the low relief of the top created by thousands of tiny stitches, stuffing some areas and flattening down others [7].

Besides the top designed layer, quilts have two other layers—the padding for warmth and the backing. All three layers are held together by the "quilting," that is, the tiny stitches which go through all three layers and contribute the lights and rhythms of their own design to the quilt.

Quilts as they were first made in America were the product of necessity as well as tradition. Factory-made blankets were unavailable until the mid-nineteenth century; fabric was scarce and expensive, and winters were cold. Women had to reuse every available scrap from worn-out clothing in their quilts, lining them with worn-out homespun blankets, wool, cotton or rags, and backing them with muslin or homespun. Before 1750, quilting

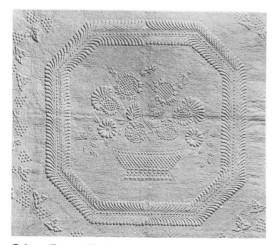

7. Lucy Foote, All-white trapunto coverlet, center detail, Colchester, Connecticut, 1816. Stamford, Connecticut, The Stamford Historical Society (*Stamford Historical Society*).

was the universal form of needlework in America, practiced in all households, by all females old enough to hold a needle. Even after economic circumstances eased somewhat, girls were still taught to sew even before they were taught to read—there are many beautiful quilts made by girls younger than ten years old.

Although American women, including slave women, made quilts from colonial times at least until the 1876 Centennial (and many still do), that was merely one of their duties, and their accomplishments should be seen against the sum total of their work. For most of the Colonial period, and in rural areas up to and even after the Civil War, women were responsible for an amount of work hardly to be believed: besides cooking and cleaning and raising and educating children they spun, wove and dyed cloth, made the clothing and bedding, curtains and rugs for the entire family, canned the food, milked cows, tended garden and chickens and made soap and candles. With the rise of industrialization in the Northeast it is not surprising that single women in large numbers left the farms for the relatively easy life of a twelve-hour day in the factories. Making quilts, though a necessity, was virtually the one area in which women could express themselves creatively—a woman worked on her quilt in the evenings after she had done the day's chores. The importance of quilts in women's lives is best expressed in the statement of one nineteenth-century farm woman who is quoted as saying, "I would have lost my mind if I had not had my quilts to do."[3]

All three arts, piecing, appliqué and quilting, are extremely ancient and can be traced to Syria, Egypt, India and China. Flags are piecework (remember Betsy Ross?) and quilted bed coverings were made by Chinese and East Indian women in the seventeenth century as well as by the women of Europe.[4] The tradition as well as quilts themselves came to America with the first women immigrants,

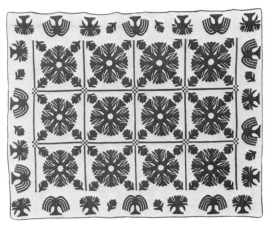

8. The grandmother of Virginia Kearney, *Willow Oak Quilt*, navy blue and white appliqué, Boston, before 1861. Shelburne, Vermont, The Shelburne Museum (*Shelburne Museum*).

and several early designs exist which are identical to those done in England. Gradually, however, women began to redesign their quilts and create new patterns, so that eventually more quilt designs were created in America than in all of Europe put together. In particular, the repeat patterns of the appliqué quilts became peculiarly American [8], as did the institution of the Quilting Bee and the custom of creating quilts for special occasions. Although most writers on quilts remark on the change in design from Europe to America, no one has pursued it further than to attribute it to some mystical "spirit of freedom" in the new land.[5] I think a more down-to-earth explanation exists—the same explanation that has accounted for every change in all of art history: namely, that when there is contact with new design traditions, art changes.

Early American immigrants came from England, Ireland, Germany, and the Netherlands and mingled the needlework traditions of those countries. In America, they met with new design traditions from the various American Indian tribes whose influence is obvious in the many quilts named for them: *Indian*

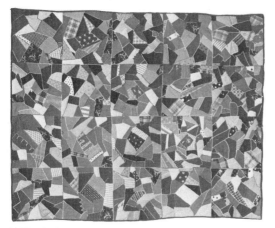

9. Elizabeth Ann Cline, *Crazy Quilt,* silk and velvet,
1875. Denver, Colorado, The Denver Art Museum
(*Denver Art Museum*).

Meadow, Indian Hatchet, Indian Trails, to
name a few. The familiar saw-tooth pattern,
for example, seen in both pieced and appli-
qué quilts, is strikingly similar to Indian
women's weaving. Furthermore, intermar-
riage between Indian women and white men
was fairly common, and the Indian women
and their female descendants' quilts would
bring together design influences from both
cultures.[6]

The other unacknowledged (for much the
same reasons) design influence on American
quilts I feel came from African women, who
actually made many of the Southern quilts,
particularly at the large plantations where
many bedrooms necessitated many quilts. It
is too great a coincidence that the South was
the "home" of appliqué quilts, while many of
the quilt makers in the South were from Da-
homey where much beautiful appliqué was
made. I think it should be acknowledged that
some of that "spirit of freedom" which en-
riched quilt design actually came from the
very women for whom the new land provided
not a spirit of freedom, but of tragedy.[7]

The earliest quilts made were known as
Crazy Quilts. Women sewed odd-shaped
scraps of fabric together with no attempt at

design, and the result tended to resemble a
jigsaw puzzle. Since they were utilitarian,
they mostly wore out and few have survived.
This Crazy Quilt was the basic quilt design.
Whenever times were lean and fabric scarce,
especially in rural communities far from
stores, women made crazy quilts. Years later,
in the late nineteenth century, after the Civil
War and the Centennial celebration, there
again came a vogue for them, now made not
of the crude scraps and patches of earlier
days, but of velvets and silks, scraps from
"best" clothing, and of a size meant not for a
bed, but for a parlor throw [9]. By a change of
fabric and size, the content of the quilt as art
changed from the hardship and poverty of the
earlier period to a more relaxed evocation of
the past—a poetic reminiscence.

It is interesting to note that there are few
quilts, even among the crazy quilts, totally
lacking in a sense of design, for almost imme-
diately women began the process of making
their quilts beautiful as well as useful. With
the same poverty of means, but the addition
of a sense of design, women began to cut
their scraps into patches of uniform size and
shape (the *Hit an' Miss* pattern), or to sew all
the light-colored ones into one strip, the dark
ones into another and alternate the stripes
(the *Roman Stripe* pattern). These are "one-
patch" patterns, in which there is no organi-
zation into a series of blocks to form the de-
sign. An example is the *Mosaic* pattern,
another early design brought from England.
Later called *Honeycomb* or *Grandmother's
Flower Garden* [10], it consisted in cutting
the points off a square to form an octagon.
Pieced quilts evolved from the one-patch
through two-, three-, and four-patch and then
nine-patch [10], depending on how many
pieces the original square was divided into.
As the quilt designs evolved, women went to
greater pains to have their quilts fulfill their
conceptions: they traded fabric scraps with
other quilt makers, dyed some to obtain the
shades they wanted, and embroidered on the

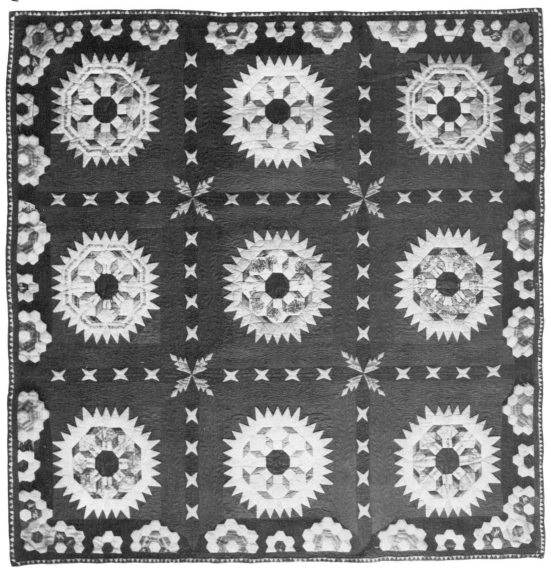

10. Zubie Cole Spaulding, *Sunburst and Grandmother's Flower Garden,* brown and gray silk, pastel cottons, feather quilting, Bloomington, Illinois, 1849. Denver, Colorado, The Denver Art Museum (*Denver Art Museum*).

plain homespun if that was all they had. Women became the artists in a society in which their efforts were likely to be the only art that most of the populace saw, certainly the only art most of them possessed. Although these quilts didn't look anything like the European-influenced painting done in America at the time, a period of over two hundred years of exposure to this women's art, on *permanent* exhibition in most households of America, finally influenced the male artists of today to work in a similar style.

Although pieced quilts are primarily geometric in design, and as such could be considered only in formalist terms, that would be only half the story. All quilt designs were named by the maker. If other women liked the name and used it, it became traditional. The names of the quilts give rich insights into the lives of the women who made them, and their lives give insight into the content that the design elements held for them. A repeat pattern of cubes in space, for example, was known as *Baby's Blocks.* The fact that it is more common for contemporary male artists to call this type of design by a scientific or mathematical name merely points up the different content this visual symbol evokes in different lives. There are hundreds of names for quilt designs, and often women changed the names, discarding the old ones as the visual image it evoked became irrelevant to their lives. In this way, they gradually transformed both the names and designs of the European tradition until they had built a new American one.

For example, a design known in England as *Prince's Feather* (after the Prince of Wales) became *Princess Feather* on arrival in America and afterwards became *Ostrich Plume* or *California Plume.* A pattern called *Jacob's Ladder* before the American Revolution was later called *Stepping Stones* in New England and Virginia, *The Tail of Benjamin's Kite* in Philadelphia, the *Underground Railroad* in Western Reserve, *The Trail of the Covered Wagon* in Mississippi and, after the first commercial railroad (1830), an unknown woman included a striped railroad symbol and called it *Railroad Crossing.*

It must be understood that quilt names were generic rather than specific; that is, although the image was recognizable within the visual vocabulary of women, it was rarely if ever exactly the same as to size, style and color. When the additional design elements which make up the quilt are considered, such as borders, choice of fabric (color, pattern,

weave) and the quilting itself, it is clear that two identical quilts would be even rarer than two identical paintings.

In designing their quilts, women not only made beautiful and functional objects, but expressed their own convictions on a wide variety of subjects in a language for the most part comprehensible only to other women. In a sense, this was a "secret language" among women, for, as the story goes, there was more than one man of Tory political persuasion who slept unknowingly under his wife's *Whig Rose* quilt. Women named quilts for their religious beliefs, such as *Star of Bethlehem* or *Job's Tears,* or their politics—and at a time when women were not allowed to vote. The *Radical Rose* design, which women made during the Civil War, had a black center for each rose and was an expression of sympathy with the slaves. Other political quilts had names such as *Lincoln's Platform, Clay's Choice, The W.C.T.U.* or *Union Star.* In fact a quarrel broke out between the Whigs and the Democrats in Pennsylvania in 1845 as to a certain Rose design claimed by both parties. Other quilt names expressed the farm lives of their makers, such as *Corn and Beans, Toad in the Puddle* or *Flying Bats,* or their urban lives as in *Philadelphia Pavement* or *Court House Square.* In fact, from their social life (*Swing in the Center*) to their flower gardens (*Rose of Sharon* or *North Carolina Lily*) to occupations (*Churn Dash, Chips and Whetstones*) or themselves (*Fanny's Fan, My Mother's Star*), there is virtually nothing in the lives of these women that did not get expressed in quilts; but the most popular motifs always remained Sun, Rose and Star designs [11].

There are several categories of quilts, each of which was made for specific occasions and in a definite way.

There was the Bridal Quilt, begun after a young woman's engagement had been announced. By the time she was engaged a woman had customarily completed twelve

quilt tops, which were then quilted up before her marriage, as the expense of padding and backing would only be undertaken when a new household was in preparation. The thirteenth, the Bridal Quilt, was the equivalent of the male guild custom of the "masterpiece," particularly when one considers that marriage was virtually the only employment available to women at that time. This quilt was made of the best materials she could afford, her most skilled and intricate needlework, with the most carefully planned design. The *Rose of Sharon* was the most favored design for the Bridal Quilt because of these lines from the *Song of Solomon* (2:1), which every woman knew, and which seemed to them particularly appropriate for brides:

I am the Rose of Sharon, And the Lily of the
 Valleys.
As the Lily among thorns, so is my love among the
 daughters.
As the apple tree among the trees of the wood, so
 is my beloved among the sons.

Bridal Quilts were used after the wedding only on special occasions or for honored guests, and have frequently come down to us without ever having been laundered. They were virtually always appliqué, and it was customary to incorporate hearts either into the appliqué or in the quilting. But it was considered bad luck for a woman to use hearts in a quilt before her engagement had been announced.

 Freedom, Friendship Medley and Presentation Quilts were the only quilts made by more than one woman and accounted for a small percentage of quilts made, although they have become quite well known. The Freedom Quilt was made for a young man on his twenty-first birthday by all his female friends at a party arranged by his mother and sisters—a custom popular until approximately 1825. Each woman would bring fabric scraps from her own dresses, and at the party make and sign a block of her own design. By

11. Charlotte Jane Whitehill, *Spice Pink,* also called *Whig Rose,* cotton appliqué, feather and diamond quilting, 1932. Denver, Colorado, The Denver Art Museum (*Denver Art Museum*).

the end of the day, all the blocks had been made and set together into the top; it would take another all-day event, the "Quilting Bee," to quilt it. The significance of the twenty-first birthday was that a young man was legally free at that age, whereas previously his labor and wages legally belonged to his father. There was no Freedom Quilt for women since their labor legally belonged to their father until marriage and afterwards to their husband. The term "Freedom Quilt" acquired another meaning around the time of the Centennial when the nation celebrated its survival through the Civil War, an end to slavery, and an end to the troubles and uncertainties of the first hundred years. These later Freedom Quilts, made by individual women, were another example of political quilts and incorporated symbols such as eagles, flags, stars and liberty bells into the designs.

 Friendship Medley Quilts and Presentation Quilts were made in the same way as Freedom Quilts, and became popular around

12. Mary Everist, *Friendship Medley Quilt*, Cecil County, Maryland, ca. 1849–50. Baltimore, The Baltimore Museum of Art, Gift of Dr. William Rush Dunton, Jr. (*Baltimore Museum of Art*).

1840. When a woman became engaged to marry, a friend usually gave a party at which all her friends brought fabric from one of their dresses and made her a Friendship Medley top [12]. Custom dictated that the young woman's mother invite all the participants to a return party at which the actual quilting was done. Friendship Medley quilts were also made for neighbors in distress, and for neighbors moving away. When it was made to honor a respected member of the community, it was called a Presentation Quilt.

Album Quilts were similar to the various kinds of Presentation Quilts in that each block was different. Album Quilts were made by individual women, however, and had a theme—birds or flowers, for example. The Friendship Quilt (different from the Friendship Medley) was a type of Album Quilt, each block being made of the dress material of a female friend, although all the blocks had the same design and maker. Quilts were also made that recorded the family history (Fam-

ily Record Quilts) with blocks showing family members, pets, their home, and so on.

Finally, there were the somber Memory or Mourning Quilts pieced from the dresses of a friend or relative who died. In the center of these quilts the woman-maker would cross-stitch an inscription with the name, date of death and perhaps a poem. The period during and after the Civil War is characterized by a great number of Mourning Quilts, in blacks, grays and browns, with the quilting done in the design of a weeping willow tree. The Widow's Quilt [13] is a variation on the Mourning Quilt, as it is for a man's death. Designed for a single bed, its black motifs signify the "Darts of Death," and the quilting is in the shape of lyres.

From the above descriptions of quilts, it should be obvious that the use of material having an emotional significance in addition to the formal characteristics of color, shape and design added a spiritual and emotional dimension to the quilts as art which is miss-

ing from most art today, and which modern formalist criticism attempts to define as "non-art." But to the early quilt makers, this dimension was an *essential* part of the art. Aunt Jane of Kentucky expressed this feeling when she said, "There is a heap of comfort in making quilts, just to sit and sort over the pieces and call to mind that this piece or that is of the dress of a loved friend."[8]

The "Quilting Bee" as an American institution is well known, but most Americans have a false idea of its nature. An examination of myths usually reveals, not the reality of the situation, but what the society feels the reality should have been (witness the Noble American Cowboy myth). In view of the male lie that women lack individuality, creativity and initiative, it is not surprising that the Quilting Bee has become in the popular mind the place at which women all collaborated on the making of the quilt. In actuality, Quilting Bees were called for the purpose of assisting an individual quilt maker in the tedious work of quilting the top, which she had already made. Even the design of the quilting stitches was chosen in advance by the maker of the quilt. The various kinds of Presentation Quilts which were a composite of individually produced, designed and signed

blocks were the only exception to the individual nature of quilt making, and the number of quilts so produced was a tiny percentage of all the quilts made. Interestingly enough, male artists who have had assistants for the routine aspects of their creativity (and whose numbers stretch throughout art history) have never been popularly stereotyped as lacking in *individual* creativity because of it. For the American quilt makers, even the *choice* of assistants was an individual choice, made on the basis of craftswomanship—invitations to Quilting Bees only went out to expert needlewomen—and it was common knowledge that those who were not expert with their needles had little access to the major institution of women's social life. Moreover, there are many stories of women whose stitches were uneven being sent to help in the kitchen, or of the quilt maker herself ripping out poorly done work and redoing it. In other words, the part played by collectivity in the quilt-making art had more in common with traditional methods of art-making than with mythological interpretations of women by nature being prone to collective art production.

The Quilting Bee was an all-day affair, lasting from dawn to late in the evening. It was

13. Unknown woman, *Widow's Quilt,* black and white pieced quilt, New Jersey, 19th century (*American Museum in Britain*).

second only to church in social importance to women, and they probably enjoyed it more. In a time of bad roads and poor transportation, women frequently went for long periods without seeing each other, each isolated in her own house. A letter from a woman in Ohio dated February 7, 1841, says:

We have had a deep snow. No teams passed for over three weeks, but as soon as the drifts could be broken through, Mary Scott sent her boy Frank around to say she was going to have a quilting. Everybody turned out. Hugh drove on to the Center where he and several other men stayed at the Tavern until it was time to come back to the Scotts for the big supper and the evening. . . . One of Mary's quilts she called "The Star and Crescent." I had never seen it before. She got the pattern from a Mrs. Lefferts, one of the new Pennsylvania Dutch families, and pieced it this winter. . . . Her other quilt was just an old-fashioned "Nine Patch.". . .[9]

It was customary to work all day, usually on two quilts, and then have husbands, brothers and friends in for supper and dancing. Although most of the records claim that women at the Quilting Bees "exchanged gossip and recipes," it should be obvious to women that that was not all that was going on. The fact that Susan B. Anthony made her first speech in Cleveland to women at a church quilting bee gives an indication that then, as always, women had important things to say to each other that could best be said out of earshot of men. I don't think it was coincidental that the Seneca Falls Conference of 1848, which marked the beginning of an organized American Women's Liberation Movement, came at the virtual height of the quilt-making period, nor is it coincidental that the size of the quilting party (eight to sixteen women) coincides exactly with the size of modern consciousness-raising groups.

Quilting itself was done by stretching the lining, padding and top on a horizontal wooden frame. The design was marked with chalk or pencil, after which eight women, two at each side of the frame, would stitch along the chalked outline of the motif through all three layers. Besides the functional purpose of holding the lining in place, the stitching has the aesthetic function of throwing the top of the fabric into low relief through the manipulation of lights and shadows by the thousands of tiny stitches. Thick quilts called comforters or winter quilts were tied with little snips of yarn at intervals because the padding was too thick to be closely quilted, whereas counterpanes, particularly in the South, were not lined or quilted at all and served only an aesthetic function like the modern bedspread. A comparison between quilts and counterpanes, however, makes it obvious that the quilting changed more than the function of the quilt, but changed the character of the object as art besides. Quilts are more sculptural, "heavier" both actually and visually, and are visually more complex. The interaction of the patchwork design with the chiaroscuro of the quilting was of great concern to quilt makers and the choice of quilting stitch every bit as important as the patchwork design. Frequently there were several quilting designs in one quilt: one for the patches, one between the patches and one for the border. The quilt makers strove for balance; that is, opulent floral and arabesque designs usually had severe quilting, while simple designs had elaborate quilting. Quilting served to enhance and complement the design, not to overpower it. Quilting was generally of two varieties: plain (straight lines, either diamond shaped, diagonal or parallel) or fancy (either block or running). The block designs were clam shells, wreaths, eagles, weeping willows, et cetera, and the running included vines, ropes, feathers [10]. Quilting designs could be traced from patterns or invented by the maker. In any case the combination and disposition of the quilting, as well as the quality, was one of the important design elements in the quilt.

Because quilts are women's art, the literature and history concerning them has been

written in the peculiar way familiar to all women artists. They are omitted from all general reference within the history of art, and they have no "place" in art history. They are not included in books on American art, and they have even been excluded from works that supposedly deal with decorative and folk art.[10] "Professional" art historians have not written about them as art, but have used them to do endless chronicling of the history of English and American textiles— somewhat akin to a work on Rembrandt which focuses on his paints and mediums while quickly passing over the paintings themselves. Of the authoritative books on quilts, most are written by women with a sincere love of needlework and an appreciation of the value of the quilts as art, but without the art-historical background to place these women's accomplishments in an art-historical context. For example, I found not a single reference to the painting going on in America at the time the quilt-making art was at its height—an illuminating comparison which would show that the quilt makers anticipated modern painting by at least 150 years. William Dunton, the only male "authority," runs true to form and characterizes quilts as the work of "nervous ladies."[11] (Another man in the history of quilt making who runs to type is one Charles Pratt, who came to America in 1886 from England and promptly declared himself quilt-making champion of the world, having in his possession, he said, over two hundred letters of testimony proclaiming his [male] supremacy in this field.)[12]

Writers on quilts seem to feel the need to tell us that not all quilts were beautiful works of art, although the same could be said for any of the arts—if all bad paintings were held against that art, it would be immediately outlawed.

Although virtually every museum and historical society in America has a collection of quilts, most do not keep them on permanent exhibition, but in permanent storage. The of-

ficial explanation for this is that quilts cannot be displayed without damaging them, but this seems more like a rationalization than the truth when one reflects on the crumbling manuscripts, peeling paintings and other "man-made" artifacts museums manage to exhibit. Mrs. H. N. Muller of the Shelburne Museum in Vermont, one of the few museums in the country to display a large permanent exhibition of quilts, acknowledged in a letter to me the problems in displaying quilts, but added, "In our view, they do not serve anyone's purposes in continual storage—better to be seen and enjoyed."[13] Feminists desirous of ending this suppression of a female art form should make appointments with their museums, for themselves, their groups or classes, to view the collection (and complain vigorously to the public relations director if such appointments are not forthcoming). The pressure will eventually force the museums to put quilts on permanent exhibition.

The recent revival of interest in quilts by the Whitney and Smithsonian, which resulted in exhibitions of piecework quilts at both museums, on closer investigation reveals another phenomenon of which modern women artists are all too aware. That is, that although the sexist and racist art world will, if forced, include token artists, they will never allow them to *expand* the definitions of art, but will include only those whose work can be used to rubber-stamp already established white male art styles. Because our female ancestors' pieced quilts bear a superficial resemblance to the work of contemporary formalist artists such as Stella, Noland and Newman (although quilts are richer in color, fabric, design and content), modern male curators and critics are now capable of "seeing" the art in them. But the appliqué quilts, which current male artists have not chosen to imitate, are therefore just written off as inferior art. Throughout his catalogue essays for both exhibitions, Jonathan Holstein praises pieced

quilts with the words "strong," "bold," "vig-orous," "bravado," and "toughness," while he dismisses the appliqué quilts as "pretty," "elegant," "beautiful" but "decorative."[14] This is exactly the kind of phallic criticism women artists are sick of hearing and is made all the more ridiculous by the fact that wom-en actually made *both* types of quilts. The purpose in exhibiting *only* the pieced quilts becomes further apparent with the following statement from the Smithsonian catalogue:

The finely realized geometry of the pieced quilt, coupled with this sophisticated sense for the possi-bilities of color and form, produced such works which mirror in startling ways contemporary painting trends. We can see in many such phe-nomena as "op" effects, serial images, use of "color fields," a deep understanding of negative space, mannerisms of formal abstractions, and the like. Too much can of course be made of these resem-blances, to the confusion of the intrinsic merits of both the paintings and the quilts. They were not made as paintings, nor did the people who made them think of themselves as "artists."[15]

What Holstein has done here, with the blessings of both the Whitney and the Smith-sonian, is to turn history upside down and backwards. He has turned the innovators into the followers and used the quilts to legitimize contemporary formalist painting, while man-aging to dismiss these women as artists at the same time. It is a historic impossibility for art to "mirror" (note the passivity of the word) *forward* into time—when male artists are ahead of their time, they are called the "avant-garde." Similarly it is impossible for art to have the "mannerisms of formal ab-straction" before formal abstraction was de-veloped, let alone before its current descent into mannerism. This shabby motive for ex-hibiting only a certain style of quilts—distort-ing our heritage to prop up the sagging repu-tations of the modern formalist school of painting—is shown again in the Whitney catalogue, entitled *Abstract Design in Ameri-*

can Quilts, and dedicated to none other than Barnett Newman.[16]

Quilts have been underrated precisely for the same reasons that jazz, the great Ameri-can music, was also for so long underrated—because the "wrong" people were making it, and because these people, for sexist and racist reasons, have not been allowed to represent or define American culture. The definitive institutions of American culture, museums, schools and art history, are all under the con-trol of a small class of people, namely, white males, who have used their power to gerry-mander the very definition of art around the accomplishments of all those who are not white and male. Their terms "primitive art," "folk art" and "decorative art" reveal more about the prejudices of the art historians than about the art itself. Just as the old joke has New Yorkers drawing a map of America composed mostly of a huge Manhattan Island with the rest of the country squeezed down to minuscule size, so have white male art his-torians distorted the history of art to the point where the painting and sculpture done by white males over a five-hundred-year peri-od in a small section of the world—namely, western Europe—is the subject of intense and nauseating analysis and re-analysis while the entire rest of the *world* is lucky to get a chap-ter in their books or a course in their schools. The textile and needlework arts of the world, primarily because they have been the work of women, have been especially written out of art history. It is a male idea that to be "high" and "fine" both women and art should be beautiful but not useful or functional. The truth is that "high" art has always fed off the vigor of the "lower," "folk" and "primitive" arts and not the other way around. The Afri-can sculptors needed Picasso as little as the Japanese printmakers needed the Impression-ists or the American quilt makers need the Minimalists. In music it became an open scandal that while black jazz and blues musi-

cians were ignored, their second-rate white imitators became famous and rich. Feminists must force a similar consciousness in art, for one of the revolutionary aims of the women's cultural movement is to rewrite art history in order to acknowledge the fact that art has been made by all races and classes of women, and that art in fact is a human impulse and not the attribute of a particular sex, race or class.

What an unbiased study of American quilts shows is that when women artists were allowed to follow their own creative impulses, their work ranged over an enormous area. Their sense of color went from the palest pastel and all-white quilts, to the boldest and most vibrant colors, to muted earths and somber blacks. Not knowing women were supposed to favor delicate lyrical design, they were free to do that when they so desired, but also to work out the most precisely mathematical geometries or strongly rhythmic natural forms. They made political, personal, religious, abstract and every other kind of art. Women quilt makers enjoyed this freedom only because their work was not even considered art, and so they were exempt from the harassment experienced by most women artists. Left in peace, women succeeded on their own in building a design tradition so strong its influence has extended almost four hundred years and which must today be acknowledged as The Great American Art.

> Priscilla Halton's Work
> 1849
> Life looks beyond the hands of time
> Where what we now deplore
> Shall rise in full immortal flower
> And bloom to fade no more.
>
> —Inscription on a Friendship Quilt,
> Fulton, Lancaster County, Pennsylvania[17]

NOTES

Editors' note: Patricia Mainardi wrote this classic essay in 1972 and first published it in 1973. The fire and anger which animate it are accurate reflections of the mood of the time in which it was written. Five years later, in the preface to the expanded 1978 edition, Mainardi wrote of its style: "If it seems passionate, at times outrageous, well that's the way things were in the early seventies and Thank God for it. Had we been polite and mild-mannered then, things would be unchanged now."

1. As quoted by Carrie A. Hall and Rose G. Kretsinger, *The Romance of the Patchwork Quilt in America,* New York, 1935, p. 107.

2. See the Smithsonian Institution, *American Pieced Quilts,* Washington, D.C., 1972, p. 5. (Holstein responded to this in a later publication by suggesting that the signature, "E. S. Reitz," was a later addition referring to the owner rather than the maker of the quilt. See his *The Pieced Quilt: An American Design Tradition,* Greenwich, Conn., 1973, pl. 21.)

3. As quoted by Lydia Roberts Dunham, "Denver Art Museum Quilt Collection," *Denver Art Museum Quarterly,* Winter, 1963, p. 7.

4. It is outside the scope of this essay to deal with the history of these forms of needlework, but for an excellent account, read Marie D. Webster, *Quilts: Their Story and How to Make Them,* New York, 1915, pp. 3–60.

5. For a typical example of this "mystical" explanation, see Marguerite Ickis, *The Standard Book of Quilt Making and Collecting,* New York, 1959, p. 260.

6. Confirmation of this theory came from New York printmaker Eleanor Magid, the great-granddaughter of a Miami Indian woman, who has in her family many quilts made by her female ancestors.

7. For a discussion of quilts and weaving done by slave women on Southern plantations, see Judith Wragg Chase, *Afro-American Art and Craft,* New York, 1971, pp. 88–90. Many examples of their needlework are in the Old Slave Mart Muse-

um, Charleston, South Carolina. I am grateful to Faith Ringgold, artist and lecturer on Black Art, for informing me of the fact that many Southern quilts were made by slave women (including her great-grandmother, Betsy Bingham), and for helping me find the documentation for this fact. Although Dahomey appliqué was made by men, the technique and visual vocabulary were part of the culture.

8. As quoted in Hall and Kretsinger, *op. cit.,* p. 17.

9. As quoted in Ruth E. Finley, *Old Patchwork Quilts and the Women Who Made Them,* Philadelphia, 1929, p. 37.

10. See, for example, the book *The Arts in America: The Nineteenth Century,* by Wendell D. Garrett, New York, 1969, for a horrible example in which painting, sculpture, glass, silver, pottery, furniture, etc., are covered—but not one word about quilts.

11. William Rush Dunton, Jr., *Old Quilts,* Catonsville, Md., 1946, pp. 1, 3, 4.

12. See Hall and Kretsinger, *op. cit.,* p. 36.

13. From an unpublished letter to the author, December 12, 1972.

14. Smithsonian, *American Pieced Quilts,* p. 13, and Whitney Museum of American Art, *Abstract Design in American Quilts,* New York, 1971, p. 10. For a thorough analysis of how women's art is stereotyped, see Cindy Nemser's "Stereotypes and Women Artists," *The Feminist Art Journal,* 1, April 1972, p. 12. To that I would like to add, from my experience in researching this article, that sentence structure can be sexist, too: I found constant use of the passive tense in reference to quilts, e.g., "Quilts were made," "Quilting was done," "Names changed"—never *"Women* made quilts," *"Women* changed the names." There is also subtle sexism in the constant use of the word "pattern" instead of "design."

15. Smithsonian, *Pieced Quilts,* p. 13.

16. Another example of how art history can be twisted to uphold male supremacy in art is that recently, when great numbers of blankets woven by Navajo women were revealed to be in the collections of male artists, not one critic commented on the obvious derivation of the men's work. Their comments were on the same order as Holstein's: that the Navajo women really looked quite up to date compared to the "real" artists (the men), but no one should confuse them—because the women, of course, were not "real" artists. See Hilton Kramer, "How Primitive Is the Folk Art of the Navajos?", *The New York Times,* October 8, 1972.

17. Quoted by Florence Peto, *American Quilts and Coverlets,* New York, 1949, p. 32.

Notes on Contributors

SVETLANA ALPERS, who earned her Ph.D. in art history from Harvard University, is Professor of the History of Art at the University of California at Berkeley. She is a specialist in seventeenth-century art and the northern European tradition, with broad theoretical interests in the nature of art and its history. Alpers is the author of *The Decoration of the Torre de la Parada* (1971), a book on a series of Ovidian works by Rubens, and has written articles on Vasari's *Lives,* Bruegel, Rubens, realism, and the assumptions of the study of the history of art. She has recently completed a book on Dutch art entitled *The Art of Describing.* A recipient of fellowships from the American Association of University Women, the American Council of Learned Societies, and the Guggenheim Foundation, she has also been a Fellow at the Center for Advanced Study in the Behavioral Sciences at Stanford, at the Netherlands Institute for Advanced Studies at Wassenaar, and at the Institute for Advanced Study at Princeton.

NORMA FREEDMAN BROUDE (B.A., Hunter College; M.A. and Ph.D., Columbia University) is Associate Professor of Art History at The American University. She has also taught at Connecticut College, Vassar College, Oberlin College, and Columbia University. Broude is the editor of *Seu-*

rat in Perspective (1978), and the author of articles and reviews on the Italian Macchiaioli, Degas, Seurat, Picasso, and feminist art history, in journals that include *The Art Bulletin, Art Journal, Arts Magazine, Burlington Magazine,* and the *Gazette des Beaux-Arts.* She has been an officer of the Women's Caucus for Art and has served as its editorial correspondent to College Art Association publications. Currently, she is writing a monograph on the Macchiaioli under a grant from the National Endowment for the Humanities; she is also working with Mary D. Garrard, under a grant from the Department of Education, on a non-sex-biased general textbook for the history of art.

ALESSANDRA COMINI received her B.A. from Barnard College, her M.A. from the University of California at Berkeley, and her Ph.D. from Columbia University, where she taught for nine years. She has been a visiting professor at Yale and Berkeley, was the 1972–73 Alfred Hodder Resident Humanist at Princeton, and is currently Professor of Art History at Southern Methodist University. She has lectured extensively both in the United States and abroad on subjects ranging from the changing image of Beethoven to portraiture in the age of Freud. Her monograph *Egon Schiele's Portraits* (1974) was nominated for the 1975 Na-

tional Book Award and received the College Art Association's Charles Rufus Morey Book Award. Her most recent books are *Gustav Klimt* (1975) and *The Fantastic Art of Vienna* (1978).

CAROL DUNCAN was educated at the University of Chicago (B.A. and M.A.) and Columbia University (Ph.D.). She is a Professor of Art History in the School of Contemporary Arts at Ramapo College of New Jersey, and has also taught at Sarah Lawrence College, and as a visiting professor at the University of California at Los Angeles and at San Diego. Her work focuses on problems of ideology in art from the eighteenth century to the present. Duncan is the author of *The Pursuit of Pleasure: The Rococo Revival in French Romantic Art* (1976). She is an editor of *Socialist Review,* and a frequent contributor to journals such as *The Art Bulletin, Artforum, Art History,* and *Heresies.*

MARY DuBOSE GARRARD (B.A., Newcomb College; M.A., Harvard University; Ph.D., The Johns Hopkins University) is Professor of Art History at The American University. Her publications include articles and reviews in *The Art Bulletin, Art Journal, Burlington Magazine,* and the *Journal of the Warburg and Courtauld Institutes,* on Jacopo Sansovino, aspects of Renaissance sculpture, Artemisia Gentileschi, and feminist approaches to art history. Garrard was the second President of the Women's Caucus for Art, and has served as Chairperson of the College Art Association's Committee on the Status of Women. She was the editor of *Slides of Works by Women Artists: A Sourcebook* (1974). She is currently preparing a monograph on Artemisia Gentileschi; and, with Norma Broude, she is writing a non-sex-biased history of art textbook, under a grant from the Department of Education.

CHRISTINE MITCHELL HAVELOCK received her B.A. degree from the University of Toronto, and her M.A. and Ph.D. degrees from Harvard University. She is Professor of Art History at Vassar College, where she is also Curator of the Classical Collection and Director of the Women's Studies Program. Her published articles on Greek art reveal her special interest in archaizing revivals and their causes, and the impact of Greek sculpture and painting on the ancient spectator. She is the au-

thor of *Hellenistic Art* (1970), and she co-edited and contributed to *Communication Arts in the Ancient World* (1978).

FRIMA FOX HOFRICHTER earned her B.A. at Brooklyn College, her M.A. at Hunter College, and her Ph.D. at Rutgers University. She has taught at Princeton University, Rutgers University, and Marymount Manhattan College. Presently she is a curator at the Rutgers Art Gallery, where she is organizing an international loan exhibition. *Haarlem: The Seventeenth Century.* She has published articles in the *Feminist Art Journal* and the *Rutgers Art Review,* and her doctoral dissertation on Judith Leyster is currently being prepared for publication.

MADLYN MILLNER KAHR (B.A., Barnard College, Columbia University; M.A. and Ph.D., Institute of Fine Arts, New York University) has been Professor of Art History and Criticism at the University of California, San Diego, having taught also at Manhattanville College, Columbia University Graduate School, Queens College of the City University of New York, Stanford University, and the University of Texas, Arlington. She is the author of a number of articles, mainly concerned with sixteenth- and seventeenth-century European painting or with thematic problems, which have been published in scholarly journals in the United States and Europe, and of the books *Velasquez: The Art of Painting* (1976) and *Dutch Painting in the Seventeenth Century* (1978).

NATALIE BOYMEL KAMPEN (B.A. and M.A., University of Pennsylvania; Ph.D., Brown University) is Associate Professor of Art History at the University of Rhode Island. She is the author of *Image and Status: Representations of Roman Working Women at Ostia* (Berlin, 1981) and of articles on Roman sculpture, most recently in the *American Journal of Archaeology* and *L'Antiquité Classique.* She is currently at work on a corpus of Roman provincial historical reliefs and a study of the iconography of women's symbols on Roman funerary monuments. She has been involved in feminism, as both scholar and activist, since 1969, and teaches several courses in Women's Studies.

HENRY KRAUS (B.A., University of Chicago; M.A., Western Reserve University) is the author of several books on medieval art and architecture. These include *The Living Theatre of Medieval Art* (1967), *The Hidden World of Misericords* (with Dorothy Kraus) (1975), and *Gold Was the Mortar: The Economics of Cathedral Building* (1979). Kraus's study of the evolving position of women in medieval society as reflected in art was anticipated in his first book, *The Many and the Few* (1947), which dealt with a famous labor struggle in which women played an extraordinary role, the General Motors sitdown strike at Flint, Michigan. Similar interests characterized his second work, *In the City Was a Garden* (1951), an examination of an interracial housing project in San Pedro, California, where women once again took a major part. In both of these events that Kraus chronicled, he and his wife Dorothy were active as organizers and participants. They are currently working together on a study of fifteenth-century misericords in Oviedo Cathedral in Spain, to be published shortly.

NANCY LUOMALA received her B.A. from the University of Minnesota at Duluth, and her M.F.A. from Arizona State University, with concentrations in both studio art and art history. She is presently an Associate Professor of Art at Mankato State University, Minnesota, where she also served as Director of the Art Gallery from 1968 to 1971. Active in establishing the Women's Studies Program at Mankato State, she has taught a "Women in Art" course there since 1972, and has lectured widely throughout the upper Midwest on feminist topics in art and art history. In 1975 she served as Coordinator of the Smithsonian Institution's Bicentennial Inventory of American Painting for Southern Minnesota.

PATRICIA MAINARDI (B.A., Vassar College; M.F.A., Brooklyn College; M.A., Hunter College; M. Phil., City University of New York) was a founding member of Redstockings, a New York-based group of radical feminists instrumental in initiating the contemporary women's liberation movement. She is the author of "Politics of Housework," in Robin Morgan, ed., *Sisterhood Is Powerful* (1970). A founding editor of the *Feminist Art Journal*, Mainardi has also contributed articles and reviews to

many periodicals, including *Art News, Art in America,* and *Arts Magazine,* of which she is a Contributing Editor. She has taught at Brooklyn College and at the School of Visual Arts. Currently, she resides in Paris as a Chester Dale Fellow of the Center for Advanced Study in the Visual Arts, National Gallery of Art, Washington, D.C.

LINDA NOCHLIN (B.A., Vassar College; Ph.D., Institute of Fine Arts, New York University) is Distinguished Professor, The Graduate School and University Center, City University of New York, and was formerly Mary Conover Mellon Professor of Art History at Vassar College. Her publications include: ed., *Realism and Tradition in Art, 1848–1900* (1966); ed., *Impressionism and Post-Impressionism, 1874–1904* (1966); *Realism* (1971); ed., with Thomas Hess, *Woman as Sex Object, Studies in Erotic Art, 1730–1970* (1972); with Ann Sutherland Harris, *Women Artists: 1550-1950* (1976); and ed., with Henry Millon, *Art and Architecture in the Service of Politics* (1978). She has contributed numerous articles and reviews to such journals as *The Art Bulletin, Art News, Art in America, Art News Annual,* and *Arts Magazine.* Nochlin has served as Chairperson of the College Art Association Committee on the Status of Women, and on the editorial board of *The Art Bulletin.* In 1967 she was awarded the C.A.A.'s Arthur Kingsley Porter Prize for the best article in *The Art Bulletin,* and in 1977, its Frank Jewett Mather Prize for critical writing.

VINCENT J. SCULLY, JR. (Ph.D., Yale University) is Professor of the History of Art at Yale University. Noted as a teacher and as an architectural historian, he is the author of *The Shingle Style and the Stick Style: Architectural Theory and Design from Richardson to the Origins of Wright* (1955; rev. edn. 1971), *Frank Lloyd Wright* (1960), *Louis I. Kahn* (1962), *The Earth, the Temple, and the Gods: Greek Sacred Architecture* (1962; rev. edns. 1969, 1979), *American Architecture and Urbanism* (1969), *Modern Architecture: The Architecture of Democracy* (rev. edn. 1974), and *The Shingle Style Today; or, the Historian's Revenge* (1974).

CLAIRE RICHTER SHERMAN (B.A., Radcliffe College; M.A., University of Michigan; Ph.D., The Johns Hopkins University) is a medievalist, and author of

The Portraits of Charles V of France (1338–1380) (1969) and of various studies of the iconography and library of this bibliophile king. She is the editor, with Adele M. Holcomb, of the collective biography *Women as Interpreters of the Visual Arts (1820–1979)* (1981), to which she also contributed several chapters. Sherman has taught at the University of Michigan, The American University, and the University of Virginia. For 1981–82 she was appointed a Senior Fellow at the Center for Advanced Study in the Visual Arts at the National Gallery of Art, Washington. She is currently writing a monograph on illustrations of Aristotle's *Ethics* and *Politics* in French manuscripts of the fourteenth and fifteenth centuries.

Index